Psychomotor Aesthetics

Psychomotor Aesthetics

Movement and Affect in Modern Literature and Film

ANA HEDBERG OLENINA

OXFORD

UNIVERSITY PRESS

OXFORD
UNIVERSITY PRESS

Oxford University Press is a department of the University of Oxford. It furthers
the University's objective of excellence in research, scholarship, and education
by publishing worldwide. Oxford is a registered trade mark of Oxford University
Press in the UK and certain other countries.

Published in the United States of America by Oxford University Press
198 Madison Avenue, New York, NY 10016, United States of America.

Library of Congress Cataloging-in-Publication Data
Names: Olenina, Ana Hedberg, author.
Title: Psychomotor aesthetics : movement and affect in modern literature
and film / Ana Hedberg Olenina.
Description: New York : Oxford University Press, 2020. |
Includes bibliographical references and index.
Identifiers: LCCN 2019053076 (print) | LCCN 2019053077 (ebook) |
ISBN 9780190051259 (hardback) | ISBN 9780190051266 (paperback) |
ISBN 9780190051280 (epub) | ISBN 9780190051297 (online)
Subjects: LCSH: Psychophysiology and the arts. | Audiences—Psychology. | Modernism.
Classification: LCC NX180.P79 O44 2020 (print) | LCC NX180.P79 (ebook) |
DDC 700.1/9—dc23
LC record available at https://lccn.loc.gov/2019053076
LC ebook record available at https://lccn.loc.gov/2019053077

1 3 5 7 9 8 6 4 2

Paperback printed by Marquis, Canada
Hardback printed by Bridgeport National Bindery, Inc., United States of America

Contents

Acknowledgments

Writing this book has been a journey in all senses of the word, and I am humbled to recognize the networks of support that came together to stimulate its progress: from friendships and intellectually enriching partnerships to grants and institutional affiliations that enabled me to pursue my research.

This project first began to take shape, conceptually and methodologically, in my doctoral program in Comparative Literature and Visual and Environmental Studies at Harvard University. Giuliana Bruno, Yuri Tsivian, and the late Svetlana Boym were its first overseers, and I am profoundly grateful for their generosity and expert guidance. Workshops led by William Todd, Eric Rentschler, and John Hamilton helped me polish the arguments of my first chapters. The publication of this book has been subsidized in part by Harvard Studies in Comparative Literature.

Further research for this project was made possible by the American Council of Learned Societies Research Fellowship, the University of North Carolina Wilmington Charles L. Cahill Research Award and Summer Research Grant, and travel grants from the Melikian Center for Russian, Eurasian and East European Studies at Arizona State University.

The Film Studies Department at the University of North Carolina Wilmington provided a lively, nurturing environment for exploring the intersections of film history, theory, and cinematic practice, and I treasure the memories of conversations with Todd Berliner, Mariana Johnson, Carlos Kase, Tim and Liza Palmer, Andre and Shannon Silva, Sue and Stephanie Richardson, Nandana Bose, Terry Linehan, Pat Torok, and Dave Monahan.

At Arizona State University's School of International Letters and Cultures, I have found a home for my interdisciplinary research interests. I am deeply grateful to the School's Director, Nina Berman, for her gracious support and mentorship. The founding chair of ASU's Center for Film, Media and Popular Culture, Peter Lehman, and his wife, Melanie Magisos, have fostered a community of early cinema aficionados in Phoenix, and I have been privileged to be a part of this passionate and intellectually stimulating group. ASU's Institute for Humanities Research, and particularly, Sally Kitch and Cora Fox, have encouraged me to consider the implications of my historical inquiry for contemporary neurocognitive approaches to aesthetics, opening a productive new direction for my work. Keith Brown, Stephen Batalden, David Brokaw, and the late Mark von Hagen at ASU's Melikian Center for Russian, Eurasian and East European

Studies have shown unwavering support for my research and programming of cultural events. I also wish to thank my ASU colleagues Hilde Hoogenboom, Saule Moldabekova Robb, Don Livingston, Danko Sipka, Christopher Johnson, Dan Gilfillan, Mark Cruse, Francoise Mirguet, Jiwon Shin, Xiaoqiao Ling, Young Oh, Steve West, Joanne Tsao, Steve Bokenkamp, Rob Tuck, Ebru Turker, Eiji Suhara, Aaron Baker, Kevin Sandler, Jason Scott, and Elena Rocchi. A grant from ASU's Barrett Honors College has allowed me to engage Robert Brown as my research assistant—his meticulous attention to detail has streamlined the book's bibliographic apparatus.

I have had the privilege of sharing my book research in several lecture events and symposia at the Freie Universität Berlin, the Russian Cinema Research Group at the University College London, Monash University Prato Centre, Princeton University, The University of Arizona, and the Institut national d'histoire de l'art in Paris. I would like to extend my sincere gratitude to the organizers Elena Vogman, Ekaterina Tewes, Rachel Morley, Phil Cavendish, Julia Vassilieva, Serguei A. Oushakine, Liudmila Klimanova, Ada Ackerman, and Antonio Somaini for their invitations and the feedback that I received from the passionate, brilliant audiences they had brought together. At various stages of this project, I had a chance to discuss my research with scholars Caryl Emerson, Michael Wachtel, Maria Gough, Michael Cowan, Emma Widdis, Lilya Kaganovsky, Joan Neuberger, Naum Kleiman, Vera Roumiantseva, Nikolai Izvolov, Ekaterina Khokhlova, Irina Schulzki, Barbara Wurm, Anna Toropova, Natalie Ryabchikova, Svetlana Ishevskaya, Susanna Weygandt, Rossen Djagalov, Kyohei Norimatsu, Muneaki Hatakeyama, and Maxim Pozdorovkin. I am most grateful for their collegiate support, intellectual challenges, and bibliographical recommendations that became crucial for my work. My deepest gratitude also goes to Valeriy Zolotukhin and Witalij Schmidt for referring me to valuable materials related to the history of oral verse recitation studies in Russia, as well as to Irina Sirotkina for answering my many questions on Russian performance culture. It goes without saying that all errors and inadvertent misinterpretations are entirely my own.

In preparing the illustrations for this book, I have relied on the generosity of private archive owners Aleksandr Lavrent'ev, Natal'ia Galadzheva, Sophia Bogatyreva, Elena Radkovskaia, and Aleksandra Radkovskaia, as well as the helpful, considerate service of the staff at the Russian State Archive of Literature and Arts (RGALI), the State Museum of V.V. Mayakovsky, the State Central Film Museum in Moscow, the U.S. National Library of Medicine, the Harvard University Archives, Cambridge University Library, Columbia University Library, and F.I.L.M. Archives Inc., New York.

Above all, I wish to thank my family for their patience, curiosity, humor, and gentle encouragement. I owe my interest in the history of science to my parents,

Sergei and Irina Olenin. Growing up in a home of biologists, one of my earliest childhood fascinations was poring over images in scientific books in our home library, from contemporary photographs of the nervous systems of invertebrates captured via electronic microscopy, to historical gems such as Ernst Haeckel's sublimely symmetrical drawings of living beings. Deciphering methods of representation has been my passion ever since. My brother Aleksej was a brilliant, joyous presence on these childhood explorations and a perceptive critic of my works as a young adult. I will forever hold his memory in light. My in-law family, Steve and Melida, Gina and Rob, and their daughter Lily, have shown me nothing but kindness over the years. My ultimate words of thanks go to my husband, Will Hedberg, and our son, Alan, for being the beacon of inspiration in this world for me.

Portions of this book have appeared in an earlier form in the following publications: "Embodying the Literary Form: Approaches to the Corporeal Aspects of Poetry in the Works of Russian Formalists at the Institute of the Live Word and Beyond," in *Zhivoe slovo: Logos, golos, dvizhenie, zhest*, ed. Vladimir Feshchenko (Moscow: Novoe Literaturnoe Obozrenie, 2015), 456–480; "Engineering Performance: Lev Kuleshov, Soviet Reflexology, and Labor Efficiency Studies," *Discourse: Journal for Theoretical Studies in Media and Culture* 35.3 (2013): 297–336; "Partitury dvizhenia: Kak ni stranno, o psikhologii naturshchika u Kuleshova," *Kinovedcheskie zapiski* 97 (2011): 20–50; "The Doubly Wired Spectator: Psychophysiological Research on Cinematic Pleasure in the 1920s," *Film History: An International Journal* 27.1 (2015): 29–57; and "A Case for Neurohumanities," *In the Moment*, an online blog of *Critical Inquiry*, September 2017, https://critinq.wordpress.com/2017/09/I. They are used in this book with the publishers' permission.

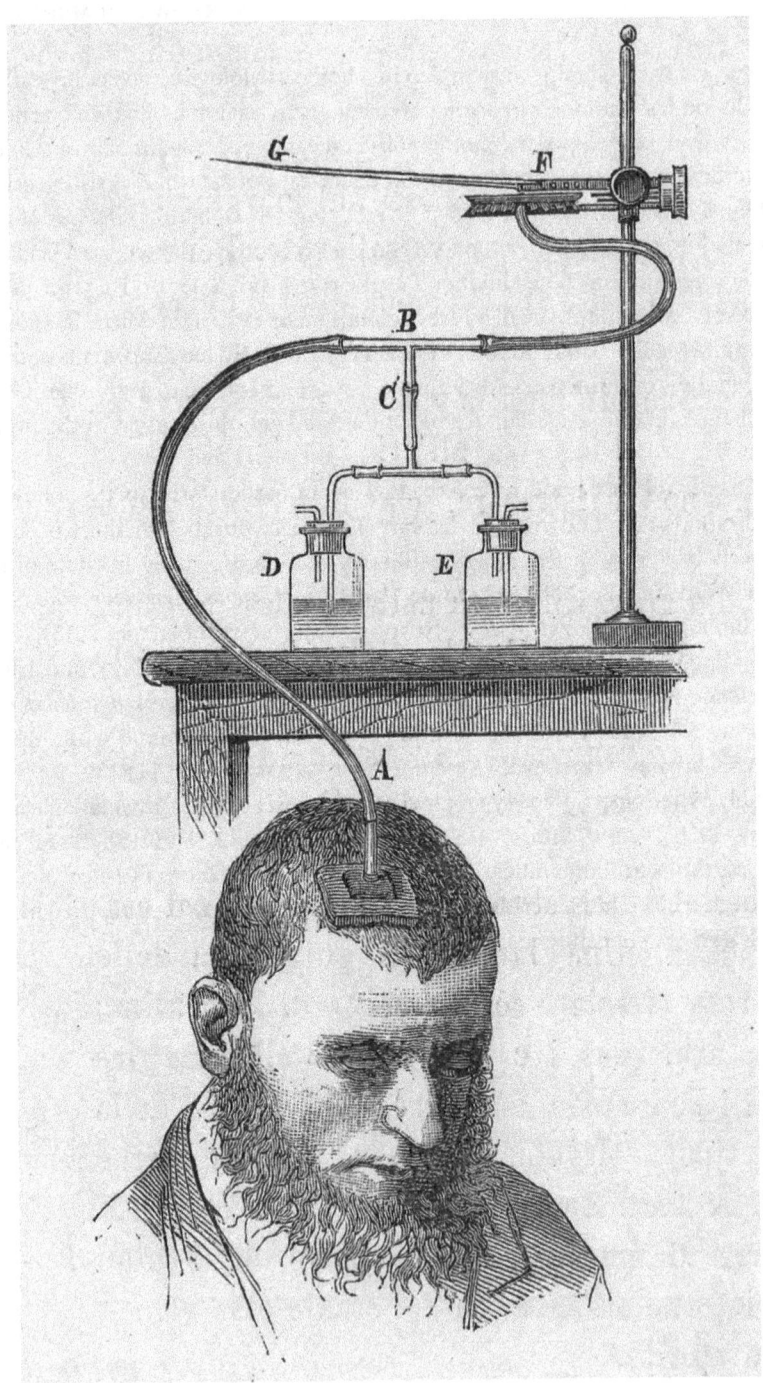

Fig. I.1 An apparatus for the recording of "cerebral pulse," used by the Italian scientist Angelo Mosso to detect fluctuations in blood flow as his patent completed various mental tasks. Image source: Angelo Mosso, *Sulla Circolazione del Sangue nel Cervello dell'Uomo: Ricerche Sfigmografiche* (Rome: Coi tipi del Salviucci, 1880), 12. Scan courtesy U.S. National Library of Medicine.

Introduction

> primeval physiological processes, governed by the rhythm of blood
> circulation evoke in us an urge for action; we extrapolate this tempo
> of our blood onto the creation of images.
>
> —Andrei Bely[1]

Psychology as a modern discipline emerged in the late 19th century, as it dis-
sociated itself from philosophy and turned toward the natural sciences. A key
step in this transformation was the abandonment of the notion of the soul in
favor of neurophysiological approaches to the study of the mind and beha-
vior. As William James, the father of American psychology, put it in 1890, the
soul should be thought of as "a medium upon which . . . manifold brain-pro-
cesses combine their effects."[2] He insisted that only this "psycho-physic for-
mula," which postulates a correlation between states of consciousness and the
activity of the nervous system, opened viable research directions for a science
that sought to remain "non-metaphysical and positivist."[3] Wilhelm Wundt in
Germany was one of the central figures in the international effort to elaborate the
scientific foundations of psychology. He argued that the widely accepted method
of self-observation was insufficient, because one cannot reach out to areas in-
accessible to conscious thought. To supplement introspection, Wundt devised
laboratory procedures for examining the elemental functions of the mind and
introduced usable definitions for stimulus and reaction. He measured the speed
of subjects' response, thus assessing the spread of innervation from nerve centers
to muscle tissues. For the first time, the notoriously fleeting, nebulous, and un-
accountable life of the psyche appeared to be visible, measurable, and analyzable.
Experimental laboratories probed into the mechanisms of perception, cogni-
tion, memory, and affect, decomposing these complex psychological faculties
into constituent parts and investigating their material substrate. The French
neurologist Jean-Martin Charcot photographed the spasms and paralyses of

[1] Andrei Bely, "Emblematika smysla (1904)," in *Simvolizm kak miroponimanie*, ed. L. A. Sugai
(Moskva: Respublika, 1994), 25–82, 66. All translations are mine, unless otherwise noted - A.H.O.
[2] William James, *The Principles of Psychology*, vol. 1 (New York: H. Holt and Co., 1890), 181.
[3] Ibid., 182.

Psychomotor Aesthetics. Ana Hedberg Olenina, Oxford University Press (2020). © Oxford University Press.
DOI: 10.1093/oso/9780190051259.001.0001

hysterical patients as indices of their interiorized traumas.[4] The Italian Angelo Mosso measured the increase of the blood flow to the brain when the subject completed mental tasks (Fig. I.1).[5]

The institutionalization of physiological psychology created a discursive space for interpreting corporeal symptoms as indicative of inner processes. Laboratories developed instruments, procedures, and modes of representation that focused on patterns of muscular contractions and changes in vital signs as markers of nervous activity. In pursuing these research directions, psychology was stretching familiar notions of the sovereign subject and his or her individual inner world. The uncharted territories that this discipline was uncovering inspired both awe and the will to control. On the one hand, the scientists were delving into unprecedented depths, where there was nothing recognizable and old categories were helpless. What used to be called, metaphorically, movements of the psyche materialized as circuits of nervous energy and reflex automatisms. New studies revealed vast areas of behavior that lay beyond conscious control. Feeling, action, thought, and other familiar functions dissolved into neurological mechanisms, and further, into chemical and electrical signals between cells. On the other hand, the discoveries stimulated the positivist drive to explain, define "norms," and find practical applications for newly established truths about the substrate of the mind. The conquest of the psyche proceeded along these lines well into the 20th century.

The birth of psychology was happening against the backdrop of modernity. This was the epoch marked by profound transformations of social structures, when fissures occurred in the grand narratives that regulated the subjects' rights, values, opportunities, and self-understanding. The rise of avant-garde and mass culture challenged previous notions of art and modes of its appreciation. Mechanization—in the words of Sigfried Giedion—took command of all spheres of life, from the production of goods and services, transportation,

[4] On Charcot's theory of traumatic neurosis and his photographic staging of hysterical patients' "passionate attitudes," see John Fletcher, *Freud and the Scene of Trauma* (New York: Fordham University Press, 2013), 19. For a discussion of Charcot's harrowing treatment of his female patients, see Georges Didi-Huberman, *Invention of Hysteria: Charcot and the Photographic Iconography of the Salpêtrière*, trans. Alisa Hartz (Cambridge, MA: The MIT Press, 2005).
[5] Angelo Mosso, *Sulla Circolazione del Sangue nel Cervello dell'Uomo: Ricerche Sfigmografiche* (Rome: Coi tipi del Salviucci, 1880). The subject, a peasant man named Michele Bertino, had suffered a cranial trauma, which left a sensitive spot with detectable pulsations under the skin. Anticipating the methods of contemporary neuroscience, Mosso, in his experiments, asked the patient to complete mental tasks, such as saying a prayer or solving a math problem, while the apparatus recorded the increased pulsations indicating the blood flow to the brain. For a discussion of this study as a precursor of contemporary neuroscientific methods, see Paolo Legrenzi and Carlo A. Umiltà, *Neuromania: On the Limits of Brain Science*, trans. Frances Anderson (Oxford: Oxford University Press, 2011), 14.

and communication, to warfare, medicine, and cultural expressions.[6] The everyday life in industrial urban environments, as theorized by Georg Simmel and Walter Benjamin, exposed the city dwellers' senses to shock and over-stimulation, fragmenting their experience and disintegrating secure notions of social belonging. In "The Mass Ornament" (1927), Siegfried Kracauer suggested that two quintessential emblems of his time were the movements of workers' hands on the assembly line and synchronous kicks of the Tiller girls' cancan.[7] For Kracauer, these repetitive motions revealed the modern subjects as deindividualized, anonymous, replaceable, and alienated from the products of their labor—their entire lives reduced to one body movement, to one calculated effect in the economic mechanism. On another level, both the assembly line and spectacles of mass entertainment provided novel modes of sensory experience and patterns of energy expenditure—both physical and psychological. In this respect, these new regimens attracted the interest of applied psychology, a new discipline that grew out of 19th-century experimental psychophysiology. This science began asserting its usefulness for such tasks as selecting factory personnel with good motor skills and eye-hand coordination, examining conditions that lead to labor fatigue, assessing the perceptual properties of safety posters and commercial advertisements, and so forth. Shows and film screenings also came under the scrutiny of this science, as it attempted to explain the ways in which spectacles activate neurophysiological mechanisms responsible for attention, recollection, emotional response, and implantation of new behavioral programs in the viewers.

This expansion of modern psychology into a broad cultural sphere was not a unilateral, top-down process. Many artists and writers of the epoch—especially those who rebelled against earlier forms of representation—searched for new insights and inspiration in the psychological discourse. They were looking for methods allowing them to transcribe volatile impulses of consciousness and to capture moods, sensations, and ideas in the very state of their emergence and decomposition. No longer satisfied with the standard language and conventional means of visual communication, the avant-gardists were intrigued by psychologists' explorations of the organic links between inner states and corporeal motorics. Similarly, scholars of literature and theorists of cinema and performance arts were turning to science in the hope of understanding the nature of psychological processes underlying the experience of the form—for instance, in order to assess the role of kinesthetic and rhythmical sensations for the overall

[6] Sigfried Giedion, *Mechanization Takes Command, a Contribution to Anonymous History* (New York: Oxford University Press, 1948).

[7] Siegfried Kracauer, *The Mass Ornament: Weimar Essays*, trans. Thomas Y. Levin (Cambridge, MA: Harvard University Press, 1995), 75–88, 84.

aesthetic impression of an art piece. Yet another fraction of cultural producers, such as film industry officials, commercial advertisers, and politicians in charge of propaganda, reached out to psychology in order to devise techniques of mass appeal and assert control over the audiences' reactions.

This study traces reverberations of ideas stemming from physiological psychology in theory and creative practice in multiple cultural domains in the 1910s–1920s. These decades, crucial for the interlocked development of Modernism and modernity, saw the intensification of aesthetic debates, which emerged in the 19th-century interdisciplinary discourse at the juncture of scientific psychology and the arts. I propose the term *psychomotor aesthetics* to account for the multiple dimensions of this phenomenon. Though this cross-disciplinary exchange took a variety of forms and was fueled by diverse motivations, there was one central feature that granted it the coherence of an episteme. Psychomotor aesthetics was a network of theoretical notions and practices that emphasized muscular movement, connecting it to cognitive and affective processes. Under this paradigm, the types of movement that aroused special interest included not only emotional expressions as discussed, for instance, in Darwin's landmark 1872 treatise on this subject.[8] The articulation of speech sounds, automatisms of the writing hand, involuntary gestures accompanying language, micro-movements of spectators attuned to the action onscreen—these are just a few examples of the corporeal events that came to the forefront of artists' and theorists' attention. How these physical phenomena were theorized and where these interpretations led are the questions that I explore in my research.

The chapters of this book examine conceptions of corporeal movement pertaining to the composition of literary texts, oral performance, cinema acting, and the experience of film viewing. Through these case studies, I demonstrate the ways in which ideas, practices, and representational strategies originating in scientific discourse influenced the production of artistic works, as well as the modes of their reception by audiences, scholars, and regulatory agencies. My analysis suggests that in embracing the insights of psychophysiology, artists and theorists introduced new questions about the nature of creative expression and aesthetic experience. Gestures and bodily motions came to be viewed as participating in the creation of art and its appreciation. These corporeal events started to be regarded as a trigger for complex inner experiences, as well as a measure of their intensity. At the same time, a new outlook on artistic products—poems, performances, and films—began to take shape. Art forms were now viewed as matrices, or blueprints for eliciting sensations. Works of art were analyzed as combinations of prompts and stimuli for inducing particular kinesthetic and affective experiences.

[8] Charles Darwin, *The Expression of the Emotions in Man and Animals* (London: John Murray, 1872).

The goal of my study is to reveal the emergence of the conceptions that initiated these changes and investigate their consequences.

In particular, my book highlights the philosophical problems associated with biological approaches to the arts, such as physiological reductionism, normative standards, and false transparency in interpreting inner experiences. In interrogating the claim that somatic indices provide privileged access to psychological processes, the book attends to the blind spots and aporias that accompanied the quest for the unmediated truth of the body in scientific laboratories and cultural venues. In what way was this newly found "truth" contingent on technologies and analytical methods of the experimenters? To what extent did it reflect the cultural ideologies and social hierarchies of the period? Moreover, how did neurophysiological discourse configure the modern perception of creativity, specifically, the dichotomies of the instinctive and the artificial, the hard-wired and the learned, the universal and the personal, the automatic and the deliberate, the compulsory and the playful, the boundlessly open and the predetermined? By accentuating these issues in historical case studies, the book exposes tensions between the two components of the term *psychomotor*—the "psychological" and the "motor"—where the former element acknowledges the inscrutable complexity of the mind, while the latter denotes a mechanistic, managerial outlook on the automatisms of the nervous system.

I further argue that the debates stirred by the incursion of neurophysiology into the arts threw into sharp relief the anxieties of the industrial age. In their investigations of the technological dimension of modernity, historians Anson Rabinbach, Friedrich Kittler, Cecelia Tichi, Mark Seltzer, Sara Danius, Felicia McCarren, Ute Holl, and others have shown how various cultural practices negotiated the changing notions of human agency, autonomy, coherent selfhood, and free will within the techno-centric modern economy.[9] My study suggests that the crises of modern subjectivity—the radical reformulation of our experience as deindividualized, fragmented, and potentially programmable—were anticipated by neurophysiology's probing of mental faculties. As feeling, sensation, thought, action, expression, and other psychological functions dissolved into patterns of innervation recorded by laboratory instruments, the individual self emerged as a traffic of impulses—a vision at once disorienting,

[9] Anson Rabinbach, *The Human Motor: Energy, Fatigue, and the Origins of Modernity* (Berkeley: University of California Press, 1992); Friedrich Kittler, *Gramophone, Film, Typewriter* (Stanford, CA: Stanford University Press, 1999); Cecelia Tichi, *Shifting Gears: Technology, Literature, Culture in Modernist America* (Chapel Hill: University of North Carolina Press, 1987); Mark Seltzer, *Bodies and Machines* (New York: Routledge, 1992); Sara Danius, *The Senses of Modernism: Technology, Perception, and Aesthetics* (Ithaca, NY: Cornell University Press, 2002); Felicia McCarren, *Dancing Machines: Choreographies of the Age of Mechanical Reproduction* (Stanford, CA: Stanford University Press, 2003); Ute Holl, *Cinema, Trance and Cybernetics*, trans. Daniel Hendrickson (Amsterdam: Amsterdam University Press, 2017).

liberating, and seductive, in that it obliterated the already crumbling notion of the rational, sovereign subject and opened new terrains for exploring and exploiting the subconscious. In a complete reversal of the Cartesian *cogito*, turn-of-the-century experimental psychology asserted that the structure of reasoning in itself was conditioned by the peculiarities of our neural apparatus, including the feedback loop between the brain and the muscles.

Motor Innervation within the Framework of Physiological Aesthetics

The idea of documenting muscular contractions—whether of the "voluntary" skeletal muscles, or the "involuntary," soft and cardiac, muscles responsible for regulating blood circulation, breathing, the emptying of the bladder, and other functions of the organism—became an essential method of experimental neurophysiology in the 19th century. Detailed real-time records of these impulses provided an ingress into such phenomena as the unfolding of emotions; the execution of labor tasks and locomotion; the effects of fatigue, shock, and neuromuscular disorders; the mechanism of attention; and ways in which the entire body is implicated in the act of perception. Graphic inscriptions appeared to exteriorize the forces shaping the inner life of subjects in the form of the abstract sinusoids and chrono-photographic series. As Robert Brain has masterfully demonstrated, these scientific images facilitated the transfer of ideas from physiological laboratories into the boarder culture, publicizing the "techniques, ontologies and anthropology developed by experimental physiologists" among artists and theorists.[10]

The technology-assisted analysis of gestures, rhythms, and various micro-motions of the body took a prominent place in the growing discourse on physiological aesthetics, also known as psychologism. Psychologism was not a unified theory, but rather a miscellany of approaches, which attempted to explain aspects of artistic creation and art appreciation from the biological and psychological standpoints. Some directions in this field were represented by pseudo-Darwinist attempts to define aesthetic preferences (such as symmetry, harmony, and certain bodily proportions) on the basis of presumed evolutionary advantage.[11] Yet

[10] Robert Brain, *The Pulse of Modernism: Physiological Aesthetics in Fin-de-Siècle Europe* (Seattle: University of Washington Press, 2015), xxx.

[11] In Russia, this pseudo-Darwinist approach is exemplified by V. Veliamovich, *Psikhofiziologicheskie osnovaniia estetiki: Suchshnost' iskusstva, ego sotsial'noe znachenie, i otnoshenie k nauke i nravstvennosti* (Sankt-Peterburg: Tip. L. Fomina, 1878). His notable predecessor in England is Grant Allen, *Physiological Psychology* (London: Henry S. King, 1877). In Austria-Hungary, a famous example is Max Simon Nordau—a follower of Cesare Lombroso, who denounced the decadent

the core of psychologism was taken up by theories describing the elemental laws of perception. This foundation began to take shape in the mid-19th century, with Hermann von Helmholtz's and Gustav Fechner's inquiries into the psychophysics of auditory and visual sensation. Perceptual psychology informed contemporary analyses of the formal structural properties of artworks by Johannes Herbart, Heymann Steinthal, Moritz Lazarus, and others. It was within the framework of perceptual psychology that the first scientific descriptions of the phenomenon of kinesthetic empathy began to emerge. Vague feelings of muscular tension and rudimentary co-movements evoked by the sight of others' actions and certain dynamic shapes had fascinated Romantic philosophers since the late 18th century, but laboratory instruments allowed for this corporeal response to be tested empirically. In France, an associate of Jean-Martin Charcot, Charles Féré, investigated the "dynamogenic" effects of various stimuli, such as lights of different color or piano sounds, by registering the changes in his subjects' muscular tone with a dynamometer.[12] Féré also documented the tendency of his susceptible subjects ("hysterical" women treated at the Salpêtrière hospital) to mirror others' actions, an effect he termed "psychomotor induction."[13] As Jonathan Crary and Robert Brain have noted, Féré and other psychophysiologists' ideas set the tone for artistic experimentation in fin-de-siècle Paris, influencing numerous Modernist literati and painters.[14] For instance, Crary shows that the pointillist painter George Seurat aimed to balance "dynamogenic and inhibitory effects" in his compositions, so as to orchestrate a "harmonious equilibrium of psycho-kinetic response" from the spectators.[15] These goals were inspired by Féré's concepts.

From Europe, psychophysiological methods of research were rapidly spreading to other modernizing parts of the world. It was customary for promising young scientists from countries such as Russia and the United States to tour research hubs in Germany and France, work in the European luminaries' laboratories, publish in continental journals, and export new ideas back home, establishing their own independent centers of research. Due to these international contacts,

fin-de-siècle culture from the standpoint of "medical materialism" in his book, provocatively titled *Degeneration* (Max Nordau, *Entartung* [Berlin: C. Dunker, 1892]).

[12] Charles Féré, *Sensation et Mouvement: Études Expérimentales de Psycho-Mécanique* (Paris: F. Alcan, 1887), 9, 35, 43. On Féré's experiments, see Jonathan Crary, *Suspensions of Perception: Attention, Spectacle, and Modern Culture* (Cambridge, MA: MIT Press, 1999), 166–169; Brain, *The Pulse of Modernism*, 105–106; Cowan, *Cult of the Will*, 59.

[13] Féré, *Sensation et Mouvement*, 13.

[14] Crary, *Suspensions of Perception*, 165; Brain, *The Pulse of Modernism*, 152–153, 187–188.

[15] Crary, *Suspensions of Perception*, 177.

physiological approaches to aesthetics spread as well. Robin Veder provides an account of the British psychologist Edward Titchener, who studied under Wilhelm Wundt in Leipzig and went on to become the director of the psychological laboratory at Cornell University in 1892. A proponent of the concept of kinesthetic empathy, Titchener taught his American students to cultivate awareness of their own proprioceptive sensations of movements and postures.[16] Another alumnus of Wundt's doctoral program, the German Hugo Münsterberg, was invited by William James to direct Harvard's Psychological Laboratory in 1892. In 1904, Münsterberg wrote an applied psychology book, called *The Principles of Art Education*, in which he proclaimed kinesthetic empathy to be an essential aspect of the perceiver's engagement with artistic forms.[17] Eminent Russian neurophysiologists Ivan Sechenov and Ivan Dogel' studied under Helmholtz and began their careers from research on perception. In his early career, Sechenov investigated the impact of ultraviolet rays on the micro-anatomy of the eye, and Dogel' recorded the changes in humans' and animals' pulse in response to various styles of music.[18] The founder of the Russian school of "objective psychology" and future reflexologist Vladimir Bekhterev studied under Wilhelm Wundt, Jean-Martin Charcot, Paul Emil Flechsig, and Emil Du Bois-Reymond. Bekhterev's own psychological laboratories in Kazan, and later, in St. Petersburg, sponsored many applied studies in the field of aesthetics, such as Il'ia Spirtov's investigations of the impact of music on muscular work and blood circulation.[19] In the last decades of the 19th century, Russia saw the appearance of the first thoroughly psychologist treatises on aesthetics. One such book was Aleksandr Neustroev's *Music and Feeling* (1890), which advocated an anti-representational view of music and argued that instead of emotions and concrete images, a melody dynamically conveyed "certain aspects of psychological movement—its speed, slowness, force, weakness, rise, and fall."[20] In highlighting these abstract

[16] Robin Veder, *The Living Line: Modern Art and the Economy of Energy* (Hanover, NH: Dartmouth College Press, 2015), 199–200. As Veder notes, Titchener's students, such as Margret Washburn, became influential advocates of embodied approaches to art.

[17] Veder, *The Living Line*, 200. Münsterberg's ideas influenced many aesthetic theorists, who took classes at the Harvard Psychological Laboratory, including Ethel Puffer, the author of *The Psychology of Beauty* (Boston: Houghton, Mifflin, and Co., 1910) and Willard Huntington Wright, whose *Creative Will: Studies in the Philosophy and the Syntax of Aesthetics* (New York: John Lane Co., 1916) was a favorite reading of Georgia O'Keefe (Veder, *The Living Line*, 201).

[18] Johannes Dogiel, "Ueber den Einfluss der Musik auf den Blutkreislauf," *Archiv f. Anatomie und Physiologie* (1880), 416–428. (The author's Russian name is Ivan Dogel'.) On Sechenov's research in Helmholtz's laboratory, see Crary, *Suspensions of Perception*, 169n41; Galina Kichigina, *The Imperial Laboratory: Experimental Physiology and Clinical Medicine in Post-Crimean Russia* (Amsterdam: Rodopi, 2009), 121.

[19] I. N. Spirtov, "O vliianii muzyki na myshechnuiu rabotu," *Obozrenie psikhiatrii, nevrologii i eksperimental'noi psikhologii* 6 (1903): 425–448; Il'ia Spirtov, "O vliianii muzyki na krovianoe davlenie," *Obozrenie psikhiatrii, nevrologii i eksperimental'noi psikhologii* 5 (1906).

[20] A. Neustroev, *Muzyka i chuvstvo: Materialy dlia psikhicheskogo osnovaniia muzyki* (S.-Peterburg: Tip. V.F. Kirshbauma, 1890), 12.

dynamic parameters, Neustroev argued that music influenced the listener inter-
nally, impacting the character of his movements, cardiac contractions, and pulse.
The philosophical part of Neustroev's treatise was based on Moritz Lazarus's per-
ceptual psychology and a theory of "pure music" by the German critic Eduard
Hanslick. Neustroev's psychophysiological sources included Ivan Dogel's studies
of pulse in relation to music, and the research of a Wundtian psychologist from
Strasburg, Ernst Leumann, on the fluctuations of pulse and respiration patterns
under the influence of different meters of poetry.[21]

The method of graphic inscription used in psychophysiological research
had profound philosophical implications. A kymograph attached to the body
traced continuous curves on a revolving drum, thus providing a nonfigurative
representation of somatic indices. Similarly to Etienne-Jules Marey's chrono-
photographic records, which reduced the moving figure to several illuminated
vectors, the direct graphic transcription of bodily motions with a kymograph
resulted in a mathematical image of biomechanical forces shaping our behavior.
These records supplied visual data that appeared objective, quantifiable, and
deindividualized. Compared to the subject's verbal testimony, the kymograph
curve seemed much more revealing—not mediated by language or symbol, not
censored by the consciousness, and not abbreviated by the fallible memory and
imperfect senses. The researchers' fascination with these corporeal inscriptions
bifurcated into two mutually opposing trends. On the one hand, the scientists'
ability to rationalize the somatic data in a form that was optical and numer-
ical paradoxically began to obliterate the subject at the core of the experiment,
resulting in a seemingly disembodied abstraction. On the other hand, the mi-
nute transcriptions of all these transient bodily states and micro-motions raised
curiosity about the subject's embodied experience, even if it was clear that a large
part of bodily processes happens beyond the threshold of consciousness. Artists,
dancers, and cultural theorists inspired by this research began to conceptualize
the life of the body as energy flows and biomechanical vectors, which could be
vaguely sensed as interoceptive attunements and which could be adjusted by
changing the schemas of one's motions. Scientists discovered that the "muscular
sense"—the nerve signals helping the brain understand the specific way in which
certain muscles have been engaged—plays an essential role in perceptual and
emotional processes, as well as in the acquisition of skills and habits. Terms such
as the "muscle memory" and the "motor image" of a certain action came to de-
scribe our ability to create and follow specific physical routines.

[21] Neustroev, *Muzyka i chuvstvo*, 43. His citations refer to Ernst Leumann, "Die Seelenthätigkeit in
ihrem Verhältnisse zu Blutumlauf und Athmung," *Philosophische Studien* 5 (1888), 618–631, 624 ff.;
Dogiel, "Ueber den Einfluss . . ."

The scientists' emphasis on the objective markers of behavior in the 19th century problematized the notion of psychological interiority, contributing to the philosophical questioning of volition and individual self-determination, started by Arthur Schopenhauer. A few years after returning from his studies in Germany and Austria, the Russian physiologist Ivan Sechenov published a popular science essay, "Reflexes of the Brain" (1863), which shook the intellectual circles in his country with its anti-metaphysical, determinist message. Sechenov's article suggested that thoughts in our head were a modified version of what could have been a motor reaction, and likely *was* a motor reaction at a prior evolutionary stage. In other words, thoughts happen, because the energy that could have gone into the motor discharge stays in the brain, reverberating throughout it. Sechenov further explained that the muscular sense should be recognized as an integral part of perception and cognition, and indeed, an underpinning of all states of mind. Observable behavior, he argued, was a real-time index of the ongoing cerebration:

> The entire endless diversity of external manifestations of the brain activity is eventually reduced to just one phenomenon—muscular movement. . . . Without exception, all qualities of the external manifestations of brain activity that we denote through words such as spiritedness, passion, derision, sadness, joy, etc. are a result of either tighter or looser contraction of some muscle group—a purely mechanical act.[22]

From there, Sechenov proceeded to outline the implications of this view for aesthetics:

> We know that a musician's hand extracts sounds full of life and passion from an inanimate instrument, while a sculptor's hand brings stone to life. Yet, the musician's or the sculptor's hand creating life makes purely mechanical movements, which may be studied mathematically and expressed in a formula.[23]

This approach to artistic creation emblematizes the issues that will go on to haunt artists and cultural theorists well into the 20th century. Sechenov implies that the artist's movements can be recorded and subjected to quantificational analysis.

[22] Ivan Sechenov, "Reflexes of the Brain," in *Selected Physiological and Psychological Works*, ed. Kh. Koshtoyants, trans. S. Belsky and G. Gibbons (Moscow: Foreign Languages Publishing House, 1965), 31–139, 11.

[23] Ibid.

The material form of the artwork is thus determined by physical parameters, and one may precalculate its impact on the human perceptual apparatus. The mystery of the artwork's "life"—its ability to move the audience and stir up a profound emotional and intellectual response—appears to be solvable. Yet where does this deterministic conception leave the question of the artist's and the audience's agency?

For Friedrich Nietzsche—Sechenov's more famous contemporary, similarly grappling with Schopenhauer's reconceptualization of volition—psychophysiology offered additional weapons for attacking the traditional notions of ethics and individual responsibility. In *The Will to Power* (1888), Nietzsche discussed empathy as a predetermined psychological effect, caused by the subconscious corporeal imitation of others' actions:

> What is called altruism is merely a product of that psychomotor relationship which is reckoned as spirituality (psycho-motor induction, says Charles Féré). People never communicate a thought to one another, they communicate a movement, an imitative sign, which is then interpreted as thought.[24]

Yet however fascinated Nietzsche was by psychophysiology, he chose to rebel against the mechanistic determinism it implied. As Crary explains, Nietzsche's notion of the "will to power" presupposes the individual's ability to harness the interplay of the dynamogenic and inhibitory impulses within his body, and to assert his own strong, life-affirming urges against the passive acceptance of external stimuli and inner biological predispositions. In Nietzsche's conception, the artist thus becomes a conduit of a "force that initiates and imposes itself through its inner dynamism."[25] A powerful work of art is the one capable of communicating a pleasurable surge of dynamogenic energies to the audience.

Involuntary movements of the body attracted a great interest of the 19th-century authors, serving as part of character representation in realist novels and as a source of Gothic horror in stories about hypnotism, double-consciousness, telepathy, mediumship, and other mystical occurrences. In Leo Tolstoy's *Anna Karenina* (1877), the adulterer and unrepentant bon vivant Stepan Oblonsky is unable to disguise his facial expression in front of his suspicious wife— something that this impudent character explains to himself as "reflexes of the brain."[26] In Aleksandr Kuprin's novella *Olesya* (1898), a beautiful village witch

[24] Friedrich Nietzsche, *The Will to Power. An Attempted Transvaluation of All Values*, vol. 2 (1888). Trans. Anthony M. Ludovici (London: Allen and Unwin, 1910), 253. For an analysis of this passage in the context of physiological aesthetics, see Crary, *Suspension of Perception*, 173–174; on Niezsche and Féré, see Cowan, *The Cult of the Will*, 278n145; Brain, *The Pulse of Modernism*, 182.

[25] Crary, *Suspension of Perception*, 173.

[26] Leo Tolstoy, *Anna Karenina*, trans. Marian Schwartz, ed. Gary Saul Morson (New Haven, CT: Yale University Press, 2014), 4.

hypnotizes the male narrator and begins to control his gait by first imitating his steps and then willing him to stumble. Kuprin's narrator explains this hypnotic trick with reference to "Dr. Charcot's report on the experiments he made with two Salpêtrière patients—professional sorceresses, suffering from hysteria."[27] In these two literary examples, the subconscious motor tendencies of the body do not yet threaten the idea of a coherent personhood: Oblonsky is capable of rationally assessing his behavior, and Kuprin's narrator regains self-control after the mesmerizing charm of the witch dissipates.

Yet matters stood very differently for other fin-de-siècle authors and artists, who made the unconscious automatisms of the body the center of their creative explorations and an essential precondition of their experimental styles. Rae Beth Gordon has vividly described the acting style of turn-of-the-century French performers, who imitated medical images of hysteria and epilepsy to produce a "popular spectacle of the body as a collection of nervous tics, dislocations, and mechanical reflexes."[28] This spectacle presupposed the dissolution of a coherent, self-possessed selfhood. Modernist painters, such as Edvard Munch, cultivated an ability to absorb sensory stimuli, especially the wounding and traumatic ones, and to react to them by color and line, so as to "get the moment of stress to vibrate anew."[29] As Robert Brain has shown, Munch's interpretation of his mission was indebted to "the French psychophysiological doctrine of symbol formation as a condensation of impressions in the protoplasm that then becomes externalized by the motor functions as idea or symbol in the work of art."[30]

The image of the human individual as a biological organism, responding to the environment via the filter of its own motor predispositions, began to acquire increasingly apocalyptic undertones in the first decade of the 20th century. A symptomatic example of this attitude is the theoretical essays of a major Russian symbolist writer, Andrei Bely. In a 1909 essay with a telling title "The Sin of Impersonality," Bely criticizes the decadent belletrist, Stanisław Feliks Przybyszewski, who transposed his professional training in neurophysiology onto his writing (incidentally, Przybyszewski was an admirer of Nietzsche and a friend of Edvard Munch and August Strindberg in Berlin, responsible for initiating these two intellectuals to psychophysiological doctrines).[31] Bely compared Przybyszewski's novels to silent cinema, and this was not a compliment: "we have before us a photographer, or an anatomist—not a writer."[32] Przybyszewski's

[27] Aleksandr Kuprin, *Olesia* (S.-Peterburg: Izdat. M. O. Vol'f, 1900), 48.

[28] Rae Beth Gordon, "From Charcot to Charlot: Unconscious Imitation and Spectatorship in French Cabaret and Early Cinema," *Critical Inquiry* 27.3 (2001): 515–549, 524.

[29] Munch's statement in 1890, cited in Brain, *The Pulse of Modernism*, 183.

[30] Brain, *The Pulse of Modernism*, 183.

[31] On Munch and Przybyszewski, see Brain, *The Pulse of Modernism*, 180.

[32] Andrei Bely, "Porok bezlichiia," in *Simvolizm kak miroponimanie* (Moskva: Respublika, 1994), 145–152, 147, 148. For a sustained analysis of Bely's and other Russian Symbolists' views

fault, according to Bely, was that he presented his characters solely by depicting their gestures and physical outbursts without ever explaining the psychological motivations behind these actions. Since there are no expositions of narrative situations, the novel's "view incoherently rushes along the surface," and Przybyszewski's "mute heroes speak by silence and contraction of muscles."[33] Because of this, Przybyszewski's characters have no interiority. In the words of Bely, "we do not know what contorts the faces [of his characters]: whether it is an expression of psychological affect, or an effect of the electrical wire surreptitiously brought to [their] face by a cold-blooded experimenter."[34] Thus evoking the French neurologist Duchenne de Boulogne's famous photographs of faces mobilized by galvanic currents, Bely voiced his dismay at the crisis of literary representation happening in his time. A few years earlier, in "The Emblematics of Meaning" (1904), Bely himself engaged with psychophysiological perspectives, while explaining humankind's ability to create artistic and religious symbols, as well as scientific concepts. In this article, Bely acknowledged that there indeed was a "law governing the sources of all creativity": subconscious physiological processes, regulating the fluctuations of pulse and motor discharges, contribute to our symbol-making process on some primeval level.[35] Despite recognizing this fact, in a Nietzschean manner, Bely tried to recuperate the artist's power to rise above this condition, and learn to fuse raw sensations with higher knowledge, so as to create progressively more sophisticated symbols and "shield" himself from the "formless chaos of life."[36]

Depersonalization: Emancipation or Subjugation?

The trend toward depersonalization that Bely detected in the physiological novels of Przybyszewski, medical photography, and gesture-heavy silent cinema was in fact a blessing for other turn-of-the-century authors. By looking at the scientific records of bodily movements, some of these intellectuals felt that they were not simply outsourcing insights about the human psyche to technology, mathematics,

on the medium of cinema, see Yuri Tsivian, *Early Russian Cinema and Its Cultural Reception* (London: Routledge, 1994), 108–113.

[33] Bely, "Porok bezlichiia," 148.
[34] Ibid.
[35] Bely, "Emblematika smysla," 66.
[36] Ibid. For an insightful discussion of Bely's "Emblematics of Meaning," as well as the role of gesture in his novel *Petersburg*, see Timothy Langen, *The Stony Dance: Unity and Gesture in Andrey Bely's Petersburg* (Evanston, IL: Northwestern University Press, 2005), 28. On Bely's conception of embodiment in the context of religious philosophy, see Steven Cassedy, *The Flight from Eden: The Origins of Modern Literary Criticism and Theory* (Berkeley: University of California Press, 1990), 109–110.

and natural sciences, but rather enriching their own perceptive capabilities and bodily dynamism. Researchers such as Etienne-Jules Marey, Brain points out, conceived of the graphic inscription instruments as a prosthetic extension of the sensorium capable of detecting complex dynamic processes within the observed living beings.[37] Brain further argues that this nonlinguistic and nonhermeneutic method of accounting for the body's rhythms paved the way for the early Modernist artists' "explorations of the affective, preconscious attunements of the physiological body" in a variety of media, from abstract painting, to modern dance, to experimental poetry.[38] As Michael Cowan has established, the popularity of rhythmic gymnastics and various movement therapies in Germany in the 1910s and 1920s was supported by their promise to help subjects "overcome automatic determinations" instead of passively reenacting the routines prescribed by habit or some physical constraints.[39] Contextualizing this goal, Cowan situates it within German expressionist aesthetics, which supplanted the earlier impressionist phase by switching away from exploring the psychophysical conditions of sensory perception toward a more active harnessing of bodily resources "and the willful shaping of the material."[40] The route toward these more self-serving goals was nevertheless the same: it involved testing and documenting motor reflexes, cultivating kinesthetic awareness, and experimenting with new rhythms and corporeal techniques for accomplishing various tasks in industrial urban society. In this respect, the valorization of subconscious bodily mechanisms did not necessarily spell doom. For many Modernist authors, the return to the body implied the end of conservative constraints and traditional norms that used to define subjectivity. Deindividualization likewise appeared liberating, as it opened a path toward reckoning with the human condition, acknowledging the biological determinants, and forging new possibilities of intersubjective communion. The fact that the early 20th-century body cultures were subsequently co-opted by totalitarian authorities and capitalist marketing executives does not diminish the radical emancipatory potential that some of the turn-of-the-century authors ascribed to psychomotor aesthetics. In his study *Technology's Pulse*, Cowan points out that the Modernist authors' fascination with the life-affirming organic rhythms of the body was not exclusively a proto-Fascist tendency, but rather a much broader cultural reaction to the exigencies of the industrial age and the alleged malaises of modern civilization (nervousness, apathy, inertia,

[37] Brain, *The Pulse of Modernism*, 31–32.
[38] Brain, *The Pulse of Modernism*, xxiv, 23.
[39] Cowan, *The Cult of the Will*, 3.
[40] Ibid., 4.

overstimulation, ineffective expenditures of energy, and social alienation).[41] Similarly, Robin Veder's and Irina Sirotkina's investigations of modern dance and abstract painting in the United States and Russia in the beginning of the 20th century confirm that conceiving of movement and spatial forms in terms of energy flows, kinesthetic sensations, and empathetic corporeal responses was a liberating trend for innovators, who rebelled against the conventions of academic realism and regimens of classical ballet.[42] Regaining unity with one's own body—whether harmonious and purposeful, or disjointed and spasmodic—was a way of confronting the limits of one's agency and experimenting with kinesthetic sensations accompanying motor innervations.

This book offers in-depth case studies of creative projects, theoretical explorations, and cultural policies that sought to take advantage of the psychophysiological discoveries without fearing the deindividualization, materialist determinism, and the breakdown of traditional conventions of communication that these discoveries brought forward. My primary focus is the Russian and Soviet avant-garde, considered within a rich network of intellectual connections to European and American predecessors and contemporaries. The protagonists of this book all had a pragmatic approach toward the psychomotor dimension of existence: an attitude of fearless curiosity characterized their probing of motor automatisms and kinesthetic sensations. For better or worse, this audacious approach dismissed the frightening, dark connotations associated with the idea of bodily automatisms in fin-de-siècle decadent culture and Romantic horror narratives. Thanks to the late 19th-century discourse on hysteria, uncontrollable somatic outbursts had often been interpreted as evidence of split personality and disintegrating ego, as aftershocks of the experienced traumas, or an uncanny sign of hypnotic manipulation. These connotations lingered on in Western European Modernist literature and visual arts well into the 1920s, becoming a tragic trope pointing to the social malaise of "a world out of joint." To cite a few famous examples, the compulsive behavior of the shell-shocked World War I veteran Septimus Warren Smith in Virginia Woolf's novel *Mrs. Dalloway* (1925) served as a reminder of his wounded psyche, deprived of compassion and understanding.[43] In German Expressionist films, the motif of somnambulist bodies, responding like puppets to the will of a maleficent hypnotizer, tapped

[41] Michael Cowan, *Technology's Pulse: Essays on Rhythm in German Modernism* (London: IMLR, 2011), 43.

[42] Veder, *The Living Line*; Irina Sirotkina, *Svobodnoe Dvizhenie i Plasticheskii Tanets v Rossii* (Moskva: Novoe literaturnoe obozrenie, 2011); Irina Sirotkina, *Shestoe Chuvstvo Avangarda: Tanets, Dvizhenie, Kinesteziia v Zhizni Poetov i Khudozhnikov* (Sankt-Peterburg: Izdatel'stvo Evropeiskogo universiteta, 2014).

[43] Karen DeMeester, "Trauma and Recovery in Virginia Woolf's Mrs. *Dalloway*," *Modern Fiction Studies* 44.3 (1998), 649–673.

into popular fears and conspiracy theories of the turbulent postwar years in the Weimar Republic.[44] In contrast to this pessimistic outlook, the protagonists of the present study—the Russian Futurists and Formalists, the Soviet avant-garde filmmakers and propaganda authorities—had a much more emboldened attitude toward bodily innervations. Automatisms of the body became for them an object of marvel, a creative medium, and an instrument for amplifying the audience's aesthetic response.

Thus the Russian Futurist poet Aleksei Kruchenykh—the subject of Chapter 1—drew inspiration from the psychiatric records of "possessed" behavior: he was intrigued by the material traces of strong affects, represented in graphological analyses of manic-depressive patients' handwriting and religious sectarians' ecstatic trance and glossolalia. In an anarchic fashion, the medical documentation of these practices provided the poet with a model of unrestrained freedom of expression. In my analysis, I concur with Ekaterina Bobrinskaia's parallel between Kruchenykh's theory of "instantaneous creativity" and the automatic writing techniques of the French Surrealists: following Cesare Lombroso's identification of genius with insanity, both the Muscovite and the Parisian bohemians voyaged to the threshold of madness in search of epiphanies that the everyday commonsensical mind could not fathom.[45] Yet, as Bobrinskaia notes astutely, while the Surrealist authors such as André Breton and Antonin Artaud used automatic writing to probe the depths of their own unconsciousness as in Freudian psychoanalysis, Kruchenykh pursued the impersonal, structural properties of Russian phono-semantics.[46] In Chapter 1, I analyze the ways in which an early champion of Kruchenykh, the literary critic Viktor Shklovskii, interpreted this poet's experiments as an inquiry into the biodynamics of verbal expressivity. Shklovskii suggested that Kruchenykh's trans-rational poetry (*zaum'*) uncovered deeply ingrained motor programs, which shape the verbalization of various ideas and states of consciousness. Shklovskii contended that identifying these motor programs, or "sound gestures," and putting them to play was the Futurists' method of palpating the "inner form" of words in the Russian language. A creative toying with the phono-semantic, articulatory, and gestural aspects of speech, he argued, allowed these avant-garde poets to invent unusual, but strikingly evocative sound combinations and rhythms. In contextualizing Shklovskii's conception, the chapter maps the spread of psychoneurological terms in Russian

[44] Stefan Andriopoulos offers an in-depth analysis of the cultural connotations of hypnosis in Weimar film and literature in *Possessed: Hypnotic Crimes, Corporate Fiction, and the Invention of Cinema* (Chicago: University of Chicago Press, 2008).

[45] Ekaterina Bobrinskaia, "Predsiurrealisticheskie motivy v esteticheskikh kontseptsiakh A. Kruchenykh kontsa 1910-ykh godov," *Russian Literature* 65 (2009): 339–354, 342.

[46] Ibid., 349.

literary theory and linguistic scholarship in the 1910s, with a particular emphasis on the echoes of William James's theory of the corporeal experience of emotion and Wilhelm Wundt's ideas on the gestural origin of language. In addition to drawing a parallel between this scientific research and the Futurists' project, Shklovskii acknowledged the creative potential of poetry, calling it a "ballet for the organs of speech."[47] Parts of this chapter are devoted to the Russian Futurists' paradoxical desire to bare the subconscious processes of verbalization while reserving the right for deliberate travesty and play.

Chapter 2 explores scholarly theories that accounted for the role of kinesthetic sensations of pronunciation in the aesthetic experience of the poetic form. The Russian Formalists such as Boris Eikhenbaum, Yuri Tynianov, Sergei Bernshtein, and Sofia Vysheslavtseva described the articulatory properties of various poetic styles as an objective, impersonal formal structure. They aimed to establish whether this structure configures the poet's experience during the process of verse composition and whether the reader subsequently interacts with the author's rhythmical-melodic imprint. In historicizing the Formalists' conceptions of the performative, embodied aspect of poetry, my analysis centers on a circle for studying verse, which opened in 1919 at the Petrograd Institute of the Living Word (*Institut Zhivogo Slova*) and continued as the Laboratory for the Study of Artistic Speech under the auspices of the Institute of Art History (*Kabinet Izucheniia Khudizhestvennoi Rechi pri Institute Istorii Iskusstv*) between 1924 and 1930. The chapter draws attention to the fact that the initial phase of these scholars' research was conducted alongside speech therapists and psychophysiologists. The Formalists adapted the laboratory methods of articulation analysis for the purposes of stylistic inquiry: they began using phonograph records of poetry performances to examine individual authors' prosodic patterns. In this respect, their endeavor to register poetic rhythms and intonations closely resembled the methods of experimental phonetics, such as poetry analyses conducted by the American phoneticians Edward W. Scripture and Raymond H. Stetson. My analysis points to numerous common sources shared by the Russian and American authors—notably, the publications coming out from Jean-Pierre Rousselot's pioneering laboratory of experimental phonetics in France. I argue that the instruments and methods geared toward visualizing the flow of voice modulations made it possible for literary scholars to conceptualize poetic sounds as an embodied, physical experience. Further, I show that in locating the origins of each poem's rhythm and other acoustic properties within the body of the poet-performer, these scholars arrived at new definitions of the poetic form. In particular, they began to view rhythm not simply as a function of

[47] Viktor Shklovskii, *Literatura i kinematograf* (Berlin: Russkoe universal'noe izdatel'stvo, 1923), 9.

the set meter, but rather as a deeply experienced somatic affair, whereby the poet intuitively judged the equivalence of beats based on sensations of physical strain, or expenditure of motor energy. The final section of the chapter unravels the concept of "formal emotions," proposed by the Russian Formalists, as they attempted to distance themselves from the simplistic biographic interpretations of affects encoded in literature and considered the psychomotor properties of verse from the standpoint of genre and style.

In Chapter 3, I examine the approaches to film actor training developed by the Soviet avant-garde filmmaker Lev Kuleshov in the early 1920s. Inspired by the radical innovations of contemporary theater, Kuleshov's perspective on film acting relied on Ivan Pavlov's and Vladimir Bekhterev's reflexology, as well as psychotechnics and Taylorist labor efficiency training. Based on archival materials, this chapter establishes Kuleshov's connection to the Central Institute of Labor (*Tsentral'nyi Institut Truda*) in Moscow, which promoted a utopian program of ingraining effective working skills in the nervous systems of factory workers by optimizing their trajectories of movement. Kuleshov embraced the concepts and techniques popularized by this Institute. He theorized his actors' ideal performance in terms of energy expenditure and maximal use of the audiences' attention span. My analysis of Kuleshov's program for actors' bodily discipline scrutinizes the training apparatuses he relied on in the hopes of achieving geometrically precise, rhythmical gestures, which he believed could form a legible "ornament" in rapid montage. Surprisingly, as a film theorist renowned for his claim that editing can decontextualize a facial expression and endow gestures with new meanings, Kuleshov placed tremendous value in his actors' physical training. In requiring grace, precision, and convincing reflexes from his actors, the director aimed for the quality building blocks for his film sequences. His practice raises the question of the extent to which cinema may serve as an objective record of bodily behavior. He oscillates between praising the documentation of organically aroused reactions and a commitment to spectacle that presents natural reflexes with an unprecedented level of detail, enhances them through staging, and amplifies their impact through cropping and re-editing. In assessing Kuleshov's legacy, the final segment of this chapter challenges the commonly held opinion that Kuleshov fostered mindless actors-marionettes ready to fulfill the mastermind director's orders. Not only did he teach all acting members of his workshop to become filmmakers in their own right, but his film essays celebrated the kind of acting that could only result from the personal creative investment of the performers—from their ability to respond to the script's circumstances in a nontrivial and fascinating way. He valorized not only spectacular athleticism and grotesque gags, requiring a remarkable self-control on the part of his film actors, but also spontaneous reactions, involuntary automatisms, and trance-like twitching indicative of strong affects. Driven

by the desire to understand the nature of the cinematic medium and cultivate the actors' physique in a way that would match cinema's laws, Kuleshov's film art epitomizes the avant-garde's will for radical experimentation.

Chapter 4 explores Sergei Eisenstein's theory of the audience's "co-movement" with the screen image—the idea that enthralled spectators subconsciously imitate the actors' movements and the resultant innervations trigger appropriate emotions. Spectators' corporeal empathy, according to Eisenstein, could also be activated by graphical, nonhuman "gestures"—that is, "movements" implied by the structure of the shot composition, editing, and other formal devices. In scrutinizing Eisenstein's theory that spectatorship is, fundamentally, an enactive experience, this chapter traces the roots of his ideas and evaluates the aesthetic and political implications of his position. First, I analyze the filmmaker's engagement with psychological theories of William James, William Carpenter, Vladimir Bekhterev, Alexander Luria, and Lev Vygotsky, as well as philosophical treatises of Ludwig Klages and 19th-century German theorists of empathy. Special attention is devoted to one of Eisenstein's major sources—Vladimir Bekhterev's *Collective Reflexology* (1921), a seminal work of early Soviet psychology, which discussed nonverbal communication in crowds and argued that the processing of visual sensations by the brain instantaneously impacts motor networks. Contextualizing Bekhterev's viewpoint, I demonstrate his indebtedness to Charles Féré's theory of "psychomotor induction," which described the subconscious compulsion to imitate observed actions. I further consider the place of these neurophysiological premises in Eisenstein's theory of spectatorship, foregrounding the fact that he also recognized cultural, psychological, and sociological factors that influence film interpretation. The final section of the chapter reflects on Eisenstein's provocative suggestion that cinema could be seen as a means of providing catharsis on an industrial, collective scale.[48] I argue that although Eisenstein's model of spectatorship appears manipulative, it is also potentially emancipatory. Embracing the utopian spirit of the avant-garde, he was willing to subject himself and his audience to radical experimentation aimed at testing the sensory properties of cinema and demystifying the mass production of emotions.

Chapter 5 considers psychophysiological approaches to film spectatorship, focusing on American and Soviet efforts to assess the emotional responses of filmgoers by photographing their facial reactions and registering changes in their vital signs. These studies were done in the USSR for the purpose of raising the effectiveness of film propaganda among proletarian, rural, and juvenile audiences, and in the United States, for identifying crowd-pleasing narrative formulae. The

[48] Sergei Eisenstein, "Kak delaetsia pafos?" RGALI f. 1923 op. 2. ed. khr. 793, l. 43–44.

chapter juxtaposes spectator tests conducted by the inventor of the polygraph lie detector, William Moulton Marston, for Universal Studios in Hollywood with analogous initiatives launched by various agencies under the jurisdiction of the *Narkompros* (a Soviet ministry for education and propaganda), such as The Theater Research Workshop (*Issledovatel'skaia Teatral'naia Masterskaia*) and The Institute for the Methods of Extracurricular Education (*Institut Metodov Vneshkol'nogo Obrazovaniia*). The chapter reconstructs the institutional and cultural-political settings of psychophysiological spectator studies in the two countries. I further trace the roots of these empirical methods to late 19th-century trends in physiological psychology, when chrono-photography served alongside the kymograph for obtaining indexical records of corporeal processes that were thought to reflect the workings of the psyche. Offering a critical reading of this legacy, the chapter shows how these spectator studies replicated the universalist fallacies of biologically oriented psychology, in addition to strengthening a patronizing attitude toward the subjects of research: women, children, and illiterate peasants.

It is worth noting that the scientific trends highlighted in these chapters are non-Freudian. My exclusion of psychoanalysis is not intended to dismiss or mischaracterize its tremendous influence on Modernist culture or, indeed, to disregard overlaps between Freudian approaches to bodily movement and certain experimental practices I have described in *Psychomotor Aesthetics*. In shifting attention away from psychoanalysis in this book, my goal is to spotlight lesser known discourses, which existed alongside Freudianism and frequently—but not always—presented themselves in opposition to it.

Without a doubt, psychoanalysis enjoyed prestige in Russia, with the first translations and original studies by the domestic followers of Sigmund Freud and Adolf Adler appearing in the early 1910s.[49] Enthusiasm for the doctrine peaked around 1922–1923 and subsided only in the 1930s with the Stalinist streamlining of psychology along the lines of Pavlovian dogmas.[50] Many subjects of this book had more than cursory interest in Freud. The avant-gardists such as Aleksei Kruchenykh and Sergei Eisenstein perused Freud's writings on childhood, sexuality, and creative expression, while professional psychologists consulting Eisenstein on various aspects of his film theory and personal life—Alexander Luria, Aron Zalkind, Iurii Kannabikh, and others—were among the first propagandists of Freud in Russia. These intellectual connections are

[49] Martin A. Miller, *Freud and the Bolsheviks: Psychoanalysis in Imperial Russia and the Soviet Union* (New Haven, CT: Yale University Press, 1998), 37–44.

[50] Miller, *Freud and the Bolsheviks*, 66–67. On the history of psychoanalysis in Russia, see also Aleksandr Etkind, *Eros Nevozmozhnogo: Istoriia Psikhoanaliza v Rossii* (Moskva: Gnozis-Progress-Kompleks, 1994).

well documented.[51] Instead of repeating what has already been established, this book aims to highlight other psychophysiological trends, which came before and existed alongside Freud, and which exhibited a somewhat greater faith in transcribing micro-motions of the body than the Viennese psychiatrist. It is important to recognize that the origins of psychoanalysis, as a method of diagnostics and therapy, lie in Freud's reaction against the positivistic equation of mental illnesses with purely nervous dysfunctions.[52] In his monumental study *The Discovery of the Unconscious*, the historian Henri Ellenberger points out that only a small segment of Freud's theory intersects with neurophysiological methods of research.[53] Despite Freud's allegiance to Charcot, under whose influence he began studying the somatic signs of hysterical neurosis, his own practice broke away from the strictly neurological framing of mental syndromes and underscored the psycho-social and sexual roots of mental disturbances.[54] Freud's method was based on introspective narrative accounts of patients' lives, tests of verbal associations, situation modeling, and other techniques that emphasized psychological rather than neuroanatomical factors. Freud's early writings preserve much of the terminology associated with 19th-century psychophysiological laboratories, yet he always links these neurological concepts to psychogenic dramas tormenting the patient. For example, the term "innervation," referring to the activation of muscles by impulses traveling along nerves, appears in Freud's articles on hysteria in connection to the concept of "conversion"—a process by which an inhibited idea makes itself known in the form of torturous convulsions, hysterical paralysis, and other somatic symptoms of the repressed trauma.[55] An ingenious synthesizer, Freud amalgamated influences from positivist neurophysiology and philosophical theories of the mind, including Franz Brentano's notion of "psychic energy" streaming to fulfill instinctual goals, Fechner's principles of repetition and pleasure-unpleasure, Schopenhauer's sexual mysticism, and Romantic psychiatry, which located the sources of psychosis in the patient's feelings of guilt, sexual frustration, and unresolvable trauma.[56] An influential 19th-century theory by Herbart, which described a dynamic struggle of ideas

[51] On Kruchenykh's perception of Freud, see Ekaterina Bobrinskaia, "Predsiurrealisticheskie motivy," 346; on Eisenstein's engagement with psychoanalysis, see Oksana Bulgakowa, "Eizenshtein i ego psikhologicheskii Berlin: Mezhdu psikhoanalizom i strukturnoi psikhologiei," *Kinovedcheskiie Zapiski* 2 (1988): 174–189.

[52] Miller, *Freud and the Bolsheviks*, 20.

[53] Ellenberger shows that Freud began as a neuropathologist in 1886 but within ten years switched away from these early interests and developed his own system. See Henry Ellenberger, *The Discovery of the Unconscious: The History and Evolution of Dynamic Psychiatry* (New York: Basic Books, 1970), 443.

[54] On Freud and Charcot, see Ellenberger, *The Discovery of the Unconscious*, 440–447.

[55] Bertrand Vichyn, "Innervation," in *International Dictionary of Psychoanalysis*, ed. Alain de Mijolla, vol. 2 (Detroit, MI: Macmillan Reference, 2005), 836.

[56] Ellenberger, *The Discovery of the Unconscious*, 534–536, 545–546.

before they present themselves to the consciousness, furnished Freud with an image of the displacement and sublimation of the repressed impulses.[57] His psychiatric case histories often took the form of detective exposes, unmasking the dark subconscious undercurrents affecting the person's behavior unbeknownst to him.[58] For Modernist artists, espousing Freudian beliefs, psychoanalytic approach resonated with Nietzsche, Bergsonian vitalism, and the German "philosophy of life" (*Lebensphilosophie*), which depicted reason and the conscious mind as censoring forces suppressing the irrational, sensual unconsciousness. Artistic experiments, which developed in dialog with Freudianism, endeavored to shed light on this subconscious realm of tabooed phantasies and phobias, cultivating a morbid fascination with the irrational side of the psyche.

Though equally committed to probing the limits of rational sensibility, the cultural projects described in this book lacked the social pessimism characteristic of Freudianism. This fact may be attributed to the rebellious spirit of the Russian avant-garde groups highlighted in this study, from the Futurists' rejection of decadent fin-de-siècle culture, to the Soviet filmmakers' sense of active participation in revolutionary transformations. Besides Freud, these intellectuals had access to other traditions in psychology, which provided an alternative perspective on the mind, without the Romantic privileging of the unconscious as a mysterious, dark source of intuition, creativity, and genius. Whereas Freud's clinical practice focused on pathological bodily automatisms, in the utilitarian research on attention, motor coordination, and habit formation, reflexes were treated as a product of regular brain operations. In this latter type of research, the boundary between the conscious and unconscious was presented in cooperative rather than oppositional terms.

This fluid, indivisible vision of the mind was already a feature of Sechenov's *Reflexes of the Brain*, and it crystallized into an axiom in Bekhterev's positivist psychology. Bekhterev contended that "for the objective psychology, which should more properly be termed the psycho-reflexology of cerebral hemispheres, terms such as voluntary and involuntary, conscious and unconscious, have no meaning."[59] Although Bekhterev made a point of acknowledging the value of Freud's "treatment by confession" and Pavlov made use of Freud's clinical case of Anna O. in his own conception of neurosis, there was a significant rift between the Russian reflexological schools and psychoanalysis.[60] Soviet historiography would go on to inflate this gap inordinately, yet it is hard to deny that the Russian approaches, which focused on neurophysiology rather than symbolic

[57] Ibid., 536.
[58] Ibid., 537.
[59] Vladimir Bekhterev, *Ob"ektivnaia psikhologiia*, ed. V. A. Kol'tsova (Moskva: Nauka, 1991), 193.
[60] Though Bekhterev criticized Freud for overestimating the role of sexuality, he endorsed elements of Freud's theory and explained it in reflexological terms (see Vladimir Bekhterev, *Obshchie osnovy refleksologii cheloveka*, ed. A. V. Gerver, 4th ed. (Moskva: Gosudarstvennoe Izdatel'stvo,

representations, lent themselves better to a mechanicist outlook on the human mind. In this capacity, they were eventually enlisted in the utopian programs of the Socialist state. As a side note, a totalitarian version of "Freudian Marxism" also nearly became a theoretical platform for the forging of the New Man in Russia of the 1920s. Propagated by Leon Trotsky, *freidomarksizm* called for the top-down purging of all chaotic and spontaneous elements from man's psyche, a veritable exorcism of the unconscious.[61] Reflexology was presented by the Bolshevik ideologues with the same fervor, as a means of conquering and streamlining man's reflexes. This radical disciplinarian pathos was hardly a defining feature of Pavlov's and Bekhterev's own scientific publications, although their followers in various applied fields, such as criminology and children's education, did indeed engage in practices worthy of Anthony Burgess's pen in *A Clockwork Orange*.[62] Overall, the relationship of scientific laboratories to state power is a complex issue, and even within the ideologically charged context of the early Soviet state, it would be a mistake to treat the work of all psychophysiological laboratories as complying with the nascent authoritarianism. Take, for instance, The Central Labor Institute, discussed in detail in Chapter 3 of this study: it was, simultaneously, the site of Aleksei Gastev's highly ideological, top-down program of perfecting the motor skills of workers through repetitive drills, and the cradle of Nikolai Bernshtein's forward-looking research on biomechanics, which revealed the self-coordinating capacity of the human motor system and laid the foundation for contemporary theories of embodied cognition.[63]

To further illustrate the way in which a non-Freudian, positivist approach to the functioning of the mind and the body could inspire both the utilitarian— potentially exploitative and disciplining—social practices and an iconoclastic, free-spirited experimentation in the arts, it is worthwhile to consider the legacy of Hugo Münsterberg. This German-American scientist is mostly known for launching the field of psychotechnics, which applied psychophysiological

1928), 501. On the convergence between Pavlov's notion of the conflicting psychical factors and the reflexological processes of inhibition and excitation, see Daniel P. Todes, *Ivan Pavlov: A Russian Life in Science* (Oxford: Oxford University Press, 2015), 499.

[61] Etkind, *Eros Nevozmozhnogo*, 226.
[62] Pavlov's associate, Nikolai Krasnogorskii, for instance, studied children's reflexes by collecting saliva through perforations in their cheeks. On the representation of Krasnogorskii's lab in Vsevolod Pudovkin's film *The Mechanics of the Human Brain*, see my essay "The Junctures of Children's Psychology and Soviet Film Avant-garde: Representations, Influences, Applications," in *The Brill Companion to Soviet Children's Literature and Film*, ed. Olga Voronina (Leiden: Brill Press, 2019), 73–100.
[63] On Bernshtein's pioneering work in biomechanics, see I. Sirotkina and E. V. Biryukova, "Futurism in Physiology: Nikolai Bernstein, Anticipation, and Kinaesthetic Imagination," in *Anticipation: Learning from the Past. The Russian and Soviet Contributions to the Science of Anticipation*, ed. M. Nadin (Berlin: Springer, 2015), 269–285; Irina Sirotkina, *Mir kak zhivoe dvizhenie: Intellektual'naia Biografiia Nikolaia Bernshteina* (Moskva: Kogito-Tsentr, 2018).

knowledge for tasks such as professional aptitude testing, design of commercial advertising, forensics, and so forth. On the other hand, the value he accorded to the sensorimotor aspects of perception and phenomena such as kinesthetic empathy trickled down into aesthetic theories, nourishing budding American modern dance and abstract art.[64] As a psychologist, Münsterberg stood much closer to Bekhterev and Pavlov than Freud. Regarding the treatment of psychiatric patients, Münsterberg believed that a successful turn toward healing comes down to rechanneling the "psychomotor processes" in their brain.[65] He maintained that this rerouting of pathological circuits could be accomplished not only by hypnosis, but also in regular wakefulness, and he sought to empower his patients by "strengthening the thoughts opposite of those causing problems."[66] In an often-quoted maxim from his *Psychopathology* (1909), Münsterberg refuted the concept of the id by proclaiming: "The story of the subconscious mind can be told in three words: there is none."[67] The author problematized the very idea of consciousness—this narrow and shifting scope of awareness, capable of accounting for only a tiny fraction of external and internal processes.[68] Echoing William James's famous metaphor of consciousness as a stream, Münsterberg argued that consciousness has no unity, because the "mental facts" that make up its contents at any given moment organize autonomously.[69] Consequently, consciousness should not be equated with a sense of selfhood: rather than the foundation of one's identity, consciousness should be thought of as the coordinated functioning of attention, perception, memory, and motor dispositions, all of which are underpinned by the neurological processes in the brain.[70] Various devices in Münsterberg's laboratory deciphered separate mental faculties, providing a technological proof for his vision of the mind as an assemblage of functions.[71] A representative example of a Modernist writer, inspired by this non-Freudian view of the human mind, may be found in Gertrude Stein, a one-time student of James and Münsterberg at the Harvard Psychological Laboratory. Her two scientific publications in the 1890s dealt with the automatization of actions, reporting the experiments in which her subjects read, wrote,

[64] Veder, *The Living Line*, 200–201.
[65] Hugo Münsterberg, *Psychotherapy* (New York: Moffatt, Yard, and Co., 1909), 109.
[66] B. R. Hergenhahn, *An Introduction to the History of Psychology*, 6th ed. (Boston: Wadsworth Cengage Learning, 2009), 349. On Münsterberg's notion that there is no sharp division between the hypnotic state and wakefulness, see Münsterberg, *Psychotherapy*, 109.
[67] Münsterberg, *Psychotherapy*, 125.
[68] Ibid., 130 ff.
[69] Ibid., 135.
[70] Ibid., 137–140.
[71] Margarete Vöhringer, *Avangard i Psikhotekhnika: Nauka, Iskusstvo, i Metodiki Eksperimentov nad Vospriiatiem v Poslerevoliutsiuonnoi Rossii*, trans. K. Levinson and V. Dubina (Moskva: Novoe Literaturnoe Obozrenie, 2019), 38.

and traced rhythmical lines under conditions of constant distraction.[72] This research taught her about the auto-pilot mode, in which we perform most of our everyday actions. According to the literary scholar Barbara Will, Stein prized this state of "attentive inattentiveness" and "indifferent watchfulness," believing it to be the "neutral background of cognition," freed from subjective biases that typically come with close conscious monitoring.[73] She applied this principle in her early prose works, which give voice to the impersonal "machine beneath the surface of the conscious thought."[74] Stein's treatment of automatism offers a striking contrast to the French Surrealists' practice of automatic writing, more directly indebted to Freud. As Will remarks, for Stein, automaticity was "not a vehicle for revelation," but an effort to bring to light the "ground-zero murmur of the psyche, the sound-hum of the human motor."[75] Whereas the Surrealists practiced automatic writing as a means of reckoning with the unconscious self in all of its unbearable authenticity, Stein's experiments were geared at defamiliarizing cognition and documenting the mind's repetitive, fragmentary operations.

The example of Stein is useful for introducing some key aspects of the cultural experiments that *Psychomotor Aesthetics* seeks to foreground in the Russian context: a tendency toward depersonalization, an exploration of bodily mechanisms without demonizing the unconscious, and a fascination with the possibility of capturing the imprints of inner processes in the artistic medium—in the same way they had been transcribed and deciphered in psychophysiological laboratories. The American Modernist's willingness to surpass the personal and enter on the level of consciousness, where the signals of the individual self—its fears, desires, calculations, and judgments—become distant and irrelevant, bespeaks a preoccupation with the structural, instrumental properties of the mind (instead of tackling the monsters produced by the sleep of reason). Metaphorically speaking, the hum of psychological instruments, testing the subjects' mental faculties in Münsterberg's Psychological Laboratory, matches the operational noise Stein detects in her characters' consciousness. Though light years separate Stein's original aesthetics from the authors considered in this book, it is interesting to note that in their theories of the Futurist verse, Kruchenykh and

[72] Leon M. Solomons and Gertrude Stein, "Normal Motor Automatism," *Psychological Review* 3.5 (1896): 492–512; Gertrude Stein, "Cultivated Motor Automatism: A Study of Character in Its Relation to Attention," *Psychological Review* 5.3 (1898): 295–306.

[73] Barbara Will, "Gertrude Stein, Automatic Writing and the Mechanic of the Genius, *Forum for Modern Language Studies* 37.2 (2001): 169–172. On Stein's automatic writing experiments, see also Catharine R. Stimpson, "The Mind, the Body, and Gertrude Stein," *Critical Inquiry* 3.3 (1977): 489–506; Michael J. Hoffman, "Gertrude Stein in the Psychology Laboratory," *American Quarterly* 17.1 (1965): 127–132; and Wilma Koutstaal, "Skirting the Abyss: A History of Experimental Explorations of Automatic Writing in Psychology," *Journal of the History of the Behavioral Sciences* 28.1 (1992): 5–27.

[74] Will, "Gertrude Stein, Automatic Writing and the Mechanic of the Genius," 171.

[75] Will, "Gertrude Stein, Automatic Writing and the Mechanic of the Genius," 169.

Shklovskii similarly laid emphasis not on the lyrical hero's individuality, but rather on the abstract, impersonal aspects of the spoken language, such as the motor dynamics of verbalization and semantic effects evoked by specific kines- thetic sensations. The Russian Formalists studied the embodied nuances of artic- ulation as an objective criterion for classifying the performative styles of poets. Filmmakers Lev Kuleshov and Sergei Eisenstein experimented with vectors of actors' movements, arranged in effective sequences through montage, in order to exert a calculated impact on the audiences' perception. Eisenstein stressed the difference of his approach to the unconsciousness from the Surrealists. He faulted his French colleagues for being fixated on "the contents of the uncon- sciousness" instead of attempting to reproduce the laws of its "movement" like James Joyce did in *Ulysses*, or like he himself attempted in his film montages.[76] Whereas the Surrealists used "the unconscious and automatic elements" for the purpose of self-expression, Eisenstein argued, the revolutionary Soviet directors deployed the same elements "to achieve an emotional, intellectual, or ideolog- ical influence on the spectator."[77] The last three chapters of this book, devoted to the mass art of cinema, pause over the sensitive issue of when an artistic ex- ploration becomes the means of organizing collective sensations (*kollektivnaia chuvstvennost'*), to use an apt term Igor' Chubarov has proposed in his investi- gation of the Soviet utopian art in the 1920s.[78] A perspective on cinema as an apparatus conveying animating impulses to the plugged-in audience, which comes forward in Chapter 5 of this study, provides a historical illustration to philosopher Valerii Podoroga's observation that "one of the avant-garde's key achievements [was] the de-anthropologization of the world: the mechanization of the senses and all channels of perception."[79]

The last chapter of this book comes closest to describing a posthumanist world, in which mechanisms interface with mechanisms: the apparatus for recording

[76] Viacheslav Ivanov, *Izbrannye Trudy po Semiotike i Istorii Kul'tury: Tom 1* (Moskva: Iazyki russkoj kul'tury, 1998), 319. Despite drawing this distinction, Eisenstein admired the French Surrealists and befriended several key figures of the Surrealist scene in Paris. See Marie Rebecchi, *Paris 1929: Eisenstein, Bataille, Buñuel* (Milan: Mimesis, 2018); Marie Rebecchi, Elena Vogman, and Till Gathmann, *Sergei Eisenstein and the Anthropology of Rhythm* (Rome: Nero, 2017). Following Freud and proponents of *Lebensphilosophie* such as Ludwig Klages, Eisenstein entertained the idea of consciousness as a censoring force for the unconscious impulses, but his engagements with other psychological trends, such as the Soviet reflexology, Lev Vygotsky's and Alexander Luria's sociocul- tural theory of personality development, and Kurt Lewin's action theory provided the director with a more functionalist, systemic view of the brain and its operations (see Chapter 4 of this study).
[77] Sergei Eisenstein, "Printsipy novogo russkogo fil'ma: Doklad S. M. Eizenshteina v Sorbonnskom universitete" (1930), in *Sobranie Sochinenii v Shesti Tomakh*, vol. 1 (Moskva: Iskusstvo, 1964), 547–559, 558.
[78] I. M. Chubarov, *Kollektivnaia Chuvstvennost': Teorii i Praktiki Levogo Avangarda* (Moskva: Izdatel'skii dom Vysshei shkoly ekonomiki, 2014).
[79] V. A. Podoroga, *Mimesis: Materialy po Analiticheskoi Antropologii Literatury*, vol. 2 (Moskva: Kul'turnaia revoliutsiia, 2011), 242.

the spectators' somatic data work in sync with the apparatus projecting images. This a thoroughly Kittlerian vision, but in my analysis, I also point to glitches in the cohesive running of the cogs—gaps, through which the evacuated psyche and the neglected individual body come back into play. Friedrich Kittler's seminal research raised awareness of the vicissitudes of a posthumanist world, inaugurated by the technocratic modernity. The German media theorist pointed to the defining role that the technologies used in psychophysiological laboratories played in deciphering the workings of the human perception, as well as in the subsequent design of aesthetic objects to maximize the engagement of our sensorium. Münsterberg's theoretical legacy was a prime example for Kittler. Commenting on Münsterberg's *The Photoplay: A Psychological Study* (1916), Kittler stated that for this scientist, the cinema was "a medium [that] instantiates the neurological flow of data."[80] In the words of Giuliana Bruno, Münsterberg conceived "of psychic life as a mechanism to be unraveled—a technology of sorts," and this view helped him recognize that the moving pictures acted "as a psychic instrument," soliciting our attention and emotions in specific ways.[81] The psychophysiological spectator studies I analyze in Chapter 5 take Münsterberg's idea to its logical conclusion. However, a closer look at their biased experimental set-ups, their methodological problems, and their lack of practical outcomes for the film industry reveals the remarkable opacity of the somatic data, which frustrated the experimenters' hope to transform filmmaking.

All in all, the embodied approaches to aesthetics explored in this book cannot be brought to a common denominator. While the cultural authorities sponsoring psychophysiological spectator tests indeed hoped that the objective, quantificational data would feed into recipes for producing captivating films, the iconoclastic experiments of the Russian Futurists hijacked the scientific methodologies to playfully explore the kinesthetic foundation of verbal expression. The psychophysiological inquiry into the motoric side of our existence enabled the Russian Formalists to identify the stylistic signatures of the poets' voices, allowed Kuleshov's actors to expand the expressive potential of their bodies, and helped Eisenstein to imagine the audience's empathetic co-vibrations with the screen. This wide spectrum of possibilities upholds Robert Brain's corrective to Kittler, which questions the argument that technologies, introduced in the turn-of-the-century psychophysiological labs, had imposed an autonomous, abstract

[80] Kittler, *Gramophone, Film, Typewriter*, 161.
[81] Giuliana Bruno, "Film, Aesthetics, Science: Hugo Münsterberg's Laboratory of Moving Images," *Grey Room* 36 (2009): 88–113, 90. Regarding Münsterberg's views on cinema in relations to his psychological research, see also Robert Michael Brain, "Self-Projection: Hugo Münsterberg on Empathy and Oscillation in Cinema Spectatorship," *Science in Context* 25.3 (2012): 329–353; Jeremy Blatter, "Screening the Psychological Laboratory: Münsterberg, Psychotechnics, and the Cinema," *Science in Context* 28.1 (2015): 53–76.

framework onto the human sensorium, translating the plenitude of human experience into quantificational, disembodied abstract data, thus preparing the groundwork for the age of cybernetics.[82] Though much can be said in favor of Kittler's pessimistic prognosis, a solely teleological outlook prevents us from noticing all the detours and ambiguous developments in the history of psychophysiological technologies, many of which actually reinforced explorations of embodiment rather than the proliferation of abstract data.

The cultural experiments presented in this book range from those conducted under the banner of rational organization to those celebrating the irrational impulses, from those aiming to control and streamline the motoric processes to those recognizing the intrinsic aesthetic value of twitches, fumbles, and breakdowns. The implications of these projects similarly range from profoundly humanistic to alarmingly posthumanist, and it is a worthwhile task to sort these tendencies apart.

Unraveling Discursive Entanglements: The Contribution of This Study

As a critical history, this book is the first to bring together various conceptions of embodiment and views on the role of kinesthetic sensations in the creation and reception of art, which circulated in the scientific and creative communities in Russia during the first quarter of the 20th century. Spanning prerevolutionary times and the first decade of Communist rule, this study examines both the cultural practices that contributed to the Soviet ideological project and those which bore no relation to it. In highlighting an intricate network of international and cross-disciplinary connections, this book points to the shared roots of many Russian, European, and American conceptions of expressive movement, as well as the divergent applications these ideas received in different settings.

This broader perspective forges a new path for exploring the intersection of the arts and psychological sciences in Russia, complementing existing studies, which have thus far concentrated mostly on the political imperatives of the postrevolutionary culture. The history of psychology is acknowledged in works emphasizing the political aspects of modern body cultures, configured by the Proletkul't, the Left Front for the Arts, and, eventually, by the Stalinist ideological apparatus. Pioneering research by Mikhail Iampolski, Valerii Podoroga, Igor' Chubarov, Charlotte Douglas, Lilya Kaganovsky, Julia Vaingurt, and other scholars has elucidated the contours of Soviet ideological programs geared at

[82] Brain, *The Pulse of Modernism*, xxiii.

enhancing the citizens' bodily self-control, responsiveness to discipline, and mastery of technologies.[83] Another wave of research has targeted the phenomenological experience of the Soviet subject through the lens of the cultural history of the senses, emotions, and everyday practices.[84] Among these, Emma Widdis's recent book, *Socialist Senses: Film, Feeling, and the Soviet Subject, 1917–1940*, stands out as a fresh and stimulating compendium of approaches to tactile sensations in biomedical, philosophical, and ideological discourses. Widdis's goal is to reveal the ways in which touch was appropriated for the task of forging a new, distinctly Soviet outlook on the human body and its interaction with the material environment.[85] Focusing on films and film theory during several phases of the Soviet history—from the utopianism of the 1920s and the reign of the avant-garde, to the First Five Year Plan, to high Stalinism—Widdis contrasts the early Soviet films, which celebrated the sensory richness of physical labor and crafts like lacemaking, and the later Socialist Realist works, which centered on character-driven narratives to streamline emotional identification. She astutely maps these shifts of Soviet sensibility onto the struggle between various schools of psychology and changes in the political climate of the country. The early 1920s were dominated by psychophysiological positivism, which promoted the view of mankind as a biosocial organism and a collective force transforming the environment. Toward the end of this decade, this materialist approach gave way to a more psychologically oriented view that elevated the individual's unique personality. While initially this was a healthy development for the discipline, quite soon the personality approach turned rigid and doctrinaire, with individuals' psychology being gauged by the strict norms of the Stalinist moral code. A remarkable feature of Widdis's work is her nuanced analysis of the filmic techniques eliciting tactile sensations—an interest prompted by the haptic turn in cinema

[83] Mikhail Iampolskii, "Kuleshov and the New Anthropology of the Actor," in *Inside the Film Factory: New Approaches to Russian and Soviet Cinema*, ed. Richard Taylor and Ian Christie (London: Routledge, 1991), 31–50; Valerii Podoroga, *Mimesis*; Igor' Chubarov, *Kollektivnaia Chuvstvennost'*; Charlotte Douglas, "Energetic Abstraction: Ostwald, Bogdanov, and Russian Post-Revolutionary Art." in *From Energy to Information: Representation in Science and Technology, Art, and Literature*, ed. Bruce Clarke and Linda Dalrymple Henderson (Stanford, CA: Stanford University Press, 2002), 76–94; Julia Vaingurt, *Wonderlands of the Avant-Garde: Technology and the Arts in Russia of the 1920s* (Evanston, IL: Northwestern University Press, 2013); Lilya Kaganovsky, *How the Soviet Man Was Unmade: Cultural Fantasy and Male Subjectivity under Stalin* (Pittsburgh: University of Pittsburgh Press, 2008); Lilya Kaganovsky, *The Voice of Technology: Soviet Cinema's Transition to Sound, 1928–1935* (Bloomington: Indiana University Press, 2018)..

[84] Jan Plamper, Schamma Schahadat, and Marc Elie, eds., *Rossiiskaia Imperiia Chuvstv: Podkhody k Kul'turnoi Istorii Emotsii* (Moskva: Novoe literaturnoe obozrenie, 2010); Jan Plamper, ed., *Emotional Turn? Feelings in Russian History and Culture*. Special Section of *Slavic Review* 68.2 (2009): 229–330; Konstantin Bogdanov, "Pravo na son i uslovnye refleksy: kolybel'nye pesni v sovetskoi kul'ture (1930–1950-e gg.)," *Novoe literaturnoe obozrenie* 86 (2007) *Zhurnal'nyi Zal*, http://magazines.russ.ru/nlo/2007/86/bo1.html.

[85] Emma Widdis, *Socialist Senses: Film, Feeling, and the Soviet Subject, 1917–1940* (Bloomington: Indiana University Press, 2017), 5.

studies brought about by Giuliana Bruno, Laura Marks, Vivian Sobchack, Jennifer Barker, and other theorists. Widdis points out that the Soviet avant-garde theorists writing about the embodied experience of spectators in the 1920s have anticipated many of the contemporary arguments.[86] My book searches for the roots of these embodied approaches in psychophysiological discourses, originating in the 19th-century laboratories, as well as in the aesthetic theories inspired by the research on perception, motor innervations, and kinesthetic empathy. By starting with the prerevolutionary period and digging deeper into the 19th century, *Psychomotor Aesthetics* spotlights the preconditions for the intensified convergence of psychophysiology and aesthetics in the 1920s—the decade when, in the words of Margarete Vöhringer, "seemingly incompatible scientific and artistic methods came together in the process of creating a common object—the new Socialist man."[87]

The formation of this interdisciplinary terrain at the juncture of psychophysiology and performance arts in early 20th-century Russia may be appreciated from Irina Sirotkina's pivotal works on topics such as the notion of "biomechanics" in Vsevolod Meyerhold's theater and Nikolai Bernshtein's science of motor coordination, theories of the "muscular sense" pertaining to modern dance, and representations of expressive movement in photographs of the "kinemological" section of the State Academy of the Artistic Sciences (*Gosudarstvennaia Akademiia Khudozhestvennykh Nauk*, GAKhN).[88] Oksana Bulgakowa's and Julia Vassilieva's archival research has clarified Sergei Eisenstein's engagement with various trends of psychology, including Freudian psychoanalysis, Lev Vygotsky's and Alexander Luria's cultural-historical psychology, and Kurt Lewin's action theory.[89] Mikhail Iampolski, John MacKay, and Valerie Pozner have reflected on Vladimir Bekhterev's neurophysiology and energeticism in connection to

[86] Widdis, *Socialist Senses*, 8–10.
[87] Vöhringer, *Avangard i Psikhotekhnika*, 289.
[88] Irina Sirotkina, "Biomekhanika: Mezhdu naukoi i iskusstvom," *Voprosy istorii estestvoznaniia i tekhniki* 1 (2011): 46–70; Irina Sirotkina, *Svobodnoe Dvizhenie i Plasticheskii Tanets v Rossii* (Moskva: Novoe literaturnoe obozrenie, 2011); Irina Sirotkina, *Shestoe Chuvstvo Avangarda: Tanets, Dvizhenie, Kinesteziia v Zhizni Poetov i Khudozhnikov* (Sankt-Peterburg: Izdatel'stvo Evropeiskogo universiteta, 2014); Irina Sirotkina and Roger Smith, *Sixth Sense of the Avant-Garde: Dance, Kinaesthesia and the Arts in Revolutionary Russia* (London: Methuen, 2017); Irina Sirotkina, "Kinemologiia, ili nauka o dvizhenii. Zabytyi proekt GAKhN," in *Mise en geste. Studies of Gesture in Cinema and Art*, ed. Ana Hedberg Olenina and Irina Schulzki, Special issue of *Apparatus. Film, Media and Digital Cultures in Central and Eastern Europe* 5 (2017), http://dx.doi.org/10.17892/app.2017.0005.81.
[89] Oksana Bulgakowa, "Eizenshtein i ego psikhologicheskii Berlin: Mezhdu psikhoanalizom i strukturnoi psikhologiei," *Kinovedcheskiie Zapiski* 2 (1988): 174–189; Oksana Bulgakowa, "From Expressive Movement to the "Basic Problem," in *The Cambridge Handbook of Cultural-Historical Psychology*, ed. Anton Yasnitsky, René Veer, and Michel Ferrari (Cambridge: Cambridge University Press, 2014), 423–448.

Dziga Vertov's representation of movement onscreen.[90] Despite these and many other remarkable interventions, the full picture of psychology's interaction with the arts in early 20th-century Russia is far from complete. Particularly scarce are studies underpinned by methodologies introduced by Michel Foucault and Bruno Latour—those equally vested in the analysis of material practices within scientific laboratories and the cultural politics of agent networks which helped disseminate the scientific research. In this respect, the works of the German media scholars Ute Holl, Margarete Vöhringer, and Elena Vogman are exemplary in bringing out the relationship between Leftist aesthetic theories, Soviet film avant-garde, and the reflexology of Pavlov and Bekhterev.[91] My book is similarly concerned with ways in which neurophysiological laboratories inscribed and interpreted salient micro-movements of the body, as well as the further fate of these methods and concepts in the hands of artists and cultural authorities.

However, the platform from which *Psychomotor Aesthetics* approaches its subjects would be more accurately characterized as post-Foucauldian. My study of material practices, institutional spaces, and scientific instruments is not guided by the singular goal of exposing the mechanisms of top-down social regulation, interiorized self-disciplining, and ways in which technologies are implicated in articulating power and establishing social hierarchies. Philosophically, equally as important as Foucault for me has been Michel de Certeau's validation of rogue interpretations of dominant discourses—appropriations, in which everyday users individualize and transform the passed-down schemata.[92] Profoundly influential for my understanding of the early 20th-century cultural history in Russia has been the work of my late mentor, Svetlana Boym, whose "off-modern" historiography has emphasized "the play of human freedom vis-à-vis political teleologies and ideologies that follow the march of revolutionary progress, or the invasive hand of the market."[93] The chapters dealing with the Russian Futurists, Formalists, and the avant-garde filmmakers, discuss the creative liberties these authors took with the scientific concepts, and new applications they found for scientific methodologies while adopting them to their own goals. I have aimed to preserve a space for seeing their projects on their own terms, as independent

[90] Ute Holl, *Cinema, Trance, Cybernetics*, trans. Daniel Hendrickson (Amsterdam: Amsterdam University Press, 2017), 219–245; John MacKay, "Film Energy: Process and Metanarrative in Dziga Vertov's *The Eleventh Year*," *October* 121 (2007): 41–78; Mikhail Iampolski, "Smysl prikhodit v mir: Zametki o semantike Dzigi Vertova," *Kinovedcheskie Zapiski* 87 (2008): 54–65; Valerie Pozner, "Vertov before Vertov: Psychoneurology in Petrograd, in *Dziga Vertov: The Vertov Collection at the Austrian Filmmuseum*, ed. Thomas Tode and Barbara Wurm (Vienna: SINEMA, 2007), 12–15.

[91] Holl, *Cinema, Trance, Cybernetics*; Vöhringer, *Avangard i Psikhotekhnika*; Elena Vogman, *Sinnliches Denken. Eisensteins exzentrische Methode* (Zürich-Berlin: Diaphanes, 2018), 221 ff..

[92] Michel de Certeau, *The Practice of Everyday Life*, trans. Steven Rendall (Berkeley: University of California Press, 1984).

[93] Svetlana Boym, "History Out-of-Sync," in *The Off-Modern*, ed. David Damrosch (London: Bloomsbury Academic, 2017), 3–8, 4.

creative explorations, without rushing to identify their role in the emerging ideological and technocratic regimes. By comparing Russian cultural practices to their European and American counterparts, this study shows how all of these authors are trying to stake out their own territory in a world, where psychophysiology has challenged traditional notions of what it means to sense, feel, think, express, and communicate. This view allows us to see the Russian avant-gardists' engagement with psychological sciences as part of broader shifts englobing modern societies, as their response to issues absorbing the minds of Modernist theorists in the West.

My approach takes inspiration from the inquiry into the interconnected histories of psychology, technology, and the arts in Germany and France. Over the past thirty years, this interdisciplinary research has reinvigorated the fields of media studies, art history, and performance studies. Within these domains, trailblazing studies by Jonathan Crary, Georges Didi-Huberman, Rae Beth Gordon, Susan Buck-Morss, Michael Cowan, Stefan Andriopoulos, Scott Curtis, Robert Brain, and other scholars have revealed the cultural implications of neurophysiological research on sensory perception, attention, and rhythmical sense, as well as psychiatric discourses on hypnotism, neurosis, hysteria, double-consciousness, willpower, fatigue, shock, and sensory overload.[94] My work traces the repercussions of the psychophysiological approaches beyond the European epicenter and their engrafting into new contexts and discursive frameworks. My study emulates the aforementioned scholars' commitment to archival research across disciplinary divides, as it puts into dialog materials as diverse as scientific treatises, experiment documentation, poetry, literary scholarship, artist memoirs, performance manuals, filmmakers' manifestoes, film production shots, and charts of film viewers' responses, as well as periodicals on literature, film, theater, psychology, and industrial labor management. The chapters of this book show how these texts and visual documents illuminate each other, producing a history of discursive configurations of "expressive movement" and material practices that consolidated the view of corporeal motion as inextricably linked to higher nervous activity.

[94] Jonathan Crary, *Suspensions of Perception: Attention, Spectacle, and Modern Culture* (Cambridge, MA: MIT Press, 1999); Georges Didi-Huberman, *Invention of Hysteria*; B. Rae Gordon, *Why the French Love Jerry Lewis: From Cabaret to Early Cinema* (Stanford, CA: Stanford University Press, 2001); Susan Buck-Morss, "Aesthetics and Anaesthetics: Walter Benjamin's Artwork Essay Reconsidered," *October* 62 (1992): 3–41; Michael Cowan, *Cult of the Will: Nervousness and German Modernity* (University Park: Penn State University Press, 2012); Stefan Andriopoulos, *Possessed: Hypnotic Crimes, Corporate Fiction, and the Invention of Cinema* (Chicago: University of Chicago Press, 2008); Scott Curtis, *The Shape of Spectatorship: Art, Science, and Early Cinema in Germany* (New York: Columbia University Press, 2015); Brain, *The Pulse of Modernism*.

My primary investigative strategy in this book was following up on references to psychological and neurophysiological treatises cited in theoretical texts by writers, artists, and scholars. This inductive research has allowed me to trace the circulation of terms, methods of accounting for the corporeal movement, and explanations of its role in affective and cognitive processes. Since the ideas borrowed from science never fell into a vacuum, but rather came into contact with the other notions accepted in a given cultural sphere, what I present in this book may be called "discursive entanglements." Of particular importance to my study was the task of reconstructing the cultural milieu of each author and mapping the institutional forces, intellectual fashions, and ideological programs that aided in the dissemination of scientific ideas. Historical reconstruction also enabled me to interrogate the exact nature of the relationship between the sciences and the arts. Thus, rather than simply positing the direct influence of psychological science on various cultural practices, I demonstrate the degree to which misappropriation and defamiliarization characterized this exchange.

Fig. 1.1 Gustav Klutsis, "Aleksei Kruchenykh Reading His Poetry," photomontage, silver gelatin print, 1927. This image was published in Aleksei Kruchenykh's book *Piatnadtsat' let russkogo futurizma, 1912–1927* (Moskva: vserossiiskii soiuz poetov, 1928), 49. © The State Museum of V.V. Mayakovsky, 2019.

1

Sound-Gesture

Psychological Sources of Russian Futurist Poetry

> All motion of the tongue in the cavity of our mouth is a gesture of an
> armless dancer, twirling the air, like a gaseous, dancing veil . . . Sounds
> are ancient gestures in the millennia of meaning . . . sounds know
> the mysteries of ancient movement of our spirit . . . Gestures are
> youthful sounds of meanings implanted in my body, but not yet
> composed.
>
> —Andrei Bely[1]

> We must remember here the psychomotor character of our brain
> processes . . . We recognized the fundamental truth that there is no
> sensorial state which is not at the same time the starting-point for
> motor reaction.
>
> —Hugo Münsterberg[2]

Viktor Shklovskii's essay "On Poetry and the Trans-sense Language" (1916),
dedicated to experiments of Russian Futurists, offers an insight into his early
views on language and its operations.[3] Defending the Futurists' project as some-
thing greater than a youthful escapade, a "slap in the public face," Shklovskii
considers their play with nonsensical sound combinations—*zaum'*, or poetry
"beyond reason"—to be an experiment that probes into the very conditions of
verbal expression. An early draft of this article bears an inscription "To the first
examiner of this issue, the poet Aleksei Kruchenkykh" (Fig. 1.1).[4] This dedica-
tion, which enlists the leader of Moscow Kubo-Futurists as a fellow explorer

[1] Andrei Bely, *Glossolalie—Glossolalia—Glossolaliia: Poem Über Den Laut—A Poem about Sound-
Poema o Zvuke*, ed. and trans. Thomas R. Beyer (Dornach, Switzerland: Pforte, 2003), 49.

[2] Hugo Münsterberg, *Psychotherapy* (New York: Moffatt, Yard, and Co., 1909), 98.

[3] Viktor Shklovskii, "O Poezii i Zaumnom Iazyke," in *Poetika: Sborniki po teorii poeticheskogo
iazyka* (Petrograd: 18-aia Gos. Tipografiia, 1919), 13–26. This essay first appeared in the Formalist
collection *Sborniki po teorii poeticheskogo iazyka* in 1916. For an annotated English translation, see
Viktor Shklovskii, "On Poetry and Trans-Sense Language," trans. by Gerald Janecek and Peter Mayer,
October 34 (1985): 3–24.

[4] Viktor Shklovskii, "Zaumnyi Iazyk i Poeziia" (1913–1914), RGALI f. 562. op. 1. ed. khr. 63.

Psychomotor Aesthetics. Ana Hedberg Olenina, Oxford University Press (2020). © Oxford University Press.
DOI: 10.1093/oso/9780190051259.001.0001

and theoretical pioneer, is indicative of the direction that Shklovksii would take in interpreting the avant-garde poets' project at large. By the end of the article, Futurists' experiments like Kruchenykh's scandalous nonsense poem "Dyr bul shchyl/ubeshchur" would appear to be more than an attempt to detonate the euphony of the classical Russian poetry, but a transcription of processes that went on in the poet's psyche at the moment of the poem's creation.[5] Commenting on this 1916 essay nearly seventy years later, Shklovskii summarized what intrigued him about the Futurists' play with the limits of language as a young man:

What interests me most in *zaum*? It is the fact that the Futurist poets wanted to express their perception of the world [*oshchushcheniie mira*] while bypassing the established linguistic systems. Our perception of the world is not verbal. The trans-sense language is the language of pre-inspiration, it is the quivering chaos of poetry [*sheveliashchiisia khaos poezii*]; a chaos that is anterior to the bookish language and that comes prior to the word—a chaos out of which everything is born and where everything passes to.

Likewise, Khlebnikov told me that poetry was more than just the word.

The trans-sense poets [*zaumniki*] attempted to reproduce this vibrating chaos of pre-words, of pre-language [*koposhashchiisia khaos pred-slov, pred-iazyka*]. Strictly speaking, the trans-sense language [*zaum*] is not a language, but a pre-language.

A child is born possessing the cry of its forefathers. This cry is not yet broken into words; it is a mumble, a language of palpating the world, a language of dumbfounding it [*iazyk oshchupyvaniia mira, osharashivaniia ego*]. As we probe the world by sound, we run into objects and mark them with particular sounds.[6]

The view of the poetic language that emerges from this 1984 commentary, as well as from the 1916 essay itself, insists on the Futurists' discovery of some

[5] In a manifesto called "Word as Such," Kruchenykh and Velimir Khlebnikov famously mocked the sound orchestration of literary classics. Ridiculing Mikhail Lermontov's poem "Po nebu polunochi angel letel" ("In the midnight sky, an angel was flying"), Kruchenykh wrote: "Like pictures painted with gooey fruit brew and milk, we reject poems built upon pa-pa-pa/pi-pi-pi/ti-ti-ti, etc. A healthy person can only get indigestion from such food. We present an example of a different sound- and word-composition: dyr bul shchyl/ubeshchur/skum/vy so bu/r l ez. Incidentally, this five-line poem contains more of the Russian and the national than the whole of Pushkin's poetry" (Aleksei Kruchenykh and Velimir Khlebnikov, *Slovo kak takovoe* [Moscow: Tipo.-lit. Ia. Dankin i Ia. Khomutov, 1913], 8–9).

[6] Viktor Shklovskii, "O zaumnom iazyke. 70 let spustia," in *Russkii literaturnyi avangard: Materialy i issledovaniia*, ed. Marzio Marzaduri, Daniela Rizzi, and Mikhail Evzlin (Trento: Universita di Trento, 1990), 253–259, 255. Marzio Marzaduri, who commissioned this article and first published it in the Italian journal *Il Verri*, n. 9–10 (1986), notes that Shklovskii completed the text several months before his death in 1984.

chaotic, elemental motion beneath the crust of stable verbal forms. Shklovskii metaphorically equates our coming to terms with language and the testing of space by an acoustic sounder—touching along the contours of objects, communicating by groping, by trial and error. With an ear to phantom resonances, Shklovskii juxtaposes *oshchushchenie—oshchupyvanie—osharashivanie* [sensing—palpating—dumbfounding] and other similar-sounding words as if to illustrate, or to perform for the reader his understanding of the poet's creative search. The alliterative echoing creates a connection between nouns that have no etymological relation to each other, enriching them with new semantic nuances beyond their dictionary definitions. The writer's fixation on one consonant makes the reader perceive the sentences of the passage as a single sonorous field and a semantic continuum, in which the notion of poetic expression becomes inextricably linked to the poet's sensory being in the world and his drive for stunning, surprising, or "dumbfounding" the world. This latter notion of "dumbfounding"—for which Shklovskii uses an unusual, colloquial word *osharashivanie*—must be a veiled reference to the concept that he is most famous for: estrangement, *ostranenie*. The repetition of sounds in Shklovskii's passage clearly is not simply a rhetorical embellishment, but a performative rehearsal of ideas that were crucial for him at the start of his career. In his 1916 essay on *zaum'*, he wrote:

> Often, verses arise in the poet's psyche as sound spots [*zvukovye piatna*], not yet realized as words. The spot comes closer, then recedes again, until it finally gets clarified [*vysvetliaetsia*] as it coincides with a similar-sounding word. The poet does not dare to use a trans-sense word [*zaumnoe slovo*]—usually, he hides the trans-sense [*zaum'*] under the guise of some kind of content, which often remains deceptive, illusory, not fully comprehensible for the poet himself.[7]

With his term "sound spots," Shklovskii suggests that during the process of verse composition, the poet's consciousness first begins to apprehend some indistinct yet persistent sound shapes, which later become the inner core of the expression verbalized in terms of the normative language. In the essay, he goes through examples of alliterative effects, inner rhymes, and homonymy in many types of poetry from Japanese *tanka* to Slavic folk songs, drawing the reader's attention to the fact that word choice in poetic texts is frequently determined by phonetic affinity. Shklovskii interprets the poets' tendency to use words containing similar sounds as a haunting influence of "the inner sound-speech" (*vnutrenniaia zvukorech'*)—that primordial murmur which precedes the production of

[7] Viktor Shklovskii, "O poezii i zaumnom iazyke," in *Poetika: Sborniki po teorii poeticheskogo iazyka* (Petrograd: 18-aia Gos. Tipografiia, 1919), 13–26, 21.

articulate language and which reflects the operations of consciousness as it works toward the expression of its dispositions.

Shklovskii's analysis centers on the question of how an idea, a mood, or a "feeling-tone" acquires a verbal form and why it becomes associated with certain sound shapes. This approach is based on a long tradition of seeing the structures of language as related to the structures of perception and cognition—a tradition which received a particular impetus in the works of the 19th-century post-Kantian philologists Wilhelm von Humboldt and Heymann Steinthal. It was the ideas of this school in combination with psychophysiological approaches to aesthetics pioneered by Johann Friedrich Herbart, Hermann von Helmholtz, and Gustav Fechner, that exerted a defining influence on the intellectual framework of Russian literary studies and linguistics at the turn of the 20th century.[8] The generation of scholars, who were immediate predecessors of Shklovskii and other Formalists, passed on to them a constellation of research questions and methodologies directed at examining the ways in which inner—perceptual, cognitive, and emotional—mechanisms give shape to cultural forms.

This chapter charts out discursive links that situate Shklovskii's views on the act of poetic creation within this tradition. By examining Shklovskii's concepts in "On Poetry and the Trans-sense Language" and following up on his references, I am revealing how his text and its sources are engaging—at times rigorously, and at times flirtingly—with turn-of-the-century psychophysiology and philosophy of mind. Ultimately, this exploration aims to offer an understanding of what it meant for Shklovskii and the poets he analyzed to say that their experiments were geared at "fixating the impulses of the creative consciousness within the material of verse itself."[9]

Movement as a Material Conduit of Affect

In his manifesto "The New Ways of the Word" (1913), Kruchenykh described the method of the Russian Futurists' poetic experiments:

[8] For an excellent exposition of this influence, see Ilona Svetlikova, *Istoki russkogo formalizma: Traditsiia psikhologizma i formal'naia shkola* (Moscow: Novoe literaturnoe obozrenie, 2005). The following studies also outline the impact of the 19th-century German philosophy of language on Russian Formalists: Thomas Seifrid, *The Word Made Self: Russian Writings on Language, 1860–1930* (Ithaca, NY: Cornell University Press, 2005); John Fizer, *Alexander A. Potebnja's Psycholinguistic Theory of Literature: A Metacritical Inquiry* (Cambridge, MA: Harvard University Press, 1988); Renate Lachmann, *Memory and Literature: Intertextuality in Russian Modernism*, trans. Roy Sellars and Anthony Wall (Minneapolis: University of Minnesota Press, 1997).

[9] This apt descriptor belongs to the scholar Ekaterina Bobrinskaia (see Ekaterina Bobrinskaia, "Zhest v poetike rannego russkogo avangarda," in *Russkii avangard: istoki i metamorforzy* (Moscow: Piataia Strana, 2003), 199–209, 201.

Contemporary poets [*baiachi*] have discovered that erroneous construc-
tion of sentences (with regards to thought and grammar [*graneslovie*])
generates movement and a new perception of the world [*daet dvizheniie i
novoe vospriiatie mira*]; and vice versa, movement and change of the psyche
[*dvizheniie i izmeneniie psihiki*] give birth to strange, nonsensical combinations
of words and letters.[10]

The key issue for Kruchenykh is "movement" and "change"—of the psyche, of
the body, of one's view of the world. He points to a reflection of these scissions
in sound shapes of phrases, freed from reason and grammar, as well as in
motorics of writing and drawing, liberated from a preconceived compositional
order. Whether this reflection was genuine or contrived, spontaneous or delib-
erate, conditioning the production of an artwork or discovered later as an af-
terthought was a question that the Futurists' critics liked to speculate about,
with suspicion. The very idea of instantaneous, indexical transmission of the
psyche's movements in the articulation of sounds and motions of the writing
hand came to Kruchenykh from several sources, among which, as the scholars
Ekaterina Bobrinskaia and Naamah Akavia have shown, psychiatric treatises on
out-of-the-ordinary behavior took a special place.[11] In particular, two works by
the Russian scientists provided the poet with a sense of how graphemes, trance-
like quivering, and vocalizations may indicate strong affects and altered states
of consciousness: Dmitrii Konovalov's *Religious Ecstasy among Russian Mystical
Sects* (1908) and Vladimir Obraztsov's *The Writing of the Mentally Ill* (1904).[12]
Konovalov's book, dealing with a phenomenon that the official Orthodox clergy
condemned as heretic, provided an anthropological description of the marginal
religious groups among the peasantry and attempted to vindicate their unusual
ecstatic practices by explaining them from a psychophysiological standpoint.
Jean-Martin Charcot's and Paul Richer's research on the "grand hysteria" was
an important influence for Konovalov, yet, compared to the French colleagues,
his analysis of the Russian sectarians' *radenie* (ecstatic practices) used a sympa-
thetic rather than sensationalist tone.[13] As Alexander Etkind has pointed out,

[10] Aleksei Kruchenykh, "Novye puti slova," in *Manifesty i programmy russkikh futuristov. Die
Manifeste und Programmschriften der russischen Futuristen* (München: Fink, 1967), 64–72, 68.
[11] Ekaterina Bobrinskaia, "Teoriia 'momental'nogo tvorchestva' A. Kruchenykh," *Russkii
avangard: Istoki i metamorforzy* (Moscow: Piataia Strana, 2003), 94–117. Naamah Akavia, *Subjectivity
in Motion: Life, Art, and Movement in the Work of Hermann Rorschach* (New York: Routledge,
2017), 148.
[12] D. G. Konovalov, *Religioznyi Ekstaz v Russkom Misticheskom Sektanstve: Izsledovanie*
(Sergiev Posad: Tip. Sergievoi Lavry, 1908); V. N. Obraztsov, *Pis'mo dushevno-bol'nykh: Posobie k
klinicheskomu izucheniiu pikhiatrii s risunkami i tablitsami pis'ma* (Kazan: Tipo-lit. Imperatorskago
Universiteta, 1904).
[13] Konovalov applied Charcot's and Richet's classification of phases of "grand hysteria" in his
analysis of religious ecstasy, but he considered this model somewhat forced and artificial. See D. G.
Konovalov, "Magisterskii disput. *Religioznyi Ekstaz v Russkom Misticheskom Sektanstve*. Chast' 1,

Konovalov took recourse to William James's reflections on the varieties of religious experience to offer a sober outlook on the seemingly scandalous elements of *radenie*.[14] References to psychophysiological investigations of involuntary spasms by Pierre Janet, Paolo Mantegazza, George Gilles de la Tourette, and other European scientists provided a framework for Konovalov's clinical picture of his subjects' symptoms: tremors, agitation, sudden exclamations, and heart palpitations.[15] Prior to catching Kruchenykh's eye, Konovalov's study had already produced a great resonance in the Russian culture of Decadence, striking a chord with the Symbolists.[16] Andrei Bely's murder-plot novel *The Silver Dove* (1909) attributed traits of Dionysian bestiality to peasant sectarianism, while Vladimir Solov'ev interpreted spontaneous manifestations of religiosity among the Russian folk through the prism of his own religious mysticism. In contrast to the Symbolist thinkers, Kruchenykh stripped the sectarians' ecstatic practices of all Romantic flair, treating their *glossolalia* (speaking in tongues) as a technique—a method of creative release. In *Explodity* (*Vzorval'*), the poet incorporated citations of the sectarians' *glossolalia* amid his own poems, so as to illustrate the far-reaching goals of the "trans-sense" language and its momentous relationship with the inner experience (Fig. 1.2). Viktor Shklovskii replicated this perspective in his 1916 essay on the trans-sense poetry, interspersing his analysis of the Futurist poetry with examples of linguistic ecstasy taken from Konovalov's book.

Kruchenykh's second source, Obraztsov's treatise *The Writing of the Mentally Ill*, was based on the author's clinical work at Kazan Psychiatric Hospital, a prominent center of psychiatric and neurophysiological research, which engaged

vypusk 1, Fizicheskie iavlenia v kartine sektantskogo ekstaza," *Bogoslovskii Vestnik* 1.1 (1909): 152–167, 167. *Khristianskaia Teologiia i Antropologiia*, http://www.xpa-spb.ru/libr/Konovalov-DG/magisterskij-disput-1.pdf; D. G. Konovalov, "*Religioznyi Ekstaz v Russkom Misticheskom Sektanstve. 1. Kartina sektantskogo ekstaza*," *Bogoslovskii Vestnik* 1.3 (1907): 595–614, 602. *Khristianskaia Teologiia i Antropologiia*, http://www.xpa-spb.ru/libr/Konovalov-DG/religioznyj-ekstaz-3.pdf.

[14] Alexander Etkind, "James and Konovalov: The Varieties of Religious Experience and Russian Theology Between Revolutions," in *William James in Russian Culture*, eds. Joan Delaney Grossman and Ruth Rischin (Lanham, MD: Lexington Books, 2003), 169–188. An insightful analysis of Kruchenykh's and other avant-garde poets' interest in the *Khlysts'* linguistic ecstasy is offered in Ekaterina Bobrinskaia, "Teoriia 'momental'nogo tvorchestva' A. Kruchenykh."
[15] Konovalov, "*Religioznyi Ekstaz v Russkom Misticheskom Sektanstve. 1. Kartina sektantskogo ekstaza.*"
[16] Andrei Bely described a religious sect reminiscent of the *Khlysty* in his novel *The Silver Dove* (Andrei Bely, *Serebriannyi golub'* [Moskva: Skorpion, 1909]). On Viacheslav Ivanov's notion of glossolalia in relation to Russian sectarian practices, see Maria Candida Ghidini, "Zvuk i smysl. Nekotorye zamechaniia o glossolalii u Viacheslava Ivanova," in *Viacheslav Ivanov i ego vremia* (Frankfurt am Main: Peter Lang, 2002), 65–83; Thomas Seifrid, *The Word Made Self: Russian Writings on Language, 1860–1930* (Ithaca, NY: Cornell University Press, 2005), 65. On Sergei Solov'ev fascination with the sect of the *Khlysty* and folk religiosity, see Piama Gaidenko, *Vladimir Solov'ev i Filosofiia Serebriannogo Veka* (Moskva: Progress-Traditsiia, 2001), 23–24.

Fig. 1.2 A handwritten page from Kruchenykh's *Explodity* (*Vzorval'*), with the author's reflections on the *Khlysty* sectarians' linguistic ecstasy as "an expression of tumultuous psyche," as well as the "trans-sense" speech occurring during emotionally overwhelming moments. The abstract watercolor shapes, vibrating and curling up in the background, seem to evoke a reclining figure of a mother holding a child, a possible allusion to the Virgin Mary in the sectarians' prayers— although like a Rorschach's test, these associations are in the eye of the beholder. Image source: Aleksei Kruchenykh, *Vzorval'*, 2nd ed., with illustrations by N. Kul'bin, N. Goncharova, O. Rozanova, K. Malevich, and N. Al'tman (Sankt-Peterburg: Litografiia Svet, 1913). © The State Museum of V.V. Mayakovsky, 2019.

authoritative scientists such as Vladimir Bekhterev among its consultants.[17] Obraztsov's book highlighted the markers of nervous disorders in samples of patients' handwriting, drawings, and lexical peculiarities of their delirious speech, replete with neologisms and nonsequiturs. Following the graphologists Cesare Lombroso and Christoph von Schroeder, Obraztsov claimed, for instance, that

[17] K. V. Lebedev, I. N. Volkova, and L. N. Zefirov, *Iz istorii Kazanskoi fiziologicheskoi shkoly* (Kazan': Izdatel'stvo Kazanskogo universiteta, 1978), 228.

Fig. 1.3 A sample of a "maniacal" patient's writing in Vladimir Obraztsov's book. Image source: V. N. Obraztsov, *Pis'mo dushevno-bol'nykh: Posobie k klinicheskomu izucheniiu psikhiatrii s risunkami i tablitsami pis'ma* (Kazan': Tipo-lit. Imperatorskago Universiteta, 1904), 107.

the symptoms of "exaltatio maniacalis" in writing are represented on the level of content by rapid switching of ideas and ellipses in the logics of reasoning, and, on the level of execution, by an increasing speed, confidence, and expansiveness of handwriting suggestive of the "hyper-dynamism of the neural-muscular apparatus" (Fig. 1.3).[18] Undoubtedly, Kruchenykh's own endeavors were much more playful, anarchic, and anti-systematic compared to Obraztsov's attempts to trace the effects of psychological disorders on the manner of patients' handwriting. However, on some basic level, the poet and the psychiatrist shared the same belief in the expressive capabilities of handwriting. As Sergei Tret'iakov remarked, "Kruchenykh's letters and syllables [are] fractured and vary in size and script style; less frequently, they are handwritten, but in such rough manner, that even without being a graphologist, you immediately sense some sort of sinewy, brawny, tight-jointed psychology behind these letters".[19]

[18] Obraztsov, *Pis'mo dushevno-bol'nykh*, 101–108.
[19] Sergei Tret'iakov, "Buka russkoi literatury," *Strana-perekrestok* (Moskva: Sovetskii pisatel', 1991), 530–538, 532.

In addition to the Russian psychiatrists' treatises, there were other sources that inspired the authors of Shklovskii's generation to search for—or experiment with—the materialization of sensory, affective, and cognitive processes in the articulatory and acoustic aspect of speech. A comparison with the Italian Futurists and the French *vers-libristes* points to the existence of an entire theoretical platform, which served as a springboard for these ideas in the turn-of-the-century European culture. Paris, a capital of Modernist experimentation, where Filippo Tommaso Marinetti's "parole in libertà" first gained wide recognition, had been a site of intensive interdisciplinary exchange at the juncture of aesthetic theories and neurophysiology.[20] According to Robert Brain, two prominent trendsetters of the Parisian artistic scene—the psychophysiologist Charles Henry and a champion of Marinetti, the poet Gustave Kahn—took inspiration in the scientific recordings of corporeal motions to advance their perspective on poetry, dance, and painting as forms of vibration and affective rhythms. Their aesthetic theories focused on the sensory processing of the world by the artist and the workings of his neurophysiology during the expressive act. A sense of rhythm, as an internally-felt recurrence of intensities, became a unifying category for all impressions, whether visual, auditory, or kinesthetic.[21] The rhythmic motion of the body was also an objective, recordable parameter, which could be studied with the help of graphic recording devices. This kind of research was carried out by the pioneering center of experimental phonetics, established by the linguist and cleric Abbé Jean-Pierre Rousselot at The Collège du France (more on him in Chapter 2). Thanks to Roussellot's investigations, the Parisian literati came to believe that the "periodicities of the poet's physiology" may have more to do with the rhythm of verse than classic meter schemes. [22] This psychophysiological approach to the poetic rhythm resonated with the Modernist rebellion against traditions, providing further theoretical justification for the free verse explored by the French Modernists and foreign authors, such as Marinetti, Ezra Pound, and William Carlos Williams.[23]

The Russian Futurists preferred to insist on their independence from Marinetti, as well as the Symbolists, and indeed, the manifestos of Kruchenykh and his brothers-in-arms, such as Velimir Khlebnikov and Vladimir Mayakovsky, articulate unique goals for their creative quests (including the idea of baring the device and the emphasis on the structural properties of Russian phono-semantics).

[20] Robert Brain, *The Pulse of Modernism*, 213 ff.
[21] Robert Brain, "Genealogy of "ZANG TUMB TUMB": Experimental Phonetics, Vers Libre, and Modernist Sound Art," *Grey Room* 43 (2011): 88–117, 95.
[22] Brain, *The Pulse of Modernism*, xxxi.
[23] Ibid. On Rousselot's influence on Pound and Williams, see Michael Golston, *Rhythm and Race in Modernist Poetry and Science: Pound, Yeats, Williams, and Modern Sciences of Rhythm* (New York: Columbia University Press, 2008).

However, similar to their rivals and predecessors, the *budetliane*, as the Russian Futurists liked to call themselves, cultivated an introspective awareness of their sensory experiences, taking recourse to onomatopoeia to express an amalgam of fleeting, transitory states of consciousness. This psychophysiological view of the process of poetic composition is expounded in the theoretical essay "How to make verses?" ("Kak delat' stikhi?," 1926) by Mayakovsky, who had been associated with the Moscow Kubo-Futurists in the 1910s. The act of creation, writes Mayakovsky, begins with some indeterminate hum [*gul*], which forms the foundation of the rhythmical structure of the future poem:

> I walk around swinging my arms and mumbling still almost without words, sometimes shortening my step to match the mumbling, sometimes starting to mumble faster to match the beat of the steps. Thus, rhythm is hewed and shaped—the foundation of any poetic thing, permeating it as a hum [*gulom*]. Gradually, out of this hum one begins to pick out individual words. . . . Where this main hum-rhythm comes from is unknown. In my case, it is every repetition within me of a sound, a noise, a swinging motion, or in general, every repetition of a phenomenon that I mark by sound. . . . An attempt to organize movement, to organize sounds around oneself, discovering their character and peculiarities, is the main feature of the poet's toil, generating rhythmical pre-forms [*ritmicheskiie zagotovki*]. I don't know if the rhythm exists outside of me or only within me; most probably within.[24]

Mayakovsky's introspective focus on rhythm and movement, as well as his description of the poet's work on processing and organizing sensations, brings him close to the aesthetic theories of the Parisian *vers-libristes*. Additionally, this autobiographic account of creative process appears to follow Shklovskii's view of poetry's birth in the form of wavering sound spots emerging from the subliminal stratum. Even if Mayakovsky was describing his own experience, it is curious to note how well his account matches Shklovskii's ideas on the trans-sense poetry. Did this view, we may wonder, take shape in the Futurists' literary cabarets that Shklovskii and Mayakovsky frequented in the 1910s?

In Shklovskii's case, however, there is another source that is responsible for the specific idea of "sound spots" and the "quivering" chaos out of which poetry is born. This source is Aleksandr Potebnia's psycholinguistic study *Thought and*

[24] Cf. Vladimir Mayakovsky, "Kak delat stikhi?" in *Polnoe Sobranie Sochinenii*, 13 vols., vol. 12 (Moskva: Gos. izd-vo khudozhestvennoi literatury, 1959), 81–117, 100–101. The similarity of Mayakovsky's and Shklovskii's ideas on the process of poetic composition has also been noted by Gerald Janecek and Peter Mayer in their annotations to "On Poetry and Trans-Sense Language" by Viktor Shklovskii, trans. and ed. Gerald Janecek and Peter Mayer, *October* 34 (1985): 3–24, 16.

Language, a book that Shklovskii knew well.[25] Potebnia devotes a large discussion to Heymann Steinthal's theory of consciousness, where the term "trembling" refers to the state of sensory perceptions or representations (*predstavleniia*) that are yet unconscious but are on the verge of becoming available for the consciousness (*schwingende Vorstellungen*).[26] The only difference is that Shklovskii speaks of a sound series, whereas Steinthal operated with series of ideas. Ilona Svetlikova has demonstrated that *schwingende Vorstellungen* is a term of Herbartian psychology, which may have inspired another Russian Formalist, Iurii Tynianov, to formulate his theory of the "density of sound series" (*plotnost' zvukoriada*) in poetry—the idea that the proximity and repetition of sounds is responsible for the interpenetration of semantic fields of words in a poetic line.[27]

The idea that the "trans-sense speech" reflects the flux of ideas and emotions parallels the attempts of psychophysiological laboratories to decipher neurophysiological states on the basis of images. In the 1890s, the Salpêtrière psychiatrist and mystic Hyppolite Baraduc claimed to have recorded emanations of emotional energy on photosensitive plates touching his subjects—a piece of news that captured the imagination of the Russian Symbolists (Fig. 1.4).[28] As a related phenomenon, notice how a reference to "instantaneous photography" figures in the Symbolist Viacheslav Ivanov's 1925 essay on Pushkin, in which he laments the impossibility of reconstructing how the *grand maître* picked out sounds and rhythms for his poems:

Capturing the initial phase of this act would give us instant photographs of pure glossolalia and authentic "trans-sense speech" ["*zaumnoi rechi*"] (rather than the artificially fabricated, and therefore counterfeit trans-sense speech of certain Futurists). . . . Connected through its phonetic properties with a particular language, this articulate, yet wordless sound-speech [*chlenorazdel'naia, no besslovesnaia zvukorech'*] represents the labors of bringing into the sphere of

[25] Aleksandr Potebnia, *Mysl' i iazyk* (1913), 3rd ed. (Kiev: Sinto, 1993). The first edition of *Mysl' i iazyk* appeared in 1862. Shklovskii's relationship with Potebnia will be discussed in more detail further in this chapter.

[26] Potebnia, *Mysl' i iazyk*, 91. Potebnia refers to Heymann Steinthal, "Assimilation und Attraktion," *Zeitschrift für Völkerpsychologie und Sprachwissenschaft* 1 (1859): 107–117.

[27] Svetlikova, *Istoki russkogo formalizma*, 120.

[28] On Baraduc's method, see George Didi-Huberman, *Invention of Hysteria: Charcot and the Photographic Iconography of the Salpêtrière*, trans. Alisa Hartz (Cambridge, MA: MIT Press, 2003), 92–100. In 1900, Viacheslav's Ivanov's friend, the symbolist poet Valerii Briusov, who frequented spiritualist seances in St. Petersburg, published an essay "Esche raz o metodakh mediumizma" ["Once Again on the Methods of Mediumism"] in the journal *Rebus* 41 (1900): 349–351, in which he praised Baraduc for his studies of exceptional states of consciousness as a possible approximation of the medium's special powers. The essay is reprinted in full in N. A. Bogomolov, "Spititizm Valeriia Briusova: Materialy i nabliudeniia" ["Valerii Briusov's Spiritism"], in *Russkaia literatura nachala XX veka i okkul'tizm* [Russian Early 20th-Century Literature and Occultism] (Moscow: Novoe literaturnoe obozreniie, 1997), 279–310, 306.

Fig. 1.4 The drive to register psychological experiences, to make them visible and suitable for scientific analysis, compelled the late 19th-century psychiatrists to experiment with photography in the clinic. What for Viacheslav Ivanov was simply a nice metaphor—"instantaneous photographs" of the poet's mental concentration that activates his organs of speech—had been explored in earnest by the French psychiatrist Hyppolite Baraduc. Of course, the images obtained by Baraduc and his associates such as Louis Darget were all sham: what they took for the recordings of the "nervous energy," "movements of the psyche," or "auras of mental states" was simply a play of photochemical reactions. The image here is Baraduc's "Vortex: A Fluidic Swirl" (1896). The accompanying description states that this photograph was obtained by making the subject, experiencing sadness, touch a photo-sensitive plate with his right hand. Image source: Hyppolite Baraduc, *L'âme humaine: Ses mouvements, ses lumières et l'iconographie de l'invisible fluidique* (Paris: G. Carré, 1896, 204). Scan courtesy Cambridge University Library.

language the word as a symbol of the "trans-sense" image—the first, as of yet nebulous idea, striving to crystallize out of the emotional element. The fact that poetic creativity starts with the gestation of these nebulous spots [*tummannykh piaten*] testifies that poetry is truly a "function of language" and a phenomenon of its organic life, rather than some mechanical activity that is extraneous to it

and that involves recombining ready-made verbal material in a new way. Every time [he is writing], the poet repeats phylogenetically the process of birthing the word, and thus Schopenhauer was right when he said that true poetry is located within the element of language itself.[29]

Ivanov's dream of the instantaneous photographs of the poet's mind questions the limits of the Futurists' notion of the trans-sense language.[30] This eloquent discussion points to the tensions and dilemmas we will examine further in this chapter. Is poetry a function of "the emotional element," or "the element of language"? What is at stake, if we posit that it is both? Would we be justified in excluding some types of poetry as "inauthentic" as, ironically enough, Ivanov did with the Futurists in the earlier passage?[31]

Trans-Sense Speech: A Matter of Linguistic Convention or Subjective Emotion?

Most readers today may find it surprising that Shklovskii and other Russian Formalists would consider the choice of phonemes in a poetic text as motivated by the workings of the poet's psychology. This idea seems to suspend the axiom that language and literary style are purely a matter of convention. The latter tenet is typically perceived as fundamental for the Formalists' exploration of the intrinsic laws of literary evolution. Yet we may recall that Shklovskii's colleague Roman Jakobson, toward the end of his career, would ponder over the issue that "there is a latent tendency for the sounds to be congruent with their meanings" and claim that "such correspondences are very often built on the phenomenal interconnection between different senses—on synesthesia."[32] Likewise, the linguist Lev Iakubinskii, whose essay "On the Sounds of the Poetic Language" (1919) Shklovskii published in one of the first Formalists' collections, went to

[29] Viacheslav Ivanovich Ivanov, "K probleme zvukoobraza u Pushkina," in *Lik i Lichiny Rossii: Estetika i Literaturnaia Teoriia* (Moskva: "Iskusstvo," 1995), 242–247, 243.

[30] For an detailed analysis of this article, demonstrating that Ivanov is responding to Osip Brik's and Viktor Shklovskii's publications in *Poetika: Sborniki po teorii poeticheskogo iazyka* (1919), see Efim Etkind, "Vjaceslav Ivanov et les questions de poétique. Années 1920," *Cahiers du monde russe: Russie, Empire russe, Union soviétique, États indépendants* 35.1–2 (1994): 141–154. *Persee.* http://www.persee.fr/web/revues/home/prescript/article/cmr_1252-6576_1994_num_35_1_2381.

[31] A prominent leader of the Symbolists, Ivanov was for most part amicably predisposed toward the Futurists. He particularly favored Velimir Khlebnikov, who attended literary sessions at Ivanov's "Tower" salon, and Elena Guro. For more on Viacheslav Ivanov's complex and everchanging attitudes toward the Futurists, see A. E. Parnis, "Zametki k dialogu Viacheslava Ivanova s Futuristami," in *Viacheslav Ivanov: arkhivnye materialy i issledovaniia*, ed. L. A. Gogotishvili and A. T. Kazarian (Moscow: Russkie slovari, 1999), 412–432.

[32] Roman Jakobson and Linda R. Waugh, *The Sound Shape of Language*, 2nd ed. (Hague: Mouton de Gruyter, 2002), 266.

great pains to explain that the arbitrariness of the sign is true of the everyday, "practical" language of communication, but it may not apply for the poetic language.[33] Another friend of Iakubinskii and Shklovskii, the linguist Evgenii Polivanov, used the term "phonetics" interchangeably with "psychophonetics" and "sound imagination" (*zvukopredstavlenie*).[34] Having written an essay on onomatopoeia in the Japanese language for the Formalist volume *Poetika* (1919),[35] Polivanov preserved an interest in this phenomenon for the rest of his career. He researched such topics, for instance, as "psychological perception of foreign language sounds in relation to the phonetics of the mother tongue."[36]

Shklovskii's analysis of the Futurists in the early 1910s paved the way for this direction in later Formalist literary theory. Let us now look closely at Shklovskii's conception of what happens during a prolonged aesthetic experience of poetry, during which, as Iakubinskii puts it, "sounds of speech buoy up into the clear field of consciousness [*vsplyvaiut v svetloe pole soznaniia*],"[37] the customary content of words gets dissolved, and the person plunges into an exploration of his own associative chains and emotional reactions.

One of the key terms in Shklovskii's essay "On Poetry and the Trans-sense Language," is emotion. It appears in the beginning of the article, in a thesis that Shklovskii presents as the Futurists' claim that merits scholarly attention:

> Thus a number of people assert that their emotions are best expressed by a special sound-speech [*zvukorech'iu*], which often has no definite meaning and acts outside of meaning, or in spite of it directly upon the emotions of others. There arises a question: is this method of showing emotions simply a peculiarity of this small cohort, or a universal linguistic phenomenon, which has not yet been properly understood? [38]

The latter option is the one toward which Shklovskii gravitates himself. In the course of his essay, he presents multiple examples of "sound-speech"—the clustering of sounds that apparently contributes something to the overall effect of an utterance—insisting that this phenomenon can be found not only in poetic texts and folklore, but also in children's speech and ecstatic mumbling of religious

[33] Lev Iakubinskii, "O zvukakh poeticheskogo iazyka," in *Poetika* (Petrograd: 18-aia Gos. Tipografiia, 1919), 44–45.

[34] V. M. Alpatov, "Evgenii Polivanov," *Otechestvennye Lingvisty XX Veka: Sbornik Statei*, vol. 2, ed. Fedor Berezin (Moskva: INION RAN, 2003), 97–110, 102.

[35] Evgenii Polivanov, "Po povodu 'zvukovykh zhestov' iaponskogo iazyka," in *Poetika* (Petrograd: 18-aia Gos. Tipografiia, 1919), 26–36.

[36] Alpatov, "Evgenii Polivanov," 102.

[37] Lev Iakubinskii, "O zvukakh poeticheskogo iazyka," *Poetika* (1919), 38.

[38] Viktor Shklovskii, "O poezii i zaumnom iazyke" ["On Poetry and the Trans-sense Language"], *Poetika* (1919), 14.

sectarians, the *Khlysty*. However, what is most curious about the earlier passage is that Shklovskii brings up such notions as "expression" and "emotion" at all. For the contemporary reader, who is used to looking at the Formalists as precursors of Structuralism and Poststructuralism, Shklovskii's return to the poet's inner experience may seem rather surprising. In Shklovskii's conception—if we were to reformulate it in different terms—the literary text appears to be more than an infinite play of signs, more than an aggregation of structures generated by the intrinsic mechanisms of the linguistic system of a given society. In his model of poetic composition, Shklovskii comes close to saying that the poet's corporeal nature, *physis*, conditions the production of sounds and is ultimately responsible for the emergence of symbolic forms, *poēsis*. The body intones its psychological state. The acoustic, articulatory shape of the utterance intimates the speaker's cognitive and affective condition, providing ingress into the prelogical, precommunicative pure expression.

An important qualification of what Shklovskii and other Formalists understood under the term "emotion" is made in Aage Hansen-Löve's classical study.[39] He points out that the Formalists and the Futurist poets often proclaimed their lack of interest in "emotions" but what they were attacking in such declarations was "a thematic and content-oriented interpretation of poetic suggestiveness."[40] Instead, they cultivated an interest in the " 'non-figurative emotions' of estrangement effects ['*bespredmetnye emotsii' effektov ostraneniia*], which they initially interpreted from a purely sensory point of view."[41] Hansen-Löve cites a line from the turn-of-the-century literary scholar Aleksandr Veselovskii, which illustrates the kind of emotional suggestiveness that appealed to many artists since Mallarmé: "Gradually, the language of poetry will be filled with hieroglyphs that will be perceived as music, rather than as ideas; as attuning to a particular mood, rather than as representing something."[42] In the Russian context, this view of poetry came into fashion even before Futurism—with the Symbolists. But, as Hansen-Löve astutely observes, the Symbolists theorized the evocativeness of sound orchestration and rhythm as "the magic of poetry"—the lulling of the listener into a state of trance in which he would be able to catch a glimpse of the transcendent world; whereas the avant-gardists were interested in phonosemantics for the sake of "baring the device" and provoking the listener's awareness of the material underpinning of meaning effects.[43]

[39] Aage Ansgar Hansen-Löve, *Russkii formalizm: Metodologicheskaia rekonstruktsiia razvitiia na osnove printsipa ostraneniia*, trans. S. A. Romashko (Moscow: Iazyki russkoi kul'tury, 2001), 45.
[40] Hansen-Löve, *Russkii formalism*, 45.
[41] Ibid.
[42] Quoted in Hansen-Löve, *Russkii formalism*, 45.
[43] Hansen-Löve, *Russkii formalism*, 45–47. Maria Ghidini has demonstrated that the Symbolists interpreted the phenomenon of glossolalia ("speaking in tongues"), as well as the gestation of "sound-images" in poetry from the point of view of religious philosophy, which was completely alien for the Futurists and the Formalists. Maria Candida Ghidini, "Zvuk i smysl. Nekotorye zamechaniia po teme

Yet let us dwell for a moment on Shklovskii's "non-figurative emotions," as Hansen-Löve aptly calls them. The reason why Shklovskii felt compelled to consider the "emotional" aspect of language and the way in which he understood it is far from obvious and requires a separate inquiry. One thing is certain: as Shklovskii's contemporary, the psychologist Lev Vygotsky remarked, had the Formalists completely eschewed the role of psychology for aesthetics, they would have run into a dead end trying to explain how estrangement—a striking new sense of the object's palpability—occurs in the artist's or his addressee's perception.[44]

What exactly, in Shklovskii's view, justifies a privileged relation between "sound-speech" and "emotions"? Let us try to unravel this question by considering the notion of "sound-speech" first. As we have seen, in "On Poetry and the Trans-sense Language," Shklovskii uses the term "sound-speech" to refer to elusive sounds twirling in the poet's mind as he is attempting to formulate a verse:

> There is no adequate term for the inner sound-speech [*vnutrenniaia zvukorech'*] yet, and when one wants to speak about it, the word "music" comes to mind— as a transcription of certain sounds that are not words. In this case, they are not yet words, but eventually they flow out in the form of words [*vylivaiutsia slovoobrazno*].[45]

This acoustic fringe, this elusive remainder that did not fit into the procrustean bed of some normative word, according to Shklovskii, still exerts its haunting influence upon the listener's perception of the utterance. As Hansen-Löve points out, one of the key ideas that Shklovskii arrived at in his explorations of *zaum'* is that "the listener perceives not the ready-made elements of content, but 'the direction of thought' (and affects), known as the 'inner form.'"[46] Thus in Shklovskii's theory, the sounds of an utterance, contemplated for their own sake, may guide the listener to discover the plenitude and fluidity of meaning beyond stable dictionary definitions of words. What is even more important, the sounds invite the listener to intuit vectors of forces that necessitated the verbal expression: the "sound-speech" mirrors the speaker's train of thought and changing nuances of his psychological attitudes. Hansen-Löve's comment on this issue references Alexandr Potebnia's influential conception of "the inner form of the

glossalalii u Viacheslava Ivanova," in *Viacheslav Ivanov i ego vremia: materialy VII Mezhdunarodnogo simpoziuma*, eds. Sergei Averintsev and Rosemarie Ziegler (Frankfurt: Peter Lang, 2002), 65–81.

[44] Vygotskii points out that in explaining the function of art, the Formalists rely on psychological theories—for instance, Shklovskii's idea of estrangement, or deautomatization of perception, at its core relies on particular theories in psychology of perception (Lev Vygotskii, *Psikhologiia iskusstva* [Moscow: Iskusstvo, 1965], 74–76).

[45] Viktor Shklovskii, "O poezii i zaumnom iazyke," *Poetika* (1919), 22.

[46] Hansen-Löve, *Russkii formalizm*, 45.

word," which Shklovskii studied, polemicized with, and used as a springboard for his own ideas on the poetic language.[47]

In Potebnia's theory, influenced by Humboldt's and Steinthal's philosophy of language, the term "the inner form of the word" refers to the etymon of the word—its phonetic and semantic kernel, which singles out a particular feature within this word's larger semantic field: for instance, as Potebnia writes, the root *stl-* in the Russian word *stol* (table) comes from *stlat'* (to lay, to spread), and this notion of "spreading" works as a common denominator for a variety of objects that may be called *stol* (table), regardless of their shape or material. [48] Through metaphoric operations, the inner form—this core constituent—may be employed to designate various notions; hence the emergence of etymological cognates. Potebnia conceptualizes the inner form as some kind of mercurial linkage between the idea that the person has in mind ("content") and the sound-shape ("the external form of the word") that he chooses as a speaker of a given language. "The inner form of the word," he writes, "is the relation of the content of the word to the consciousness; it shows how the person perceives his own thought." [49] In other words, the inner form works as a prism though which the person approaches the phenomenon he wishes to name, and he may become aware of this prism through introspection. In Potebnia's Kantian terminology, the inner form of the word "allows the speaker to apperceive his perceptions [*appertsirovat' svoi vospriiatia*]."[50] The following passage from Humboldt is used by Potebnia to explain the relation of the chosen sound to the whole complex of sensory and cognitive elements that make up a given phenomenon in the person's mind:

Man strives to accord a certain unity to the objects that affect him by a variety of their attributes, and for the expression of this unity [*um ihre (dieser Einheit)*

[47] Shklovskii's changing attitudes to Potebnia's theories can be traced in his early articles, ranging from wholesale appropriation in "The Resurrection of the Word" ("Voskresheniie slova," 1914) to relentless rejection in "Potebnia" (1916). In his study of Potebnia, John Fizer has demonstrated that at times, the Formalists willfully misinterpreted Potebnia's claims, suppressing the fact that his works anticipated at least some of the criticism that they levied against him (notably, with regard to the topic of *obraz*, or image contained within the word). See John Fizer, *Alexander A. Potebnja's Psycholinguistic Theory of Literature: A Metacritical Inquiry* (Cambridge, MA: Harvard University Press, 1988), 75–76 and 124–132. For an excellent analysis of Potebnia's theory of "the inner form of the word," demonstrating that its roots lie in Wilhelm von Humboldt's theory of "the inner form of language" (*innere Sprachform*), see Thomas Seifrid, *The Word Made Self: Russian Writings on Language, 1860–1930* (Ithaca, NY: Cornell University Press, 2005), 66–73. See also Renate Lachmann's discussion of Potebnia's links to the German philosophical tradition in the chapter "Semantics of Inner Verbal Form (Potebnia)" of her book *Memory and Literature: Intertextuality in Russian Modernism*, trans. Roy Sellars and Anthony Wall (Minneapolis: University of Minnesota Press, 1997). Brief discussions of Potebnia and the Formalists are also provided in Victor Erlich, *Russkii formalizm: Istoriia i teoriia*, trans. A. Glebovskaia (St. Petersburg: Akademicheskii proekt, 1996), and Steven Cassedy, *Flight from Eden: The Origins of Modern Literary Criticism and Theory* (Berkeley: University of California Press, 1990).

[48] Aleksandr Potebnia, *Mysl' i iazyk* (Kiev: Sinto, 1993), 74.

[49] Ibid., 74.

[50] Ibid., 100.

Stelle ze vertreten], an external sound unity of the word is needed. The sound does not displace any of the remaining impressions produced by the object, but becomes their container [*wird ihr Träger*]. An individual property of the sound that corresponds to the properties of the object, as they have been perceived by someone's personal feeling, adds to the given impressions a new one, characterizing the object. [51]

The key issue here is that the "object as it has been perceived by someone's personal feeling" is a flux of impressions, whereas the name that the person gives to this phenomenon imposes a unity on this irreducible fluctuation.

In his essays "Art as a Technique" ("Iskusstvo kak priem," 1917) and "Potebnia" (1916), Shklovskii accused Potebnia of equating the inner form of the word with some unique, vivid pictorial image (*obraz*) and of arguing that the task of poetry was to restore these images, or originary metaphors, within words that had been obliterated by these words' everyday usage. Shklovskii's main source of uneasiness with Potebnia was the danger of reducing a variety of possible ways by which words may affect the listener to ready-made images. Indeed, Shklovskii was correct to argue that Potebnia tended to neglect the acoustic, articulatory, and rhythmical aspects of the poetic language, and privileged the word to the extent that he failed to notice that in poetry, it is not just the word itself but its combination with other words that produces the poetic effect.[52] However, in his polemical thrust, Shklovskii forgot to give credit to Potebnia for introducing into Russian literary and linguistic scholarship a way of conceiving the semantics of the word as a fluid continuum activated by the associative processes within the mind of the language user. According to Potebnia, "the inner form of the word . . . only gives a stimulus, a way for the listener to develop its meanings. . . . It is only by virtue of the fact that the content of the word is capable of growing that language may serve as a means of understanding the other."[53] As John Fizer has noted, the inner form of the word was, for Potebnia, a mold to be filled in by a plethora of elusive contents; a trigger that gave a direction to the thoughts of the language speaker.[54] On the other hand, it was also a minimal unit of signification—a blending of sound and meaning recognizable for the speakers of

[51] This is a passage that Potebnia (100) translates from Humboldt's "Über die Verschiedenheit des menschlichen Sprachbaus und ihren Einfluß auf die Entwicklung des Menschengeschlechts" ("On the Diversity of Human Language Construction and Its Influence on the Mental Development of the Human Species"). The original German is cited by Potebnia.

[52] These are Shklovskii's key objections in his essay "Potebnia" (1916), in *Poetika. Sborniki po teorii poeticheskogo iazyka*, 2nd ed. (Petrograd: 18-aia Gos. Tipografiia, 1919), 3–6.

[53] Potebnia, *Mysl' i iazyk*, 129.

[54] John Fizer, *Alexander A. Potebnja's Psycholinguistic Theory of Literature: A Metacritical Inquiry* (Cambridge, MA: Harvard University Press, 1988), 127.

a given language—that potentially could evoke the sensory image [*chuvstvennyi obraz*] of a certain phenomenon that gave rise to the original metaphor harbored within the word's etymology. The mechanism of such evocation was never quite explained by Potebnia, and it was easy to misinterpret his treatment of the "inner form of the word" as a mystical search for an eternal Platonic idea, or at best as a restoration of "clarity and vividness" of thought in a Lockean and Cartesian sense. What is important to acknowledge, however, is that, for Potebnia, the "sensory image" evoked by the inner form of the word was not necessarily a picture: it did not have to be a concrete visual idea; nor was it in any simple way iconic, as it did not have to bear any objective resemblance to the phenomenon signified. What Potebnia wanted to show was that our giving of a name to a certain phenomenon is not entirely arbitrary and that there is some strange logic governing this process, whether it has something to do with our lexical competence, or the cognitive operations of our mind that compel us to create metaphors. What interested him more than anything was actualization of thought in language—and he very much understood this as an open-ended process. Thus, for instance, when Viacheslav Ivanov seconded Shklovskii's opinion that poetry cannot, as Potebnia supposedly thought, be reduced to "thinking in images," because "before the image [*obraz*], there was the sound-image [*zvukoobraz*],"[55] what he did not realize was that he inadvertently repeated the very essence of Potebnia's thesis, rather rejecting it.

We may appreciate just how important was Potebnia's foregrounding of the word's semantic potential and his notion of the inner form for the Russian thought on language in the first decades of the 20th century by considering the reverberation of the latter concept in writings as diverse as Andrei Bely's essays on symbolism and Gustav Shpet's and Aleksei Losev's phenomenology of language. It may be argued that Velimir Khlebnikov's experiments with the "inner declension" of words (*vnutrennee sklonenie slov*) and "the braiding of sound-letters" (*splety zvuko-bukv*) move in the direction pointed out by Potebnia—even though an immediate influence is arguable.[56] In Iurii Tynianov's poignant characteristics, Khlebnikov "was animating, within the semantics of the word, its forgotten kinship with other cognate words, or he was forging a kinship between unrelated words."[57] A fellow Futurist, Benedikt Livshits, called Khlebnikov's

[55] Viacheslav Ivanov quoted in Efim Etkind, "Vjaceslav Ivanov et les questions de poétique. Années 1920," *Cahiers du monde russe* 35.1–2 (1994): 141–154, 148.

[56] On Khlebnikov's sources see A.V. Garbuz and V.A. Zaretskii, "K etnolingvisticheskoi kontseptsii mifotvorchstva Khlebnikova," in *Mir Velimira Khlebnikova*, ed. Viacheslav Ivanov, Zinovii Papernyi, Aleksandr Parnis (Moscow: Iazyki russkoi kul'tury, 2000), 331–347.

[57] Iurii Tynianov, "Promezhutok," in *Poetika. Istoriia literatury. Kino* (Moscow: Nauka, 1977), 168–195.

verbal art an illustration to Humboldt's theory of language as creation—with the exception that Humboldt spoke of the process involving the collective consciousness of the entire ethnos, while Khlebnikov executed acts of linguistic creativity on his own.[58] Sergei Tret'iakov said that Khlebnikov was extremely "sensitive to the process of the word's birth, to the clarification and objectification of that what a minute ago was only an immaterial, blind hustle beneath the floorboards of the human thought."[59] According to Tret'iakov, Khlebnikov was obsessed with the task of

> scouring the official roots of everyday words for their progenitors and proto-roots; searching for elemental sounds that express elemental movements of the human psyche—the sounds, whose modifications create the chaotic jewel scatters of our language; identifying the organizational principle that underlies the transformations of words.[60]

Osip Mandel'shtam stated that Khlebnikov gave a new life to centuries of Russian literature thanks to the fact that his Futurist poems were "delving into the depths of Russian word stems, into the etymological night, pleasant to the heart of a knowledgeable reader."[61] In the same essay, "On the Nature of the Word" ("O prirode slova," 1922), Mandel'shtam proposed a view of the poetic language that echoed Potebnia, [62] when he claimed that there exists a complex, systematic link between the meaning of the word (*znachenie*) and its sounding nature (*zvuchashchaia priroda*)—a link that can be explored and exploited by the poet. [63] In his article "Word and Culture" ("Slovo i kul'tura," 1921), Mandel'shtam took on Potebnia's idea that the word can uncannily inhabit a multiplicity of referents thanks to its evocative sound shape. He also employed the term the "inner image of the word" to speak about something very similar to what Shklovskii described as the noise that pre-echoes the actualization of poetic utterance in "On poetry and the Trans-sense Language" (1916):

> The poem is alive through its inner image—that sounding mold of the form [*zvuchashchim slepkom formy*] which prefigures the written poem. There is not

[58] Benedikt Livshits, *Gileia* (New York, M. Burliuk, 1931), 11.

[59] Sergei Tret'iakov, "Velimir Khlebnikov," *Strana-perekrestok* (Moskva: Sovetskii pisatel', 1991), 524–530, 524.

[60] Sergei Tret'iakov, "Velimir Khlebnikov," 524.

[61] Osip Mandel'shtam, "O prirode slova, " in *Sobranie sochinenii* (3 vols.), vol. 2, ed. A. Mets and F. Lhoest (Moskva: Progress Pleiada, 2010), 64–81, 67–68.

[62] On Mandel'shtam's reading of Potebnia, see Omry Ronen, *An Approach to Mandel'shtam*, in *Bibliotheca Slavica Hierosolymitiana* (Jerusalem: Hebrew University Magness Press, 1983), 78–79.

[63] Osip Mandel'shtam, "O prirode slova," 78; Osip Mandel'shtam, "Slovo i kul'tura," in *Sobranie sochinenii* (3 vols.), vol. 2, ed. A. Mets and F. Lhoest (Moskva: Progress Pleiada, 2010), 49–55, 53.

a single word yet, but the poem is sounding already. This is the sounding of the inner image [*vnutrennii obraz*], palpated by the poet's hearing [*ego osiazaet slukh poeta*].[64]

This passage continues the line of thinking that Mandel'shtam began in his poem "Silentium" (1910)—"May you remain sea foam, Aphrodite/ And you, the word, return to music" ("*Ostan'sia penoi Afrodita/I slovo v muzyku vernis'*")— which actually was one of the privileged references in Shklovskii's "On poetry and the Trans-sense Language."[65] Mandel'shtam's notion of the "inner image," which invites the poet to explore the suggestive quality of sound orchestration, describes a phenomenon that seems very similar to what Russian symbolists called *sound-symbol* and what the Formalists like Brik, Jakobson, Shklovskii, Tynianov, Eikhenbaum, and others called "sound-image" [*zvuko-obraz*] in their analyses of phonosemantic properties of verses.[66]

Shklovskii's term "sound-speech" [*zvukorech'*] is best understood in relation to this discourse. A good example of the way in which the Formalists used the term "sound-speech" appears in a commentary on Boris Pasternak's poem "Poetry" ("Poeziia," 1922) by Shklovskii's colleague Iurii Tynianov. Tynianov writes that Pasternak's piece is constituted of "nearly senseless sound-speech" [*pochti bessmyslennaia zvukorech'*], and yet the poem succeeds in creating a parallel between the falling of rain and the writing of verses.[67] Tynianov's observation is tied to the following stanza:

Otrostki livnia griaznut v grozd'iakh	Offshoots of downpour drown in clusters
I dolgo, dolgo do zari	All through the night, till break of dawn
Kropaiut s krovel' svoi akrostikh,	They drum on rooftops their acrostic
Puskaia v rifmu puzyri.	And rhyme their bubbles on and on.[68]

In this nearly untranslatable excerpt, Pasternak not only weaves a net of alliterative correspondences in each line, but he also uses words in such a way that they

[64] Mandel'shtam, "Slovo i kul'tura," 53–54.

[65] Shklovskii, "On Poetry and the Trans-sense Language," 22.

[66] According to Svetlikova, *Istoki russkogo formalizma* (73), Jakobson claimed that the term "sound-image" ("zvukoobraz") was coined by Osip Brik. Based on Shklovskii's 1916 essay on the trans-sense language, it is possible to hypothesize that the term "zvukoobraz" in the Russian Formalists' lexicon was a derivative of Wundt's *Lautbilder* (sound images).

[67] Iurii Tynianov, "Promezhutok," in *Poetika. Istoriia literatury. Kino* (Moscow: Nauka, 1977), 168–195, 183.

[68] Cited in Iurii Tynianov, "Promezhutok," *Poetika, Istoriia Literatury, Kino* (Moskva: Nauka, 1977), 168–195, 183.

recall other words, whose semantics has something to do with "rain": for example, thanks to the appearance of the word *liven'* ("downpour") in the first line, the verb that follows it—*griaznut'* ("to drown," "to get submerged")—immediately brings to mind its cognate *griaz'* ("liquid dirt"); while *kropat'* (which I have translated as "to drum," but which literally means "to tinker," "to hammer," or "to forge" and is usually used ironically in phrases like *kropat' stikhi*, "to scribble verses") evokes another, unrelated verb *krapat'* ("to drizzle"). Pasternak's poem accomplishes its simile not by a marked comparison between the rain and the process of versification, but by eliciting, within the sound-shapes of the given words, the echoes of other meanings. "The word," says Tynianov in his interpretation of Pasternak, "has merged with the downpour . . . poetry has been interlaced with the surrounding landscape, interlaced via images connected to each other by sounds." [69]

The untranslatability of Pasternak's poem illustrates the fact that the formation of sound-images that Tynianov picks up upon depends, to a large extent, on one's familiarity with the lexicon of a given language. Thus the ghosting of the word "to drizzle" within the word "to tinker" is a pun perceivable only to a speaker of Russian: it is a sound-image that emerged out of "the element of language," as Viacheslav Ivanov would have put it. Perhaps it is only the rhythmical repetition of sounds in nearly every line of Pasternak's poem (*dolgo, dolgo, do; kropaiut, krovel', akrostikh*) that conveys a sense of insistence and monotony of raindrops independently of the words' semantics. Yet the question that we have posed in the beginning still stands: what does a sound-image—whether a punbased or a rhythmical one—have to do with emotions and affects? Why could theorists like Shklovskii or Viacheslav Ivanov leap so effortlessly from sounds to "the element of emotion"? To answer this question, we have to remind ourselves of the fact that in the 1900s and 1910s, the question of how sense perceptions reach consciousness and enter into associative chains belonged to the domain of psychology. When Shklovskii uses the word "emotions," what he seems to have in mind are some psychological processes that accompany sensory perception, the triggering of associations and other forms of cognitive processing, as well as the reflectory responses of the body. In the most influential reference source in Russia at the turn of the century, *The Encyclopedic Dictionary of Brockhaus and Efron* (1890–1907 edition), we find the following three definitions of "emotion" (*emotsiia*), cross-listed as "feeling" (*chuvstvovaniie*), in an essay prepared by the philosopher Ivan Lapshin:

1. sensation (*oshchushcheniie*). This is the way in which the word "feeling" (*sens, sentiment*) was used by Descartes, Malebranche, Bossuet, Locke, and others;

[69] Iurii Tynianov, "Promezhutok," *Poetika, Istoriia Literatury, Kino* (Moskva: Nauka, 1977), 168–195, 183.

2. for materialists, "feeling" is intermixed with the stimulation that has provoked it; thus "emotions" for Karl Lange are indistinguishable from corporeal changes that accompany them;

3. "the feeling tone" (*chuvstvennyi ton*), or "tonality of pleasure or displeasure" accompanying sensations (*oshchushcheniia*) and ideas (*predstavlenia*). Further down in his encyclopedic article, Lapshin discusses the role of affects and feeling tones for cognitive processes (*poznavatel'nye processy*): "memory," "association of ideas," "creative imagination," and "reasoning."[70]

The encyclopedia's positioning of emotion in relation to perception, cognition, and corporeal responses (as theorized by Karl Lange and William James) explains the usage of this term in Shklovskii's texts. While today we use the term *emotion* to denote states such as sadness or joy, turn-of-the-century authors had in mind the entire psychophysiological attitude, provoked by a sensory stimulus. It is no accident that the first Russian translation of Charles Darwin's *The Expression of Emotions in Animals and Man*, published in St. Petersburg in 1872, rendered the term "emotion" as "*oshchushchenie*," which in modern usage typically denotes sensory perception.[71] As Emma Widdis has argued, *oshchushchenie* was an essential concept in Russian Modernist aesthetic theories.[72] It underpinned the Symbolists' impressionist aesthetics, which aimed to replicate the very act of perceptual processing in poetic sounds and painterly compositions. Further, starting with the Futurists, the impressionist phase gave way to a more proactive stance, with artists consciously seeking to "revitalize sensory apprehension of the material."[73] Shklovskii's famous concept of defamiliarization (*ostranenie*) in "Art as Device" (1917) spoke to this objective. In the 1920s, the Soviet avant-garde filmmakers and Constructivist designers would use *oshchushchenie* (sensation) as a guiding principle for selecting and organizing material textures, so as to promote the audience's active, transformative attitude toward the world they live in.[74]

[70] Ivan Lapshin, "Chuvstvovaniie," *Entsiklopedicheskii slovar' Brokgauza i Efrona*, based on the 1890–1907 edition, CD-ROM, IDDK Media Project, ed. Mikhail Zlokazov, Ekaterina Aleksandrova, and Vitalii Belobrov (Moscow: Adept, 2002).

[71] Charles Darwin, *O Vyrazhenii Oshchushchenii u Cheloveka i Zhivotnykh*, ed. A. Kovalevskii (Sankt Peterburg: Tip. F. S. Sushchinskago), 1872.

[72] Widdis, *Socialist Senses*, 5.

[73] Widdis, *Socialist Senses*, 2.

[74] Ibid. Christina Kiaer, *Imagine No Possessions: The Socialist Objects of Russian Constructivism* (Cambridge, MA: MIT Press, 2008); Maria Gough, *Artist as Producer Russian Constructivism in Revolution* (Berkeley: University of California Press, 2014).

Bearing this context in mind, it becomes easier to understand the logic behind Shklovskii's statement that "the closest relatives of sound-image kind of words (*zvukoobraznye slova*) are 'words' devoid of any image or content that serve for the expression of pure emotions."[75] One of the examples that Shklovskii gives to illustrate "the gestation of a sound image" out of emotion is a passage from Knut Hamsun's novel *Hunger* (1890): "I stopped and stared at her face to face, and on the spot a name came to me I'd never heard before, a name with a smooth nervous sound: Ylayali."[76] What seems to interest Shklovskii here is the way in which the intensity of the encounter and the impression that the speaker receives from watching the woman's face get converted by his consciousness into sound. A new word is born, and its significance is closely linked to the speaker's subjective experience of the situation. Shklovskii emphasizes that "Ilayali" does not have a definable meaning; it encompasses the whole complexity of psychic responses that the speaker is living through and thus is not reducible to any clear-cut image. "Ilayali" is pure innervation translated to mental sound.

Shklovskii's Psycholinguistic Notion of Sound-Gesture and Its Sources

Shklovskii's suggestion that trans-sense words may be regarded as an outcome of a prolonged neurophysiological and cognitive processing of a certain phenomenon has been inspired by his reflections on synesthetic words theorized by the eminent German psychologist Wilhelm Wundt:[77]

The fact that emotions can be evoked by the acoustic and articulatory side of the word is proved by the existence of words which Wundt called *Lautbilder*

[75] Viktor Shklovskii, "O poezii i zaumnom iazyke," 17.

[76] Cited in Gerald Janecek and Peter Mayer's commentary to Shklovskii's article (Viktor Shklovskii, "On Poetry and Trans-Sense Language," trans. by Gerald Janecek and Peter Mayer, *October* 34 [1985], 3–24, 10). Hamsun's translation is by Robert Bly (Knut Hamsun, *Hunger* [New York: Farrar, Straus and Giroux, 1967], 14).

[77] In his references to Wundt, Shklovskii is relying not on the original text in German, but on a comprehensive summary of the first volume of Wundt's *Ethopsychology* [*Völkerspsychologie*] in Russian that was prepared by Faddei Zelinskii. See Faddei Zelinskii, "Vil'gel'm Vundt i psikhologiia iazyka" (1901), in *Iz zhizni idei: nauchno-populiarnyia statii F. Zelinskago*, 2nd ed. (St. Petersburg: Tipografiia M.M. Stasiulevicha, 1908), 151–221. As Gerald Janecek and Peter Mayer point out, the idea cited by Shklovskii appears in Wundt's *Völkerpsychologie. Eine Untersuchung der Entwicklungsgesetze von Sprache, Mythus und Sitte* (Leipzig: W. Engelmann, 1900–09), vol. 1 (*Die Sprache*, 1900), ch. 3, IV, 1. However, the first German example that Shklovskii gives is misspelled; in Wundt it is *bummeln* (to stroll, bum around) or *wimmeln* (to swarm). Zelinskii's summary of Wundt's passage gives *tummeln*, *torkeln*, and *wimmeln* (p. 181) as examples, and though the first verb does not originate in Wundt, it was probably the basis for Shklovsky's misspelled *timmeln* (Gerald Janecek and Peter Mayer, Annotations to "On Poetry and Trans-Sense Language" by Viktor Shklovskii, trans. Gerald Janecek and Peter Mayer, *October* 34 [Autumn 1985], 3–24, 9).

[sound-images]. Under this term Wundt groups words which express not an acoustic, but rather a visual or some other idea, but in such way that a certain correspondence is felt between this idea and the choice of sounds in this sound-image type of word [*zvukoobraznoe slovo*]. For example, in German: *timmeln torkeln* [to stagger], in Russian: *karakuli* [scribbles].[78]

Once again, the way in which Shklovskii uses the term "emotions" here confirms that he has in mind peculiarities of perception: *Lautbilder* are words which, for Shklovskii, point to the existence of phenomenal interconnections between senses. Thus, for instance, the Russian word *karakuli* (*scribbles*) may not be ono-matopoeic in the sense of sound imitation; however, there is something about its sound that is conducive for acquiring a visual and kinetic impression of angular, squiggly handwriting. If Shklovskii's example is unconvincing, we may think of other words whose sounds seem uncannily pertinent for the content they de-note, such as the word *zigzag* in English.[79]

Further contemplating the question of seeming congruency between the sound shape and meaning in some words, Shklovskii cites a hypothesis that the Polish-Russian literary scholar Faddei Zelinskii made in his review of Wundt's writings on language.[80] Zelinskii proposed that the articulation of some words activates the organs of speech and facial muscles in such a way that these movements correspond to the expression of particular emotions. Thus if an emo-tional attitude provoked by the lexical meaning of the word matches the emotion expressed by the peculiar contraction of the muscles, the sound shape of the word will be perceived as especially pertinent. Zelinskii illustrates this idea by an ex-ample from Dostoyevsky, which shows that an invented word (in Dostoyevsky's case, the verb *tilisnut'*) can be perceived as expressive for this reason:

"And then I'll *tilisnu* [her] with a knife on the throat," says a labor camp convict in Dostoyevsky's *Notes from the House of the Dead* [1860], II, Ch. 4. Is there

[78] Viktor Shklovskii, "O poezii i zaumnom iazyke," *Poetika* (1919), 16.

[79] For an interpretation of classical English poetry that considers the kinetic sensations during ar-ticulation see Donald Salper, "Onomatopoeia, Gesture, and Synaesthesia in the Perception of Poetic Meaning," in *Studies in Interpretation*, vol. 2., eds. Esther M. Doyle and Virginia Hastings Floyd (Amsterdam: Rodopi, 1977), 115–123.

[80] Faddei Zelinskii (Tadeusz Zieliński) was a well-known scholar of ancient Greek and Roman lit-erature, as well as an expert in questions of poetic meter, who participated in the literary gatherings at the Tower of Viacheslav Ivanovich Ivanov. Zelinskii summarized and reviewed the first volume, *On Language* (*Die Sprache*, 1900), of Wundt's monumental study *Ethnopsychology. Interchanging Laws of Development of Language, Myth, and Customs* (*Völkerpsychologie. Eine Untersuchung der Entwicklungsgesetze von Sprache, Mythus und Sitte*, 1900–1909). See Faddei Zelinskii, "Vil'gel'm Vundt i psikhologiia iazyka," in *Iz zhizni idei: nauchno-populiarnyia stat'i F. Zelinskago* (St. Petersburg: Tipografiia M.M. Stasiulevicha, 1908), 151–221. This essay by Zelinskii is one of the key theoretical sources in Shklovskii's essay on the trans-sense language.

a similarity between the articulatory movement of the word *tilisnut'* and the movement of the knife sliding along and cutting into human body? No, but this articulatory motion corresponds perfectly to the position of the facial muscles called forth instinctively by the specific feeling of nervous pain, experienced by us when we imagine a knife sliding along the skin (but not stuck in the body); the lips are spasmodically drawn apart, the throat constricted, the teeth gritted; this permits the use of only the vowel *i* and the tongue consonants *t, l, s*, whereby the selection of them and not of the voiced sounds *d, r, z*, involves a certain sound-imitating element.[81]

Shklovskii offers no comment on this example, which he took from Zelinskii, except for restating his conviction that there is nothing mimetic about the word *tilisnut',* because strictly speaking, Dostoyevsky's character had nothing to imitate but his own psychic state. The idea that articulatory sensations may lead the interlocutor to intuit the meaning of the trans-sense word remains a running thread throughout Shklovskii's article. "Perhaps it is the articulatory aspect—something akin to the dance of the organs of speech—that is responsible for most of the pleasure given to us by poetry,"[82] he proposes.

Shklovskii's thesis thus is that in some types of poetic practice, notably in the Futurists' performances, the dispositions of the speaker's psyche find a release, a pleasurable discharge in the motor sensations of articulatory muscles—more so than in the lexical content of the utterance. The same idea will be picked up upon by Shklovskii's linguist colleagues, who contributed to the famous Formalist collection *Poetika* (2nd edition, 1919): particularly, in Lev Iakubinskii's essay "On the Sounds of the Poetic Language" ("O zvukakh poeticheskogo iazyka") and in Evgenii Polivanov's "Sound Gestures of the Japanese Language" ("Zvukovye zhesty iaponskogo iazyka"). Iakubinski, for instance, argues that the emotional impact of the poetic speech is dependent, in part, on the fact that the organs involved in the production of speech—laryngeal and respiratory organs, the tongue, the lips, the lower jaw—are all activated in a particular way when the person is experiencing certain emotions. "Roughly speaking," says Iakubinskii, "if the poet experiences such emotions for which a smile (that is, the stretching of the lips to the sides) is appropriate, he will naturally avoid sounds made by the protruding of the lips (for example, *u, o*)."[83]

[81] Viktor Shklovskii, "On Poetry and Trans-Sense Language," trans. by Gerald Janecek and Peter Mayer, *October* 34 (1985), 3–24, 8. I have adjusted the English translation of this passage, based on Viktor Shklovskii, "O poezii i zaumnom iazyke," 16–17. As Janecek and Mayer point out (9), Shklovskii took this example from Faddei Zelinskii, "Vil'gel'm Vundt i psikhologiia iazyka," in *Iz zhizni idei: nauchno-populiarnyia statii F. Zelinskago*, 2nd ed. (St. Petersburg: Tipografiia M.M. Stasiulevicha, 1908), 151–221, 185–186.
[82] Viktor Shklovskii, "O poezii i zaumnom iazyke," 24.
[83] Lev Iakubinskii, "O zvukakh poeticheskogo iazyka," 37–49, 48

This line of thinking comes to Shklovskii, Iakubinskii, and Polivanov through Zelinskii's interpretation of Wundt, because all of them cite Zelinskii's essay (Iakubinskii and Polivanov, in contrast to Shklovskii, also cite Russian translations of Wundt's books). In the case of Shklovskii's 1916 essay on the trans-sense poetry, however, there is another source out of which a Wundtian thread emerges—it is an essay by the phonetician and speech therapist Boris Kiterman called "The Emotional Meaning of the Word" (1909).[84] Kiterman's approaches to diction became known in Russian theatrical and literary circles in the early 1910s thanks to his publications in the journal *Voice and Speech: Questions of Tone and Facial Expression* (*Golos i rech': Voprosy Tona i Mimiki*), launched by a renowned theater critic and performance coach, Iurii Ozarovskii.[85] Kiterman's article, referenced by Shklovskii, offers a kinesthetic perspective on onomatopoeia:

Some authors, and chiefly Wundt, argue that it is not just sounds that are responsible for the impact of words. Rather, the mimetic or representational aspect of the word [*podrazhatel'nost', izobrazitel'nost' slova*] has to do with the movements of the organs of speech, as well as accompanying facial and body gestures [*mimicheskie i pantomimicheskiie zhesty*]. It is important to bear in mind that in addition to the auditory image of the word [*slukhovoi obraz slova*], our consciousness contains a kinetic or motor image of it [*motornyi, dvigatel'nyi obraz*], that is, a certain idea about a unified complex of muscle movements necessary for this word's pronunciation. The latter motor image, according to Bourdon, who in this case agrees with Kussmaul, comprises ideas about muscle sensations evoked by the pronunciation of the word and ideas about tactile sensations of the tongue, palate, lips, etc. as they move. Both kinds of sensations, in Bourdon's view, can contain an element of mimesis.[86]

[84] Viktor Shklovskii, "O poezii i zaumnom iazyke," 24. Shklovskii's source is Boris Kiterman, "Emotsional'nyi smysl slova," in *Zhurnal ministerstva narodnago prosveshcheniia* 19.1 (1909): 164–176. Kiterman's area of specialization was Russian phonetics, and after the Revolution, he would go on to work in the field of children's speech therapy at the Pedological section of the Psycho-Neurological Institute in Petrograd.

[85] The journal *Voice and Speech* (*Golos i Rech'*) was sponsored by a well-known theater critic Iurii Ozarovskii, who organized courses of oral performance in the 1910s. In his essay "O poezii i zaumnom iazyke" (24), Shklovskii cites Iurii Ozarovskii's book *The Music of the Living Word* (*Muzyka zhivogo slova*, 1914). For more information on Kiterman and Ozarovskii, see Raffaella Vassena, "K rekonstruktsii istorii i deiatel'nosti Instituta zhivogo slova (1918–1924)," *Novoe Literaturnoe Obozreniie* 86 (2007): 79–95; Ekaterina Choun and Craig Brandist, "Iz Predystorii Instituta Zhivogo Slova: Protokoly Zasedanii Kursov Khudozhestvennogo Slova," *Novoe Literaturnoe Obozreniie* 86 (2007): 96–106.

[86] Boris Kiterman, "Emotsionalnyi smysl slova," *Zhurnal ministerstva narodnogo prosveshcheniia* 1 (1909): 164–176, 166. Benjamin Bourdon was a French psychologist who had studied under Wilhelm Wundt. Bourdon's research focused on visual and haptic perception, and educational psychology. In citing his work, Kiterman probably refers to Bourdon's study *L'expression des émotions et des tendances dans le langage* (Paris: F. Alcan, 1892). An overview of Bourdon's biography is provided in Serge Nicolas, "Benjamin Bourdon (1860–1943): Fondateur du laboratoire de psychologie et de linguistique expérimentales à l'Université de Rennes (1896)," *L'année psychologique* 98.2

If he were to comment on Kiterman's claim that there is an element of imitation in the "motor image" of the word, Shklovskii would undoubtedly reject it, or render it problematic—even though the discussion of the articulatory aspect of speech would most certainly interest him. As we have seen, this was exactly the point of Shklovskii's discussion of Faddei Zelinskii's analysis of Dostoyevsky's neologism *tilisnut'*, which underscored the fact that in articulating this verb, the movement of the speaker's facial muscles and speech organs was not motivated by the task of producing an iconic resemblance of the action (the knife sliding along the victim's neck), but rather reflected an unpleasant nervous tension that the speaker felt as he imagined this act. In emphasizing the lack of some external object's imitation, Shklovskii attacked what he believed to be a key issue in Wilhelm Wundt's theory of onomatopoeic words (*Lautbilder*, "sound-images"), namely the idea that in pronouncing these words, the organs of speech and muscles of the body produce "imitative gestures" [*upodobitel'nye zhesty*].[87] "This point of view," wrote Shklovskii,

> fits well into Wundt's larger claim about language; most probably he is trying to link this phenomenon to the language of gestures, which he analyzed in one volume of his *Ethnopsychology* (*Völkerpsychologie*); but this explanation hardly accounts for the whole phenomenon.[88]

As a counter proposition, Shklovskii invites us to consider "words without image or content" (*slova bez obraza i soderzhaniia*)—words which "cannot be said to exhibit any imitative articulation, for there is nothing to imitate, but which point to a connection between sound-movement (*zvuka-dvizheniia*), empathetically reproduced as some mute spasms by the listeners' organs of speech, and emotion."[89] Thus, for instance, Shklovskii argues that a nonexistent verb *tilisnut'* becomes emotionally comprehensible to the perceiver if he mimics the speaker's articulation.[90]

It is worthwhile to pause on Shklovskii's argument here, to tease out the premises it builds upon and the sources it references. This exploration will help us to appreciate what is encapsulated within Shklovskii's peculiar term

(1998): 271–293. Adolph Kussmaul was a German physiologist and medical doctor, renowned for his work on nervous diseases. According to *The Encyclopedia of Brockhaus and Efron*, Kussmaul was especially famous in Russia for his study of speech disorders (Adol'f Kussmaul', *Entsiklopedicheskii slovar' Brokgauza i Efrona*, based on the 1890–1907 edition, CD-ROM, IDDK Media Project, ed. Mikhail Zlokazov, Ekaterina Aleksandrova, and Vitalii Belobrov [Moscow: Adept, 2002]).

[87] Viktor Shklovskii, "O poezii i zaumnom iazyke," 16.
[88] Ibid., 17.
[89] Ibid.
[90] Ibid., 24.

"sound-movement" (*zvuk-dvizhenie*), which he uses to foreground the somatic foundation of the verbal act. What must be clarified is the nature of sound-movement's referentiality and its communicative potential, as well as its connection to one's emotional experience and neurophysiological state, or one's sensory responsiveness to a particular phenomenon. Questioning the primacy of some concrete, premediated meaning (image, content) for the production of the poetic utterance, Shklovskii challenges the idea that sound shapes of "expressive" words are necessarily imitative of some external objects or phenomena. In rejecting iconic mimesis, Shklovskii shifts his focus to the movement of facial and articulatory muscles, presenting them as the locus of the speaker's emotional experience. Further, communication in his model becomes a function of corporeal empathy: the interlocutor is able to intuit the affect experienced by the speaker by literally "trying on" the position of facial muscles that he sees displayed.

To put the matter in different words, Shklovskii emphasizes the process of *miming*, which has a referent not in the external reality but in the inner psychological reality. He thus creates a theory of *mimesis*, in which the performer strives not for a recognizable analogy with some external phenomenon, but rather for a precise activation of neurophysiological mechanisms governing the perceptual and affective life of man. Moreover, the interlocutor's recognition of what is being mimed depends on his or her own ability to imitate the speaker.

In the Russian language, the word "mimika" refers to contractions of the facial muscles (as in the French *mimique*, and German *Mimik*). This noun is etymologically related to "mimesis," originating in the same Ancient Greek term *mimos* that denotes a "mime," an "actor," or an "imitator." English has preserved a similar association between playacting and the face as Russian, but only in the archaic and medical usages.[91] The etymology of *mimika* may alert us to the conventions of theatricality—that is, the rites of display and semiotic customs that give shape to the facial action. Bearing in mind the possibility of deliberate performativity, we may be better equipped for critiquing Shklovskii's theory of internally oriented mimesis, as well as his suggestion that the sight of articulatory motions creates a program for the listener's own imitative actions, successfully transmitting the emotions.

[91] *The OED* gives the fourth definition of the adjective "mimic" and the seventh definition of "mimetic" as "relating to, or affecting the superficial muscles of the face that surround the eyes, nose, and mouth and are innervated by the facial nerve." (See "mimic, adj. and n.," *The Oxford English Dictionary Online*, 3rd ed., March 2002, http://www.oed.com.ezp-prod1.hul.harvard.edu/view/Entry/118651.)

James and Wundt on Gestural Expression, Affective Perception, and Communication

To fully appreciate the implications and limitations of Shklovskii's model, we must first turn to its foundational sources: William James's and Wilhelm Wundt's writings on corporeal movement, its connection to emotional attitudes, and its communicative possibilities enacted via articulated sounds and kinesthetic empathy. In James's *Principles of Psychology* (1890), movement was described as the end-point in a chain of reactions that begins with sensory innervations streaming toward the brain, proceeds in the form of the brain's processing activity, and then reverberates through the body. Drawing on Alexander Bain's "law of diffusion" formulated in *Emotions and the Will* (1859), James contended that the brain's processing of impression always results in movement—even if it is of a rudimentary or imperceptible kind. According to James,

> Every impression which impinges on the incoming nerves produces some discharge down the outgoing ones, whether we be aware of it or not. Using sweeping terms and ignoring exceptions, *we might say that every possible feeling produces a movement, and that the movement is a movement of the entire organism, and of each and all of its parts.*[92]

A sensory impression thus produces an attitude (feeling), and this attitude is manifested in terms of the motor discharge, reverberating through the entire body, regardless of the subject's conscious awareness. This explanation corresponds to Shklovskii's discussion of Knut Hamsun's character's spontaneous articulation of the sound "Ilayali" at the sight of a strikingly beautiful woman's face. As if in accordance with James's law, the visual impression generated the nonsensical, yet painfully sincere exclamation. The articulatory motion of Hamsun's character is undoubtedly expressive, although the exact referent of this expressive act—that flux of feelings experienced by him—is hard to pin down. Digging deeper into James's theory, it is interesting to note the interjection of "feeling" in that pause during which the brain is processing the sensory perception. This interjection is precisely the site in which perception, emotion, and movement become intertwined, and it receives special attention in Wilhelm Wundt's writings:

> [Emotions] always begin with a more or less intense *inceptive feeling* which . . . is due either to an idea produced by an external impression (outer emotional stimulation) or to a psychical process arising from associative or apperceptive

[92] William James, "The Production of Movement," in *The Principles of Psychology* (2 vols.), vol. 2 (New York: Henry Holt and Co., 1890), 372–381, 372; original emphasis.

conditions (inner stimulation). Following this inceptive feeling, comes an *ideational process* accompanied by its corresponding feelings. . . . As a result of the summation and alternation of successive affective stimuli there is in emotions not only an intensification of the effect on the heart, blood-vessels, and respiration, but the *external muscles* are always affected in an unmistakable manner. Strong movements of the mimetic [facial] muscles appear at first, then movements of the arms and of the whole body (pantomimetic movements). . . . Because of their symptomatical [sic] significance for the emotions, all these movements are called *expressive movements*. As a rule they are entirely involuntary, being either reflexes following emotional excitations, or else impulsive acts prompted by the affective components of the emotion. They may be modified, however, in the most various ways through voluntary intensification or inhibition.[93]

Similarly to James, Wundt describes the dispersal of innervations throughout the body that activates the smooth muscles of the inner organs first and then mobilizes the face and the limbs. These muscular contractions, occurring under the influence of emotion, are defined as "expressive movements." Wundt points out that the stimulus that initiated the whole process does not necessarily have to come from the external world. It can be a recollection, or a chain of associations that some object has evoked. In *Principles of Physiological Psychology*, Wundt argued against the common habit to give the name "sensation" to processes aroused by an external signal and reserve the name "idea" only for "sensations dependent on any sort of internal condition," or "memory images."[94] If in both cases the visual centers of the cortex are engaged in a similar manner, from the psychophysiologist's point of view the two instances are identical.[95] Ideas are never immaterial—they are a product of the higher nervous activity and can be triggered by many means, such as direct stimulation, associative processes, or even hallucination.[96] Wundt considered the brain not a passive receptacle of sensations, but a dynamic system that is selective in its intake of stimuli. Moreover, its complex architecture structures the sensory information, integrating it into pre-existent programs that the organism has acquired in the

[93] Wilhelm Max Wundt, *Outlines of Psychology*, trans. Charles Hubbard Judd, 2nd English ed. (Leipzig: Wilhelm Engelmann, 1902), 188–189; original emphasis.

[94] Wilhelm Max Wundt, *Principles of Physiological Psychology*, trans. and ed. Edward B. Titchener (London: Sonnenschein, 1904), 13–14.

[95] Jonathan Crary argues that the irrelevance of the external world for the purposes of psychophysiological inquiry was an essentially modern notion, which emerged in the 19th century. Crary's discussion of Shopenhauer's claim that "what occurs in the brain" does not have to have a precise reference point in the external reality helps to contextualize Wundt's position (see Jonathan Crary, *Techniques of the Observer: On Vision and Modernity in the Nineteenth Century* [Cambridge, MA: MIT Press, 1992], 75).

[96] Wundt, *Principles of Physiological Psychology*, 14.

course of phylogenetic and ontogenetic development. This act of processing is called "apperception" in Wundt's writings. Apperception is responsible, for instance, for the fact that sensations usually do not appear in our consciousness as isolated, simple qualia, but rather as compounds.[97]

As the historian of science Kurt Danziger has shown, this view of apperception was an integral part of Wundt's voluntarist psychology.[98] Wundt believed that all actions of the organism, from the most primitive reflex reactions to conscious, goal-oriented movements, are essentially volitional activities. What this means is not that they are deliberate acts of will in the narrow sense of the word, but rather that they originate in drives. Danziger explains that the term *Trieb* ("drive") in the 19th-century German psychological literature is the living organism's striving toward pleasure and getting away from unpleasure.[99] Denoted in German as *Lust* and *Unlust*, pleasure and unpleasure are primary affects (Freud later used the same terms in his theory).[100] The nervous system of animals on each stage of evolutionary development contains structures that determine their behavior, calling forth those movements that once proved to escape the negative state and achieve the positive. As Danziger puts it, Wundt's voluntarism, as a psychological system, "emphasized the primacy of affective-motivational processes and regarded them as the indispensable foundation for the explanation of psychological effects."[101] Wundt argued that in primitive organisms, sensation, affect, and movement are all linked together, forming an undifferentiated complex. In fact, even when thinking about the higher animals and humans, Wundt suggested that these three psychological categories—"sensation," "affect," and "movement"—are nothing but intellectual abstractions, which do not account for the complexity of interlocked processes that go on in the organism.[102]

Wundt's beliefs determined his outlook on gesture, which he proposed to regard as the origin of language. He assumed, rather controversially, that "the primary cause of natural gestures does not lie in the motivation to communicate a concept but rather in the expression of an emotion. Gestures are first and foremost affective expressions."[103] He focused on the process of articulation, considering this muscular work as just one case of "expressive movement." Putting this

[97] Kurt Danziger, "Wundt and the Two Traditions of Psychology," in *Wilhelm Wundt and the Making of a Scientific Psychology*, ed. R. W. Rieber (New York: Plenum Press, 1980), 73–115, 79–81.

[98] Ibid., 85.

[99] Ibid., 95.

[100] Ibid., 95.

[101] Ibid., 96.

[102] Danziger, "Wundt and the Two Traditions of Psychology," 97–98.

[103] Wilhelm Max Wundt, *The Language of Gestures*, trans. J. S. Thayer, C. M. Greenleaf, and M. D. Silberman, *Approaches to Semiotics Paperback Series*, ed. Thomas Sebeok (The Hague: Mouton, 1973), 146. This book is a translation of Wundt's *Völkerpsychologie. Eine Untersuchung der Entwicklungsgesetze von Sprache, Mythus und Sitte*, vol. 1 (*Die Sprache*), part I, chapter 2, 4th ed. (Stuttgart: Alfred Kröner Verlag, 1921).

assumption at the foundation of his theory of gestural expression made Wundt
disregard the question of interpretation. As his opponents in linguistics and so-
cial studies were quick to point out, his idea of expression was rather "monolog-
ical."[104] He took it for granted that expressive movements should be readable to
other beings of the same nature. This problem is detectible throughout Wundt's
writings on language. For instance, we can see it in the following passage, in
which Wundt describes the unity of sound and corporeal movement on the early
stages of humankind's development, and their subsequent differentiation:

> But just as gestures owe their intelligibility to their immediate relation that
> exists between the character of the movement and its meaning, so here also
> we must presuppose a like relation between the original articulatory move-
> ment and its meaning. Then, too, it is not improbable that articulation was at
> first aided by accompanying mimetic [facial] and pantomimetic movements
> [involving the whole body, and especially the limbs]. . . . The development of
> articulate language is, accordingly, in all probability to be thought of as a pro-
> cess of differentiation, in which the articulatory movements have gradually
> gained the permanent ascendency over a number of different variable expres-
> sive movements which originally attended them.[105]

Wundt's theory of the gestural origin of language included the belief that
some words and sound combinations have a privileged relation with emotions,
due to the fact that their articulation corresponds to the expressive movements
necessitated by these inner states. These are onomatopoeic words, which
Wundt calls *Lautgebärden*—"sound gestures," connecting them to the ancient
Lautbewegungen, "sound-movements." Either of these German terms might
have been the prototype of Viktor Shklovskii's term "sound-movement" (*zvuk-
dvizheniie*). In his *Ethnopsychology*, Wundt gives the following description of the
sound-gesture:

> we can define "sound-gestures" [*Lautgebärden*] as mimic movements of the
> articulation organs, which mostly belong to the category of imitative gestures
> [*nachbildenden Gebärden*], and differ from other gestures only by the fact
> that connected to them is a vocal sound [*Stimmlaut*] that expresses the corre-
> sponding affect and that acquires its characteristic articulation and modula-
> tion through the facial movement [*mimische Bewegung*]. Thus, in this case, the

[104] Brigitte Nerlich and David D. Clarke, "The Linguistic Repudiation of Wundt," *History of Psychology* 1.3 (1998): 179–204, 184. This essay provides a historical survey of Wundt's reception as a theorist of language and gesture.
[105] Wilhelm Max Wundt, *Outlines of Psychology*, trans. Charles Hubbard Judd, 2nd English ed. (Leipzig: Wilhelm Engelmann, 1902), 334.

speech-sound [*Sprachlaut*] is a connection of gesture and sound, in which the sound is determined by the gesture.[106]

This passage contains a proposition that stirred up Shklovskii's objections—the idea that the movement of articulatory organs "imitates" something.

As we have seen earlier, Shklovskii could not agree that the effect of "sound-gesture" type of words is based on resemblance between an object that the speaker has in mind and the shape taken by his mouth (for example, shaping the lips as if for the pronunciation of the sound "o" when imagining a round object). Yet, to give justice to Wundt, his view of the imitative aspect of muscular movement was not as simple. In the earlier quotation, mimetic articulatory motions are classified as belonging to the class of "imitative" gestures, but this term referred to a rather complex concept, which emphasized not a direct correspondence with a certain object in reality, but rather the apperceptive filter organizing our sensations and making sense of them. Wundt proposed to divide human gestural expressions into three types: demonstrative, imitative, and symbolic (Table 1.1). [107] These categories recall Charles Sander Pierce's three types of signs: index, icon, and symbol.

Wundt's concept of "imitative, or descriptive" gestures emphasized the fact that in re-creating some object through pantomime, the subject relies on his imagination and representational conventions that he is acquainted with and holds in value. Nevertheless, the primary expressive impulse that calls forth these gestures originates in the psychophysiological mechanisms, which help regulate the organism's interaction with the environment. For Wundt, both "imitative" and "demonstrative" gestures are "affective," because they originate in

> instinctive drives, i.e. willed actions which follow from and are adapted to a single motivation. . . . The indication of an object or, in the case of stronger emotions, the mime of a movement is, therefore, at the same time a symptom of the emotion and a symptom of the motivation. The gesture is the direct expression of the concept which at the moment governs the affect.[108]

Mimesis for Wundt is a matter of the individual "affective" response, originating in the somatic drives. Does he also regard expressive movements as intersubjective? What guarantees that the referent of the descriptive gesture—the performer's

[106] Wilhelm Max Wundt, *Völkerpsychologie. Eine Untersuchung der Entwicklungsgesetze von Sprache, Mythus und Sitte*, first volume (*Die Sprache*), first part, chapter 4, 2nd ed. (Leipzig: Wilhelm Engelmann, 1904), 332.

[107] This table is based on Wilhelm Max Wundt, *The Language of Gestures*, trans. J. S. Thayer, C. M. Greenleaf, and M. D. Silberman, *Approaches to Semiotics Paperback Series*, ed. Thomas Sebeok (The Hague: Mouton, 1973), 127–133.

[108] Wundt, *The Language of Gestures*, 147.

Table 1.1 Wilhelm Wundt's Classification of Gestures

Affective Gestures		
1. Demonstrative	**2. Imitative, or Descriptive**	**3. Symbolic**
—Pointing gestures, deictic markers —Their form does not change over time —Their meaning is dependent on the deictic situation of the speaker	—Originate in the impulse to imitate the object that aroused interest —Depend on representational conventions (therefore, the term "imitative" may be a misnomer)	—Are "etymologically" traceable to demonstrative and descriptive gestures —Like metaphors, transmit the concept from one field of perception to another (e.g., the expression "far ahead," implying a temporal relation through spatial means) —A "symbol" is a sensory image that represents a concept different from itself but related to it by association (e.g., using the gesture for "drinking" to denote "water")

The descriptive-gesture subcategory within column 2:

Two Subcategories of Descriptive Gestures	
Mimed	Connotative
—Imitate the object (but the object may be transformed by the performer's fantasy)	—Not only outline the object, but also single out one of its traits

Two Subcategories of Mimed Gestures	
Indicative	Plastic
—Drawing the outlines of the object in the air with fingers	—The image of the object is imitated three-dimensionally by the hands

inner state or inner response to a certain object—would be comprehended by the addressee? How does individual gestural expression work for the purposes of communication and interaction, giving rise to a language?

These issues constitute the weakest point of Wundt's theory, and he was rightfully challenged on these counts by his contemporaries in the field of historical linguistics, as well as in philosophy and sociology of language.[109] Wundt collected evidence on the similarity of gestures developed by different communities and subcultures around the world and across time, arguing that these facts testify to the "psychological regularity" of humankind.[110] For instance, Wundt found

[109] Brigitte Nerlich and David D. Clarke, "The Linguistic Repudiation of Wundt," *History of Psychology* 1.3 (1998): 179–204, 183–187.
[110] Wundt, *The Language of Gestures*, 145.

that gestures denoting such concepts as eating, drinking, shelter, and barter exchange have strikingly similar features in many culturally distant groups. The essence of these phenomena—as perceived by the consciousness of different people and encoded in the form of gesture—remained the same. According to Wundt, such uniformity could only be the product of "universally recurring psychological laws" and "the general psycho-physical organization of man."[111] He recognized that there can be important variations and nuances in gestural expressions: for example, two palms touching at the fingertips as if to form a "roof" signifies "a house" in the gestural language of Native Americans and "a prison" in the secret argot of German criminals.[112] He also took into account the historical development of gestural expressions, when they get abbreviated or modified over time and no longer resemble the original prototype. However, it was the initial expressive impulse that was the most important for Wundt— that is, an indication of the human way of processing signals from the world, the human way of synthesizing concepts, and demonstrating correspondent volitional actions. Without this initial impulse, which Wundt considered to be affective in nature, no communication would have been possible at all.[113] His theory of gestural language included some considerations on forms of reciprocity and interaction between the performer and the addressee, but this part of Wundt's theory was somewhat nebulous. He contended that the affective motivation, or drive that called forth the communicator's gesture would be immediately apparent to the addressee.[114] In fact, he thought that the affect would transfer to the addressee, producing what Wundt called "co-gestures."[115] Then, the addressee would develop his own affects in response to the impulse he received, formulate concepts, and express his position through a new gesture. Such initial exchanges, Wundt thought, eventually became more complex and nuanced, producing arbitrary, or symbolic expressions that were the basis of language.

Wundt put this elaborate discussion of the gesture-language at the opening of his magnum opus, the ten-volume treatise *Ethnopsychology* (*Völkerpsychologie*, 1900–1920). This work was conceived by him as a counterpart to his project in establishing experimental psychology that concentrated on the individual. In *Ethnopsychology*, Wundt planned to go out onto the supra-individual level, focusing on language, mythology, and customs as "objective manifestations" of the collective consciousness. The foundations for the study of cultural phenomena as mental products of a collective "soul" were laid in Germany by Heymann Steinthal and Moritz Lazarus in the 19th century.[116] By focusing on

[111] Ibid.
[112] Ibid.
[113] Ibid., 146.
[114] Ibid., 148.
[115] Ibid.
[116] Nerlich and Clarke, "The Linguistic Repudiation of Wundt," 182.

such phenomena as language and social rituals, Wundt intended to create a psychology dealing with factors beyond the grasp of psychophysiology.[117] Yet some central assumptions from his psychophysiological research carried over onto the new project, producing more problems than they offered solutions, due to the lack of rigorous reflection on the mechanisms of social interaction. Vladimir Bekhterev, who had travelled to Wundt's laboratory in Leipzig in the 1880s as a young researcher, offered this critique of *Ethnopsychology*:

> According to W. Wundt, the common products of creative activity are determined by the fact that "creativity of one person can be acknowledged by another as an adequate expression of the latter's concepts and feelings, which is why large numbers of different persons can be creators of the same concept to an unequal degree." The matter is thereby reduced to the following: in social organizations there are individual mental processes which, inasmuch as they correspond to similar processes in other individuals, are the collective products of the mental activity of a certain number of people. But in such a case there can be no social psychology, since under these circumstances it will have no new goals except those in the province of individual psychology.[118]

Essentially, all critics seemed to agree, Wundt's *Ethnopsychology* was "not social enough."[119]

The limitations of Wundt's theory, which was unsuccessful in integrating the psychophysiological model of subjective expression and the notion of communication, apply to Shklovskii's view of the poetic language. The literary scholar attempted to solve the problem of reciprocity and interaction on the basis of sympathetic corporeal reactions, which the interlocutor might experience, as in Wundt's phenomenon of the "co-gesture." In his essay on the "trans-sense" language, Shklovskii stressed that language comprehension engages motor circuits in our brain:

> There are facts which prove that when we perceive another's speech or simply imagine some kind of verbal act, our organs of speech mutely reproduce the movements that are necessary for the articulation of the given sounds. Perhaps, these movements stand in some sort of hitherto unexamined relation to the emotions that are evoked by the sounds of speech, and particularly, by the "trans-sense language."[120]

[117] Ibid.
[118] Vladimir Bekhterev, *Collective Reflexology: The Complete Edition*, ed. Lloyd H. Strickland, trans. Eugenia Lockwood and Alisa Lockwood (New Brunswick, NJ: Transaction Publishers, 2001), 30.
[119] Nerlich and Clarke, "The Linguistic Repudiation of Wundt," 184.
[120] Shklovskii, "O poezii i zaumnom iazyke," 24.

For Shklovskii, the act of absorbed listening is also an act of empathy, in which the interlocutor is literally being moved. The faint, automatic movements of his lips bear testimony to a contagion by the same affect, or the same mental motor image that is animating the speaker. Though in this model, there is no material conduit by which the affective state is transferred from one person to another, Shklovskii implies that the similarity of the interlocutor's psychophysiological constitution enables him to intuit the speaker's feelings. The very act of perception activates sympathetic muscular contractions, which in turn trigger emotions. To support this statement, the scholar draws on William James's famous argument concerning the somatic nature of emotional states. Here is how Shklovskii incorporates a reference to James into his discussion of poetic performance:

> Iurii Ozarovskii has noted in his book *The Music of the Living Word* [*Muzyka zhivogo slova*] that the timbre of the voice depends on the movement of facial muscles; and if one goes a bit further than he did and relates to his remark James's thesis that every emotion appears as a result of some particular corporeal state (a sinking heart is the cause of fear, and tears are the cause of the emotion of sorrow), one might say that the impression produced by the timbre of speech may be explained by the fact that when hearing it, we reproduce the speaker's facial play [*mimiku*] and therefore experience his emotions.[121]

Shklovskii does not cite James directly, and simply points to his famous theory that established the primacy of visceral responses to a stimulus for the subsequent conscious experience of emotions. In the 1900s–1910s, James was a widely recognized figure in Russia, and the evocation of his name would have elicited nods of approval particularly among theater reformers, concerned with the physical aspects of acting (Iurii Ozarovskii, Sergei Volkonskii, Vsevolod Meyerhold, and others).[122] In "What Is an Emotion?" (1884), James had argued that "the bodily changes follow directly the perception of the exciting fact," and a wave of innervations that reports to the brain on all alterations that have already taken place constitutes our conscious experience of the emotion: "we feel sorry because we cry, angry because we strike, afraid because we tremble," and not vice versa.[123] The connection between the somatic and the mental, established by James, serves as a foundation for Shklovskii's claim about the origin of the interlocutor's emotional experience. But the idea of sympathetic mimicry,

[121] Viktor Shklovskii, "O poezii i zaumnom iazyke," 24.
[122] On the reception of James's psychology and philosophy in Russia, see Joan Delaney Grossman and Ruth Rischin, eds., *William James in Russian Culture* (Lanham, MD: Lexington Books, 2003).
[123] William James, "What Is an Emotion?" *Mind* 9.34 (1884): 188–205, 190–191.

triggered by the perception of a speech act, is an element that Shklovskii supplies himself. It is possible to surmise that he must be relying on a popular version of James's theory interlaced with echoes of other 19th-century psychophysiological theories, dealing with phenomena such as emotional contagion, psychomotor induction, and kinesthetic empathy (*Einfühlung*). As we shall see in Chapter 4, it is precisely this mix that informed Sergei Eisenstein's and other Russian and European film theorists' understanding of the kinesthetic impact of film images. The idea that the sight of motion triggers psychophysiological reactions may be found in Siegfried Kracauer's explanation of the spectators' engagement with the screen.[124] Eisenstein's colleague Vsevolod Pudovkin was convinced that "there is a law in psychology that lays it down that if an emotion give birth to a certain movement, by imitation of this movement the corresponding emotion can be called forth."[125]

Viktor Shklovskii's introduction of James and Wundt into discussions of poetry declamation produced ripple effects for the Russian literary and performance theory, as it gave a new relevance to the ideas of soon-to-be-forgotten Symbolist philosophers and professional literary historians, such as Potebnia, Zelinskii, and Aleksandr Veselovskii. After the Revolution, the younger generation of authors, inspired by the Formalists' essays and the Futurists' literary endeavors, assimilated the idea that articulatory movements and sounds are linked to the ineffable flux of affects and neurophysiological states. Consider, for instance, an indirect evocation of James's thesis in Varlam Shalamov's reflections on poetry. Today, Shalamov is mostly remembered as the author of *The Kolyma Tales*, a collection of stories about Stalin's labor camps, rivalling Alexander Solzhenitsyn in their scathing exposure of totalitarian repressions. As a young man, in the second half of the 1920s, Shalamov studied at Moscow University and frequented literary performances and public disputes of various avant-garde groups. He also attended sessions of the Formalist Moscow Linguistic Circle and the New Left Front of the Arts, where he struck up an acquaintance with Mayakovsky, Sergei Tret'iakov, and Osip Brik.[126] In a 1979 essay "Sound Repetition, a Quest for Meaning," Shalamov harkened back to his youth, while discussing the animating force of the oral performance:

> I was extremely astonished to see and to hear how Mayakovsky performed his "Left March" ["Levyi marsh"] in 1928 at the request of the audience. My lips

[124] Siegfried Kracauer, *Theory of Film: The Redemption of Physical Reality* (New York: Oxford University Press, 1960), 159.

[125] Vsevolod Pudovkin, "From Film Technique," *Film Theory and Criticism: Introductory Readings*, ed. Leo Braudy and Marshall Cohen (New York: Oxford University Press, 2009), 7–12, 10.

[126] Biographical details are provided in Varlam Shalamov, *Novaia kniga: Vospominaniia, Zapisnye Knizhki, Perepiska, Sledstvennye Dela*, ed. I. P. Sirotinskaia (Moskva: Eksmo, 2004).

would not have been capable of [*u menia by guby ne povernulis'*] reading something that I had written so long ago. Apparently, Mayakovsky's lips must have automatically folded up in some crucial way, because the repetition [of his old poem] seemed to give him a purely physical pleasure.[127]

This peculiar statement seems to fault Mayakovsky for a certain hypocrisy, exposing his almost machine-like ability to repeat the old verses with the same élan as if they had been just written. What is especially interesting about Shalamov's review is that he concentrates on the action of Mayakovsky's lips as a trigger of the poet's inner state, as well as its symptom. In Shalamov's discussion, the poem is thus presented as a program of articulatory actions—a blueprint for motions and emotions. Shalamov explains that in composing poetry, the first strophe defines the poem's intonation: "its first words are already chosen, they have emerged involuntarily in the brain so that the vowels and consonants form something similar to a geometrically-precise crystal—a recurring sound ornament."[128] This is the legacy of Shklovskii and his influential interpretation of the "trans-sense poetry" par excellence.

[127] Varlam Shalamov, "Zvukovoi povtor—poisk smysla: zametki o stikhovoi garmonii," *Semiotika i informatika* 7 (1976): 128–147, 132.
[128] Ibid., 129.

Did you ever make a Phonograph Record?

Did you ever hear yourself talk, sing or play?

Talk about entertainment— there is nothing that approaches the fun and fascination of making records at home on the

Edison Phonograph

THE EDISON will record what you or your friends say, or sing, or play, and then instantly reproduce it just as clearly and faithfully as the Records you buy are reproduced. This is a feature of the Edison Phonograph you should not overlook.

You can send your voice to a friend, preserve the sayings of children, record your progress as a speaker, a singer or a musician. Anyone can make records on an Edison. It requires no special machine. The blank records can be used over and over.

Let us demonstrate this great feature of the Edison Phonograph and when you buy make sure you get an Edison, the instrument that gives you not only the best renditions of the world's best entertainers, but also the opportunity for home record making. Edison Phonographs, $15.00 to $200.00. Edison Standard Records, 35c. Edison Amberol Records (play twice as long), 50c. Edison Grand Opera Records, 75c. to $2.00.

ANOTHER HOME RECORDING AD FREE

The new four-minute Recorder and accessories offer you a big field. Take advantage of it now and get this ad into the papers. It tells a similar story to that offered in our last issue, but tells it in a different way. This is a ready-made ad electro No. 28 and the cut of the Phonograph is Stock electro No. 790. Either are yours for the asking if you will send us a clipping of the ad.

Fig. 2.1 An advertisement for the Edison phonograph—a device capable of recording and reproducing speech. The phonograph provided a material trace of voice, which could be scrutinized as data by scholars of oral performance. An Edison phonograph was used in this capacity by the Russian pioneer of poetry recitation studies, Sergei Bernshtein. Image source: "Did You Ever Make a Phonograph Record?" *The Edison Phonograph Monthly* 10.9 (1912): 11.

2

Motor Impulses of Verse

Russian Formalists on Poetry Recitation

I believe that every movement finds its correspondence in a certain sound. Voice is a kind of gesture, one made by the organs inside our throat.

—Sergei Eisenstein[1]

Motricity [*motornost'*], or the ability to evoke motor sensations and body movements, is a crucial property of verse.

—Sofia Vysheslavtseva[2]

The Institute of the Living Word

What role does the physical experience of form play in aesthetic appreciation? Could it be that when reading poetry, the sensations of articulation contribute as much to the aesthetic impact as the meaning of words? The feeling of the moving tongue and lips, the bursts of air passing through the mouth, the resonant vibrations of the chest, the rhythmical waving of the hand, the walking to and fro on stage—how do all these sensations affect the performer? Following Shklovskii's definition of poetry as "a ballet for the organs of speech,"[3] the text may be regarded as a program of physical actions, bound to evoke a particular set of sensations marked by pleasure or unpleasure, ease or awkwardness, familiarity or strangeness, and even proximity to emotional expressions (according to the Zelinskii-Wund hypothesis, which I have discussed in Chapter 1). Does the speaker's experience transfer in any way to the listeners, thanks to some form of corporeal empathy? Could this transfer be analyzed and streamlined? How can

[1] Sergei Eisenstein, "Printsipy novogo russkogo fil'ma: Doklad S. M. Eizenshteina v Sorbonnskom universitete" (1930), in *Sobranie sochinenii v shesti tomakh*, tom 1 (Moskva: Iskusstvo, 1964), 547–559, 554.

[2] Sofia Vysheslavtseva, "Motornye impul'sy stikha," in *Poetika: Vremennik otdeleniia slovsenykh iskusstv*, vol. 3 (Leningrad: Academia, 1927), 45–62, 46.

[3] Viktor Shklovskii, *Literatura i kinematograf* (Berlin: Russkoe universal'noe izdatel'stvo, 1923), 9.

Psychomotor Aesthetics. Ana Hedberg Olenina, Oxford University Press (2020). © Oxford University Press.
DOI: 10.1093/oso/9780190051259.001.0001

recording technologies aid in the task of detailing the individual poets' signature intonations (Fig. 2.1)?

In 1918, questions of this kind formed the research agenda of literary scholars, orators, performers, phoneticians, physiologists, and psychologists, gathered under the umbrella of the newly established Institute of the Living Word (*Institut Zhivogo Slova*) in Petrograd.[4] Only a year had passed since the October Revolution. Russia was suffering from political turmoil and famine, and yet the Bolshevik authorities found it necessary to invest in an organization that would "develop the art of live speech through scientific research and artistic experiments."[5] The reason for official support was the ideologues' determination to launch a new revolutionary culture. At the opening ceremony, the Commissar of Enlightenment, Anatolii Lunacharskii, stated that the art of oratory was crucial for a socialist democracy and expressed a wish that the Institute would introduce it to the masses.[6] The Institute, as he saw it, had to become an educational venue and research center that would investigate all aspects of oral performance and promote new forms of collective cultural experience.[7] The organization would aim to develop individuals' "abilities to express their feelings, influence others, and improvise," and advance their knowledge of crowd psychology and non-verbal communication through body language.[8] Among the list of subjects proposed for the Institute's educational program was Lunacharskii's own course called "Aesthetics," in which "conceptions of beauty" were to be considered with regard to "the physiological basis of aesthetics," "its bio-emotional foundation," and "social-ethical criteria."[9] This declaration of the course program was symptomatic of the utopian aspirations that informed the authorities' support for the Institute—the idea that biomedical sciences must be recruited for mastering all secrets of the arts. The power of oral performance and its impact on the audience had to be rationalized with the help of state-of-the-art physiological psychology, so that—as Lunacharskii put it—nothing would hinder the process by which the orator's or poet's word "gets transformed from a simple vibration of gas molecules into a complex, endlessly delicate vibration of the nervous system, and finally, mysteriously becomes a phenomenon of spirit."[10]

[4] Raffaella Vassena, "K rekonstrukcii istorii i deiatel'nosti Instituta Zhivogo Slova (1918–1924)," *Novoe Literaturnoe Obozrenie* 86 (2007): 79–95.

[5] Ustav Instituta Zhivogo Slova (c. 1922). RGALI f. 941 op.4, ed. khr. 2(1), l.8.

[6] Anatolii Lunacharskii, "Rechi, proiznesennye na otkrytii Instituta Zhivogo Slova 15 noiabria 1918 g," in *Zapiski Instituta Zhivogo Slova* (Petrograd: Narodnyi kommisariat po prosveshcheniiu, 1919), 12–24.

[7] Ibid.

[8] Vassena, "K rekonstrukcii istorii," 79–80.

[9] Anatolii Lunacharskii, "Programma kursa 'Vvedenie v estetiku,'" in *Zapiski Instituta Zhivogo Slova* (Petrograd: Narodnyi kommisariat po prosveshcheniiu, 1919), 48.

[10] Anatolii Lunacharskii, "Rechi, proiznesennye na otkrytii Instituta Zhivogo Slova 15 noiabria 1918 g," in *Zapiski Instituta Zhivogo Slova* (Petrograd: Narodnyi kommisariat po prosveshcheniiu, 1919), 14.

In this utopian vision, the communication of ideas and feelings had to become completely transparent—scientifically examined and available for mastery. The courses at the Institute, to cite Lunacharskii's elevated metaphors, had to help the underprivileged classes straighten their spine, regain their voices, and liberate their speech from "all kinds of deficiencies and impediments" that afflicted free expression in "the unjust regimes of the past."[11] "We must return the living word to humanity . . . to make human speech sonorous, harmonious, and purposeful," proclaimed Lunacharskii, defining the Institute's mission as "paving the correct path between the person's inner world and verbal expression, in all of its aspects—emotion, tonality, timbre, rhythm, and [gestural] accompaniment."[12]

This utopian fantasy of improving humankind was only one interpretation of the Institute's mission. The official endorsement formulated by Lunacharskii at the opening ceremony simply created a new, ideologically charged framework for a number of independent research initiatives, which had been developing in diverse disciplines since prerevolutionary times. The Institute united poets and literary scholars, theater specialists and dance instructors, orators and cultural historians, psychologists and speech therapists—all of whom had a unique outlook on performance and motivations for studying it. In joining the Institute, each researcher was driven by his or her own professional interests, and it would be wrong to assume that all of them understood the purpose of their work in the same way as Lunacharskii. The official endorsement, which gathered them under one roof, created new opportunities for interaction. The interdisciplinary space of the Institute made scholars and performers face methods and technological tools offered by science, while scientists at the Institute found themselves considering aesthetic problems.

In this chapter, I will examine the ways in which these connections were unfolding. The central critical question that will inform my historical discussion is this: what did psychology and neurophysiology have to offer scholars dealing with the aesthetics of verbal performance? One of the reasons why these theorists were turning to science was their focus on the body as an instrument of articulation. The problematic of embodiment governed their research, as it seemed to open avenues for assessing the material substance of expression, its very medium. This bottom-up approach to aesthetics—a desire to delve into the elemental mechanisms of the verbal art—made scholars look for answers outside their own field of expertise and turn to scientists' attempts to explain how the body and the brain work in producing and processing meaningful sounds. Yet the way in which scholars of oratory and poetry declamation understood

[11] Ibid., 13. Raffaella Vassena argues that a similar vision was shared by the director of the Institute, Vsevolod Vsevoldskii-Gerngross (Vassena, "K rekonstrukcii istorii," 83).
[12] Lunacharskii, "Rechi, proiznesennye," 13.

the promise of science was never straightforward, or one and the same for all. There were those who espoused the radical beliefs of Lunacharskii, which bordered on physiological determinism—the idea that the key to understanding the functioning of artistic expression lies in wired-in corporeal mechanisms. This view often implied that a mastery of the physique would somehow lead to a more powerful, sincere, and transparent communication, seen as a boon to the utopian society of the future. But there were also those who did not subscribe to this vision. More often than not, the professional integrity of the Institute members prompted them to question the feasibility of this plan. They preferred to leave grandiose ambitions to the ideological Olympus and concentrate on more modest research tasks with clearly defined goals and methods. There were a number of critical issues, which especially troubled more conscientious scholars. One source of unease was the implicit universalism of the psychophysiological approach to the art of diction: the emphasis on "the bio-emotional foundation of aesthetics" was patently at odds with evidence of variation in performance styles of individual readers, actors, and orators, to say nothing of different cultures and historical periods. Another, even more explosive issue that prevented scholars of performance from embracing the psychophysiological direction was their acute awareness that fundamentally, art differs from nature. To put it bluntly, the problem they sensed was that reducing performance to biological laws of emotional expression—if such laws indeed existed—took away its essence as performance, as an act of play.

In what follows, I will look more closely at the ways in which the members of the Institute thought about the dangers and advantages of scientific approaches to the study of oral expression. My main focus will remain with the Russian Formalists employed in this organization—the poetry scholars Boris Eikhenbaum and Sergei Bernshtein[13]—whose work offers a complex negotiation of these problems. Their research in the late 1910s and early 1920s centered on the auditory and articulatory aspects of Russian lyrical verse, its rhythm, melody, and intonation. Their Formalist commitments (both Eikhenbaum and Bernshtein were associates of the OPOIaZ circle: the Petrograd Society for the Study of the Poetic Language) prevented them from sharing anything remotely resembling Lunacharskii's vision. Foregrounding the notion of "estrangement" and the idea of art's autonomy and self-referentiality, the OPOIaZ group

13 Eikhenbaum and Bernshtein worked at the Institute since 1919 until its closure in 1924, when it fell apart into smaller constituents, some of which focused on the practice of performance and teaching, and some on academic research. After 1924, Bernshtein went on to found The Laboratory for the Study of Artistic Speech (*Kabinet po izucheniiu khudozhestvennoi rechi*) at the Institute of Art History in Leningrad (*Institut Istorii Isskusstv*), where he and a number of colleagues continued research on the art of poetic recitation. The Laboratory was closed down in 1930 as part of the official campaign against Formalism and scholars associated with it.

resisted simplistic notions of "expression." Reluctant to judge a poetic work as an encoding of the author's feelings, they concerned themselves primarily with compositional and stylistic aspects—that is, the form proper, considered in relation to pre-existent literary traditions. This "anti-expressionist" emphasis has long served as the main focus point in the reception and interpretation of Russian Formalism throughout the 20th century.[14] However, even though "anti-expressionist" claims have certainly been a staple of Formalists' texts, I would like to offer a corrective to the predominant views on their theoretical legacy. As literary scholars, they were remarkably sensitive to what may be called the *experience of form*. Of course, their approach to analyzing poetry was aimed at defining "objective" criteria of various styles and their aesthetic impact, so as to move beyond impressionistic literary criticism that, they felt, plagued their profession.[15] Aiming for a new rigor and precision, the Formalists began to identify and systematize linguistic and extra-linguistic facts characteristic of one or another style, genre, or epoch. They posited that it is the complexity of such details that differentiates styles from one or another and makes up the compositional structure of an art piece. They also claimed that it is the unique sum of these distinctive properties that produces an aesthetic impact on the perceiver. Eager to ground their interpretation in unmistakable, verifiable data, they began to document, for example, how poetic meters interact with morphology and syntax, how repetition of sounds or syntactic structures creates rhythmical patterns, or how particular phrasing calls for one or another type of pronunciation. But listing such details was not everything. Even more crucial for the Formalists was looking at the text as a blueprint, or a matrix for evoking particular experiences and sensations—in which the physical aspect (articulatory work, the rhythmical sense, etc.) was inseparable from cognitive processing (logical deciphering, associations, etc.) and a plethora of emotional responses.

The idea of viewing elements of a text from a performative, experiential aspect was strongly promoted by the academic milieu that nourished the OPOIaZ. Among the teachers of the future Formalists at St. Petersburg University was the linguist Jan Baudouin de Courtenay, who proposed the notion of the "phoneme" that took into account a mental experience of sound. "A phoneme," wrote

[14] Cf. Victor Erlich, *Russian Formalism: History, Doctrine*, 3rd ed. (New Haven, CT: Yale University Press, 1981); Amy Mandelker, "Russian Formalism and the Objective Analysis of Sound in Poetry," *The Slavic and East European Journal* 27.3 (1983): 327–338; Peter Steiner, *Russian Formalism: A Metapoetics* (Ithaca, NY: Cornell University Press, 1984); Carol Any, "Boris Eikhenbaum in OPOIaZ: Testing the Limits of the Work-Centered Poetics," *Slavic Review* 49.3 (1990): 409–426.

[15] Cf. Eikhenbaum's statement: "contemporary poetics is characterized by a desire to use the methods of linguistics in order to get rid of subjective-psychological interpretation and make the analysis of poetic texts objective, morphology-based" (Boris Eikhenbaum, *Melodika Russkogo Liricheskogo Stikha* [Peterburg: Opoiaz, 1922], 13). In the same text, Eikhenbaum attempts to define relationships between "lyrical intonation," syntax, and poetic meter.

Baudouin de Courtenay, "is a conception of the sound [*predstavleniie o zvuke*] permanently planted in our psyche; i.e. a simultaneous concurrence of articulatory work and sensations accompanying this process."[16] Another young teacher and colleague of the Formalists was the linguist Lev Shcherba, who advocated the study of poetry through linguistic parameters.[17] Thus, for instance, in his 1923 study of Pushkin's prosody, Shcherba analyzed how the poet places the "logical stress" in each phrase, highlighting its "psychological predicate"—the most important word in the clause.[18] Two decades later, writing about syntax, Shcherba would go on to consider syntactic elements not as abstract grammatical structures, but rather as discrete units of "speech-thought," which cannot be viewed separately from their meaning effects and articulatory patterns. "A syntagm," in his definition, "is a phonetic unit, expressing a semantic whole within the flow of verbal thinking [*v protsesse reche-mysli*]."[19] In terms of pronunciation, it is "a single-breath group," the end of which is usually marked by the lowering of the tone, at least in the Russian language.[20] A student of Baudouin de Courtenay and Shcherba, Lev Iakubinskii went even further in discussing the performative and experiential aspects of language use. In 1923, in a linguistic study of dialogical communication, he emphasized connections between semantics, articulation, and psychological experience. Iakubinskii wrote:

> The role of facial expressions and body language on the one hand, and tone and timbre on the other hand is especially important in direct communication, because they are related to each other and originate from the same "source"— a particular corporeal disposition corresponding to a certain emotional and mental state.[21]

In Iakubinskii's statement about "the same source," we can see once again the influence of the Wundtian thesis that informed much of Russian literary and

[16] Baudouin J. N. de Courtenay, "Lektsii po vvedeniu v iazykoznanie (1917)," cited in Lev Zinger, "Scherba i fonologiia," in *Pamiati Akademika L'va Vladimirovicha Shcherby (1880–1944): Sbornik Statei*, eds. B. A. Larin, L. R. Zinder, and M. I. Matusevich (Leningrad: Izdatel'svo Leningradskogo gos. universiteta, 1951), 61–72, 65.

[17] Lev Shcherba, "Opyty lingvisticheskogo tolkovaniia stikhotvorenii. I. 'Vospominanie' Pushkina," in *Russkaia rech': Sborniki statei pod red. L. Shcherby* (Petrograd: Izdaniie foneticheskogo instituta prakticheskogo izucheniia iazykov, 1923), 13–56.

[18] Shcherba, "Opyty lingvisticheskogo tolkovaniia stikhotvorenii," 23.

[19] Lev Shcherba, "Fonetika frantsuzskogo iazyka (1937)," cited in V. V. Vinogradov, "Obshchelingvisticheske i grammaticheskie vzgliady akad. L. V. Shcherby," in *Pamiati Akademika L'va Vladimirovicha Shcherby (1880–1944): Sbornik Statei*, eds. B. A. Larin, L. R. Zinder, and M. I. Matusevich (Leningrad: Izdatel'svo Leningradskogo gos. universiteta, 1951), 31–62, 57.

[20] Shcherba, "Fonetika frantsuzskogo iazyka (1937)," cited in V. V. Vinogradov, "Obshchelingvisticheske i grammaticheskie vzgliady akad. L. V. Shcherby," 57.

[21] Lev Iakubinskii, "O dialogicheskoi rechi," in *Russkaia rech': Sborniki statei pod red. L. Shcherby* (Petrograd: Izdanie foneticheskogo instituta prakticheskogo izucheniia iazykov, 1923), 96–194, 128.

linguistic studies in the first decades of the 20th century. Iakubinskii was a friend and colleague of Boris Eikhenbaum, Viktor Shklovskii, and Sergei Bernshtein at the OPOIaZ circle. He also worked at the Institute of the Living Word.[22] Undoubtedly, the idea that there might be some correspondences between "emotional and mental states," articulation, and body movements would have been familiar to all of them. However, in Eikhenbaum's and Bernshtein's analyses of the poetic language and performance, made in the early 1920s, we will witness a much more cautious approach to this topic. These scholars placed many qualifications on the idea of evaluating the mental and psychological response to the literary text. I will review these reservations in detail in the second half of this chapter, when presenting the Formalist theory of emotional response. For now, I would simply like to emphasize that a fundamental theoretical premise of their work was a heightened attention to the feeling of the material structure of the (pronounced) poem as an aesthetic object. Wishing to avoid the pitfalls of the sloppy and old-fashioned "subjective-psychological" literary criticism, the Formalists preferred to speak of the experiential aspect of poetry in an abstract, scientific language.

In this chapter, I will look at Eikhenbaum's and Bernshtein's studies of the lyrical intonations and performance styles of their contemporaries in light of their conception of the literary form as the "emotional-dynamic organization" of verbal material (Bernshtein),[23] or as "architectonics" of rhythmical and intonational structures (Eikhenbaum).[24] I will argue that for these scholars, the experience of the literary form—by the poet, the performer, and the listener—was not only an intellectual process or matter of detached judgment, but also a physically and emotionally captivating, electrifying affair. Bernshtein and Eikhenbaum relied on the experience of form in their analyses of lyrical styles, which paid special attention to the sensations of articulation and acoustics. And it is in this domain that they found application for methods and vocabulary derived from psychophysiologically oriented phonetics. One of the goals of this chapter is to show how and why the instruments and ideas from physiological psychology found a place in their methodological arsenal.

Eikhenbaum's and Bernshtein's interest in the "objective," palpable qualities of the poetic form stems from their student years at St. Petersburg University, where they learned about the methods of experimental phonetics from the linguist Lev Shcherba and grew to admire the German school of verse studies, which analyzed rhythm, melody, intonation, and sound orchestration of poems

[22] Vassena, "K rekonstrukcii istorii," 79.

[23] Sergei Bernshtein, "Estheticheskie predposylki teorii deklamatsii" (1926), in *Poetika: Vremennik otdela slovesnykh iskusstv*, vol. 3 (Leningrad: Academia, 1927), 25–44, 29.

[24] Boris Eikhenbaum, *Melodika Russkogo Liricheskogo Stikha* (Peterburg: OPOIaZ, 1922), 64.

(the leaders of this research trend were Eduard Sievers, Ottmar Rutz, and Franz Saran).[25] When, in January 1919, Professor Shcherba invited Eikhenbaum and Bernshtein to join the study group on "speech melody" that he co-chaired at the Institute of the Living Word,[26] the two young scholars found themselves in a milieu that stimulated broad interdisciplinary cross-pollination.

Let us now look at some of the key figures that set the tone in this organization when Eikhenbaum and Bernshtein joined. The director of the Institute and the main person responsible for its opening was the theater historian and actor Vsevolod Vsevolodskii-Gerngross. The slightly old-fashioned phrase "living word" that he used in the title of the Institute was a tribute to his teacher, the theater scholar and aesthete Iurii Ozarovskii,[27] who authored a treatise on oral performance entitled *Music of the Living Word: Foundations of Russian Artistic Reading* (*Muzyka zhivogo slova: Osnovy russkogo khudozhestvennogo chteniia*, 1914).[28] Ozarovskii's book, along with Sergei Volkonskii's *Man on Stage* (*Chelovek na stsene*, 1912), *The Expressive Word* (*Vyrazitel'noe slovo*, 1913), and *The Expressive Man* (*Vyrazitel'nyi chelovek*, 1913), was among the most comprehensive prerevolutionary accounts of oral performance, furnished with practical advice for actors. In the years to come, Boris Eikhenbaum would go back to Ozarovskii's and Volkonskii's studies, attacking their methods for identifying, classifying, and training "proper" readers' intonations. Witnessing Vsevolodskii-Gerngross's efforts to create a working method for the oral performers was an important experience for the Russian Formalists employed at the Institute. This line of research taught Eikhenbaum, Bernshtein, and other scholars of poetics to attend to matters of diction in the most meticulous way possible. At the same time, they learned to rebel against previous methodologies, pointing out, for instance, that it was wrong to transpose the intonations of a prose text onto poetry, and that one needed to distinguish between diction styles implied in

[25] Sievers's views were summarized by Viktor Shklovskii's brother Vladimir in the OPOIaZ periodical *Poetika* 2 (1917). The most representative publications of Sievers's school include the following: Eduard Sievers, *Ziele und Wege der Schallanalyse* (Heidelberg: C. Winter, 1924); Eduard Sievers, *Rhythmisch-melodische Studien, Vorträge und Aufsätze Von Eduard Sievers* (Heidelberg: C. Winter, 1912); Eduard Sievers, *Metrische Studien* (Leipzig: B. G. Teubner, 1901); Ottmar Rutz, *Psyche und Tonorgan, Joseph Rutz und Seine Tonstudien* (München: Allgemeinen Zeitung, 1904); Ottmar Rutz, *Musik, Wort und Körper Als Gemütsausdruck* (Leipzig: Breitkopf & Härtel, 1911); Ottmar Rutz, *Sprache, Gesang und Körperhaltung: Handbuch Zur Typenlehre Rutz* (München: C.H. Beck, 1922); Franz Saran, *Der Rhythmus Des Französischen Verses* (Halle: M. Niemeyer, 1904); Franz Saran, *Deutsche Verslehre*, München: Becksche Verlagsbuchhandlung, 1907.

[26] Raffaella Vassena, "K rekonstruktsii deiatel'nosti Instituta Zhivogo Slova (1918–1924)," *Novoe Literaturnoe Obozreniie* 4 (2007): 79–95, 82.

[27] Vassena, "K rekonstruktsii deiatel'nosti Instituta Zhivogo Slova (1918–1924)." Ozarovskii's sister, Olga Ozarovskaia, was a prominent scholar of oral folklore and a pioneer of *skaz* studies.

[28] In his essay "On intimate declamation" ("O Kamernoi deklamatsii"), Eikhenbaum will rebel against Ozarovskii's definition of poetry as "expression of one's thoughts in a musical and laconic form, pleasant to the ear and easy to remember" (Boris Eikhenbaum, "O Kamernoi deklamatsii [1923]," *Literatura. Kritika. Polemika* [Leningrad: Priboi, 1927], 226–249, 229).

an ode, a fable, and a narrative poem, on the one hand, and experimental non-figurative poetry, on the other hand. Such nuances, they felt, were absent from Ozarovskii's and Volkonskii's classical analyses, championed by the Institute's director Vsevolod Vsevolodskii-Gerngross.[29] Additionally, Vsevolodskii-Gerngross adhered to a naive view of the emotional foundation of articulation, which the Formalists, as we shall see, would complicate and render problematic. Looking through Vsevolodskii-Gerngross's early theoretical texts on diction, we notice the onomatopoeic theory of the poetic sound familiar to us from Faddei Zelinskii's interpretation of Wundt, centered on the premise that muscle contractions during articulation correspond to the experienced emotions. In a 1913 essay with a characteristically normative title "The Laws of the Melody of Human Speech" ("*Zakonomernosti melodii chelovecheskoi rechi*"), Vsevolodskii-Gerngross presented an early version of what would soon become a theory of "bio-emotional foundations of aesthetics" promoted by the Institute's officials:

> Under the influence of one or another sensation, the animal, or let us say the primeval man, assumed particular plastic positions. When happy, the man opened up; when frightened, he concentrated all his powers on self-defense; when intrigued, he stretched out, turning into a kind of a question mark . . . Happiness, fear, pain, threat, surprise, etc. call for particular tensions of the body, and, consequently, of the vocal chords. Due to this, the vowels *a, o, i, u,* etc. are each marked by a specific pitch. . . . Try writing a funny poem with the sound "u" dominating over the others, or try to speak of your sorrow by verses with the vowel "a" . . . Regardless of whether it occurs in a song or in a word, the vocal sound is determined by physical, mechanical, physiological, and psychological laws, which are impossible to ignore.[30]

As we can appreciate from the last sentence in this quotation, Vsevolodskii-Gerngross believed in the necessity of investigating all aspects of voicing,

[29] Vsevolodskii-Gerngross also was a member of the group on the study of the melody of speech, which Eikhenbaum and Bernshtein joined at the Institute in 1919. Describing this period, Bernshtein wrote: "I first took part in the activities of the Institute of the Living Word in 1919, when I was invited to join the Committee on Speech Melody [*Komissiia po melodike rechi*]. As a member of this Committee, I participated in the debates on Vsevolodskii's presentation on speech melody; then, together with Boris Eikhenbaum I began to compile a bibliography on the melody of speech and poetry" (Sergei Ignat'evich Bernshtein, "Curriculum vitae," *Materialy Instituta Zhivogo Slova Narkomprosa RSFSR.* RGALI f. 941. op. 4. ed. khr. 2(2). 1.43–44.) Eikhenbaum's *Melodika* provides this bibliography as an appendix.

[30] Vsevolod Vsevolodskii-Gerngross, "Zakonomernost' melodii chelovecheskoi rechi," *Golos i rech'*, March 13 (1913): 10–14; esp. 11, 13, 14. The first sentence in this quotation paraphrases Francois Delsarte's theory of the "excentric" and "concentric" body positions, which was popularized in Russia by Sergei Volkonskii. In Chapter 3, I discuss Delsarte's and Volkonsky's ideas in relation to film acting.

considered from a psychophysiological perspective. In 1913, he was on the list of active contributors to the interdisciplinary journal *Voice and Speech* (*Golos i rech'*),[31] which published such diverse essays as Volkonskii's manual of pronunciation "The Anatomy of Consonants," Boris Kiterman's speculation on the emotional impact of words' connotations, and Vladimir Bekhterev's scientific article "On the Causes of Slips of the Tongue," [32] in which the eminent psychologist described his laboratory experiments on the role of attention and memory for articulation. A wide range of approaches presented in *Voice and Speech* in 1913 must have given Vsevolodskii-Gerngross the ambition to reach across disciplinary boundaries five years later, when he began to plan the research directions to be pursued at the Institute of the Living Word. A charismatic and energetic leader, he managed to instill enthusiasm for a common project in greatly diverse circles. In addition to the Minister of Enlightenment Lunacharskii, Vsevolodskii-Gerngross secured the support of renowned academics like the classicist Faddei Zelinskii, the linguists Lev Shcherba and Lev Iakubinskii, the poets Nikolai Gumilev and Vladimir Piast[33]—acclaimed for their unique reading styles—and many others theorists and practitioners of oral performance. One theme that was clearly dominating the research program of the Institute was the physical side of articulation—the work of the body. Among the lecturers employed was the dancer Stefanida Rudneva—the founder of the studio of "musical movement" and rhythmics called "Geptakhor," which implemented Isadora Duncan's choreographic principles and sought inspiration in ancient Greek sculpture and vase painting, with consultations from Faddei Zelinskii.[34] The idea of cultivating

[31] The journal *Voice and Speech* (*Golos i rech': ezhemesiachnyi zhurnal dlia oratorov, iuristov, propovednikov, pevtsov, lektorov, artistov i liubitelei krasnorechiia*) began to come out in St. Petersburg in January 1913, and its editor-in-chief was the actor Anatolii Dolinov of the Aleksandrinskii theater. Vsevolodskii-Gerngross's name appears on the front page "list of journal participants" in all issues for 1913.

[32] Sergei Volkonskii, "Anatomiia soglasnykh," *Golos i rech'*, February 2 (1913): 3–6; Boris Kiterman, "Emotsional'nye elementy slova," *Golos i rech'*, May 5–6–June (1913): 30–33; Vladimir Bekhterev "O prichinakh obmolvok rechi," *Golos i rech'*, September 9 (1913): 3–6.

[33] At the Institute, Gumilev taught courses on ancient epic poetry, while Piast collaborated with Sergei Bernshtein on examining the phonograms of Russian poets and wrote essays on oral performance (Sergei Ignat'evich Bernshtein, "Curriculum vitae," *Materialy Instituta Zhivogo Slova Narkomprosa RSFSR: Plany, otchety deiatel'nosti za 1918–1921 gg.* RGALI f. 941. op. 4. ed. khr. 2(2). l.45).

[34] Stefanida Dmitrievna Rudneva, "Curriculum vitae," *Materialy Instituta Zhivogo Slova Narkomprosa RSFSR*. RGALI f. 941. op. 4. ed. khr. 2(2). l.57. In this document, Rudneva claims that she studied Emile Jaques-Dalcroze's rhythmical gymnastics in 1913, but abandoned this style in favor of Isadora Duncan's approaches. Since 1919, she was teaching at the Institute of Rhythm and the Institute of the Living Word, with a focus on staging ancient Greek drama. At the Institute of the Living Word, Rudneva was researching "movement accompanied by music and words," a theme that was also pursued by the members of her studio "Geptakhor." The director of The Institute of the Living Word was favorably impressed by the achievements of modern dance in Russia, and his reflections on the art of dance may be found in Vsevolod Vsevolodskii-Gerngross, "Svobodnyi tanets," *Zhizn' Iskusstva* 16 (1925). Another follower of Isadora Duncan, Ada Korvin, taught an introductory course on movement and plastics at the Institute in 1919 (A. A. Korvin, "Programma kursa

a harmonious physique went hand in hand with the utopian aspirations of the Institute's leadership. Modern dance exercises in the vein of Duncan promoted a new confidence of movement, releasing it from the fetters of Victorian propriety. Duncanism positioned itself as battling the weary neurasthenia and abulia of the Western civilization by restoring "Greek" youth, vitality, and health.[35] In addition to dance artists pursuing such goals in workshops and seminars, the Institute also employed professional psychologists and physiologists, whose job was to address disabilities of speech and hearing through scientific research and therapeutic practice. The German-educated professor Polina (Perla) Efrussi taught courses on the "psychology of thought and language,"[36] while the doctor Efim Borishpol'skii pursued research on such topics as the "experimental study of the impact of voice training on lung capacity" and "the innervation of voice by the central nervous system."[37] The laryngologist Mikhail Bogdanov-Berezovskii, a renowned reformer of deaf and mute children's education, served on the Institute's committee charged with creating a medical laboratory for speech and hearing disorders.[38] The chair of the same committee[39] was Davyd Fel'dberg, the vice-president of Vladimir Bekhterev's State Psycho-Neurological Academy, who lectured on "psychophysiology, hygiene, and the pathology of voice, speech, and hearing."[40] In 1922, the themes of Fel'dberg's research at the Institute included "the influence of speech exercises on the phonic and acoustic human apparatus," "the objective criteria for a well-trained voice," and "a psychological

'Vvedenie v prakticheskie zaniatiia po plastike,'" *Zapiski Instituta Zhivogo Slova* [Petrograd: Narodnyi kommissariat po prosveshcheniiu, 1919], 93).

[35] Daniel Beer offers a sustained analysis of the notion of "decadence" as "physical degeneration" in early 20th-century Russia (Daniel Beer, *Renovating Russia: The Human Sciences and the Fate of Liberal Modernity, 1880–1930* [Ithaca, NY: Cornell University Press, 2008]). Within this discursive framework, various kinds of gymnastics and dance exercises were perceived as a way of correcting the disjointed, nervous movements of the modern human. On the association between rhythmical dance and the functioning of the healthy organism in Soviet Russia, see also Nicoletta Misler, *V nachale bylo telo: Ritmoplasticheskie eksperimenty nachala XX veka: Khoreologicheskaia Laboratoriia GAKhN* (Moskva: Iskusstvo XXI vek, 2011); Irina Sirotkina, *Svobodnoe Dvizhenie i Plasticheskii Tanets v Rossii* (Moskva: Novoe literaturnoe obozrenie, 2012). For a broader European context of these Russian trends, see Michael Cowan's illuminating study of German body culture techniques aimed at mastering the modern human's "neurasthenia" (Michael Cowan, *Cult of the Will: Nervousness and German Modernity* [University Park: Penn State University Press, 2012]).
[36] P. O. Efrussi, "Programmy kursov 'Obshchaia psikhologiia,' 'Psikhologiia myshleniia i rechi,' 'Psikhologiia tvorchestva,'" in *Zapiski Instituta Zhivogo Slova* (Petrograd: Narodnyi kommissariat po prosveshcheniiu, 1919), 42–43.
[37] Efim Solomonovich Borishpol'skii, "Curriculum vitae," *Materialy Instituta Zhivogo Slova Narkomprosa RSFSR*, RGALI f. 941 op.4, ed. khr. 2(1), l.26.
[38] Raffaella Vassena, "K rekonstrukcii istorii i deiatel'nosti Instituta Zhivogo Slova (1918–1924)," *Novoe Literaturnoe Obozrenie* 86 (2007): 79–95, 82.
[39] Vassena, "K rekonstrukcii istorii," 82.
[40] Davyd Vladimirovich Fel'dberg, "Curriculum vitae," *Materialy Instituta Zhivogo Slova Narkomprosa RSFSR*, RGALI f. 941 op.4, ed. khr. 2(2), l.59.

typology of stage performers (orators and actors) in accordance with the princi-
ples of psychotechnics."[41]

What influence did these research endeavors bear on the scholars of poetics
associated with the Institute? Undoubtedly, seeing how their colleagues in bio-
medical sciences and performance arts were approaching the issues of acoustics,
voicing, and articulation must have reinforced the literary scholars' interest in
the physical properties of verse. Scientific treatment of these topics must have
appeared an intriguing counterpart to the methods of *Ohrenphilologie*—the
German school of "sound philology" led by Sievers—that Boris Eikhenbaum
and Sergei Bernshtein embraced and polemicized with.[42] However, as literary
scholars, the Formalists insisted on a precise definition of their discipline,
arguing that the focus of their professional inquiry was limited to features of
poetic style and composition. For instance, in his book *The Melodics of Russian
Lyric Poetry* (*Melodika Russkogo Liricheskogo Stikha*, 1922), Eikhenbaum argued
that poetics must be distinguished from linguistics: the latter, he claimed,
is a "natural science" concerned with physical causality and comprehensive
descriptions of phenomena, whereas the former is a "science of the spirit," which
investigates relationships between stylistic devices and constructions of compo-
sitional unity.[43] While it may seem that comments like this effectively excluded
"natural sciences" like linguistics and physiological psychology of speech from
the field of Eikhenbaum's interest, he was actually remarkably well-informed
about the most prominent developments in these disciplines. Anything relevant
to the study of intonation, speech melody, and articulation did not escape his
attention. The bibliographic list of Eikhenbaum's *Melodics* features publications
by German and American psychologists working in the field of phonetics:[44]

[41] Davyd Vladimirovich Fel'dberg, "Curriculum vitae," RGALI f. 941 op.4, ed. khr. 2(2), l.59. The
term *psychotechnics*, associated with the German-American psychologist Hugo Münsterberg, usually
appeared within the domain of applied psychology in Soviet Russia. Specifically, it denoted various
experimental techniques of testing and classifying workers according to their professional aptitudes.

[42] In 1922, Eikhenbaum wrote: "From 1917, I began to research the theory of verse and prose,
with a special focus on topics in 'sound philology' (*Ohrenphilologie*). I wrote a number of articles
on these issues in the Neo-Philological Society, OPOIaZ, the Pushkin Society, and the Society for
the Study of Artistic Literature" (Boris Eikhenbaum, "Curriculum vitae," *Materialy Instituta Zhivogo
Slova Narkomprosa RSFSR*, RGALI f. 941 op.4, ed. khr. 2(1), l.32 verso). On Eikhenbaum's relation
with *Ohrenphilologie*, including his departure from Sievers and a search for more precise methods,
see Boris Eikhenbaum, *Melodika Russkogo Liricheskogo Stikha* (Peterburg: OPOIaZ, 1922), 11–
14; Krystyna Pomorska, *Russian Formalist Theory and Its Poetic Ambiance* (The Hague: Mouton,
1968), 17–18.

[43] Boris Eikhenbaum, *Melodika Russkogo Liricheskogo Stikha* (Peterburg: OPOIaZ, 1922), 14. The
dichotomy of "poetics" versus "linguistics" was to a large extent conditioned by the polemics between
OPOIaZ and the Moscow Linguistic Circle, and particularly by Eikhenbaum's argument with the lin-
guist Roman Jakobson in this period (see *Melodika*, 11).

[44] Eikhenbaum, *Melodika*, 197–199. Eikhenbaum states that many of the texts featured in this bib-
liography were not available to him at the time of writing. However, he cites several lines from Edward
Scripture's *Researches in Experimental Phonetics* on p. 12 in *Melodika*. I will discuss Scripture's re-
search objectives and methodology in detail further later in this chapter.

Daniel Jones' *Intonation Curves* (1909);[45] Edward Scripture's *Researches in Experimental Phonetics: The Study of the Speech Curves* (1906)[46] and "Studies in Melody of English Speech" (1902);[47] and Karl Marbe's and Bruno Eggert's works on "melody of speech," presented at the Sixth Congress of Experimental Psychology in Frankfurt in 1909.[48] Even though Eikhenbaum did not engage with these texts directly in his own analyses of lyrical intonations (he uses only one quotation from Scripture's *Researches in Experimental Phonetics*), the presence of these citations at the end of his book suggests that he must have considered psychophysiologists' research worthy of attention. Writing around the same time, Eikhenbaum's colleague at the Institute, the Formalist scholar Boris Tomashevskii likewise reviewed French, German, and American studies of literary texts by experimental methods in his essay "The Problem of Verse Rhythm" ("Problema Stikhotvornogo ritma," 1923). Discussing the usefulness of new laboratory methods emerging in the West, Tomashevskii cited Karl Marbe's work on the rhythm of prose,[49] as well as Edward Scripture's, Paul Verrier's, Eugene Landry's, and Robert de Souza's[50] techniques for transcribing acts of oral poetry

[45] Daniel Jones, *Intonation Curves, a Collection of Phonetic Texts, in Which Intonation Is Marked Throughout by Means of Curved Lines on a Musical Stave* (Leipzig: B. G. Teubner, 1909).

[46] E. W. Scripture, *Researches in Experimental Phonetics: The Study of Speech Curves* (Washington, DC: Carnegie institution of Washington, 1906).

[47] E. W. Scripture, "Studies in Melody of English Speech," *Philosophische Studien*, Festschrift Wilhelm Wundt zum Siebzigsten Geburtstage überreicht von seinen Schülern (Leipzig, 1902), 599–615.

[48] For an overview of Eggert's and Marbe's methods, see B. Eggert, "Untersuchungen über Sprachmelodie," *Zeitschrift für Psychologie und Physiologie der Sinnesorgane*, ed. H Ebbinghaus and W. A. Nagel, 49 (1908): 218–237. The phonetician Bruno Eggert was a student of Karl Marbe—a German scientist who became famous for his work in applied psychology, particularly in the fields of psychotechnics and railway insurance policy (see John C. Burnham, *Accident Prone: A History of Technology, Psychology, and Misfits of the Machine Age* (Chicago: The University of Chicago Press, 2009), esp. 39–44, 248–249).

[49] References to Marbe's method come to Tomashevskii from E. Kagarov, "O ritme russkoi prozaicheskoi rechi," *Nauka na Ukraine* 4 (1922): 324–332. In their commentary to Tomashevskii's essay, S. I. Monakhov, K. Iu. Tver'ianovich, and E. V. Khvorost'ianova note that Kagarov studied the rhythm of Russian prose language based on the methodology of Karl Marbe. In particular, Kagarov used these texts: Karl Marbe, *Über den Rhythmus der Prosa* (Giessen: J. Ricker, 1904); and Karl Marbe, "Die Anwendung russender Flammen in der Psychologie und ihren Grenzgebieten," *Vortrag am III Kongress. der Exper. Psychologie* (Frankfurt a/M., 1908). (Boris Tomashevskii, "Problema stikhotvornogo ritma," *Izbrannye raboty o stikhe*, ed. and comment. by S. I. Monakhov, K.Iu. Tver'ianovich, and E. V. Khvorost'ianova [St. Petersburg: Filologicheskii fakul'tet SpbGU; Moscow: Akademiia, 2008), 24–52, 370–379.)

[50] In their commentary to Tomashevskii's essay, S. I. Monakhov, K.Iu. Tver'ianovich, and E. V. Khvorost'ianova state that Tomashevskii had in mind the following works: Edward W. Scripture, *Researches in Experimental Phonetics: The Study of Speech Curves* (Washington, DC: Carnegie Institution of Washington, 1906); Paul Verrier, *Essai Sur Les Principes De La Métrique Anglaise*, vol. 1 (Paris: H. Welter, 1909); Paul Verrier, *L'isochronisme dans le vers français* (Paris: Alcan, 1912); Eugène Landry, *La théorie du rythme et le rythme du français déclamé: avec une étude "expérimentale" de la déclamation de plusieurs poètes et comédiens célèbres, du rythme des vers italiens, et des nuances de la durée dans la musque* (Paris: H. Champion, 1911); Robert Souza, *Questions de métrique. Le rythme poétique* (Paris: Perrin, 1892). (Boris Tomashevskii, "Problema stikhotvornogo ritma," *Izbrannye raboty o stikhe*, ed. and comment. by S. I. Monakhov, K.Iu. Tver'ianovich, and E. V. Khvorost'ianova [St. Petersburg: Filologicheskii fakul'tet SpbGU; Moscow: Akademiia, 2008], 371–379, 377.)

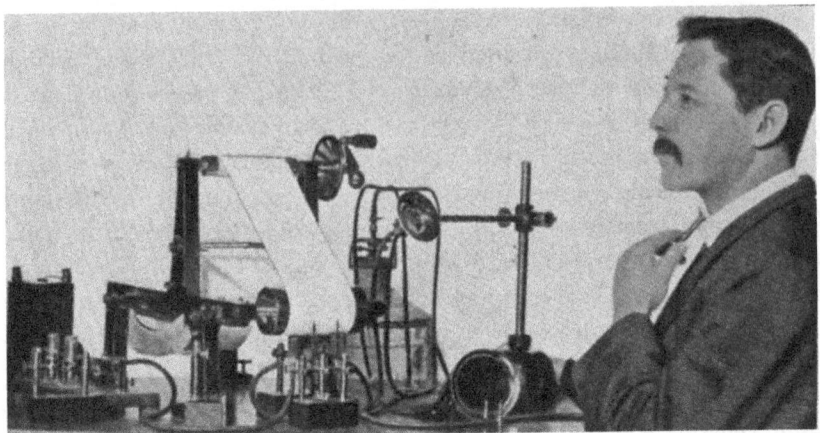

Fig. 2.2 Karl Marbe's apparatus for studying speech melody. The vibrations of a rubber membrane in this apparatus register the course of the speech melody and its dynamic accents on a revolving soot-covered drum. Image source: E. Zimmermann. *Psychologische und Physiologische Apparate: Liste 50* (Leipzig: Zimmermann Wissenschaftliche Apparate, 1928), 144. Scan courtesy Columbia University Library.

performance with the help of the kymograph. Verrier, Landry, and de Souza were Parisian researchers, associated with the pioneering center of experimental phonetics, established by Abbé Jean-Pierre Rousselot at the Collège du France, which the American Edward Scripture also visited. Marbe, who had once studied under Münsterberg at Freiburg, would eventually go on to become a major specialist in psychotechnics. In the 1900s, Marbe's research centered on psychophysiological aspects of speech. Initially inspired by Eduard Sievers, he quickly began to doubt Sievers's claim that "it was possible, on the basis of difference in voice quality alone, to decide whether a given piece of prose or poetry was to be ascribed to one author or two different authors."[51] Similarly to Edward Scripture, Marbe used soot-covered plates to record "speech melodies" (Fig. 2.2).[52] In his 1904 treatise *On the Rhythm of Prose*, which had influenced the Russian Formalists, Marbe argued that "the aesthetic impression of a prose work depends essentially

[51] Karl Marbe, "Autobiography," in *History of Psychology in Autobiography*, ed. Carl Murchison, vol. 1 (New York: Russell & Russell, 1930), 181–213, 187–188.

[52] His representative publications on this method include Marbe Karl and Albert Thumb, "Experimentelle Untersuchungen über die psychologischen Grundlagen der sprachlichen Analogiebildung" (Leipzig, 1901); Karl Marbe, "Über die Verwendung russender Flammen in der Psychologie und deren Grenzgebieten," *Zeitschrift für Psychologie und Physiologie der Sinnesorgane*, ed. H. Ebbinghaus and W. A. Nagel, 49 (1908): 206–217; K. Marbe and M. Seddig, "Untersuchungen schwingender Flammen," *Annalen der Physik* 30.4 (1909): 579 ff.

upon the rhythm of the work, that this rhythm is different in different works and authors."[53]

It is plausible that Eikhenbaum's and Tomashevskii's respectful mention of these works is an homage to their scientist colleagues at the Institute. In fact, these scientific papers might have appeared in their bibliographies thanks to their colleagues' recommendations, or else, thanks to the library of Eikhenbaum's former professor, the linguist Lev Shcherba. In 1907, Scherba studied with Rousselot at the Collège du France and was well versed in the latest methodological trends in phonetic research in the West.[54] In the most general sense, scientific methodologies geared at an "objective," "materialist" scrutiny of articulation fit well with the empirical approaches to oral performance cultivated in many of the Institute's multifaceted departments. Eikhenbaum and Bernsthein must have been attracted to the apparent precision of the empirical data for the purposes of analyzing the sensory textures of literary texts. There is evidence that during one of the Institute's Board meetings, the psychologist Davyd Fel'dberg put forward a plan to record his patients' voices for pedagogical and therapeutic purposes, and this idea was enthusiastically welcomed by the poet Nikolai Gumilev, who suggested that the same equipment could be used for making phonograms of contemporary poets' performances.[55] Since Fel'dberg chaired Eikhenbaum's and Bernshtein's group for the study of "speech melody," in February 1920, the project of recording and analyzing the poets' voices fell to Bernshtein. By December 1925, he made recordings of approximately seven thousand literary texts performed by professional actors and literati as famous as Aleksandr Blok, Nikolai Gumilev, Anna Akhmatova, Valerii Briusov, Fedor Sologub, Osip Mandel'shtam, Vladimir Mayakovsky, Vladimir Piast, Sergei Esenin, and Alisa Koonen among others.[56] This collection provided the foundation for Bernshtein's

[53] Karl Marbe, "Autobiography," 183. See also Karl Marbe, *Über den Rhythmus der Prosa* (Giessen: J. Ricker, 1904).

[54] B. A. Larin, L. R. Zinder, and M. I. Matusevich, eds., *Pamiati Akademika L'va Vladimirovicha Shcherby, 1880–1944* (Leningrad: Izdatel'stvo Leningradskogo Gos. Univeriteta, 1951), 8.

[55] Vassena, "K rekonstrukcii istorii," 82.

[56] Sergei Bernshtein, "Zvuchashchaia khudozhestvennaia rech' i ee izucheniie," *Poetika: vremennik slovesnogo otdela Instituta istorii iskusstv Leningradskogo universiteta* 1 (1926): 41–55; 49. Toward the end of the 1920s, many of the recorded poets and the Formalist scholars themselves fell out of favor with Stalin's regime. The collection of records for the most part was squandered or perished due to inadequate storage. The surviving records are now at the Vladimir Dahl Russian State Literary Museum. On the collection's history and attempts to restore it, see Lev Shilov, *Ia slyshal po radio golos Tolstogo: ocherki zvuchashchei literatury* (Moscow: Iskusstvo, 1989), 25 ff.; Lev Shilov, "Istoriia odnoi kollektsii," *Zvuchashchii mir: Kniga o zvukovoi dokumentalistike* (Moscow: Iskusstvo, 1979), 121–145; A. Iu. Rassanov, "Serebrianyi vek russkoi literatury v fonofonde Gosudarstvennogo muzeiia istorii rossiiskoi literatury imeni V.I.Dalia," in *Zvuchashchii Serebriannyi Vek: Chitaet Poet*, ed. E.M. Shuvannikova, St. Petersburg: Nestor-istoriia, 2018, 367–409.

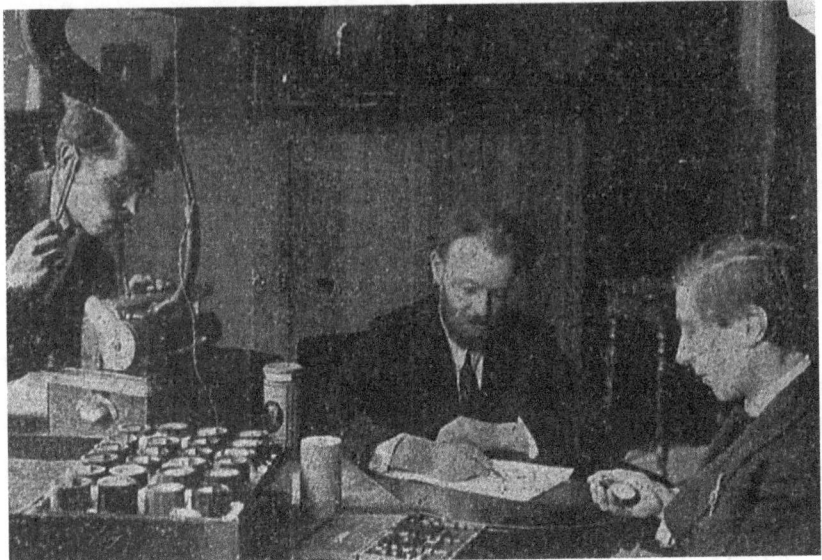

Fig. 2.3 A working moment at the Laboratory for the Study of Artistic Speech: scholars gathered around the phonograph appear to be intently listening to a recording, with Sergei Bernshtein (center) following the lines of a printed text, scholar Andrei Fedorov (right) measuring time with a stopwatch, and another colleague evaluating the rises and falls of speech melodies with a pitchfork. Note also the wax cylinders with poetry recordings on the table. Image source: A. Gruzinskii, "Golosa poetov," *Stroika* 13 (1930), 15. My gratitude to Valeriy Zolotukhin for scanning this periodical in Moscow.

research program at the Institute: "a phonographic study of Russian lyrical declamation in the performances of poets and actors."[57]

What interests me most in these instances of interdisciplinary collaboration emerging spontaneously at the Institute of the Living Word is the way in which the technological tools of biomedical sciences were appropriated for a new use, opening up innovative research avenues for scholars of poetics. Having a large database of phonograph recordings at his disposal permitted Bernshtein to attend to minute nuances of poets' intonations, with the same precision that phoneticians and speech therapists analyzed voice modulation. The technology allowed for automatic capturing of voice data, with all nuances of the sound flow noted in real time. The record carrying audio evidence could be replayed multiple times, making an analysis of any given performance verifiable. The

[57] Sergei Bernshtein, "Curriculum vitae (c.1922)," *Materialy Instituta Zhivogo Slova Narkomprosa RSFSR*, RGALI f. 941 op. 4. ed. khr. 2(2). l.44.

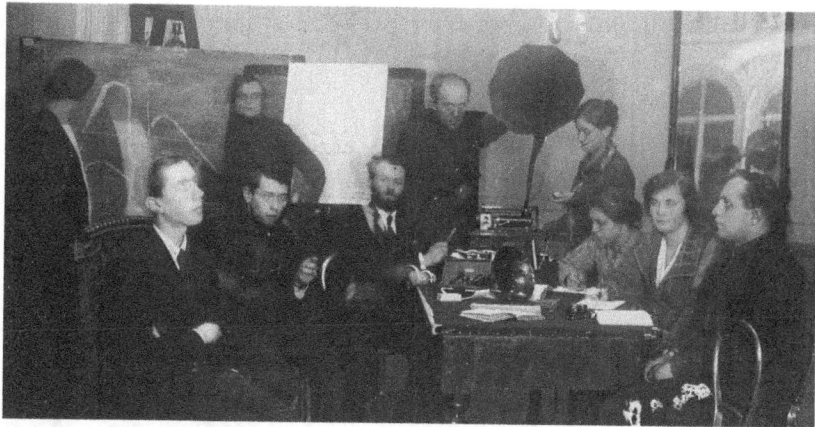

Fig. 2.4 Sergei Bernshtein (center) and his colleagues demonstrating their research methods at the Laboratory for the Study of Artistic Speech. Absorbed in the act of listening, some scholars are keeping their eyes on their stopwatches, while others are making notes on paper. Next to the chalkboard with abstract charts, likely representing the dynamics of melody lines, stands the scholar and performer Sof'ia Vysheslavtseva (second on the left). A large poster behind her shows segmented wavy lines – possibly, a notation of rising and falling intonations. Photo from the personal archive of Sophia Bogatyreva.

availability of concrete, unchangeable data called forth attempts to document rhythmical patterns, placements of stress, lengths of cadences and pauses, and rising or falling intonations peculiar to one or another poet or literary circle. Photographs of Bernstein and his colleagues from this period capture their intense listening sessions (Figs. 2.3 and 2.4). Scholars, gathered around the phonograph, compared the oral performance with the written text, evaluated the length of rhythmical units with chronometers, measured tones with pitch forks, and marked fluctuating intonations.

Based on these investigations, Bernshtein charted diagrams that represented the modulation of pitch and rhythmical subdivisions in poems read by authors such as Aleksandr Blok and Osip Mandel'shtam (Figs. 2.5a and 2.5b). These charts provided a visualization of the evanescent voice changes in a graphical form that looked like a hybrid between musical notation and the "intonation curves" made by the American speech physiologist Edward W. Scripture. In contrast to the latter, of course, Bernshtein's charts were not an indexical, analog record of vibration but rather an image of sound, constructed on the basis of his perception of the poet's voice emanating from the phonograph.

As such, Bernstein's graphs pose a curious exception to the epistemic and cultural shift, theorized by Friedrich Kittler in his work on the gramophone. Kittler

(a)

Фиг. 1. Б л о к. «Все, что память сберечь мне старается...» (ср. примеры 9 и 24; и примеч. 27).
Строфа I.

Ст. 1. Все, что память сберечь мне старается,
2. Пропадает в безумных годах,
3. Но горящим зигзагом взвивается
4. Эта повесть в ночных небесах.

(b)

Фиг. 5. М а н д е л ь ш т а м. «Сегодня дурной день...», ст. 1—4 (ср. пример 27).

Ст. 1. Сегодня дурной день:
2. Кузнечиков хор спит,
3. И сумрачных скал сень
4. Мрачней гробовых плит.

Fig. 2.5 (*a* and *b*) Sergei Bernshtein's diagrams representing the "movement of pitch" in stanzas of Aleksandr Blok's "All that memory struggles to save for me . . ." and Osip Mandel'shtam's "Today is an ominous day." To make these charts, Bernshtein listened to the poets' phonograph recordings. The vertical lines mark a relative division of intervals, while the numbers indicate "melodiously significant" syllables in the text and the diagram. Images from Sergei Bernshtein, "Golos Bloka (1921)," ed. A. Ivich and G. Superfin, *Blokovskii Sbornik* (Tartu: Tartusskii gos. universitet, 1972), 454–525; 521, 523.

asserts that the invention of recording technologies in the last decades of the 19th century prompted theorists of acoustics to stop visualizing sound as discrete notes distributed on the five lines of the traditional European staff, and instead picture it as the flow of frequencies.[58] Instead of clearly defined hierarchy

[58] Friedrich A. Kittler, *Gramophone, Film, Typewriter,* trans. Geoffrey Winthrop-Young and Michael Wutz (Stanford, CA: Stanford University Press, 1999), 24.

of notes, related to each other by harmonious ratios, sound specialists, perceptual psychologists, and composers such as Arnold Schoenberg came to recognize what Kittler calls "pure acoustics": overtones and atonal series.[59] The Edison's phonograph, which recorded "nothing but vibrations," epitomized this cultural trend of acknowledging the nuances of noise that escaped the "Old European alphabetism".[60] In examining the shape of the record's groves, the experts abandoned the practice of pre-selecting the units of meaning within the sound flow. The fact that Bernshtein and his colleagues, in contrast to phoneticians such as Scripture and Marbe, still relied on their ears to filter out salient elements of the phonograph record, appears to be a conscious strategy, rather than a choice dictated by the lack of equipment: their approach transcends the method of natural sciences, despite being indebted to it. By using the recording, the Formalists grounded their observations in concrete material data.[61] By creating their own graphs, with rises and falls of the pitch verified with the help of pitchforks, the Formalists placed emphasis on the aesthetic impression of the oral delivery—the declamatory composition created by the reader—rather than the entirety of sound frequencies captured on the record. Elucidating this composition required a certain degree of subjective selection on behalf of the scholars, and Bernshtein's circle accomplished this task with recourse to their own erudition, by drawing on theoretical frameworks derived from the Formalist poetics, linguistics, and musical education, as well as their intimate knowledge of diverse literary styles and stage acting practices. Their illustrations of sound in poetic performances thus reflect their understanding of the unfolding structure of the voiced poem and the interaction of performative devices responsible for its impression. In 1928, Bernshtein's group recruited the painter and inventor Grigorii Gidoni, a pioneer of installation art combining movement, music, and colored light, to help visualize the performative structure (*deklamatsionnoe stroenie*) of Richard Beer-Hoffmann's poems performed by Alexander Moissi.[62] This collaboration with the visual artist is symbolic of the group's belief that the impression produced by the performer "does not always correspond to the physical data,"[63] and

[59] Ibid.

[60] Ibid., 24–25.

[61] Bernshtein's analyses did not distinguish between the recording and the actual oral performance. On this methodological peculiarity, see Valeriy Zolotukhin, "Ob izuchenii zvuchashchei khudozhestvennoi rechi v Rossii v 1910–1920-e gody," in *Zvuchashchii serebriannyi vek. Chitaet poet*, ed. E.M. Shuvannikova, St. Petersburg: Nestor Istoriia, 2018, 301–317, 311.

[62] Zolotukhin 421.

[63] Vysheslavtseva, S.G., Z.M. Zadunaiskaia, L.A. Samoilovich-Ginzburg, S. I. Sergei Bernshtein, "Stikhotvoreniie Ber-Gofmana 'Schlaflied für Mirjam' v interpretatsii A.Moissi," in *Zvuchashshaia Khudozhestvennaia Rech', 1923–1929*], ed. Witalij Schmidt and Valerii Zolotukhin, Moscow: Tri Kvadrata, 2018, 292–324, 320.

therefore, analytical and artistic means of representing sound and articulation might be more appropriate than the direct transcription, used in experimental phonetics. In addition to the acoustic dimension of performance, the group recognized the importance of the corporeal factor: they believed that impressions of "articulatory tension" and gestures accompanying the performance impacted the audience's perception of the poem's dynamics.[64] Though the Formalists did not document this articulatory dimension with film cameras or devices such as Marbe's speech melody apparatus, their written analyses underscored their own embodied perception of the performed poems. Bernshtein theorized this aspect of the aesthetic experience with references to Heinrich Wölfflin's reflections on kinesthetic empathy (*Einfühlung*) and the musicologist Ernst Kurth's writings, which used embodied terms such as the "kinetic energy of the melody line" and "arks of tension" to describe the impression produced by musical compositions.[65]

In addition to the technological tools of recording, which created a common, if tenuous, ground between scientists and scholars of poetry, one more sign of the interdisciplinary cross-pollination can be seen in the terminology used by the poetry specialists in the 1920s. Scholars associated with Bernstein's circle predominantly focus on questions of intonation, rhythm, breath, and the work of the articulatory organs, representing these aspects of poetry in scientific terms that emphasize the physiology of declamatory experience. For example, the Formalist literary scholar Iurii Tynianov refers to the term "the motor energy character [*motorno-energeticheskaia kharakteristika*] of the verse,"[66] drawing attention to the expenditure of muscular energy required for the pronunciation of one or another combination of sounds. Around 1922, Tynianov submitted a resume to the Institute of the Living Word, in which he described his work on "topics as the inner image [*vnutrennii obraz*] of the word and its external sign, as well as the question of non-figurativeness and the motor image of the word [*bezóbraznost' i motornyi obraz slova*]."[67] As this phrasing suggests, Tynianov was pursuing the theoretical line that united all Russian Formalists since Shklovskii's attack on Potebnia's reduction of poetry to "thinking in images." And, like Shklovskii and other Formalists, he shifted attention from the "image," or decipherable figurative meaning, to the experience of articulation, suggesting that the performance

[64] Ibid. See also Ana Hedberg Olenina, "Poeziia kak dvizhenie: teoria stikha S. Vysheslavtsevoi mezhdu formalizmom i revoliutsionnoi estradoi," in *Zvuchashshaia Khudozhestvennaia Rech', 1923–1929*, ed. Witalij Schmidt and Valeriy Zolotukhin, Moscow: Tri Kvadrata, 2018, 459–489.

[65] S.I. Bernshtein, "Opyt esteticheskogo analiza slovesno-khudozhestvennogo proizvedeniia," in *Zvuchashshaia Khudozhestvennaia Rech', 1923–1929*, ed. Witalij Schmidt and Valeriy Zolotukhin, Moscow: Tri Kvadrata, 2018, 325–377, 348–350.

[66] Iurii Tynianov, *Problema stikhotvornogo iazyka* (1924) (Photomechanic Reprint, The Hague: Mouton and Co., 1963), 130 ff.

[67] Iurii Tynianov, "Curriculum vitae (c.1922)," *Materialy Instituta Zhivogo Slova Narkomprosa RSFSR*, RGALI f. 941 op. 4. ed. khr. 2(2). l.53.

of the organs of speech is crucial for savoring the texture of the literary object. He would go on to develop this idea in more detail in *The Problem of Verse Language* (*Problema Stikhotvornogo Iazyka*, 1924). Describing the phenomenon of rhythm in poetry and various means of achieving it (meter, rhyme, alliterative repetition of sounds, etc.), he emphasizes the role of the sensation of articulation. He states that the recurrent sensation of physical effort serves as the key psychological signal responsible for the rhythmical sense, felt by the poet composing the verses, as well as his or her subsequent reader.[68] What comes to the fore in Tynianov's notions of "motor-energy" and "expended physical work" is a desire to describe an aesthetic factor—rhythm—in the abstract language of psychophysiology. The mechanics of articulation and perception of this physical effort become a crucial part of the aesthetic experience. A similar kind of abstract language, underscoring the "objective" material parameters of poetry experience, appears in the works of yet another Formalist scholar—Boris Tomashevskii. His resume of 1922 is kept alongside Iurii Tynianov's in the files of the Institute of the Living Word. In this research statement, Tomashevskii presents his project of studying "the rhythmical impulse [*ritmicheskii impul's*]" carrying Pushkin's iambic pentameter. He defines "the rhythmical impulse" as the "general background of intonation, breathing, and accent placement, maintained by the momentum of a recurring main pattern of the poem [*intonatsionnyi i ekspiratorno-udarnyi fon, podderzhivaemyi inertsiei vozvrashcheniia srednego risunka stikha*]."[69] The way in which Tomashevskii and Tynianov approached the study of the poetic form illustrates a research trend which Boris Eikhenbaum initiated and vigorously elaborated around the time he worked at the Institute of the Living Word. All works by Eikhenbaum written in this period, from "How Gogol's 'Overcoat' is Made" ("Kak sdelana 'Shinel'' Gogolia?," 1918), to "On Reading Poems" ("O chtenii stikhov," 1918), to *The Melodics of Russian Lyrical Verse* (*Melodika russkogo liricheskogo stikha* 1922), to *Anna Akhmatova* (1923) draw particular attention to the role of the corporeal experience of a literary text—its intonational structure, its rhythms, and the articulatory work it requires—for the overall aesthetic impact that it produces. Thus one of the typical ideas postulated by Eikhenbaum at this time in relation to verse composition is the following:

The organizing impulse of the lyrical poem is provided not by the ready-made word, but by a complex combination of rhythm and speech acoustics. The

[68] Iurii Tynianov, *Problema stikhotvornogo iazyka* (1924), reprint (The Hague: Mouton and Co., 1963), 128–133.

[69] Boris Tomashevskii, "Curriculum vitae," *Materialy Instituta Zhivogo Slova Narkomprosa RSFSR*, RGALI f. 941 op. 4. ed. khr. 2(2). l.51–51verso.

sounds of the poem (and mental images of speech—the acoustic and articulatory ones) are valuable and significant in themselves.[70]

Like the examples from Tynianov's and Tomashevskii's research that I cited earlier, this passage from Eikhenbaum is premised on the idea that physical sensations of literary form are indispensible for the aesthetic experience. Though their primary professional interest lies in describing the properties of literary styles and compositional principles, the Formalists are open to such questions as "what experiential mechanisms permit us to perceive and interpret the phenomenon of poetic rhythm," or "how does the articulation of seemingly misplaced and unusual words in Gogol's short story affect us physically, evoking additional shades of meaning and emotional attitudes regardless of the words' primary signification?"

Discussions of the Formalists have traditionally focused on their preoccupation with the *faktura* of poetic and prose language. However, the psychophysiological discourse at the foundation of their literary analyses is almost entirely forgotten. The vast international and interdisciplinary context that stimulated the Formalists' attention to the performative and experiential aspects of literary forms was obvious for intellectuals of the 1920s. Yet in subsequent decades it fell into obscurity. For instance, Victor Erlich's seminal study *Russian Formalism: History, Doctrine*, written in the 1950s, already had trouble interpreting the way in which the Formalists were seen by their contemporaries. Defending the Formalists from the attack of the literary scholar Pavel Medvedev (known to us today primarily as Mikhail Bakhtin's coauthor), Erlich wrote:

> In discussing Shklovskii's dichotomy of "automatization" versus "perceptibility," Medvedev, one of Shklovskii's Marxist opponents, accused the Formalist spokesman of straying from the path of objective analysis and bogging down in "the psycho-physiological conditions of aesthetic perception." Disregarding the *completely misapplied adjective "physiological,"* Medvedev's charge seems unwarranted. Works of literature are knowable objects, accessible only through individual experience. Consequently, *the mechanism of aesthetic response is a legitimate concern of an "objectivist" art theoretician*, provided the emphasis is placed not on the individual reader's idiosyncratic associations, but on the qualities inherent in the work of art and capable of eliciting certain "intersubjective" responses.[71]

[70] Boris Eikhenbaum, "O zvukakh v stikhe" (1920), in *Skvoz' literaturu* (Leningrad: Akademia, 1924), 201–208, 206.

[71] Victor Erlich, *Russian Formalism: Doctrine History*, 3rd ed. (New Haven, CT: Yale University Press, 1981), 178–179; emphasis added.

This passage offers a valuable and entirely adequate interpretation of the Formalists' preoccupation with the issue of the experience of form. The merits of Erlich's influential work are undeniable: his study was one of the first to introduce the legacy of the Formalists to Western scholarship, rescuing it from the obliteration to which it was condemned by official literary scholarship in the Soviet Union. Erlich is absolutely correct in describing the desire of the Formalists to create an "objective" method for the study of immanent qualities of literary works and their experiential properties. Yet, in dismissing the unfamiliar term "psychophysiology," which had become archaic by the 1950s, Erlich inadvertently deprives the Formalists of some of the essential elements in their intellectual lineage. In fact, in 1920s Russia, physiological psychology was the only branch of psychology that appeared to provide an "objective," materialist perspective on mental processes. The Russian Formalists were familiar with one of the offshoots of physiological psychology—the field of experimental phonetics, in which questions of linguistic order were addressed from the point of view of perceptual psychology, as well as physiology of speech and hearing. The Formalists' knowledge of these scientific trends is attested to in Boris Tomashevski's essay "The Problem of Verse Rhythm" ("Problema stikhotvornogo ritma," 1923), written at the time he worked at the Institute of the Living Word:

> The discipline of experimental phonetics has produced a great number of projects, which applied experimental methods of phonetic research to the analysis of poetry (Verrier, Landry, Scripture, R. de Souza). This school substituted visual analyses of typed poetic texts by the study of their vocalization, recorded with the help of special equipment as a kymographic "curve" reflecting air vibrations—the very medium of sound. Analysis of texts has been replaced by the painstaking scrutiny of the curves representing the sounds of the pronounced poem.[72]

The Methods of Psychophysiological Poetry Studies

The Formalists' approach to the experiential properties of poetic language is a constituent part of a large turn-of-the-century field of inquiry that I call *psychomotor aesthetics*. This discourse emerged in diverse disciplines, in which professional conversations about artistic performance and aesthetic experience began to take into account ideas stemming from the novel discipline of physiological

[72] Boris Tomashevskii, "Problema stikhotvornogo ritma," in *Izbrannye raboty o stikhe*, ed. and comment. by S. I. Monakhov, K. Iu. Tver'ianovich, and E. V. Khvorost'ianova (St. Petersburg: Filologicheskii fakul'tet SPbGU; Moscow: Akademiia, 2008), 24–52, 47.

psychology. This materialist approach to the psyche introduced experimental methods and representational technologies geared at analyzing neurophysiological processes at the core of our psychological life. Motorics of the body, or its muscular movement, attracted the attention of researchers as an especially valuable psychophysiological indicator. A variety of theories linked voluntary and involuntary movement to the activity of the brain. For example, Wilhelm Wundt measured the quickness of his subjects' muscular reactions as a way of evaluating how long it takes for the brain to process one or another signal and innervate the appropriate tissues. J.-M. Charcot recorded seizures and temporary paralyses of hysterical patients in the hopes of mapping the short-circuited parts of the brain controlling these muscles. Many of their contemporaries attached special importance to the sensation of muscular effort. These authors ranged from William James, who believed that emotions are launched by one's physical actions ("we fear *because* we are running away"), to multiple proponents of the "motor theory of consciousness," who argued that sensation of effort stands at the origin of conscious thought.[73] So prominent was the place of movement in psychological research, that in 1911 Walter Bowers Pillsbury, the president of the American Psychological Association, felt compelled to dedicate his entire keynote lecture at the congress to reviewing various theories that considered motorics from a psychological point of view. Pillsbury stated:

> All would agree, I think, that the most important advance in psychological theory in recent years is the enhanced value placed upon movement in explaining mental processes. . . . James initiated the movement with his theory of emotion; it was continued and amplified by Dewey and in one form or another has been extended by many of the most vigorous writers among the younger psychologists. . . . The new theory introduced more of a practical interest into psychology, has made a break in the development of the theory of consciousness as pure thought, and has increased the tendency toward the concrete and away from the abstract. . . . The motor processes have been used . . . in the explanation of practically every one of the psychological problems. Berkeley gave a motor interpretation to space and has been followed by some writer in every generation. Time, rhythm, and each of the perception qualities has [sic] been referred to movement. Bain found movement important in abstract ideas, and the more recent theories have added practically every one of the cognitive processes on the list. If we add to these the affective processes, the clearness of

[73] Some of the representative English-language publications on the relation of movement and consciousness include E. B. Delabarre, "Volition and Motor Consciousness Theory," *Psychological Bulletin* 9.11 (1912): 409–413; G. V. N. Dearborn, "The Relation of Muscular Activity to the Mental Process," *American Psychological Education Review* 14.1 (1909):10–16; S. Alexander, "Foundations and Sketch-Plan of a Conational Psychology," *British Journal of Psychology* 4.3 (1911): 239–267.

attentive consciousness, and the subordinate motor processes, there is nothing in mind that has not been explained in terms of movement.[74]

Though in this passage Pillsbury names only English-speaking authors, similar psychological theories privileging the role of motor processes dominated the research agenda of experimental laboratories in Germany, France, Russia, and other countries. This vast discourse eventually began to influence discussions pertaining to aesthetics. Bodily movement and accompanying sensations during the production and consumption of art came to be viewed as a key element for understanding the psychological experience of artistic forms. In this chapter, I will explore only one field—the oral performance of literature—in which the impact of physiological psychology was engendering new ways of thinking about what poetry is and how we experience it.

Of course, the theme of the physiological foundation of artistic forms existed in Western aesthetic thought since ancient times. The idea of analyzing the experience of the human sensorium as it encounters art dates back at least to Pythagoras's quest for harmonious proportions in music.[75] In the 19th century, the rise of perceptual psychology gave this issue a formal disciplinary grounding, with scientists like Gustav Fechner and Hermann von Helmholtz investigating the correlations between physical sensation (of color, of musical tones, etc.) and subjective experience.[76] Toward the beginning of the 20th century, this idea grew into a large-scale research program, as an increasing number of laboratories began to delve into neurophysiological mechanisms with the help of new experimental methods and technologies. The articulation of language and oral performance of literary texts likewise came under the scrutiny of this objective science of the body and the mind. The expansion of physiology into the verbal arts was first driven by the task of investigating the elemental muscular mechanics of speech production. With time, there emerged more ambitious projects, which engaged aesthetic questions directly.

[74] Walter Bowers Pillsbury, "The Place of Movement in Consciousness," *Psychological Review* 18.2 (1911): 83–99, 83–84.
[75] Daniel Heller-Roazen, *The Fifth Hammer: Pythagoras and the Disharmony of the World* (New York: Zone Books, 2011). For a philosophical discussion of ideas on sensory perception and aesthetic experience throughout the history of Western civilization, see also Daniel Heller-Roazen, *The Inner Touch: Archaeology of a Sensation* (New York: Zone Books, 2007).
[76] Gustav Fechner, *Elemente Der Psychophysik (Elements of Psychophysics)* (Leipzig: Breitkopf und Härtel, 1860). Among Helmholtz's influential studies are *Handbuch der physiologischen Optik* (A Handbook of Physiological Optics) (Hamburg und Leipzig: L. Voss, 1896); and *Die Lehre von den Tonempfindungen als physiologische Grundlage für die Theorie der Musik* (On the Sensations of Tone as a Physiological Basis for the Theory of Music) (Braunschweig: Friedrich Vieweg und Sohn, 1863). On the relation of Helmholtz's research and German aesthetic philosophy, see Gary Hatfield, "Helmholtz and Classicism: The Science of Aesthetics and Aesthetics of Science," in *Hermann Von Helmholtz and the Foundations of Nineteenth-Century Science*, ed. David Cahan (Berkeley: University of California Press, 1993), 522–558.

One of the most famous early experiments, in which aesthetic questions were not yet a motivating force behind the inquiry, is Georges Demenÿ's *Photography of Speech* (1891). Working in Étienne-Jules Marey's laboratory, Demenÿ produced a chronophotographic sequence, demonstrating the movement of his lips while uttering two phrases, "Vive la France" and "Je vous aime."[77] These serial images revealed particularities of muscular work too minuscule and too fleeting for the unaided eye. Demenÿ's automated apparatus produced a record that showed speech as it had never been seen before: disassociated from audible sound, broken down into phases, reduced to hardly recognizable curvatures of the lips. To identify these mouth positions, one literally had to enact the utterance. As such, Demenÿ's project exemplifies the late 19th-century drive to use new technologies for examining the corporeal basis of imperceptible processes of the human spirit—speech being one of them. Translating elusive orality into a clear visual record, available for measurements and analysis, Demenÿ was primarily concerned with its potential application as a didactic tool or a normative gauge for speech production.[78]

In Russia, physiological laboratories of this period also pursued projects examining the physical substrate of speech production and perception. In 1900, the neurophysiologist Aleksandr Samoilov, working in Ivan Sechenov's laboratory in Moscow, made collotypes of speech sounds (Fig. 2.6). He attached a small mirror to a thin membrane that was shaken by the air passing from the speaker's mouth. Next, he shone a light beam onto the mirror, directing its reflection onto photosensitive paper, attached to a rolling cylinder.[79] The apparatus was an improved version of the phonautograph, known since the 1850s.[80] The curves

[77] Scholars of visual media have discussed ideological implications of Demenÿ's work in connection with the emergence of film and sound recording technologies—see Kittler, *Gramophone, Film, Typewriter*, 136–137; Noel Burch, *Life to Those Shadows*, ed. and trans. Ben Brewster (Berkeley: University of California Press, 1990), 26–27.

[78] Demenÿ's photographic record of speech originally was meant to serve as an aide in teaching the deaf to speak.

[79] A. Samojloff, "Graphische Darstellung der Vokale," *Le Physiologiste Russe* 2 (1900–1902): 62–69. Between 1896–1903 Aleksandr Samoilov held the position of the privatdozent at the Department of Physiology of Moscow University, where he was invited by Ivan Sechenov after having worked under Ivan Pavlov in St. Petersburg. Samoilov's research centered on the physical and chemical underpinning of physiological processes and innervations of the cardiac muscles. Between 1906–1910, in Kazan, Samoilov laid the foundations of modern electrocardiography. See A.L. Zefirov and N.V. Zvezdochkina, "Aleksandr Filippovich Samoilov—osnovopolozhnik elektrofiziologicheskikh issledovanii kazanskoi fiziologicheskoi shkoly," *Zhurnal Fundamental'noi Meditsiny i Biologii* 2 (2017): 50–57.

[80] For a history of sound recording technologies, see Lisa Gitelman, *Scripts, Grooves, and Writing Machines: Representing Technology in the Edison Era* (Stanford, CA: Stanford University Press, 1999). The principle of using the physical force of air vibration for the visual representation of voice was used in the "phonautograph" technology invented by Édouard-Léon Scott de Martinville. In terms of methodological sources, Samoilov also cites H. Rigollot and A. Chavanon, "Projection des phénomènes acoustiques," *Journal de Physique Théorique et Appliquée* 2.1 (1883): 553–555. Yet Samoilov's method was unique in that it "translated" vibrations into light and captured the flickering of the beam on a photosensitive surface attached to a rolling cylinder.

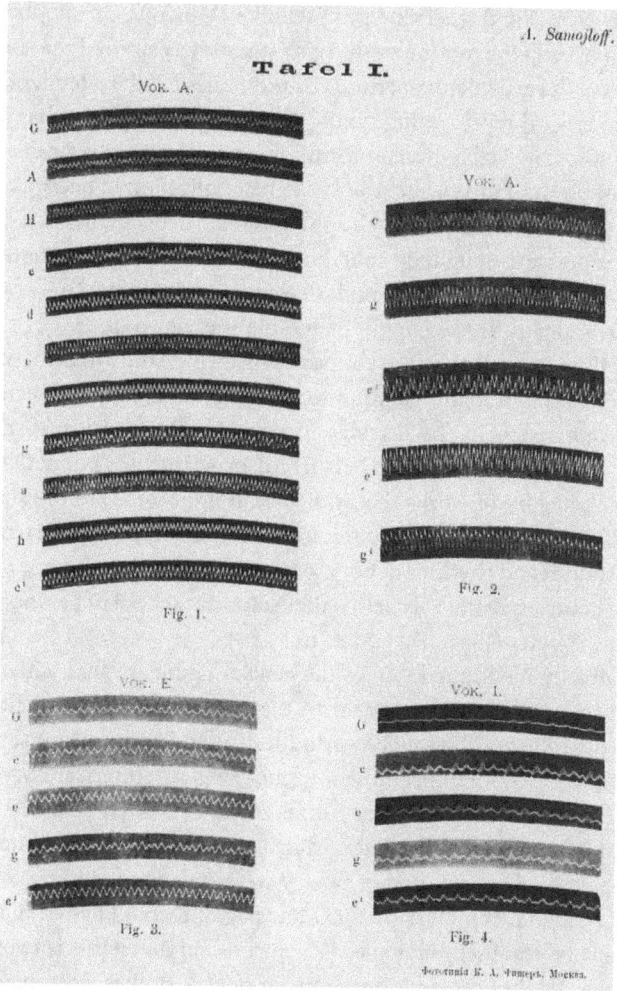

Fig. 2.6 Aleksandr Samoilov's collotype representation of the Russian vowels. Image from A. Samojloff, "Graphische Darstellung der Vokale," *Le Physiologiste Russe* 2 (1900–1902): 62–69. Samoilov's research is cited in Edward Scripture's *The Elements of Experimental Phonetics* (New York: Scribner, 1902), 29.

obtained with its help were the *waveforms* of Russian vowels—an indexical im-print of the airstream shaped by the efforts of articulatory organs and captured by a membrane designed like an eardrum. It is possible to say that Samoilov realized the dream of the 19th-century pioneer of photography Félix Nadar to

produce an "acoustic daguerreotype."[81] Unlike Demenÿ's chronophotographic series, emphasizing the motion of the lips, Samoilov's captured the sound—that is, the *result* of the articulatory action. His wave lines exhibit a tendency towards abstraction, toward representing bodily processes in a manner that has no resemblance to recognizable human form. The act of voicing is "translated" into dynamics of physical forces, recorded as a materialization of energy. Samoilov's original apparatus was devised by the physicist Petr Lebedev, the first scientist to measure the pressure of light on solid bodies.[82] It is interesting to note that later Samoilov laid the foundations of modern electrocardiography.[83]

Samoilov's idea to make sound analyzable was not unique, but rather typical for his time. It would require a separate historical study to chart all international efforts in this domain, the volume of which was already significant around 1900 and kept rising in the decades to come.[84] Among turn-of-the-century publications dealing with general issues of experimental phonetics, there is a particular category of works that is of special importance to my study. These are scientific papers that describe the use of physiological equipment for analyzing the sounds and rhythms of poetry. I would like to pause on one of the most prominent contributors to this field—the American school of psychophysiological studies of poetry (Figs. 2.7a and 2.7b).

I have already mentioned one of the central figures of this school, Edward W. Scripture, as one of the scientists that Boris Eikhenbaum cited in his *Melodics of the Russian Lyrical Verse*. In the United States, Scripture worked at Yale University. Another prominent center, where American psychologists and phoneticians worked on poetry, emerged at the Psychological Laboratory of Harvard University led by Hugo Münsterberg. Among the alumni of this center who studied articulation of poetry were Raymond Herbert Stetson and Robert Chenault Givler. Over the next few pages, I would like to outline some of their most typical methodologies. My purpose in doing this is twofold. First, to show what kind of research questions in poetry studies were explored with the help of laboratory equipment, and how the representational strategies

[81] For an excellent discussion of the "acoustic daguerreotype" and other 19th-century ideas on the material traces of sound, see Laura Marcus, *The Tenth Muse: Writing About Cinema in the Modernist Period* (Oxford: Oxford University Press, 2007), esp. Chapter 1, p. 33 ff.

[82] A.R. Serdiukov, *Petr Nikolaevich Lebedev, 1866-1912*. Moscow: Nauka, 1978, 114.

[83] Dennis M. Krikler, "The Search for Samojloff: A Russian Physiologist, in Times of Change," *British Medical Journal* 295 (1987): 1624–1627.

[84] On the relation between the experimental phonetic laboratories in Paris and theorists of French Symbolism and Italian Futurism, see Robert Brain, "Étienne-Jules Marey and Charles Rosapelly. Vocal Polygraph," *Grey Room* 43 (2011): 88–117. Some of the early examples of laboratory research on poetry include Ernst Wilhelm von Brücke, *Die physiologischen Grundlagen der neuhochdeutschen Verskunst* (Wien: C. Gerold, 1871); Benjamin Bourdon, "L'application de la méthode graphique à l'étude de l'intensité de la voix," *L'année psychologique* 4 (1897): 369–378; Georges Lote, *L'alexandrin d'après la phonétique expérimentale*, vol.1 (Paris: Editions de la Phalange, 1913).

(a) Vol. XIX PSYCHOLOGICAL REVIEW PUBLICATIONS APRIL, 1916
No. 2 Whole No. 82

THE
Psychological Monographs

EDITED BY

JAMES ROWLAND ANGELL, University of Chicago

HOWARD C. WARREN, Princeton University (*Index*)

JOHN B. WATSON, Johns Hopkins University (*Review*) and

SHEPHERD I. FRANZ, Govt. Hosp. for Insane (*Bulletin*)

STUDIES FROM THE PSYCHOLOGICAL LABORATORY OF HARVARD UNIVERSITY

The Psycho-physiological Effect of the Elements of Speech in Relation to Poetry

By

ROBERT CHENAULT GIVLER, Ph.D.

Instructor in Psychology in the University of Washington

PSYCHOLOGICAL REVIEW COMPANY

PRINCETON, N. J.

and LANCASTER, PA.

Agents: G. E. STECHERT & CO., London (2 Star Yard, Carey St., W. C.),
Leipzig (Koenigstr., 37); Paris (16 rue de Condé)

Fig. 2.7 (*a* and *b*) An example of the psychophysiological approach to poetry published in the American series *The Psychological Monographs* 19.2 (1916): 1–132, cover and p. 1. In this study, "lying on the borderland between Esthetics and Psychology," Robert Chenault Givler, presented his doctoral research, conducted at the Harvard Psychological Laboratory under the guidance of Hugo Münsterberg and Herbert Sidney Langfeld in 1911–1914. Givler's objective in examining the role of the "auditory, kinaesthetic, and organic sensations" of articulation for the cognitive and emotional impact of various types of poetry bespeaks the same belief in the value of the experiencial properties of the poetic language that motivated the Russian Formalists. Unbeknownst to each other, Russian literary scholars and American psychologists were part of the same intellectual network. Many of Givler's bibliographic sources were shared

THE PSYCHO-PHYSIOLOGICAL EFFECT OF THE ELEMENTS OF SPEECH IN RELATION TO POETRY

The purpose of this investigation is to determine by means of the expressive method, the effects produced by the speech elements in poetry upon both the motor and introspective consciousness.

Lying on the borderland between Esthetics and Psychology, the investigation aims to throw light (1) upon the so-called "tonal theory of poetry," by measuring the emotional value of the sounds in poetic language without reference to alliterative or grammatical devices, and (2) to discover what auditory, kinaesthetic and organic sensations are aroused by the play of vocal functions in meaningful as well as meaningless collocations of the elements of language.

The material is presented in the following order:

1. A statistical determination of the frequency of the various speech elements in English poetry,

2. Experiments upon the psycho-physiological effect of such elements combined in simple relations,

3. Transmogrifications of English poetry to determine reaction to the bare tonal elements, and

4. The esthetic and psycho-physiological question: Is the psycho-physiological value of the poetic sum equal to the sum of the psycho-physiological values of the separately contributing phonetic elements?

1. SOUND FREQUENCY IN ENGLISH POETRY

Prior to undertaking the experimental work in the laboratory, an elaborate statistical record was made by the writer of the percentage of frequency of the various letter sounds in the leading English poets from Sydney to Rossetti. The basis for this work was the observation of very striking differences in the acoustic and kinaesthetic sensations aroused by the audible

Fig. 2.7 *Continued* (*a* and *b*) by the Formalists and their colleagues at the Institute of the Living Word—Wilhelm Wundt, William James, Hugo Münsterberg, Edward W. Scripture, and Benjamin Bourdon. One of the theoretical premises of Givler's approach to articulation is the "motor theory of consciousness," elaborated by the Russian-French psychophysiologist, Nikolai Kostylev (Nicolas Kostyleff), a proponent of Pavlov's and Bekhterev's reflexology.

dictated by this equipment influenced the ways in which scientists began to im-
agine the experiential properties of poetry (rhythm, melody, intonations, dy-
namics, etc.). Second, I would like to compare the assumptions and findings
of the experiments done in the United States to poetry studies by the Russian
Formalists Boris Eikhenbaum and Sergei Bernshtein. As I will demonstrate,
there was an unacknowledged dialogue between these research camps on oppo-
site sides of the Atlantic. Without knowing each other, the Russian and American
poetry researchers were raising similar questions, emphasizing the performa-
tive and experiential properties of verse language. Moreover, they were inspired
by the same theoretical sources in physiological psychology and experimental
phonetics.

The American phonetician Edward W. Scripture was one of the pioneers of
experimental phonetics who began to investigate poetry.[85] Scripture completed
his doctoral dissertation under the guidance of Wilhelm Wundt in Leipzig, and
the neurophysiological orientation he received there determined his subsequent
methodology. Most of his research was conducted at Yale University, and two
German laboratories, Theodore Lipps's in Munich and Carl Stumpf's in Berlin.[86]
From 1899 onward, Scripture was preoccupied with the project of "applying the
methods of natural science in studying the nature of verse."[87] What this approach
meant was concentrating on the physics of articulation, defined by exact quan-
tifiable measures. Boris Eikhenbaum was familiar with one of Scripture's major
first publications, *Researches in Experimental Phonetics* (1906). The preface of
this book stated:

> The only true verse is that which flows from the mouth of the poet and which
> reaches the ears of the public . . . It is evident that the only way to undertake a
> scientific analysis of verse is to get it directly as it is spoken and then to use the
> methods of analysis and measurement.[88]

[85] For Scripture's biography, see Judith Felson Duchan, "Edward Wheeler Scripture," *A History of Speech—Language Pathology* (Department of Communicative Disorders and Sciences at the State University of New York at Buffalo), http://www.acsu.buffalo.edu/~duchan/history_subpages/scripture.html.

[86] (Edward W. Scripture, *Researches in Experimental Phonetics. The Study of Speech Curves* [Washington, DC: Carnegie Institution of Washington, 1906], 5).

[87] Scripture, *Researches in Experimental Phonetics*, 3.

[88] Scripture, *Researches in Experimental Phonetics*, 3–4, emphasis added. This is the sentence that Eikhenbaum quotes approvingly in his book *The Melodics of Russian Lyric Verse*. Eikhenbaum compares Scripture's point of view to Eduard Sievers's school of *Ohrenphilologie*, with its emphasis on the pronounced, voiced poetry rather than texts that are simply scanned by the eyes (Boris Eikhenbaum, *Melodika russkogo liricheskogo stikha* (Petrograd: OPOIaZ, 1922), 12).

To obtain quantifiable data that would reflect voice modulations in the performance of poetry, Scripture used several methods, all of which produced a graphical representation of "speech vibrations." One method involved using a gramophone to record voice performance of poems and short phrases. Scripture focused on the grooves made by the gramophone stylus on the surface of the disk. Using a special automated apparatus, he traced off these lines onto on a band of smoked paper attached to a rotating cylinder, so that the record would look like a continuous wavy line. These were the "speech curves" that he analyzed with mathematical precision. Another method of obtaining the "speech curves" involved asking the actor to speak directly into a mouthpiece connected to a device for reading off changes in pressure, known as the Marey tambour, after its inventor Etienne-Jules Marey (it consisted of a small drum attached to a kymograph, or a writing device).

Scripture's curves reflected minute fluctuations in the pitch and strength of the voice in the articulated sentence or verse line. In a sense, the curves provided a spatiotemporal scheme of any given voicing act. The apparatus used by Scripture translated sound into a visual abstraction. While they were an indexical record of the performer's voice (i.e., a transcript of the soundwaves scratched by a gramophone stylus), the curves were also curiously detached from their human source. What they were was evidence—an analyzable imprint, usable for quantificational analysis. Sergei Bernshtein and his colleagues similarly valued the concrete, material data that the phonograph made available. However, they saw their mission in analyzing the aesthetic impression of the voiced poem. Conceptually, this was a new step, but one that would not have been possible without the groundwork laid by experimental phonetics.

Bernshtein stated that his initial ideas for analyzing oral performances of poetry were indebted to the linguist Lev Shcherba and his laboratory of experimental poetics at St. Petersburg University.[89] Both Shcherba and Edward W. Scripture in turn were indebted to the French phonetician J.-P. Rousselot, who studied articulation in French dialects and later, the rhythm of poetic texts with the help of devices he designed on the basis of Marey's instruments (Fig. 2.8).[90] Scripture's "speech curves" (Figs. 2.9a and 2.9b; Figs. 2.10a, 2.10b, and

[89] Sergei Bernshtein, "Golos Bloka" (1921–1925), publikatsiia A. Ivicha i G. Superfina, *Blokovskii Sbornik* (Tartu: Tartusskii gos. universitet, 1972), 454–525, 455.
[90] On Rousselot's method, see Marianne Deraze et Xavier Loyant. "Représenter la parole. Autour des premiers appareils de laboratoire de l'Institut de phonétique de Paris," *Revue de la BNF* 48. 3 (2014): 12–18.

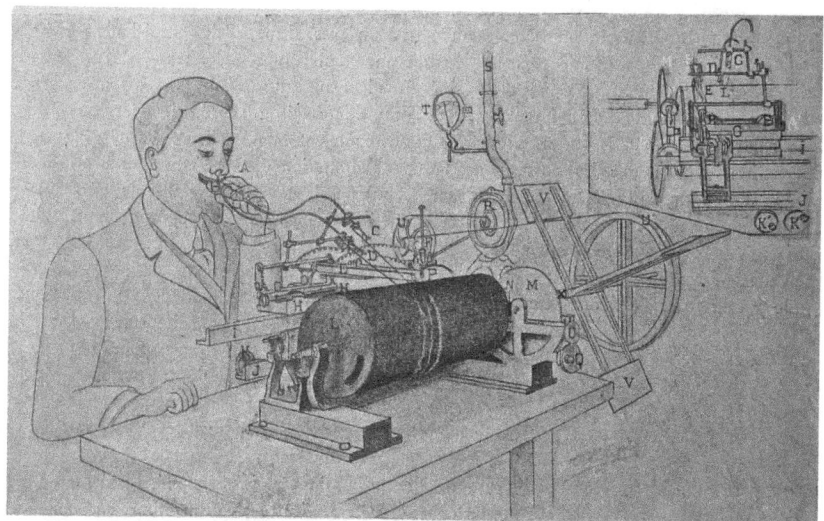

Fig. 2.8 Abbé J.-P. Rousselot's apparatus for transcribing air vibrations coming from the mouth during speech. Image source: Georges Lote, *L'Alexandrin d'après la phonétique expérimentale*, vol. 1 (Paris: Editions de la Phalange, 1913).

2.10c) were first recorded with the technological and conceptual support of Rousselot's laboratory at the Collège du France.[91] Shcherba visited the Parisian laboratory in 1907, after his studies in Leipzig under Sievers. In Paris, using his student stipend, he purchased the first equipment for his future laboratory of experimental phonetics in St. Petersburg—a kymograph, models of the human palate, collections of pitch forks, and other instruments.[92]

When Scripture began his work in experimental phonetics, he was initially driven by the idea of discovering the generic phonetic "laws of verse."[93] He immediately understood that this goal proved far beyond his capacity. He first had to elaborate a methodology for interpreting the shapes of the curves and correlating them with minute details of articulation and phonation. In the 1900s, Scripture's technology recorded only very short segments of speech, but

[91] Rousselot provided Scripture with a Marey tambour and a Verdin drum for his experiments in transcribing "speech melody"—the rises and falls of the pitch during normal speech (E. W. Scripture, "Studies in Melody of English Speech," *Philosophische Studien. Festschrift Wilhelm Wundt zum Siebzigsten Geburtstage überreicht von seinen Schülern* [Leipzig, 1902], 599–615, 601).

[92] L. V. Bondarko, "Eksperimental'naia fonetika v Sankt-Peterburgskom gosudarstvennom universitete:vtoraia polovina stoletiia," *Kafedra fonetiki i metodiki prepodavaniia inostrannykh iazykov. Sankt-Peterburgskii Gosudarstvennyi Universitet*, http://phonetics.spbu.ru/history.html.

[93] Scripture, *Researches in Experimental Phonetics*, 4.

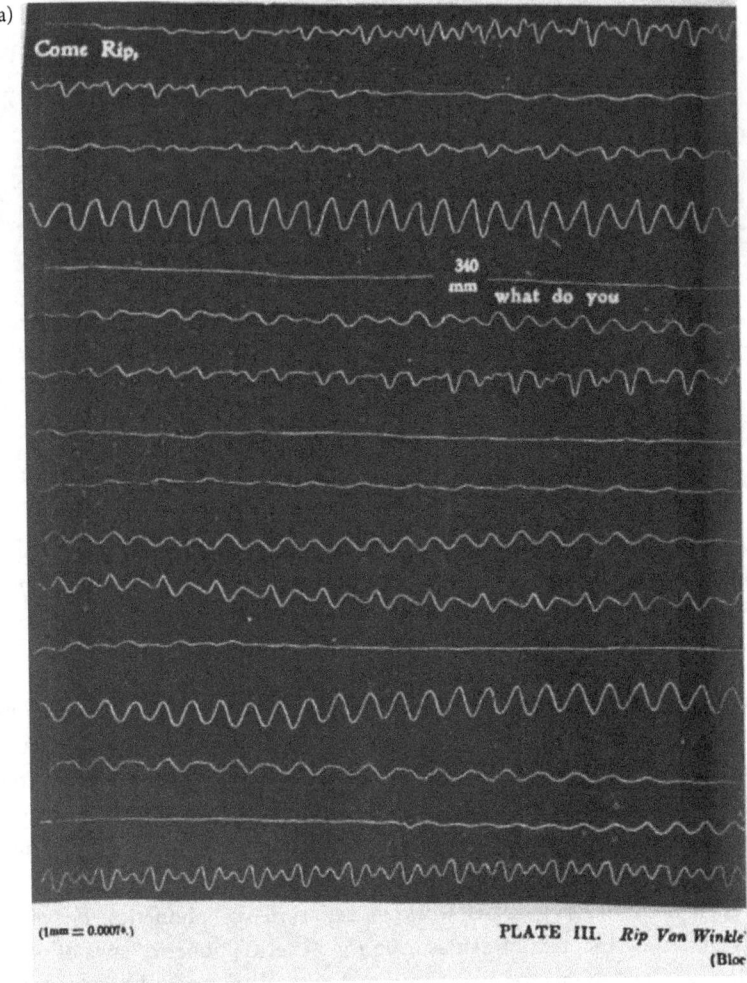

(a)

Come Rip,

340 mm

what do you

(1mm = 0.0007s.)

PLATE III. *Rip Van Winkle*
(Bloc

Fig. 2.9 (*a* and *b*) Scripture's curves representing the first line of "Rip Van Winkle's Toast"—a scene in a stage adaptation of Washington Irving's story, performed by the famous American actor Joseph Jefferson. "Rip Van Winkle" was one of Jefferson's most well-known performances, immortalized in an eponymous 1896 film made by the American Mutoscope Company. Image source: E. W. Scripture, Plates III–IV, *The Elements of Experimental Phonetics* (New York: Scribner, 1902).

(b)

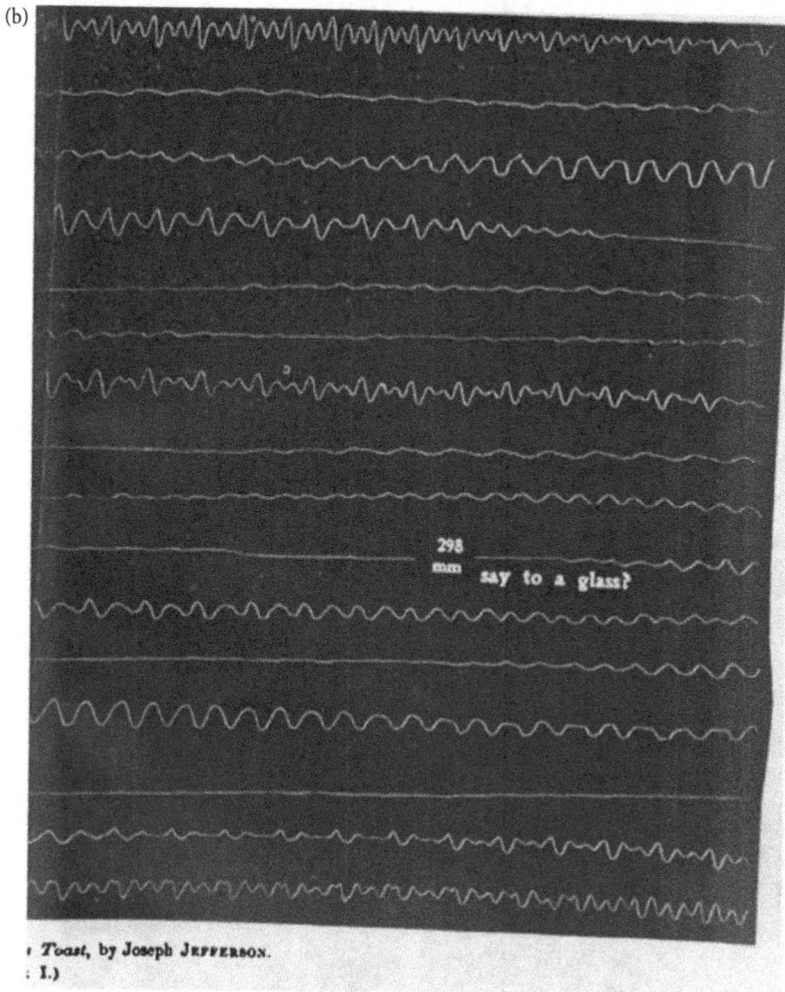

r *Toast,* by Joseph JEFFERSON.
: I.)

Fig. 2.9 *Continued*

he never abandoned his ambition of studying poetry. In 1921, he would go on to publish an article entitled "The Nature of Verse," showing how his method of curves can be used to determine whether iambus consists of an alternation of long and short, or strong and weak syllables.[94] Even in his early textbook *Elements of Experimental Phonetics* (1902), he made sure to include samples of literary texts, producing extensive curve transcriptions of the nursery rhyme "Who Killed Cock Robin" and a scene from a stage adaptation of Washington

[94] Edward W. Scripture, "The Nature of Verse," *The British Journal of Psychology* 11 (1921): 225–235.

Fig. 2.10 (*a–c*) Edward Scripture's speech curves and equipment for recording them. The letters of the phrase "Somebody said that it couldn't be done" are distributed to match the respective curves. Image source: Edward W. Scripture, "The Nature of Verse," *The British Journal of Psychology* 11 (1921): 225–235.

Irving's story "Rip Van Winkle" (Fig. 2.9a and Fig.2.9b).[95] The rich prosody of these texts, performed for Scripture by the renowned actor Joseph Jefferson, resulted in highly variable curves. Examining the fluctuations of the traced line, Scripture attempted to evaluate the "melody, duration and amplitude" of sounds in each segment of the utterance.[96] His definition of "melody" was "the rise and fall in pitch of the tone from the vocal chords during spoken words, just as during singing."[97]

It is precisely this property that Sergei Bernshtein investigated in his charts of "melodious movements" in Russian poets' performances. The same issue was also at the core of Boris Eikhenbaum's book *The Melodics of Russian Lyric Verse* (1922). Of course, it would be wrong to assert that Scripture was a key figure who inspired these studies. The Russian Formalists' exploration of melody, or intonation patterns, in poetry was much more likely responding to later and more familiar Russian, French, and German sources. These included the studies of oral performance and stage acting by pre-revolutionary theorists Sergei Volkonskii, Iurii Ozarovskii, and Vasilii Serezhnikov, Symbolists poets' Andrei Bely's and Valerii Briusov's discussions of poetic rhythm and meter, Leonid Sabaneev musical approaches to poetry,[98] the German school of *Ohrenphilologie*, the French school of experimental poetry analysis growing out of Abbé Rousselot's base,[99] Lev Shcherba's phonetic research program, and the whole atmosphere of the Institute of the Living Word.[100] Scripture's work belongs to the same discursive network as that of the Russian Formalists. His research program focused on the precise analysis of intonational patterns, lengths of poetic periods, and their rhythmical alternation, and it displays a great affinity to the way in which Eikhenbaum and Bernshtein approached poetry. To be sure, there were significant differences between Scripture and the Russian Formalists. The latter were first and foremost literary scholars. Their analysis of intonations and melodies focused on tasks such as comparing various styles, or showing how one or another author reworked the intonational

[95] Edward W. Scripture, *The Elements of Experimental Phonetics* (New York: Scribner, 1902).

[96] Scripture, *Researches in Experimental Phonetics*, 6.

[97] Scripture, "Studies in Melody of English Speech," *Philosophische Studien*, Festschrift Wilhelm Wundt zum Siebzigsten Geburtstage überreicht von seinen Schülern (Leipzig, 1902), 599–615, 599.

[98] Olenina, "Poeziia kak dvizhenie," 371, 381.

[99] Rousselot's laboratory at the Collège de France fostered a number of French phoneticians who studied poetry by methods of experimental phonetics in the 1910s. Representative publications of this school include Eugène Landry, *La Théorie Du Rythme et le Rythme Du Français Déclamé* (Paris: H. Champion, 1911; Paul Verrier, *Théorie Générale Du Rythme* (Paris: Welter, 1909); Paul Verrier, *Essai Sur Les Principes de la Métrique Anglaise: Notes de métrique expérimentale* (Paris: Welter, 1909); Georges Lote, *L'Alexandrin d'après la phonétique expérimentale* (Paris: Editions de la Phalange, 1913).

[100] Russian sources that the Formalists referred to and polemicized with also included discussions of the poetic meter by the Symbolist theorists Andrei Bely, Valerii Briusov, and Sergei Bobrov, as well as intonation analyses of performed poems by Sergei Volkonskii and Iurii Ozarovskii.

patterns associated with a certain tradition (for instance, Eikhenbaum wanted to demonstrate that Aleksandr Blok's poetry evokes intonations of urban songs [gorodskie romansy], while Anna Akhmatova often uses emotional exclamations typical of the folkloric lament genre).[101] Edward Scripture, for all his ambitions of studying poetry, never considered issues of style. A phonetician, trained in physiological psychology, he concentrated on much smaller elements of vocalization. For example, transcribing the speech curves, Scripture noticed that it is impossible to establish a permanent alphabet of vibration patterns corresponding to individual letters (phonemes). Each vowel or consonant appeared idiosyncratic, because of slight variations in conditions affecting pronunciation. Scripture interpreted this finding as a sign that linguists must rethink the existent categories of phonemes:

> The first curve I obtained showed that every individual vowel had its peculiar curve. An attempt to classify them according to types indicated a far larger number of different typical vowels than was allowed for in the works of phoneticians. Again, *the curve of the vowel changed with every shade of emotion* ... [102]

As a physiologist, he tried to model the action of articulatory organs, responsible for one or another wave pattern. The speech curves, he argued, demonstrated that the action of the glottal lips differs for each vowel and each emotional nuance in verbal expression, because in each case, the brain sends nervous impulses to different portions of the glottal muscles.[103]

Considerations of this kind can never be found in Formalists' texts. In fact, the whole question of whether or not emotions can be reflected in sounds of poetry was, from their point of view, a highly contestable and complicated issue. Thus, for instance, when Eikhenbaum wrote in his analysis of Anna Akhmatova's poetry that she evokes intonations of lament songs (golosheniie, vyklikanie) and folk chastushki, marked by sharp "outcries and abrupt intonational jumps from the high pitch to low," he described these patterns of voice modulation as a conscious stylistic device.[104] These intonations bespeak an affinity with low genres, distinguishing Akhmatova's poetry from the predominantly elevated register of her contemporaries. For Eikhenbaum, the intonations of folkloric laments have become the *material* of Akhmatova's

[101] Boris Eikhenbaum, *Anna Akhmatova: Opyt Analiza* (1923) (Paris: Lev, 1980), 76–77.
[102] Scripture, *Researches in Experimental Phonetics*, 3–4, emphasis added.
[103] Ibid., 7.
[104] Boris Eikhenbaum, *Anna Akhmatova: Opyt Analiza* (1923) (Paris: Lev, 1980), 76–77.

art, and they do not have a simple, direct relationship with the emotional experiences we normally associate with wailing. Art defamiliarizes emotions, as well as articulatory patterns associated with their expression.

Scripture's hypothesis that voice changes in emotional experience happen because the brain innervates different segments of the glottis and other articulatory muscles emphasizes the corporeal basis of vocal expressivity. There is only one step between this utterly physiological statement and the onomatopoeic theory of "sound-gesture," which we have seen in Faddei Zelinskii's interpretation of Dostoevsky's neologisms and Viktor Shklovskii's discussion of Russian Futurists' experiments. According to Hansen-Löve's periodization of the Russian Formalists' theoretical evolution, the thesis about potential correspondences between sound orchestration in poetry and emotion became contested in their works by the early 1920s. Indeed, Viktor Shklovskii treated this thesis much more skeptically in his works of the 1920s than in his earlier essays on the Futurists. For Boris Eikhenbaum, Sergei Bernshtein, Iurii Tynianov, and many other OPOIaZ affiliates, this thesis appeared suspicious, especially because it was always associated with the intuitive, impressionistic theories of the Symbolists, whom the Formalists antagonized. Nevertheless, the idea of investigating the "bio-emotional foundation of aesthetics"—to use Anatolii Lunacharskii's phrase—persisted in Russia throughout the 1920s, making its appearance in various contexts and institutionalized research programs. It was particularly prominent in Soviet organizations like the Institute of the Living Word, where the import of natural sciences into aesthetics was especially intense.[105] For instance, one of the associates of the Institute, the musicologist Leonid Sabaneev, wrote in his theoretical monograph *The Music of Speech* (1923):

> We could consider speech as a particular case of gestural expression—a gesture of the mouth, if you will. But the connection between emotion and gestural expression remains mysterious and understudied. Likewise, little is known about the link between emotion as a psychological phenomenon and human speech sounds. One thing is certain: this link has a physiological foundation . . . Nearly identical sounds, evoked by analogous physiological mechanisms, are emitted by humans and beasts to express emotions. . . . Emotional expressivity of music in its pure form is nothing but an equivalent of this primeval physiological

[105] For an informative overview of Soviet research institutions investigating musical perception see Alla Mitrofanova, "Conditioned Reflexes: Music and Neurofunction," *Lab: Jahrbook 2000 für Künste und Apparate*, ed. Hans U. Reck, Siegfried Zelinskii, Nils Röller, and Wolfgang Ernst (Köln: Kunsthochschule für Medien, 2000), 171–182.

expressivity. . . . In music, we stylize elements of physiological expression, re-flected in the forms of sound intonation.[106]

Such assertions of linkages between the physiology of emotions and voice intonations—some of them more grounded in scientific references, and some of them less—enjoyed great popularity in Russian discussions of verbal arts through the 1920s. As late as 1928, the literary scholar Nikolai Kovarskii, as-sociated with Bernshtein's circle, wrote a review of German approaches to the question of melody in poetry, in which he included Julius Tenner's theory that speech intonations are connected to emotions by physiological mechanisms.[107] Kovarskii explained:

> Tenner maintains, with a reference to the founder of physiognomy Piderit, that each feeling is expressed only by a particular combination of facial muscles. Since facial muscles are linked to the resonating cavities of the mouth and the nose, each activated muscle combination corresponds to a particular emotional timbre of speech. Therefore, the feelings incorporated into the poet's text, are expressed during performance of the piece through the work of facial muscles and the corresponding emotional timbres.[108]

Besides the melodious changes of pitch and intonational patterns of verse, there was one more property of poetic language that lent itself well to psychophysi-ological considerations. This was the issue of rhythm. Edward Scripture's text-book *Elements of Experimental Poetics* (1902) describes an entire host of early experiments aimed at discovering how the body of the performer experiences the rhythm of verses.[109] Scientists such as E. Brücke in Wien, J. Král a F. Mareš in Prague, A. S. Hurst and J. MacKay in Toronto, E. Meyer in Marburg, I. Miyake at Yale University,[110] and others, including Scripture himself, asked their subjects to tap their finger while reciting poems. The kymograph was employed to record

[106] Leonid Sabaneev, *Muzyka Rechi: Esteticheskoe issledovanie* (Moskva: Izdatel'vo rabotnik prosveshcheniia,1923), 16.

[107] Nikolai Kovarskii, "Melodika Stikha," *Poetika: Vremennik otdeleniia slovsenykh iskusstv* (Leningrad: Academia, 1928), 26–44, esp. 35. Kovarskii is referring to the following publica-tion: Julius Tenner, "Uber Versmelodie," *Zelfschrift für Aesthetik und allgemeine Kunstwissenschaft* 8 (1913): 247–279.

[108] Kovarskii, "Melodika Stikha," 35. Tenner is citing Theodor Piderit, *Wissenschaftliches System Der Mimik Und Physiognomik* (Detmold: Klingenbergische Buchhandlung, 1867).

[109] Scripture, *Elements of Experimental Poetics*, Chapter 37.

[110] Ernst W. Brücke, *Die Physiologischen Grundlagen Der Neuhochdeutschen Verskunst* (Wien: C. Gerold, 1871); Joseph Král and F. Mareš, "Trvání hlásek a slabik dle objektivní míry," *Listy filologické* 20 (1893): 257–290; A. S. Hurst and John MacKay, "Experiments of the Time Relations of Poetic Meters," *University of Toronto Studies Psychological Series* 1.3 (1899): 157–175; Ernst A. Meyer, "Beiträge Zur Deutschen Metrik," *Neure Sprachen* 6.1 (1898): 121ff; Ishiro Miyake, "Researches on Rhythmic Action," *Studies from the Yale Psychological Laboratory* 10 (1902): 1–48.

the taps and articulatory movements in order to evaluate how they correspond to each other in time, and how regularly they occurred. The same kymograph tracings were also used for measuring the lengths of stressed and unstressed syllables. This task was relevant for determining how classical notions of poetic meters compare to their actual pronunciation. From the psychological point of view, these experiments also aimed at examining the nature of the subjects' "rhythmical sense"—when and why sequences were perceived by them to have a rhythmical pattern, and whether the "motor rhythm" (repetitions of muscular strain) was identical to the "sound rhythm" (repetitions of stressed syllabi and similar-sounding phonemes). Scripture's 1902 study, in particular, showed that the beats of the finger nearly coincide with the points of stress determined by the poetic meter, although the taps tend to precede the pronunciation by a few hundredths of a second.[111] Scripture concluded that "the two moments are so closely associated" that the innervations to the hand and the vocal organs "must take place almost simultaneously" and possibly come from one and the same nervous impulse.[112]

Another American physiologist of speech, Raymond Herbert Stetson, an alumnus of Münsterberg's Psychological Laboratory at Harvard,[113] went even further in investigating the neurophysiological basis of rhythmical sense. Stetson was a proponent of the "motor" theory of rhythm, according to which our perception of rhythmical regularity depends on sensations of muscle engagement and relaxation. At the turn of the 20th century, he was not the only advocate of this understanding of rhythm, but he was the one who consistently tested it through experiments using poetry recordings (Fig. 2.11). In his monograph "Rhythm and Rhyme" (1903), Stetson names some of the eminent predecessors of his approach—all of whom, by the way, were well known to the Russian Formalists.[114] These include Johann Friedrich Herbart, who "pointed out the effect of a whole rhythmic series in giving rise to the emotion of expectation, delay, or haste;"[115] Hermann Lotze, who "applied [Herbart's] principle severally to each unit group (each foot) in the rhythm, and made the emotional effect of rhythm depend on these alternate feelings of strain, expectation,

[111] Scripture, *Elements of experimental phonetics*, 543.

[112] Scripture, *Researches in experimental phonetics*, 544.

[113] Louis D. Harston, "Stetson: A Biographical Sketch," in R. H. Stetson, *R.H. Stetson's Motor Phonetics*, ed. J. A. S. Kelso and K. G. Munhall (Boston: Little, Brown and Co., 1988), 1–8, 2.

[114] The Formalists' engagement with this school of 19th-century philosophy and perceptual psychology is examined in Ilona Svetlikova, *Istoki Russkogo Formalizma: Tradicija Psichologizma i Formal'naja Shkola* (Moskva: Novoe Literaturnoe Obozrenie, 2005).

[115] R. H. Stetson, "Rhythm and Rhyme," *Psychological Review: Monographs Supplements* 4.1 (1903): 413–466, 413. Stetson cites Johann F. Herbart, "Psychologische Untersuchungen," *Johann Friedrich Herbart's Sämmtliche Werke*, herausgeg. von Gustav Hartenstein, vol. 7 (Leipzig: L. Voss, 1850–1852), 291 ff.

Fig. 2.11 For his studies of poetry, Stetson adapted a commercially available model of the gramophone, connecting it to another recording device that scratched grooves onto a metallic disk. The apparatus thus recorded simultaneously on the disk and on the soot-covered glass cylinder revolving in the gramophone. Stetson examined the shapes of both curves under the microscope. Image source: R. H. Stetson, "Rhythm and Rhyme," *Psychological Review: Psychological Monographs* 4.1 (1903): 413–466, 437 Plate X.

and satisfaction produced by the repetition of the unit group;"[116] Ernst Mach, who noted the involuntary "subjective accentuation of objectively uniform series" and emphasized the "motor nature of the phenomenon of rhythm,"[117] and Wilhelm Wundt, who considered rhythm "as a special temporal form of psychic synthesis," combining sensations of "qualitative changes, intensive changes and melodic changes" in a series.[118] Stetson embraced the idea that the rhythmical sense has to do with expectations of recurrent stimuli, but he also argued that

[116] Stetson, "Rhythm and Rhyme," 413. Stetson cites Hermann Lotze, *Geschichte Der Aesthetik in Deutschland* (Munich: J.G. Cotta, 1868), 487 ff.

[117] Stetson, "Rhythm and Rhyme," 414. Stetson cites Ernst Mach, "Untersuchungen übeFr den Zeitsinn des Ohres," *Wiener Sitzungsberichte der Kaiserlichen Akademie der Wissenschaften: Mathematisch-Naturwissenschaftliche Classe* 51.2 (1865): 133–150.

[118] Stetson, "Rhythm and Rhyme," 414. Stetson cites Wilhelm Wundt, *Grundzüge Der Physiologischen Psychologie*, vol. 2 (Leipzig: Engelmann, 1893), 83 ff.

perception of rhythm is always connected to sensations of muscular movement. These sensations, he claimed, are not simply imaginary, but involve actual muscular straining, no matter how weak it is. Stetson wrote:

> When one says that rhythm consists of a series of sensations of movement, or, of a series of sensations (sound, sight, touch) that occur precisely as if they were produced by that movement, and that the rhythmic group has the unity of a co-ordinated action, it is important to know in just what sense the word "consists" is used. . . . Every rhythm is dynamic; it consists of *actual movements*. It is not necessary that joints be involved, but changes in muscular conditions which stand in consciousness as movements are essential to any rhythm, whether "perceived" or "produced." [119]

Based on the assumption that rhythmical sense has a motor nature, Stetson produced a number of laboratory tests that aimed to study the role of rhymes at the end of verse lines as a factor of recurrent voice intensification, which is responsible for the psychic synthesis of syllables into a rhythmical series.[120] He also pushed further into investigating muscular engagement during poetry reciting accompanied by the tapping of the finger. He used the kymograph to record the phases of contraction and relaxation in two sets of muscles, involved in lifting the finger and bringing it down. The nearly perfect sinusoids that he drew based on the kymograph data (Fig. 2.12) demonstrate that the uniformity of muscular strain occurs in cycles. According to Stetson:

> The continuity of the rhythmic series, whereby all the beats of the period seem to belong to a single whole, is due to the continuity of the muscle sensations involved and the continuous feeling of slight tension between positive and negative muscle sets; nowhere within the period does the feeling of strain die out.[121]

Stetson's study, with its motor understanding of rhythm and its well-elaborated methodology for examining vocal action, became a source of inspiration for many other American research projects, in which the experimental approaches of physiological psychology were put at the service of studying rhythm in music and literature. Thus the alumnus of the Harvard Psychological Laboratory Walter

[119] R. H. Stetson, "A Motor Theory of Rhythm and Discrete Succession," *Psychological Review* 12.4 (1905): 250–270, 255, 257; original emphasis.
[120] R. H. Stetson, "Rhythm and Rhyme," *Psychological Review: Monographs Supplements* 4.1 (1903): 413–466, 455.
[121] Ibid.

Fig. 2.12 In this figure from Stetson's study "Rhythm and Rhyme" (1903), "the upper curve represents the actual movements of the fingertip, and the heavy lines *a, a', a"* represent the pressure-tension-sound sensation which we call a 'beat', and which is the limiting sensation of the rhythm, and the regulating movement in the cycle of the rhythm. . . . The curves below represent the changes in the two opposing sets of muscles whose interaction brings about the movement cycle. The contraction of the flexors, the positive muscle set, is represented by the curve above the base line. . . . The sensations from this positive muscle set have the principle place in consciousness during the rhythm experience." The image and caption are from R. H. Stetson, "Rhythm and Rhyme," *Psychological Monographs* 4.1 (1903): 413–466, 453–454.

van Dyke Bingham argued in his "Studies in Melody" (1910) that our experience of unity and coordination in a succession of musical notes also has cycles of muscular strain and relaxation at its basis.[122] Bingham maintained that the rise of the pitch is experienced by the listener as an increase in the straining of the vocal apparatus.[123] Each note triggers a "motor disposition or attitude"—an emotion of expectation. If the final note in the series coincides with the first one, the listener

[122] Walter Van Dyke Bingham, "Studies in Melody," *Psychological Review Monograph Supplements* 12.3 (1910): 1–88. After this study, Bingham would go on to become one of the pioneers of applied psychology in the field of professional aptitude testing.
[123] Van Dyke Bingham, "Studies in Melody," 86.

will feel "muscular resolution" signaling for him that what he just had heard was a complete whole, rather than discrete notes.[124] In the field of literary studies, Stetson's research inspired William M. Patterson's study *The Rhythm of Prose* (1916),[125] which examined sensations of rhythm during reading by looking at graphical records of vocalizations (Fig. 2.13).

Now, let us zoom out for a moment from the details of psychophysiological experiments and think about their implications for aesthetic philosophy. Surely, the pattern of the corporeal work can be recorded, measured, and expressed in a graph. But what exactly does it say about the subjective experience of the literary piece? How does it correlate to the mystery of aesthetic pleasure, the sense of intellectual profundity and emotional power—that is, everything that we tend to associate with the experience of art? It is in posing this kind of question in relation to the laboratory data that we run into the limits of *physiological determinism*.

In contrast to American psychologists and phoneticians, the Russian Formalists did concern themselves with the larger aesthetic impact of literary texts. When Boris Tomashevskii reviewed the relevance of experimental phonetics for literary analysis, he pointed out two significant drawbacks. First, the kymographic curves transcribe *all* elements of vocalization—those that have a stylistic significance, and those that are simply an inevitable effect of speech mechanics.[126] Second, not all of these elements actually evoke a response in the psyche of the perceiver. How can the researcher find out, Tomashevskii wondered, what properties of the recited poem engage the audience?[127] Besides the perception of sound, Tomashevskii maintained, the act of listening to a familiar language evokes one's motor-articulatory knowledge: we intuitively know what muscular work would be necessary for the production of one or another sound cluster. These articulatory movements, or their mental image, were considered by the Formalists a crucial property of the poetic *faktura*, equally as important as sound.[128] But how to find out which motor patterns are activated in the listener's mind, preferably taking into account his cultural upbringing? Which of his reactions will be idiosyncratic, and which of them intersubjective (that is, applicable to many other people as well)? How do we know what kind of diction the audience is habituated to? Which elements of the performed text will strike them as unusual or dull, pleasant or disturbing, daring or complacent?

[124] Ibid.

[125] William M. Patterson, *The Rhythm of Prose: An Experimental Investigation of Individual Difference in the Sense of Rhythm* (New York: Columbia University Press, 1916).

[126] Boris Tomashevskii, "Problema stikhtotvornogo ritma," *Literaturnaia Mysl'* 2 (1923): 124–140, 138.

[127] Tomashevskii, "Problema stikhtotvornogo ritma," 137.

[128] Ibid., 137–138.

VOICE–PHOTOGRAPHS

The syllable "tah," photographed Aug. 14, 1915. The higher summits of the time-line are approximately one sixtieth of a second apart. The negative has been slightly reinforced by the engraver.

"Ah" — film at slow speed — photographed July 25, 1915. A moment of roughness in the tone is recorded near the center.

"Top! Top!", from the test for sense of rhythmic "swing." Part of the record of Observer No. 4. (See Chapter III.)

Fig. 2.13 William M. Patterson's "voice-photographs" which relied on the equipment of experimental psychology for the analysis of rhythm perception in the reading of prose. R. H. Stetson's and E. W. Scripture's analyses of speech curves were an important methodological source for Patterson. Image source: William Morrison Patterson, *The Rhythm of Prose: An Experimental Investigation of Individual Difference in the Sense of Rhythm* (New York: Colombia University Press, 1916), 2.

These objections raised by Boris Tomashevskii in relation to the experimental approach point toward the larger aesthetic theories of the Formalists. In the next section of this chapter, I will explore the way in which their analysis of the material properties of verse fits in with their understanding of the poetic

composition as an ongoing perceptual experience. From the Formalists' point of view, the compositional *architectonics* of the poem called for the listeners' active engagement. Its comprehension involved evaluating the relations between various elements that make up a poem and the properties of its *faktura*. I will suggest that the structural intensities of composition were often conceptualized by the Formalists in reference to corporeal experience. Thus Iurii Tynianov judged the rhythm and the relational value of verse lines in a stanza by the "expenditure of motor energy" needed for each line's pronunciation.[129] Boris Eikhenbaum spoke of the peculiar kind of "rhythmical emotion" that is evoked in the audience by poetry performance.[130] Sergei Bernshtein claimed that the perception of compositional relations is based, fundamentally, on the sensations of "relaxation and strain."[131] Sofia Vysheslavtseva, a student of Bernshtein and Eikhenbaum, argued in 1927 in favor of classifying poetic styles on the basis of their ability to evoke muscular movement. On one side of the spectrum, she argued, are Vladimir Mayakovsky's and Sergei Tret'akov's marches, which require the straining of the vocal chords, and which benefit from the rhythmical motions of the hand during recitation. On the opposite end is the meditative lyrics of Fedor Sologub and Aleksandr Fet, which loses none of its artistic charm during quiet reading.[132]

The next section will examine the role of these "motoric" aspects of the poetic text in the Formalists' conceptions of the aesthetic experience of form. As we shall see, the Formalists' emphasis on the corporeal dynamics of poetry performance was a way to circumvent and reframe the issue of poetry's emotional engagement. While in the 1910s, Viktor Shklovskii drew on Wundt's hypothesis, which correlated articulatory movements with emotional experience, his primary interest lay in the evocative texture of the word and its potential for artistic defamiliarization (Chapter 1). By the early 1920s, the Russian Formalists working in the Institute of the Living Word, as well as Viktor Shklovskii himself, expressly negated emotional interpretations of sound orchestrations in poetry. Their attention to corporeal motorics and their adoption of the impersonal, mechanistic vocabulary of the physiological psychology was in part a reaction to naïve and trivializing literary criticism focused on the emotional content of poems.

[129] Tynianov, *Problema stikhotvornogo iazyka*, 129–130.

[130] Boris Eikhenbaum, "O Kamernoi deklamatsii" (1923), in *Literatura: Teoriia, kritika, polemika* (Leningrad: Priboi, 1927), 226–249, 248.

[131] Sergei Bernshtein, "Esteticheskie predposylki teorii deklamatsii," in *Poetika: Vremennik otdeleniia slovsenykh iskusstv*, vol. 3 (Leningrad: Academia, 1927), 25–44, 34.

[132] Sofia Vysheslavtseva, "Motornye impul'sy stikha," in *Poetika: Vremennik otdeleniia slovsenykh iskusstv*, vol. 3 (Leningrad: Academia, 1927), 45–62, 58.

Formal Emotions and the Issue of Embodiment

For Boris Eikhenbaum, Sergei Bernshtein, and other members of the OPOIaZ group, the idea of studying emotions harbored within a literary piece was a dubious and unscholarly topic. The danger of focusing on this issue, the Russian Formalists argued, was that it could throw literary studies back to moralistic criticism and idolatrous exploration of the authors' biographies. Or it would attach too much value to the unverifiable and, more often than not, irrelevant subjective responses of readers. Clearing the ground for a new type of form-sensitive aesthetic analysis—one that would engage, first and foremost, the inner structural laws of an artwork—these scholars insisted that the author's life experiences are never reflected in a literary piece directly, but are always filtered through the prism of his or her stylistic preferences and compositional considerations. As Viktor Shklovskii once put it:

> It is completely wrong to use authors' diaries for examining how works of arts were created. It is a lie that the author is writing autonomously, in isolation from the whole literary evolution and competing movements. For the writer, creating a monograph is an impossible task. Moreover, diaries lead us to the psychology of art and the issue of the "laboratory of the genius." ... With regards to the artist, art has several freedoms: 1) the freedom of not entirely reflecting his personality; 2) the freedom of being selective with regards to his personality; 3) the freedom of sampling from all kinds of other material.[133]

This effort to liberate literature from a simplistic relation to "external life" was, to a large degree, responsible for the Formalists' reluctance to incorporate questions of psychological order into their primary research program. And yet, these questions kept coming back and always loomed large in the background of their analyses. For in order to say that a certain form was chosen by the author because of the impact it produces, one inevitably had to confront the problem of perception and consider the ways in which sensory stimulation translates into an aesthetic experience.

Among the Formalists, Boris Eikhenbaum was the first to address the issue of emotion directly. "Wouldn't it be ridiculous, and even horrific," he wrote in 1919, "if the spectators came to the theater and watched playacting all night long in order to be frightened, or to suffer along with the characters?"[134] It was already

[133] Viktor Shklovskii, "Pis'mo Tynianovu" in "Tret'ia Fabrika," *Eshche nichego ne konchilos'* . . . (Moskva: Propaganda, 2002), 375–376.

[134] Boris Eikhenbaum, "O tragedii i tragicheskom" (1919), in *Skvoz' literaturu* (Leningrad: Academia, 1924), 71–83, 75. Carol Any identifies this essay as one of the earliest examples of Eikhenbaum's treatment of the subject of the audience's emotional engagement.

Schiller, wrote Eikhenbaum, who understood that watching a tragedy on stage was a pleasure, a pleasure derived from sympathy.[135] To this maxim the Russian scholar added: "It is a pleasure coming not from [the experience of] sympathy, but from [the experience of] the form in which it is presented."[136] In other words, Eikhenbaum contended that the spectators are delighted by witnessing a masterful deployment of "tragic devices," which intensify their sympathy for the protagonist at each narrative juncture, without, however, letting them forget about the artfulness of the events they see. Well aware of the rules of the genre, the audience lets itself be enticed into a game, lending its attention to the twists and turns of the plotline and subjecting itself to the artificially stretched out narrative development—those repeated delays of the dénouement that not only tickle the spectators' nerves through suspense, but also remind them of the masterful craftiness of the play's design. As far as the spectators' sympathy for the tragic hero was concerned, Eikhenbaum argued that the evocation of this emotion was part of the deal, yet this experience was only a pretext for the enjoyment of the dramaturgical composition on a larger scale. In tragedy, he claimed,

Sympathy is employed as one of the forms of perception [*sostradanie ispol'zovano, kak odna iz form vospriiatia*]. It is taken out of the spectators' soul and put before their eyes, becoming a lens through which they follow the unfolding labyrinth of artistic linkages [*sledit za razvertyvaiushchimsia labirintom khudozhestvennykh stseplenii*].[137]

Eikhenbaum's reflections on the nature of the aesthetic response prompted him to distinguish between "soul emotions" (*dushevnye emotsii*) and "spiritual," or "formal emotions" (*dukhovnye, ili formal'nye emotsii*). This part of his theoretical legacy has been examined in the works of Viktor Erlich, Douglas Robinson, and especially Carol Any.[138] As these commentators explain, the first

[135] Eikhenbaum, "O tragedii i tragicheskom," 76.

[136] Ibid., 76.

[137] Ibid., 83. "An infinite labyrinth of linkages" is a metaphor that Leo Tolstoy invented in a letter to the critic Nikolai Strakhov. It entered the Formalists' lexicon thanks to Shklovskii's "Sviaz' priemov siuzhetoslozheniia s obshchimi priemami stilia," in *Poetika: Sborniki po teorii poeticheskogo iazyka* (Petrograd: 18 Gos. tipografiia, 1919), 113–150, 143. According to Shklovskii, Tolstoy stated that he could not have expressed himself in *Anna Karenina* in any other way but the way he wrote it. The meaning of each sentence in the novel has value only in relation to the system of other elements that make up the text—not just thoughts, but also images, actions, moods (Viktor Shklovskii, "Sviaz' priemov siuzhetoslozheniia s obshchimi priemami stilia," *Poetika*, 1919, 143).

[138] Victor Erlich, *Russian Formalism: History, Doctrine*, 3rd ed. (New Haven, CT: Yale University Press, 1981), 209–210; Douglas Robinson, *Estrangement and the Somatics of Literature: Tolstoy, Shklovsky, Brecht* (Baltimore: Johns Hopkins University Press, 2008), x; Carol J. Any, "Teoriia iskusstva i emotsii v formalisticheskoi rabote Borisa Eikhenbauma," *Revue des Etudes Slaves* 57.1 (1985): 137–144; Carol J. Any, *Boris Eikhenbaum: Voices of a Russian Formalist* (Stanford, CA: Stanford University Press, 1994), 48.

of Eikhenbaum's categories refers to private affective reactions, derived from the projection of one's life experience onto the work of art. Sympathy for a close relative, self-pity, jealousy, anger, or joy tied to the particular circumstances of one's personal experiences are all examples of "soul emotions" that one encounters on a daily basis.[139] In recognition of the utilitarian value of these reactions—that is, their ability to move one to practical problem-solving action—Eikhenbaum also called them "goal-oriented emotions" (tselevye emotsii).[140] In his view, this level of emotional reaction to art manifested itself only in a degree of identification with the characters, and it was largely extraneous to the aesthetic experience proper. In contrast, the second category, "formal" emotions, constituted the very fabric of aesthetic response.[141] These were nonindividual, abstract intensities that transcended the level of intimate, personal reactions, and indeed extinguished, or "neutralized,"[142] the spectator's initial impulse to judge the characters and situations by the criteria derived from his or her own life. In this sense, formal emotions brought the spectator closer to the implied addressee of the performance.[143] Most important, Eikhenbaum maintained that formal emotions were linked to one's recognition of the artful—nonordinary, deliberate—nature of all elements that make up the play, as well as an appreciation for the creative process that accorded them this idealized status.

Another essential feature of formal emotions was that they arose in response to the structural organization, or *architectonics*, of the art piece. Eikhenbaum was particularly keen on this idea, and he aimed to prove its applicability to a variety of verbal arts. In novels, plays, and other narrative genres, he claimed, it is the build-up of the story's elements that is responsible for the aesthetic effect of the piece. In lyric poetry, this effect is a function of the melodic arrangement of speech sounds, a productive confrontation of intonation patterns and rhythms orchestrated by the poet. Whether it was the movement of the plotline (the zigzagging of the plot with regard to the fabula) or the movement of the poem's melody (the variations in rhythm with regard to the set meter),[144] Eikhenbaum

[139] Boris Eikhenbaum, "O kamernoi deklamatsii," *Literatura: Teoriia, kritika, polemika* (Leningrad: Priboi, 1927), 226–249, 246–247.

[140] Any, "Teoriia iskusstva i emotsii v formalisticheskoi rabote Borisa Eikhenbauma," 138.

[141] Eikhenbaum also called them "intellectual" emotions (*intellektual'nye emotsii*). See "O kamernoi deklamatsii," 247.

[142] Eikhenbaum, "O kamernoi deklamatsii," 247.

[143] Carol J. Any, *Boris Eikhenbaum: Voices of a Russian Formalist* (Stanford, CA: Stanford University Press, 1994), 50.

[144] Shklovskii's theoretical texts draw a parallel between the construction of the plot and principles of versification. For instance, he considers rhyme to be a type of repetition, similar to the recurrent motif in a story: "A fairytale, a short story, or a novel consist[s] of a combination of motifs; a song is a combination of stylistic motifs; therefore the plot and plottedness [*siuzhet i siuzhetnost'*] are the same kind of form as a rhyme" (Viktor Shklovskii, "'Sviaz' piemov siuzhetoslozheniia s obshchimi priemami stila," *Poetika* [1919], 144). On parallels between compositional principles of prose and verse in the Formalist theory, see also Aage A. Hansen-Löve, *Russkii formalizm: Metodologicheskaia*

considered them to be much more important for the aesthetic effect than what is traditionally understood by "content"—the referential value of words or the prototypes of characters and events.

The strengths and weaknesses of Eikhenbaum's position and his differentiation between "formal" and "soul" emotions have been an object of multiple studies. Particularly astute and comprehensive in this respect is the work of Carol Any, in which she usefully summarizes the objections raised against Eikhenbaum and the Formalists by Bakhtin, Medvedev, and other contemporaries. The opponents criticized them for bracketing off the complex sociological underpinning of the literary text and failing to acknowledge its nature as a communicative, dialogical act taking place within an inherently hierarchical sociopolitical milieu. Writing from the vantage point of the 1980s, prepared by semiotics and reader-response theory, Any adds that Eikhenbaum tends to universalize the addressee of the literary text and views him as a passive receiver, rather than an active interpreter. Moreover, Any points out that in his battle against the "mimetic" and "expressive" fallacies of literary studies, Eikhenbaum nearly denies literature the possibility of carrying a social message. It is not my intention to debate these conclusions, which constitute a classical outlook on Russian Formalism and are dutifully negotiated in any good college course on Slavic intellectual history today, although I do believe that the theme of the Formalists' views on the sociopolitical resonance of art is far from being a closed topic and would benefit from a careful revision and more nuanced elaboration.[145] Instead, I would like to focus on another aspect of the Formalists' theory that has not yet received due critical attention: the issue of the literary form's impact on the perceiver. I would like to look closely at Eikhenbaum's category of the "formal emotions," which is the most concrete articulation of a problem that to a varying extent concerned all of the OPOIaZ scholars, although few of them took care to address it directly. How does the "architectonics" of the literary piece provoke "formal emotions," and

rekonstruktsiia razvitiia na osnove printsipa ostraneniia (Moskva: Iazyki russkoi kul'tury, 2001), 310 ff.

[145] Shklovskii's theory of "estrangement" in particular endows art with an ethical and political significance (see Svetlana Boym, "Poetics and Politics of Estrangement: Victor Shklovsky and Hannah Arendt, *Poetics Today* 26.4 (2005): 581–611; Douglas Robinson, *Estrangement and the Somatics of Literature: Tolstoy, Shklovsky, Brecht* (Baltimore: Johns Hopkins University Press, 2008)). Cf. Boris Eikhenbaum's statement that during the tumultuous years following the Revolution, one's artistic perspective coincides with the political one: "All of us today—those who are alive and want to live—are artists. This is because life has become difficult, mysterious, new, and incomprehensible; it has become slow and coherent, but at the same time vertiginously fast. Grotesque, buffoonery, circus, tragedy—all of this has become intertwined in one grandiose performance. It is "a labyrinth of linkages," where only an artist can move around and discern anything" (Boris Eikhenbaum, "O chtenii stikhov," *Zhizn' Iskusstva* 290 [1919], 1).

how are they connected to the aesthetic experience? What elements of "architectonics" are significant in this respect?

The notion of "architectonics," favored by the Formalists and avant-garde artists, is a metaphor borrowed from architecture, where it denotes a dynamic balance of forces, a coordinated relationship between the masses that make up the construction. Applied to literature, this metaphor suggests that the text can be broken down into structural blocks and emphasizes interaction between these strata—their tectonic play. Now, if we consider this structural organization from the point of view of the reader, we will notice the strength of the Formalists' architectural metaphor in revealing the spatial and temporal aspects of perception and interpretation. The layout of textual segments, the sequence in which these elements appear before the audience, and the changing rhythm that marks their appearance—all contribute to the unique impression of the literary piece. Additionally, since each element of the text may exhibit certain stylistic characteristics (i.e., it might recognizably recall a particular register, genre, or style), the reader will be involved in the evaluation of stylistic relations between the components, their harmonies and clashes, predictable concords and unexpected contrasts. Thus the reader's perception of tension created by the insertion of noncanonical elements will help him to appreciate the differential force distinguishing the text from the established tradition. The readers' navigation within the "unfolding labyrinth of linkages," their experience of the tectonic play of elements, was a parameter that Eikhenbaum deemed crucial for understanding the aesthetic impact of the literary piece. Significantly, one other metaphor that he frequently used was *khod*, which can be translated as a "move," or a "movement pattern." As Carol Any has shown, Eikhenbaum considered the "narrative, dramaturgical, or rhythmical movement pattern" to be the defining feature of the literary text.[146] Examples of the "movement patterns" could include, in narrative genres, different directions of plot development, for instance, "chronological, circular, retrospective, divergent, parallel, false-parallel, etc.," and in lyric poetry— variations of melody, produced by *enjambements* and noncoincidence of words' stress pattern with the meter in any given line.[147] Just how important the idea of the "movement pattern" was for the Formalists can be illustrated by Viktor Shklovskii's insistence on this metaphor in many of his theoretical texts. In Shklovskii's novels, the trajectory of the reader is deliberately made to resemble a series of gambits, as the development of one idea or one plotline is frequently interrupted by counterpropositions, alternative examples, unrelated anecdotes,

[146] Carol J. Any, "Teoriia iskusstva i emotsii v formalisticheskoi rabote Borisa Eikhenbauma," *Revue des Etudes Slaves* 57.1 (1985): 137–144, 140.

[147] Ibid., 140. On the issue of rhythm in prose and poetry see also Viktor Shklovskii, "'Sviaz' piemov siuzhetoslozheniia s obshchimi priemami stilia," *Poetika* (1919), 121.

and startling analogies. Thus accentuated, "bared" architectonics of Shklovskii's prose, in which all paragraphs seem to collide with each other, creates an intellectually charged field that teaches the reader to resist easy conclusions and entertain suggestive ambiguity.

That the architectonics of the literary piece, from the Formalists' point of view, was responsible for intellectual stimulation is confirmed by Eikhenbaum's interchangeable usage of the terms "formal" and "intellectual emotions," when speaking about the audience's aesthetic reaction to literature. Yet the aesthetic experience of the text must have contained something else in addition to purely cognitive engagement, otherwise Eikhenbaum probably would have avoided using the word "emotion" altogether. The meaning of Eikhenbaum's concept of the "formal emotion" must be probed further. I would like to suggest that at the core of his approach lies the assumption that the architectonics of the literary text corresponds to the structural play of some *abstract intensities* within the reader's mental processing of the literary text. The apperception of these intensities is based on the sensory experience of form, its acoustic, motor-articulatory, and visual-graphical *faktura*.

Nowhere is this view better developed than in Eikhenbaum's early articles on the oral performance of poetry and his discussions of intonation and articulation patterns typical of different poetic styles. These studies, written right before and during his employment at the Institute of the Living Word, are explicitly engaged with questions of perception and interpretation, by virtue of the fact that they negotiate various ways of vocalizing the printed text. In one such study, "On Chamber Declamation" ("O kamernoi deklamatsii, 1923), Eikhenbaum writes: "Reaction to rhythm is a formal emotion. It is this kind of emotion that the performer of poetry [*deklamator*] should aim to evoke in the audience."[148] This statement, urging performers to highlight the rhythm of poems, rather than propositional content and syntactic logics of phrases, is motivated by the anti-mimetic (anti-referential) and anti-expressive (anti-biographical) emphasis in the Formalists' approach to poetry. It also illustrates their belief that rhythm, as an artistic principle that defamiliarizes regular speech, somehow *moves* the audience.

Yet "moving" in this case does not imply inciting well-definable noble feelings. Such a jump from the experience of poetry to catharsis and universal wisdom was much too complicated an affair to be treated so nonchalantly. The Formalists despised unscrupulous literary critics and philistine audiences who took this step all too readily.[149] As Viktor Shklovskii put it,

> if we are experiencing the most noble and charitable feelings imparted to us by our most-humane-in-the-world poets, then this kind of experience has nothing

[148] Eikhenbaum, "O kamernoi deklamatsii," 247.
[149] Ibid., 227.

to do with art. . . . The existence of people who prefer Nadson to Tiutchev testifies to the fact that literary works are judged by the quantity of noble thoughts. This approach, by the way, is very common among the Russian youth. The apotheosis of experiencing "art" from the point of view of "noble feelings" is presented in Chekhov's "Old Professor," where two students watching a theater play have the following conversation: "What is he saying out there? Is it noble?"—"Very noble!"—"Bravo!" This dialogue summarizes the way our critics treat new movements in art.[150]

The Formalists, in contrast, focused on "what" is really being said and "how." They concerned themselves with the technical side of literary production and experience. Thus the "emotion of rhythm," which Boris Eikhenbaum referred to, might not be an emotion in our usual sense of the word (what Eikhenbaum called personal, or "soul" emotions). Rather, it is an experiential property of verses. As such, it poses many interesting research questions.

For example, Iurii Tynianov's book *The Problem of Verse Language* makes references to perceptual psychology and experimental phonetics in order to discuss the nature of rhythmical feeling. How do the poets endow verbal material with rhythm? How do the authors of *vers libre* judge the relational equivalence of lines, so that these strings of syllabi would make a rhythmical pattern, when read sequentially? Tynianov cites Hermann Lotze, who argued that "time plays no role whatsoever in verse rhythm."[151] Further, he refers to Eugène Landry's and Sergei Bernshtein's experimental investigations, which proved that during poetry recitals, the feet of the poetic meter never take the same time to pronounce. From the chronometrical point of view, verses tend to be irregular. Commenting on this issue, Tynianov accepts Rousselot's suggestion that a subjective, psychological sense of time may play a role here. Particularly important, according to Rousselot, is the perception of time during pronunciation:

> a major element of rhythm is in vowel sounds perceived by the ear, but I think however, that this is not the sole basis for the poet. Would it not then follow to search for the source of rhythm in the organic rhythm of the poet? He articulates his verses and speaks them to his own ear, which judges rhythm, but does not create it. And if the poet were mute, to him each sound would be presented as an expiratory effort, corresponding to the movement of organs

[150] Viktor Shklovskii, "Voskresheniie slova," *Gamburgskii Shchet: Stat'i, Vospominaniia, Esse, 1914–1933*, eds. A. Iu. Galushkin and A. P. Chudakov (Moskva: Sovetskii pisatel', 1990), 36–42, 37.

[151] Iurii Tynianov, *The Problem of Verse Language*, trans. Michael Sosa and Brent Harvey (Ann Arbor, MI: Ardis, 1981), 153. Tynianov refers to Hermann Lotze, *Geschichte Der Aesthetik in Deutschland* (Munich: J.G. Cotta, 1868), 300.

involved in its production.... From this, I conclude that rhythm is not based on acoustic time, but on time of articulation.[152]

Rousselot's idea about the subjective perception of one's own articulatory time is developed in Tynianov's work into a theory of "motor-energy expenditure." He argues that it is the sensation of muscular efforts that signals the recurrence of accent points in a poem, and therefore serves as the most crucial factor for the subjective experience of rhythm.[153] Tynianov suggests that each poetic meter has its own motor-energy characteristics. Our regular, everyday speech also has its peculiar rhythms—something that becomes obvious when dialects are compared. In a poetic composition, each word and each phrase may fall under the influence of one or another rhythmical program. There emerges a hierarchy of rhythmical patterns. For example, in classical syllabotonic styles of poetry, rhythmical patterns of habitual everyday speech collide with and give way to the enforced metrical system. By this process, the verbal material of regular speech is deliberately made difficult. Speech is defamiliarized, and its experience is slowed down—as Viktor Shklovskii would put it. Tynianov interprets this process with reference to his "motor-energy" thesis: "meter deforms the sentence in the accentual respect, redistributing strengths to a certain degree, and via this, more than any other component, complicates and foregrounds the motor-energy side of speech."[154]

From the Formalists' point of view, rhythm is a "constructive factor of verse."[155] A dynamic confrontation of rhythmical patterns is a feature of each poem's architectonics. It is a stylistic choice of the poet to give prevalence to one rhythmical pattern over the other. For instance, Tynianov states that the poet Vasilii Zhukovskii strived to make his metered poetry resemble regular speech as much as possible, thus weakening the perception of meter. Using the Formalists' terminology, Zhukovskii wanted his audiences to see the rhythmical patterns of everyday speech as a "dominant." The author's view of the dominant, however, does not necessarily need to coincide with the interpreter's idea. Boris Eikhenbaum lamented the fact that many professional actors performing poetic texts on stage tend to rework metered poetry so that it sounds like regular speech, with

[152] J. P. Rousselot, *Principes De Phonétique Expérimentale: 2* (Paris: Welter, 1908), 307; cited in Iurii Tynianov, *The Problem of Verse Language*, 154. For a sustained analysis of Rousselot's impact on the Parisian literary scene, and particularly on Ezra Pound's theories of rhythm, see Michael Golston, *Rhythm and Race in Modernist Poetry and Science: Pound, Yeats, Williams, and Modern Sciences of Rhythm* (New York: Columbia University Press, 2008); Robert Brain, *The Pulse of Modernism: Physiological Aesthetics in Fin-De-Siècle Europe* (Seattle: University of Washington Press, 2015); Haun Saussy, *The Ethnography of Rhythm: Orality and Its Technologies* (New York: Fordham University Press, 2016).
[153] Tynianov, *The Problem of Verse Language*, 154.
[154] Ibid., 155. (I have modified the translation.)
[155] ibid., 31 ff.

recognizable everyday intonations and emphasis of the words' content.[156] In this way, he felt, they are doing violence to the intended hierarchy of elements within these poems' architectonics.

The issue of rhythmical patterns was closely related in Formalist theory with the consideration of syntactic structures and intonations. All of these aspects were grouped under the notion of "verse melody." Boris Eikhenbaum's work in particular focused on describing the intonational patterns characteristic of various authors and stylistic systems. He maintained that our consciousness contains rhythmo-syntactic schemes, which help us intuitively foresee where the members of the sentence should be placed in relation to each other, and how the sentence might be divided into clauses (rhythmical units).[157] Any deviation from these schemata attracts attention, and therefore may become a feature of a new style. From Eikhenbaum's point of view, regular communication-oriented speech is not subject to codified melodious patterns, in contrast to verse. In *The Melodics of Russian Lyrical Verse*, Eikhenbaum gives many anecdotal examples of poets imagining a song-like rhythmical hum when composing verses and emphasizing rhythm at the expense of words' content when reciting verses on-stage. These facts, Eikhenbaum argued, suggest that

> the nature of verse (especially the lyrical) is organically connected to matters of acoustics and articulation. [Everyday] speech intonation loses its emphasis on logic and sense, becoming subject to melodious deformation. If a foreigner decided to study Russian intonations from poetry and use them in regular communication, his speech would produce a strange and comical impression.[158]

Variations in rhythmical and intonational patterns not only distinguish regular and poetic speech, or individual poetic styles from each other. Relations between intonational patterns may also play an important role for poetic composition, thus becoming a crucial factor of architectonics. In his famous discussion of Gogol's story "The Overcoat," Eikhenbaum established that one of the key techniques in this text is the interaction between contrasting intonational styles. Gogol surprises the reader by alternating the narrator's solemn and pitiful diction (*pateticheskaia deklamatsiia*) with comic and grotesque elements.[159] Another illustration of Eikhenbaum's analysis of intonational relations with regard to the

[156] Boris Eikhenbaum, *Melodika Russkogo Liricheskogo Stikha* (Peterburg: Opoiaz, 1922), 19; Boris Eikhenbaum, "O Kamernoi deklamatsii (1923)," *Literatura. Kritika. Polemika* (Leningrad: Priboi, 1927), 226–249, 227–231.

[157] Eikhenbaum, *Melodika*, 19.

[158] Eikhenbaum, *Melodika*, 20.

[159] Eikhenbaum, "Kak sdelana 'Shinel'" Gogolia" (1918), *Skvoz' literaturu* (Leningrad: Academia, 1924), 171–195, 177.

architectonics of a literary text is his study of Lomonosov's and Derzhavin's poems that fill in stanzas with numerous rhetorical questions. Discussing these texts, Eikhenbaum speaks of the "impulses" of interrogatory intonations that create a repetitive, cyclical feeling and add symmetry to the composition.[160]

The theory of compositional architectonics and its experience, considered from the point of view oral performance, is further elaborated in Sergei Bernshtein's seminal article "The Aesthetic Premises of the Theory of Declamation" ("Esteticheskiie predposylki teorii deklamatsii," 1926).[161] This piece sums up Bernshtein's ideas developed in the course of his research at the Institute of the Living Word, as well as The Laboratory for the Study of Literary Speech (*Kabinet po izucheniiu khudozhestvennogo iazyka*) at the Institute of Art History in Leningrad. The essay presents a tour de force blend of Formalist theoretical ideas, data from Bernshtein's research on poetry recordings, references to German and French experimental phonetics and perceptual psychology, as well as the aesthetic philosophy of Broder Christiansen. This German author was brought to the attention of the OPOIaZ circle by Viktor Shklovskii,[162] and the influence of his *Philosophy of Art* may be felt in many of their texts. The Formalists were particularly sensitive to Christiansen's ideas on the perception of art objects and cognitive processing of their composite nature. Christiansen argued that our encounter with any work of art has two phases. It starts with a sensory experience of the "artifact's" materiality and proceeds to a "synthesis of an aesthetic object" within our mind. This "aesthetic object" is dynamic, because it is constantly readjusted by our ongoing cognitive evaluation of its constituent parts and our understanding of the relations between them. It was Broder Christiansen who popularized the term *dominanta* (the dominant element) to mark the compositional elements that acquire more value in our perception than others. This concept was later incorporated into the Formalists' theoretical arsenal. Sergei Bernshtein used Christiansen's theory of the multistep aesthetic experience to discuss the ways in which interpreters cognize the compositional architectonics of literary works. In Bernshtein's theory, Christiansen's "low-level syntheses" correspond to the perception of the poetic meter and plot. On the next level, these elements begin to interact with other "compositional factors," such as syntactic structures and sound orchestration. A complex chain of consequential

[160] Eikhenbaum, *Melodika*, 64.

[161] Sergei Bernshtein, "Esteticheskie predposylki teorii deklamatsii," in *Poetika: Vremennik otdeleniia slovsenykh iskusstv*, vol. 3 (Leningrad: Academia, 1927), 25–44.

[162] Viktor Shklovskii, "Sviaz' priemov siuzhetoslozheniia s obshchimi priemami stilia," *Poetika* (1919), 120. On Christiansen's key concepts, see Horst-Jürgen Gerigk, *Lesendes Bewusstsein: Untersuchungen Zur Philosophischen Grundlage Der Literaturwissenschaft*. Berlin: W. De Gruyter, 2016, 95-113.

mental syntheses brings about the general impression of the aesthetic object.[163] Emotional response plays an important role in Bernshtein's theory of the experience of composition. Yet, like Boris Ekhenbaum, he attaches value to abstract intensities, rather than well-defined "personal" feelings:

> The emotional aspect manifests itself within the very substrate of compositional structure—these are elemental feelings of strain and relaxation [*substrat kompozitsionnogo postroeniia—chuvstva napriazheniia i razriazheniia*]. With regards to composition, we [the Formalists] take into account only their mutual relation, alternation, and dynamics. In this respect, they are simply vectors of force going in opposite directions, which create—as Boris Eikhenbaum aptly put it—"pressure from within." When we refer to their qualities ("strain," or "relaxation"), we speak of emotional values. Examples of compositional factors that produce an emotional impact include the values of various rhythmical patterns (rising and falling rhythms; feminine and masculine endings considered in relation to each other and to the beginning of the next verse; long and short verse lines; lines with or without caesura, etc.); the values of strophe forms; and ultimately the values of syntactic and semantic constructions (parallelisms, enumerations, etc.).[164]

As can be seen from this passage, Sergei Bernshtein places some elemental abstract emotions—concentration and release, straining and relaxation—at the foundation of the perceiver's experience of the poetic composition. Although in accordance with Broder Christiansen's theory, these emotions are mental acts (that is, they occur at the level of cognitive synthesis of the aesthetic object), Bernshtein's terminology suggests that these feelings have a precedent in the sensations of muscular movement. In fact, in other parts of his theoretical essay on the oral performance, he emphasizes the importance of associations evoked in our mind by the motor sensations of articulation. Elaborating on this topic, he makes references to experimental phonetics and psychophysiology. Based on Wilhelm Wundt's *Principles of Physiological Psychology*, Bernshtein states that our experience of rhythmical patterns depends on a cyclic recurrence of feelings of strain and release, or upsurge and weakening.[165] Motor sensations also influence our interpretation of vocal sounds— on this topic, Bernshtein cites Wolfgang Köhler's and Ekaterina Mal'tseva's

[163] Bernshtein, "Esteticheskie predposylki teorii deklamatsii," 39n1.

[164] Bernshtein, "Esteticheskie predposylki teorii deklamatsii," 41–42.

[165] Bernshtein, "Esteticheskie predposylki teorii deklamatsii," 34–35. Bernshtein cites Wilhelm Wundt, *Grundzüge Der Physiologischen Psychologie*, 5. Aufl. Bd. III (Leipzig: Engelmann, 1903), 23–24.

psychological research on "the motor nature of pitch perception"; Wundt's theory of sound-gesture onomatopoeia; and the theories of the German school of *Ohrenphilologie* (Rutz, Sievers, Tenner) that correlate motorics of articulation and emotional expressivity.[166]

Perhaps the most direct association of motor sensations and experience of compositional dynamics can be found in the original offshoot of the Formalist poetic theory—the work of Sofia Vysheslavtseva. Today, this name is almost entirely forgotten, but in the 1920s, Vysheslavtseva was among the most promising students of Boris Eikhenbaum and Sergei Bernshtein.[167] In 1927, she published a summary of her long-term research on the oral performance of poetry, entitled "The Motor Impulses of Verse" ("Motornye impul'sy stikha") in the journal *Poetics* associated with the OPOIaZ circle. In this essay, Vysheslavtseva starts from the premise that "the excitation and deliberate regulation of motor-muscular sensations make up the process of one's psychophysical "feeling into" the poetic work (*protsess psikhofizicheskogo vzhivaniia v poeticheskoe proizvedenie*)."[168] She theorizes the aesthetic experience of poetry composition quite literally in reference to corporeal movement. Arguing that "motricity [*motornost'*], or the ability to evoke motor sensations and body movements, is a crucial characteristics of verse,"[169] Vysheslavtseva proposes a typology of poetic styles based on how intensely they engage the reader's body. The "marches" of Vladimir Mayakovsky and Sergei Tret'iakov, for instance, call for maximal straining of the voice. Their oral performance benefits from rhythmical hand gestures that mark stressed syllabi. Other kinds of poetry—Akhmatova, Blok, and Gumilev—call for a simple, unexaggerated pronunciation; and finally, there are styles which do not lose anything if they are read silently (Fedor Sologub and Afanasii Fet).[170] Vysheslavtseva's ideas on the experiential, articulatory properties of verse styles were inspired in part by her experience as a stage performer of poetry. In the 1910s, she had attended Vsevolod Meyerhold's acting

[166] Bernshtein, "Esteticheskie predposylki teorii deklamatsii," 35. He refers to Mal'tseva's research grounded in Köhler's methodology (E. A. Mal'tseva, "Osnovnye elementy slukhovykh oshchushchenii," *Sbornik rabot Fiziologo-Psikhologicheskoi Sektsii G.I.M.N.*, 1 [1925]: 29–30); Wundt's *Völkerpsychologie. Eine Untersuchung der Entwicklungsgesetze von Sprache, Mythus und Sitte* (Leipzig: W. Engelmann, 1900–09), vol. 1 (*Die Sprache*, 1900); Julius Tenner, "Uber Versmelodie," *Zelfschrift für Aesthetik und allgemeine Kunstwissenschaft* 8 (1913): 247–279.

[167] She recalls this period of her life in S. Vysheslavtseva, "Prikhodite pogovorit' o poezii . . . ," *Avrora* 10 (1975):70–72, stating that in 1924 she worked in The Laboratory for the Study of Artistic Speech. Sergei Bernshtein mentions her as his student and cites her research in his essay "Esteticheskie predposylki teorii deklamatsii," 34, 35.

[168] S. Vysheslavtseva, "Motornye impul'sy stikha," in *Poetika: Vremennik otdeleniia slovsenykh iskusstv*, vol. 3 (Leningrad: Academia, 1927): 45–62, 51.

[169] Ibid., 46.

[170] Ibid., 58.

workshops, which explains her interest in the physical, corporeal side of verse performance.[171]

In her 1927 article, Sofia Vysheslavtseva has a beautiful phrase:

For the performer, "the movement of verse" ["*dvizhenie stikha*"] consists of concrete sensations and an active experience of the moving energy of articulation, with all of its ebbs and flows, jumps, stresses, and slides; all of its rises and falls, retardations and accelerations.[172]

For her, the metaphor of "movement" used to describe the changes of melodies and rhythms in a poetic text translates, quite literally, into corporeal motorics. The experience of a poem means embodying its compositional dynamics. This was a practitioner's point of view—in addition to her scholarly research, Vysheslavtseva recited poetry on stage (Sergei Esenin allegedly proclaimed her the single best interpreter of his texts) and taught courses on "collective declamation" in workers' clubs.[173] Yet her perspective was also a theoretical one. Her theoretical platform was prepared by years of Boris Eikhenbaum's, Sergei Bernshtein's, and other Formalists' research on poetry, oral performance, and aesthetic experience, which began under the auspices of the Institute of the Living Word and the Laboratory for the Study of Artistic Speech.

[171] Lev Karokhin, "Vospominaniia S. G. Vysheslavtsevoi o Mandel'shtame," *Sankt-Peterburgskie vedomosti*, January 13, 2001, *Elektronnyi Arkhiv Gazet i Zhurnalov na Servere DUX*, February 13, 2011. <http://www.pressa.spb.ru/newspapers/spbved/2001/arts/spbved-2396-art-21.html>.

[172] Sofia Vysheslavtseva, "Motornye impul'sy stikha," in *Poetika: Vremennik otdeleniia slovsenykh iskusstv*, vol. 3 (Leningrad: Academia, 1927), 45–62, 53.

[173] Vysheslavtseva, "Prikhodite pogovorit' o poezii . . . ," *Avrora* 10 (1975): 70–72, 72.

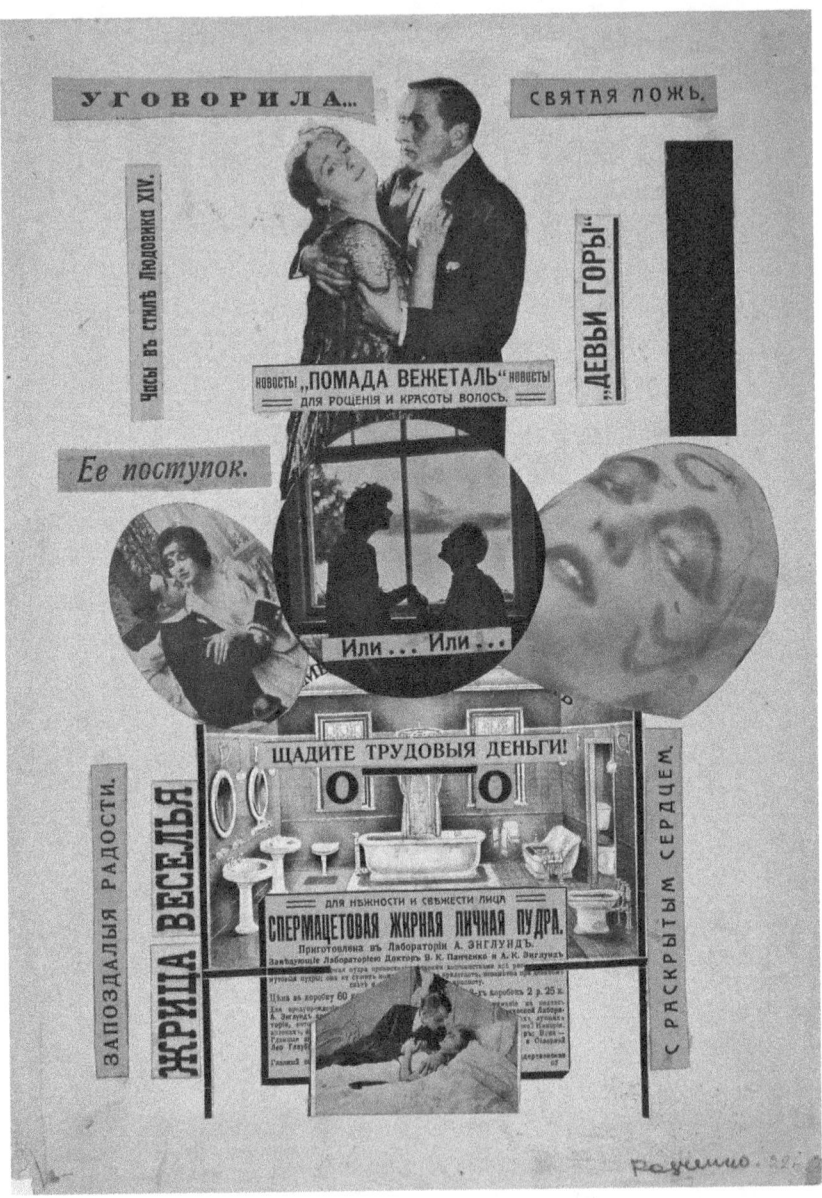

Fig. 3.1 Aleksandr Rodchenko's photomontage "Psychology," published in *Kinofot* 3 (1922): 12. Image courtesy the Rodchenko Estate; reproduced with the kind permission of Aleksandr Lavrent'ev.

3

Scores of Movement

Lev Kuleshov's Approach to Film Acting

The "psychological" prevents man from being as precise as a stop-watch; it interferes with his desire for kinship with the machine.
 —Dziga Vertov[1]

The film actor performs not in front of an audience but in front of an apparatus. The film director occupies exactly the same position as the examiner in an aptitude test. . . . To accomplish it [this test] is to preserve one's humanity in the face of the apparatus.
 —Walter Benjamin[2]

"There is a question: does our montage-oriented cinema need the actor at all? Our actor is fragmented, analyzed, and exists in the form of montage," wrote Viktor Shklovskii in 1928, summing up some of the most radical approaches to cinema acting that had emerged in Russia within the past decade. [3] His point referred to the manifestoes of his friend, the filmmaker Lev Kuleshov, who proclaimed that cinema actors had nothing to learn from theatrical traditions, and particularly from the venerated notion of "experiencing" (*perezhivanie*) associated with Konstantin Stanislavsky's method—the idea that the actor must conjure up the emotional states that he seeks to portray.

Thus in his influential article "Montage" (1922), Kuleshov described several editing experiments that proved that one and the same actor's pose or facial expression will be interpreted differently by the spectators, depending on the

[1] Dziga Vertov, "We: Variant of a Manifesto" (1922), in *Kino-Eye: The Writings of Dziga Vertov*, ed. Annette Michelson, trans. Kevin O'Brien (Berkeley: University of California Press, 2008), 5–9, 7.

[2] Walter Benjamin, "The Work of Art: Second Version," in *The Work of Art in the Age of Its Technological Reproducibility and Other Writings on the Media*, ed. Michael W. Jennings, Brigid Doherty, and Thomas Y. Levin, trans. Edmund Jephcott et al. (Cambridge, MA: Harvard Belknap Press, 2008), 19–55, 30–31.

[3] Viktor Shklovskii, "Sovetskaia shkola akterskoi igry," *Za sorok let. Stat'i o kino* (Moskva: Iskusstvo, 1965), 107–108, 108. At the time of writing this essay, Shklovsky must have been responding to the changing political climate, when the radical avant-garde experimentation of Kuleshov and Eisenstein was increasingly coming under attack.

Psychomotor Aesthetics. Ana Hedberg Olenina, Oxford University Press (2020). © Oxford University Press.
DOI: 10.1093/oso/9780190051259.001.0001

context in which the shot is placed. Describing this effect, Kuleshov concluded that "in cinema, the actor's expression of a certain feeling has nothing to do with its cause." [4] The article also contained examples showing that the cinema actor is not necessarily a unified organism existing in a particular space and time. Montage can synthesize an image of a person out of various people's body parts; it can create a "dynamic image of dance" out of shots taken at different times from different angles; it can assemble a scene of two people's meeting in a fictitious topography, combining shots from Moscow and Washington. [5] All in all, according to this article, the image of the actress on screen turned out to be an arrangement of details and fragments of movement, carefully chosen by the editor to evoke a sense of what this person looks like, what she is doing, what she sees, what is on her mind, where she is headed, and so forth. Emphatically rejecting the old-fashioned, "theatrical" ways of thinking about the actor's craft, Kuleshov stated that his own workshop aimed to explore rhythmically precise movements with clear trajectories, which add up to a legible, neat ornament when they are put together in a montage sequence. [6] Simple geometry of movements and clarity of shot compositions, according to Kuleshov, guaranteed that the spectator's perception of characters and narrative developments would proceed in a most expedient and effective way. "First of all, we must get rid of the actor [aktera] and construct the human apparatus from a scientific point of view. The actor [naturshchik] must become a machine.... [T]he human instrument must present its movement in space and time in a calculated way," wrote the Constructivist designer Aleksei Gan, praising Kuleshov's principles after visiting the filmmaker's workshop in 1922. [7]

Kuleshov's seemingly mechanistic theory of the cinematic model (he preferred the term "model," naturshchik, to the more common "actor," akter) secured him a long-lasting reputation as an "anti-psychological" director. Indeed, the very term "psychology" was something of a curse word for all leftist artists of Kuleshov's generation. A typical example of this attitude is Aleksandr Rodchenko's photocollage entitled "Psychology" (Fig. 3.1) that accompanied Kuleshov's article "Montage" in the avant-garde journal Kino-fot.[8] Rodchenko's illustration combined photographs of languorous divas, still frames of passionate love scenes

[4] Lev Kuleshov, "Montazh," Kino-fot 3 (1922): 11–12, 12. Kuleshov made similar claims earlier—see Lev Kuleshov, "Znamia Kinematografii" (1920), in Stat'i. Materialy (Moskva: Iskusstvo, 1979), 87–113, 102.

[5] On the history of these experiments, see Ekaterina Khokhlova, Kristin Thompson, and Yuri Tsivian, "The Rediscovery of a Kuleshov Experiment: A Dossier," Film History 8.3 (1996): 357–367.

[6] Lev Kuleshov, Otchet za pervuiu polovinu 1923 g. i preiskurant raboty zhivogo materiala eksperimental'noi laboratorii na 1923/24 gg," Sobranie sochinenii, vol. 1 (Moskva: Iskusstvo, 1987), 356–370, 365.

[7] Aleksei Gan, "Kino-tekhnikum," Ermitazh 10 (1922): 10–11, 11.

[8] Lev Kuleshov, "Montazh," Kino-fot 3 (1922): 12.

with phrases "She persuaded him," "Either . . . or . . . ," "With wide-open heart," "A sacred lie," and titles of tear-jerking melodramas. At the foundation of the composition stood a magazine clipping that seemed to pass a verdict on the whole boudoir atmosphere with the words of a commercial: "Spermaceti Grease Personal Cream Powder." Thus, "psychology" was associated for Rodchenko with coquettish intrigues, false pathos, pretentiousness, and gaudy histrionics. The imagery of his collage brought to mind the second-rate theater and sloppy film dramas despised by Kuleshov for clichéd and exaggerated acting.

The sharp wit with which the avant-garde artists of the 1920s condemned so-called psychological cinema and ridiculed the principle of "experiencing" (*perezhivanie*) has perpetuated a belief that Kuleshov's ideal actor was a puppet or passionless automaton, performing stunts with machine-like precision. However, it would be wrong to assume that by extolling the technical aspect of the actor's training, Kuleshov erased the term "emotion" from his lexicon. While formulating his "laws of cinematic expression," Kuleshov was searching for the most effective ways of capturing the viewers' attention, as well as provoking and regulating their reactions. As far as the actor's craft was concerned, Kuleshov's explorations were driven by his conviction that the performer must exploit the abilities of his or her body to the maximum extent and create corporeal spectacles that would strike the audience with their unusualness, dynamism, and perfection in every detail. Thus the acting etudes and films created by Kuleshov's troupe in the 1920s were marked by a clear tendency toward tragicomic grotesquerie and buffoonery, on the one hand, and, on the other hand, extreme physical performances. This combination can be seen in *The Extraordinary Adventures of Mr. West in the Land of the Bolsheviks* (*Neobychainye prikliucheniia Mistera Vesta v strane bol'shevikov*, 1924), in a scene where Cowboy Jeddy makes his way across the street by means of tightrope stretched at the height of the fifth floor. Another similar example is a scene of combat on the swamps in *The Ray of Death* (*Luch smerti*, 1925), where the fighters get sucked into the bog. Of course, in considering the actor's work, Kuleshov was first and foremost concerned not with the inner experience of the person, but with the external result—with a dynamic corporeal action corresponding to his or her psychological state. However, as I would like to show in this chapter, Kuleshov's preoccupation with the question of what constituted a plausible and convincing gestural expression—as well as the way in which the actor and the director-editor might achieve it—compelled him to confront problems that were of importance to modern experimental and applied psychology. Like his contemporaries, Kuleshov was addressing these issues through recourse to popularized scientific sources.

If we carefully examine Kuleshov's argument in his essay "Montage," we may notice that that he is not saying that "the emotional aspect of the actor" has little importance, but that "up until now it has been little studied" and never duly

considered in earlier cinema.[9] In 1923, when he was developing a curriculum
for his cinematic workshop at the State School of Cinematography in Moscow,
he emphasized that "the actor must be aware of the psychological and physiolog-
ical meaning of movement"[10] and learn to "distribute the durations of his actions
harmoniously."[11] Later, he would state that one of the major achievements of his
workshop was the fact that "the training of actors stopped referring to the magic
of inspiration and began to be organized scientifically."[12] In 1925, he supported
his former student Vsevolod Pudovkin's plan to make a scientific documentary
on Ivan Pavlov's reflexology and accompanied Pudovkin to Pavlov's laboratory
near Leningrad in order to discuss the production of the film that would come
out in the next year under the title *Mechanics of the Human Brain* (*Mekhanika
golovnogo mozga*).[13]

Contemporary developments in experimental psychology and their
reverberations in popular culture provide a key dimension of a historical un-
derstanding of Kuleshov's conceptions of expressive movement. By the time
Kuleshov wrote his first manifestoes, psychology in Russia, Western Europe,
and the United States had been dominated by approaches derived from nat-
ural sciences for several decades. Since the opening of the Wilhelm Wundt's and
William James's experimental laboratories in the 1870s, psychology as a disci-
pline came to prioritize empirical methods that examined the functioning of the
nervous system by registering its external manifestations. Vladimir Bekhterev,
who founded the first laboratory of this kind in Russia in 1886, argued—with
reference to the legacy of Ivan Sechenov—that psychology cannot be limited by
the study of phenomena available to consciousness through self-observation.
This discipline, he insisted, must develop methods capable of accounting for
psychological processes that are inaccessible to consciousness or will. The new
"objective psychology" had to introduce observations on changes in breathing,
heartbeat, and temperature in different psychological states; and to pay special
attention to the motor reactions of the organism.[14] In the early 1920s, this ma-
terialist approach to psychology received a special impetus, because Bolshevik
leaders (in particular, Vladimir Lenin, Leon Trotsky, Nikolai Bukharin, and
Grigorii Zinov'ev) saw in it an opportunity to use science for the purposes of ide-
ology. For them, a simplified version of reflexology became a key to fostering the

[9] Lev Kuleshov, "Montazh," *Kino-fot* 3 (1922): 12.
[10] Lev Kuleshov, "Otchet za pervuiu polovinu 1923 g . . . ," 366.
[11] Ibid.
[12] Lev Kuleshov, "Rabota ruk" (1926), *Sobranie sochinenii*, vol. 1 (Moskva: Iskusstvo, 1987),
109–110, 110.
[13] Lev Kuleshov and Aleksandra Khokhlova, *50 let v kino* (Moskva: Iskusstvo, 1975), 96.
[14] Vladimir Bekhterev, "Obosnovanie ob"ektivnoi psikhologii," *Vestnik psikhologii, kriminal'noi
antropologii i gipnotizma* 1 (1907): 3–20, 6–7.

New Soviet Man.[15] As Trotsky famously proclaimed in 1923, during socialism, "man will finally be able to harmonize his own nature. He will eventually take control of all unconscious processes: breathing, blood circulation, digestion, etc.; he will bring himself up to a new level, becoming a higher social-biological type; a superman, if you will." [16]

As the film scholar Mikhail Iampolski has shown, Kuleshov's efforts to train his actors for maximum precision cannot be considered apart from this ideologically saturated discourse on "new anthropology."[17] The atmosphere of the 1920s in the Soviet Union was permeated by utopian beliefs in technological progress and the possibility of improving the psychology and physiology of the New Soviet Man by optimizing his daily habits with the help of the latest achievements in labor efficiency studies. These studies were referred to in Russia as Taylorism—after Frederick W. Taylor, a famous American industrial management consultant, who proposed to rationalize time and labor efforts in Henry Ford's assembly line units. In her book called *The Factory of Gestures*, the cultural historian Oksana Bulgakowa discusses a utopian idea, characteristic of the 1920s, that cinema as a mass medium could help disseminate "the new techniques of the body," and especially, "Taylorized" habits of factory work, among common people.[18] She places Kuleshov's method in the context of other schools of actors' training in

[15] Orlando Figes, *A People's Tragedy: A History of the Russian Revolution* (New York: Viking Penguin, 1996), 734. According to the German journalist René Fülöp-Miller, who visited Russia in the mid-1920s, Bolshevik ideologues simplified and vulgarized Pavlov's reflexology as they adapted it for propaganda means: "The fact that Pavlov's 'conditioned reflexes' seem to demonstrate the transition from purely physiological automatism to associations of ideas and primitive forms of thought, was grotesquely exaggerated by the Bolsheviks in their claim that all spiritual endeavors of mankind whatsoever, even art and science, are an expression of a mere mechanism, a product of a more or less complicated factory. Whether Pavlov himself held such materialistic-metaphysical views is in the highest degree doubtful; it is generally known that, by political conviction, he was anything but a Bolshevik." (René Fülöp-Miller, *The Mind and Face of Bolshevism: An Examination of Cultural Life in Soviet Russia* (London: G. P. Putnam's Sons, 1927), 58.

[16] Leon Trotsky, *Literatura i revoliutsiia* (1923) (Moskva: Izd.-vo politicheskoi literatury, 1991), 197.

[17] Mikhail Iampolski, "Kuleshov and the New Anthropology of the Actor," in *Inside the Film Factory: New Approaches to Russian and Soviet Cinema*, ed. Richard Taylor and Ian Christie (London: Routledge, 1991), 31–50. Iampolski shows that Kuleshov's methods of actors' training were inspired by earlier traditions of François Delsarte and Émile Jaques-Dalcroze, which likened the actor's body to an instrument and sought to systematize his gestural capabilities. It is this pursuit of control over the performer's body that, in Iampolski's view, underscores the authoritarian tendencies of Kuleshov's system. In turn, Jaques-Dalcroze's technique of rhythmical movement, created in the first decades of the 20th century, similarly received controversial scholarly evaluations for its role in German body-cultures (on Jaques-Dalcroze and German vitalist approaches to liberating the inner rhythm of the modern man, see Nina Lara Rosenblatt, "Photogenic Neurasthenia: On Mass and Medium in the 1920s," *October* 86 (1998): 47–62; Michael Cowan, *Technology's Pulse: Essays on Rhythm in German Modernism*. London: Institute of Germanic & Romance Studies, School of Advanced Study, University of London, 2011, 13).

[18] Oksana Bulgakova, "Laboratoriia pravil'nogo dvizheniia," *Fabrika zhestov* (Moscow: NLO, 2005), 130–136. See also Susan Buck-Morss, *Dreamworld and Catastrophe: The Passing of Mass Utopia in East and West* (Cambridge, MA: MIT Press, 2000), 104–111.

this epoch—Vsevolod Meyerhold's *biomechanics*, Boris Ferdinandov's *metro-rhythm*, Nikolai Foregger's *ta-fia-trenazh*, and the Factory of the Eccentric Actor (FEKS)—noting one common trait in all of these systems: their emphasis on "clear rhythm defined not by the biological body but by the machine."[19]

Kuleshov's cinematic theory and practice fits within this context. His strategies for registering, classifying, and drafting movement, as well as specific material tools and apparatuses speak to his efforts in for developing a new, more effective corporeal plasticity in his actors. Kuleshov's approach descends from the techniques of recording and representing corporeal movement that emerged in the late 19th and early 20th centuries in domains such as neurophysiology, locomotion studies, and industrial labor management. In these fields, cinema and its precursor, chronophotography, often functioned alongside graphs of muscular tension and records of vital signs as an indexical record—that is, as a direct material indicator of processes occurring in the person's body, including psychological acts. The data gathered using all of these new techniques were often used for the purpose of rationalizing or optimizing natural movement, systematizing the capabilities of the organism, and asserting control over it.

Considering Kuleshov in this context reveals the discursive sources of metaphors that the director employed when speaking of his approach to the actor's craft:

> The actor . . . must be analytically taken apart and examined . . . as a complex work of engineering. We must register his excitement as if it were an electric current feeding a factory and inscribe his techniques using algebraic formulas. . . .[T]he actor must be Taylorized and work in accordance with a time management chart.[20]

At the same time, I would like to demonstrate that despite the radical metaphors that Kuleshov uses in his theoretical texts, his practice escapes the positivism and utilitarianism that characterized scientific studies aimed at optimizing man's motor habits and controlling the expenditures of his psychophysiological energy. As we will see, the result of Kuleshov's work—the way his actors perform in his early films—does not fit in the framework of normalized corporeality.

[19] Bulgakowa, *Fabrika zhestov*, 130.
[20] Lev Kuleshov, "Kinematograficheskii naturshchik," *Zrelishcha* 1 (1922): 16.

Taking Expression Apart

Kuleshov's approach to the expressive capabilities of the body may be illustrated by a telling example. In 1926, the director and a troupe of actors that he trained embarked on filming their third project, *By the Law* (*Po zakonu*, 1926). This film was conceived from the start as an exploration in "psychological action," as Viktor Shklovskii, the scriptwriter for the film, recalled in his memoirs. [21] This tightly wrought drama was written with the intention of showcasing the acting skills of Kuleshov's students.

The plot of the film was based on Jack London's story "The Unexpected." It deals with a murder that happened among a small group of gold diggers cut off from the rest of the world in the snowy deserts of the Klondike. Two survivors take upon themselves the moral responsibility of conducting a trial over their former comrade and sentence him to death by hanging. The dramaturgical charge of this fabula was presented in the film by the escalating nervous tension, as the actors' performance swung from hysteria and rage to stupor and complete catalepsy. One of the most striking sequences in this respect is the scene of the fight after the murder. The gunman Michael Dennin (Vladimir Fogel') is attacked by the terrified Edith (Aleksandra Khokhlova), who attempts to wrestle the rifle out of his hands. During the fight, Dennin grabs Edith by the waist and hurls her around, at one moment turning her upside down. [22] In this sequence, Kuleshov inserts a brief close-up of Khokhlova's distorted face. This is an image that was produced by Kuleshov's crew in the following manner: they constructed a special apparatus, a "mill-centrifuge," to which they tied Khokhlova and gave her a mini hand-held camera so that she would be able to film her own facial expressions while spinning. [23] This stunt was proudly advertised by Kuleshov in the popular film magazine *Sovetskii Ekran* 34 (1926), in which he published a photograph of Khokhlova tied upside down to this strange machine for obtaining the "special effects" of facial motorics (Fig. 3.2). [24]

[21] Viktor Shklovskii, "Ikh nastoiashchee," *Za sorok let. Stat'i o kino* (Moskva: Iskusstvo, 1965), 65–86, 66.

[22] As a writer inclined to naturalistic descriptions, Jack London presented the fight scene in great detail, and Kuleshov's film faithfully followed his story. The combat scene in "The Unexpected" contains a moment where Dennin hurls Edith about, albeit the "rotation" happens on a plane parallel to the floor, rather than vertically like in Kuleshov's film: "She threw herself to one side, and with her grip at his throat nearly jerked him to the floor. . . . Still faithful to her hold, her body followed the circle of his whirl so that her feet left the floor, and she swung through the air fastened to his throat by her hands." (Jack London, "The Unexpected," *The Complete Short Stories of Jack London: 3* [Stanford, CA: Stanford University Press, 1993], 998–1016, 1003).

[23] Lev Kuleshov and Aleksandra Khokhlova, *50 let v kino* (Moskva: Iskusstvo, 1975).

[24] The shot was later republished in Lev Kuleshov and Aleksandra Khokhlova, *50 let v kino* (Moskva: Iskusstvo, 1975).

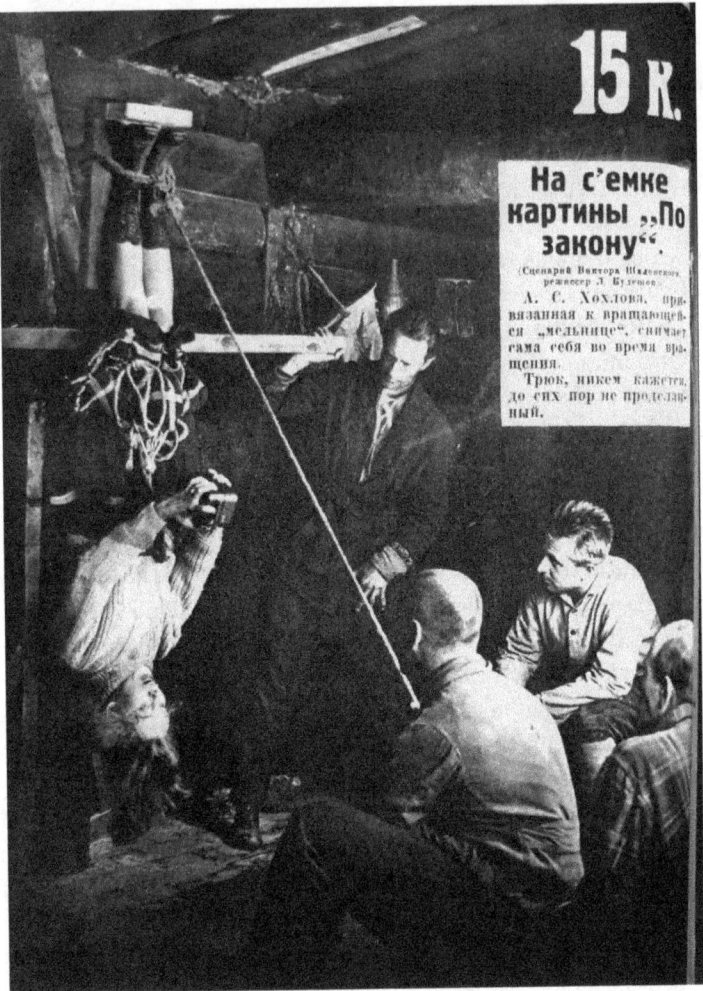

Fig. 3.2 Kuleshov and his crew filming a scene for *By the Law* (1926). Kuleshov's wife, the actress Aleksandra Khokhlova, tied to a spinning "mill," is filming herself with a handheld camera. This production shot was published on the back cover of *Sovetskii Ekran* 34 (1926).

Why did Kuleshov need this image? What logic prompted him to obtain it in this manner? We know that initially, he planned to dramatize the chaotic dynamism of the fight by splicing together the shots of the blows with vertiginously filmed images of the room. The director's script for the film published by Shklovskii mentions "views of the room upside down and tilted to the sides"

Fig. 3.3 The scene of the fight between Dennin (Fogel') and Edith (Khokhlova) in By the Law. Image source: *By the Law [Po Zakonu]*, dir. Lev Kuleshov. DVD. *Landmarks of Early Soviet Film* (Los Angeles: Flicker Alley, 2011).

in the fight scene.[25] A similar device had already been used by Kuleshov in *Mr. West*, where the view of the room was blurred and began to float before the eyes of the protagonist to suggest his emotional turmoil during his trial by villains. While shooting *By the Law*, however, Kuleshov changed his original plan and substituted the envisaged point-of-view shots of the madly spinning room with a reflection of an extreme physical condition on the actress's face (Figs. 3.3 and 3.4). Perhaps he thought that a close-up of these out-of-the-ordinary facial contortions would convey the experience of spinning in a more gripping way and produce a stronger impression on the audience than a pale approximation of what the room might look like to someone engaged in a violent fight. I would argue that another motive behind Kuleshov's decision was a desire to stage an experiment, that is, to recreate the conditions of the spin in order to investigate an array of involuntary facial reactions in this situation. In other words, Kuleshov and his group were approaching the portrayal of heightened affective states

[25] Viktor Shklovskii, "Po zakonu:" otryvok stenariia," *Kino* 13(133), March 30, 1926, 1.

Fig. 3.4. A close-up of Edith's (Khokhlova's) face, which Kuleshov added to the montage sequence of the fight in *By the Law*. Image source: *By the Law* [*Po Zakonu*], dir. Lev Kuleshov. DVD. *Landmarks of Early Soviet Film* (Los Angeles: Flicker Alley, 2011).

characterizing London's heroes through physical means, by forcing their bodies to experience extreme physical conditions. The guiding aesthetic principle at work here may be called "physiological realism." It is fueled by the same belief in the power of naturalistic detail that—to use a famous example—compelled Flaubert to describe Madam Bovary's arsenic-induced agony by using medical treatises on poisoning. What such scenes reveal, more that anything, is how the pursuit of the "truth" of the body can verge on sensationalism, a search for verisimilitude can mix with the need to impress, and the scientist's adherence to raw data can clash with the artist's desire to force mute nature into communication. A curious complication to the principle of physiological realism in the case of *By the Law* is, of course, the fact that it is a staged performance and an edited sequence. In placing his lead actress on the "mill-centrifuge," Kuleshov seems to care first and foremost about the peculiar facial distortions provoked by the experience of spinning. The plausibility of facial reactions during the rotation is a matter of crucial importance. But imbuing the face with emotions significant for the narrative is a task that Kuleshov leaves to the viewer, guiding him by

montage. As long as the spectators find the spinning convincing, Kuleshov seems to reckon, they will also read off that frenzied mixture of fear, anger, and courage which characterizes London's heroine from Khokhlova's face. Comparing the close-up with the photograph of the actress on the apparatus—the meta-text that Kuleshov publicized as the film was about to appear in theaters—the peculiarities of his approach to acting come to the fore. If it was spontaneous, unfeigned reflexes of the face that he was after, the shooting setup that he built bespeaks a meticulous control over the conditions in which this corporeal performance can occur. Rather than giving the play of the flesh a free reign, the filmmaker delimits the range of corporeal reactions that appear useful for the image of the fighting Edith. Likewise, the fact that Khokhlova is given a handheld camera to film her own face may suggest a striving for a greater intimacy of the close-up—so that nothing would inhibit or disturb the recording of her facial distortions. Yet the network of gazes that surrounds her on the filming set testifies to a complex dynamics of display and calculated exhibitionism at work here. Overall, this scene is presented in the journal as a scientific experiment in cinema acting and an ultimate example of athletic prowess, no less spectacular than those in the American adventure films that Kuleshov competed against.

The example of Khokhlova on the spinning apparatus illustrates what I see as one of the most fundamental elements in Kuleshov's philosophy of acting: his predilection for extreme physical experiences. In addition to encouraging his actors to perform life-threatening stunts and endure extraordinary physical strain, he would often combine such scenes with acrobatic numbers and grotesque action. As a result, Kuleshov's films often confront the viewer with unusual physical performances—what may be called "monstrous" spectacles of corporeal plasticity. Kuleshov famously used the word "monster" in his description of the ideal cinematic model-actor:

> We know that cinema does not need theater actors; we know that an ordinary man with his wimpy physique is not acceptable in cinema. We need "monsters" [*chudovishcha*], as Akhramovich-Ashmarin, one of the first leftist Russian filmmakers, has put it. "Monsters," that is, the people who have managed to nurture their body with reference to a precise study of its mechanical construction. "Monsters," whose vigor, strength and heroism would translate into the reality much needed by cinema, rather than the conventionality that kills it. [26]

[26] Lev Kuleshov, "Esli teper' . . . " (1922), in *Sobranie sochinenii*, vol. 1 (Moskva: Iskusstvo, 1987), 90–91. Vitol'd Akhramovich-Ashmarin had been a scriptwriter at Evgenii Bauer's studio, where the seventeen-year-old Kuleshov began his film career as an assistant set designer.

The Russian word for "monster," *chudovishche*, derives from *chudo*—"marvel," or "a fiend." In Kuleshov's usage, this word refers to a type of superhuman athleticism that is terrific and terrifying at the same time. Translating this term as "monster" (phonetically reminiscent, if not etymologically related to the Latin words *mōnstrum* "a miracle" and *mōnstrāre* "to show")[27] has the advantage of pointing out the element of spectacle that is absolutely crucial for Kuleshov's idea of the model's performance.

But even without this convenient play of language and the serendipitous mention of "monster" by Kuleshov, one could make an argument that the stylistics of his first films puts them squarely in the same camp as other avant-garde works of the 1920s that, in Tom Gunning's definition, continue the tradition of the early "cinema of attractions."[28] Gunning's concept refers to the pioneering forms of filmmaking that predate the period of "narrative consolidation," during which cinema turned into the big business of storytelling. Prior to 1907, Gunning argues, motion pictures were perceived predominately as a new form of visual experience and also as a tool for producing new kinds of visual knowledge. Emerging technologies of film recording and projection were employed for the first time for creating new perspectives on the physical world, and in particular, for an impressive representation of human movement, unavailable to the naked eye. One of the prime examples of this preoccupation, according to Gunning, is the early "physiognomic films" like *Fred Ott's Sneeze* (1894) and *The May Irwin Kiss* (1896), in which the main attraction is an unprecedentedly detailed view of facial grimacing.[29]

Beyond the pursuit of entertaining spectacles, this tradition was nourished by a belief that the camera could penetrate the secrets of physiological processes and reveal something new about the sensory perceptions and psychological experiences that accompany them. Among Kuleshov's contemporaries, we can see traces of this belief in the writings of Dziga Vertov. In 1918, Vertov started

[27] "monster, n.," *OED Online* (Oxford University Press, 2010), http://www.oed.com ; "†monstration, n.," *OED Online* (Oxford University Press, 2010), http://www.oed.com ; "mōnstrum, n.," *An Elementary Latin Dictionary* by Charlton T. Lewis (New York: American Book Company, 1890); *Perseus Digital Library*, Perseus 4.0, http://www.perseus.tufts.edu.

[28] The synonymous concepts of the "cinema of attractions" and "cinema of monstration" were introduced by Tom Gunning and André Gaudreault to capture the aesthetics of early prenarrative cinema, which was oriented toward spectacle. They argued that this type of cinema engaged the viewer on a visceral, kinesthetic level instead of prompting emotional identification with characters. An ostentatious, self-aware art form, early cinema allowed the viewers to retain their critical distance vis-à-vis the events onscreen. See Tom Gunning, "The Cinema of Attractions: Early Film, Its Spectator and the Avant-Garde," in *Early Cinema: Space, Frame, Narrative*, ed. Thomas Elsaesser and Adam Barker (London: British Film Institute, 1990), 56–62. For a history of these terms and their usefulness for identifying elements of "monstration" in contemporary cinema, see Wanda Strauven, ed., *Cinema of Attractions Reloaded* (Amsterdam: Amsterdam University Press, 2006).

[29] Tom Gunning, "In Your Face: Physiognomy, Photography, and the Gnostic Mission of Early Film," *Modernism/modernity* 4.1 (1997): 1–29, 2.

his career in cinema by filming his own face during a jump from a two-story building. Upon watching the footage, he stated:

> [The slow projection] allowed me to see my thoughts during the jump, the hesitant expression of my face, then the desire to hide hesitation, to put on the mask of firmness, then the actual decision to jump no matter what, then my fear during the flight down.[30]

In the 1920s, Jean Epstein and Béla Balázs wrote about the enchanting "dramaturgy" of the face filmed in close-up—about the play of facial muscles, reflecting the polyphony of emotions taking over the person.[31] Walter Benjamin stated that photo enlargement does not simply clarify the details but "reveals entirely new structural formations of the subject," while slow motion turns regular movements into some kind of "supernatural" gliding, opening up in them aspects that were as of yet unknown.[32] Before the invention of cinema, he wrote, nobody knew how the posture of the walking man changes "during the fractural second of a stride," or how the fingers picking up a lighter or a spoon interact with the metal, "not to mention how this fluctuates with our moods."[33] Drawing a parallel between the cameraman and surgeon-anatomist, or else, between the cameraman and a psychologist, Benjamin wrote: "Actually, of a screened behavior item which is neatly brought out of a certain situation, like a muscle of a body, it is difficult to say which is more fascinating, its artistic value or its value for science." [34]

As far as the photo-observation of corporeal motorics was concerned, the crossing of interests between the sciences and the arts began in the 19th century. To give just a few examples, in 1872, Charles Darwin illustrated his treatise *The Expression of Emotions in Animals and Man* with photographs of crying children, smiling old men, frowning young men, and ladies contemptuously curling their lips.[35] A special place in the book was taken up by photo-experiments sent to

[30] Dziga Vertov, "Three Songs of Lenin and Kino-Eye," *Kino-Eye: the Writings of Dziga Vertov*, ed. Annette Michelson (Berkeley: University of California Press, 1984), 123–125, 123. See also Dziga Vertov, "O kino-pravde," in *Dziga Vertov: Iz naslediia. Tom vtoroi: stat'i i vystuplenia* (Moscow: Eizenshtein-tsentr, 2008), 267–275, 270.

[31] Béla Balázs, *Béla Balázs: Early Film Theory: Visible Man and the Spirit of Film*, trans. Erica Carter (New York: Berghahn Books, 2010), 38–39; Jean Epstein, "Magnification," in *French Film Theory and Criticism: A History/Anthology, Volume I: 1907–1929*, Richard Abel, ed. (Princeton, NJ: Princeton University Press, 1988), 235–240, 236–238.

[32] Walter Benjamin, "The Work of Art in the Age of Mechanical Reproduction," in *Illuminations*, ed. Hannah Arendt, trans. Harry Zorn (London: Pimlico, 1999), 217–252, 236.

[33] Benjamin, "The Work of Art in the Age of Mechanical Reproduction," in *Illuminations*, 237.

[34] Ibid., 236.

[35] On Darwin's use of photographs, some of which featured actors and some of which featured ordinary adults and children genuinely experiencing various emotions, see Phillip Prodger, *Darwin's Camera: Art and Photography in the Theory of Evolution* (Oxford: Oxford University Press, 2009);

Darwin by the French physiologist Duchenne de Boulogne. Duchenne applied electricity to the faces of his patients to see which muscular contractions produce expressions recognizable as signs of emotions.[36] Astonished by the capabilities of photography, Darwin stated that he rejected the idea of examining facial expression on the basis of paintings and sculptures, because artists' representations were too often guided by their own ideas about beauty, rather than a faithful reproduction of anatomy. To reinforce this thought, he cited Gotthold Lessing's famous claim that Laokoon's face is not disfigured by ugly spasms.[37] For both Darwin and Duchenne, photography provided a more perfect anatomical tool than previous methods like vivisection, which could never exhibit the minute articulations of the living flesh in motion.[38] Duchenne later donated his works to the French École des Beaux-Arts as a model for painters. The fame of these photographs, after their publication by Darwin, was far reaching. In Russia, they were known not only to biomedical specialists, but also to the wider public. For example, in 1912, a popular Moscow film magazine *Sine-Fono* published a long article on "The Significance of Photography for Psychology," praising Duchenne as the pioneer of a new methodology for examining the fleeting transformations of the face during affect.[39] "Movements of various muscles of the face and the body," the article stated, "define the external manifestations of various psychological experiences,"[40] which means that photography and, especially, cinema, capable of instantaneously recording these corporeal events, provide useful data for scientific analysis. "Of great use to the psychologist," the essay surmised,

will be photographic images and motion pictures conveying natural colors. . . . The flushing of the face accompanying the movements of the psyche (rage, happiness, fright, etc.) is in constant fluctuation, and our visual perception of it is composed of a whole series of consequent color changes. A detailed examination of this phenomenon is impossible at present, and getting to it is as difficult

Daniel Gross, "Defending the Humanities with Charles Darwin's *The Expression of Emotions in Animals and Man* (1872)," *Critical Inquiry* 37.1 (2010): 34–59.

[36] G. B. Duchenne de Boulogne, *Mécanisme de la physionomie humaine, ou Analyse électro-physiologique de l'expression des passions applicable à la pratique des arts plastiques* (Paris: Chez Ve Jules Renouard, Libraire, 1862). In addition to his neurophysiologic experiments, this treatise discusses expressive strategies of pantomime actors.

[37] Charles Darwin, *The Expression of the Emotions in Man and Animals* (New York: D. Appleton and Co., 1897), 14.

[38] François Delaporte, *Anatomy of the Passions*, trans. Susan Emanuel, ed. Todd Meyers (Stanford, CA: Stanford University Press, 2008), 2–5.

[39] P. S. "Znachenie fotografii dlia psikhologii," in *Sine-fono: zhurnal sinematografii, govoriashchikh mashin i fotografii* 7 (1912): 8–9.

[40] Ibid., 8.

as it was at some point to imagine the invention of instantaneous photography for studying the changing positions of a flying bird or a falling cat.[41]

The author established a direct lineage from the psychophysiology of the future to its distinguished roots: Étienne-Jules Marey's studies of human and animal locomotion via chronophotography and myography (graphs of muscular tension). It is impossible to overestimate the influence that Marey's methods had on various arts and sciences from the 1870s onward. In the 1880s, the French neurophysiologist Paul Richer, who worked alongside a famous disciple of Duchenne, the psychiatrist Jean-Martin Charcot, used Marey's method for recording muscular tensions of patients undergoing hysterical attacks (Figs. 3.5 and 3.6).[42] In the 1910s, Marey's chronophotography inspired Marcel Duchamp, Giacomo Balla, and other Futurist painters to create representations of human movement decomposed into consecutive phases.[43]

In the 1890s, the French military commissioned Marey to analyze the ergonomics of soldiers' performance on endurance tasks so as to streamline their movement routines and avoid unnecessary strain.[44] In Russia, the practical potential of Marey's chronophotography was acknowledged in scientific and popular journals before the Revolution, achieving an even greater fame in the utopian atmosphere of the early 1920s (Fig. 3.7).[45] The French scientist's methods of recording bodily movement for the sake of optimizing motor habits became a prototype for the research on biomechanics and labor efficiency carried out at The Central Institute of Labor in Moscow. Avant-garde theater reformers

[41] Ibid., 9. The article mentions chronophotographic studies of the falling cat and the flying bird in passim, as if they were something that the readers may well have heard of. These were, of course, some of the most famous image series captured by Étienne-Jules Marey in the early 1890s. See Marta Braun, *Picturing Time: The Work of Etienne-Jules Marey (1830–1904)* (Chicago: University of Chicago Press, 1992), 166–170, 401.

[42] Paul Marie Louis Pierre Richer, *Études cliniques sur la grande hystérie ou hystéro-épilepsie* (Paris: A. Delahaye, 1885). Besides myographic charts of muscular tension and drawings of the patients' changing body positions during different phases of the hysteria attack, a large part of Richer's book is devoted to an analysis of artistic representations of "the possessed" throughout the centuries of European history.

[43] Sigfried Giedion, *Mechanization Takes Command, a Contribution to Anonymous History* (New York: Oxford University Press, 1948), 21–30. Friedrich A. Kittler, *Gramophone, Film, Typewriter*, trans. Geoffrey Winthrop-Young and Michael Wutz (Stanford, CA: Stanford University Press, 1999), 139.

[44] Marta Braun, "Le corps au travail: éducation physique," in *La Science du Mouvement et l'Image du Temps: Exposition Virtuelle Marey* (Collège de France & Bibliothèque Interuniversitaire de Médecine et d'Odontologie), http://www.bium.univ-paris5.fr/marey/debut2.htm. Also see Marta Braun, *Picturing Time: The Work of Etienne-Jules Marey (1830–1904)* (Chicago: University of Chicago Press, 1992); Anson Rabinbach, *The Human Motor: Energy, Fatigue, and the Origins of Modernity* (Los Angeles: University of California Press, 1992).

[45] Marey's work was reviewed in both scientific and popular publications, dealing with chronophotography and cinema, for instance: L. Morochowetz, "Die Chronophotographie im physiologischen Institut der K. Universität in Moskau," *Le Physiologiste Russe* 2 (1900): 51–61; Anonymous, "Sinematograf pri nauchnykh issledovaniiakh," *Sine-fono* 4 (1911): 10.

(30) DE L'HYPNOTISME HYSTÉRIQUE OU GRAND HYPNOTISME

ARTICLE V

De la forme de la secousse musculaire dans les diverses périodes
de l'hypnotisme

Ces recherches ont été faites au moyen des procédés de la méthode
graphique de M. le professeur Marey. Sans entrer dans la description
des appareils bien connus qui nous ont servi, je donnerai schémati-

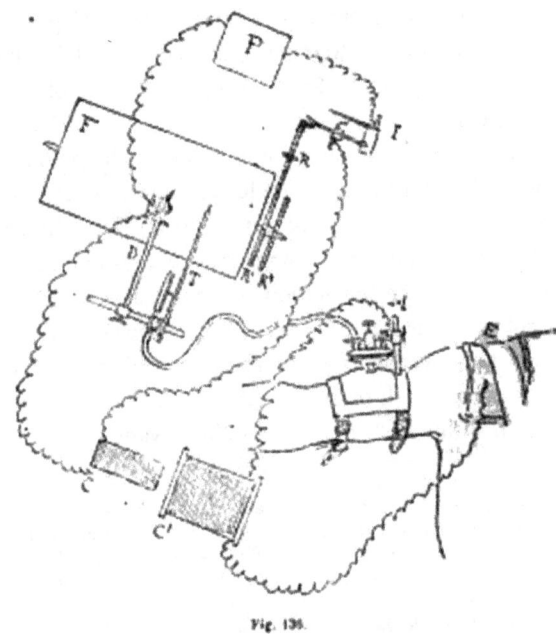

Fig. 136.

Fig. 3.5 The myograph, a device for measuring the changes of muscular tension
invented by Marey and used by Richer for examining phases of hysterical attacks.
Image source: Paul Marie Louis Pierre Richer, *Études cliniques sur la grande hystérie
ou hystéro-épilepsie* (Paris: A. Delahaye, 1885).

evoked Marey's name to substantiate their view of the human body as a pliable
neurophysiological mechanism, ready to be perfected and put to use. Thus in
1922, the performance theorist Ippolit Sokolov, who planned to open a studio
of "Taylorized" theater, proclaimed: "It is only on the basis of physiological

ARTICLE IV

Secousse musculaire pendant l'état de somnambulisme

Pendant l'état de somnambulisme, la forme de la secousse musculaire

Fig. 3.6 Richer's myographic record of muscular tensions. Image source: Paul Richer, *Études cliniques sur la grande hystérie ou hystéro-épilepsie* (Paris: A. Delahaye, 1885).

Fig. 3.7 An article on Marey's chronophotography featuring his images of French soldiers in the popular film journal *Sovetskii Ekran* 9 (1925).

research, from Marey to Sechenov and Amar [Fig. 3.8], that we can seriously think about the education and indeed the construction of the human and the actor as a living machine."[46]

[46] Ippolit Sokolov, "Vospitaniie aktera," *Zrelishcha* 8 (1922): 11. In addition to Marey, Sokolov seems to have in mind "Notes on the Labor Movement" ("Ocherk rabochikh dvizhenii," 1901) by

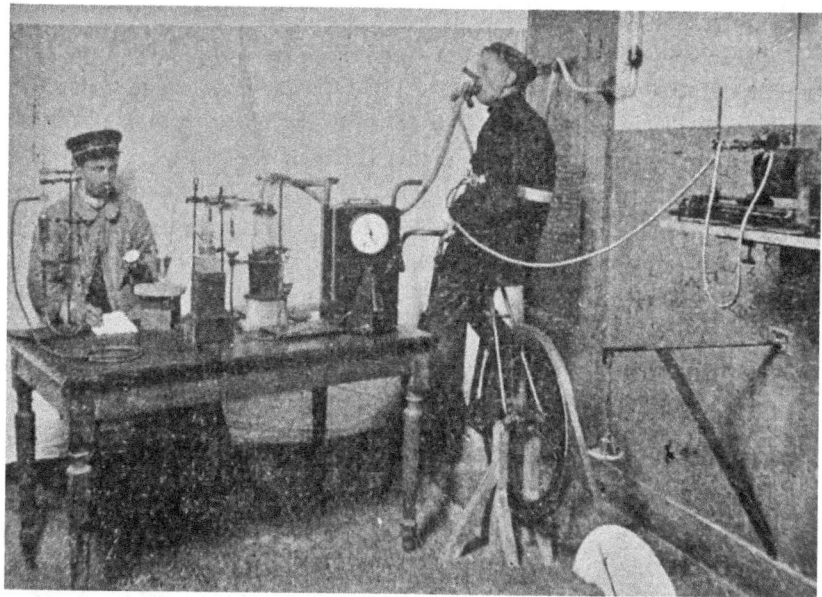

Fig. 3.8 Jules Amar's study of breathing and metabolism in a cyclist, 1914.
Image source: Jules Amar, *Le Moteur Humain et les bases scientifiques du travail professionnel* (Paris: H. Dunod et E. Pinat. 1914), 250.

In 1915, the Moscow film journal *The Herald of Cinematography* (*Vestnik Kinematographii*) published Vladimir Bekhterev's article on the use of motion pictures in psychological and physiological studies. "It is only cinema," the scientist exclaims, "that is capable of reproducing individual moments of movement, acts of walking, dysfunctions of gait, gestural articulations; only cinema can capture the peculiarities in the development of facial expressions. These expressions can be prone to pathologies, and cinema is particularly useful for the study of various spasms."[47] Bekhterev's proposed program for using cinema

Ivan Sechenov and a monumental study of the physiology labor efforts completed by Jules Amar in the early 1910s: Jules Amar, *Le moteur humain et les bases scientifiques du travail professional* (Paris: H. Dunod et E. Pinat, 1914).

[47] Vladimir Bekhterev, "Kinematograf i nauka," *Vestnik kinematografii* 110.8 (1915): 39–40. After the revolution, Bekhterev's ideas on the use of cinema for the study of nervous maladies were enthusiastically endorsed by many authors. For example, a collection of essays entitled *Kinematograf* (1919), edited by Anatolii Lunacharskii, contains an article about the use of cinema for the purposes of psychiatric examination in Russia and abroad, ending with a quotation from the Italian physiologist Osvaldo Polimanti: "Perhaps, there will come a time when one will be able to make diagnoses simply on the basis of a cinematic record of the patient with nervous dysfunctions" (A. Tikhonov, "Kinematograf v nauke i tekhnike," *Kinematograf* [Moscow: Gosizdatel'stvo, 1919], 73).

in neurophysiological investigations was based on the methods that he first learned as a young man, during his tour of Charcot's laboratory at his Paris clinic Salpêtrière in 1884. Charcot was convinced that a detailed recording of muscular contractions during hysterical fits would shed light on the pathologies of the nervous system and help to locate the affected centers of the brain. With this goal in view, Charcot's assistants made plaster casts of spasmodically contracted wrists, photographed convulsions, and drew the positions of patients' extremities during the attack, producing series reminiscent of chronophotography. These images, often obtained in a manner that would be deemed unethical today, were systematized by Charcot in special catalogs so as to identify repeated patterns and phases in the course of hysterical attacks experienced by various patients. [48] The way in which corporeal movement is represented in *Iconographie photographique de la Salpêtrière* (1876), an atlas composed by Charcot's colleagues Désiré Magloire Bourneville and Paul Régnard, differs radically from the portrayal of "passions" in classical physiognomic treatises for actors and painters, such as, for instance, Charles Le Brun's *Conférence sur l'expression des passions* (1668). The idealized images of "hatred," "hopefulness," and "veneration" presented as readable codes in the classical typology give way to photographic series of corporeal spasms that resist categorization. The psychiatrists' terms for hysterical poses—such as "the phase of clowning," "passionate attitudes," and "delirium"—underscored the difficulty of labelling the patients' irrational, fluid corporeal behavior: gestures reminiscent of meaningful signals crystallized momentarily within the flow, only to dissolve into the chaos of spasmodic contractions (Fig.3.9).

As Rae Beth Gordon has shown in her seminal study, a repertory of uncontrollable convulsions popularized by an avalanche of scientific photographs coming out of the Salpêtrière caught the attention of numerous European artists and performers at the turn of the century. A vivid example of the Salpêtrière's influence could be seen in the stylized imitations of hysterical trance and tortured gesticulation in spectacles of the French cabaret and silent film comedies.[49]

This brief excursion into the history of cinematic and photographic approaches to the study of movement helps to explain some of the psychophysiological theories and methods which shaped modern ideas on corporeal performance, as well as peculiar iconographies of the "estranged" and "eccentric" gestures produced by avant-garde artists of the 1910s–1920s, including Kuleshov. In terms of form,

[48] See a critical analysis of Charcot's methods in Georges Didi-Huberman, *Invention of Hysteria: Charcot and the Photographic Iconography of the Salpêtrière*, trans. Alisa Hartz (Cambridge, MA: MIT Press, 2003).
[49] Concerning the impact of the iconography of hysteria on the French and larger European visual culture at the turn of the 20th century, see Rae Beth Gordon, *Why the French Love Jerry Lewis: From Cabaret to Early Cinema* (Stanford, CA: Stanford University Press, 2001) and Friedrich A. Kittler, *Gramophone, Film, Typewriter*, trans. Geoffrey Winthrop-Young and Michael Wutz (Stanford, CA: Stanford University Press, 1999), 141–145.

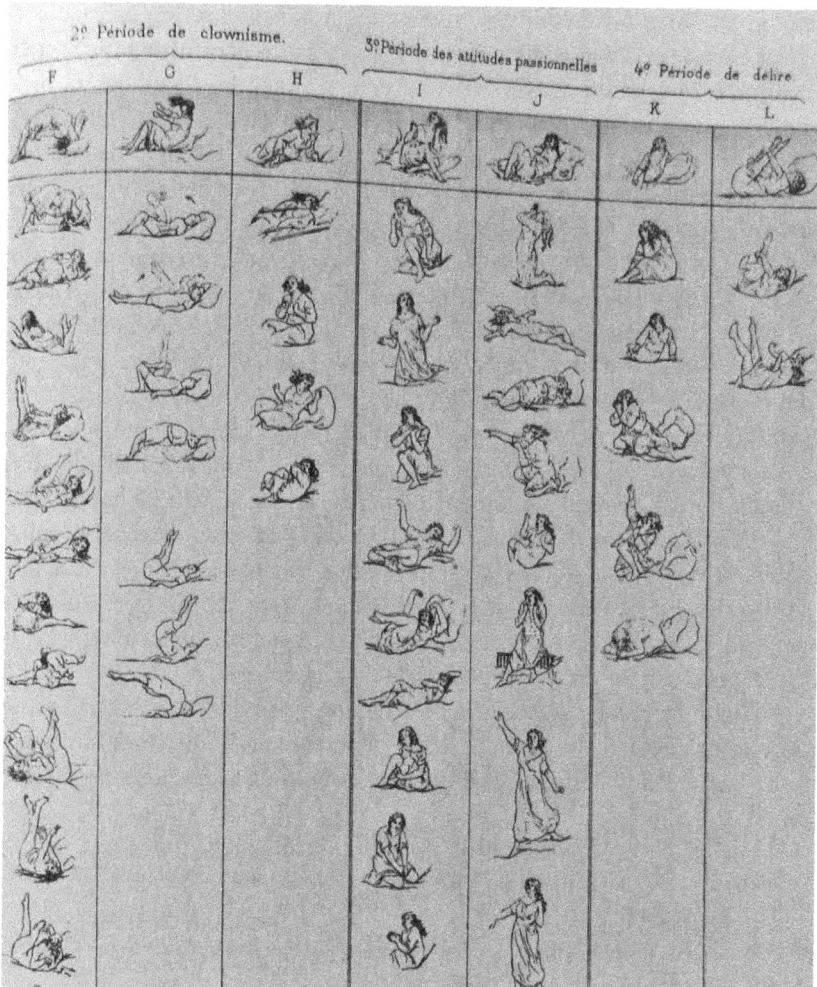

Fig. 3.9 Richer's table of the sequential phases of a hysteric attack, featuring detailed drawings of the patient's poses and gestures that resemble chronophotographic series. Image source: Paul Marie Louis Pierre Richer, *Études cliniques sur la grande hystérie ou hystéro-épilepsie* (Paris: A. Delahaye, 1885).

these tendencies were reflected in such stylistic techniques as decomposition of movement into phases, individuation of particular muscle groups and organs, and assemblage of the image out of fragments. Performers took a special interest in unconscious motor reflexes and automatisms of the acrobatic body, achieved by training and extraordinary concentration of attention. On the aesthetic level, the result of these tendencies was an orientation toward experiments, toward

finding the unknown within the mundane, toward discovering unusual corporeal plasticity. "Photogenic neurasthenia"[50] was the term that Jean Epstein used to characterize the style of acting demonstrated by Kuleshov's favorite actor, Charlie Chaplin.[51] "His entire performance," wrote the French filmmaker, "consists of the reflex action of a nervous, tired person. A bell or an automobile horn makes him jump, forces him to stand anxiously, his hand on his chest, because of the nervous palpitations of his heart."[52] A similar style of performance can be found in the films of Igor' Il'inskii—one of the most famous Russian cinema actors of the 1920s, who received training in Vsevolod Meyerhold's theater and was much admired by Kuleshov for his exuberant comedic action. (Kuleshov wrote two film scripts in the hopes of getting Il'inskii to work with him.)[53] Russian audiences were captivated by Il'inskii's "cubist gesticulation" (kubistskii zhest),[54] the ornate and "poignant psychological contour" (ostryi psikhologicheskii risunok)[55] of his movements, created by incessant Tourette-like seizures of his facial muscles, puffing up of his cheeks, and disjointed motions of his limbs that seemed to be going in all directions at once. A defining feature of this performance aesthetics is a gesture that is emphatically unreadable, that defies codes and recognizable clichés. Gesture in this style is no longer a readable sign; rather, it is a constantly changing signifier that confronts the viewer with its opaqueness, with a mesmerizing spectacle of corporeality.

Kuleshov's approach to acting is characterized by similar tendencies. Looking through the photographs of acting etudes performed in the director's workshop,[56] one cannot fail to notice his dedication to examining the motoric capabilities

[50] Jean Epstein, "Magnification" (1921), in French Film Theory and Criticism: A History/ Anthology, Volume I: 1907–1929, ed. Richard Abel (Princeton, NJ: Princeton University Press, 1988), 235–240, 238.

[51] For an excellent account of the Russian and French leftist artists' appreciation of Chaplin in the 1920s, see Yuri Tsivian, "O Chapline i v russkom avangarde i zakonakh sluchainogo v iskusstve," Novoe Literaturnoe Obozrenie 81 (2006): 99–142.

[52] Epstein, "Magnification," 238. Epstein discerns a similar kind of "neurasthenia" in the performance style of two other Hollywood actresses, Alla Nazimova and Lilian Gish, and it is curious to note how his description of their jumpy, paroxysmal actions combines the tropes of both a nervous compulsion and chronometric precision: "The first time I saw Nazimova, agitated and exothermic, living through an intense childhood, I guessed that she was Russian, that she came from one of the most nervous people on earth. And the little, short, rapid, spare, one might say involuntary gestures of Lilian Gish who runs like the hand of a chronometer" (Epstein, "Magnification," 238).

[53] In 1925, Kuleshov, together with Viktor Shklovskii, wrote a film script called Funtik that envisaged Igor Il'inskii in the lead role. One more adventure film script for this actor was prepared by Kuleshov in the early 1930s. None of the scripts was realized. See Lev Kuleshov, Sobranie sochinenii, vol. 2 (Moskva: Iskusstvo, 1988), 332–355, 374–379.

[54] Vadim Shershenevich, Igor' Il'inskii (Moscow: Kinopechat', 1926), 5.

[55] Shershenevich, Igor' Il'inskii. 12.

[56] Many of these photographs are reproduced in Kuleshov's books and scholarly essays about him: Lev Kuleshov, Sobranie sochinenii, 2 vols. (Moskva: Iskusstvo, 1987), 88; Lev Kuleshov, Stat'i. Materialy (Moskva: Iskusstvo, 1979); Lev Kuleshov and Aleksandra Khokhlova, 50 let v kino (Moskva: Iskusstvo, 1975); Ekaterina Khokhlova, "Kuleshov's Effects," Russian Heritage 2 (1993): 110–115.

of the body in extraordinary conditions. The photographs show faces distorted by grotesque expressions and bodies strained midair, at the high point of an acrobatic stunt. All these images constitute a pool of "defamiliarized" plastic articulations of the body—gestures stripped of easily perceptible meaning; signs devoid of referents, whether emotional, deictic (i.e., marking space and time), or pragmatic (i.e., explaining the communicative relations between characters). These gestures are a result of Kuleshov's and his troupe's explorations of the abstract expressivity of the body, a product of their obsession with creating tables of all possible postures and gestures that different body parts may take. Drawing up catalogs of the "living material's" capabilities (*preiskuranty vozmozhnostei zhivogo materiala*)—as Kuleshov put it—was the primary occupation of his workshop participants in the first years of its existence.

The very idea of fragmenting the body into parts and cataloging these parts' possible positions leads to a very specific attitude toward the actor. Returning to the analogy between gesture and sign one more time, it seems that what is happening here is the foregrounding of the signifier's texture, while the boundaries of the signified are undone. As Viktor Shklovskii has once observed:

> For the cinema professional, the person captured on the film strip does not laugh, or cry, or suffer, but rather opens his mouth and squints his eyes in a particular way. He is the material. The signification of the word depends on the phrase in which I place it. . . . Whereas the spectator is prone to searching for some true meaning of the word, for a dictionary definition of expression [*zritel' ishchet kakogo-to istinnogo znacheniia slova, slovarnogo znacheniia perezhivanii*].[57]

In perfect agreement with this insight, Kuleshov's method questions conventional definitions of gestures, becoming a quest for various body movements—the more unusual, the better—to be included in future montage phrases.

As Kuleshov explained, "in order to account for the entire mechanism of [the cine-model's] work, the entire motorics of movements, we have broken down the person into constituent parts [*razbili cheloveka na sostavnye chasti*]."[58] A similar approach was already practiced at the State School of Cinematography (*Gosudarstvennaia Shkola Kinematografii*) when Kuleshov opened his workshop under its auspices in 1921. The School's director at the time, Vladimir Gardin, recalled that his exploration of all possible positions of the model's head and camera angles from which it could be filmed produced a table with 1,245

[57] Viktor Shklovskii, "Kinofabrika" (1927), in *Za sorok let. Stat'i o kino* (Moskva: Iskusstvo, 1965), 56–64, 62.
[58] Lev Kuleshov, "Iskusstvo kino. Moi opyt," *Sobranie sochinenii*, vol. 1 (1987): 161–226, 181.

entries.[59] However, unlike Gardin, Kuleshov did not attempt to define the entire palette of potential expressions, but instead tried to devise a system for describing a few principal body movements. In creating his own catalog, Kuleshov was guided by these considerations:

> Movements of the human body are as diverse and innumerable as sounds in nature. But to perform any musical piece, one needs only a particular diapason, or a system of sounds, that will serve as a foundation for building the melody. Similarly, it should be possible to create a certain system of human movements, on the basis of which one would be able to build any plastic task.[60]

One of the chief examples that gave Kuleshov the idea of creating such a system was the codex of gestures and postures invented by the French teacher of opera performance François Delsarte in the mid-19th century. It became popular in Russia in the early 1910s, thanks to the theater connoisseur and performance theorist Sergei Volkonskii. As Mikhail Iampolski has shown,[61] Volkonskii, who lectured at the Proletkul't[62] and the State Cinema School[63] after the October Revolution, exerted a great influence on Kuleshov's early approach to the actors' training.

According to Volkonskii, Delsarte's goal was "shaping the aesthetics of the human body, that is, its expressivity, on a scientific basis [*postanovka estetiki cheloveka . . . na nauchnoi pochve*]."[64] For this purpose, the French performance theorist created a system of movements and positions of the human body with reference to their directions and a few additional parameters that he established. At the core of this system was a triad of directions: the action could be defined as "eccentric" (directed away from oneself, unfolding), "concentric" (directing toward oneself, folding in), or "normal" (maintaining a balanced position). Different combinations of these three elements were used by Delsarte to classify various gestures and postures, as well as describe various complex trajectories of the actor's limbs. Thus, for instance, even though "Delsarte's table of arm and

[59] Vladimir Gardin, *Vospominania*, 2 vols., vol.1 (Moscow: Goskinoizdat, 1949), 203.

[60] Kuleshov, "Iskusstvo kino," 181.

[61] Mikhail Iampolski, "Kuleshov and the New Anthropology of the Actor," in *Inside the Film Factory: New Approaches to Russian and Soviet Cinema*, ed. Richard Taylor and Ian Christie (London: Routledge, 1991), 31–50. Vladimir Gardin mentions in his memoirs that Volksonskii's official position at the State School of Cinema in 1919 was listed as the instructor of "gestural expressivity" [*prepodavatel' mimicheskoi vyrazitel'nosti*] (Vladimir Gardin, *Vospominania*, vol. 1, 175).

[62] Sergei Volkonskii, *Moi vospominania*, 2 vols., vol. 2 (Moskva: Iskusstvo, 1992), 298.

[63] Ekaterina Khokhlova, "Commentary on Kuleshov's *Znamia Kinematografii* [*The Banner of Cinema*]," in *50 let v kino*, ed. Lev Kuleshov and Aleksandra Khokhlova (Moskva: Iskusstvo, 1975), 230.

[64] Sergei Volkonskii, *Vyrazitel'nyi chelovek: Stsenicheskoe vospitanie zhesta po Del'sartu* (St. Petersburg: Apollon, 1913), 15.

hand positions," in Volkonskii's account, could include up to 243 entries,[65] all of them were identified by applying the aforementioned triad to various sections of the upper limb: fingers, palm, wrist, forearm, elbow, and shoulder. Here is an example from a "Delsartean" chart of "The Attitudes of the Arm": "Action: ex.-nor. [eccentric-normal]. Signification: expansion of will-power in the assertion of its force, or affection. Description of action: arms extended from shoulders in breadths; elbows unbent."[66] Or here is another example from "The Table of Brow and Upper Lid": "Action: nor.-con. [normal-concentric]. Signification: subjective reflection, interiority of will, quiescent tendency of will in mind. Description of action: brow normal = nor. [normal]; lid depressed = con. [concentric]."[67]

This system for describing corporeal movements, in conjunction with exercises, promoted an outlook on acting that favored the fragmentation of the body into parts, assembling a line of action out of separate phases, and using abstract denominations for all poses. These tendencies can be observed in Kuleshov's programs for the actors' training as well. For example, one of the techniques that Kuleshov's employed was "schematic exercises aimed at developing a capacity to engage individual muscles of the face independently of each other."[68] Peculiar facial expressions produced by way of these exercises are well documented in the photo albums of Kuleshov's workshop. What distinguishes Delsarte from Kuleshov, however, is that the French theorist insisted on a "grammar of pantomime." In Delsarte's "tables of attitudes," each pose and each movement was associated with a specific meaning. The followers of Delsarte pedantically observed what their teacher called a "semiotics" of corporeal movement, believing that he discovered "uniquely correct" expressions for the inner states, which at the same time happen to be the most natural, noble, and elevating for the spirit (Figs. 3.10–3.14).

Citing authoritative scientific sources in the domain of psychophysiology, Volkonskii wrote in 1913 that Delsarte's discoveries are "confirmed by the works of Darwin, Piderit, Mantegazza, etc."[69] In 1887, a well-known American propagandist of Delsarteanism, Genevieve Stebbins, defended the foundations of the system by citing a psychological experiment described in a certain French "science monthly of last year," which revealed that if an artist shapes the body of a

[65] Volkonskii, *Vyrazitel'nyi chelovek*, 41.

[66] Genevieve Stebbins, *Delsarte System of Expression* (New York: E. S. Werner, 1892), 111.

[67] Stebbins, *Delsarte System of Expression*, 150.

[68] Lev Kuleshov, "Programma kinematograficheskoi eksperimental'noi masterskoi kollektiva prepodavatelei po klassu naturshchika" (1923), in *Sobranie sochinenii*, vol. 1 (Moskva: Iskusstvo, 1987), 349–353, 352.

[69] Volkonskii, *Vyrazitel'nyi chelovek*, 48. These scientific references were actually taken by Volkonskii from another major advocate of Delsarte's system—Alfred Giraudet. See Alfred Giraudet, *Mimique, Physionomie et Gestes: Méthode Pratique D'après le Système de F. Del Sarte pour Servir à L'expression des Sentiments* (Paris: Ancienne Maison Quantin, 1895), 2.

Послѣ нормальной линіи кверху ладонь понемногу повора-
чивается, и на послѣднемъ жестѣ, — Дельсартъ назвалъ его

жестомъ абсолютной истины, — рука повернута
ладонью наружу.

Fig. 3.10 Sergei Volkonskii's chart representing movements of the forearm,
the elbow, and the shoulder when the actor performs "the gesture of absolute
truth" according to Delsarte. Image source: Sergei Volkonskii, *Vyrazitel'nyi
chelovek: stsenicheskoe vospitanie zhesta po Del'sartu* (St Petersburg: Apollon,
1913). 137.

hypnotized person in a particular way, then, upon awakening, this person will
feel an emotion corresponding to the pose he experienced (in the experiment,
the person reported to feel "the throes of terror").[70] Commenting on this phe-
nomenon, Stebbins wrote:

> Certain attitudes, by extending or contracting the muscles, by compelling the
> breath to come more rapidly, by increasing the heart-beats, cause physical

[70] Stebbins, *Delsarte System of Expression*, 62–63.

Fig. 3.11 Delsarte's table of hand positions classified in accordance with his triadic system. Image source: Sergei Volkonskii, *Vyrazitel'nyi chelovek: stsenicheskoe vospitanie zhesta po Del'sartu* (Sankt-Peterburg: Apollon, 1913), 107.

interior sensations which are the correspondences of emotion. The emotion is then slightly felt.[71]

This explanation seems to be in tune with the William James–Karl Lange theory of emotions that was popular at the turn of the 20th century. Yet Stebbins cites

[71] Ibid., 63.

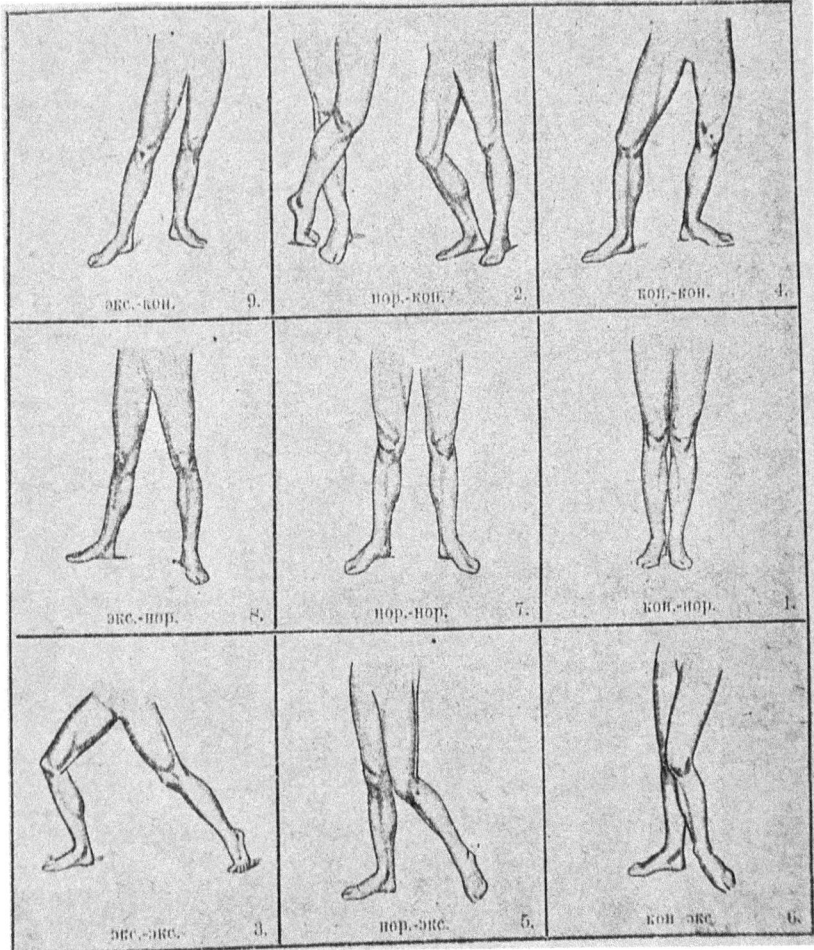

Fig. 3.12 Delsarte's table of leg positions classified in accordance with his triadic system. Image source: Sergei Volkonskii, *Vyrazitel'nyi chelovek: stsenicheskoe vospitanie zhesta po Del'sartu* (Sankt-Peterburg: Apollon, 1913), 115.

the anecdote about the feeling triggered by the pose as evidence in support of her claim that there is one particular natural expression of fear, which was guessed correctly by the artist. It is precisely this claim that reveals the metaphysical orientation of Delsarteanism—a feature that would make this doctrine unacceptable for the purposes of Soviet avant-garde artists like Kuleshov. Stebbins is convinced that there exists an ideal corporeal expression of fear, akin to a Platonic idea. She insists that the "idea" from "the artist's mind" was transferred

Fig. 3.13 Delsarte's positions of the mouth. Image source: Genevieve Stebbins, *Delsarte System of Expression* (New York: E.S. Werner, 1892), 164.

onto the mesmerized patient[72] and fails to consider any alternative possibilities. In fact, the patient might have had a variety of kinaesthetic sensations and fleeting affective states, but he reduced this flux of experiences to a single culturally codified emotion, "terror." It could also be that the patient's claim about the fear he allegedly experienced might have been caused by the desire to please the doctors conducting the experiment.

[72] Stebbins, *Delsarte System of Expression*, 63.

Fig. 3.14 Delsarte's positions of the brow and the upper lid. Image
source: Genevieve Stebbins, *Delsarte System of Expression* (New York: E.S. Werner,
1892), 152.

It must have been this type of essentialism that ultimately made Kuleshov
turn away from Delsarte's teachings. Another likely off-putting aspect was the
Delsartians' propensity to raise their teacher's postulates to the level of dogma,
expressed in elevated, metaphysical terms (Fig. 3.15). To give an example of typ-
ical Delsartean rhetoric, here is an excerpt from Volkonskii's book *The Expressive
Man* (*Vyrazitel'nyi chelovek*, 1913), explaining Delsarte's triad of gestural
directions—eccentric, concentric, and normal:

THE HEAD. 131

CHART V.

ZONES OF THE HEAD.

1. Vital.
2. Mental.
3. Moral.

Fig. 3.15 "Zones of the head" classified according to Delsarte. Image source: Genevieve Stebbins, *Delsarte System of Expression* (New York: E.S. Werner, 1892), 131.

In our *sensations*, in the manifestations of Life, corporeal actions are directed outwards (thus we say that someone is "drawn" to sunshine and warmth); in our *thinking*, in the manifestations of Reason, corporeal actions are as if folding in—they are aimed at avoiding external sensations (thus the worst affliction of the mind is being unconcentrated, scattered); finally, in our *feelings*, in the manifestations of the Soul, our body stays serene; and the deeper the feeling, the more stability there is (thus the word "unbalanced" denotes someone whose feelings are fickle and unreliable).[73]

Rejecting the dogmatic assertions of this kind, Kuleshov took from Delsarte and Volkonskii only the idea of methodical registration of gestures, poses, and movements. In Kuleshov's texts, references to Delsarteanism are always

[73] Volkonskii, *Vyrazitel'nyi chelovek*, 51.

followed by a disclaimer that this system may be useful for actors, but only as "an account of possible transformations of the organism, and not as a method of acting."[74]

In Kuleshov's case, a desire to explore the plastic capabilities of various body parts and combinations of their movements resulted in the type of abstract exercises he called "scores of movement" (*partitury dvizheniia*). "A score," he wrote, "is a precise plan, a scheme given to the actor by the director, and it shows what happens in every cadence of movement."[75] In this plan, all aspects of movement are meticulously described with the help of specific parameters and scales. For example, there is a "rhythmical scale, which determines the temporal side of the etude and defines the order and length of each movement"; there are gesture notations, which reflect the directions of movements using spatial coordinates; there is also a scale of "registering energy, [which shows] how the charge is rising, or falling, and when a break in the state occurs," [76] and so forth.

However, it is remarkable that while applying these abstract scores in his teaching practice, Kuleshov asked his actors to invent a narrative—that is, a motivation—for any given contour of movement and to define additional moves in accordance with the scales.[77] Thus Kuleshov's practice exhibits a turn toward a greater acknowledgment of acting situations—the imagining of specific physical spaces and actions oriented toward them. This turn was partially motivated by Kuleshov's polemics with his older colleague at the State Cinema School, Vladimir Gardin, another aficionado of systematized movement catalogs (Fig. 3.16). In his classes, Gardin asked the students to take poses from dictation: standing behind a special frame, symbolizing the limits of the camera's field of vision, the actors had to follow commands and exhibit "happiness," "agitation," and so on.[78] Watching these exercises, Kuleshov understood that they result in strained and unconvincing performances. He became interested in the real "reflexes" that the person demonstrates in concrete physical and psychological conditions. As an example of such reflex, we can recall Khokhlova's facial expressions during her spinning on the mill-centrifuge, or the face of nearly frozen actor Fogel', who had to lay on ice for two hours during the shooting of another scene in *By the Law*. However,

[74] Kuleshov, "Iskusstvo kino," 214. On Kuleshov's attitude toward Delsarteanism, see also Lev Kuleshov, "Chto nado delat's v kinematograficheskikh shkolakh?" in *Stat'i. Materialy* (Moskva: Iskusstvo, 1979), 155–160, 158.

[75] Kuleshov, "Iskusstvo kino," 219.

[76] Ibid.

[77] Ibid.

[78] Lev Kuleshov, "Chto nado delat' v kinematograficheskikh shkolakh," in *Stat'i. Materialy* (Moskva: Iskusstvo, 1979), 157.

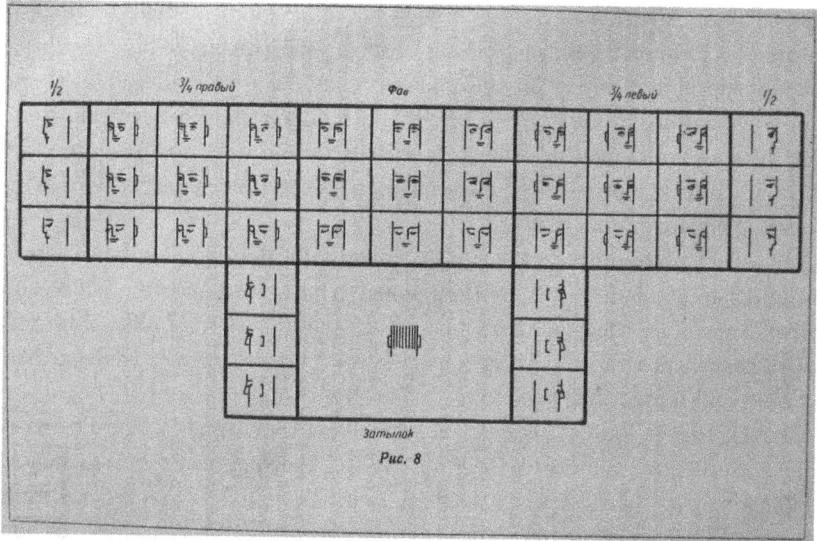

Fig. 3.16 Vladimir Gardin's table of different head positions. Image source: Vladimir Gardin, *Vospominania*, 2 vols., vol. 1 (Moscow: Goskinoizdat, 1949).

Kuleshov's demands for the reflex are not as straightforward as they may appear, and this aspect of his theory certainly does not represent a return to the theatrical principle of "experiencing." First of all, in Kuleshov's view, the reflex action exhibited by the actor must necessarily be something extraordinary and striking—something "monstrous," as he would put it. Secondly, the film editor, in his theory, reserves the right to recontextualize the shot with the reflex by placing it into other sequences, thus annulling its meaning as a reaction to a particular situation.

Soviet Reflexology and Taylorism

The term "reflex" appears several times in Kuleshov's book *The Art of Cinema: My Experience* (*Iskusstvo kino. Moi opyt*)—a major theoretical text that he wrote between 1922 and 1926 and published in 1929.[79] For example, in the chapter outlining an ideal curriculum for the cinema school, he states: "The training of the

[79] These dates are given in Lev Kuleshov and Aleksandra Khokhlova, *50 let v kino* (Moskva: Iskusstvo, 1975), 75.

model's [*naturshchik*] exterior techniques should be complemented by the study of reflexes in human behavior."[80] "The model's work [*rabota kinonaturshchika*] should appear as a sum of organized movements," he argues, adding that these confident gestures would look especially convincing if "the film script has room for showing the characters' reflex reactions to the situations." [81] "Bad films," he says, are those that provide "no material for demonstrating man's behavior in relation to his surroundings."[82]

In order to determine the place of reflexology in Kuleshov's film theory—how he understood this doctrine, how he planned to integrate it into his practice, and what came of this idea—we must first ask the question of what reflexology was as a scientific program in this epoch, and how it was interpreted in the artistic circles that Kuleshov belonged to.

Reflexology in Russia originates in the influential neurphysiological treatises of Ivan Sechenov ("Reflexes of the Brain," 1863; *Physiology of the Nervous System*, 1866; *Physiology of Nerve Centers*, 1891), in which he argued that reflexes must be regarded as the elementary basis of human behavior. [83] Reflex action for him was a chain with three links: first, the reception of the stimulus and its transmission to the central nervous system (the spinal cord and the brain); second, the processing of the signal by the central nervous system; and third, efferent innervation that causes a motor reaction, for example, the pulling away of one's fingers from a flame. Today, when we hear the word "reflex," we tend to think of involuntary, instantaneous muscular reactions, such as, for example, the knee-jerk reflex, or the contraction of the eye's pupil in response to light. However, for the Russian scientists of the 1920s, the concept of "reflex" was much broader and included whole patterns of behavior based on established synapses in the brain. For example, Vsevolod Pudovkin's documentary film *Mechanics of the Human Brain* (1926), produced in consultation with Ivan Pavlov's laboratory colleagues, presents the idea of "the goal reflex" (*refleks tseli*), illustrating it through a scene in which kindergarten children construct a staircase from chairs and tables to reach a toy hanging high on the wall.[84]

Another common misconception today is the tendency to associate the development of reflexology in Russia solely with Ivan Pavlov. In reality, a massive project for the canonization of this author took place in Stalin's era, when his writings

[80] Kuleshov, "Iskusstvo kino," 219.

[81] Kuleshov, "Iskusstvo kino," 208.

[82] Kuleshov, "Iskusstvo kino," 205.

[83] "Refleksologiia," in *Bol'shoi psikhologicheskii slovar'*, ed. B. G. Meshcheriakov and V. P. Zinchenko (St. Petersburg: Praim-Evroznak, 2003), 470.

[84] For analysis of Pavlovian trends in children's psychology, represented in Pudovkin's film, see Ana Hedberg Olenina, "The Junctures of Children's Psychology and Soviet Film Avant-garde: Representations, Influences, Applications," in *The Brill Companion to Soviet Children's Literature and Film*, ed. Olga Voronina (Leiden: Brill Press, 2019), 73–100.

were harmonized with Marxism and turned into a dogma that allowed the officials to repress all independently minded scientists.[85] In the 1920s, Russian psychology was a much more vibrant scene, with many voices engaging in scientific debates. Pavlov was not the only person by far to approach the questions of human psychology from a neurophysiological perspective. One figure as renowned as Pavlov at the time was Vladimir Bekhterev, whose research, in contrast to Pavlov, focused directly on human psychology and the activities of the human brain. Equal in stature and scientific reputation, these two scientists often considered each other opponents.[86] Pavlov came to psychology as a physiologist, a specialist on the digestive system, whose discovery of the "conditioned reflexes" in dogs (their salivation in response to artificial stimuli that previously accompanied feeding), made it possible for him to leave his primary field of specialization and transition to the study of "higher nervous activity." Pavlov's understanding of "conditioned reflexes" (uslovnye refleksy) was heavily indebted to the work of his laboratory assistants, who had been trained by Bekhterev. [87] In contrast to Pavlov, who worked mainly with animals, Bekhterev started his career as a practicing psychiatrist, who specialized in questions of hysteria, hypnotism, auto-suggestion, and crowd psychology, in addition to his clinical research on the physiology of the brain.[88] According to the historian Alex Kozulin, it was only in the early 1920s that Bekhterev succumbed to the temptation of explaining all aspects of human behavior through one fundamental process—associative reflexes (sochetatel'nye refleksy), [89] which were analogous to Pavlov's "conditioned reflexes" in that they were described as behavioral algorithms acquired by the person because of the links that were established in his cortex. However, despite Bekhterev's emphasis on reflexes, his approach to the study of the human psyche remained complex and the methodology that he used excluded the possibility of reducing all human behavior to wired-in or acquired reactions. [90]

To illustrate how eclectic Bekhterev's methods were and how peculiar his use of reflexological terminology was, let us turn to one of his essays from the mid-1920s dealing with a topic that is of major concern for this chapter: the expression

[85] Daniel P. Todes considers Pavlov's canonization in his article, showing, for instance how *Bolshaia Sovetskaia Entsiklopedia*, the leading Soviet encyclopedia, altered a quotation from Pavlov to make it fit with Marx. See Daniel P. Todes, "From the Machine to the Ghost within: Pavlov's Transition from Digestive Physiology to Conditional Reflexes," *American Psychologist* 52.9 (1997): 947–955.

[86] Alex Kozulin, *Psychology in Utopia: Toward a Social History of Soviet Psychology* (Cambridge, MA: MIT Press, 1984), 40–61.

[87] Daniel P. Todes, "From the Machine to the Ghost within: Pavlov's Transition from Digestive Physiology to Conditional Reflexes," *American Psychologist* 52.9 (1997): 947–955.

[88] Kozulin, *Psychology in Utopia*, 51–52.

[89] Kozulin, *Psychology in Utopia*, 56.

[90] Kozulin, *Psychology in Utopia*, 57.

of emotions.[91] In his work, Bekhterev calls emotions a "facial-somatic reflex" (*mimiko-somaticheskii refleks*) and focuses on one particular type of psychological state, which he calls the "the reflex of alertness" (*refleks nastorazhivaniia*). Bekhterev suggests that a scientific study of this state should involve not only a meticulous registration of changes in the patient's vital signs and physiological reactions, such as heightened perception, rising body temperature, and dilation of blood vessels. A holistic study should also take into consideration the patient's personal report on "the power and character of the stimulus," his past experience, and current manifestations of his mental processes, such as "the excitation of the creative apparatus with a predominant concentration on the provoking object, acceleration of 'hidden' reflexes (associations), and heightened recollection."[92]

What is obvious from this description is that this program of study cannot be accomplished through a simple measurement of physiological reactions—it requires questionnaires and systematic observation. Also, the way in which Bekhterev employs the term "reflex" in this work reveals how multifaceted this concept in his system was, compared to our conventional usage: as we saw, he used this term even in reference to processes of consciousness.

However, Bekhterev's complex approach to reflexology did not fit in with the ideological imperatives of his epoch, which required an expedient demonstration of how scientific discoveries could apply to life, and moreover, how they could legitimize political slogans. Pavlov's and Bekhterev's reflexology, along with other physiologically oriented approaches to psychology, like the "reactology" of Konstantin Kornilov (the study of motor reactions using a dynamometer, a chronometer, and graphs of muscular activity), carried a lucrative promise of explaining human behavior from a materialist point of view, grounded in concrete empirical data. All these efforts soon turned into vulgar simplification. For instance, the young scientist Kornilov, who made a name for himself at The First All-Russian Conference on Psychoneurology in 1923 by proclaiming that psychology should become a Marxist science, began to apply his method of reaction studies to such ambitious tasks as investigating the influence of the social environment on an individual's psychology.[93] Thus the research topic of his laboratory in 1925 was "An Examination of Psychological Features of a Native-Born Moscow Proletarian by Measuring the Speed and Force of His Reactions."[94]

Further integration of reflexology and reactology into the ideological programs of the Party was fueled by the emergence of the utopian project of

[91] V. M. Bekhterev and G. E. Shumkov, "Mimiko-somaticheskii refleks nastorazhivaniia," in *Novoe v refleksologii i fiziologii nervnoi sistemy*, ed. V. M. Bekhterev (Leningrad: Gos. Izdatel'stvo, 1925), 248–253.

[92] Bekhterev and Shumkov, "Mimiko-somaticheskii refleks nastorazhivaniia," 252–253.

[93] V. A. Petrovskii, *Psikhologiia v Rossii. Dvadtsatyi vek* (Moscow: URAO, 2000), 8.

[94] Petrovskii, *Psikhologiia v Rossii*, 9.

fostering a generation of "New Soviet Men." To cite one of the main proponents of this biopolitical program, here is a quotation from the Freudian psychoanalyst-turned-Marxist Aron Zalkind:

The materialist endeavors of the proletariat, the only revolutionary class today, go along well with reflexology—this objective, experimental, monistic, and materialist doctrine. This has been duly confirmed by our ideologues Bukharin, Zinoviev, and others. Reflexology . . . will provide us with invaluable means for educating and reeducating man according to the goals of the proletarian revolution. [95]

The pathos of creating a new humankind with the help of scientific principles was the driving force behind the mass-scale projects of Aleksei Gastev, the founder of the Central Institute of Labor and one of the chief leaders of Proletkul't, a movement aiming to engage workers in ideological art. [96] In 1921, The First Conference on the Scientific Organization of Labor was held in Moscow.[97] Under Vladimir Bekhterev's guidance, it drew up a "Resolution on the Reflexology of Labor," which stated that "a comprehensive study of physiology, reflexology, hygiene, and psychotechnics of labor" was necessary in Russia.[98] Gastev's Institute took upon itself the task of finding ways to maximize industrial efficiency and rationalize the organization of labor in factories (Fig. 3.17). In pursuing these goals, the Institute investigated Western management models: Henry Ford's standardization principles, Frederick W. Taylor's time and effort optimization studies, and Henry Gannt's time charts. Equally important for the Institute's purposes was Western research on the physiology of movement and labor efforts conducted by the followers of Étienne-Jules Marey—Frank B. Gilbreth in the United States (Figs. 3.18 and 3.19) and Jules Amar in France

[95] A. B. Zalkind, "Refleksologiia i nasha sovremennost'," in Novoe v refleksologii i fiziologii nervnoi sistemy, ed. V. M. Bekhterev (Leningrad: Gos. Izdatel'stvo, 1925), v–vii, v. It is interesting to note that the film studio Mezhrabpom-Rus', which produced Pudovkin's kultrufilm Mechanics of the Human Brain (Mekhanika golovnogo mozga, 1926) on Pavlov's reflexology, was planning to shoot a film called Contemporary Neuroses (Sovremennye nevrozy) based on Aron Zalkind's script. Bekhterev was supposed to be the film's chief scientific consultant, as stated in the Mezhrabpom-Rus' advertisement brochure: "In the season 1926–27, we will be showing . . ." ("My v sezone 1926–27 pokazhem . . .", RGALI f. 1921. op. 2. ed. khr. 29. l. 17).

[96] On the history of The Central Institute of Labor, see Kurt Johansson, Aleksej Gastev: Proletarian Bard of the Machine Age (Stockholm: Almqvist and Wiksell, 1983), 104–115. For a general history of Taylor-based labor management in Russia before and after the October Revolution, see A. I. Kravchenko, Istoriia menedzhmenta (Moscow: Akademicheskii proekt, 2005).

[97] Aleksei Gastev, Kak nado rabotat': Vvedenie v nauchnuiu organizatsiu truda, 2nd ed. (Moscow: Ekonomika, 1972).

[98] Vladimir Bekhterev, "Chto dala initsiativnaia konferentsiia po nauchnoi organizatsii truda," in Voprosy izucheniia truda, ed. V. M. Bekhterev, V. P. Kashkadamov, and V.V. Belousov (St. Petersburg: Gos. Izdatel'stvo, 1922), 5–26, 17.

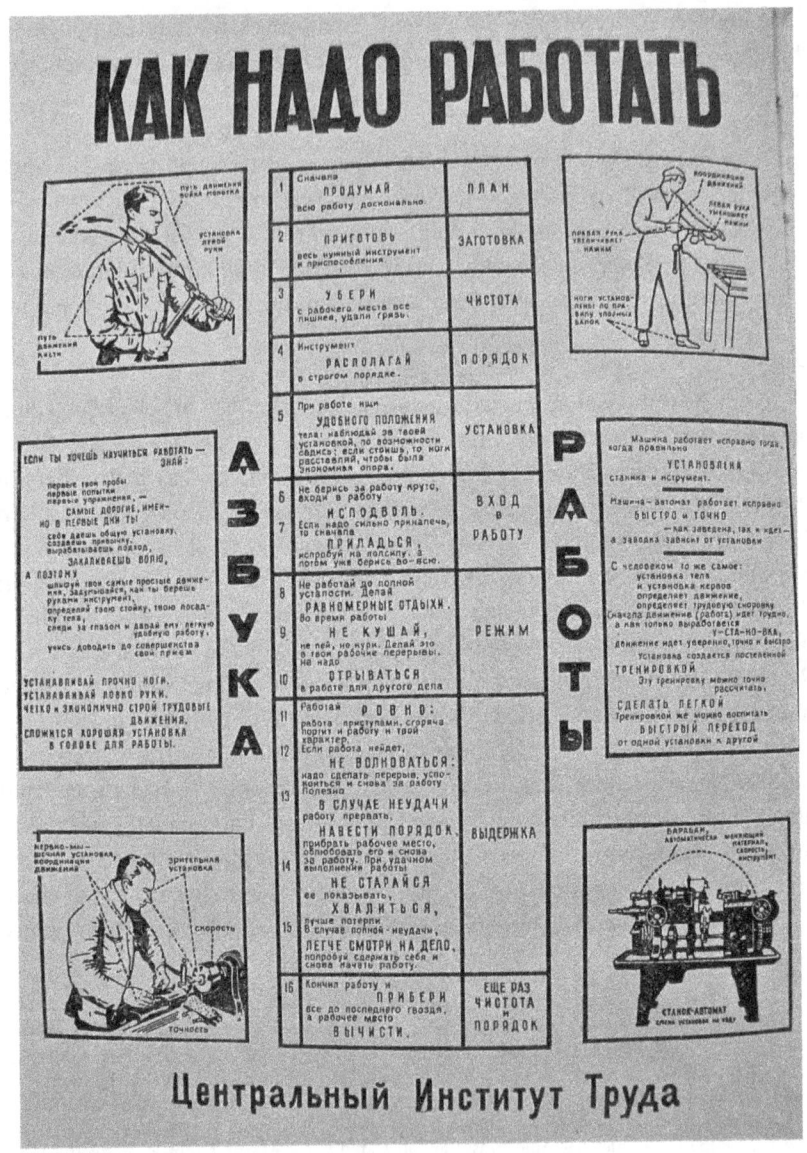

Fig. 3.17 A poster from The Central Institute of Labor called "How one must work." Image source: Aleksei Gastev, *Kak nado rabotat': Vvdedenie v nauchnuiu organizatsiu truda*, 2nd ed. (Moscow: Ekonomika, 1972).

IN THE LABORATORY
Motion pictures of the entire workings of a factory
were obtained, with the result that production was
greatly increased

Fig. 3.18 The filming of workers' movements at Frank Bunker Gilbreth's laboratory for labor efficiency studies, United States, 1916. Image source: Reginald D. Townsend, "The Magic of Motion Study," *The World's Work* 32.3 (1916): 321–336, 328.

(Fig. 3.8). Neurophysiological research in Gastev's Institute was led by Nikolai Bernshtein, an expert in biomechanics, who studied the dynamics of muscular contractions and neurophysiology of motor acts using high-speed film cameras equipped with a special device, called the kimo-cyclograph (Figs. 3.20, 3.21, and 3.24–3.26). [99] Another chief researcher was a psychotechnics specialist, Isaak Shpilrein (Spielrein), who focused on tests of professional aptitude, as well as

[99] Bernshtein describes his methods at the Central Institute of Labor in his *Ocherki po fiziologii dvizhenii i fiziologii aktivnosti* (Moscow: Meditsina, 1966), 11–38. A detailed account of Bernshtein's life and scientific discoveries appears in Irina Sirotkina, *Mir kak zhivoe dvizhenie: Intellektual'naia Biografiia Nikolaia Bernshteina* (Moskva: Kogito-Tsentr, 2018); I. Sirotkina and E. V. Biryukova, "Futurism in Physiology: Nikolai Bernstein, Anticipation, and Kinaesthetic Imagination," in *Anticipation: Learning from the Past. The Russian and Soviet Contributions to the Science of Anticipation*, ed. M. Nadin (Berlin: Springer, 2015), 269–285. On Bernshtein's research on piano techniques, see Julia Kursell, "Piano Mécanique and Piano Biologique: Nikolai Bernstein's Neurophysiological Study of Piano Touch," *Configurations* 14.3 (2006): 245–273.

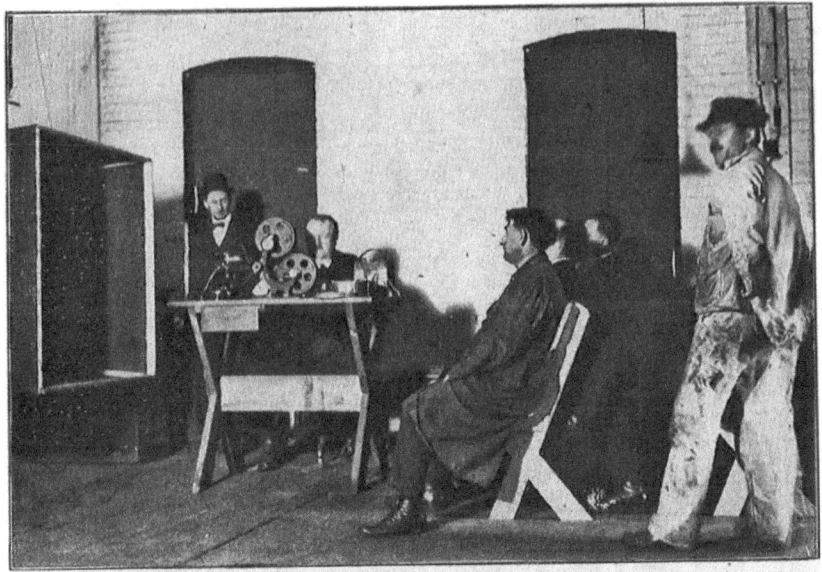

EXHIBITING A FILM

To an audience of workingmen so that they may study and criticise the methods of the worker. The film may be run as slowly as is desired or stopped altogether to illustrate a point

Fig. 3.19 Screening the footage of workers' movements to other workers. Frank Bunker Gilbreth's laboratory for labor efficiency studies, United States, 1916. The cinematic record here becomes a model for the worker's actions, and its function thus resembles various templates and molds used by the Taylorists. Image source: Reginald D. Townsend, "The Magic of Motion Study," *The World's Work* 32.3 (1916): 321–336, 328.

studies of fatigue and automation of work movements.[100] The founder of the Institute, Aleksei Gastev, did not participate in psychophysiological research directly, having chosen the propaganda of labor enthusiasm as his main domain. To create a universal "labor front" and to inoculate the young generation with the "bacilli" of revolutionary fervor—these were Gastev's goals, as he himself formulated them.[101] However, looking though his texts, one may notice how fundamental Bekhterev's theory of the associative reflexes (*sochetatel'nye refleksy*) was to Gastev's worldview. Thus, for instance, in 1929, Gastev wrote:

[100] On Bernshtein's biomechanics and Shpil'rein's psychotechnics, see Kozulin, *Psychology in Utopia*, 16, 62–82.
[101] Aleksei Gastev, *Kak nado rabotat': Vvdedenie v nauchnuiu organizatsiu truda*, 2nd ed. (Moscow: Ekonomika, 1972), 62–63, 120.

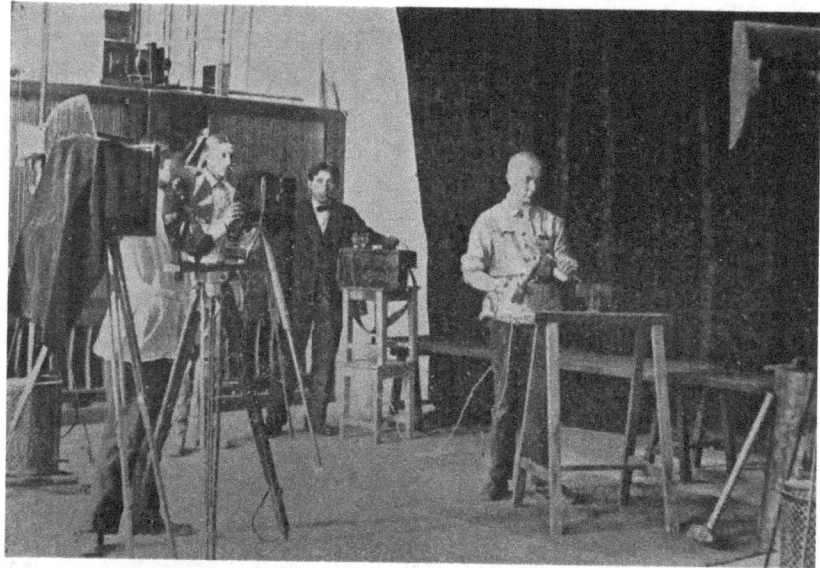

Fig. 3.20 A chrono-photographic study of chiseling at the Central Institute of Labor, Moscow, 1923. The scene features two cameras and a kimo-cyclograph. The revolving shutter placed in front of the camera on the left breaks down the movement into phases, which are precisely timed. Image source: René Fülöp-Miller, *The Mind and Face of Bolshevism: An Examination of Cultural Life in Soviet Russia* (London: G. P. Putnam's Sons, 1927).

Suppose we could use some microscopic gauges to measure the energy processes of the brain and the nerves, or to detect electricity flowing though the nerve ganglia and receptors of the motor cells, as well as the whole reflex activity going on in the brain. What would this give us? This would give us the measure of work spent on linking, on connecting those reflexes [*sviazyvanie, sochetanie tekh refleksov*] that accumulate in the nervous system as its main capital, so to speak. This capital to a large extent consists of the associative-distributive work culture [*sochetatel'no-raspredelitel'nuiu trudovuiu kul'turu*] ingrained in the nervous system, which gets activated each time a motor reaction occurs.[102]

In Gastev's opinion, this "work culture"—the optimized motor habits of the "Taylorized" workers, accumulated in their nervous system—would eventually reach a critical mass, capable of bringing about social and economic progress (Figs. 3.22 and 3.23).

[102] Gastev, *Kak nado rabotat'*, 288.

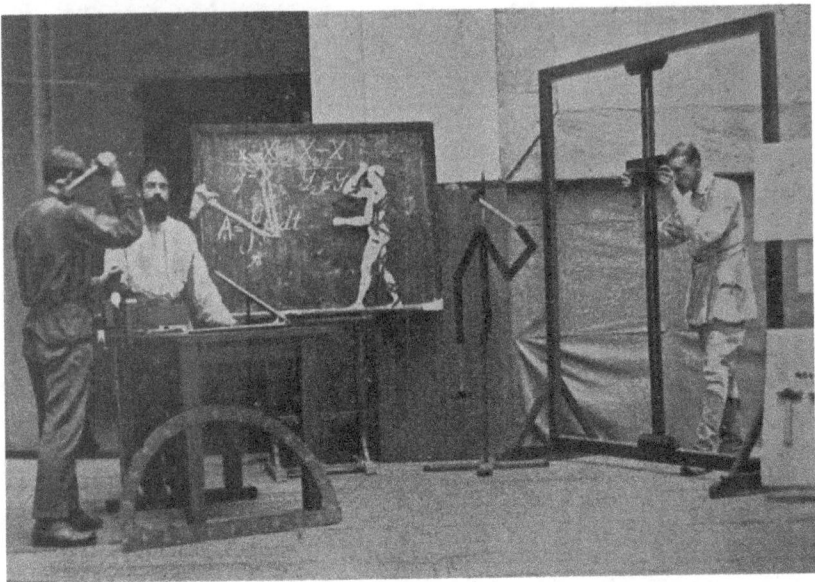

Fig. 3.21 A study of chiseling at the Central Institute of Labor with the help of an optical device and a frame of coordinates. In the background, one may see wire models of movement, anatomical visual aids, and algebraic formulae on the blackboard. Image source: René Fülöp-Miller, *The Mind and Face of Bolshevism: An Examination of Cultural Life in Soviet Russia* (London: G. P. Putnam's Sons, 1927).

How did this discourse of reflexology, generated by scientists and promoted by ideologues, influence Russian performance arts and cinema in the early 1920s? To answer this question, we must first of all turn to the major leftist studios of modern drama that gained prominence in this period. New theories of acting elaborated on by such directors as Vsevolod Meyerhold (his system was called "biomechanics"), Nikolai Foregger ("ta-fia-trenazh"), and Boris Ferdinandov ("metro-rhythm") all contained theses derived from teachings on reflexology, albeit often in a new and unusual artistic interpretation.[103] One such idea, shared by all three directors, and to a certain extent also by Kuleshov, was the notion of "reflex excitability" (*reflektornaia vozbudimost'*)—the idea that a good actor should be capable of translating the director's dramaturgical task into a series

[103] On Meyerhold's peculiar understanding of reflexology see Joseph R. Roach, *The Player's Passion: Studies in the Science of Acting* (Ann Arbor: University of Michigan Press, 1993); a chapter on Meyerhold in Jonathan Pitches, *Science and the Stanislavsky Tradition of Acting* (London: Routledge, 2006); and Oleg Aronson, "Teatr i affekt. Biomekhanika Meierkhol'da vs. psikhotekhnika Stanislavskogo," in *Sovetskaia vlast' i media*, ed. Hans Günther and Sabine Hänsgen (St. Petersburg: Akademicheskii proekt, 2006), 296–305.

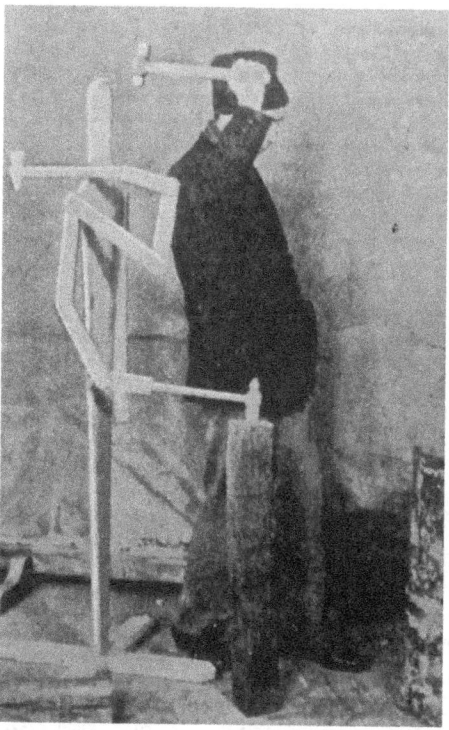

Fig. 3.22 A model of an optimal hammering motion produced at Gastev's Institute and advertised in an American publication "The Russian Central Institute of Work and Its Methods and Means for Training Workers," *Management Engineering: The Journal of Production* 4.4 (1923): 243.

of physical actions in an instantaneous and semiautomatic manner.[104] All these directors believed that proper exercise leads to a "proper set-up," a proper disposition for movement, in addition to developing in the actors a certain dynamism, receptiveness, and readiness for any kind of dramaturgical tasks. This idea of "reflex excitability" is very similar to Aleksei Gastev's slogan concerning the proper psychophysiological "tune-up" of the worker that he calls *ustanovka* (this term can be translated as a "set-up," a "tune-up," an "orientation," or an "attitude"): "The tune-up of the body and the tune-up of the nerves (*ustanovka tela*

[104] See the use of this term in their texts: Nikolai Foregger, "Otvety na voprosy redaktsii," *Zrelishcha* 6 (1922):12; Sergei Eisenstein, "Konspekt lektsii V.E. Meierkhol'da, GVYRM i GVYTM, 1921–1922," *K istorii tvorcheskogo metoda. Publikatsii. Stat'i* by Vsevolod Meierkhol'd [Meyerhold], ed. N. V. Pesochinskii and E. A. Kukhta (Sankt-Peterburg: Kul'tInformPress, 1998), 32–33.

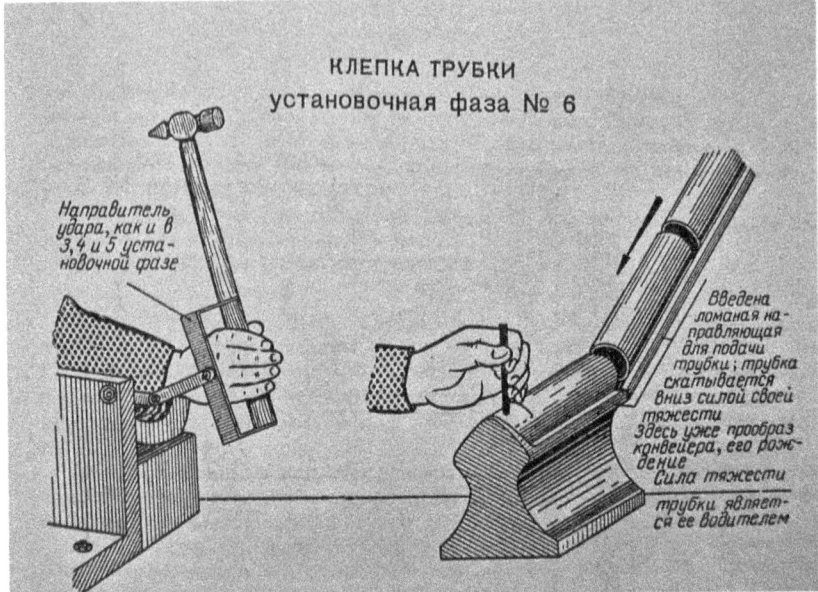

Fig. 3.23 An illustration of a proper *ustanovka* for riveting pipes: a directive mold guides the worker's hand, while pieces of pipe slide down the chute, as if on an assembly line. Image source: Aleksei Gastev, *Kak nado rabotat': Vvedenie v nauchnuiu organizatsiu truda*, 2nd ed. (Moscow: Ekonomika, 1972), 153.

i ustanovka nervov) determines movement, determines work dexterity" (Fig. 3.17). [105]

Kuleshov explicitly mentions Gastev's program for the "scientific organization of labor" (*Nauchanaia Organizatsiia Truda, NOT.*) in the description of stage etudes, acted out by the students of his workshop at the State School of Cinematography in 1921.[106] He says that the students charged with the task of replacing the props during uninterrupted action on stage had calculated the

[105] Aleksei Gastev, Poster "Kak nado rabotat'. Azbuka raboty. Central'nyi Institut Truda," *Kak nado rabotat': vvdedenie v nauchnuiu organizatsiu truda*, 2nd ed. (Moscow: Ekonomika, 1972), 2. Cf. also Gastev's claim concerning the self-disciplining effects of physical exercises that he calls a "psychological training" (*psikhologicheskii trenazh*): "The psychological qualities that we need more than anything at the present moment include the fastness of reactions and automatism of work. Scientists still debate whether or not the fastness of reaction can be trained, but one thing is certain: what we absolutely must have right now is psychological alertness [*sostoianie psikhologicheskoi nastorozhennosti*], zero absent-mindedness, and readiness to give a precise and succinct response to the question" (Gastev, *Kak nado rabotat'*, 56).

[106] Lev Kuleshov, "Praktika rezhissury" (1934), in *Sobranie sochinenii*, vol. 1 (Moskva: Iskusstvo, 1987), 227–342, 290.

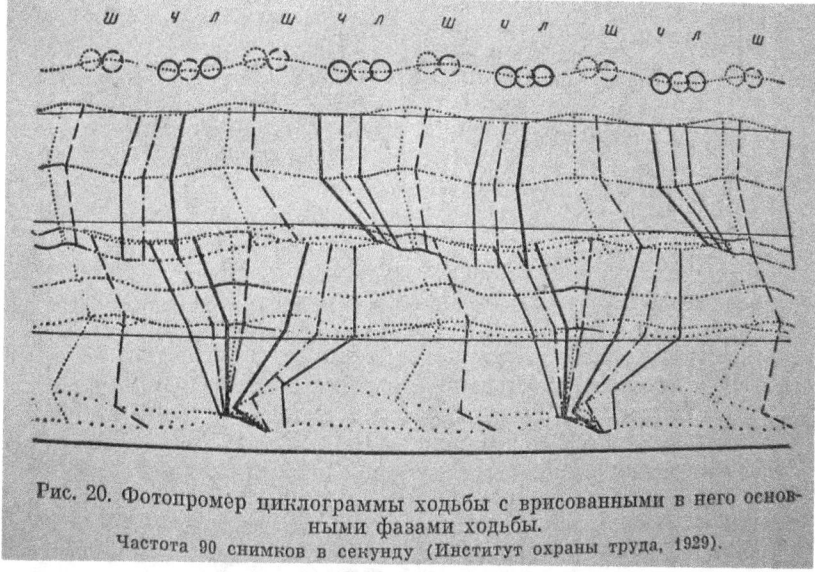

Рис. 20. Фотопромер циклограммы ходьбы с врисованными в него основ-
ными фазами ходьбы.
Частота 90 снимков в секунду (Институт охраны труда, 1929).

Fig. 3.24 Nikolai Bernshtein's cyclogram of walking (1929). The dotted curves
stretching across the image are the result of miniature lamps, which are flickering at
precise intervals to help determine the position of specific joints in space and time.
Image source: Nikolai Bernshtein, *Ocherki po fiziologii dvizhenii i fiziologii aktivnosti*
(Moscow: Meditsina, 1966), 37.

position of objects and their own movements so rationally and precisely, that
their efficient work seemed to be based on "NOT principles."[107] According to
Kuleshov, this experience was important for improving the student's acting tech-
nique: "Well-organized moving of the props played an enormous role in teaching
the students proper movement."[108]

However, in drawing this parallel between the utilitarian, state-sponsored pro-
gram of "taylorizing" labor efforts and the methods of actors' training developed
in Kuleshov's workshop and avant-garde theater studios in the 1920s, it is impor-
tant to note that the artists did not assimilate the tendencies of standardization
and suppression of performers' creativity that we may associate with Gastev's pro-
ject. I will return to this issue and discuss it in more detail later. For now, I would
like to consider some evidence showing how performance artists of the 1920s
interpreted and made use of specific techniques of recording, representing, and

[107] Ibid.
[108] Ibid., 291.

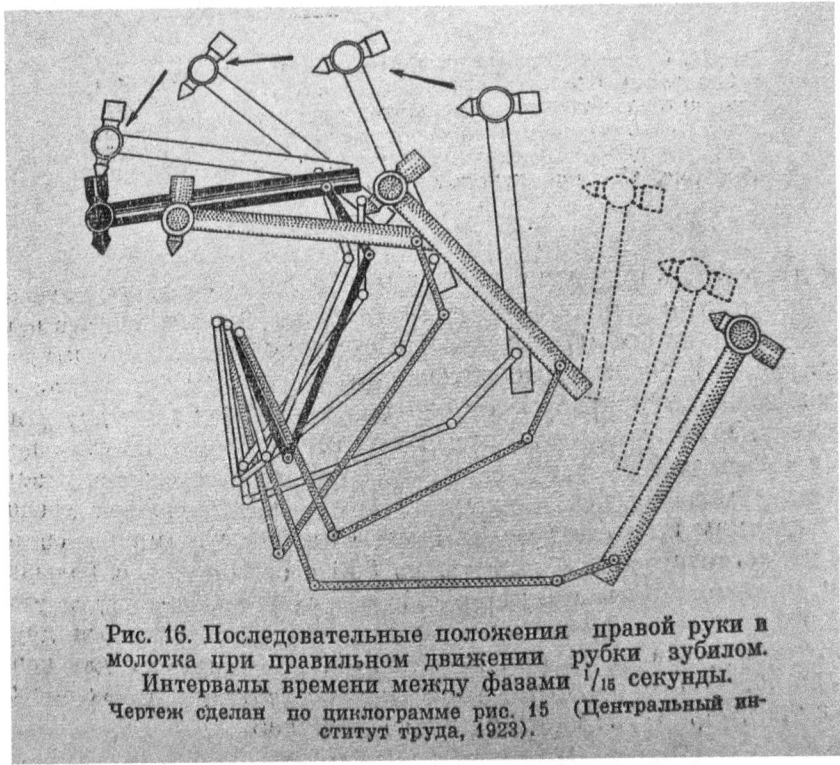

Рис. 16. Последовательные положения правой руки в молотка при правильном движении рубки зубилом. Интервалы времени между фазами ¹/₁₅ секунды. Чертеж сделан по циклограмме рис. 15 (Центральный институт труда, 1923).

Fig. 3.25 Consecutive positions of a hammer attached to a mechanical arm. The Central Institute of Labor, 1923. Image source: Nikolai Bernshtein, *Ocherki po fiziologii dvizhenii i fiziologii aktivnosti* (Moscow: Meditsina, 1966), 32.

training movement that were elaborated in Gastev's Institute. Gastev's artistic inclinations and his involvement with the Proletkul't movement propelled the dissemination of ideas on labor efficiency in artistic circles. In 1923, Gastev's Institute hosted an experimental performance troupe called "The Projectionist Theater,"[109] which was led by young painters Solomon Nikritin and Sergei Luchishkin, who had just graduated from the Moscow Art Institute Vkhutemas, where they studied under the famous Constructivists Liubov' Popova, Aleksandra Ekster,

[109] Irina Lebedeva, "The Poetry of Science: Projectionism and Electroorganism," in *The Great Utopia: the Russian and Soviet Avant-Garde, 1915-1932* (New York: Guggenheim Museum, 1992), 441–449, 449; Nicoletta Misler, "Iskusstvo dvizheniia," in *Shary sveta-stantsii t'my. Iskusstvo Solomona Nikrinina (1898-1965)*, ed. N. Adaskina et al. (Thessaloniki: State Museum of Contemporary Art, 2004), 116–138.

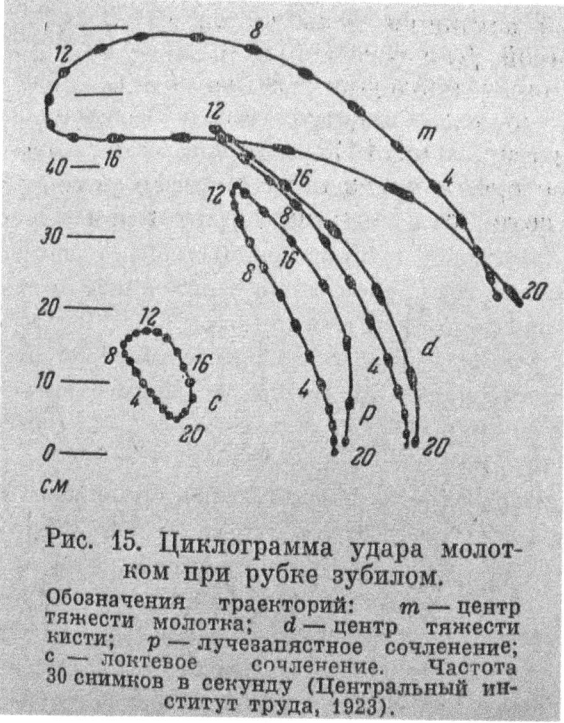

Рис. 15. Циклограмма удара молот-
ком при рубке зубилом.
Обозначения траекторий: m — центр
тяжести молотка; d — центр тяжести
кисти; p — лучезапястное сочленение;
c — локтевое сочленение. Частота
30 снимков в секунду (Центральный ин-
ститут труда, 1923).

Fig. 3.26 A cyclogram of hammering effort, showing a loop trajectory of this movement comprising specific points in space and time. The Central Institute of Labor, 1923. Image source: Nikolai Bernshtein, *Ocherki po fiziologii dvizhenii i fiziologii aktivnosti* (Moscow: Meditsina, 1966), 32.

and Aleksandr Rodchenko.[110] Gastev invited the Projectionists to the Central Institute of Labor and gave them shelter, because he enjoyed their experimental performance *The Tragedy A.O.U.*—a "rhythmo-dynamic composition" freed from conventional plot and dialogue. Gastev saw this production in 1922 in the Palace of the Press, on the very same stage where, according to Sergei Luchishkin's memoirs, the Projectionists would watch the productions of Nikolai Foregger, Boris Ferdinandov, and Lev Kuleshov.[111] One possible reason why Gastev felt

[110] Sergei Luchishkin, *Ia ochen' liubliu zhizn'. . . Stranitsy vospominanii* (Moscow: Sovetskii khudozhnik, 1988), 81–83.

[111] Luchishkin, *Ia ochen' liubliu zhizn'*, 80. Here is Luchishkin's description of the performance of *The Tragedy A.O.U.*: "Our theatrical experiment started out with our determination to develop a score of movement [*partitury dvizhenia*] analogous to a musical score, composed of several parts, each having a different rhythmo-dynamical character. In each of these parts, we searched for the plastic expressive form in movements of the body—their development, their nuances, and transitions,

compelled to make The Projectionist Theater a protégé of his Institute was negative publicity that their performances had received in the Western press. The journalist René Fülöp-Miller had published an article in a major Berlin newspaper in which he spoke of the dangerous cult of the machine that had arisen in Bolshevik Russia, and referred to the performance of the Projectionists as a bacchanalia of "machine worshippers." [112] To spite such reviewers and to prove that the "machine cult" was a legitimate and progressive state endeavor, Gastev adjoined the Projectionists to his Institute. Their first commission in the new setting was to stage didactic plays that would demonstrate ergonomic and efficient ways of chiseling to worker audiences in factories.[113] The Projectionists calculated the movement of performers with mathematical precision. The archive of Solomon Nikritin at the RGALI has preserved his blueprints with trajectories of the performers' torsos and joints, drafted in a style that resembles cyclograms used by scientists at the Central Institute of Labor.[114]

While working under the auspices of this organization, Nikritin also constructed a special "perspectival box" which permitted one to calculate the spatial and temporal coordinates of a figure moving inside it (Fig. 3.27). [115] The prototype of this coordinate system was a marked background surface used by Étienne-Jules Marey and Eadweard Muybridge in their chronophotographic studies of human and animal locomotion. An even closer precursor is the calibrated chart used in the 1910s by Frank Bunker Gilbreth, an American labor efficiency specialist and advocate of Taylorism, to chart out the most economic movement schemes for workers (Figs. 3.28–3.31 b).

Kuleshov's description of actors' training in his cinematic workshop also mentions a "spatial metric grid" (*prostranstvennaia metricheskaia setka*), by which the actors had to orient themselves as they performed exercises.[116] The

including the voicing—and all of this was reflected in the emotional score [*emotsional'naia partitura*], which provided the foundational structure of the whole piece (Luchishkin, *Ia ochen' liubliu zhizn'*, 79). In 1918, Luchishkin studied oral performance with Sergei Volkonskii, using the methods of Delsarte and Jaques-Dalcroze. Therefore, the idea of a "score" prescribing the oral and gestural performance of the actor most probably was inspired by this experience. Luchishkin said that in his classes, "Volkonskii defined each phrase as a musical composition, where the central logical elements were to be performed with an elevation of the tone at the start and the lowering of the tone, or cadence, at the end. He taught us to elaborate a musical score of speech [*razrabotka muzykal'noi partitury rechi*]" (Luchishkin, *Ia ochen' liubliu zhizn'*, 77).

[112] René Fülöp-Miller, "Die Machinenanbeter," *Vossiche Zeitung*, Berlin (1923): October 13, no. 485, 3. Cited in Misler, "Iskusstvo dvizheniia," 136.

[113] Luchishkin, *Ia ochen' liubliu zhizn'*, 82.

[114] Solomon Nikritin, "Zapisi k zaniatiiam v masterskoi Proektsionnogo teatra" (1926), RGALI f. 2717, op.1, ed.kh. 22.

[115] Misler, "Iskusstvo dvizheniia," 116–138.

[116] See notes on "axial" exercises using the "metrical spatial grid" in Lev Kuleshov, "Plan eksperimental'noi kinolaboratorii, 1923–1924," in *Sobranie sochinenii*, vol. 1 (Moskva: Iskusstvo, 1987), 371–380, 379–380; and Kuleshov, "Iskusstvo kino," 215–219.

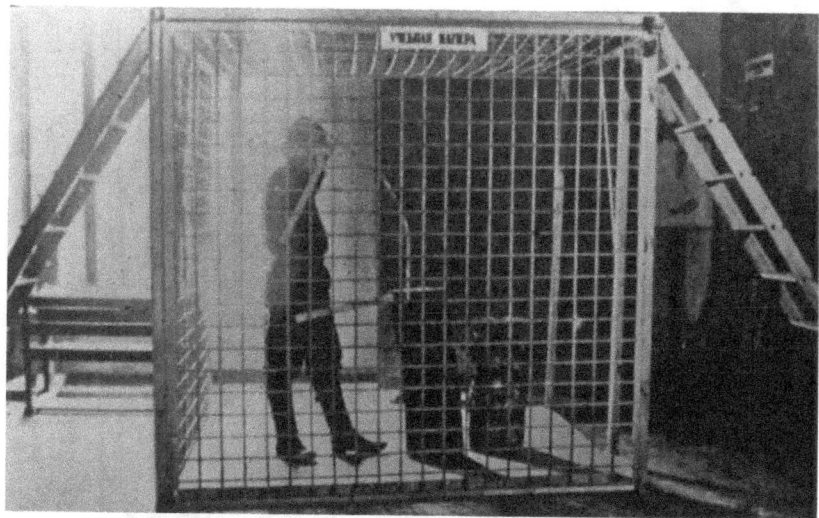

Fig. 3.27 Nikrinin's structure likely served the same purposes as this "training chamber" (*uchebnaia kamera*) with calibrated walls, used at The Central Institute of Labor for registering the coordinates of the worker's movements. This illustration was printed in the American publication "The Russian Central Institute of Work and Its Methods and Means for Training Workers," *Management Engineering: The Journal of Production* (New York) 4.4 (1923): 243.

film historian Yuri Tsivian has suggested that this method must be a close cousin of Solomon's Nikritin's devices at The Central Institute of Labor.[117] Because no drawings of Kuleshov illustrating this tool have survived, we can only attempt to reconstruct it from his descriptions. Based on Kuleshov's texts, it seems that his actors needed the grid in order to imagine how their movements would look onscreen—to use a draftsman's terminology, the grid allowed them to get a projection of the three-dimensional vectors of their movement on the two-dimensional plane of the imagined film screen. The most detailed description of this method appears in Kuleshov's text "The Art of Cinema: My Experience," in which he uses the word "grid" to refer to the marked surface of the screen, or the camera's viewfinder:

> We call this imagined grid on the screen a metric spatial grid [*metricheskoi prostranstvennoi setkoi*]. It provides a point of reference for the actor, as he constructs his movement; the only catch being, obviously, that he moves not on

[117] Yuri Tsivian, "O Chapline v russkom avangarde i o zakonakh sluchainogo v iskusstve," *NLO* 81 (2006): 99–142.

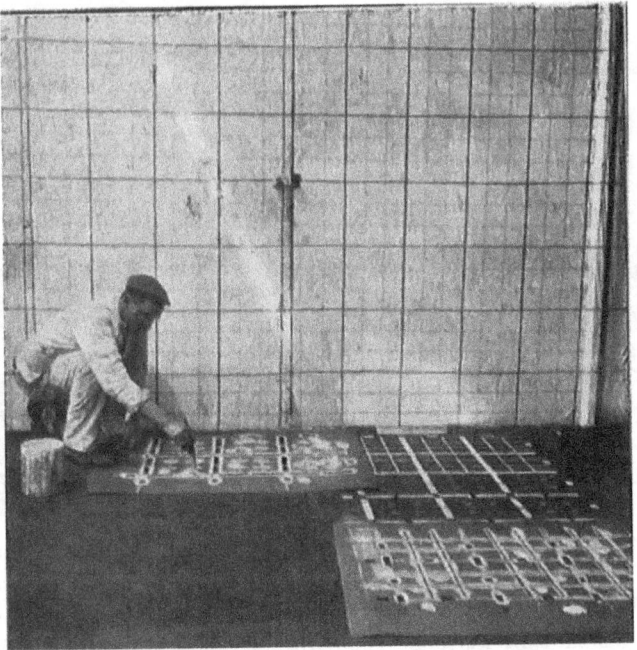

Fig. 3.28 Frank B. Gilbreth's laboratory for labor efficiency studies, United States, 1916. An assistant is charting a grid for capturing the coordinates of the workers' movements. Image source: Reginald D. Townsend, "The Magic of Motion Study," *The World's Work* 32.3 (1916): 321–336, 326. This text is cited by Ippolit Sokolov in his essay "Industrial rhythmical gymnastics" ["Industrial'no ritmicheskaia gimnastika"] published in Gastev's journal *Organizatsia Truda* 2 (1921): 114–118, 115.

the two-dimensional surface of the screen, but in the three-dimensional space of the studio or outdoors. His field of action is a pyramid (lying on its side), the top of which coincides with the center of the camera's lens. Therefore, the two-dimensional screen grid must be transformed into a three-dimensional space within the pyramid where action takes place. The actor thus moves within the cubature—the grid before him, the grid on the floor and the grid on the wall (that is, in case, he is facing the camera). The intersections of lines from all of these surface grids make up the cubature. And the cubature is inside the pyramid, defined by the camera's angle.[118]

[118] Kuleshov, "Iskusstvo kino," 216.

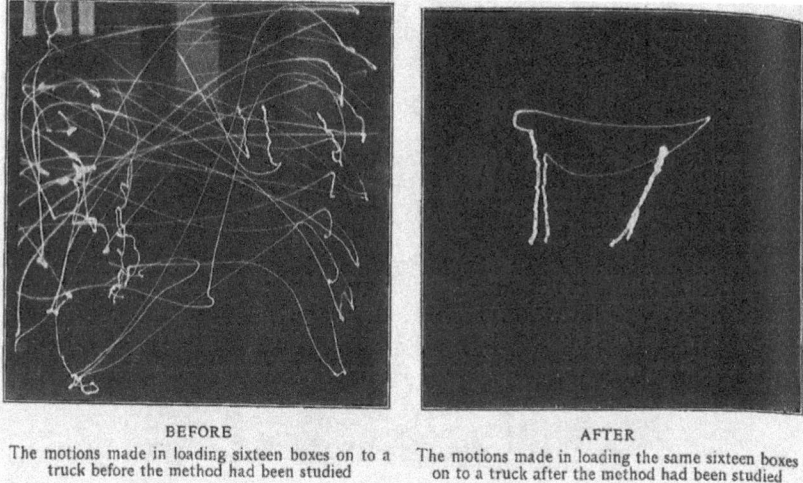

BEFORE
The motions made in loading sixteen boxes on to a truck before the method had been studied

AFTER
The motions made in loading the same sixteen boxes on to a truck after the method had been studied

Fig. 3.29 Light-marked trajectories of a person loading a truck, before and after the "optimization" by Gilbreth. Image source: Reginald D. Townsend, "The Magic of Motion Study," *The World's Work* 32.3 (1916): 321–336, 334.

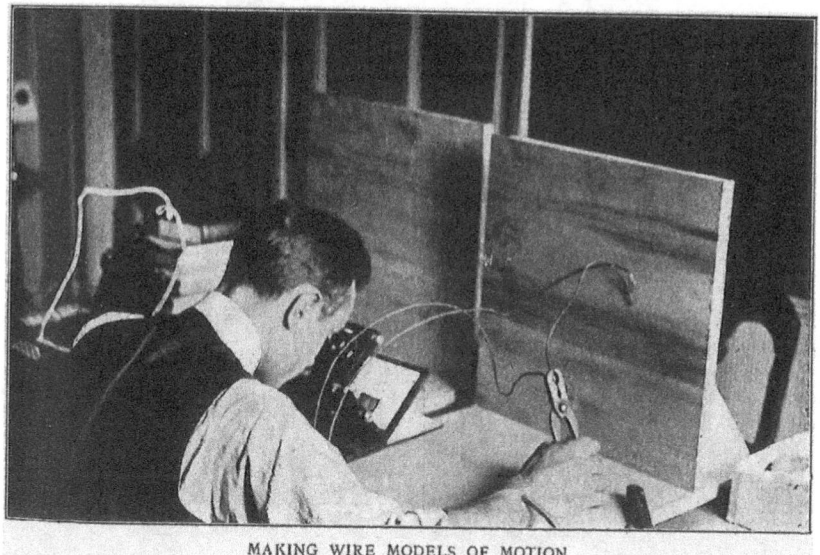

MAKING WIRE MODELS OF MOTION

Fig. 3.30 A technician at Gilbreth's laboratory makes a three-dimensional wire model of an optimal trajectory. Image source: Reginald D. Townsend, "The Magic of Motion Study," *The World's Work* 32.3 (1916): 321–336, 335.

(a)

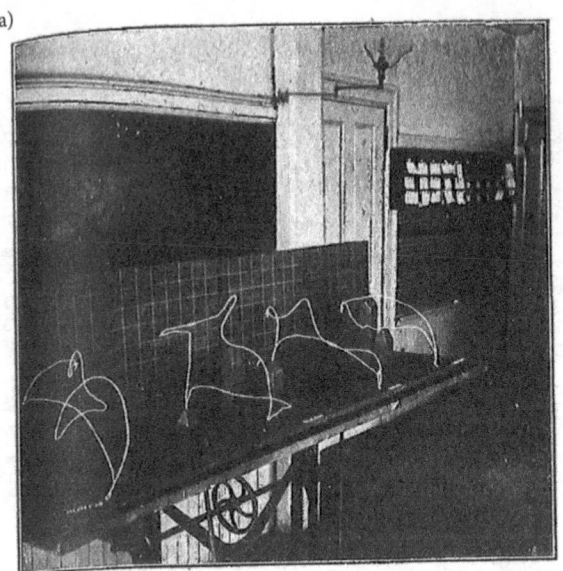

STANDARD WIRE MODELS

What the phonograph has been to the music lover
in standardizing and aiding the study of music, these
wire models have been to the mechanic in aiding the
study of skilled motion

(b)

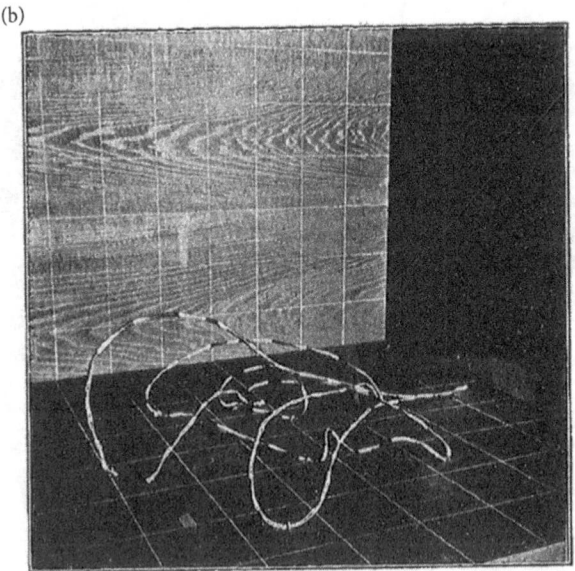

THE TIME AND SPEED OF A MOTION

By means of black and gray paint the time, speed,
and direction of a motion, can be shown on white
painted wire models. In a photograph this result can
be obtained by the use of intermittent flashes of light

Fig. 3.31 (a and b) Gilbreth's wire models of optimal trajectories presented
against a calibrated background for easy recognition of coordinates. Image source:
Reginald D. Townsend, "The Magic of Motion Study," *The World's Work* 32.3
(1916): 321–336, 336.

Thus the actor had to orient himself using the marked floor and the wall on his side, as well as possibly some wire mesh in front of him, in order to imagine a projection of his movement on the plane parallel to the wire mesh—the aperture of the camera standing behind it (what Kuleshov called the "imagined grid" on the screen).

Kuleshov was convinced that particular types of movement on screen can be perceived more effortlessly by the spectator than others. Particularly effective, in his view, were those movements whose vectors were parallel or perpendicular to either side of the screen's rectangle or those that cut either of its sides at a 45 degree angle.[119] "If we register the lines of movement of a regular actor on the screen, we will get chaos; but if we register well-calculated organized work, we will get a rigid linear ornament, which will be much more legible than the previous one,"[120] he wrote. To ensure the strict "organization" of the actors' "work," Kuleshov proposed to verify their movements with respect to three coordinate axes—height, width, and length—and created tables of all possible directions for different body parts. In his workshop, he introduced "axial movement" exercises in order to train actors to take positions that he considered geometrically most advantageous with respect to the envisaged screen rectangle (Figs. 3.32a and 3.32b). Later the director recalled what these exercises looked like:

What was the movement guided by the metric grid? Suppose I had to turn my head to the right using the vertical axis. This meant that I had to hold my head facing the camera, or turn it abruptly at an oblique angle. We were afraid to make small intermediate movements. . . . Because of this, our first exercises and etudes looked rather unusual: most of them were grotesque in character (consisting of simplified movements).[121]

In the same period, Kuleshov also developed a system of notation for actors' movement—he filled his notebooks with schematic drawings of different poses, aiming to chart out all flexions, directions, and articulations of their moving bodies (Fig. 3.33).[122] Very similar schematic drawings were drafted with the same goal by Solomon Nikritin for his Projectionist Theater, but it is unclear whether Kuleshov was aware of his system (Figs. 3.34a–3.34g). In drafting the gestures and poses of his performers, Kuleshov imagined the "rigid linear ornament" that their trajectories would create after they are combined. Over a decade later, in 1934, he would write that drawing schematic figures taught his troupe to "think

[119] Ibid.
[120] Ibid.
[121] Kuleshov, "Praktika rezhissury," 284.
[122] Ibid.

(a)

Осевые движения.

На установке: доска, шест и канат
Натурщица Хохлова

Fig. 3.32 (a and b) Drawings of Kuleshov's acting exercises, titled "Axial movements of the cine-model Khokhlova" and "A three-point lyrical score: talking on the phone. The cine-model Komarov." These illustrations, drawn by one of Kuleshov's actors, the graphic artist Petr Galadzhev, accompanied Aleksei Gan's article about the filmmaker's workshop. Note the angular geometry of Khokhlova's movements on a "set-up" (*ustanovka*), consisting of "a pole, a rope, and a board," as well as a dotted trajectory of a hand, lifting the phone handle. Image source: Aleksei Gan, "Kino-tekhnikum," *Ermitazh* 10 (1922):10.

in terms of movement" and prompted them to "think in terms of shots" and approach everything that they had to film by envisaging it as a "montage image."[123] By pruning away the unnecessary bits from the actors' movements and reducing their trajectories to the most expressive elements, Kuleshov was most concerned with the future spectators' perceptual psychology. He tried to formulate optical laws that would ensure the most economic and effective rationing of the viewers' attention. The principle of economy permeated all levels of Kuleshov's montage

[123] Kuleshov, "Praktika rezhissury," 284–285.

(b)

Трехдольная лирическая
партитура.

«Разговор по телефону»
Иатурщик Комаров.

Fig. 3.32 *Continued*

theory in its initial phase. On the one hand, this principle manifested itself as a desire to convey the gist of the scene in the most expedient and effective way. On the other hand, it prompted Kuleshov to reformulate the goals of the actors' training with the emphasis on efficiency, conceived in categories that resemble the rhetoric of the Central Institute of Labor. Thus, in 1923, Kuleshov stated:

> The laboratory will teach the actor to construct his movement in a business-like manner [*po-delovomu stroit' svoe dvizhenie*], to work, to move realistically before the camera, instead of feigning his role like a thespian. Economy, minimum expenditure of effort, uncovering the mechanical essence of action, eliminating excessive movements—those compulsive, unnecessary movements—these are the main goals that the actor [*naturshchik*] must strive for.[124]

[124] Kuleshov, "Plan eksperimental'noi kinolaboratorii, 1923–1924," 367. Emphasis added.

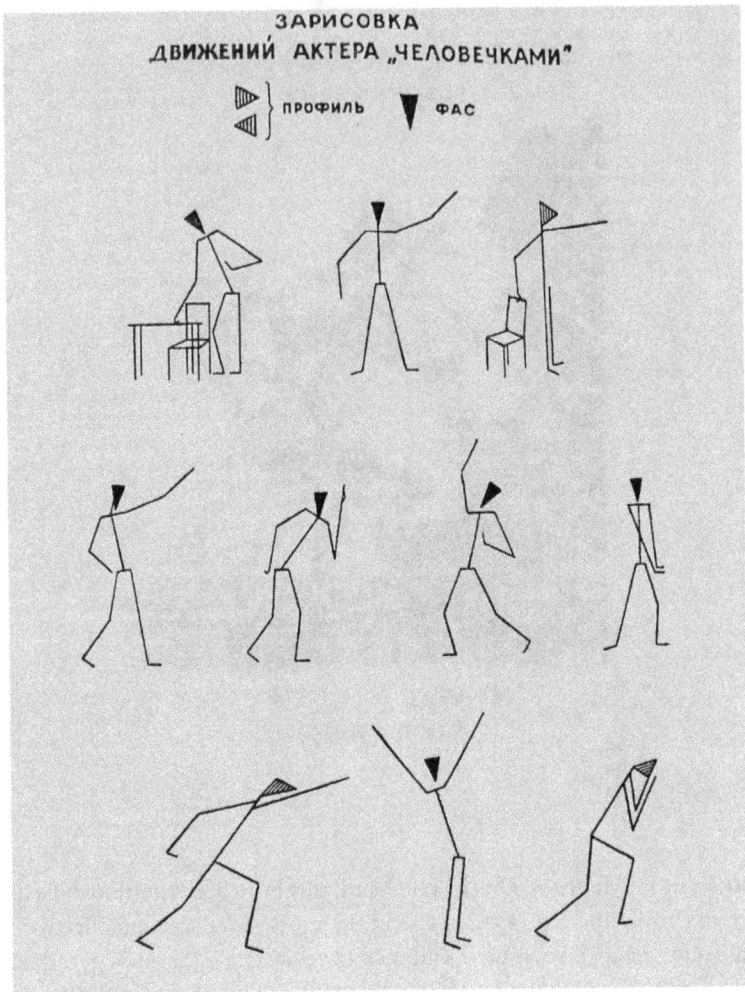

Fig. 3.33 Kuleshov's gesture notation, 1920s. Image source: Lev Kuleshov, *Sobranie Sochinenii*, vol. 1 (Moscow: Iskusstvo, 1987), 285.

It is worth noting that actors' training by the metric grid in Kuleshov's workshop hardly economized their physical energy. Rather, these exercises demanded an extraordinary effort, because Kuleshov's principle of "uncovering the mechanical essence of action" was motivated less by the idea of streamlining man's natural motor habits than by the idea of stylizing his movements in accordance with some abstract "laws of cinematic expressivity." It is significant that Aleksei Gan, who visited Kuleshov's workshop in 1922, wrote that his method grew out of conviction that "at the present moment, the cheapest material is the

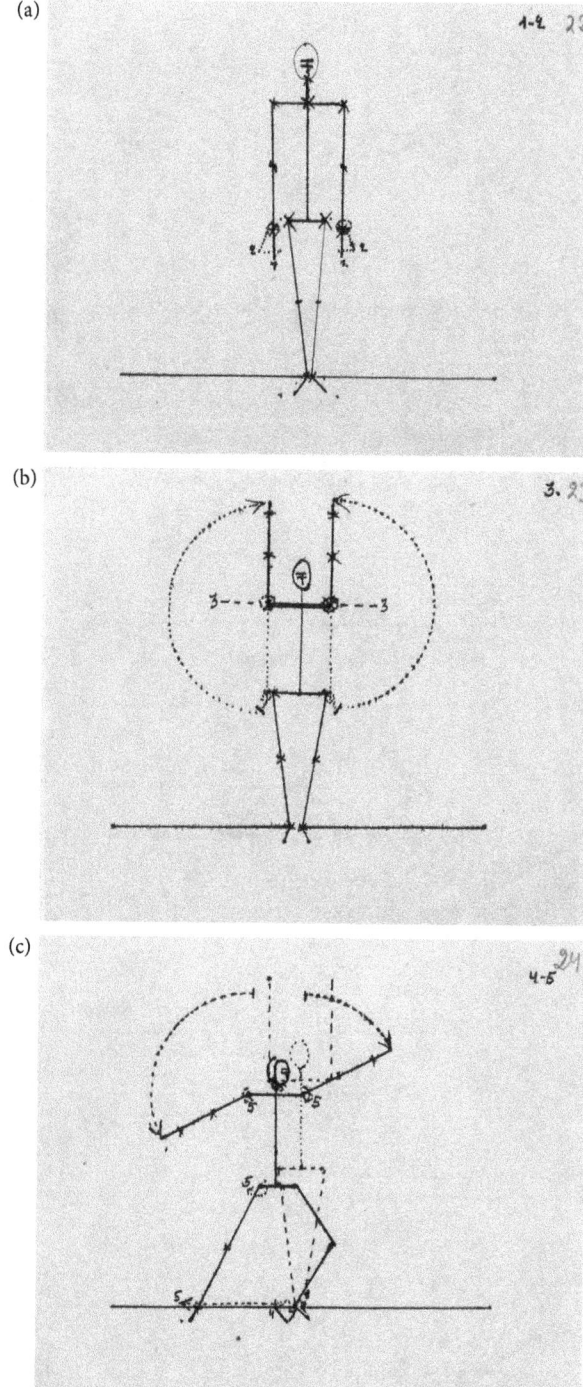

Fig. 3.34 (a,b,c,d,e,f,g) Solomon Nikritin's drafts of actors' gestures for the exercises at his Projectionist Theater studio, 1926 (RGALI f. 2717 op.1. ed. khr. 22).

(d)

(e)

(f)

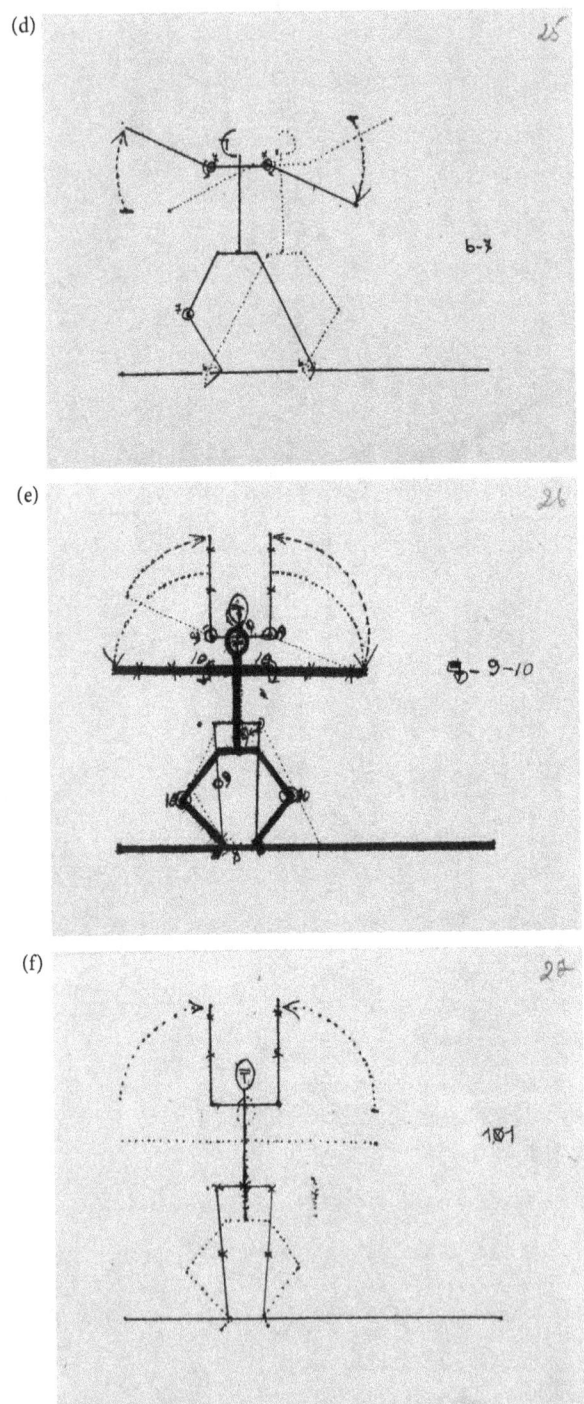

Fig. 3.34 (a,b,c,d,e,f,g) *Continued*

(g)

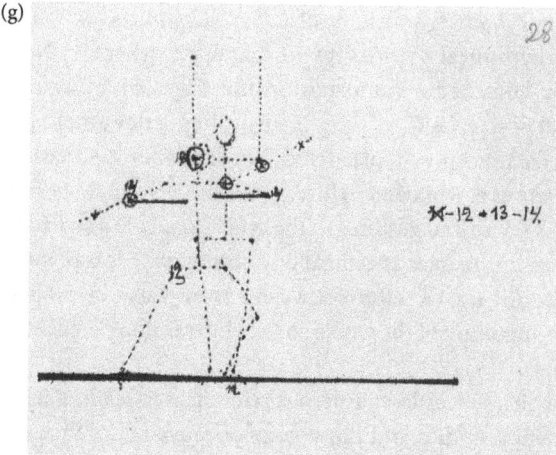

Fig. 3.34 (a,b,c,d,e,f,g) *Continued*

living human nature" and that Kuleshov began by "reconfiguring" this material, because he had no means "to start his work from the most important thing—from the automated technology of cinematic production."[125] Yet the paradox of Kuleshov's approach to acting lies in the fact that even though he extolled stylized movements in theory (abrupt turns, sharp angles, elimination of intermediate phases, "emphatic" positions with respect to the sides of the screen rectangle, etc.), in practice, he was often drawn to filming involuntary gestures and expressions—such as, for instance, the face of Khokhlova as she was being spun on the mill-centrifuge. The involuntary, compulsive movements that have no place in rational theoretical formulas attracted the director as much as the preprogrammed ones.

The paradoxical quality of Kuleshov's position and its incompatibility with the proto-behaviorist programs of the Central Institute of Labor become even more evident, if we compare him to yet another advocate of "taylorizing" actors' movement—Ippolit Sokolov. A young poet, who liked to call himself an "Expressionist," Sokolov studied modern dance at the Moscow Institute of Rhythm—an organization that sought to further the methods of Delsarte and Jaques-Dalcroze.[126] In 1921, Sokolov began to collaborate with Aleksei

[125] Aleksei Gan, "Kino-tekhnikum," *Ermitazh* 10 (1922): 10.

[126] In 1921–1924, Sokolov worked in the Scientific-Artistic Laboratory of the Moscow Rhythm Institute. This organization was founded by the Russian followers of Delsarte and Jaques-Dalcroze, and it had Sergei Volkonskii, Vera Griner, and Nina Aleksandrova among its faculty. In his autobiography (RGALI f.941 op.10. ed. khr. 583), Sokolov wrote that his research interests included "methods of professional aptitude testing for artists and rhythmicalization of labor processes." In the same document, he also stated that he led a theater workshop called "The Laboratory of the Taylorized

Gastev's journal *The Organization of Labor* (*Organizatsiia truda*), publishing an essay on rhythmical gymnastics for factory workers.[127] Next, in the year 1922, Sokolov launched a campaign on the pages of an avant-garde performance journal *Spectacles* (*Zrelishcha*), advocating a new, more precise and efficient, "Taylorized" corporeal plasticity. "Regular labor gymnastics teaches man Taylorized gestures at work and in life," he wrote.[128] By analogy, he continued, we must develop "Taylorized gestures in the arts," "to create a stylized, machine-like gesture ... using principles of reflexology on stage."[129] It is possible to infer that such applicationist use of reflexology came from Gastev's propaganda of optimizing the body culture of the whole society by training people for the right "set-up" (*ustanovka*).

Sokolov's articles included numerous references to leading names in the field of labor efficiency studies and physiology of movement. Thus one article cites Gilbreth's optimized work cycles and proclaims that wire models of Taylorized gestures are the "symbol of our new industrial culture."[130] The same page contained illustrations showing robot-like creatures moving against a marked background reminiscent of Gilbreth's calibrated grid. Sokolov was not concerned about the fact that he aestheticized and distorted the scientific achievements of the Central Institute of Labor when he transposed them onto stage performance (Figs. 3.35 and 3.36). In his hands, the idea of Taylorized movement that was supposed to ease the effort of workers and raise their productivity turned into a theory of stylized gesture capable of communicating the gist of dramatic scenes in the most efficient and fast way. The more laconic the actors' movements, Sokolov wrote, "the sharper each angle, the more precise our perception of the thing or an event will be, and the stronger our movement into the future."[131] An apparent metaphoric quality of such theses did not prevent Sokolov from presenting his utopian theory as an incarnation of scientific achievements in reflexology and the organization of labor.

From this platform, the founder of *The Laboratory of the Expressionist Theater* (*Laboratoriia Teatra Ekspressionizma*)[132] attacked Vsevolod Meyerhold and

Theater" and taught such courses as "Anthropomechanics," "Neuro-muscular Gymnastics," and "Reflexology of Stage Movements."

[127] Ippolit Sokolov, "Industrial'no-plasticheskaia gimnastika," *Organizatsiia truda* 2 (1921): 114–118. On Sokolov's ideas, see John Bowlt, "Ippolit Sokolov and the Gymnastics of Labor," *Eksperiment/Experiment* 2 (1996): 411–421.
[128] Ippolit Sokolov, "Teilorizovannyi zhest," *Zrelishcha* 2 (1922): 11.
[129] Sokolov, "Teilorizovannyi zhest," 11.
[130] Ibid.
[131] Ibid. Cf. Ippolit Sokolov, "Metody igry pered kino-apparatom," *Kino-front* 5 (1927): 10–14; *Kino-front* 6 (1927): 10–13.
[132] In 1921, Sokolov started a performance studio called *The Laboratory of the Expressionist Theater* (*Laboratoriia Teatra Ekspressionizma*). He defined its artistic direction as a search for

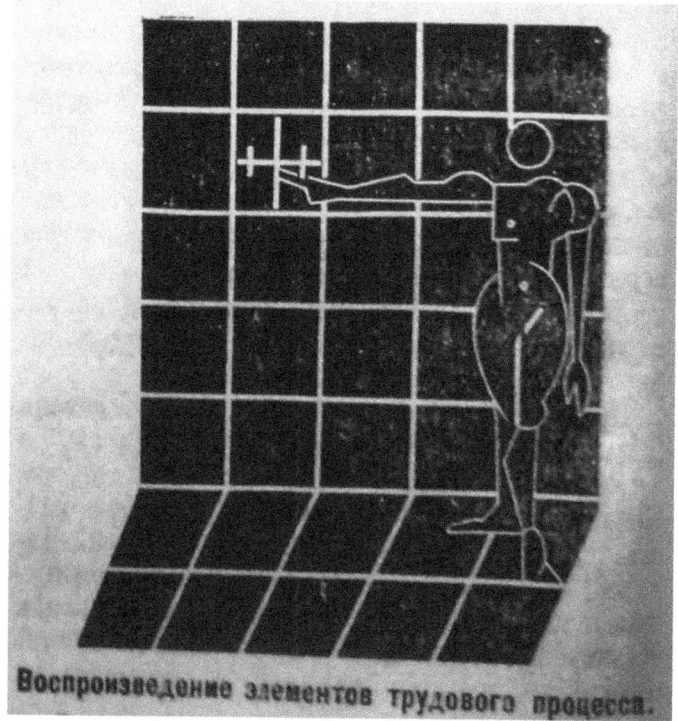

Fig. 3.35 Vladimir Liutse's drawing "Reproducing the Elements of Labor Process," with a stylized feminine figure measuring its movements against a calibrated background. Image source: Ippolit Sokolov, "Teilorizirovannyi zhest," *Zrelishcha* 2 (1922): 10.

Nikolai Foregger, deriding them for their half-baked theory of "reflex excitability." Acting and the capability of showing wired-in reflexes have nothing in common, argued Sokolov, and it is ridiculous to imagine that someone will make a good actor simply because he can "blink when a grain of sand gets into his eye" or "kick up his foot when someone pricks his sole with a needle."[133] Sokolov wrote:

"rhythmical movement," "Taylorized theater," and its method as exercises in "anthropo-kinematics" and "reflexology." Among the instructors invited by Sokolov to teach in his studio were Nikolai L'vov, Vitalii Zhemchuzhnyi, Valentin Parnakh, and others. See M. N. Liubomudrov, "Teatry Moskvy. Po materialam arkhivov i periodicheskoi pechati," ed. A. Ia. Trabskii, *Russkii Sovetskii Teatr, 1921–1926* (Leningrad: Iskusstvo, 1975), 353–360, 355.

[133] Ippolit Sokolov, "Vospitaniie aktera. Kritika ne sleva, a priamo," *Zrelishcha* 8 (1922), 11.

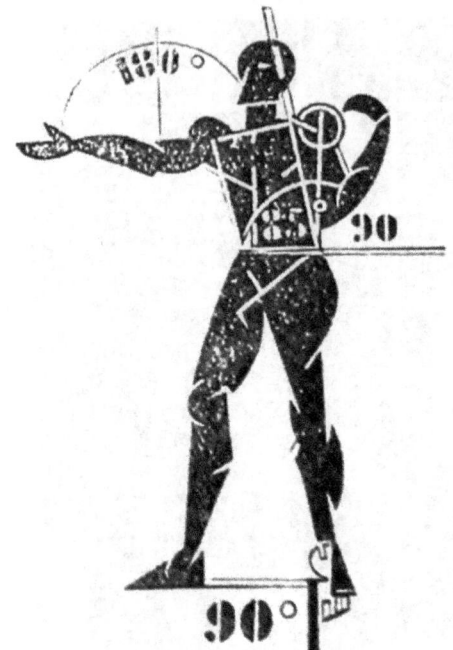

B. Лице.

Fig. 3.36 Vladimir Liutse's drawing "Angles of Labor," inspired by the aesthetics of labor efficiency studies. Image source: Ippolit Sokolov, "Teilorizirovannyi zhest," *Zrelishcha* 2 (1922): 10.

The claim that emotion, temperament, reflex excitability, etc.—in short, any kind of psycho-physiological property—has the same relation to the body mechanism of the actor as petroleum has to the engine amounts to the old theory of acting by intuition [*staraia teoriia 'nutra'*], never mind the new term "motricity" [*motornost'*] that they use now. . . . This claim belies a complete ignorance of reflexology, as well as the "motor" and "psycho-motor" education of the person and the actor, which consists of strengthening and developing the psycho-motor zone of the nervous centers in the cortex.[134]

Thus criticizing Meyerhold and Foregger for being insufficiently well-versed in reflexology, Sokolov associated himself with Gastev by emphasizing that his approach to the actors' training was based on the idea of improving and

[134] Ibid.

rationalizing the physical culture of man by ingraining new working habits in his brain.

But what exactly is *reflex excitability*? It is worthwhile to pause on this concept for a moment and look at it in a greater detail, because a very similar view of the psychophysiological disposition of the actor can be found in Kuleshov's writings. It is known that Meyerhold demanded of his actors that they be in constant motion while performing, in order to be sufficiently warmed up for upcoming acrobatic stunts.[135] In his 1922 lecture on Meyerhold's principles, Sergei Eisenstein stated: "Biomechanics is a method to give the actor healthy excitement, i.e. a state reached by organized muscular work. Different types of physical motion provoke different types of excitement; thus laughter promotes a jolly mood, and tears sadness. James."[136] In this way, using the William James–Karl Lange theory of the physiological basis of emotions, Meyerhold postulated that muscular work provokes particular emotional states in a trained actor, helping him to find necessary gestures and move automatically. In other words, *excitability* in Meyerhold's theory is not exactly mystical "intuition," as Sokolov polemically put it, but a general emotional élan, or psychophysiological tonus provoked by sensations of muscular contraction.

If we take the famous Kuleshov's essay "Notes on the Model" ("Spravka o naturshchike"), which is often cited as an illustration of the director's mechanistic and soulless attitude toward the actor, we will notice that a similar conception lies at its foundation. I would like to argue that in this text, Kuleshov is far from rejecting the emotional aspect of the actor's craft. Rather, like Meyerhold, he changes emphasis from the actor's intuitive groping for the contours of the prescribed role to the immediate muscular sensations of the trained actor-athlete performing a particular physical program. In other words, Kuleshov, in the same way as Meyerhold, attempts to offer an alternative to the outmoded conception of the actor's inspiration and imagines the actor's élan along the lines of James-Lange's theory of emotion. Thus, Kuleshov's description of the cinema actor's, or "model's," training contains the following statement:

> The model must feel *how* he performs particular combinations of poses and movements; he must know how he looks in action and *what* each pose and each gesture expresses. The model should rejoice in his expressivity and be aware of what he is doing; this will make him *feel* the work he is engaged in and get excited by it, which will in turn evoke his emotional awareness of the process of posing [*emotsiiu protsessa pozirovania*], rather than compelling him to fake

[135] Sergei Eisenstein, "Biomekhanika," *Stenogramma lektsii v Proletkul'te* (1922), ed. V. V. Zabrodin, *Kinovedcheskie zapiski* 41 (1999): 68–72, 68.
[136] Eisenstein, "Biomekhanika," 68.

the emotion (the so-called experiencing [*perezhivanie*]) that is suitable for the given scene or that is supposed to help him to find the necessary pose.[137]

It is, of course, tempting to compare this "exciting feeling of work," or this "joy" at correctly performed actions with Gastev's promotion of labor enthusiasm and proper psychophysiological setup. Indeed, it is possible to draw a parallel between Kuleshov's training of the actors for "precise and economical" movement and Gastev's desire to engraft optimized motor habits onto the workers' brains. Such an analogy would be legitimate. But in Kuleshov's case, this comparison touches only the tip of the iceberg. His creative practice and even many of his theoretical texts carry ideas that contradict this utilitarian program. The actors' gestures and movements that Kuleshov praises in his essays are not always purposeful, and not always standard. Even when he trains his workshop participants using the metric chart, axial movement exercises, rhythmical scores, and catalogues of gestures, Kuleshov always relies on the improvisational abilities and inventiveness of the actors themselves. He asks them to fill in and adjust the given blueprints in a way that they themselves consider necessary.[138] He also includes in his films close-up shots of actors' faces as they naturally experience extreme physical conditions, as we saw with the example of his film *By the Law*. These are experimental shots that exhibit involuntary facial expressions, which cannot be calculated in advance.

The peculiarity of Kuleshov's attitude toward reflexology and Gastev-style Taylorism comes to the fore if we look at the examples of ideal cinema models that he gives in his texts. Unsurprisingly, the first place among the exemplary film subjects is given to cargo carriers, with their rhythmical, economical movements honed during long years of loading goods on ships. But this is not all. Other ideal models for Kuleshov include Chaplin and D. W. Griffith's actors. What makes them similar to the cargo carriers in Kuleshov's eyes is—as he puts it—a convincing demonstration of "work processes" and "reflexes." However, if we look closely at the way he uses these terms in his discussion of film scenes, we will notice that his point of view has little to do with Gastev's program. In Chaplin's films, Kuleshov states,

all performance comes down to establishing various work processes, because something is constantly being done with objects—either disrupting or reaffirming the usual way of dealing with them. Approaching the things in either rational, or senseless manners, *the cinema model demonstrates working*

[137] Lev Kuleshov, "Spravka o naturshchike," *Sobranie sochinenii*, vol. 1 (1987), 86, original emphasis.
[138] Kuleshov, "Iskusstvo kino," 219.

processes. A working process is nothing but mechanics; ergo, movement; ergo, the ultimate material of cinema.[139]

In this instance, Kuleshov is fascinated not only by adroit and rational movements, but also by their opposite, and applies the term "working processes" to any kind of dynamic articulation of the actor's body that is oriented at his surroundings and objects in his reach. Concerning the style of acting in Griffith's films, Kuleshov says:

> Griffith laid emphasis either on pure film dynamism, or the pure emotional experience of his actors [*chistoe perezhivanie naturshchikov*], forcing them to convey psychological states by sophisticated movements of their body mechanism. These movements were not some kind of grimacing; they were *reflex actions*, so perfectly performed that they always reached the goal. Griffth's models did not simply go goggle-eyed, for instance, out of horror, but performed a variety of other actions that reflected their condition even more convincingly. Biting the lips, twisting the fingers, touching objects, etc.—these are signature techniques of Griffith's actors. Naturally, these actions were most suitable for the moments of strong emotional disturbance—usually, hysterics.[140]

Here, Kuleshov praises the compulsive, minuscule movements betraying a heightened emotional state that the actor worked himself into. These are unconscious reflex actions—a direct opposite to the well-organized rational work.

In *By the Law*, Kuleshov employs the techniques that he discovered in Griffith's and Chaplin's films. There are scenes of hysteria, performed by Aleksandra Khokhlova with the same spasmodic activation of facial muscles and limbs that Kuleshov diagnosed in Mae Marsh's performance in *Intolerance*. There are visceral close-ups, in which an involuntary reflexes dramatize the character's extreme state of mind (Figs. 3.37a and 3.37b).

Finally, there are scenes, where a conspicuous absence of an ordinary reaction—that is, a type of behavior that seems irrational from the everyday point of view—becomes a dramaturgical device, highlighting the characters' psychological condition. As an example, we may consider the scene of Edith's birthday party, where the cake gets covered by dripping candle wax, because everyone sitting around the table had succumbed to gloomy thoughts.

Contrary to what it may seem at first sight, Kuleshov's references to Taylorism and reflexology, as well as his efforts to rationalize the actors' movement using methods reminiscent of The Central Institute of Labor, did not make

[139] Kuleshov, "Iskusstvo kino," 204; emphasis added.
[140] Kuleshov, "Iskusstvo kino," 203.

(a)

(b)

Fig. 3.37 (a and b) Still frames from the shaving scene in *By the Law*, which exemplify Kuleshov's use of reflex action for dramatic effect. Here, a close-up of Dennin's (Vladimir Fogel's) spasmodic swallowing when the shaving blade touches his throat conveys his fear of Edith's husband (Sergei Komarov). Image source: *By the Law*, dir. Lev Kuleshov. DVD. *Landmarks of Early Soviet Film*. Los Angeles: Flicker Alley, 2011.

the director's approach mechanistic and authoritarian. Kuleshov's work on improving the actors' movement was motivated by his struggle against "false psychologism"—against clichés, banality, ready-made stage gestures. He defined the "theatricality" that he fought against as a lazy compromise with convention—a situation in which the actor gives up exploring his own expressive capabilities.[141]

Viktor Shklovskii once said: "The poetic word is a dance, or a movement made at a moment of psychological scission, rather the movement of a man going to work."[142] The same can be said about acting in Kuleshov's films: it is an unusual and striking type of corporeal plasticity, rather than the "industrial rhythmical gymnastics" that Ippolit Sokolov wanted to introduce in factories.

Critiques of Kuleshov's System

Kuleshov's theory of acting has had a complicated history of reception, and even today this aspect of his legacy is the least understood and appreciated. It was as early as the first half of the 1930s that a teleological outlook on early Soviet cinema began to take root in Stalin's Russia. Biomechanics, metro-rhythm, and all other acting practices that promoted the "defamiliarized" gesture and stylized corporeal plasticity were condemned as a pernicious digression that hindered the progress of Soviet film art toward a more "natural" psychologism. In fact, Kuleshov himself inadvertently contributed to the making of this narrative. Conceding to the pressures of the political climate, he went through numerous sessions of public self-denouncement, in which he stated that his experiments of the early 1920s were leading to a dead end. Ironically, for subsequent generations of Russian film scholars from the Thaw to Perestroika, Kuleshov's methods of actor training appeared too authoritarian, too similar to the Bolshevik aspirations for total control. Gradually, Russian film scholars have adopted the unspoken rule of dismissing Kuleshov's acting techniques as something "unnatural," "mechanistic," "inhumane," and unworthy of appreciation. Needless to say, this attitude prevents us from evaluating the anarchic avant-garde potential, that will for the "ultimate experience,"[143] which characterized Kuleshov and his troupe. There is, to my mind, yet another serious problem that is created by the

[141] Kuleshov, "Praktika rezhissury," 259.

[142] Viktor Shklovskii, "Osnovnye zakony kinokadra" (1927), in *Za sorok let. Stat'i o kino* (Moskva: Iskusstvo, 1965), 43–56, 44.

[143] This notion of George Bataille has been used by the art historian Ekaterina Bobrinskaia to characterize the radical impulses in Russian Futurist art, and I consider it very appropriate for the Soviet film avant-garde of the 1920s. See E. A. Bobrinskaia, *Russkii avangard: Istoki i metamorfozy* (Moscow: Piataia Strana, 2003), 76.

negligence of his legacy—up until now, we know very little about the context that nourished new ideas on corporeal plasticity.

In Russia of the 1920s, the idea of applying methods of experimental psychology for analyzing actors' craft was held in great esteem. For instance, the Film Department of the State Academy of the Artistic Sciences (*GAKhN*) announced in 1926 that its research priority for that year was "psycho-physiology pertaining to the actor's and director's work."[144] Around the same time an influential leftist intellectual, Boris Arvatov, wrote that

> The experimental work of the proletarian director . . . must take the form of scientific lectures with demonstrations of techniques. It is obvious that the director's lab work is inconceivable without an organic link to the Scientific Organization of Labor, psychotechnics, reflexology, and physical training.[145]

During Stalin's epoch, this discourse was erased from history. Productive developments in psychophysiology of expressive movement and perception were abruptly cut off after purges in the ranks of psychologists and an official endorsement of Pavlovian reflexology in its "acceptable" Marxist-Leninist version. In cinema, Socialist Realism became the dominant style, and experiments of the 1920s were dismissively branded as "Formalism." As an example of ideological break that happened in the 1930s, I would like to cite an essay by Kuleshov's colleague Abram Room, known as the director of *Bed and Sofa*. In this article, published in 1932 in the major film newspaper *Kino*,[146] Room writes that, being an alumnus of Bekhterev's Psycho-Neurological Institute, he had made attempts to examine the actor's behavior on the film set from the point of view of reflexology. Thus while teaching at the State Institute of Cinematography in 1926, he wanted to adapt Pavlov's theory for a more plausible "expression of feelings and sensations during film shooting."[147] But in 1932, Room categorically rejects these pursuits and points his finger at Kuleshov, calling him the initiator of the false and harmful theory of the actor as an "über-trained mechanism."[148] This chapter presents an attempt to chart out new possibilities for rereading Kuleshov and investigating the rich interdisciplinary and cross-cultural context which emerged at the juncture of avant-garde performance, psychophysiology, and cinematic technologies.

[144] Anonymous, "Raboty GAKhN," *Kino* 46 (1926): 1.
[145] Boris Arvatov, "Teatr i byt. V poriadke diskussii," *Zhizn' Iskusstva* 31(1925): 8–9, 9.
[146] Abram Room, "Akter-polpred idei," *Kino* 7 (1932): 3; 11 (1932): 3; 15 (1932): 3; 17 (1932): 3.
[147] Room, "Akter-polpred idei," *Kino* 15 (1932): 3.
[148] Room, "Akter-polpred idei," *Kino* 7 (1932): 3.

Fig. 4.1 For Eisenstein, this image of a wave smashing into the pier in the beginning of *The Battleship Potemkin* (1925) was an "ecstatic explosion"—at once a symbol of violent unrest and a kinesthetic prompt for the audience. Anthropomorphizing the splash, the director likened this scene to "a short pantomime that prefaced Elizabethan tragedies and condensed them to their quintessential focus" (Sergei Eisenstein, "Kak delaetsia pafos?" RGALI f. 1923 op. 1 ed. khr. 793 l. 149). Image source: *The Battleship Potemkin*, dir. Sergei Eisenstein. DVD (Kino Lorber, 2007).

4

Kinesthetic Empathy in
Sergei Eisenstein's Film Theory

How is it possible for us to "penetrate the object with our bodily feeling"?

—Heinrich Wölfflin[1]

I would dare to go even further and assert that inspiration has something in common with convulsion, and that every sublime thought is accompanied by a more or less strong nervous shock resounding in the cerebellum. The man of genius has sound nerves; while those of the child are weak. In one, reason has taken up a considerable place, in the other, sensibility occupies almost the entire being. Yet genius is nothing but childhood recovered at will . . .

—Charles Baudelaire[2]

In his autobiographic notes of 1945, Eisenstein describes a "eureka!" moment that occurred in the year 1920, at the very beginning of his career. During a rehearsal of his troupe at the First Proletkult Workers' Theater, the future filmmaker happened to glance at a seven-year-old son of a ticket lady, who was watching the actors in rehearsal. The spellbound child's facial movements reproduced the unfolding scene as "in a mirror."[3] "Not only the facial expressions and actions of individual characters appearing on stage were reflected," Eisenstein marveled, "but all and everything simultaneously."[4] By physically recreating the external

[1] Heinrich Wölfflin, "Prolegomena to a Psychology of Architecture" (1886), in *Empathy, Form, and Space: Problems in German Aesthetics, 1873-1893*, ed. Harry Francis Mallgrave and trans. Eleftherios Ikonomou (Santa Monica, CA: The Getty Center for the History of Art and the Humanities, 1994), 149–190, 154.

[2] Charles Baudelaire, "Le Paintre de la Vie Moderne," *Oeuvres Complètes de Charles Baudelaire: L'art Romantique*, ed. Calmann Lévy, Vol.3., Paris: Ancienne Maison Lévy Frères, 1885, 51–114, 62.

[3] Sergei Eisenstein, "How I Became a Director," in *Selected Works*, 3 vols., vol. 3, trans. William Powell, ed. Richard Taylor (London: I.B. Tauris, 2010), 284–290, 286. For the Russian original, see Sergei Eisenstein, "S zaranee obdumannym nameremiem: 'Montazh attraktsionov,'" in *Metod*, vol. 1 (Moskva: Muzei kino, 2002), 49–63, 51.

[4] Eisenstein, "How I Became a Director," 286. A similar anecdote about the child spectator's face "simultaneously reflecting" the actions of the main characters and extras on stage is included in

Psychomotor Aesthetics. Ana Hedberg Olenina, Oxford University Press (2020). © Oxford University Press.
DOI: 10.1093/oso/9780190051259.001.0001

signs of the characters' behavior, the child tunes into the emotions and attitudes encoded in the drama. Adult spectators, engrossed in action, are prone to the same kind of kinesthetic empathy, although their imitative tendencies are not manifested overtly. Quite likely, Eisenstein speculated, this suppression of mimicking in adults amplifies the intensity of their mental experience of dramatic situations in the play.[5] Thus writing in 1945, the director claimed that this observation and the train of thoughts that it prompted stood at the origins of his lifelong inquiry into the enactive nature of aesthetic experience.

Indeed, from this early epiphany during his formative period in the avant-garde theater throughout the late stages of his career as a filmmaker, the concept of the spectators' co-movement with the seen action remained a central tenet in his explanations of art's impact. This postulate is articulated in one of his earliest programmatic essays, "The Montage of Film Attractions" (1924), where he asserts that "emotional perception is achieved through the motor reproduction of the movements of the actor by the perceiver."[6] This formula already contains all elements of the theory, which would go on to underwrite Eisenstein's outlook on the mechanisms of perception: the presumption of the imitative instinct, the emphasis on muscular sensations inextricably linked to emotions, and the dream of intersubjectivity, or the possibility of transmitting the emotional charge from performers to the audience by locking the two in unison motion (Fig. 4.1). Regarding the types of movement the audience may respond to, it is worth noting that already in the early 1920s, Eisenstein was convinced that it was not only the actors' gestures that delineated spectators' experience, but also the trajectories of their bodies within the mise en scène. His experience as a set designer taught him what stage machines and acrobatic apparatuses could do to fill the space of the proscenium with exhilarating lines of action. In Eisenstein's writings of the 1930s, the category of "movement" capable of outlining the audience's somatic and emotional response explicitly includes the "pathways" implied in the compositional structure of images (Fig. 4.1), in the running course of the unfolding mise en scène, in "shifts of density" of color and lighting, in the twists of the plotline, and in shot-to-shot jolts of montage.[7]

Eisenstein's 1934 lecture for his students at the All-State Institute of Cinematography, VGIK (Sergei Eisenstein, "Iz Lektsii vo VGIKe, 22 sentiabria 1934 goda," in *Eizenshtein o Meierkhol'de*, ed. Vladimir Zabrodin (Moscow: Novoe izdatel'stvo, 2005), 205–223, 211).

[5] Ibid., 286.
[6] Sergei Eisenstein, "The Montage of Film Attractions," ed. and trans. Richard Taylor, *Selected Works: Writings, 1922–34* (London: I.B. Tauris, 2010), 39–58, 48.
[7] See Sergei Eisenstein, "Montage 1937," in *Selected Works, Vol.2: Towards a Theory of Montage*, trans. Michael Glenny, ed. Michael Glenny and Richard Taylor (London: I. B.Tauris, 2010), 11–58; and Sergei Eisenstein, *The Film Sense*, ed. Jay Leyda (New York: Harcourt, Brace and World, 1970), 171. Several commentators have noted Eisenstein's tendency to project meaning onto the dynamic geometry of images onscreen (see P. M. Atasheva and N. Kleiman, "Kommentarii," in Sergei Eisenstein, *Izbrannye proizvedeniia v shesti tomakh*, vol. 4., 747; Mikhail Iampolski, "Ot Proletkul'ta k

Predicated on kinesthetic empathy, Eisenstein's model of spectatorship raises a whole host of questions regarding the audience's agency and the nature of exchange happening in the movie hall. Why does the director prioritize the embodiment of visual forms above all other aspects of the audience's engagement with the film image, particularly, above the rational processing of themes, socio-ideological message, and cultural associations, as well as the passing of moral judgment? Is Eisenstein's mode of film viewing passive or active? Does cinema empower the spectators by animating them, or subjugate them to total control? Does Eisenstein consider this mechanism to be universal or individual, that is, contingent on specific circumstances? What, in Eisenstein's model, can guarantee that the spectator will experience film sequences as intended?

These overarching questions provide the background for this chapter's inquiry into the sources of Eisenstein's model of embodied spectatorship at its initial stages of development. The full implications of the director's vision cannot be properly understood without mapping its roots. My goal here is to highlight the psychophysiological and philosophical trends that anchor his approach to embodiment and to evaluate the place of these intellectual influences in his theoretical and creative projects. Specifically, I will examine three themes that are foundational for his conception of the viewers' embodied response. The first of these is bodily imitation—a subconscious tendency to mirror the seen action or the dynamic geometry of shapes. The roots of this theory reach deep into the 19th- century German philosophy, where the notion of *Einfühlung* ("empathy," literally "feeling-into") emerged as a way of theorizing the intuitive, corporeal response prompted by visual and spatial forms. As I will demonstrate, however, Eisenstein's access to this intellectual tradition in the 1920s is mediated by a materialist, monistic understanding of the psyche in line with the utopian perspective of the Soviet avant-garde. This utopian lens amplifies the significance of neurophysiological explanations of the imitative act, drawing on sources such as William James's theory of "ideomotor actions," as well as Vladimir Bekhterev's writings on "emotional contagion" and "collective reflexology."[8] The resultant

Platonu: Eizenshtein i proekt smyslovoi samoorganizatsii zhizni," *Kinovedcheskkie Zapiski*, 89 (2009), http://www.kinozapiski.ru/ru/article/sendvalues/960/; Luka Arsenjuk, "The Notes for a General History of Cinema and the Dialectic of the Eisensteinian Image," in *Sergei M. Eisenstein: Notes for a General History of Cinema*, ed. Naum Kleiman and Antonio Somaini (Amsterdam: Amsterdam University Press, 2016), 289–298, 294.

[8] Oksana Bulgakowa has noted that William Carpenter's "ideomotor" effect, discussed by William James, was an important point of reference for Eisenstein in his reading of Ludwig Klages (see Oksana Bulgakowa,"From Expressive Movement to the 'Basic Problem,'" in *The Cambridge Handbook of Cultural-Historical Psychology*, ed. Anton Yasnitsky, René van der Veer, and Michel Ferrari [Cambridge: Cambridge University Press, 2014], 423–448, 427). On Eisenstein and Bekhterev, see Mikhail Iampolski, "Ot Proletkul'ta k Platonu. Eizenshtein i proekt smyslovoi organizatsii"; Ute Holl, *Cinema, Trance and Cybernetics* (Amsterdam: Amsterdam University Press, 2017), 231, 274–276.

hybrid model of embodied spectatorship, in which visual impressions are coupled with motor reactions, inherits many of the promises and contradictions from its vitalist and positivist sources. On the one hand, this model valorizes the subconscious corporeal responses, paying a due tribute to the entire realm of bodily sensations that underpins cognitive and emotional processes. On the other hand, in laying emphasis on simulation, or mirroring, Eisenstein tends to overestimate the universality of this mechanism and ascribes false transparency to nonverbal communication. Even if the traces of imitative impulses could indeed be detected in the viewers' bodies, it is a stretch to say that they experience and interpret the images in the intended way—an issue that Eisenstein acknowledged, but did not fully confront in his theory.

The second, related theme in Eisenstein's conception of embodied spectatorship that I would like to highlight is his assumptions about the inhibition of the motor discharge: why are adults capable of suppressing overt imitation, while children's bodies react so effusively? The distinction between the mature and young viewers in Eisenstein's theory points to the polarization between an intense emotional involvement and a cold-blooded, detached intellection. Yet, in drawing a line between reason and emotion, Eisenstein does not simply repeat the age-old adage contrasting these two forces of the human psyche. Crucially, the difference between a more cerebral and a more spontaneous, emotive reaction lies in the degree of physical outburst exhibited by spectators' bodies. As I will show, Eisenstein evokes the psychophysiological tradition that considered thought as parallel to physical action, that is, as a rechanneled nervous impulse that reverberates through the brain instead of activating the muscles immediately. This perspective highlights the role of the limbic system for preparing high-order intellectual decisions. Instead of the dichotomies of the body and the mind, or of the voluntary and involuntary reactions, Eisenstein's sources describe processes of inhibition and excitation as regulated by the functional structures of the hierarchically organized brain and affecting the entire organism.

Finally, the third theme I would like to address is Eisenstein's assumptions about the intersubjective nature of the audience's communion with the moving image. His is a vision that blurs the boundaries between the spectator's individual self, the collective, and the work of art, which bears the imprint of its creator's physicality. The director imagines stage plays and films as happenings (to use an anachronistic term), in which the audience is so tensely intertwined with the action it is witnessing that it literally shares the heartbeat with the ebbs and flows of the unfolding drama. Undeniably, Eisenstein's inquiry into the enactive, embodied nature of spectatorship is motivated at least in part by a quest for manipulative tactics. Yet the same quest leads him to imagine a liberating, mind-opening experience for the audience. By the end of the 1920s, he explicitly articulates the viewer's emotional involvement with the screen image as

an ecstatic, trance-like state.[9] Granted, the spectator's rapture that Eisenstein envisages remains a violent transformation, but it is justified by the will to push the boundaries of what is possible in art and in society at large—in short, by the will for a radical ultimate experience where there was always room for play and for the unexpected. In this respect, Eisenstein's approach to embodied spectatorship shares much with Walter Benjamin's vision of film audience's "innervation" by the moving image, brought to light by Miriam Hansen.[10] However, the unique elements of the Soviet director's experimental drive are best understood in the context of Soviet avant-garde artists' efforts to revolutionize the sensory appeal of mass art.[11]

The Spectator's Sensate Body: Eisenstein Theory of Empathy between Lipps and Bekhterev

A foundational element in Eisenstein's model of embodied spectatorship is empathy—the spectators' ability to project themselves into the shapes in the cinematic image and to be affected by the kinesthetic sensations associated with poses suggested by these shapes. Peculiarly, in describing this process of spectatorial involvement, Eisenstein conspicuously avoids the word *Einfühlung* (typically rendered as *vchuvstvovanie* in Russian), as well as references to influential 19th-century German theorists who popularized this term, such as Theodor Lipps and Robert Vischer. In "The Montage of Film Attractions" (1924), the filmmaker calls on Lipps only once, in order to preface his claim about the spectator's "motor reproduction" of the actors' performance, and he prefers to cite the German philosopher via a more authoritative source in the Soviet context—Vladimir Bekhterev's *The General Principles of Human Reflexology*:

> by feeling our own self into the other person's facial expressions (*vchustvovaniem svoego ia v chuzhuiu mimiku*), we get a tendentious prompt to experience our own emotions of the same kind, but not a confirmation that the other's self exists.[12]

[9] Sergei Eisenstein, "Kak delaetsia pafos?" (1929), RGALI f. 1923 op. 1 ed. khr. 793 l. 31.

[10] Miriam Hansen, *Cinema and Experience: Siegfried Kracauer, Walter Benjamin, and Theodor W. Adorno* (Berkeley: University of California Press, 2012), 132–140.

[11] Among the groundbreaking contributions to analyzing the sensory dimension of avant-garde artists' cultural politics, see Oksana Bulgakova, *Sovetskii Slukhoglaz: Kino i ego organy chuvstv* (Moskva: Novoe literaturnoe obozrenie, 2010); I. M. Chubarov, *Kollektivnaia chuvstvennost': Teorii i praktiki levogo avangarda* (Moskva: Izdatel'skii dom Vysshei shkoly ekonomiki, 2014); Emma Widdis, *Socialist Senses: Film, Feeling, and the Soviet Subject, 1917–1940* (Bloomington: Indiana University Press, 2017).

[12] Sergei Eisenstein, "Montazh kinoattraktsionov," in *Formal'nyi metod: Antologiia russkogo modernizma*, Tom 1, Sistemy, ed. (Serguei Oushakine, 2016), 379–400, 389. Eisenstein's second-

The cautionary tone of Bekhterev's presentation of Lipps's *Einfühlung* in this passage signals dissatisfaction with an all-too-easy model of spectator's identification with the object of his gaze. Despite criticizing Lipps, Bekhterev himself was intrigued by the possibilities of nonverbal communication, suggestion, and emotional contagion, but he called for investigating a materialist, neurophysiological foundation for these effects. Bekhterev proposed to construe a seemingly imitative reaction not as a direct copying, but as the subject's own, individual associative reflex triggered by the seen "symbol."[13] In his article, Eisenstein set aside Bekhterev's warning about the impenetrability of the other person's psyche and highlighted the fact that visual perceptions can indeed elicit a visceral reaction from the viewers.[14] For the Soviet filmmaker, Bekhterev's evocation of Lipps was tantamount to a tentative endorsement if not of the entire discourse on *Einfühlung*, then at least of some its key lines of inquiry, specifically those that correlated the sight of actions or shapes with affective responses involving the spectator's entire body.

Eisenstein's point of view was quite daring, because by the 1920s, the term *Einfühlung* had already become somewhat suspect not only in Soviet Russia, where "bourgeois" influences were frowned upon, but even in its birthplace, Germany. Theorized as a fusion of haptic and optic percepts, empathy once served as an influential explanation of the sensation of form at the core of aesthetic pleasure, premised, in the spirit of German Romanticism, on the idea of self-estrangement and an imaginary merge with the perceived object.[15] By nesting his gaze within the visual shape, the perceiver was thought to endow the object with an animate soul—that is, vicariously experience the object's folds, movements, and affective tendencies as if they were his own. Since the 1860s onward, German intellectuals such as Friedrich Theodor Vischer and his son Robert Vischer, Konrad Fiedler, August Schmarsow, Hermann Lotze,

hand quotation of Lipps may be found in Vladimir Bekhterev, *Obshchie osnovy refleksologii cheloveka: Rukovodstvo k ob"ektivnomu izucheniiu lichnosti*, 4-e izdanie (Moskva: Gos. Izdatel'vo, 1928), 25.

[13] Bekhterev, *Ob"ektivnaia psikhologiia*, 195.

[14] Eisenstein, "Montazh kinoattraktsionov," 389. Evgenii Bershtein has noted that the the the German term *Einfühlung* reappears in Eisenstein's thinking in the early 1930s in connection to his theory of bisexuality. In 1930, Eisenstein visited Magnus Hirschfeld at the Institute of Sexual Science in Berlin, who inscribed a book to him, addressing the director as "the master of empathy." Seeking to decipher the meaning of this inscription, Eisenstein wrote back requesting more literature on *Einfühlung* and asking to clarify Hirschfeld's views on the relationship between empathy and one's sexual "identification." See Evgenii Bershtein, "Eisenstein's Letter to Magnus Hirschfeld: Text and Context, in *The Flying Carpet: Studies on Eisenstein and Russian Cinema in Honor of Naum Kleiman*, ed. Joan Neuberger and Antonio Somaini (Milan: Éditions Mimésis, 2018), 75–86.

[15] On the articulation of these ideas by Herder and Novalis in the 18th century, see Robin Curtis, "*Einfühlung* and Abstraction in the Moving Image: Historical and Contemporary Reflections," *Science in Context* 25.3 (2012): 425–446, 427.

Johannes Volkelt, Karl Groos, Adolf Hildebrand, and others elaborated nuances of this psychological phenomenon, attempting to explain it on the basis of diverse justifications, from metaphysical to neurophysiological.[16] Toward the turn of the 20th century, Theodor Lipps emerged as the foremost proponent of *Einfühlung*. His publications explained effects such as an imaginary sense of an upward thrust one might project onto a Doric column.[17] Lipps's 1903 treatise *Aesthetics: Psychology of Beauty and Art*, widely regarded as the most comprehensive account of the concept of empathy, explained how we "feel into" the dynamic forms of inanimate objects, abstract phenomena such as atmospheres, colors, and sounds, as well as human expressions.[18] In this work, Lipps drew attention to the "involuntary, instinctive" sense of rudimentary co-movement, or a "sympathetic tension," that observers frequently experience when watching other humans' actions, such as dancing or walking on the tightrope.[19] It is this "instinctive mimicry" and the sensations accompanying such simulation that guide our comprehension of others' experiences and feelings according to Lipps's *Aesthetics*, although in other publications, he hinted that the experience of empathy may in fact be egocentric:

> I give expression to this kind of *Einfühlung* in everyday life when I say that the line stretches or bends, surges up and away again, confines itself; and when I say that a rhythm strives or refrains, is full of tension or resolution etc. This is all my own activity, my own vital, internal movement, but one that has been objectified.[20]

Despite Lipps's tremendous influence, in the first decades of the 20th century, *Einfühlung* was gradually dislodged from its pedestal in multiple arenas: in psychology, rigorous experiments proved that individuals' interpretation of geometric forms was highly subjective, and in art history, Wilhelm Worringer swayed the field toward prioritizing vision as the essential instrument of aesthetic judgment.[21] The new intellectual vogue promoted a detached, ocularcentric contemplation of abstraction instead of an embodied, compassionate involvement that was once a staple of empathy. Thanks to Worringer, the word *Einfühlung* came to be associated with the already unfashionable representational and

[16] Helen Bridge, "Empathy Theory and Heinrich Wölfflin: A Reconsideration," *Journal of European Studies* 41.1 (2011): 3–22; 4.

[17] Theodor Lipps, *Raumästhetik und geometrisch-optische Täuschungen* (Leipzig: Barth, 1897), 7.

[18] Bridge, "Empathy Theory and Heinrich Wölfflin," 4. See Theodor Lipps, *Ästhetik: Psychologie des Schönen und der Kunst. Erster Teil: Grundlegung der Ästhetik* (Hamburg: Voss, 1903).

[19] Curtis, "*Einfühlung* and Abstraction in the Moving Image," 429.

[20] Lipps, *Leitfaden der Psychologie* (1903), cited in Curtis, "*Einfühlung* and Abstraction in the Moving Image," 429.

[21] Juliet Koss, "On the Limits of Empathy," *The Art Bulletin* 88.1 (2006): 139–157, 139.

narrative trends in art.[22] Philosophically, the thrust of challenges levied against the theory of empathy attacked the weakest point of Lipps's theory—the question of the subject's relationship with the observed object. Whereas Lipps maintained that empathetic activity entailed the cognizance of the other through one's own self, or a sympathetic relation with the other occasioned by the subject's emotional investment, critics such as Worringer argued that *Einfühlung* amounted to nothing more but a solipsistic "self-affirmation within the object."[23] Toward the late 1900s, Lipps himself began to move away from the earlier, more radical versions of his theory and to describe empathy in more tame way, as premised on intuition and imagination.

Contemporary Russian commentators, who kept abreast of all intellectual developments in German philosophy, joined in criticizing some aspects of Lipps's theory and endorsing others, while offering their own clarifications. Writing about the imitative impulse in 1914, the philosopher Nikolai Losskii mused that contagiousness of someone's yawn is prompted not as much by the visual impression of this action, but rather by our intuition of how "sweet" this muscular activity feels.[24] According to Losskii, our perception of another person does not come down to a play of moving shapes and colors; we endow the other's body with a sense of active vitality, conjoining all these movements into a living, feeling figure. Losskii insisted that it is our haptic simulation of the other person that underpins our emotional comprehension of his motor expressions, and he concurred with Lipps that this connection is possible, even if it is based on intuition. The reflexologist Vladimir Bekhterev, in his book cited by Eisenstein, rejected Losskii's and Lipps's idea of a transparent, direct access to another person's inner world through such simulation.[25] However, he went out of his way in enumerating possible justifications for this psychological phenomenon. He evoked Charles Darwin's assertion that the expression of basic emotions is an automatic process that takes on the same form for different members of the same species, and therefore, an instinctive recognition of such expressions should be based on inborn capacity.[26] Bekhterev further hypothesized that there may be some hitherto undiscovered medium by which mental states could be transmitted from one person to another, for instance, via some kind of brainwaves, or energy impulses: "being an accumulator of energy, the brain of animal and man is capable, under certain circumstances, of becoming either a sender or a receiver, similar to a radio station reliant on the Hertz waves."[27] Based on his own experiments with hypnotic

[22] Koss, "On the Limits of Empathy," 150.

[23] Ibid., 147.

[24] Losskii, "Vospriiatie chuzhoi dushevnoi zhizni" (1914), cited in Bekhterev, *Obshchie osnovy refleksologii*, 27.

[25] Bekhterev, *Obshchie osnovy refleksologii*, 27.

[26] Ibid., 27.

[27] Ibid.

suggestion, Bekhterev believed that telepathy was not altogether a hoax, yet he was cautious not to present it as a reliable method of communication: even if some form of transmission may be happening between the two brains, he argued, whatever percentage of this exchange reaches consciousness may not serve as the basis of positive knowledge about the other being's experiences.[28]

Given all the debates and skepticism surrounding the notion of empathy, it is remarkable that Eisenstein chose to adhere to a version of this theory. Though he nonchalantly brushed off the problem of communication implicit in the debates on *Einfühlung*, as a film theorist, he found value in the belief that the cinematic form impacts the viewer not only via the sensory channel of vision, but also on the kinesthetic level interlinked with emotional circuits. This insistence on the embodied, enactive spectatorship process ran counter to the incipient turn toward ocularcentrism in Western aesthetic theory. Originating in Wilhelm Worringer's *Abstraction and Empathy* (1907), this trend would go on to culminate with Clement Greenberg's formalist analyses of nonobjective art the 1940s–1950s.[29] In the words of the art historian Robin Veder, Greenberg's influential works promoted "intellectualized vision" at the expense of "anti-intellectual theatricality," attacking the very premise of earlier theories of empathy—the idea of the spectator "escaping" into the pictorial space.[30] Notably, thanks to his entrenchment in the intellectual tradition of the Soviet avant-garde, Eisenstein shares Worringer's and Greenberg's passion for an anti-illusionistic, anti-sentimental, and anti-escapist understanding of art. Possibly, this is why instead of spectator's empathy based on imagination and intuition, Eisenstein foregrounds the physical act of imitation—a visceral, empirically detectable response to the artwork. Moreover, Eisenstein's spectator remains grounded in his own physical reality, even if the show captivates his mind and senses to such an extent that it begins to impact his construal of the world around him. Despite these caveats, which distance Eisenstein from Lipps, the director's framing of the imitative act as a fusion between the visual and the haptic, as well as the motor and the emotional, links his theory back to the discourse on *Einfühlung*.

In the European context, Eisenstein was not alone in valorizing embodiment despite the rise of theories promoting ocularcentrism. As Robin Veder has demonstrated, a lingering influence of embodied approaches informed an entire generation of early 20th-century aesthetic theorists, painters, architects, modern dancers, and developers of various movement therapies and rhythmic

[28] Ibid.
[29] Robin Veder, *The Living Line: Modern Art and the Economy of Energy* (Dartmouth: Dartmouth University Press, 2015), xx, 319, 322. For a critique of Greenberg's valorization of vision, see Caroline A. Jones, *Eyesight Alone: Clement Greenberg's Modernism and the Bureaucratization of the Senses* (Chicago: University of Chicago Press, 2005).
[30] Veder, *The Living Line*, xx, 322.

gymnastics.[31] Veder's mapping of these manifestations of "kin-aesthetic modernism" across Europe and the United States highlights the practice of cultivating subjective awareness of proprioceptive sensations when performing movements and responding to visual and spatial forms.[32] This introspective approach to embodiment was at times an ally, and at times, an adversary of the "systematic investigation into energy and motion" that characterized modernity overall.[33] The pursuit of efficiency and regulation of energy expenditure, described by Anson Rabinbach as emblematic of industrialization, gave rise to the methods of objectifying bodily motion in the form of abstract graphs and chronophotographic charts.[34] Inspired by the view of the human body as a dynamic system of forces, many Modernist artists jettisoned figurative representation in favor of exploring the moving body as the interplay of vectors, accelerations, counterbalances, and other mechanical parameters. Some of these experiments reduced the body to "ultimately empty and machinable elements," as Hillel Schwartz has noted in his critique of early 20th-century body culture. [35] The drive for objective schematization, however, did not immediately cancel out the value of introspective, subjective analyses of bodily sensations. Veder points out that alongside a robust Modernist trend that favored "disembodied formalism" and catered to the technocratic economy of modernity, many practitioners of abstraction in painting, as well as innovators of modern dance, retained a strong interest in embodiment.[36] Thus, despite the apparent dissolution of figurative representation, many of the abstractionist projects in visual arts at the early 20th century in fact were devoid of the ocularcentric connotations that Worringer attached to abstraction. Arguably, even Worringer's own ocularcentric notion of "abstraction" was indebted to empathy theorists' earlier efforts to isolate elements of impactful forms.[37]

Eisenstein's own theory of expressive movement in "The Montage of Film Attractions" is similarly caught in between a desire to calculate the maximally

[31] Veder, *The Living Line*, xx, 4.

[32] Ibid.

[33] Veder, *The Living Line*, xx, 4. On the intersections between scientific discourses on efficiency and rhythmic gymnastics, see Dee Reynolds, *Rhythmic Subjects: Uses of Energy in the Dances of Mary Wigman, Martha Graham and Merce Cunningham* (Alton: Dance Books, 2007), 37–38; Laurent Guido, *L'âge du Rythme. Cinéma, Musicalité et Culture du Corps dans les Théories Françaises des Années 1910–1930* (Paris: L'Age d'Homme Editions, 2014); Michael Cowan, *Technology's Pulse: Essays on Rhythm in German Modernism* (London: Institute of Germanic & Romance Studies, School of Advanced Study, University of London, 2011); Michael Cowan, *Cult of the Will: Nervousness and German Modernity* (University Park: Penn State University Press, 2012).

[34] Anson Rabinbach, *The Human Motor: Energy, Fatigue, and the Origins of Modernity* (Berkeley: University of California Press, 2016).

[35] Hillel Schwartz, "Torque: The New Kinaesthetic of the Twentieth Century," in *Incorporations*, ed. Jonathan Crary and Sanford Kwinter (Cambridge: Zone Books, 1994), 71–127, 104.

[36] Veder, *The Living Line*, xx, 22–23, 322.

[37] Curtis, "*Einfühlung* and Abstraction in the Moving Image," 434.

effective gestural pathways of actors and a realization that such an objective, "naked scheme" can only be "brought to life" by an actual, organically felt "launch of effort" (real'nyi silovoi pusk)—an indivisible unity of motive, construal of situation, and physical action involving the entire body.[38] It was precisely this lack of the organic flow that, in Eisenstein's opinion, doomed Lev Kuleshov to failure: the latter's attempt to regulate his film actors by a "metric grid" and rhythmical formulae undermined the continuous, organic unfolding of their dynamic process. Eisenstein contended that Kuleshov's external constraints are unnecessary for a trained actor, a professional musician, or a skilled laborer accustomed to the "healthy organic rhythm" of "normal physical actions," and it is this kind of resolute performance that registers well on the "rhythmically precise screen."[39] With this explanation, Eisenstein shifted the accent from the objective form to the subjective proprioceptive sensations of the actor, as well as to his or her psychophysiological preparedness (ustanovka) for a certain purposeful action. The same intellectual maneuver characterizes Eisenstein's model of embodied spectatorship. Since emotions of the audience are linked to the effectiveness of the actor's performance, and since the only criterion for judging the actor's performance is "the degree of his motor and associatively infectious capabilities vis-à-vis the audience," Eisenstein proposes to construct the contour of screen movements in advance, exposing its "imitation-inducing fundamentals" (podrazhatel'nye primitivy dlia zritelia) as "a system of jolts, rises, falls, spins, pirouettes" and other elemental motor units.[40] Thus, on the one hand, what animates the spectator is the dramatic geometry of abstract vectors onscreen. On the other hand, it is the spectator's own interior sensations—guided by the laid-out path—that constitute the essence of art.

Falling in Line with the Image:
Eisenstein and 19th-Century Aesthetic Theory

Arguments over the best way of capturing the workings of the moving energy and the impact of visual form on the spectator—the question of whether to rely on objective calculation, mathematic models, elemental Platonic geometry, subjective kinesthetic sensations, or imagination—was an issue that the early 20th-century artists and philosophers of art inherited from the 19th-century aesthetics. An

[38] Sergei Eisenstein, "Montazh kinoattraktsionov," in Formal'nyi metod: Antologiia russkogo modernizma, Tom 1: Sistemy, ed. (Serguei Oushakine, 2016), 379–400, 395.

[39] Ibid., 397.

[40] Sergei Eisenstein, "The Montage of Film Attractions," in Selected Works: Writings, 1922–34, ed. and trans. Richard Taylor (London: I.B. Tauris, 2010), 39–58, 50; translation slightly modified. For the Russian original, see Eisenstein, "Montazh kinoattraktsionov," 391.

impetus for these arguments in German philosophy was given by Immanuel Kant's *Critique of Pure Reason* (1781), which suggested that "we actively constitute form and space in our schematization of the world."[41] In foregrounding the act of perception and a priori categories of the mind, Kant's influential position left much room for interpretation: do we "schematize" the shapes of the external world, or do we "reconstitute" them in their plenitude through our own sensory-motor responses and imagination? Both of these possibilities were offered to explain what is happening during our perceptual act, or our cognitive construal of the world. Arthur Schopenhauer, for instance, commented that "architecture affects us not only mathematically, but dynamically" and emotionally—on the "lowest grades of will's objectivity," meaning that we relinquish some of our pre-existent mental schemata and our sense of the self as we lend our consciousness to the experience of the space surrounding us.[42] As art historians Harry Francis Mallgrave and Eleftherios Ikonomou have shown, Kant's ideas prompted two lines of follow-up in the 19th-century German aesthetic theory: one favoring cognitivist explanations, and the other more focused on the audience's empathy (*Einfühlung*), or the imaginative ability to endow forms with a sense of vitality, movement, and emotion.

The first—cognitivist—tradition, epitomized by Johann Friedrich Herbart, sought to identify "pure forms" singled out by our senses thanks to the sorting capacity of the mind. In Herbart's view, aesthetic judgment amounted to an "apprehension of relations."[43] The "pure," essential, characteristics of the artwork were to be found in the "elementary relations of lines, tones, planes, colors" and other salient formal properties, whereas content (including ethical, emotional, sentimental "intrusions") was only a secondary, and in fact, extraneous feature of our response to artworks.[44] In *Psychology as a Science* (1824–1825), Herbart put forward an elaborate model of the way in which our mind processes sensory stimuli and generates new ideas through referencing and modifying prior mental constructs. He used mathematical formulas to explain the dynamics of ideas in our consciousness: their fusion or repulsion, their buoying up into the spotlight of our attention, or submergence under the threshold of consciousness. For Herbart, our perception of spatial forms in visual arts and architecture was a multistage process: vision first presents the mind with "an aggregate or mass of relations," then it "isolates and unifies analogous features," distinguishes between the

[41] Harry Francis Mallgrave and Eleftherios Ikonomou, "Introduction," in *Empathy, Form, and Space: Problems in German Aesthetics, 1873–1893*, ed. Harry Francis Mallgrave and Eleftherios Ikonomou (Santa Monica, CA: The Getty Center for the History of Art and the Humanities, 1994), 1–88, 5.

[42] Cited in Mallgrave and Ikonomou, "Introduction," 9.

[43] Ibid., 8.

[44] Ibid.

foreground and the background, and proceeds to other cognitive operations, such as comparing the noted traits to features of other artworks and objects the person encountered previously. With its emphasis on processing salient formal features and relations, Herbart's "psychological" aesthetics downplayed the interpreter's quest for "meaning," "content," or authorial intention, explicitly downgrading these aspects as secondary or inessential for pure aesthetic appreciation.[45]

On the other side of the debate from Herbart in 19th-century Germany was a group of philosophers who highlighted the role of subjective emotional investment during the subject's aesthetic encounter with visual and spatial forms. These authors drew inspiration from the Romantic author Gottfried Herder's treatise *Kalligone* (1800), which called for replacing the "arid abstraction of Kant's theory of beauty" with a more nuanced recognition of the "symbolic and expressive values" that individuals tend to project onto phenomena.[46] In a seminal multi-volume work *Aesthetics; or, The Science of the Beautiful* (1846–1857), Friedrich Theodor Vischer articulated an intimate and mysterious connection between the spectator and his object: he argued that the impression produced by the object is contingent on the anthropomorphizing, animistic interpretative framework the spectator is bound to impose on it. We respond to the "internal symbolism" of architectural forms, such as the "buoyant life" of ornaments, the apparent rises and falls of masses, or the circular flow of linear embellishments, because of our own corporeal experiences.[47] Vischer's son Robert furthered his father's approach in his book *On the Optical Sense of Form* (1873)—a book famous for the first deliberate use of the term *Einfühlung* to encapsulate the mental projection of our "sensory ego" into visual and spatial forms.[48] Robert Vischer's study drew attention to the feelings of pleasure and unpleasure aroused by the subject's proprioceptive sensations. He suggested that external stimuli that make up an aesthetic form might either match or clash with the sensorimotor predispositions of the "normal" human perceptual system.[49] For example, the sight of "a gentle arc" is more agreeable than a zigzag, because it requires less effort from the eye muscles; a horizontal line pleases the eyes because it conforms to the level placement of our organs of vision.[50] Sensations aroused by aesthetic form in his theory then also serve as the basis for our symbolic comprehension of artworks. Anticipating early 20th-century phenomenology, Robert Vischer stated that

forms are never empty or reducible to mathematical ratios, for they always display the emotional drama that the perceiver brings to the process. They are

[45] Ibid., 10.
[46] Ibid., 18.
[47] Ibid., 19.
[48] Ibid., 21, 23.
[49] Ibid., 22.
[50] Ibid., 23.

harmonious only when they successfully mirror and in a certain sense complete the complexity and intensification of the perceiver's own mental life.[51]

Paradoxically, Vischer combined this proto-phenomenological approach with an idealist, Romantic conception that art moves us, because of the artist's ability to elucidate "the universal vital process" permeating all living matter.[52] Through extreme mental concentration, the artist discerns "Ideas" concealed within the chaos of everyday reality—the manifestations of the Absolute—and he then incarnates them in sensory forms, the beauty and harmony of which speak to the refined part of our psyche. In contemplating art we thus commune with something greater than the artist who created it: by allowing the artwork to engage our sensory and intellectual capacities, we endow it with life and get revitalized in return. Empathy was for Vischer a transcendental experience, which he conceived in terms reminiscent of Schopenhauer's annihilation of the "will-less self" through contact with nature's grandeur, or the dissolution of the ego in a pantheistic union with the universe.[53] It was this tradition in German aesthetic thought that nourished Johannes Volkelt's influential explanation of the "symbolic" power of spatial forms as our subjective, vicarious tracing of outlines perceived by the eyes in the 1870s,[54] as well as Theodor Lipps's turn-of-the-century reflections on Einfühlung as a psychological process by which we infuse artistic forms with life.

Eisenstein's theory of embodied spectatorship is deeply indebted to 19th-century German philosophy, despite the passage of time and change of ideology. Whereas Robert Vischer believed that art forms encapsulated aspects of world Soul, or some universal dynamic principles governing all matter, Eisenstein gave the same role to the law of dialectics. His famous essay "Dramaturgy of Film Form" (1929) speaks of Karl Marx's and Friedrich Engels's dialectics as a cognitive operation matching the "course (the essence) of external events of the world."[55] The most insightful and effective art therefore must be "a projection of the same [dialectic] system of things into concrete symbols (Gestalten) and forms."[56] As in Vischer's theory, Eisenstein's principle of dialectic infuses

[51] Ibid., 27.

[52] Ibid.

[53] Ibid., 26.

[54] Johannes Volkelt, *Der Symbol-Begriff in der neuesten Aesthetik* (Jena: Hermann Dufft, 1876).

[55] Sergei Eisenstein, "The Dramaturgy of Film Form (The Dialectic Approach to Film Form)," in *Selected Works, Volume 1: Writings, 1922–1934*, ed. and trans. Richard Taylor (London: I.B. Tauris, 2010), 161–180, 161. Eisenstein's definition of dialectics relies on *A Course on the Theory of Historical Materialism* by Isaak Razumovskii.

[56] Eisenstein, "The Dramaturgy of Film Form," 161; translation slightly modified. For the German original (Eisenstein first wrote this essay in German in 1929), see Sergei Eisenstein, "Dramaturgie der

the structure of artworks with dynamism, which appeals dramatically to the viewer's perception and cognition. The director, writing in German, chooses a vivid action verb *Aufwühlen* ("to stir up") to emphasize the corporeal drama of the spectator's aesthetic engagement: "by stirring up contradictions in the viewer *([d]urch Aufwühlen der Widersprüchen im Betrachter)* and dynamically clashing [his] opposite passions, art forges the correct intellectual concept, the correct viewpoint, through emotions."[57] Like Vischer, he suggests that our body is predisposed to a greater impact of certain dynamic patterns (for Eisenstein, these patterns are dialectic), because we always enact our inner psychological struggles through conflicted motor tendencies of our body.[58]

Commentators such as David Bordwell have judiciously faulted Eisenstein for an all-too-broad definition of dialectics and the notion of conflict.[59] A comparison with Vischer's discussion of *Einfühlung* reveals the influence of German philosophy, which prompted Eisenstein to conceptualize the isomorphic dynamism of aesthetic form, spectator's bodily reactions, and some fundamental organizational principle of life that art reveals and imparts. Of course, Eisenstein's theory is anti-metaphysical, and this fundamental organizational principle of life that the viewer is supposed to garner from art has to do with understanding the dialectics of the materialist, socioeconomic conditions in any given epoch. Besides these important caveats, the spectator's "dynamization" proceeds along similar lines in Einstein's theory and Vischer's reflections on *Einfühlung*. There is no evidence that Eisenstein read Vischer, but he most certainly imbibed German aesthetic thought directly and indirectly through other channels. Between 1923 amd 1924, in the gestational period of his theoretical perspective, Eisenstein scrutinized treatises on "expressive movement" and rhythmical gymnastics by the German vitalist philosopher and graphologist Ludwig Klages and the choreographer Rudolf Bode, who was a prominent theorist of expressionist dance (*Ausdruckstanz*) and a former student of Theodor Lipps and Emile

Film-form," *Jenseits der Einstellung. Schriften zur Filmtheorie*, ed. Felix Lenz (Frankfurt: Suhrkamp, 2006), 88–111, 89.

[57] Eisenstein, "Dramaturgie der Film-form," 89. The Russian translation by N. I. Kleiman and I. G. Epstein has picked up on the fact that Eisenstein's speaks of the entire body of the viewer being stirred up (*vzvihrivaia protivorechiia v zritele*), whereas Richard Taylor translates this phrase as "stirring up contradictions in the observer's mind," thus downplaying the visceral quality of Eisenstein's original image (Eisenstein, "Dramaturgiia kinoformy," trans. N. I. Kleiman and I. G. Epstein, *Formal'nyi metod: Antologiia russkogo modernizma*. Tom 1: Sistemy, ed. (Serguei Oushakine, 2016), 357–378, 358; Eisenstein, "The Dramaturgy of Film Form (The Dialectic Approach to Film Form)," 161. I have based my own English translation on Richard Taylor's wording with minor modifications.
[58] Eisenstein, "Montazh kinoattraktsionov," 34. On the same page, Eisenstein speculates about the "class struggle" between the hard-working body parts responsible for gross motor functions and more intellectualized, elite parts of our body, which inhibit, redirect, and modify large actions.
[59] David Bordwell, *The Cinema of Eisenstein* (Cambridge, MA: Harvard University Press, 1993), 130.

Jaques-Dalcroze.[60] Like Vischer, Klages and Bode valorized the affective life of the psyche and considered it connected to the corporeal rhythms and motions. As adherents of the anti-rationalist "philosophy of life" (*Lebensphilosophie*), Klages and Bode distinguished between "organic" bodily expression and one governed by the rational, censoring force of the will: while the first category stood for spontaneous, free-flowing affirmation of one's vital force originating in the body, the second epitomized the tyranny of intellect, which broke down, interrupted, and constrained healthy expressivity. In Klages and Bode, Eisenstein found a useful description of a conflict between the motor tendencies of one's body, when a person is experiencing a psychological struggle between "an emotive-instinctual drive and the inhibitory conscious will."[61] This highly engaging, dialectical spectacle—for Eisenstein, an expressive moment at its utmost—was sure to produce a deep impact on the audience. The task of the filmmaker was thus to accentuate the key stages of the unfolding drama in a proper way, that is, to evoke the same dialectic dynamism in the viewer. Engagement with Klages and Bode gave Eisenstein the license to recuperate the emotional element of aesthetic perception and to recognize its physical underpinning in the neuromuscular interactions, involving the entire body.

While Klages and Bode link Eisenstein's theory back to the affect- and kinesthesia-oriented trends in the German discussions of *Einfühlung*, it is also important to note the impact of the cognitivist, formalist trend of Herbart. A Herbartian influence may be visible in some of the approaches promoted by the intellectual circles close to Eisenstein—the Russian Formalists and the Left Front of the Arts. One such methodological premise is a heightened attention to the unique interplay between various formal features of an artwork, which distinguishes it from natural phenomena and other artistic specimens.[62] Another

[60] Eisenstein, "Montazh kinoattraktsionov," 31–32. According to Oksana Bulgakowa, Eisenstein studied Klages's *Ausdrucksbewegung und Gestaltungskraft* (1913) and Bode's *Ausdrucksgymnastik* (1921), when he was following Vsevolod Meyerhold's commission to prepare his own essay on expressive movement in collaboration with Sergei Tret'iakov, a playwright and prominent ideologue of the Left Front of the Arts. See Bulgakowa, "From Expressive Movement to the 'Basic Problem,'" 427. Insightful commentaries on Eisenstein's connection to Bode and Klages also appear in Jörg Bochov, "Eizenshtein—patognomik? Fiziognomicheskie aspekty v teorii vyrazitel'nosti i fil'makh Sergeia Eizenshteina," *Kinovedcheskie Zapiski* 47 (2000), http://www.kinozapiski.ru/ru/article/sendvalues/381/; Mikhail Iampol'skii, "Eizenshteinovskii sintez," in *Uskol'zaiuschshii kontekst: Russkaia filosofiia v XX v*, ed. Mikhail Ryklin, Dirk Uffelmann, and Klaus Städtke (Moskva: Ad Marginem, 2002), 77–104; Andrei Miliakh, "Teorii novoi antropologii aktera i stat'ia S. Eizenshteina i S. Tret'iakova 'Vyrazitel'noe dvizhenie,'" *Mnemozina: Istoricheskii al'manakh* 2 (2006): 280–291; Cowan, *Technology's Pulse*, 107–109.

[61] Eisenstein, "Montazh kinoattraktsionov," 33. An insightful discussion of Eisenstein's approach to the actor's craft is provided by Joan Neuberger, "Another Dialectic: Eisenstein on Acting," in *The Flying Carpet: Studies on Eisenstein and Russian Cinema in Honor of Naum Kleiman*, ed. Joan Neuberger and Antonio Somaini (Milan: Éditions Mimésis, 2018), 255–278.

[62] Consider, for instance, the way in which Eisenstein describes the "dynamic effect" of visual compositions in "The Dramaturgy of Film Form" (165): "The eye follows the direction of an element. It retains a visual impression which then collides with the impression derived from following the

shared premise is anti-sentimentalism and the downgrading of the traditional category of "content" (the hero's story and its ethical ramifications) to the status of just one of the elements stimulating the spectator. Herbart foreshadowed the idea of productive tension between content, or material, and form—an idea which would go on to crystallize into a central tenet in the writings of Russian avant-garde thinkers. In fact, Eisenstein's advocacy for the plot-less cinema and his mistrust of the ready-made narrative emotions owes its power to the ground-work that Herbart laid out in the mid-19th century. Herbart's detailing of the audience's intense cognitive activity during the act of aesthetic appreciation has paved the way for Eisenstein's assertion that the successful (dialectical) film form dynamizes "the inertia of perception" and defamiliarizes the beholder's outlook on a certain phenomenon."[63]

Overall, Eisenstein's approach to film form's impact on the audience attempts to balance the idea of the calculable, objectively analyzable external effects and visceral, emotional reactions originating in the viewer's body. He warns in "The Dramaturgy of Film Form" (1929) that the "hypertrophy of purposeful initiative—of the principle of rational logic—leaves art frozen in mathematical technicism. . . . The hypertrophy of organic naturalness—of organic logic—dissolves art into formlessness."[64] As Jorg Bochow has noted, these statements defended Eisenstein's "own model both from critiques 'on the Left' (accusations of over-emotionalism and lack of rationality) and 'on the Right' (accusations of Formalism and "departure from real life')."[65] While the critiques on the Right did not exert an eminent threat until the consolidation of Stalinist cultural pol-icies after 1929, the fellow avant-garde artists' disdain for emotion was a serious problem, which Eisenstein began to tackle already in the early 1920s. His solu-tion was to turn to neurophysiology and experimental psychology in the hope of finding an empirical, materialist justification of affective resonance of images in the spectators' bodies.

The ground for this intellectual move was likewise laid in the 19th century, when psychophysiologists started to contribute to the debates on empathy and aesthetic experience. To understand perception on the neurological level, 19th-century scientists began to investigate the reverberations of elemental stimuli—a certain pitch note, a certain color shade, a certain geometric proportion—in the subjects' nervous systems. In his treatises *Elements of Psychophysics* (1860) and *Introduction to Aesthetics* (1876), the German physician Gustav Fechner laid

direction of a second element. The conflict between these directions creates the dynamic effect in the apprehension of the whole."

[63] Eisenstein, "The Dramaturgy of Film Form," 162.
[64] Ibid., 162.
[65] Bochov, "Eizenshtein –patognomik?"

the foundations of "aesthetics from below," advocating for empirical methods to assess the sensory capabilities of the arts based on neurophysiology and psychological experiments.[66] Another eminent pioneer, Hermann von Helmholtz, scrutinized the workings of the "physiological acoustics" in his book *On the Sensations of Tone as a Physiological Basis for the Theory of Music* (1863), in which he established, among other things, that the organ of Corti in our inner ear "resolves certain tonal vibrations into sympathetic pendular oscillations" producing the sensation of "harmonious and consonant" tones.[67] Many other researchers in Europe and beyond followed suit, furthering the methodologies for answering questions of aesthetic order on the basis of psychophysiology. Philosophers incorporated psychophysiological considerations into their reflections on art. In an influential mid-century work *Microcosmos* (1857–1864), the German philosopher Hermann Lotze posed the question whether "the soul bereft of the body" would find a progression of consonant chords pleasant and beautiful just because of its inherent Platonic quality, or whether the peculiar sensation of "enjoyment springs" entirely from our "corporeal framework."[68] Though his commitment to metaphysics did not permit him to give a direct answer to this question, throughout *Microcosmos*, he accentuated the workings of the nervous system, implying that the "corporeal framework" is indeed the origin of our experience. For instance, regarding the topic of visual and spatial perception, Lotze emphasized the recent discovery of "reciprocal action between sensory and motor filaments in the eye:" the eyeballs turn toward a strong stimulus, detected in the peripheral field of vision.[69] This mechanism is unconscious and automatic, and it underlies our ability to locate objects in space. Vision therefore is not a straightforward copying of external objects onto our retina, but a complex sensorimotor process, most segments of which happen without our conscious knowledge. As noted by Jonathan Crary, the result of intensified dialog between aesthetics and psychophysiology in the 19th century was an increased recognition of what Crary calls the "carnal density" of vision and other sensory channels.[70] Scientific discoveries complicated the traditional notion of mimesis by locating the origin of sensation within the subject's neural system: the imperative of verisimilitude and objective copying gave way to a fascination with a complex relay of neurophysiological reactions that an external stimulus sets in motion.[71]

[66] Mallgrave and Ikonomou, "Introduction," 14.

[67] Ibid.

[68] Hermann Lotze, *Microcosmus: An Essay Concerning Man and His Relation to the World*, trans. Elizabeth Hamilton and E. E. Constance Jones (Edinburgh: T. & T. Clark, 1885), 322.

[69] Lotze, *Microcosmus*, 320.

[70] Jonathan Crary, *Techniques of the Observer* (Cambridge, MA: MIT Press, 1990), 150.

[71] On psychophysiology's blow to the traditional notions of mimesis, see Crary, *Techniques of the Observer*, 90–91.

It was within this scientific discourse that a neurophysiological equivalent of *Einfühlung*—motor imitation—began to take shape. Though the preconditions for this theory formed in the mid-19th century, its sharpest articulations may be found at the turn of the 20th century. In 1897, the British researcher Vernon Lee (Violet Paget), well-versed in German psychophysiology, published an article "On Beauty and Ugliness" in collaboration with Clementina Anstruther-Thomson.[72] This essay, which Theodor Lipps apparently borrowed from and criticized in his own formulations of *Einfühlung* without proper acknowledgment, articulated a concrete physiological understanding of empathy as "inner mimicry": according to Lee, certain visual stimuli provoke "localized motor conditions," such as a vaguely sensed sympathetic tensing of the muscles and "subconscious changes in the muscular, circulatory, and respiratory apparatus."[73] These "organic reverberations," Lee contended, were responsible for our conscious sensations of "aesthetic pleasure and displeasure."[74] In contrast to Lipps, who preferred to distance himself from physiologists, Lee relied on Hermann Lotze's and Gustav Fechner's observation that the sight of certain shapes and movements evokes in us faint "muscular strains" vaguely corresponding to the perceived direction of the stimulus ("up," "down," "through," "alongside," etc.).[75] Lee's contemporary, the psychologist Karl Groos, furnished her with additional confirmation of the "inner mimicry" (*Innere Nachahmung*), by pointing to the muscles of the eyes and respiratory apparatus as generating innervations, responsible for the onset of empathetic reaction to visual and spatial forms.[76] Lee's most important source for explaining the interconnected nature of kinesthetic sensations and affects was the works of the French psychophysiologist Theodule Ribot, and especially, the James-Lange theory of emotions.[77]

Lee's conception offers a telling parallel to Eisenstein's understanding of the spectators' imitation of action onscreen, precisely because of the filmmaker's reliance on William James and a trend in the Russian performance theory, which valorized the actor's physical pathway toward incarnating his character—a trend that started with Konstantin Stanislavskii's reading of Theodule Ribot and peaked in Vsevolod Meyerhold's biomechanics, Michael Chekhov's technique of

[72] On the history of this publication and Theodor Lipps's cherry-picking from it, see Lee Vernon and Clementina Anstruther-Thomson, *Beauty and Ugliness and Other Studies in Psychological Aesthetics* (London: John Lane, 1912), 64–69.

[73] Vernon and Anstruther-Thomson, *Beauty and Ugliness and Other Studies in Psychological Aesthetics*, 65.

[74] Ibid., 65.

[75] Ibid., 26.

[76] Groos's terms are discussed in Lee and Anstruther-Thomson, *Beauty and Ugliness*, 120–121. On Lee's intellectual relationship with Groos and her ideas in the context of Anglo-American aesthetic theory, see Veder, xx, 89.

[77] Lee and Anstruther-Thomson, 64–65. Among her theoretical allies, helping her to formulate the theory of inner mimicry, Lee also listed Oswald Külpe and August Schmarsow.

"psychological gesture," and Stanislavskii's own method of "physical actions" in the 1930s.[78]

Before we consider the nuances of Eisenstein's position and its conceptual underpinning, it is important to acknowledge the precise source that gave Eisenstein the idea of the spectator's motor imitation. Oksana Bulgakowa has identified this source as Ludwig Klages's book on expressive movement—more specifically, a passage that outlines the mid-19th-century theory of "ideomotor action" by the British psychologist William Carpenter.[79] Writing about such phenomena as mesmerism, hypnosis, and Ouija board divinations, Carpenter argued that thinking about a pendant or a Ouija board moving results in the unconscious micro-motions of the person's hand. This, for Carpenter, was an illustration of an "ideomotor action"—that is, "motion performed in accordance with the idea that underlies it," and whose very shape "bears some similarity with the mental idea guiding it."[80] Carpenter's theory was met with skepticism by the scientific community, but it gained traction after it was taken up by William James, who contextualized it in contemporary neurophysiological discoveries.[81] Had it not been for James, Carpenter's theory would have remained buried under accusations of charlatanism and would never have reached Klages and other early 20th-century authors. In James's reconceptualization of Carpenter's concept, the ideomotor effect could be triggered not only by the self-generated thought of a certain action, but whenever our consciousness becomes preoccupied with action—for instance, when we see it or get a vivid impression of it in a literary text. As we shall see in the next section, James's position rested on contemporary advances in German, French, and Russian science, making the concept of motor imitation much more palatable for Eisenstein.

A question arises: why did Eisenstein prioritize the spectator's motor imitation over other forms of response, such as the logical comprehension of dramatic situations and emotional alignment with characters based on narrative cues? The answer to this question has to do with his background in avant-garde theater and his affinity with the Russian Formalists and the Left Front of the Arts. These intellectual circles condemned sentimental identification with heroes, cliché scenarios leading to a false catharsis, escapist embrace of the fictional world, and other passé aesthetic ideals they associated with "bourgeois" art. Theater innovators sought to find experimental alternatives to the traditional

[78] On Stanislavsky's reading of Ribot's *The Psychology of Emotions*, see Sharon M. Carnicke, *Stanislavsky in Focus* (Amsterdam: Harwood Academic Publishers, 1998), 131, 208–209.

[79] Bulgakowa, "From Expressive Movement to the 'Basic Problem,'" 427.

[80] Carpenter cited in Wolfgang Prinz, Sara de Maeght, and Lothar Knuf, "Intention in Action," in *Attention in Action: Advances from Cognitive Neuroscience*, ed. Glyn W. Humphreys and M. J. Riddoch (Hove, UK: Psychology Press, 2005), 95.

[81] Ibid., 96.

representation of characters, which they found hackneyed, conformist, or not ideologically conscious enough. From the Modernists' standpoint, the actor's traditional approach to the role from the mental analysis of the emotional cues in the script was a sure way to run into a dead-end and fall back on ready-made acting formulas. In "Montage of the Film Attractions," Eisenstein condemns this kind of thespian playacting as shameful.[82] One way out of conundrum was to set emotions aside and start with the physical contour of the role—to model an appropriate "score" of poses, gestures, and movements for the character in a given dramatic scene. By concentrating on the proprioceptive sensations of these poses, the Modernist actor could embody the character's inner emotional landscape in a more nuanced and effective manner. Starting from a prechosen, meaningful gesture simultaneously allowed for launching a chain of psychophysiological reactions relevant for the role, and preventing these processes from spinning out of control. For the practitioners of a more realist style, such as Michael Chekhov, performing a gesture was a way of harnessing inner resources of the body that are not accessible to voluntary control. For the practitioners of a more experimental, estrangement-oriented style, such as Vsevolod Meyerhold, the actors' physical program was a way of switching on the relevant neurophysiological set-ups (ustanovki). Commenting on Meyerhold's actors' training method, the neuroscientist Gabriele Sofia has astutely observed that his exercises cultivated a flexible "body schema": they liberated the person from his usual habits of comportment and mannerisms, and allowed for a more striking incarnation of stage roles.[83] For Eisenstein, as for Meyerhlod, the actor's actual feelings were of secondary importance, compared to the effective, impactful "construction" of their physical actions. In fact, the filmmaker believed that a proper construction of the gestural pathway—literalizing the inner struggle in terms of conflicting bodily vectors—will entail an organic, fully felt physical realization of these psychological motivations. By breaking down the person's external behavior into actable, dramatic segments, Eisenstein hoped to orchestrate analogous experiences for the spectator. The entire mise en scène, the rhythm and compositional structure of editing, as well as many other cinematic elements worked, in Eisenstein's conception, toward punctuating the key stages of the spectator's unfolding experience. Significantly, the pathway that the director aimed to lead his spectators on was never predicated on a cliché narrative arch. Despite his characters being "typages"—epitomes of a certain social identity—details of their behavior are always nontrivial and captivating. From Eisenstein's point of view, the depth of the spectators' response would be short-circuited by the cliché recipes of the kind he

[82] Eisenstein, "The Montage of Film Attractions," 53.
[83] Gabriele Sofia, "Towards a 20th-century History of Relationships between Theatre and Neuroscience," Brazilian Journal on Presence Studies 4.2 (2014): 313–332.

lambasts in "The Montage of Film Attractions": "to evoke sympathy for the character . . . surround him by kittens, which unfailingly enjoy universal sympathy."[84] As a theorist, Eisenstein valued not the viewer's identification with the heroes, but their journey toward an epiphany regarding the human condition and the sociopolitical order. On this journey, spectators' optical sensations were meant to evoke complex somatic responses, thus preparing the ground organically for the spectator's cognitive transformations. This is why Eisenstein thought of his film compositions as guiding the spectator through a series of psychophysiological states, all linked together and gearing toward some ultimate effect.

With these considerations in mind, it becomes clear that Eisenstein's notion of motor imitation, which he borrowed from Klages's reading of Carpenter, bears resemblance but differs in crucial ways from its source. The similarity lies in prioritizing the organic responses engulfing the entire person, as well as foregrounding the influence of these processes on the person's mental associations and actions, which appear to his consciousness as voluntary and self-generated. Where Eisenstein differs from Klages is the filmmaker's refusal to subscribe to the vitalist depiction of ratio as a purely negative, restraining force. Eisenstein reframed the inhibitive impulses of reason, which keep our drives and instincts in check, as a positive element of the dialectical dynamics.[85] In other words, when an optical stimulus evokes in us an automatic, instinctive reaction of mimicking, the higher nervous system may put up resistance to these innervations—and these inhibitive reactions are just as valuable for Eisenstein, because they contribute to the formation of the person's attitude. In "The Dramaturgy of Film Form," Eisenstein noted his disagreement with Klages, who "attributes everything that moves to the field of 'soul' and, by contrast, only that which restrains to 'reason.'"[86] Rejecting the German philosopher's "idealistic" concepts of "reason" and "soul," Eisenstein proposed to consider the expressive dramas of human behavior as clashes between "conditioned and unconditioned reflex."[87] This materialist reconceptualization is very significant: reflexes are algorithms of the organism's response to the environment—some inborn and some acquired. Instead of "reason" and "soul" as inflexible, strictly demarcated elements locked in eternal battle, reflexology offers an image of the organism drawing on its innate and acquired adaptations, while articulating behavioral strategies and attitudes at any given moment in time. Unlike the abstract category of "reason," the system of reflexes underpinning human behavior is capable of change, based on new lessons from the environment and reinforcements of

[84] Eisenstein, "Montage of Film Attractions," 45.
[85] See Eisenstein, "The Dramaturgy of Film Form," 162.
[86] Ibid.
[87] Ibid.

the old ones. It is precisely this complex interplay of the spectator's reactions that interests Eisenstein, when he conceives of art's transformative power.

Eisenstein's view of the spectators' motor imitation, marking the onset of complex responses in their bodies, is best understood with reference to turn-of-the-century developments in psychophysiology. In the next section, I will contextualize the premises of the director's ideas by looking into the works of William James and Vladimir Bekhterev, who formulated their ideas in dialog with German, French, Russian, and other Europeans scientists. What William James had to offer to Eisenstein was the idea that a visual stimulus can generate motor innervations, which precede and prepare the ground for the nascent emotional attitude. Additionally, James's conception of our mental life and behavior problematized the traditional categories of will and consciousness.

Bekhterev and the Russian school of reflexology gave the director further clues to the interplay of excitation and inhibition, which make up the response of our nervous system to external stimuli.

From Optical Stimulus to Imitative Motor Reaction

The fact that William James was essential for Eisenstein's understanding of the spectator's mirroring of screen action is confirmed in the director's 1945 memoir, where he recalled the young boy's expressive face animated by the sight of the Proletkul't stage play:

> I was by then [by 1920] already aware of James's famous formula that "we are not crying because we are sad; but we are sad because we are crying." I liked this formula first of all aesthetically, for its paradoxical quality; and, apart from that, for the fact that corresponding emotion may be born of a particular, correctly recreated phenomenon.[88]

James's theory that movements and other physical manifestations of emotions are not a postfactum symptom, but rather a trigger or an integral part of the ongoing affective experience was highly valued in Vsevolod Meyerhold's theater, where it served as a principle justifying the rejection of the old-fashioned techniques of an actor's preparation for the role. Instead of proceeding from an intellectual analysis of the role and letting the actor rely on intuition in conjuring up the emotional state necessary for the role, Meyerhold emphasized physical training that raised the actor's tonus and heightened his ability to react to his partner in

[88] Eisenstein, "How I Became a Director," 286.

various dramatic situations in an organic, yet stylized and physically impres-
sive manner. Meyerhold believed that such movement would bring about the
appropriate state of mind and activate relevant behavioral programs, resulting
in further physical responses appropriate for the role. We are well aware of the
Jamesian trace in Meyerhold's acting theory and Eisenstein's take on it during
his apprenticeship at Meyerhold's GVYRM courses, thanks to Alma Law and
Mel Gordon's magisterial survey of biomechanics, as well as Viktor Zabrodin's
research into Eisenstein's theater years.[89] What has been studied much less is the
way in which Eisenstein applied William James's writings not for theorizing the
actors, but rather for highlighting the embodied nature of spectatorship. Yet, as
the director asserted, another fundamental area where James's theory applies "is,
of course, spectatorship."[90]

James was an important reference for Eisenstein during his theater years,
and he kept returning to the American psychologist over and over again. These
later essays allow us to clarify the precise elements of James's perspective that
appealed to the Soviet director and became a recurrent motif in his theory. In his
1937 notes on "Stanislavsky and Loyola," Eisenstein includes multiple lengthy
citations from a chapter called "Emotions" in James's *Psychology: A Briefer
Course* (1892).[91] The first key idea he underscores is James's famous rethinking of
the chain of causality in the onset of affects: first comes the sensation of a certain
stimulus, then the body reacts to it, and only the subsequent awareness of the
whole gamut of ongoing physiological changes reaches consciousness, resulting
in our experience of the emotion. In another paragraph, he copies James's pas-
sage dealing with the ideomotor effect: the ability of certain images to set the
reactive bodily mechanisms in motion:

> To begin with, particular perceptions certainly do produce wide-spread bodily
> effects by a sort of immediate physical influence, antecedent to the arousal of an
> emotion or emotional idea.[92]

What are these perceptions? What stimuli cause them? What is this sublim-
inal activation of physical changes that occurs prior to conscious realization
of emotion? An expanded two-volume treatise *The Principles of Psychology*
(1890) James wrote two years prior to *Psychology: A Briefer Course* offers a more

[89] Alma H. Law and Mel Gordon, *Meyerhold, Eisenstien and Biomechanics: Actor Training
in Revolutionary Russia* (Jefferson, NC: McFarland & Company, 2012); Vladimir V. Zabrodin,
Eizenshtein: Popytka Teatra: Stat'i, Publikacii (Moskva: Eizenshtein-Tsentr, 2005).
[90] Sergei Eisenstein, "Stanislavskii i Loiola," ed. Naum Kleiman, *Kinovedcheskie Zapiski* 47 (2000),
http://www.kinozapiski.ru/ru/article/sendvalues/384/.
[91] Eisenstein, "Stanislavskii i Loiola."
[92] Eisenstein, "Stanislavskii i Loiola." I have cited the English original from William James,
Psychology. A Briefer Course (New York: Henry Holt and Company, 1892), 376.

substantial discussion of these effects. As James explains, once a salient stimulus reaches the central nervous system, "a process set up in the centres reverberates everywhere, and in some way or other affects the organism throughout," causing fluctuations in respiration patterns, pulse rate, and "muscular tone."[93] These detectable changes were recorded in multiple experiments on humans and animals. What is interesting is how these external stimuli are processed: what grabs our attention, how we construe a certain shape or a motion, and how this perception further activates motor discharges. James underscores the importance of motor sensations (many of which remain unnoticed by our consciousness) for all stages of perception and reaction.

Drawing on Alexander Bain's *The Emotions and the Will* (1859) and Theodule Ribot's *Psychologie de l'Attention* (1889), James suggests that the "essence of attention is muscular adjustment."[94] He further entertains the notion of "ideational preparation" ("pre-perception"), whereby we anticipate a certain stimulus, based on a motor image of the object we expect to engage with. He cites the Russian scientist Nikolai Lange's observations that thinking of an "an extended object," such as a pencil, results in a "slight movement [of the eyes] corresponding to a straight line"; and that thinking of a certain sound makes us turn toward its source or "repeat muscularly its rhythm, or articulate an imitation of it."[95]

A key theorist who supplies James with data regarding the "dynamogenic" effects of external stimuli—the translation of sensation into muscular contractions—was Charles Féré.[96] In the 1880s, Féré investigated the somatic effects produced by exposure to various kinds of stimuli, such as different colors, musical notes, odors, and tastes.[97] He measured their impact not only on involuntary mechanisms of respiration and pulse, but also on the character of voluntary muscular contractions (Fig. 4.2a and b). For instance, Féré found that the sight of red light makes people press on the hand dynamometer with greater muscular effort, compared to stimulation by other colors.[98]

As Jonathan Crary has remarked, Féré's experiments carried radical implications for the study of visual perception.[99] Féré's argument that "when rays of red light strike our eyes, *our entire body sees red*, as dynamometric reactions prove" foregrounded the interdependence of innervation circuits throughout our body and externalized these processes in the form of quantifiable analog data.[100]

[93] James, *The Principles of Psychology*, vol. 2, 381.
[94] James, *The Principles of Psychology*, vol. 1, 444.
[95] Ibid.
[96] James, *The Principles of Psychology*, vol. 2, 378.
[97] Ibid., 379.
[98] Ibid., 380.
[99] Jonathan Crary, *Suspension of Perception: Attention, Spectacle, and Modern Culture* (Cambridge, MA: MIT Press, 1999), 167.
[100] Féré, translated and cited by Crary, *Suspension of Perception*, 167, italics in Crary's original.

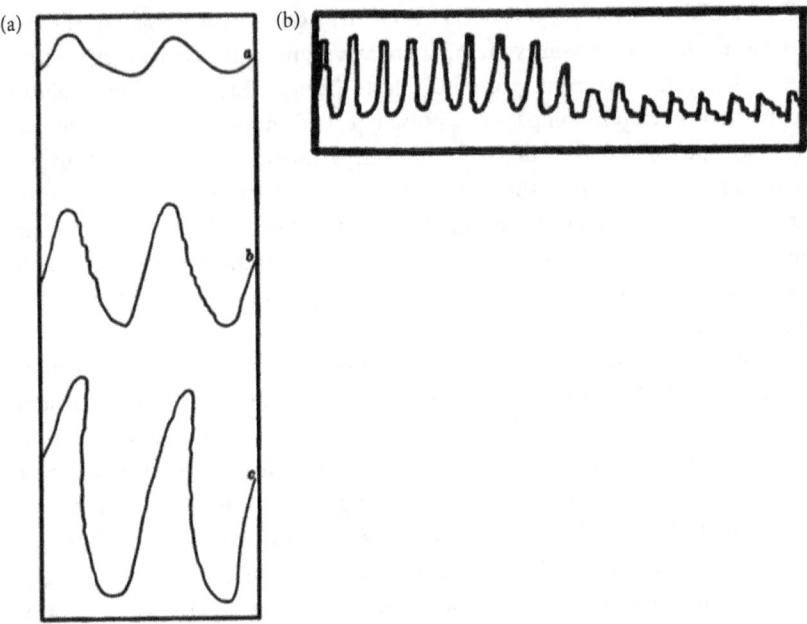

Fig. 4.2 (*a*) Féré's curves, showing the subject's respiration in response to yellow (top), green (middle), and red colors (bottom), with the latter having a more pronounced dynamogenic effect. Image source: William James, *The Principles of Psychology*, vol. 2, 377. (*b*) Féré's subject's muscular contractions: greater oscillations are induced by the red light. Image source: William James, *The Principles of Psychology*, vol. 2, 380.

Michael Cowan has commented that Féré's analysis of sensory perception epit-omized the intervention of neurophysiology into the terrain of aesthetics by laying the groundwork for recognizing the "performative force of aesthetic rep-resentation" and "infectious quality of impression."[101] Féré's assertion regarding the "infectiousness" of external stimuli rested on a theory of "psychomotor in-duction" (*l'induction psycho-motrice*), advanced by the Salpêtrière psychiatrists Jean-Martin Charcot and Paul Richer.[102] According to this theory, the "sight of action invites . . . the reproduction of this movement."[103] Féré observed this mimicking tendency particularly in his hysterical patents, but he argued that this is a common human predisposition, which is simply more pronounced in

[101] Cowan, *The Cult of the Will*, 138.
[102] Charles Féré, *Sensation et movement* (Paris: Alcan, 1887), 15. See also Crary, *Suspension of Perception*, 167.
[103] Féré, *Sensation et movement*, 15.

more sensitive persons. Emotional expressions, for Féré, likewise had infectious power, evoking a similar psychological state in a person who observes them. The scientist surmised that it is possible to infer one's interlocutor's hidden emotions and thoughts by copying their facial expressions.[104] Féré's experiments with the dynamometer led him to the conclusion that

> the energy of movement is proportional to the intensity of the mental representation of this movement. This is a demonstration of the psychologists' hypothesis that the idea of movement is already the movement that is starting. As a corollary, every time when the idea is sufficiently intense, action necessarily follows it. On the other hand, we have the right to speculate that no idea exists effectively insofar as it is not followed by an act, which is the only proof of its sufficient intensity; or at least that it is necessary to distinguish feeble and static ideas from strong and dynamic ideas provoking an irresistible impulse to act.[105]

In this striking passage, not only did Féré affirm the materiality of ideas and emotional states *qua* muscular contractions, but he also proposed to quantify the "intensity" of these mental acts in terms of measurable energy expenditure. Féré's conception was thus in line with what Anson Rabinbach has described as a common tendency among 19th-century psychophysiologists (Theodule Ribot, Charles Richet, Wilhelm Wundt, and others) to consider ideas as "representations of physical forces."[106] Ribot classified ideas into three groups: (1) intense passions and *idées fixes*, which "rapidly pass into actions"; (2) "rational thoughts, or reflections," in which the impulse to act is more subdued, or controlled; and (3) "abstract ideas," which provoke ruminations rather than actions.[107] This hierarchical gradation, reminiscent of evolutionary stages, attributed a greater degree of inhibition (the braking of the motor discharge) to the consummate ability of the mature mind—abstract thought. By looking into Féré's and Ribot's theories, we find the origins of Eisenstein's classification of spectators' reactions—his belief that the children's intense impressions result in diffuse innervations of their face, whereas adults' unmoved faces indicate the inhibitive work of their mature brain. As we shall see in the next sections of this chapter, a very similar model lies at the basis of Eisenstein's discussion of spectator reactions to various types of montage in "The Fourth Dimension in Cinema" (1929)—reactions, which he describes as ranging from motor imitation of dynamic vectors onscreen to purely mental, intellectual vibrations.

104 Ibid.
105 Féré, *Sensation et mouvement*, 15.
106 Rabinbach, *The Human Motor*, 166.
107 Ibid.

Féré's theory regarding the dynamogenic infectiousness of visible actions was taken up not only by William James, but also but another psychologist, who influenced Eisenstein in the 1920s—the Russian reflexologist Vladimir Bekhterev. Bekhterev visited Charcot's laboratory at the Salpêtrière to study hypnosis, and he was particularly interested in the implications of Féré's research for the phenomena of suggestion and "mental contagion."[108] The notion of imitation played an important role in Bekhterev's *Collective Reflexology* (1921), a treatise which tackled the existent views on the person's behavior in large groups. As Daniel Beer has shown, Bekhterev's precursors, following Herbert Spenser, discussed imitation as a conscious "social instinct," but toward the end of the 19th century, this notion became enmeshed in the discourse on hypnotic suggestion.[109] An unconscious, irrational tendency to mimic was deemed a feature of the weaker mind—someone susceptible to the hypnotist's control. With these connotations, the idea of "mental contagion" was adopted by the first theorists of the mass subjectivity—Gustave Le Bon, Gabriel Tarde, and Scipio Sighele—who argued that individuals who find themselves in a crowd setting lose part of their reasoning capabilities. In their view, a crowd was ruled by the basic human instincts and was much more susceptible to manipulation. In response, Bekhterev's *Collective Reflexology* struck a balance between a Spenserian point of view and the negative connotations that Tarde and others attached to imitation. Acknowledging the despicable instances of mass psychosis, Bekhterev contrasted unruly crowds with organized collectives, such as the army, or schools. He discussed imitation both as a conscious, fully rational process that gave humans an evolutionary advantage, and as a somewhat automatic biological mechanism. In *Objective Psychology* Bekhterev stated, with reference to the German psychologist Karl Groos, that "the drive to imitate is an inevitable transitional stage between instinctive and rational action."[110] Bekhterev suggested that however primitive the reaction of imitation may seem, it is actually a complex process. Our nervous system retains traces of innervations produced by the original stimulus, and imitation entails a "more or less precise reproduction of everything that evokes the impression (*vozbuzhdaet vpechatelenie*)" initially

[108] On Bekhterev's visit to Charcot in 1885, see Anatolii Nikiforov, *Bekhterev* (Moskva: Molodaja gvardiia, 1986), 96–97. For Bekhterev's commentary on Féré's psychomotor induction (*dvigatel'naia induktsiia*) and imitation, see Vladimir Bekhterev, *Ob"ektivnaia refleksologiia*, ed. V.A. Kol'tsova (Moskva: Nauka, 1991), 192.

[109] Daniel Beer, *Renovating Russia: The Human Sciences and the Fate of Liberal Modernity, 1880–1930* (Ithaca, NY: Cornell University Press, 2008), 136. Michael Cowan points out that the Salpêtrière psychiatrists contributed to this view of the pathological suggestibility of hysterical patients, while the Nancy school (Hyppolite Bernheim, Ambroise-Auguste Liebault) contested it, arguing that "normal" subjects fall under hypnosis just as easily (see Michael Cowan, *Cult of the Will: Nervousness and German Modernity* [University Park: Penn State University Press, 2012], 60).

[110] Bekhterev, *Ob"ektivnaia psikhologiia*, 193.

captured by one of the sensory organs.[111] As with an infant trying for the first time to repeat the word "mama," the person's predisposition to reproduce the other's actions depends on the memory traces, or engrams, which formed in his nervous system during the initial experience. Bekhterev thus sees imitation as imprecise copying—as a process shaped, fundamentally, by the structure of the synaptic chains formed in our brain, as well as by our ability to coordinate our motor actions.

Bekhterev was fascinated by Féré's finding that "sensory impressions, whether conscious or unconscious . . . always bring about a rise of the muscular strength, as measured by the dynamometer."[112] The same author also provided Bekhterev with experimental proof that merely being a part of the crowd raises the person's muscular tone.[113] This kind of direct induction (*priamaia induktsiia*) was for Bekhterev a cementing force of a collective, alongside the imitative drive and the influence of suggestion and verbal persuasion.[114] Drawing on Karl Marx's observation of the energizing effect that working alongside others has on individual laborers, Bekhterev spoke of the emergence of "collective personality" (*kollektivnaia lichnost'*), in which the actions of individuals become coordinated.[115] With regard to crowds, *Collective Reflexology* offers a striking image of innervations spreading from one person to another:

> According to [Jean-Pierre] Rambosson's theory, imitation is based on the fact that each "psychological" phenomenon has a correspondent movement in the brain, which is reflected externally in the changes of the face, gesture and posture. This movement spreads, reaching other persons and evoking in them the same movements. This spread of movement in space engenders [the others'] laughter, grief, and other phenomena, both simple and complex.[116]

In cases where the crowd was brought together by a certain touchy issue, Bekhterev argued, nonverbal communication has especially great power: by turning to others, people are instinctively seeking a reinforcement of their concerns and are therefore highly sensitive to the others' intonation, microgestures, and other somatic expressions of emotions.[117] This phenomenon

[111] Ibid., 192.
[112] Bekhterev, "Kollektivnaia refleksologiia," in *Izbrannye Raboty po Sotsial'noi Psikhologii* (Moskva: Nauka, 1994), 18–349, 63.
[113] Ibid.
[114] Ibid., 230–231.
[115] Ibid., 63.
[116] Bekhterev, "Kollektivnaia refleksologiia," 113. (Bekhterev likely relies on Jean-Pierre Rambosson, *Phénomènes nerveux, intellectuels et moraux: Leur transmission par contagion* [Paris: Firmin-Didot, 1883]).
[117] Bekhterev, "Kollektivnaia refleksologiia," 100.

contributes to the emergence of leaders, capable of shaping the crowd's mood and actions.

In "Perspectives" (1929), Eisenstein indirectly evokes the themes of Bekhterev's *Collective Reflexology* in an anecdote about an impassioned orator, capable of eliciting "collectively experienced perception" and manipulating the crowd's "single pulsating interest."[118] In "How Pathos Is Made?" (1929), the director offers another similar story, about the American intellectual Albert Williams, who like John Reed, participated in the events of the October Revolution of 1917, and at one perilous moment, managed to "persuade" an unruly crowd by reciting Robert Browning's poetry.[119] Despite the poem being not in Russian, Williams's listeners apparently became mesmerized by the reader's intonation and rhythm. In addition to these examples, one may find parallels between Bekhterev's argument in *Collective Reflexology* that, in crowd settings, gestures can incite emotional reverberations throughout the mass, and the way in which Eisenstein structures scenes of mass solidarity in his films of the 1920s. Take, for instance, a famous scene from *The Battleship Potemkin* (1925), in which the vigil for the fallen sailor Vakulinchuk turns into a spontaneous protest (Fig. 4.3). This scene shows a gradual shift from the subdued mood and resignation of individuals to a passionate collective action.[120] At first, we see people privately experiencing their grief. Their stiff bodies and downward gazes all suggest sorrow and submission, and yet each of them is alone in his anguish. The first step toward collective mobilization is the image of a female speaker—her body is still stiff, only her hands are moving in a spasmodic rhythm. In response, the fists in the crowd begin to clench (we see them in close-ups). More orators emerge, and their faces and bodies appear increasingly animated. The tension rises—a peasant woman rips off her kerchief, and a young man tears his shirt open in an explosive, ecstatic gesture. The crowd is now activated and unified. Everyone's thoughts are taking one direction. And then, Eisenstein stages an "expressive moment" of conflict to highlight this unanimity: a detractor calls out "Beat the Jews" (which implies not only an anti-Semitic outburst but also an attack on the revolutionary circles in Odessa). The crowd turns its furious face toward him and stomps him out. The scene ends with an apotheosis of the triumphant, unified crowd streaming

[118] Eisenstein, "Perspectives," 157.

[119] Eisenstein, " Kak delaetsia pafos?," l. 149. Albert Williams authored a book called *Through the Russian Revolution.*

[120] On Eisenstein's representation of mourning in this scene see Georges Didi-Huberman's polemics with Roland Barthes: Georges Didi-Huberman, "Pathos and Praxis (Eisenstein vs Barthes)," in *Sergei M. Eisenstein: Notes for a General History of Cinema*, ed. Naum Kleiman and Antonio Somaini (Amsterdam: Amsterdam University Press, 2016), 309–322. A close reading of Eisenstein's organization of motion in *The Battleship Potemkin* and *Strike* is offered in Herbert Eagle, "Visual Patterning, Vertical Montage, and Ideological Protest: Eisenstein's Stylistic Legacy to East European Filmmakers," *Eisenstein at 100: A Reconsideration*, ed. Albert J. LaValley and Barry P. Scherr (New Brunswick: Rutgers University Press, 2001), 169–192.

(a)

(b)

(c)

Fig. 4.3 (*a–c*) A scene of mass solidarity in *The Battleship Potemkin*: from a single gesture-trigger to the mobilization of the whole crowd as one organism. Image source: *The Battleship Potemkin*, dir. Sergei Eisenstein. DVD (Kino Lorber, 2007).

through the city to greet the Battleship. Eisenstein's treatment of the crowd in this scene may give us a clue about the way in which he imagined the animation, agitation, and mobilization of spectators during a successful screening.

In 1929, while working on his essay "How Pathos Is Made?," Eisenstein read a study entitled *Reflexological Approach to Pedagogy* by Bekhterev's follower, the children's psychologist Avgusta Dernova-Iarmolenko.[121] This book contains an extended discussion of imitation, proceeding from the premise that the mirroring of the seen or heard action (*echolalia*) is the simplest form of feedback in humans and animals.[122] An infant is capable of smiling in response to a smile, which means that his "visual apparatus can capture the image of the mother and convey her smile by the neuromuscular apparatus of his little lips."[123] This reproduction of the mother's action exemplifies the formation of an engram in the child's nervous system, what Dernova-Iarmolenko denotes using the German term, *Bahnung*—the "laying down of pathways," *protorenie putei*.[124] Any process of recollection is the activation of engrams, or the excitation of biochemical connections between nerve cells, which had been made in the past. Considering the role of imitation for social progress, an attempt to reproduce another person's engram allows someone with little experience in life to take advantage of another person's acquired experience.[125] However, as Dernova-Iarmolenko cautions, citing Bekhterev, emulation is facilitated by the pre-existent engrams in the person's nervous system (i.e., if "the pathways are more or less laid previously").[126] As Pierre Janet has noted, during hypnosis the psychiatrist only succeeds in suggesting actions that are already pertinent to the subject himself.[127] The person's predispositions, acquired in the course of his life, will filter his impression of the stimulus and shape the response. In her own experiments at Bekhterev's Institute of the Brain, Dernova-Iarmolenko found out that young schoolchildren do not passively copy others' actions. It is very hard to establish a conditioned reflex simply by showing the child some action, such as nodding or waving the hand, and accompanying it with some random stimulus, for example, the sound of tapping (Fig. 4.4). However, if the child is encouraged to repeat the experimenter's gesture with his own body while hearing tapping, then, after several repetitions, he will exhibit the conditioned reflex quite easily (i.e., he will perform the motor action independently at the sound of tapping).

[121] Passages from this study (not related to imitation) are cited in Sergei Eisenstein, "Kak delaetsia pafos?" (1929) RGALI f. 1923, op. 2, ed.khr. 793, l. 35.

[122] A. Dernova-Iarmolenko, *Refleksologicheskii Podkhod v Pedagogike* (Leningrad: Izd-vo khnizhnogo sektora GUBONO, 1925), 62.

[123] Ibid., 64.

[124] Ibid.

[125] Ibid.

[126] Ibid.

[127] Ibid.

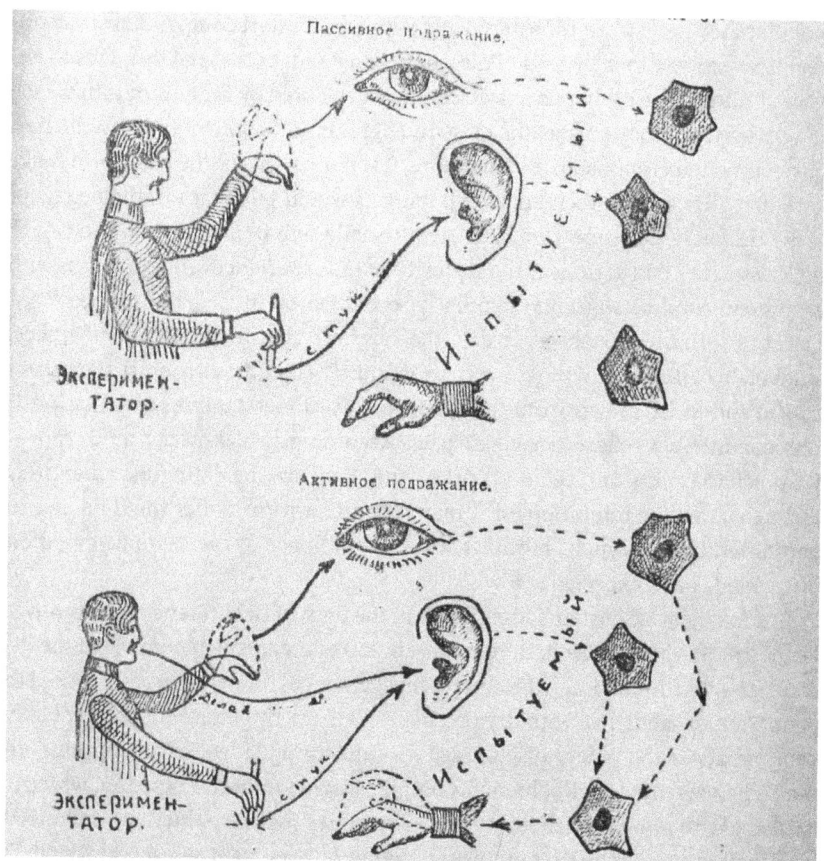

Fig. 4.4 The implanting of engrams in Avgusta Dernova-Iarmolenko's experiment. In the top image ("passive imitation"), the experimenter waves his hand and taps, while the subject's hand remains inactive. The diagram represents the engagement of the subject's aural and visual sensory nerves without any kinesthetic sensations. In the bottom image ("active imitation"), the subject is asked to wave while hearing and seeing the same stimuli. The aural, visual, and kinesthetic stimuli are now joined together. Image source: A. Dernova-Iarmolenko, *Refleksologicheskii Podkhod v Pedagogike* (Leningrad: Izd-vo khnizhnogo sektora GUBONO, 1925), 67.

Dernova-Iarmolenko explains that in the second case, the "motor engram" was formed in connection to the random stimulus, whereas in the first case, motor nerves had not been engaged.

The practical implication of this experiment is that the most effective learning for children happens through direct, hands-on enactment of the lesson. To illustrate this idea, Dernova-Iarmolenko criticizes athletic programs, such as the

popular Petr Lesgaft's gymnastics, which apparently starts out with abstract anatomical explanations instead of direct exercises and, because of this, fails to engage children.[128] Another practical lesson underscored by the author is that each new experience may engage the existent engrams and connect them to the new environmental circumstances. Therefore, it is important for the teacher to make sure that all the reinforcements the pupil gets would push him in the pedagogically desirable direction (for instance, the child will be less inclined to repeat his classmates' bad actions if the majority of his experiences supplied him with a different kind of engrams). Similarly to Bekhterev in *Collective Reflexology*, Dernova-Iarmolenko observes that the teacher's motor temperament infects students by attuning them to a certain mood.[129] The ultimate, most significant conclusion to be drawn from the reflexological understanding of imitation is that conditioned reflexes may extirpate. According to Bekhterev, as Dernova-Iarmolenko points out, the reaction of imitation may be extinguished entirely through complete inhibition, or it may take a new form under the influence of partial inhibition, which "modifies" the mental image of the example based on the person's prior experience.[130]

By looking at Eisenstein's film theory in the light of Bekhterev's and Dernova-Iarmolenko's views on imitation, we discover a context which compelled the director to seek the maximal kinesthetic engagement of film viewers, as opposed to pandering the audience with dry postulates. It is not by chance that he explicitly conceptualizes the power of montage for implanting "ideological engrams" in the audience's mind.[131] Bekhterev's complex view of imitative reaction, which is in dialog with pre-established engrams, and which may be obliterated and modified, points to a sophisticated understanding of personality—each individual's nervous system is malleable, constantly changing under the influence of biological maturation and social experience. Bekhterev opens up the possibility that the imitative motor drive may be inhibited—the person's engrams may predispose him not to reproduce an exact copy of what they see. As I will show in the next section, the process of motor inhibition is crucial for Eisenstein's explanation of why adult spectator are less responsive to visible actions compared to children,

[128] Ibid., 67. Dernova-Iarmolenko acknowledges though that Lesgaft's method works well for adults. On Lesgaft's gymnastics in Russia in the context of the new body culture, see Irina Sirotkina and Roger Smith, *Sixth Sense of The Avant-Garde: Dance, Kinaesthesia and the Arts in Revolutionary Russia* (London: Methuen, 2017), 141.

[129] Dernova-Iarmolenko, 68.

[130] Ibid., 71.

[131] On Eisenstein's use of the term "engram," which was also crucial in his friend's Alexander Luria's vocabulary, see Viacheslav V. Ivanov, *Izbrannye Trudy po Semiotike i Istorii Kul'tury*, vol. 1 (Moskva: Shkola "Iazyki russkoi kul'tury," 1998), 240; Viacheslav V. Ivanov, *Izbrannye Trudy po Semiotike i Istorii Kul'tury*, vol. 4 (Moskva: Shkola "Iazyki russkoi kul'tury," 2007), 63–64.

and what happens to the nerve impulse, when it gets directed away from the immediate motor discharge.

Motor Inhibition, Will, and Cognition

In his 1937 notes on William James, Eisenstein includes the psychologist's famous speculation: without the corporeal response, the reaction of our brain to the stimulus would have been a "cold," dispassionate calculation.[132] Out of this claim, the director draws a striking, but not altogether illogical conclusion:

> Through reproducing what he sees, the viewer comes to the appropriate emotion from bodily states that are "unmotivated" for him and are evoked purely through imitation. The very fact that his imitation does not unfold into a plenitude of movements (as is the case with children in the theater) produces a double effect: it intensifies the intellectual side of the issue the adult viewer perceives emotionally. The grownup perceives less emotionally than children, who realize the imitative process fully. The degree of physical realization is the basis of the reaction's emotional charge. The degree of curtailing is the basis of intellectual element. Both the first and the second claims are according to James.[133]

Eisenstein thus condenses James's reflections to a concise, practical maxim: he devises a scale, where the intensity of the viewers' motor excitation indicates the extent to which their response to a film scene gravitates toward a more emotional or a more rational pole. This is Eisenstein's own continuation of James's thought, because the latter's argument in *Psychology: A Briefer Course* ends simply with the proposition that a "disembodied human emotion is a sheer nonentity."[134] What James was contending was that the "mind-substance" of emotion amounted to sensations of visceral reactions taking place—without the latter, there would be no emotion, only "the cold, neutral state of intellectual perception."[135] In the same chapter, James touched upon cases of the conscious suppression of the outward

Eisenstein, "Stanislavskii i Loiola." James's statement has recently been championed by the neuroscientist Antonio Damasio, who argued that this kind of rational, dispassionate thinking is a fiction: the emotional circuits of the brain prepare the conscious decision we eventually make. (See the chapter on "Emotion" in Antonio R. Damasio, *Descartes' Error: Emotion, Reason and the Human Brain* [New York: Penguin Books, 2005]).

Eisenstein, "Stanislavskii i Loiola."

William James, *Psychology. A Briefer Course* (New York: Henry Holt and Company, 1892), 380.

James, *Psychology*, 379.

signs of emotions, but he suggested that these voluntary actions provoke new bodily sensations and therefore call forth an entirely new shade of emotion:

> During the expression the emotion is always felt. After it, the centres having normally discharged themselves, we feel it no more. But where the facial part of the discharge is suppressed, the thoracic and visceral may be all the more violent and persistent, as in suppressed laughter; or the original emotion may be changed, by the combination of the provoking object with the restraining pressure, into *another emotion altogether*, in which different and possibly profounder organic disturbance occurs. If I would kill my enemy but dare not, my emotion is surely altogether other than that which would possess me if I let my anger explode.[136]

While James's point about the struggle of attitudes, manifested as the conflict of opposite tendencies of the body, would certainly have interested Eisenstein in light of his "bi-mechanical" theory of expression, when speculating about the "scale" of physical agitation as a sign of either emotional or intellectual processing of the stimulus, the Soviet director seems to appeal to a more general theory of inhibition. What he has in mind is a kind of rechanneling of the nervous energy away from the motor discharge and into the nervous circuits, which produce emotional and intellectual reverberations in the adult's consciousness. In the chapter on "Will" in the same textbook, James discusses not only the deliberate inhibition but also the subconscious, autonomous "blocking" of the ideomotor effect (rudimentary movements instigated by the sight or imagination of physical actions):

> To quote [Hermann] Lotze once more: "The spectator accompanies the throwing of a billiard-ball, or the thrust of the swordsman, with slight movements of his arm; the untaught narrator tells his story with many gesticulations; the reader while absorbed in the perusal of a battle-scene feels a slight tension run through his muscular system, keeping time as it were with the actions he is reading of. These results become the more marked the more we are absorbed in thinking of the movements which suggest them; they grow fainter exactly in proportion as a complex consciousness, under the dominion of a crowd of other representations, withstands the passing over of mental contemplation into outward action."[137]

For James, "a crowd of other representations" within our stream of consciousness may instantaneously extinguish the initial impulse to act. With this proposition, James critiqued the lay notion of exerting one's willpower over oneself, or the

136 Ibid., 384.
137 Lotze cited in James, *Psychology*, 425.

idea that movement is necessarily a product of a deliberate command. "We do not first have a sensation or thought, and then have to add something dynamic to it to get a movement," he stated provocatively,

> Every pulse of feeling which we have is the correlate of some neural activity that is already on its way to instigate a movement. Our sensations and thoughts are but cross-sections, as it were, of currents whose essential consequence is motion, and which have no sooner run in at one nerve than they are ready to run out by another.[138]

In James's view, the nervous system senses and reacts unceasingly, while the consciousness is detecting only a fraction of these impulses. This is a view of the mind that is constantly in flux; the mind, where every impression or idea is immediately beginning to work toward activating a certain muscle group, as long as this course of reaction is not blocked by the arrival of some "antagonistic" counter-idea, or derailed by a new, unrelated sensation.[139] James wrote:

> A waking man's behavior is thus at all times the resultant of two opposing neural forces. With unimaginable fineness some currents among the cells and fibres of his brain are playing on his motor nerves, whilst other currents, as unimaginably fine, are playing on the first currents, damming or helping them, altering their direction or their speed. The upshot of it all is, that whilst the currents must always end by being drained off through some motor nerves, they are drained off sometimes through one set and sometimes through another; and sometimes they keep each other in equilibrium so long that a superficial observer may think they are not drained off at all.[140]

Even if they remain invisible to the naked eye of an external observer, and even if they escape the conscious knowledge of the subject himself, these "currents" are constantly streaming through the nerves in a relay of triggering and inhibiting certain motor reactions.

In addition to James's reflections on inhibition, to properly contextualize Eisenstein's point about the adult spectator's restraint, it is important to acknowledge the prominent role that the concepts of motor reaction and its inhibition played in Russian reflexology and neurophysiology. There was a strong native tradition of materialist psychology, which formed the background for Eisenstein's preoccupation with muscular contraction and kinesthetic experience as an

[138] James, *Psychology*, 426.
[139] Ibid.
[140] Ibid., 427–428.

integral part of emotional and cognitive processes. In the mid-19th century, Ivan Sechenov boldly proclaimed that thought is a "truncated reflex"—that is, a reaction to a stimulus which lacks the visible manifestation of the final segment of a typical reflex, namely, motor action. Once our nervous endings have picked up a signal, Sechenov stated, excitation begins traveling along the afferent nerves toward the brain, and this energy is bound to be released in one form or another: it may either immediately trigger a motor discharge, or stay on reverberating throughout the brain, with the potential of activating some different, perhaps more deliberate, reaction at a later point. Which of these two options would prevail depends on the sophistication and maturity of the brain's architecture, which develops through the organism's interaction with the environment. Sechenov's famous article "Reflexes of the Brain" (1863) contains a passage that bears an uncanny resemblance to Eisenstein's observation regarding the young spectator's face reacting to stage action. "Childhood," Sechenov writes, "is generally characterized by extremely extensive reflex movements arising in response to relatively weak (from the adult point of view) external sensory stimulation."[141] In infants, a visual or aural stimulus spreads innervation "to almost all muscles of the body," but as the child grows and develops, the same stimulus will only activate specific muscles groups, while the rest of the excitation will be inhibited.[142] For instance, a bundle of sensations that is associated in the infant's mind with a toy bell may initially provoke a smile and excited jumping, but by age two, the child is more likely to respond by naming the object, or imitating the sound that it makes—that is, solely by activating the speech organ rather than his whole body.[143] For Sechenov, the work of the speech muscles pronouncing the onomatopoeic "ding-ding" was a reflex action descended from the agitation the child exhibited at a younger stage. Simply, in the older child, the same reflex was now confined to only one specific discharge pathway with others inhibited. This example of inhibition was just one in a somewhat eclectic range of cases Sechenov discussed in "Reflexes of the Brain," which included such disparate phenomena as stoic comportment in the face of adversity and coordination of movement in walking. Such eclecticism could in part be explained by the fact that Sechenov's essay was intended for the lay audience, and his overall task, aligned with his liberal political stance in the 1860s, was to conceptualize human behavior, no matter how elemental or how complex, as reactions to external stimulation developed in the course of the person's life. In an often-cited paragraph, Sechenov stated:

[141] Ivan Sechenov, "Reflexes of the Brain," in *Selected Physiological and Psychological Works*, ed. Kh. Koshtoyants, trans. S. Belsky and G. Gibbons (Moscow: Foreign Languages Publishing House, 1965), 31–139, 114.

[142] Ibid.

[143] Ibid., 117.

All the endless diversity of the external manifestations of the activity of the brain can be finally regarded as one phenomenon—that of muscular movement. Be it a child laughing at the sight of toys, or Garibaldi smiling when he is persecuted for his excessive love for his fatherland; a girl trembling at the first thought of love, or Newton enunciating universal laws and writing them on paper—everywhere the final manifestation is muscular movement.[144]

With this wide definition of movement, the notion of inhibition in "Reflexes of the Brain" was equally all-encompassing. Sechenov's rhetorical goal was to advance a monistic, materialist understanding of human behavior, and he did not shy away from bold generalizations. In his scientific publications, Sechenov focused more carefully on elemental examples of muscle contraction in animals and attempted to describe inhibition as a strictly physiological process. The exact mechanism of its operations, however, was a question that Sechenov and alumni of his laboratory continued to explore and debate for decades.[145] As the historian of science Roger Smith has shown, based on his experiments with frogs, Sechenov initially believed in the existence of a central inhibition mechanism for motor reactions located in in the mid-region of the brain, but by the 1870s, he and his scientific community came to recognize that inhibition may also happen peripherally.[146] This proved to be a promising research direction, one that would lead to Nikolai Bernstein's breakthroughs in investigating the sensori-motor regulation of limbs in the 1920s–1940s. Though Sechenov had not yet been able to formulate the idea of the sensori-motor feedback loop, he paved the way for subsequent explorations of the muscular sense (*myshechnoe chuvstvo*) and its function for motor regulation.[147] In "Reflexes of the Brain" (1863), the scientist suggested that when the child is learning to walk, his "muscular sensation and its analysis are the guiding factors" by which the brain begins to inhibit the irrelevant innervations of muscles, so as to gain control over the coordination of the overall motor act.[148] In a 1891 paper, based on his observations of ataxia patents in Sergei Botkin's clinic, Sechenov argued that the muscular sense "together with cutaneous and visual sensations, serves, so to say, as the chief supervisor of consciousness in the procedure of coordination of movements."[149]

[144] Sechenov, "Reflexes of the Brain," 33.

[145] Roger Smith, *Inhibition: History and Meaning in the Sciences of Mind and Brain* (London: Free Association Books, 1992),109.

[146] Smith, *Inhibition*, 116.

[147] Kanunikov, I. E., "Ivan Mikhailovich Sechenov—The Outstanding Russian Neurophysiologist and Psychophysiologist." *Journal Of Evolutionary Biochemistry and Physiology* 40.5 (2004): 596–602, 600.

[148] Sechenov, "Reflexes of the Brain," 114.

[149] Ivan Sechenov, "Fiziologiia nervnykh tsentrov," cited in Kanunikov, "Ivan Mikhailovich Sechenov," 600.

Overall, Sechenov had been able to recognize the function of muscular sensations in helping us learn to accomplish precise motor acts, create mental images of external objects, and measure space and time.[150] As a young man in the 1850s, the Russian physiologist was deeply impressed by Hermann von Helmholtz's research program in psychophysics of acoustics and vision, while studying under him in Heidelberg.[151] Sechenov later hailed Helmholtz for pioneering the method of graphical inscription of muscular contractions to reveal the speed and discontinuous nature of nervous impulses, as well as for laying the foundations for an embodied approach to perception, particularly for investigating the role of eye muscle contractions for stereoscopic vision and spatial analysis (Fig. 4.5).[152]

Like Helmholtz, Sechenov believed that the ability to perceive spatial relations develops in young children as they begin to subconsciously associate specific visual effects (e.g., sharper focus, parallax, etc.) with corresponding "changes in their muscular sense" when their eyes move from one point in space to another.[153] In the same way as a bundle of sensations gets associated with a certain idea in our mind, Sechenov explained, the acquisition of motor skills (such as the coordination of eye muscles) depends on frequent repetition: we learn to identify the proprioceptive sensations that correspond with a certain type of visual signal and prune away, or inhibit, the irrelevant muscular innervations.[154] During his lifetime, Sechenov's name was frequently evoked in the intellectual circles in Russia with reference to the question of whether the notion of the soul could coexist with the view of the body as a neurophysiological mechanism conditioned by the environment, and whether human actions are a product of volition or of some predetermined set-up. Maligned by the Czarist censors as dangerously anti-religious, Sechenov's theses inspired progressive intellectuals and novelists, such as Ivan Turgenev and Leo Tolstoy, to reflect on the theme of determinism and positivist explanations of behavior in their works.[155]

Overall, it is hard to overestimate the influence that Sechenov had in Russia, specifically in terms of setting the ground for the experimental exploration of the nervous system through analyzing motor reactions as processes of excitation and inhibition.[156] Significantly for the 1920s, when Eisenstein was formulating

[150] Kanunikov, "Ivan Mikhailovich Sechenov," 601.

[151] Sechenov's own research under Helmholtz was on the penetrability of the eye by the ultraviolet rays (see Galina Kichigina, *The Imperial Laboratory: Experimental Physiology and Clinical Medicine in Post-Crimean Russia* [Amsterdam: Rodopi, 2009], 121).

[152] Ivan Sechenov, "German f.-Gel'mgol'tz kak fiziolog," *Izbrannye proizvedenia, Izbrannye proizvedenia*, ed. Kh. S. Khoshtoyants, vol. 1 (Moskva: Izdatel'stvo Akademii Nauk SSSR, 1952), 497–509, 499, 505.

[153] Sechenov, "German f.-Gel'mgol'tz kak fiziolog," 507.

[154] Ibid.

[155] Kanunikov, "Ivan Mikhailovich Sechenov," 599–600.

[156] However, Smith (*Inhibition*, 193) judiciously cautions against a simplistic assertion of direct lineage from Sechenov to Pavlov and Bekhterev, which was promoted by the Soviet historiography.

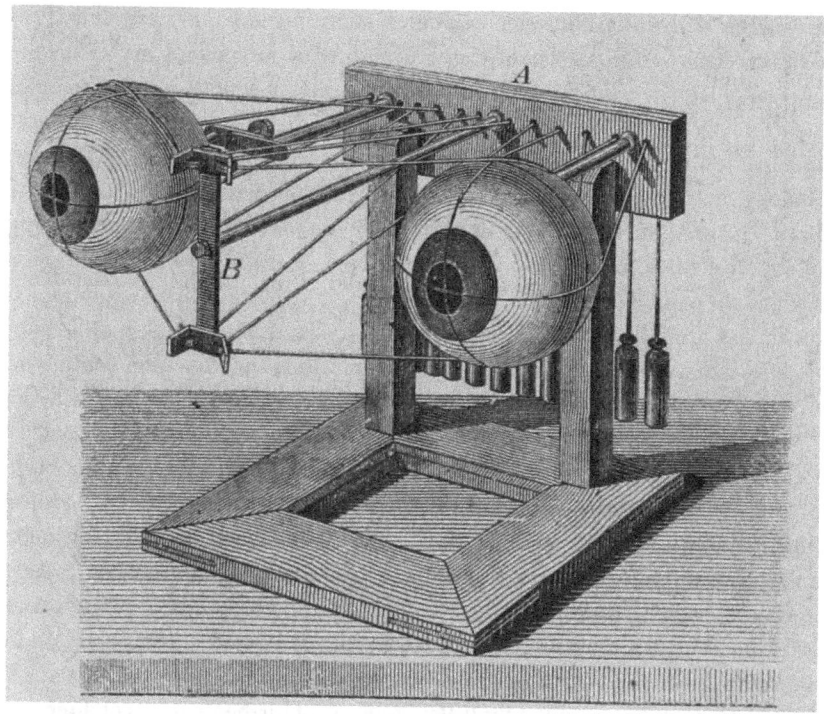

Fig. 4.5 Knapp's ophthalmotrope—a device for modeling the working of the muscles rotating the eyes in Hermann von Helmholtz's *Treatise on Physiological Optics* (*Handbuch der physiologishen Optik*, 1867). Image source: Hermann von Helmholtz, *Treatise on Physiological Optics*, trans. and ed. James P.C. Southall, vol. 3 (New York: Dover, 1962), 119.

his film theory, Sechenov's approach had been firmly cemented as the forerunner of Vladimir Bekhterev's "objective psychology" and Ivan Pavlov's reflexology, though their specific methodologies and conceptual frameworks assigned a somewhat different meaning to terms such as excitation and inhibition. Pavlov maintained that two forces, the "irradiation of excitation" throughout the brain and "inhibition" of this irradiation, are fundamental processes of the higher nervous activity.[157] The intensity and amplitude of the organism's reaction to

Despite the overall similarity, there was scientific polemics and institutional struggle between their laboratories. Pavlov studied under the neurophysiologist Ilya Tsion rather than Sechenov and formulated his own theory of inhibition, which criticized some of Sechenov's points.

[157] Smith, *Inhibition*, 200.

a stimulus depend on the spread of innervation in the brain. Each new stim-ulus threatens to misbalance the existent routines of nervous activity. While the normal organism is capable of returning to the state of equilibrium, pathologies are characterized by the brain's inability to counterbalance the spread of excita-tion by the appropriate amount if inhibition. In the realm of human psychology, Pavlov's theory remained highly speculative. Like Sechenov in "Reflexes of the Brain," he used the term "inhibition" not only in reference to the extinguishing of neural excitation, but also to explain self-control and states of consciousness such as sleep and hypnosis.[158] For example, Pavlov believed that "inhibition" is much less pronounced in children, because their cerebral cortex is still func-tionally weak, and therefore unequipped to preclude the excitation coming up from the subcortical ganglia, which are responsible for "deep-seated instincts."[159] As Roger Smith has remarked, Pavlov's description of children's lesser capacity for self-control as failures of inhibition was nothing else but a commonplace of 19th-century psychology, with the novel reflexological terminology adding little to understand the phenomenon of maturing.[160] Nevertheless, Pavlov made an attempt to account for the hierarchy of interacting brain structures at least in theory, even if his laboratory experiments for the most part were meant to infer the brain functions indirectly, through the method of salivary secretion in animals.

Pavlov's contemporary Vladimir Bekhterev went further in terms of direct re-search on animal and human brain, as well as in terms of conceptualizing the links between bodily movement, perception, and emotion. Through a series of vivisection experiments, conducted on mammals between 1883 and 1884, Bekhterev discovered that thalamus—a subcortical center where all sensory nerves lead to—plays a significant role in activating muscular contractions iden-tifiable as emotional expressions.[161] Thalamus had previously been considered only as a sensory hub, which preprocessed sensory signals before transmit-ting them to the cortex, but Bekhterev proved that its nuclei also contribute to

[158] Smith, *Inhibition*, 200–201. The speculative character of Pavlov's psychological theory did not prevent Soviet psychiatric institutions in the 1930s from devising strategies of behavioral correc-tion, including hypnotic sleep therapy, which were based on the theory of inducing "inhibition." See Smith, *Inhibition*, 201; and Konstantin Bogdanov, "Pravo na son i uslovnye refleksy: Kolybel'nye pesni v sovetskoi kul'ture, 1930–1950-e gg.," *Novoe Literaturnoe Obozrenie* 86 (2007). *Zhurnal'nyi Zal*, http://magazines.russ.ru/nlo/2007/86/bo1.html .

[159] Frolov, *Pavlov and His School*, cited in Smith, xx, 200.

[160] Smith, xx, 112.

[161] Vladimir Bekhterev, "Die Medizin der Gegenwart in Selbstdarstellungen," in *Professor V.M. Bekhterev i nashe vremia (155 let so dnia rozhdenia)*, ed. E. V. Sharova (Sankt-Peterburg: Politekhnika, 2015), 439–454, 445. On the significance of Bekhterev's findings for the theory of emotions in the early 20th century, see Lev Vygotskii, "Uchenie ob emotsiiakh: istoriko-psikhologicheskoe issledovanie," in *Sobranie sochinenii v shesti tomakh*, Tom 6, ed. M. G. Iaroshvskii (Moskva: Pedagogika, 1984), 92–318, 145.

regulating motor functions. In subsequent research, Bekhterev applied galvanic electricity to the thalami of rabbits, registering visceral effects concomitant with emotional expressions, such as the quickening of the pulse, the rise of the blood pressure, contractions of the bladder, and so on.[162] In parallel with experiments on animals, he studied the "conducting pathways" in the brain and the spinal cord of human fetuses under Paul Emil Flechsig in Leipzig and performed postmortems on subjects who were known to have suffered from brain trauma in order to locate the affected areas of the brain responsible for the neuropatholog-ical symptoms they exhibited in life.[163] His clinical research made him convinced of communication networks between brain centers, which were previously thought to be autonomous and uniquely responsible for various functions of the organism. Incorporating these discoveries into his perspective on psychology, Bekhterev argued that the input of sensory organs (efferent impulses traveling from the periphery toward the nerve centers) is always accompanied by the ac-tivation of muscles attuning the sense organs toward the stimulus (an afferent discharge from the centers back to the periphery).[164] In other words, optical, acoustic, or other sensations are simultaneous with proprioceptive sensations of muscular effort. Moreover, when all these sensations travel upward to the cortex, the innervation spreads first to the routes that had already been en-gaged in the past. In this way, novel sensations are checked against memories and are transformed into mental images (*predstavlenia*), which in turn activate motor reactions and other somatic responses.[165] External impressions produce memories by leaving "traces"—not in the sense of "photographic imprints," as Bekhterev noted, but rather as "dynamic changes" within pathways, character-ized by a diminished resistance to incoming innervations.[166] The formation of these routes is the neurophysiological underpinning of associative (conditioned) reflexes. Bekhterev maintained that rather than having localized centers of sen-sory perception and those responsible for representations, the cortex is com-posed of "areas" that combine sensory impressions with somatic and muscular reactions: the "visual-motor area," "acoustic-motor area," "motor-tactile, or ac-tively tactile area," "muscular static area," "emotive-somatic, or mimic-somatic area," the area of active concentration, and others.[167] These areas govern the

[162] Bekhterev, "Die Medizin," 446.

[163] Ibid. On Bekhterev's and his school's approaches to the study of embryos, neonates, and children, see Andy Byford, "V. M. Bekhterev in Russian Child Science, 1900s–1920s: 'Objective Psychology'/'Reflexology' as a Scientific Movement," *Journal of the History of the Behavioral Sciences* 52.2 (2016): 99–12.

[164] Vladimir Bekhterev, *Budushchee Psikhiatrii: Vvedenie v Patologicheskuiu Refleksologiiu* (Sankt-Peterburg: Nauka, 1997), 78.

[165] Ibid., 79.

[166] Bekhterev, "Zadachi imetod ob'ektivnoi psikhologii" (1909).

[167] Bekhterev, *Budushchee psikhiatrii*, 79.

organism's associative reflexes, that is, behavioral programs, launched at one point in the organism's life by some external stimulus. All acts of cognition, according to Bekhterev, have material reality. In our inner speech, "every idea is accompanied by weakly expressed external movements, in the form of words or actions, or by internal movements and internal secretions."[168] Even if we may remain unaware of these corporeal effects accompanying thinking, this does not mean that they do not exist. Regarding inhibition, Bekhterev, like Sechenov, believed in the inverse relation between outward manifestation of reflexes, that is, motor discharge, and the intensity of the internal somatic reactions. This principle of compensation, for Bekhterev, was evident in the repression of emotional expressions ("mimic-somatic reflexes"):

> As is well-known, external manifestations of mimic-somatic reflexes may be inhibited to greater or lesser degree by one or another external or internal stimulus. . . . In this case the reflex is manifested by an intense inner reaction, despite the inhibition of the external reaction. The principle of compensation takes place, whereby in lieu of the external reaction, an inner somatic reaction is amplified, for instance, the heart rate.[169]

With this theory of "compensation"—the idea that nervous impulses either get discharged by activating muscles or produce some other form of physical impact on the body—Bekhterev referenced the principle of energy preservation.

In this respect, Bekhterev's conception still owed much to the 19th-century psychology. In a historical overview of turn-of-the-century psychology, Eisenstein's friend, the psychologist Alexander Luria, noted that one of the most influential metaphors for the brain in this period was that of a telegraph switchboard, where the inward and outward traffic of nervous signals was understood in terms of only two processes, excitation and inhibition (innervation and retardation), which were though to abide by the same laws of mechanics and thermodynamics as all inorganic matter.[170] It was a step forward for scientists such as Sechenov, Pavlov, and Bekhterev to recognize that the subject's past experiences leave a mark on the functioning of his nervous system by creating a conditioned reflex. Within the first decades of the 20th century, the mechanistic image of the telegraph switchboard, channeling and inhibiting nervous impulses, gradually

[168] Vladimir Bekhterev, *General Principles of Human Reflexology* (New York: Arno Press, 1973), 402.

[169] Vladimir Bekhterev, *Obshchie osnovy refleksologii cheloveka*, 4-e posmertnoe izdanie, ed. A.V. Gerver (Moskva: Gosudarstvennoe Izdatel'stvo, 1928), 446.

[170] Aleksandr Luria, *Priroda chelovecheskikh konfliktov: ob"ektivnoe izuchenie dezorganizatsii povedeniia cheloveka*, ed. V.I. Belopol'skii (Moskva: Cogito Centr, 2002), 22. For a discussion of the 19th-century metaphor of the telegraph for the nervous system, see Dolf Sternberger, *Panorama of the Nineteenth Century* (New York: Urizen, 1977), 34–37.

began to give way to the vision of complex integrated systems of processing and regulating. These systems develop with the individual's maturing and can disintegrate under particular circumstances. Some of these systems are hardwired evolutionary adaptations, while others are acquired in the course of one's life through interaction with the natural and sociocultural environment.

Among the new trends in psychology that began inquiring into the complex, systemic nature of behavior in the 1920s was Alexander Luria's and Lev Vygotsky's cultural-historical theory of psychological development. Though this school polemically positioned itself against reflexology, Luria and Vygotsky never denied the relevance of neurophysiology for analyzing behavior. Rather, neurophysiological methods of inquiry became a supplement in their more complex research programs, which prioritized higher mental faculties, such as speech, thinking, tool making, and problem solving. Vygotsky defined thought as "a transmitter between different reflexes"—that is, a moderator and integrator of potential response patterns.[171] Under this view, corporeal movement still remained an important index of the inner processes, as evidenced in Luria experimental method of "combined motor reactions" (sopriazhennaia motornaia reaktsiia), developed between 1923 and 1930 (Fig. 4.6).[172]

Similarly to the lie detector, Luria's method helped identify sensitive topics for criminal suspects and mentally unstable patients. Instead of an isolated reflex, Luria took into account the entire behavioral act, with its cognitive, affective, and motor components. The subjects "were asked to press on a pneumatic device" while giving a verbal association to various words, some of which were related to the crime or traumatic circumstances.[173] Luria contended that the character of the recorded curve revealed nuances of the "neurodynamic process" in real time, showing the activation of "affective traces" in the subject's memory.[174] Thus "motor disturbances" appeared on the curve whenever the subject heard a trigger word.[175] According to Luria, when the criminal suspect attempted to conceal their "affective traces," his motor reactions would become more "diffused" (uncoordinated), and he would emphasize the pronounced words instead. After confessing to the crime (or passing through "catharsis" in the case of neurotic patients), the subjects' motor reactions regained a more concentrated, resolute quality.[176]

[171] Vygotsky cited in Alex Kozulin, Vygotsky's Psychology: A Biography of Ideas (Cambridge, MA: Harvard University Press, 2001), 74.

[172] Luria, Priroda chelovecheskikh konfliktov, 19.

[173] A. R. Luria, "The New Method of Expressive Motor Reactions in Studying Affective Traces," Ninth International Congress of Psychology held at Yale University, New Haven, September 1-7, 1929: Proceedings and Papers (Princeton, NJ: The Psychological Review Company, [c. 1930]), 294–296, 295.

[174] Ibid.

[175] Ibid.

[176] Ibid.

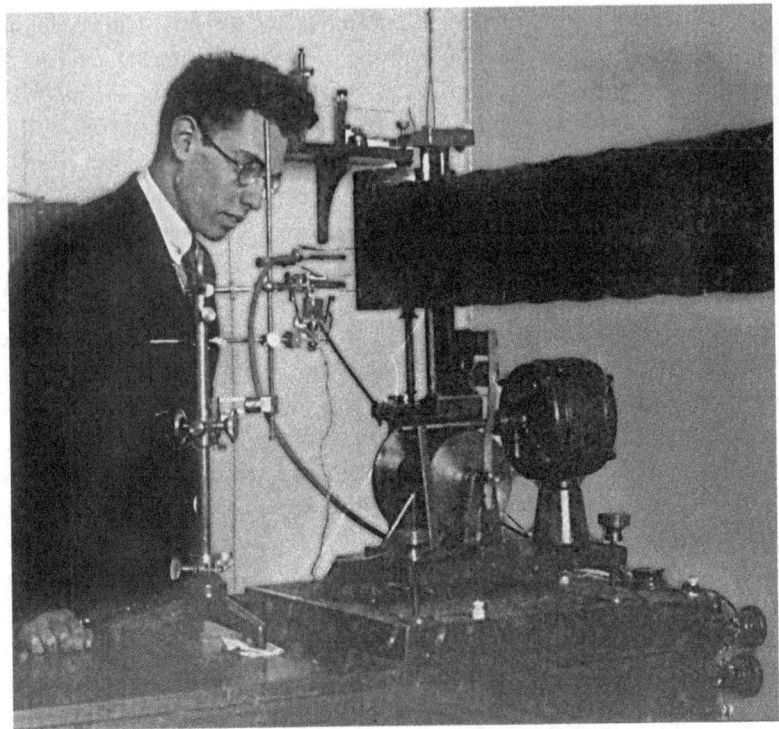

Fig. 4.6 Alexander Luria near his apparatus for the study of "combined" motor reactions. Image from Luria's family archive, courtesy of Elena Radkovskaia and Aleksandra Radkovskaia. My gratitude to Viktor Belopol'skii for helping me obtain this image.

Positioning himself vis-à-vis his predecessors in psychology, Luria urged to replace the terms "excitation and inhibition," which he considered too broad, by a focus on "organization and disorganization," or "the regulation and disintegration of behavior systems."[177] He maintained, pace Bekhterev, that universal physical laws reveal little about behavior, but just like the reflexologists, he considered child's development as the "overcoming" of the primeval patterns of response governed by the subcortical ganglia through the introduction of the "new regulatory systems."[178] Unlike Pavlov and Bekhterev, however, Luria held that psychological development cannot be explained solely by the cortical "inhibition" of the subcortex, but should be viewed as the gradual "overcoming" of "diffused" responses (i.e., those involving too many unnecessary motor reactions) when

[177] Luria, *Priroda chelovecheskikh konfliktov*, 28.
[178] Ibid., 30.

"complex organic systems, and later, higher cultural systems" begin to regulate the child's behavior.[179] As the brain matures, the young person's immersion into the cultural sphere provides opportunities for acquiring skills, mastering tools, and interiorizing specific cultural practices. The sociocultural framework nourishes consciousness. Exposure to cultural symbols and children's own active efforts at creating symbolic representations continuously shape their minds and influence the structure of their behavior. Luria garnered some interesting evidence of this developmental process from the study of children's drawings (Fig 4.7). A child aged seven years old, tasked with depicting "war," is yet unable to single out the distinctive traits of the phenomenon: his picture is nondescript and unexpressive, yet the little artist compensates by dramatizing the scene with his own exuberant gestures and sound effects.[180] In a nine-year-old, the "motor expression merges with drawing" (*motornoe izhivanie slivaetsia s risovaniem*): the vigorous line of cannon fire graphically embodies the excitation that a younger drawer would have externalized.[181] In the drawings of an eleven- and a thirteen-year-old, the direct "motor discharge accompanying the mental image" (*motornyi razriad obraza*) has completely disappeared.[182] Their pictures lack graphic energy, because teenagers are channeling their excitation via recognizable, culturally accepted symbols highlighting the salient traits of the scene.

This interpretation of children's drawings is in line with the "cultural-historical" approach to psychology that Luria was elaborating together with Lev Vygotsky. Today, we are much more familiar with the cognitive dimension of their discoveries, such as, for example, their interpretation of drawing as a precursor to writing—that is, as a mode of thinking, or an instrument that shapes mental development.[183] Vygostky maintained that the evolving ability to convey thoughts through graphic means changes the child's consciousness in the same way his ongoing mastery of the spoken language does. Through drawing, the young mind gains command over concepts, relations, and categories, articulating an active, transformative approach to the world.[184] Because of Luria's and Vygotsky's emphasis on cognition, commentators often overlook the vital role that the neurodynamics of motor and emotional processes plays in their analysis. Yet, according to Luria,

a symbolic device, integrated into the system of behavior, similarly to speech, mediates [*oposredstvuet*] the reaction and cuts off excitation from

[179] Ibid., 31.
[180] Ibid., 521.
[181] Ibid.
[182] Ibid.
[183] Lev Vygotsky, *Sobranie sochinenii*, vol. 3, in *Istoriia razvitiia vysshikh psikhicheskikh funktsii* (Moscow, 1983), 186.
[184] Ibid., 187.

Fig. 4.7 Children's drawings on the topic of "War," representing the three phases of development Luria identified: (*a*) a drawing by a seven-year-old; (*b*) by a nine-year-old; and (*c*) by eleven- and thirteen-year-olds. Image from Luria's family archive, courtesy of Elena Radkovskaia and Aleksandra Radkovskaia. Reproduced from Luria, *Priroda chelovecheskikh konfliktov*, 520.

directly impinging on the motor pathways, leading instead to a sophisticat-edly organized structure of the reactive process. In this respect, any sym-bolic system may serve as a powerful device for overcoming and organizing affects.[185]

[185] Luria, *Priroda chelovecheskikh konfliktov*, 515.

Artworks and cultural symbols provide a way to tame and rechannel over-whelming emotions. With art, the mastering of one's affective outbursts happens not through a deliberate act of will, but rather indirectly: the symbolic form created by the person acts upon him, compelling him "to realize automat-ically" the program encoded in its structure.[186] Instead of impulsive outbursts or willful auto-corrections, the artwork helps mediate and reorganize our reac-tion, making it more complex.[187] Luria believed that he was able to demonstrate this effect of the symbol-making activity empirically. In his book, he describes an experiment with a female "hysterical" patient conducted by the psychia-trist Iurii Kannabikh, which Luria witnessed in the laboratory setting together with Sergei Eisenstein.[188] Kannabikh hypnotized a thirty-year-old woman, whose neurosis was caused by living with an alcoholic husband squandering family finances. While she was in the state of hypnotic sleep, the doctor gave her a command that upon awaking, she would have an urge to share everything that afflicts her but without using words. After waking up, the woman's beha-vior was a highly expressive pantomime with compulsive, erratic actions, fits of crying, and tearing of hair. In the second séance, Kannabikh suggested that she must express herself using paper and pen, and in a third séance, the com-mand was to express her feelings via some symbolic form. Armed with a pen, after the second séance, the woman drew the drunkard with a bottle and then, sobbing, started surrounding this figure with fragments of phrases scribbled in a disorderly, rapid fashion. After the third séance, the patient's actions were still tense but considerably more calm and coordinated, without any sobbing: she picked up a pencil and drew a bottle with a snake next to it, thus referencing a common Russian idiom which compares the vice of drinking with a "green serpent" (Fig. 4.8, right).[189] Luria's commentary on this experiment states that the "motor tempest" that accompanied the woman's "affective fit" in the first case was graphically realized on paper in the second case. In the third case, the patient "mastered her affect by mediating it through a conventional sign." This "concentrated, austere drawing" no longer shows any signs of "hyper-kinesis or diffused motorics."[190]

This radical connection between affect and motor discharge, which art is ca-pable of regulating, was an idea that resonated deeply with Eisenstein. The film-maker first met and befriended Luria in 1925, initiating an intense, mutually

[186] Ibid., 508.
[187] Ibid.
[188] Ibid., 515.
[189] Ibid., 518.
[190] Ibid., 519.

Fig. 4.8 The woman's drawings after the second hypnotic séance (*a*) and after the third hypnotic séance (*b*), in an experiment witnessed by Eisenstein and Luria. Image from Luria's family archive, courtesy of Elena Radkovskaia and Aleksandra Radkovskaia. Reproduced from Luria, *Priroda chelovecheskikh konfliktov*, 516, 517.

enriching dialog that would last throughout his lifetime.[191] Various children's drawings, analyzed by Luria, are referenced in Eisenstein's essays, where they

[191] Julia Vassilieva, "Eisenstein and Cultural-Historical Theory," in *Flying Carpet, Studies on Eisenstein and Russian Cinema in Honor of Naum Kleiman*, ed. Joan Neuberger and Antonio Somaini (Paris: Mimesis, 2017), 421–442.

serve to explain the processes of cognition and the evolution of representa-
tional strategies.[192] The scope of Eisenstein's intellectual connections with Luria
and Vygotsky has been charted by Viacheslav Ivanov, Oksana Bulgakowa, Julia
Vassileva, and other scholars.[193] In my contribution to this ongoing research,
I would like to highlight the somewhat overlooked emphasis on the synergy
between motor, emotional, and cognitive processes, which was elaborated by
Luria and Vygotsky, as well as by Eisenstein. Take for instance, Vygotsky's mon-
ograph *The Psychology of Art* (1925), which Eisenstein received from the au-
thor and studied with great care sometimes in the second half of the 1920s.[194]
The central thesis of this book is that the structure of the artistic form impacts
the audience's perception and guides its cognitive and emotional processes.
Vygotsky supplemented one of his case studies, focused on Ivan Bunin's novella
"The Light Breath," with a pneumographic record of his own breathing during
the reading of this text. "In essence," Vygotsky stated,

> we feel in the same way as we breathe, and a highly indicative marker for
> studying the character of each artwork's emotional impact is the breathing pat-
> tern corresponding to it. By making us expend our breathing in terse, small
> portions, by holding it up, the writer easily creates the general emotional back-
> ground for our reaction.[195]

The reader's breathing pattern is indicative of the work that the literary text is
accomplishing in regulating emotions. In his analysis, Vygotsky argued that
Bunin's novella demonstrates a productive tension between the content and the
artistic form: Bunin's elegant prose manages to evoke a pure, edifying, and ca-
thartic experience despite dealing with murky and unpleasant subject matter.
Because of the ingenuous structure of Bunin's novella and its symbols, it exorcises
the aversion or indifference that the reader may otherwise have had toward its
melodramatic fabula about the murder of a fallen young woman. Foreshadowing
Luria's interpretation of the hysterical patient's drawings as her way of mastering
uncontrollable affects, Vygotsky, in his analysis of Bunin's novella, suggests that
"instead of depressing tension," which is appropriate for topics such as sexual

[192] Sergei Eisenstein, "Za kadrom," in *Izbrannye proizvedeniia v 6 tomakh*, vol. 2 (Moskva: Iskusstvo, 1964), 283–296, 288; Eisenstein, "Montage and Architecture," in *Selected Works*, vol. 2, ed. Michael Glenny and Richard Taylor (London: I.B. Tauris, 2010), 59–82, 59.

[193] On Eisenstein's engagement with Vygotsky's and Luria's ideas, see Viacheslav V. Ivanov, *Izbrannye Trudy Po Semiotike I Istorii Kul'tury: T. 4* (Moskva: Shkola "Iazyki russkoi kul'tury," 2007), 63–64; Oksana Bulgakowa, "From Expressive Movement to the "Basic Problem," Julia Vassileva, "Eisenstein/Vygotsky/Luria's Project: Cinematic Thinking and the Integrative Science of Mind and Brain," *Screening the Past* 38 (2013): 1–16; Vassilieva, "Eisenstein and Cultural-Historical Theory."

[194] Vassilieva, "Eisenstein and Cultural-Historical Theory," 424.

[195] Lev Vygotskii, *Psikhologiia iskusstva*, ed. M. G. Iaroshevskii (Rostov-na-Donu: Feniks, 1998), 203.

abuse, debauchery, and murder, "we feel an almost painful lightness."[196] The clash of pleasant and unpleasant affects brings about a cathartic epiphany to the reader and delivers the humanistic message of this work of art. Elsewhere in this same chapter, Vygotsky draws on Theodor Lipps's theory of *Einfühlung* to explain the effect of Bunin's ingenuous, nonchronological plotline in terms of the reader's motion through the text's structure.[197] Bunin novella opens with a depiction of the heroine's tomb from the point of view of her schoolmistress, who secretly admired her. This melancholy, yet somehow light image attunes the reader to a different mood, compared a linear chronology of the young girl's seduction and murder, which would have been distressing and unbearable. The story told chronologically would have progressively increased our inner tension (Vygotsky uses Lipps's original German term, *Spannung*).[198] A suspenseful opening, appropriate for a hard-boiled detective or a gut-wrenching tearjerker, would have obstructed "our psychological movement, our tension [would have started] to rise . . . and each new scene [would have] stretched our interest even further, directing us towards the ultimate resolution."[199] The unpleasant fabula we infer from Bunin's novella still impacts us, argues Vygotsky, but the nonlinear plot (with its flash-forward opening) counteracts the fabula's devastating effect. There is a strong parallel between Vygotsky's approach and Eisenstein's own vision of the dialectic structure of effective artworks, which stage a productive conflict within the spectator, on cognitive, emotional, and motoric levels.

By looking at Luria's and Vygotsky's works in relations to their predecessors, such as Bekhterev, Pavlov, Sechenov, James, Féré, and others, it becomes clear that there was a very fertile context, within which Eisenstein was able to imagine linkages between the muscular sense, emotion, and cognition. All of these scientists, despite their very different methodological platforms, believed that the spread of innervation provoked by the perception of a stimulus is directed toward motor discharge (in a primitive reaction) or rechanneled toward higher mental functions. This belief is echoed in Eisenstein's "The Fourth Dimension in Cinema" (1929), where he discussed the impact of different types of montage on the "'psycho-physiological' complex of the perceiver."[200] The essay presents a scale of responses, ranging from a direct motor imitation of the seen action to higher stages, in which this imitative drive is either suppressed or transformed, propelling the spectator toward a conscious awareness of emotions and, eventually, toward intellectual inferences. The most basic, "metric" montage, which

[196] Ibid.
[197] Ibid., 199. It would be important to note, however, that Vygotsky's book is frequently polemical with Lipps, despite the relevance of certain insights by the German philosopher.
[198] Ibid.
[199] Ibid.
[200] Eisenstein, "The Fourth Dimension in Cinema," 192.

combines clear-cut movement vectors within shots via ever-accelerating cuts, leads the audience to "outwardly motor states."[201] As evidence, Eisenstein cites a screening of his film *Old and New* (*Staroe i novoe*, 1929), where the "more impressionable section of the audience"—as he was delighted to note—literally rocked from side to side "with increasing acceleration" while watching the scene of the scything contest (Fig. 4.9).[202] These moviegoers' motor enthusiasm must have been similar either to the reapers or to the peasant onlookers, who urged the contestants in the film. The next, more advanced forms of montage, such as "rhythmic," "tonal," "overtonal," and ultimately, "intellectual," are distinguished by the progressive conversion of motor energy into higher psychological functions. As Eisenstein explained,

> The gradation is here determined by the fact that there is no difference in principle between the motorics of man's rocking to and fro under the influence of primitive metric montage (viz., the hay-making example) and the intellectual process inside him, for the intellectual process is the same oscillation—but in the centers of higher nervous activity. Whereas in the first case under the influence of "tap-dance montage" (*chechetochnyi montazh*) the hands and feet quiver, in the second case this quivering, provoked by an intellectual stimulant combined differently, produces an identical reaction in the tissues of the higher nervous system of the thought apparatus.[203]

Eisenstein and Spectators' Reactions

Where do we see the applications of Eisenstein's theory of spectatorship? It is a little-known fact of Eisenstein's biography that he took a great interest in psychophysiological audience studies. In 1928, he and Grigorii Aleksandrov announced:

> Slowly but surely and in the closest possible collaboration with the Communist Academy and the State Cinema School, the Polytechnic Museum's research laboratory in audience psycho-physiology is developing, involving and gathering people and experience in this most necessary and fundamental of labors. For the first time a thought-provoking methodology for reflexological inquiry into the phenomenon of cinema as the sum of stimulants and into the audience as

[201] Ibid.
[202] Ibid.
[203] Ibid., 193; translation slightly modified.

Fig. 4.9 (*a–d*) Frame grabs from the scything scene in Eisenstein's *Old and New*: the harvester's body swings from left to right, eliciting a strong motor reaction from the peasant onlookers, who urge the reaper to press forward. The raw energy of the scythe's repetitive, but accelerating motion is conveyed in the semiabstract motion blur, as the blade rushes through the grass. Image source: Sergei Eisenstein, dir. *Old and New*. DVD (Los Angeles: Flicker Alley, 2011).

the subject is being elaborated where until now we have found only primitive amateurism.[204]

Very little is known about this program: whether or not it had actually been carried out and produced any results remains a question for archivists. There is some evidence, however, that Eisenstein made concrete plans. In early December 1928, the Moscow newspaper *Kino* printed an announcement about Eisenstein's GTK students' involvement in spectator studies.[205] The film scholar Anna Toropova has recently discovered a program of research activities that Eisenstein drafted for the Moscow Polytechnic Museum's "Laboratory for the Study of Mass Behavior and Mass Psychotechnics" in late September 1928.[206] As the appointed chair of this Laboratory's Cinema Section, Eisenstein wrote a seven-page proposal for team-based investigations of (1) film stimuli (*razdrazhiteli*) and (2) the process of excitation (*razdrazhenie*), in the form of "individual" and "collective" reflexes."[207]

One of Eisenstein's ideas in this document is to assess the "physical contagiousness" of film stimuli via the spectators' facial expressions, which would be deciphered on the basis of reflexology, William James, and Jean d'Udine.[208] The viewers' faces would be recorded during their exposure to close-ups of prominent facial expressions onscreen.[209] A convenient way to study this data, Eisenstein suggests, would be to synchronize the footage of the spectators' changing faces and the corresponding film sequences in parallel projection. Screening the footage of the stimulus and the reaction in slow motion would reveal how the latter unfolds.[210]

Due to the terse, telegraphic format of this official plan, Eisenstein does not explain the method by which the facial expressions would be interpreted. In the previous sections of this chapter, we have seen what he may have taken from William James and reflexologists such as Bekhterev and Dernova-Iarmolenko,

[204] Sergei Eisenstein and Grigorii Aleksandrov, "The Twelfth Year," in *Sergei Eisenstein, Selected Works, Volume 1: Writings*, 1922–1934, ed. and trans. Richard Taylor (London: I.B. Tauris, 2010), 123–126; 125. For the Russian original, see Sergei Eisenstein and Grigorii Aleksandrov, "Dvenadtsatyi," *Sovetskii Ekran*, November 6, 1928, 4–5.

[205] The Moscow newspaper *Kino* announced that Eisenstein launched spectator research at the Polytechnic Museum, involving his film directing students from GTK (The State Institute of Cinematography, later known as VGIK) in this experimental research (*Kino* 49, December 4, 1928: 5). Aleksandrov at the time was one of these students.

[206] Anna Toropova, "Probing the Heart and Mind of the Viewer: Scientific Studies of Film and Theatre Spectators in the Soviet Union, 1917–1936," *Slavic Review* 76.4 (2017): 931–958, 942.

[207] Sergei Eisenstein, "Plan rabot kinosektsii," RGALI f. 923, op.1, ed. khr.2405, l.20. A manuscript version of the same plan by Eisenstein is dated September 23, 1928 RGALI f. 923, op.1, ed. khr.2405, l. 9.

[208] Eisenstein, "Plan rabot kinosektsii," l.20.

[209] Eisenstein, "Plan rabot kinosektsii," l.22.

[210] Ibid.

with regard to the process of motor imitation and inhibition. Jean d'Udine makes a surprising, but suitable fit in this grouping. This French performance theorist authored a book called *The Art and the Gesture* (1910), the central motto of which, as the historian Robert Brain points out, is that "to live is to vibrate."[211] Eisenstein scholars are familiar with d'Udine in the context of the filmmaker's contemplation of synesthesia (the reducibility of all senses to touch and kinesthesia) and the idea that the structural composition of any artwork may be effectively analyzed on the basis of its "underlying gesture."[212] These themes would become prominent in Eisenstein's works in the 1930s and 1940s. A closer look at *The Art and the Gesture*, however, reveals that in 1928, d'Udine may have also interested Eisenstein as a theorist of imitation. In the words of Robert Brain, d'Udine believed that "the very purpose of art was to excite the memory of affective rhythms in the observer through the microprocesses of inner imitation, or what German theorists called empathy (*Einfühlung*)."[213] In his model of the audience's response, d'Udine synthesized the views of his two teachers, the biologist Félix-Alexandre Le Dantec and the inventor of rhythmic gymnastics Emile Jaques-Dalcroze.[214] Le Dantec discovered that the protoplasm of one-cell organisms reacts to color and sound, and suggested that these colloidal vibrations prepare the ground for the perceptual and reactive capacities of organisms on higher levels of evolution.[215] Dalcroze was a musical educator who taught his students to interiorize various rhythmical patterns and melody progressions through performing gestures and dance-like movements.[216] Combining these two influences, d'Udine advanced the view that "through the hereditary memory stored in protoplasm, a rich archive of rhythmic pulsation has been bequeathed to all organic beings. The task of the artist is to learn to access this archive" and evoke resonating vibrations in the audience.[217] The relationship between the artist and the world, between the artist's subjective experience and

211 Jean D'Udine (pseudonym of Albert Cozanet), *L'art et Le Geste* (Paris: Félix Alcan, 1910); Brain, *The Pulse of Modernism*, 204.

212 Yuri Tsivian, *Na Podstupakh k Karpalistike: Dvizhenie i Zhest v Literature, Iskusstve i Kino* (Moskva: Novoe literaturnoe obozrenie, 2010); Ana Hedberg Olenina and Irina Schulzki, "Mediating Gesture in Theory and Practice," *Apparatus. Film, Media and Digital Cultures in Central and Eastern Europe* 5 (2017). http://dx.doi.org/10.17892/app.2017.0005.100; Joan Neuberger, "Another Dialectic: Eisenstein on Acting," 258, 263.

213 Brain, *The Pulse of Modernism*, 212–213. Though d'Udine never mentions Lipps, or any other German theorists directly, Brain points out that his conception must have been indebted to the discussions of *Einfühlung* in contemporary francophone periodicals, where authors such as Vernon Lee and Charles Lalo explained various nuances of the empathic process (Brain, *The Pulse of Modernism*, 285).

214 D'Udine's book is dedicated to Dalcroze and Le Dantec (see D'Udine, *L'art et Le Geste*, v).

215 Brain, *The Pulse of Modernism*, 202.

216 For an analysis of Dalcroze's approach in the context of Modernist discussions of rhythm, see Cowan, *Cult of the Will*, 180–207; Cowan, *Technology's Pulse*, 12–13.

217 Brain, *The Pulse of Modernism*, 205.

his choice of artistic structures, and between the artwork and the viewer are all explained in terms of co-movements and resonant vibrations. Similarly to another Eisenstein's influence, the choreographer Rudolf Bode, who had likewise studied under Dalcroze, d'Udine attached value to the organic expression of emotions, seeing in it the foundation for the artist's stylized and more effective representation.[218] The interjection of the artist's will thus renders the naturally felt rhythms more dramatic and impactful. Mimesis in art, for d'Udine, is rooted in subjective perception. D'Udine repeatedly underscores that the process of imitation is not direct copying, but rather a process moderated by the person's inner predispositions. The artist's style is a constant negotiation between personal vision and fashion, between spontaneous expression and acquired technique. This theory thus validates the noncoincidence between the stimulus and its reproduction, as long as the artist feels a connection subjectively.[219]

In addition to this liberating view of simulation, d'Udine presents a number of assertions that explain the mechanism of his empathy-based model of aesthetic perception. According to d'Udine, the structure of any work of art could be conceived of as a series of bodily "attitudes."[220] Symbols, whether they are based on sound, color, temperature, smell, taste, or other sensory properties, are all rooted in kinesthetic and haptic perceptions.[221] The musical expression of feeling is, in essence, a transposition of human "physiological rhythms" elicited by this feeling, onto the musical rhythms of smaller or greater scale.[222] Gestures and dance movements, in principle, are capable of conveying the melody, harmony, and timbres of instruments.[223]

The relevance of d'Udine's pronouncements for Eisenstein's views on spectatorship in the period during which he was preparing a program for spectator tests is confirmed in the filmmaker's essay "The Fourth Dimension in Cinema" (1929), which describes the impact of Eisenstein's five types of montage ("metric," "rhythmic," "tonal," "overtone," and "intellectual"). We have already seen the way in which Eisenstein draws on neurophysiology, when he conceptualizes a progressive conversion of motor energy into emotional and intellectual experiences with each new level of montage. What d'Udine adds to this model is the notion of vibration, as well as evocative analogies between gesture and musical sound. Consider, for instance, Eisenstein's analysis of the emotional tint of the dawn sequence in *The Battleship Potemkin*, where the tonality of shots is "moving from dark grey to misty white" and is therefore *"increasing in frequency."*[224] For

[218] D'Udine, *L'art et Le Geste*, 11.
[219] D'Udine, *L'art et Le Geste*, 64–65.
[220] Ibid., 91.
[221] Ibid., 79.
[222] Ibid., 84.
[223] Ibid., 63.
[224] Eisenstein, "The Fourth Dimension in Cinema," 190–191, italics in the original.

Eisenstein, this example of the "tonal" type of montage works similarly to the more primitive "metrical" montage (which literally moves the viewer as in the haymaking sequence of *Old and New*; Fig. 4.9). Perceptually, the oscillation of tonal frequency, according to Eisenstein, is simply "a new and significantly higher category of movement"—one that translates into "melodically emotional coloring."[225] Eisenstein's terminology here is identical to d'Udine's, which points to the fact that this French theorist held a special place in Eisenstein's ever-growing bibliographical pantheon of experts on kinesthesia and empathetic, visceral connections between the viewer and artistic form.

Eisenstein's plan for spectator studies at the Polytechnic Museum concludes with a boastful statement that the envisaged investigation will lead future filmmakers to the practical formulae of "maximal effectiveness," in order to influence the audience ideologically in accordance with the "tasks of the *TsK* [the Central Committee of the Communist Party]."[226] It is very likely that this rhetorical final chord is an instance of the "Aesopian language"—a prerequisite curtsy in the direction of the authorities in order to get the green light for Eisenstein's own rather esoteric explorations, which in reality could not be easily turned into recipes for effective propaganda. It is not my intention here to raise the issue of Eisenstein's relationship with the totalitarian regime, which has been the subject of many studies already. Suffice it to say that Eisenstein's film projects produced at the height of the Stalinist regime in the 1930s–1940s were so formally complex and so saturated with latent allusions that they defied and subverted the monolithic Party-sanctioned interpretation. Instead of faulting Eisenstein for bowing to the Central Committee, I would like to take his statement—which raises a red flag for the manipulative intention behind Eisenstein's explorations—as an opportunity to return to the questions I posed in the beginning of this chapter.

What are the implications of Eisenstein's enactive model of spectatorship, premised on kinesthetic empathy? Does the audience have agency, if its relationship to the film image is predicated on corporeal connection? None of the sources that paved the way for Eisenstein's perspective considered the corporeal imitation of visible actions as a passive and mindless type of reaction. Nor did they present imitation as direct and unmediated copying, or as incorporation of the received dogma. On the contrary, inquiries into the kinesthetic dimension of perception at the turn of the 20th century served as a way to understand the linkages between sensation, emotional regulation, and cognition. They recognized that configurations of these linkages are universal only to a certain degree, and that there are individual variations from person to person. The works of William

[225] Ibid., 191.
[226] Eisenstein, "Plan rabot kinosektsii," l.25; the same mention of the "Central Committee's tasks" also appears in the manuscript written in Eisenstein's hand (Eisenstein, "Plan rabot kinosektsii," l.9).

James, Vladimir Bekhterev, Lev Vygotsky, and Alexander Luria established profound and multilayered connections between the body and the mind, conscious and unconscious processes, and voluntary and involuntary reactions. Imagining the structure of filmic devices from the standpoint of their potential kinesthetic impact was Eisenstein's way to address the spectator in an indirect, yet profound manner. Similarly to innovators of the stage, who believed that consciously produced gestures allow the actor to tap into unconscious resources, Eisenstein's emphasis on the spectator's co-movement was motivated by the desire to lead the audience on a journey of self-discovery and cathartic epiphany. Taking the audience through the stages of unfolding corporeal drama was his way of presenting a richly felt, moving experience instead of a straightforward and dry exposition of themes—his way of avoiding clichés and exploring the "dialectical" nature of all phenomena.

Regarding the potential problem of Eisenstein overstretching the applicability of the perceptual "laws," this is a common pitfall of aesthetic theories that prioritize biological factors. In Eisenstein's defense, starting from the screening of his first film, *Strike* (1925), he acknowledged the possibility of idiosyncratic, unforeseen interpretations of film stimuli.[227] The parallel between the slaughterhouse and the massacre of the workers' demonstration in the finale of this film baffled peasant audiences, failing to deliver the intended connotations of horror and brutality. This mistake, for Eisenstein, pointed to the importance of the sociocultural background of specific demographics. Similarly, in "The Fourth Dimension in Cinema," he ponders whether the "sex-appeal" of a stereotypical "American heroine-beauty" may in effect alienate representatives of previously colonized and enslaved minorities.[228] In his plan for examining film viewers' reactions that he drafted for the Polytechnic Museum, there is a note that audience samples must be sociologically defined, based on class, occupation, and even psychophysiological temperament ("asthenic," "picnic").[229] Eisenstein was aware that not only the recognition of intended symbols could fail, depending on the audience, but also the reception of the rhythm and structure of montage. In "How Pathos Is Made?", he describes a miscalculated sequence in *October*, where the Georgian dance of *lezginka* failed to produce the impression of unabashed ecstasy, because of the insufficient build-up leading toward this culmination.[230]

Eisenstein's preoccupation with kinesthesia caused him to imagine the structural properties of film as attuning the spectator to specific experiences. Whereas

[227] Sergei Eisenstein, "The Method of Making a Workers' Film," in *Selected Works, vol.1 Writings 1922–1934*, ed. and trans. Richard Taylor (London: I.B. Tauris), 65–66, 65.

[228] Eisenstein, "The Fourth Dimension in Cinema," 182.

[229] Eisenstein, "Plan rabot kinosektsii," 1.23. These terms denoting temperaments are likely borrowed by Eisenstein from Ernst Krechmer.

[230] Eisenstein, "Kak delaetsia pafos?," 1.152.

his contemporaries like Lev Kuleshov and Vsevolod Pudovkin saw montage units as building blocks of the narrative, Eisenstein sought to understand the nuances of psychophysiological impact that that these segments produce on the viewer. He believed that each new shot, like a note in a melody, prepares the ground for what is to come next; and the viewer's journey through the film could be imagined quite literally as corporeal movement. This is why Eisenstein's idea of the viewer's empathetic response to a certain structural element, such as the vector of the actor's movement or the imaginary pathway of the gaze within the shot composition, is always predicated on what came before and what will come after this element. A highly indicative example of Eisenstein's montage-oriented understanding of *Einfühlung* is his criticism of the Swiss artist Paul Klee's attempt to create an alphabet of abstract curve lines with definitions of their emotional impact. While intrigued by this project, Eisenstein points out that Klee's definitions are meaningless without a context in which such lines would appear. [231]

Eisenstein's kinesthetic approach to film form is best understood in connection to the leftist avant-garde's efforts to revolutionize the sensory impact of the arts, which Emma Widdis has documented in her book *The Socialist Senses*.[232] In her analysis of Soviet cinema of the 1920s, Widdis highlights these filmmakers' endeavor to reveal the tactile richness of the represented world, particularly as it pertains to manual labor and the material culture of the working class. In eliciting novel sensations, their film images educated the audiences about the Socialist worldview and inspired new attitudes, emotions, and techniques of the body. As in all rapidly industrializing societies at the turn of the 20th century, "the ideal of the liberation of the body in Soviet revolutionary culture went hand in hand with projects for its mechanization and organization."[233] In the utopian imagination, the inevitable hurts brought about by industrialization and the radical restructuring of society would be resolved in the era of Socialism; the citizens of the Brave New World would be "emancipated" by Marxism."[234] As Oksana Bulgakowa has shown, the cinematic technologies played an essential role in the Soviet utopian project: the avant-garde filmmakers conceived of their instruments as prostheses expanding the sensory capabilities of humankind,

[231] Sergei Eisenstein, "Rezhissura. Iskusstvo mizansceny," in *Izbrannye proizvedeniia v shesti tomakh*, ed. ed. P. M. Atasheva, N. I. Kleiman, and S. I. Iutkevich, vol. 4 (Moskva: Iskusstvo), 13–674; 133. Eisenstein refers to Paul Klee, "Pädagogische Skizzenbuch," *Bauhausbücher* Bd. 2 (München, 1925).

[232] Emma Widdis, *Socialist Senses: Film, Feeling, and the Soviet Subject, 1917–1940* (Bloomington: Indiana University Press, 2017).

[233] Widdis, *Socialist Senses*, 5.

[234] Ibid.

while their montage devices suggested unprecedented cognitive operations.[235] Eisenstein's implied spectator, capable of "feeling-into" the graphic expressions onscreen, was a kind of New Soviet Man—someone forging new set-ups within his nervous system and sharing his emotional and intellectual vibrations with the collective.

[235] Bulgakowa, *Sovetskii slukhoglaz*, 12–14.

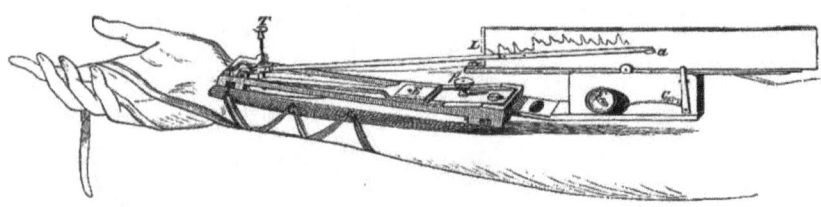

Fig. 5.1 A 19th-century sphygmograph by Étienne-Jules Marey. This is one of the early prototypes of pulse registrations devices, which would be used in the early 20th century to investigate subjects' emotions and aesthetic experiences. Image source: Elie Cyon [Iliia Tsion], *Atlas zur Methodik der Physiologischen Experimente und Vivisectionen* (St. Petersburg: Carl Ricker, 1876), 21 (Taf. XI). Part of Wilhelm Wundt's Library. *Max Planck Institute for the History of Science. The Virtual Laboratory*, http://vlp.mpiwg-berlin.mpg.de/technology/data?id=tec579

5

The Pulse of Film

Psychophysiological Studies of Film Audience

Science could hardly think up anything more alien to art than those experiments that presume to measure aesthetic experience by recording the heartbeat.

—Theodor Adorno[1]

Sovkino must know how the spectator breathes.

—Viktor Shklovskii[2]

The striking metaphor of the audience "pulsing in unison" with the film flickering onscreen belongs to Sergei Eisenstein.[3] He used it in a 1929 essay on montage to describe the way in which the rhythm of editing, when properly calculated by the director, engages the spectator's whole being, taking possession of his body and mind. Along with the notion of the cinematic attraction, Eisenstein's ideas on rhythm were part of his theory that spectatorship is an "enactive" experience.[4] Cinema, as he thought of it, was a modern, secular version of magic rituals, in which the primeval visceral responses of the spectators were the first step on a path culminating in their intellectual transformation. Though Eisenstein's views on the participatory experience of the spectators reflected his own unique conception of the cinematic pathos first and foremost, in the late 1920s the idea of the audience's "pulsations" was more than a figure of speech. Thanks to the long-established tradition of recording somatic indices (Fig. 5.1), Eisenstein's contemporaries endowed the director's ideas with

[1] Theodor Adorno, *Aesthetic Theory*, ed. Gretel Adorno and Rolf Tiedemann, trans. Robert Hullot-Kentor (Minneapolis: University of Minnesota Press, 1997), 244.

[2] Viktor Skhlovskii, "K voprosu ob izuchenii zritelia," *Sovetskii Ekran* 50 (1928): 6.

[3] Sergei Eisenstein, "Methods of Montage," in *Film Form: Essays in Film Theory*, trans. and ed. Jay Leyda (New York: Harcourt Brace, 1949), 72–83, 73.

[4] These aspects of Eisenstein's thought are explored in Rachel O. Moore, *Savage Theory: Cinema as Modern Magic* (Durham, NC: Duke University Press, 2000); Pia Tikka, *Enactive Cinema: Simulatorium Eisensteinense* (Helsinki: University of Art and Design, 2008).

Psychomotor Aesthetics. Ana Hedberg Olenina, Oxford University Press (2020). © Oxford University Press.
DOI: 10.1093/oso/9780190051259.001.0001

concrete meaning. "Sergei Eisenstein's lectures are impressive and significant," wrote Viktor Shklovskii,

> A crucial contribution to world cinema is his notion of attractions, which do not simply remind the spectators of emotions but evoke them directly. I think that if we install dynamometers in each seat of the screening hall, we will get proof that even in a film without attractions, the viewer comprehends the portrayed emotions because he also feels and enacts them in a subdued way. Quite possibly, the aesthetic experience in this case is connected to the suppression of corporeal imitation. We can see here something similar to the inner speech of the person listening to a poetry recital.[5]

As is evident from this passage, Shklovskii interpreted Eisenstein's theory of attractions as part of a larger paradigm that foregrounded the corporeal underpinning of emotional, and, by extension, aesthetic experience, not only in cinema but in other arts as well. Shklovskii's commentary references other loci of this episteme I have discussed in the previous chapters, such as the idea that witnessing a poetry recital may provoke involuntary lip movement in an enthralled listener, or that the kinesthetic and rhythmical sensations accompanying pronunciation are an integral part of the poem's stylistic structure, which influences the performer's emotions. In comparing the cinemagoers' and poetry audience's "inner speech"—that is, their stream of consciousness, cued, in the first case, by images onscreen and, in the second case, by the recited text, Shklovskii suggests that the interpretative process and the onset of emotions always involve some rudimentary muscular contractions. Thus he sides with Eisenstein and other Soviet avant-garde film theorists, who believed that the spectators' kinesthetic empathy imparted to them the emotional charge of the scenes. Yet what is remarkable about Shklovskii's reflection on Eisenstein's cinematic attractions is that he speculates about the possibility of using dynamometers to register the physical manifestation of the spectators' inner experience and, therefore, render these elusive states of mind not only empirically observable, but also quantifiable. A dynamometer is a laboratory instrument for gauging force: it detects the degree of deformation of physical matter under impact—as, for example, in a rubber ring used for measuring the strength of one's handgrip (Fig. 5.2). Shklovskii's evocation of this instrument implies that the intensity of affects emanating from the screen may be detected in the physical straining of the viewers' bodies. Pushing this line of thought further, one may say that with a dynamometer, the emotional charge of one or another scene could be expressed in newtons.

[5] Viktor Shklovskii, "Oshibki i izobreteniia (1928)," *Za sorok let. Stat'i o kino* (Moscow: Iskusstvo, 1965), 100.

Fig. 5.2 Collin's dynamometer. In the late 1920s, this device was in fact used in Soviet spectator studies, though not for assessing emotions like Shklovskii suggested, but rather for evaluating children's fatigue and the overtaxing of their nervous system by film shows. Image source: C. H. Stoelting Company, *Apparatus, Tests, and Supplies for Psychology, Psychometry, Psychotechnology, Neurology, Anthropology, Phonetics, Physiology, and Pharmacology* (Chicago: Stoelting Co., 1930), 55.

Shklovskii's comment on Eisenstein's theory of spectatorship exhibits a tension between the experimental drive of the Soviet avant-garde and the need to assess the effectiveness of the new mass culture it charged itself with creating. On the one hand, Shklovskii starts off with a celebration of a nonlogocentric, instantaneous corporeal communication, which harkens back to his championing of the Futurist sound-gestures in the 1910s. It is a dream about the unprecedented intensity and immediacy of art's impact, whereby the audience would partake in the film's emotions by virtue of its own proprioceptive sensations—the signals that the viewers' brains receive from the clenching or relaxation of their fists, contraction or dilation of their blood vessels, and other bodily changes. In a Benjaminian fashion, this vision validates each individual's ability to relate deeply to the work of art, defying bourgeois notions of cultural education, privileged access, and monopoly on authoritative interpretation. He suggests that a spontaneous, intrapersonal wave of emotions sweeps through the movie hall not only during screenings of avant-garde films but also those without strategically incorporated attractions, thus affirming the audience's right to feel moved by the kind of cinema Miriam Hansen classified under "vernacular Modernism."[6] Yet, on the other hand, the moment dynamometers are introduced on the scene, the vision of the movie theater as a site of aesthetic epiphanies and transient emotional

[6] Miriam Bratu Hansen, "Mass Production of the Senses: Classical Cinema as Vernacular Modernism," *Modernism/modernity* 6.2 (1999): 59–77.

affinities morphs into a blueprint for controlled environment for audience manipulation. It is this kind of systematizing, utilitarian approach to spectatorship that is the subject of this chapter, where I will scrutinize the notions of embodied viewing articulated by psychophysiologists at the service of film industry.

From the mid-1920s onward, the idea of gauging the corporeal reactions of spectators was increasingly considered in Soviet Russia as a valuable component of the state-sponsored program in audience studies, which had thus far relied on traditional methods, such as spectators' questionnaires, attendance statistics, and observational agents' reports. The viewers' physical responses seemed to provide an objective empirical criterion by which cultural authorities could judge the impact of films and other mass spectacles, such as circus and theater. The idea of taking the guesswork out of the assessment of films' reception and using this data to precalculate the psychological impact of future films was a hot topic in the Soviet cinema circles. With the growth of the film industry, cinefication of rural provinces, and consolidation of bureaucratic institutions in charge of ideological education and mental hygiene, the problem of evaluating and boosting film comprehension by all social strata became a widely debated issue. While questionnaires and other forms of verbal feedback remained by far the most common instrument of reception analysis, there was a growing interest in applying psychophysiological instruments for a direct monitoring of the viewers' responses. For instance, in 1925, the periodical *Kinozhurnal ARK* speculated about the possibility of photographing the "facial reflexes" of peasant viewers during film screenings by means of a hidden camera.[7] Within a couple of years, the same method was applied for children audiences.[8] With reflexology being a dominant trend in Soviet psychology, many researchers were eager to draw on its methodological apparatus. A leading reception analysis center in Moscow, The Theater Research Workshop, operating under the aegis of the Commissariat for Enlightenment (Narkompros), recorded a full range of spectators' behavior during film screenings, from yawning to the shuffling of feet, and counted these "reflexes" as salient markers of the ongoing response to film scenes (more on their methodology later). The archive of this organization contains a detailed budget plan for establishing an "experimental lounge" for audience testing.[9] The lounge was to have three armchairs, equipped

[7] Anatolii Terskoi, "S"emka refleksov litsa kak material izucheniia derevenskogo zritelia," *Kinozhurnal ARK* 8 (1925): 10–12. Anatolii Terskoi was an ethnographic filmmaker, affiliated with the film division of the Central Committee for Political Education at the People's Commissariat of Enlightenment (*kino-sektsiia Glavpolitprosveta Narkomprosa*). His article is based on his own experience of bringing films to rural spectators.

[8] A. Gel'mont, "Izuchenie detskogo kinozritelia," in *Publika kino v Rossii: Sotsiologicheskiie svidetel'stva 1910–30kh gg.*, ed. Iu.U. Fokht-Babushkin (Moscow: Gosudarstvennyi institut iskusstvoznaniia, 2013), 398–436, 429–430; V. Pravdoliubov, "Kino i nasha molodezh'," in *Publika kino v Rossii: Sotsiologicheskiie svidetel'stva 1910–30kh gg.*, ed. Iu.U. Fokht-Babushkin (Moscow: Gosudarstvennyi institut iskusstvoznaniia, 2013), 143–211, 203..

[9] Issledovatel'skaia Teatral'naia Masterskaia, "Smeta po issledovaniiu tsirkovogo aktera i zritelia," RGALI f.645 op.1. ed. khr. 312 l. 226–227.

with an apparatus for taking changes in pulse, a spiroscope for measuring the depth and rapidity of breathing, a dynamometer, a Hipp chronometer for registering the time of reactions, a kymograph, and other tools.

The belief that science could evaluate cinema's emotional dynamics by way of registering the spectators' somatic reactions found enthusiastic supporters not only in Russia, but in other countries as well. In the United States, around the same time that Soviet institutions were exploring laboratory methods of audience research, Universal Studios hired the psychologist William Moulton Marston to help create emotionally powerful scripts and assess the viewers' responses during the prescreening of films before the official release. Prior to his appointment in Hollywood, Marston gained notoriety as one of the inventors and promoters of the polygraph lie detector.[10] A former student of Hugo Münsterberg at the Harvard Psychological Laboratory, Marston built his career extending experimental methods of psychophysiology to various applied fields, such as criminology, audience research, and commercial marketing. The thrust of his scientific research focused on identifying physiological correlates of psychological processes. In his early scientific publications, he argued that the quickness of subjects' motor response to particular prompts, as well as changes in their respiration rate and blood pressure could be used as indicators of emotional states—for example, these signs might disclose the hidden anxiety and heightened alertness of someone giving false testimony in court.[11] With this theoretical platform as his base, Marston covered film spectators' bodies with sensors (Fig. 5.3). The data obtained in his tests could be used, he claimed, for evaluating the appeal of individual film stars, identifying scenes that enthuse or terrify the audience, and classifying spectators with respect to their response patterns.

A largely forgotten page in the history of cinema, the American and Soviet programs on spectator studies in the late 1920s offer fertile terrain for examining the modalities of interaction between these countries' growing film industries and the mass audiences they targeted. Juxtaposing the American and Soviet endeavors, which grew completely independently of each other, one is struck by their fundamental similarities, particularly in terms of experimental methods,

[10] On Marston's career, see Geoffrey C. Bunn, "The Lie Detector, Wonder Woman and Liberty: The Life and Work of William Moulton Marston," *History of the Human Sciences* 10.1 (1997): 91–122; Geoffrey C. Bunn, *The Hazards of the Will to Truth: A History of the Lie Detector*, PhD dissertation, York University, Ontario, 1997; Geoffrey C. Bunn, *The Truth Machine: A Social History of the Lie Detector* (Baltimore: Johns Hopkins University Press, 2012); Ken Alder, *The Lie Detectors: The History of an American Obsession* (Lincoln: University of Nebraska Press, 2009); Jill Lepore, *The Secret History of Wonder Woman* (New York: Vintage, 2015).
[11] William M. Marston, "Reaction Times Symptoms of Deception," *Journal of Experimental Psychology* 3 (1920): 72–87; William M. Marston, "Systolic Blood Pressure Symptoms of Deception," *Journal of Experimental Psychology* 2 (1917): 117–163; William M. Marston, "A Theory of Emotions and Affection Based Upon Systolic Blood Pressure Studies," *American Journal of Psychology* 35 (1924): 469–506.

Fig. 5.3 The wiring of film spectators. Dr. Marston is measuring changes in the blood pressure and respiration of two women, a blonde and a brunette, as they watch love scenes with Greta Garbo and John Gilbert. Image source: William M. Marston, "Bodily Symptoms of Elementary Emotions," *Psyche* 38 (1929): 70–86, 71.

psychological concepts, and pragmatic objectives. In planning to record every twitch of the spectators' bodies—their every gasp and sigh—Soviet and American psychophysiologists and cinema professionals hoped to demystify aesthetic experience and model ideal products suitable for mass consumption. As such, these research programs exemplify an important historical precedent for a radically embodied outlook on cinematic communication—here, subsumed to the tasks of marketing and ideological solicitation. These tests represent an attempt to "average" the mass spectator—that is, articulate the values and demands of the universal common man—while at the same time tacitly endorsing social hierarchies in each culture. In this chapter, I will reconstruct the circumstances under which these experiments developed and analyze the ways in which they configured the spectators' subjectivity. My exploration of the theoretical roots of Soviet and American experiments in the 1920s exposes the epistemological, ethical, and ideological implications of physiological determinism that these audience research programs inherited from turn-of-the-century physiological psychology. Offering a critical reading of this legacy, I will show how these spectator studies replicated the universalist fallacies of biologically oriented psychology,

in addition to strengthening a patronizing attitude toward the subjects of research: women, workers, and illiterate peasants.

The experiments of the 1920s put forward an image of a viewer who is doubly wired, doubly plugged in: his psychic energy is mobilized by the cinematic apparatus and registered through the apparatus of experimental psychology. This image points toward the emergence of complex, interconnected dispositifs, with one discipline providing data for the other. The object of this data is the living flux of the spectator's psychological and physiological processes. Which part of this flux constitutes the viewer's response to film becomes a discursive construction dependent on the methods, tools, and terminology used by the pundits of applied psychology and creators of mass visual culture. These setups and arrangements lend themselves well to a Foucauldian analysis because the utilitarian goals driving this research and its institutional sponsorship are aligned with structures of economic and political power. Indeed, the image of the doubly plugged-in film audience offers a new reinforcement to Jonathan Crary's provocative argument that in modernity, the body of the spectator "becomes a component of new machines, economies, apparatuses—whether social, libidinal, or technological."[12] In his subsequent work, Crary revealed the workings of the modern visual regime in advanced industrial societies at the end of the 19th century by juxtaposing scientific discussions of human attention and new apparatuses for regulating mental concentration—from the assembly line to magic lantern shows.[13] By way of analogy with Crary's research, it is possible to say that the psychological spectator tests illustrate the ways in which the regime of modernity lays claims on the subjects' psychic energy through novel techniques for provoking and deciphering affective responses.

The rapprochement between the film industry and experimental psychology laboratories dates back to the early 1910s. One of the most vocal advocates of this convergence was Marston's former professor at Harvard, the German-American psychologist Hugo Münsterberg. An eminent graduate of Wilhelm Wundt's experimental psychology program in Leipzig, Münsterberg authored the first serious book on film theory, *The Photoplay: A Psychological Study* (1916). In 1915, Münsterberg argued: "The more psychology enters into the sphere of the moving pictures, the more they will be worthy of an independent place in the world of art."[14] Thus promoting his discipline, he suggested that psychological research

[12] Jonathan Crary, *Techniques of the Observer: On Vision and Modernity in the Nineteenth Century* (Cambridge, MA: MIT Press, 1990), 2.

[13] Jonathan Crary, *Suspensions of Perception: Attention, Spectacle, and Modern Culture* (Cambridge, MA: MIT Press, 1999), 138.

[14] Hugo Münsterberg, "Why We Go to the Movies" (1915), in *Hugo Münsterberg on Film: The Photoplay: A Psychological Study and Other Writings*, ed. Allan Langdale (New York: Routledge, 2002), 181–182.

might help create more emotionally gripping and morally edifying films, and therefore elevate the status of the young art in the eyes of the public. In turn, cinema provided a useful milieu for testing psychologists' tools and shaping their understanding of human sensory perception, memory, and attention. In 1911, the Italian psychologist Mario Ponzo, mentored in Turin by another alumnus of Wundt's school, Federico Kiesow, used film screenings to investigate the role of association and auto-suggestion in the mental processing of screen images.[15] He analyzed illusions of smell, sound, and touch recalled by spectators after screenings, despite the fact that they watched silent, black-and-white actuality footage.[16] In the 1920s, phantom-ride style films and proto-cinematic animations representing busy streets provided a simulated immersive environment for assessing the speed of reaction in professional aptitude tests for drivers in the United States, France, Germany, and Russia.[17] Partially inspired by Hugo Münsterberg's program of "psychotechnics" outlined in his treatise *Psychology and Industrial Efficiency* (1913), drivers' tests measured the time it takes for a visual stimulus to reach the brain and get translated into appropriate muscular contractions for steering and braking. With sensors attached to the subjects' bodies, psychologists investigated how their attention to the screened street view wavered under conditions of fatigue and distraction.

In addition to sensory perception and mental concentration, emotions also became a subject of psychological study, for which cinema proved useful. In 1920, French scientists Édouard Toulouse and Raoul Mourgue used films to test the method for evaluating emotional fluctuations proposed by the Swiss psychologists of Wundt's school Ernst Meumann and Petko Zoneff, who claimed to have defined the "vascular and respiratory expression" of psychological states.[18] Meumann and Zoneff's 1901 study linked the feeling of pleasure to a

[15] Alessandro Marini, "Spettatori nel 1911," *Acta Universitatis Palackianae Olomucensis Romanica* 9 (2000): 115–124.

[16] A report on Ponzo's experiment appeared in an American trade journal produced by Carl Laemmle's Independent Moving Pictures Company: "Deceived by the Eye," *The Implet*, May 4, 1912. In the late 1920s, Laemmle—now the head of Universal Studios—would go on to employ psychologist William Moulton Marston to assess spectators' emotions.

[17] Sylvia Shimmin and Pieter J. Van Strien, "History of the Psychology of Work and Organization," in *Introduction to Work and Organizational Psychology*, ed. Pieter J. D. Drenth, Henk Thierry, and Charles J. Wolff, 2nd ed. (Hove, UK: Psychology Press, 1998), 77. Andreas Killen, "Accidents Happen: The Industrial Accident in Interwar Germany," in *Catastrophes: A History and Theory of an Operative Concept*, ed. Nitzan Lebovic and Andreas Killen (Berlin: De Gruyter, 2014), 75–92, 81. Siegfried Zielinski, *Deep Time of the Media: Toward an Archaeology of Hearing and Seeing by Technical Means* (Cambridge, MA: MIT Press, 2009), 230. K. A. Tramm, *Psychotechnik und Taylor System*, vol. 1, *Arbeitsuntersuchungen* (Berlin: Springer, 1921). Jean-Maurice Lahy, *La sélection psychophysiologique des travailleurs, conducteurs de tramways et d'autobus* (Paris: Dunod, 1927).

[18] E. Toulouse and R. Mourgue, "Des réactions respiratoires au cours de projections cinématographiques," in *Compte-rendu de la 44e session d'Association française pour l'avancement des sciences, Strasbourg 1920* (Paris: Masson, 1920), 377–382, 378. The leader of the Parisian audience study was Toulouse, an ambitious man of science with a taste for culture: subsequently, he would go on to become a psychiatrist of Antonin Artaud and author a book on Emile Zola's psychology, which

slower pulse coupled with a more relaxed, superficial breathing, while unpleasure manifested itself as a quickened pulse and more energetic drawing in of the air.[19] The state of heightened attention was matched by a deceleration of the pulse and a faster, shallower breathing intermittent with brief pauses.[20] Inspired by these vivid results, the French psychologists screened Abel Gance's drama *The Torture of Silence* (*Mater Dolorosa*, 1917) and a Pathé newsreel about World War I veterans with limb prostheses, detecting minute changes in two female spectators' respiration in the course of specific scenes.[21] What they discovered was that the subjects' breathing patterns "had a more or less specific form dependent on the nature of the films"[22] (Figs. 5.4, 5.5a, and 5.5b). This result led the scientists to speculate about the possibility of a utilitarian application of their psychophysiological audience index during prescreenings: they boasted that they had perfected a way to determine "if the film works, and if it works as intended by the filmmaker."[23] Toulouse later stated that he had hoped to aid the film magnate Charles Pathé, who was rebuilding his film empire after the damages it suffered in World War I.[24]

Being the earliest study that coupled film success with psychophysiological indices of emotions, the French experiment provides an important precedent for subsequent spectator studies of this kind that I will analyze in this chapter. Just like the Soviet and the American researchers, the Parisian psychophysiologists were motivated by pragmatic goals, and in their ambition, overestimated the explanatory power of their discoveries. The key epistemological issue that haunts all of these studies is two-pronged: on the one hand, it concerns the claimed correspondence between bodily signs and emotions, and, on the other hand, the subsequent correlation between emotions and aesthetic pleasure. As changes of pulse, blood pressure, expansion of the thorax, and other physical parameters

would end up in Sergei Eisenstein's personal library (see Jean-Paul Morel, "Le Docteur Toulouse ou le cinéma vu par un psycho-physiologiste, 1912–1928," *1895: Bulletin de l'Association française de recherche sur l'histoire du cinéma* 60 [2010]: 123–155, 123–124).

[19] J. Larguier de Bancels, "Sur les concomitants respiratoires et vasculaires des processus psychiques: Une revue de Zoneff, P. et E. Meumann, "Ueber Begleiterscheinungen psychischer Vorgänge in Athem und Puls," *L'Année psychologique* 9.9 (1902): 256–259, 258. The original study appeared as P. Zoneff und E. Meumann, "Ueber Begleiterscheinungen psychischer Vorgänge in Athem und Puls," *Wundt's Philosophical Studies* 18.1 (1901): 1–113.

[20] Larguier de Bancels, "Sur les concomitants respiratoires et vasculaires des processus psychiques," 257.

[21] Léon Moussinac gives these details about Toulouse and Mourgue's spectator test in his book *Naissance du cinema* (Paris: J. Povolozky, 1925), 171–176. For a more recent overview of Toulouse and Mourgue's study, see Jean-Paul Morel, "Le Docteur Toulouse" and Rae Beth Gordon, *Why the French Love Jerry Lewis: From Cabaret to Early Cinema* (Stanford, CA: Stanford University Press, 2001), 12, 94, 133.

[22] Toulouse and Mourgue, "Des réactions," 378.

[23] Ibid., 381.

[24] Toulouse in 1926, cited in Morel, "Le Docteur Toulouse," 133.

Fig. 5.4 A fragment of Toulouse and Mourgue's pneumograph curve representing the subject's respiration while watching a documentary film. The marks on the horizontal axis indicate intervals of 0.2 second. Léon Moussinac's caption for this image states: "*Pathé-revue No.1.* An emotive phenomenon created by an abrupt modification of the psychological attitude (an artificial arm for a war invalid). The second part of the curve indicates the phenomenon of intense attention (a dog jumping in slow motion). The cross indicates the changes of the scenes. We may note the persistence of the affective phenomenon for a few seconds while the next scene is being projected." Image and caption from Léon Moussinac, *Naissance du Cinéma* (Paris: J. Povolozky, 1925), 172.

were meticulously recorded in continuous graphic curves, the experimenters were confronted with data that were not easy to interpret. The temptation was to treat the graphs as indicators of the spectators' salient reactions to specific scenes, and this claim, as a rule, was made without proper statistical vetting. The researchers tended to bypass crucial questions, such as to what extent the physiological changes were provoked by certain formal or narrative features of the film, and to what extent the hikes and plateaus of the graph actually reflected unrelated cognitive, emotional, or even purely biological processes. The issue of

(a)
(b)

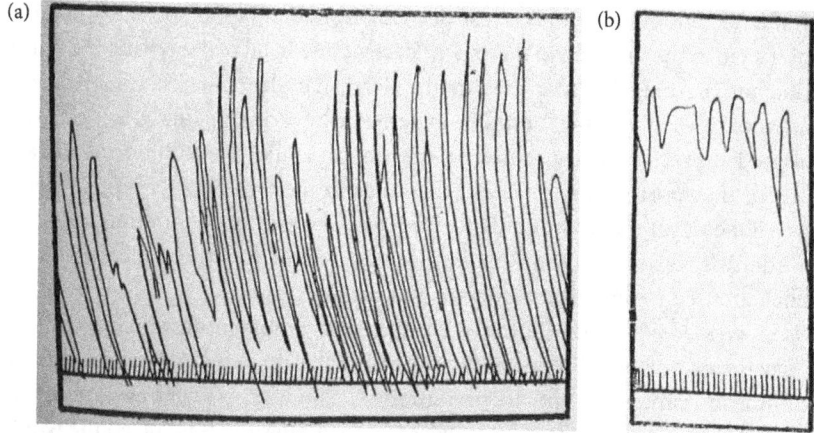

Fig. 5.5 (*a* and *b*) These respiration curves, marked by "great irregularities in height and rhythm" interspersed among "a series of plateaus" with "a transitory apnea during moments of inhaling," indicated the subject's experience of "particularly moving" scenes (Toulouse and Mourgue, "Des réactions respiratoires . . .", 380). Léon Moussinac specifies that the film used in the experiment was Abel Gance's *Torture of Silence* (*Mater Dolorosa*, 1917). Moussinac's caption for the image on the left (*a*) states: "*Mater Dolorosa*; the scene with the telephone"; for the image on the right (*b*): "the scene with the mother holding the baby's clothes" Image and caption source: Moussinac, *Naissance du Cinéma*, Paris: J. Povolozky, 1925, 173.

defining the emotions presumably experienced by the viewers was also a vexed one, as the psychophysiologists rarely considered the ways in which emotional responses were integrated with the subjects' cognition—their logical reasoning, their situational awareness, their sociocultural memory, their imagination, their aesthetic and moral judgment. With a characteristic reductionism, Toulouse and Mourgue proceeded from "the premise that the goal of a film is to excite attention, if it is a documentary, to evoke emotions, if it is a drama, and to awaken a comic sense, if it is a comedy."[25] In setting out to capture the expressions of these states in their subjects' respiration, the scientists were satisfied with this broad and nebulous definition of the viewers' response—much too simplistic, as the French film theorist Léon Moussinac remarked in his review of this spectator test in his book *Naissance du Cinéma* (1925).[26] In equating the film's intended effect with a specific feeling or attitude, the psychophysiologists typically did not exhibit the same subtlety as the Russian Formalists Boris Eikhenbaum and Iurii Tynianov, who differentiated between the audience's "private" and

[25] Toulouse and Mourgue, "Des reactions," 378.
[26] Moussinac, *Naissance du cinema*, 171.

"aesthetic" emotions—that is, those deriving from biographic sources and those connected to the savoring of the artwork's structure in all of its stylistic ingenuity (Chapter 2). Along the same lines, for the German philosopher Theodor Adorno, the whole idea of gauging "aesthetic experience by recording the heartbeat" was misguided precisely because not every emotion could rise to the level of rapture, or transport, that spectators experience in the face of truly moving art.[27] Even if the scientists' sensors did indeed detect expressions of emotions, this data in Adorno's view said nothing about the degree of their aesthetic pleasure: "The shock aroused by important works is not employed to trigger personal, otherwise repressed emotions. Rather, this shock is the moment in which recipients forget themselves and disappear into the work."[28] Akin to the encounter with the Sublime in Immanuel Kant's theory, Adorno's "shudder"—a genuine and strong aesthetic experience—was more intellectual than physical: it involved the whole consciousness and therefore could not be explained purely on the level of somatic processes. While both great art and consumerist kitsch might evoke detectable physical arousal, Adorno argued, only the former imparted a sense of epiphany—that stupor, that amazement, that annihilation of the I—that was very different from the deindividualizing effect of mass entertainment.[29] For Adorno, the somatic markers of emotion alone would be incapable of showing the distinction between the "utmost tension" one experiences in an artistic epiphany and the primitive desires that the culture of distraction banks on.[30]

This line of reasoning was almost entirely absent from the early psychophysiological spectator studies. Instead, what the experimenters were concerned with and fascinated by was cinema's reality effect: its immersive capabilities conducive to the viewers' sensory-motor attunement. Moreover, they felt emboldened by the prospect of detecting and decoding the ongoing psychological processes that the spectators themselves might be unaware of or unwilling to reveal. Toulouse and Mourgue's theoretical stance on spectatorship is emblematic of this perspective:

Cinema exerts a powerful influence on the affective life, because the sense of reality is very intense due to the three-dimensional movement that often unfolds in natural settings. What is the essential source of this sense of reality? We think it is connected to the motor suggestibility [suggestibilité motrice] of our subjects. The perception of movement, as is well-known, calls forth the rudiments of correspondent movements. It is possible to raise a hypothesis that at least some

27 Adorno, *Aesthetic Theory*, 244.
28 Ibid., 244.
29 Ibid., 245.
30 Ibid., 245.

films might activate in us particular motor complexes, with respiratory action being among the most important ones. These complexes would constitute the essential structure of the sense of reality. One would have a phenomenon of the same order as hypnotic suggestion, performed upon a subject whose body was shaped into a particular posture. We believe that it is in this effect that one should search for psychological reasons that may explain the great success of cinematographic representations among the masses. This psychological feature of cinema, noted earlier by Münsterberg, may also explain the phenomenon of illusions that often occurs during film screenings.[31]

In this model, cinema is likened to a hypnotic séance, whose effectiveness is based on the viewers' kinesthetic empathy—that is, their ideomotor mirroring of the perceived movements. Sensations of the resultant micro-motions and posture, as well as changes in the breathing patterns, are presented as a key factor in triggering and reinforcing emotions, and further immersing the viewer in the imaginary world onscreen.

This view of spectatorship is representative of the turn-of-the-century psychophysiological approaches to the functioning of the human mind. Although this statement was formulated by French scientists, it is enmeshed in the network of ideas that informed psychophysiological research in the United States, Russia, Germany, France, and other European countries in the first decades of the 20th century. One of the foundational sources in this international discourse was William James's theory of the physical substrate of emotions. James argued that emotional experiences occur when the brain is flooded by signals indicating changes in the normal functioning of organs, when the body reacts to a certain stimulus. In his seminal essay "What Is an Emotion?" (1884), the American psychologist stated that a perception of an exciting fact instantaneously launches a variety of corporeal processes:

The researches of Mosso with the plethysmograph have shown that not only the heart, but the entire circulatory system, forms a sort of sounding-board, which every change of our consciousness, however slight, may make reverberate [Figs. 5.6.a and 5.6.b]. Hardly a sensation comes to us without sending waves of alternate constriction and dilatation down the arteries of our arms. . . . The bladder and bowels, the glands of the mouth, throat, and skin, and the liver, are known to be affected gravely in certain severe emotions . . . [T]he heart-beats and the rhythm of breathing play a leading part in all emotions whatsoever. . . . And what is really equally prominent . . . is the continuous co-operation of the

[31] Toulouse and Mourgue, "Des reactions," 382.

(a)

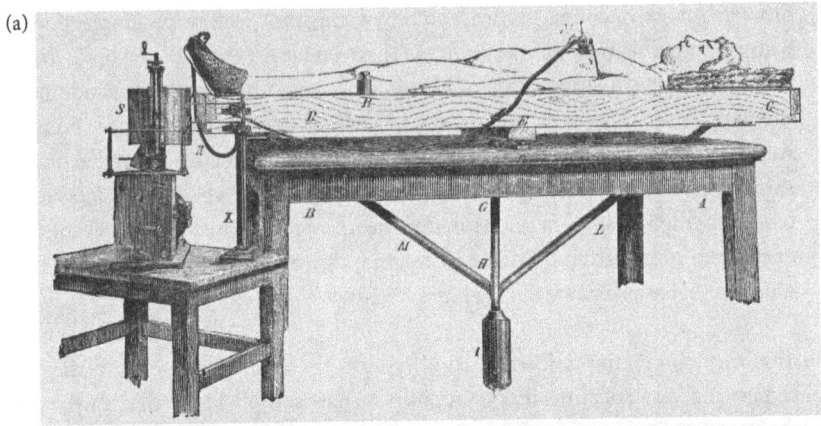

(b)

Fig. 5.6 (*a*) The Italian physiologist Angelo Mosso's balance set up for the study of blood circulation during emotional experience. Image from: Angelo Mosso, *Fear*, trans. E. Lough and F. Kiesow (London: Longmans, Green, and Co., 1896), 96. Scan courtesy Cambridge University Library. (*b*) Mosso's plethysmographic curves with patterns of accelerated cardiac pulsation (A, B), representing the onset of fear. Image source: Angelo Mosso, *Fear*, trans. E. Lough and F. Kiesow (London: Longmans, Green, and Co., 1896), 115.

voluntary muscles in our emotional states. Even when no change of outward attitude is produced, their inward tension alters to suit each varying mood, and is felt as a difference of tone or of strain.[32]

[32] William James, "What Is an Emotion?" *Mind* 9 (1884): 188–205, 192–193. See *Classics in the History of Psychology*, ed. Christopher D. Greene, http://psychclassics.yorku.ca/James/emotion.htm.

According to James, the nervous impulses generated by specific "bodily disturbances" translate into the experience of specific emotions: "surprise, curiosity, rapture, fear, anger, lust, greed, and the like."[33] Contractions of all types of muscle tissue—from the "involuntary" cardiac muscles and smooth muscles lining our blood vessels and inner organs, to the skeletal muscles that respond to our will—were singled out by James as concomitants of various emotions. An important corollary of this theory was that even an artificially induced arousal of appropriate bodily changes produces a genuine emotional experience.[34] James suggested that focusing on the somatic events could aid in understanding the impact of the arts on "the aesthetic sphere of the mind, its longings, its pleasures and pains":[35]

> In listening to poetry, drama, or heroic narrative, we are often surprised at the cutaneous shiver which like a sudden wave flows over us, and at the heart-swelling and the lachrymal effusion that unexpectedly catch us at intervals. In listening to music, the same is even more strikingly true.[36]

In the 1880s what James presents as a general observation became a foundational premise in multiple quantificational studies, which attempted to gauge the impact of various arts and identify elements of aesthetic experience by way of registering the fluctuations of physiological data. As Robert Brain points out, the method of recording a continuous curve—as in Étienne-Jules Marey's myograph tracings of muscular contractions, or in Angelo Mosso's plethysmograph inscriptions of expanding blood vessels—proved attractive for inquiring into the body's processing of movement, color, sound, and other stimuli that constitute the basic mediums of various arts.[37] For instance, the impact of music—William James's most powerful art—came to be studied with reference to vital signs in multiple laboratories in Europe, the United States, and Russia.[38] Adler G. Blumer in the United States, M. L. Patrizzi in Italy, and Ivan Tarkhanov, Ivan Dogel', and Il'ia Spirtov in the Russian Empire focused on criteria, such as the changes in the music listeners' blood pressure and the velocity of the pulse wave propagating throughout the circulatory system.[39] Muscle tone and motor activity

[33] Ibid., 190.
[34] Ibid., 198.
[35] Ibid., 189.
[36] Ibid., 197.
[37] Robert M. Brain, *The Pulse of Modernism: Physiological Aesthetics in Fin-De-Siècle Europe* (Seattle: University of Washington Press, 2016), 97.
[38] Alla Mitrofanova, "Conditioned Reflexes: Music and Neurofunction," in *Lab: Jahrbook 2000 für Künste und Apparate*, ed. Hans U. Reck, Siegfried Zielinski, Nils Röller, and Wolfgang Ernst (Köln: Kunsthochschule für Medien, 2000), 171–182, 172.
[39] Mitrofanova, "Conditioned Reflexes,"172. Representative publications include J. Dogiel [Dogel', Ivan], "Ueber den Einfluss der Musik auf den Blutkreislauf," *Archiv fur Anatomie und Physiologie*, 1880; Ivan Tarkhanov, "Influence de la musique sur l'homme et sur les animaux, *Archives italiennes*

of the music audience were investigated by the French neurophysiologist Charles Féré, as well as the aforementioned Russians Tarkhanov, Dogel,' and Spirtov, along with the latter's mentor Vladimir Bekhterev.[40] What these studies accomplished was institutionalizing a method of studying aesthetic reactions that was, to use Robert Brain's apt descriptor, "antilinguistic" and "antihermeneutic": [41] the automatically registered curves appeared to disclose the impact of specific stimuli at a specific time, presenting a self-evident break-down of the artwork's elements correlated with somatic processes at the core of aesthetic appreciation. Conversely, the subject engaging with an artwork like-wise ceased to be perceived as a uniform, self-identical entity: fatigue, overtaxed attention, and mood were now scientifically proven to exert a defining influence over the human ability to perceive and react to stimuli. A Russian researcher, V. N. Osipova-Sukhova from Kazan University (where Bekhterev founded the psychophysiological research laboratory in 1886), proved that the speed of visual reactions is influenced by mood, or what she called one's "neuropsycho-logical tonus" detectable in the "objective signs, such as pulse, breathing, facial expression, gaze, movement, and gait."[42]

With regard to cinema, the foundations for a neurophysiological outlook on the spectator's experience were laid out by Hugo Münsterberg. It is no ac-cident that Münsterberg's name appears as a privileged reference in Toulouse and Mourgue's plethysmographic study of the spectators' respiration during film screenings. The German-American scientist's book *The Photoplay: A Psychological Study* (1916) was an influential treatise, which pointed to research directions that could illuminate the "psychological factors," or "mental means" that cinema employs to "impress us and appeal to us."[43] Münsterberg famously drew parallels between the operations of the human perception and the orga-nization of visual material onscreen. Thus he presented the isolation of a detail

de biologie 21 (1894); M. L. Patrizzi, "Primi esperimenti intorno all' influenza della musica sulla circolatione del sangue nel cervello umano," *Archivio di psichiatria, scienza penale e antropologie criminale* 17 (1896): 390–406; I. N. Spirtov, "O vliianii muzyki na krovianoe davlenie," *Obozrenie psikhiatrii, nevrologii i eksperimental'noi psikhologii* 5 (1906); Adler G. Blumer, "Music in Its Relation to the Mind," *American Journal of Insanity* 48 (1892–1893): 350.

[40] Mitrofanova, "Conditioned Reflexes," 172. Charles Féré, *Sensation et movement* (Paris: Alcan, 1887); Tarkhanov, "Influence de la musique . . . "; J. Dogiel [Dogel', Ivan], "Ueber den Einfluss"; I. N. Spirtov, "O vliianii muzyki," Siegfried Zielinski, *Deep Time of the Media: Toward an Archaeology of Hearing and Seeing by Technical Means* (Cambridge, MA: MIT Press, 2009), 251.

[41] Brain, *The Pulse of Modernity*, 29.

[42] Osipova-Sukhova's 1914 paper is cited by Vladimir Bekhterev, *Ob"ektivnaia Psikhologiia* (Moskva: Nauka, 1991), 99; K. V. Lebedev, I. N. Volkova, and L. N. Zefirov, *Iz istorii Kazanskoi fiziologicheskoi shkoly* (Kazan': Izdatel'stvo Kazanskogo universiteta, 1978), 229.

[43] Hugo Münsterberg, "The Photoplay: A Psychological Study," in *Münsterberg on Film: The Photoplay: A Psychological Study and Other Writings*, ed. Allan Langdale (New York: Routledge, 2002), 45–151, 63.

THE PULSE OF FILM 253

in the close-up as a phenomenon that resembles the way in which in our daily life, we can momentarily concentrate our attention on something and screen out other parts of our environment as irrelevant.[44] Drawing on the themes of his own research at Harvard, Münsterberg called for a further inquiry into such aspects of the film-viewing experience as the engagement of spatial sense, the activation of attention, the work of memory (both in terms of evoking associations with the past and long-term retention of the data seen), as well as the influx of emotions. In outlining these research directions, Münsterberg tacitly endorsed the idea that the experimenter could ignore the vexed question of cinema's difference from reality in the name of uncovering the subject's generic response mechanisms. *The Photoplay* suggested that the functioning of our attention, for instance, is the same, whether we watch a theater performance or cross the street. In both cases, "the chaos of the surrounding impressions is organized into a real cosmos of experience by our selection of that which is significant and of consequence. This is true for life and stage alike."[45] With regard to cinema's immersive quality, Münsterberg wrote that while the perception of depth and movement was a result of specific cues and symbols onscreen, spectators succumb to the effect of three-dimensional motion, even though they are aware of its illusionary quality.[46] This provision opened the door for subsequent researchers to disregard the artificiality of the movie-viewing situation and to focus on the reactions of the viewers as if they were responding to the actual events.

Another area, in which *The Photoplay* served as a precedent for the subsequent psychophysiological perspectives was its linking of screen images, spectators' physical reactions, and emotions. In accordance with William James's theory, Münsterberg believed that the affective impact of cinema derives from the spectators' kinesthetic empathy toward characters onscreen, or else, from the proprioceptive sensations that accompany their own bodily poses assumed in response to the narrative situations:

Our imitation of the emotions which we see expressed brings vividness and affective tone into our grasping of the play's action. . . . The horror which we see makes us really shrink, the happiness which we witness makes us relax, the pain which we observe brings contractions in our muscles; and all the resulting sensations from muscles, joints, tendons, from skin and viscera, from blood circulation and breathing, give the color of living experience to the emotional reflection in our mind.[47]

[44] Münsterberg, "The Photoplay," 85–87.
[45] Münsterberg, "The Photoplay," 79–80.
[46] Ibid., 78.
[47] Ibid., 104–105.

Preparing the ground for subsequent analyses of the spectators' bodily data, Münsterberg located the emotional effect of cinema in the audience's sensory-motor reactions. *The Photoplay* also expanded James's more narrow focus on the somatic markers of emotions to include the corporeal symptoms of other psychological functions, such as "attention"—one of the primary research areas in Münsterberg's laboratory. The psychologist argued that the rising alertness of the spectators tuning in to the film is simultaneously a physical and a mental process:

> We feel that our body adjusts itself to the perception. Our head enters into the movement of listening for the sound, our eyes are fixating on the point in the outer world. We hold all our muscles in tension in order to receive the fullest possible impression with our sense organs. The lens of our eye is accommodated exactly to the correct distance. In short our bodily personality works toward the fullest possible impression.[48]

Thus, according to Münsterberg, cinema trains the body to become maximally receptive to the audiovisual stimulation. The kinesthetic sensations stemming from these familiar poses of alertness further reinforce the sense of immersion in the spectacle. This process of ideal attunement in Münsterberg's description resembles the Soviet Taylorist labor psychologists' approach to developing the optimal corporeal "set-up" (*ustanovka*) for executing a certain physical task.

In identifying these psychophysiological signs of maximal absorption in the film, Münsterberg had practical goals in mind. Knowing how perception and attention work, he implied, would help the filmmakers organize the multitude of competing stimuli in a manner most suitable for drawing the spectators in. In *The Photoplay*, the discussion of the bodily expression of attentiveness in cinema is connected with an example of urban strolling and window-shopping. Münsterberg writes: "As we are passing along the street we see something in the shop window and as soon as it stirs up our interest, our body adjusts itself, we stop, we fixate it . . . while it impresses us more vividly than before, the street around us has lost its vividness and clearness."[49] Sensitive to the dynamics of attraction and distraction within the spaces of modernity, Münsterberg drew an explicit parallel between the spectacle of commercial display and film.[50] It

[48] Ibid., 85–86.

[49] Münsterberg, "The Photoplay," 86.

[50] For a discussion of early cinema's embeddedness in the modern urban landscape, see Giuliana Bruno, *Streetwalking on a Ruined Map: Cultural Theory and the City Films of Elvira Notari* (Princeton, NJ: Princeton University Press, 1993); Anne Friedberg, *Window Shopping: Cinema and the Postmodern* (Berkeley: University of California Press, 1993); Jonathan Crary, *Suspensions of Perception: Attention, Spectacle, and Modern Culture* (Cambridge, MA: MIT Press, 1999); Klaus Kreimeier and Annemone Ligensa, eds., *Film 1900: Technology, Perception, Culture* (New Burnet, England: John Libbey, 2009).

was his project in an earlier study, *Psychology and Industrial Efficiency* (1913), to demonstrate the applicability of perceptual laws discovered by laboratory experiments for the task of arranging shop windows and designing newspaper advertisements. Foregrounding applied psychology's mission in describing the laws of "physiological psychological optics," three years before *The Photoplay* Münsterberg argued:

> Whoever is to examine the psychotechnics of displays and exhibitions must therefore study the psychology of aesthetic stimulation, of suggestion, of the effects of light, color, form, and movement, of apperception and attention, and ought not to forget the psychology of humor and curiosity, of instincts and emotions. For us the essential point is that here too the experimental psychological method alone is able to lead from mere chance arrangements founded on personal taste to the systematic construction which secures with the greatest possible certainty the greatest possible mental effect in the service of the economic purpose.[51]

Münsterberg here promotes the discipline of psychotechnics, which can be described as experimental psychology applied to various business purposes of advanced industrial society, from selecting personnel, to reducing fatigue in the workplace, to raising the effectiveness of advertising.[52] His notion of the "psychotechnics of display" approached the visual spectacle as a "systematic construction," the impact of which could be potentially be examined by the instruments of aesthesiometry and various psychological tests. In the same book, Münsterberg presents his laboratory's investigations into the design of printed commercials to evaluate "the memory-value, the attention-value, and other mental effects," such as pleasant or unpleasant associations (Fig. 5.7).[53] In these tests, the subjects were shown plaques with advertisement samples in a consecutive series, each demonstration lasting for a precise fraction of time.[54] Though these sequences cannot be called "cinema" in the common sense of the word, Münsterberg's attempt to correlate elements of an immersive spectacle with the subjects' typical reactions anticipates the methods of subsequent psychophysiological studies of cinema proper.

[51] Hugo Münsterberg, *Psychology and Industrial Efficiency* (Boston: Mifflin, 1913), 277, 278–279.
[52] Hugo Münsterberg, *Business Psychology* (Chicago: La Salle extension university, 1915), v.
[53] Münsterberg, *Psychology and Industrial Efficiency*, 258.
[54] On Münsterberg's experiments in relation to his views on cinema, see Jeremy Blatter, "Screening the Psychological Laboratory: Münsterberg, Psychotechnics, and the Cinema, *Science in Context* 28.1 (2015): 53–76; Robert Michael Brain, "Self-Projection: Hugo Münsterberg on Empathy and Oscillation in Cinema Spectatorship," *Science in Context* 25 (2012): 329–353; Giuliana Bruno, "Film, Aesthetics, Science: Hugo Münsterberg's Laboratory of Moving Images," *Grey Room* 36 (2009): 88–113.

Fig. 5.7 Harvard Psychological Laboratory: students studying the effect of sound and attention on color, 1892. Note a tachistoscope demonstration on the right side of the room. Image source: HUPSF Psychological Laboratories (2), olvwork 298401. Harvard University Archives.

An immediate outcome of Münsterberg's functional view of the tachistoscope image series as a moving construction consisting of sensory stimuli and evoking particular reactions can be seen in his tests of professional aptitude. Apt personnel selection was one of the key objectives of Münsterberg's psychotechnics, and the moving images were placed at its service.[55] The basic principle of investigating the subject–screen interaction remained the same; but whereas the project of defining the optimal "psychophysiological optics" in advertisement design emphasized the screen stimuli, the project of personnel selection focused on the subjects' reactions. Motor agility, hand-eye coordination, quickness of reaction, resistance to impulse, ability to concentrate, and other psychophysiological traits, crucial for the novel industrial tasks, could potentially be tested with the help of simulated virtual environments. In 1912, Münsterberg used a device reminiscent of Edison's kinetoscope to run a semiabstract animation for

[55] Münsterberg, *Psychology and Industrial Efficiency*, 54–55.

THE PULSE OF FILM 257

prospective motormen of the Boston Elevated Railway, representing a "quickly changing panorama of the street" with a receding pair of rails repeatedly crossed by color-coded obstacles.[56] Two years prior to this test, Münsterberg's student Charles Sherwood Ricker tested the reaction times of chauffeurs, as they sat in a modified automobile with an "opaque screen" covering the windshield and responded to projections of red, yellow, and white color signals.[57] By the early 1920s, cinema became widely used for modeling the working environment of drivers, with Karl Tramm's laboratory in Berlin and Jean-Maurice Lahy's in Paris emerging as leading research centers for this kind of studies.[58]

An image from a Soviet film *A Scientific Choice of Profession* (*Nauchnyi vybor professii*, 1928) directed by Aleksandr Dubrovskii demonstrates a typical set for immersing aspiring job candidates into a simulated environment for streetcar operators (Figs. 5.8.a. and 5.8.b). The scriptwriter for this film was the Russian pioneer of psychotechnics Isaak Shpil'rein (Spielrein), who, like Münsterberg, received his doctorate in psychology from Wundt's program in Leipzig.[59] In Russia, where traditions of labor psychology date back to the 1880s–1890s, research into such issues as the railway engineers' perception of color lights and the ergonomics of their working place had existed independently of the Western influence before the 1917 Revolution.[60] However, it was in the 1920s that "psychotechnics"—in Münsterberg's sense of the word—became part of the large-scale research and professional education program called "Scientific Organization of Labor," which was supported by the Soviet government.[61] Shpil'rein, who chaired the Applied Psychology Section at the Moscow State Institute of Experimental Psychology, and his deputy at the same institution, Solomon Gellershtein, were among the leaders of this program. Open to Western influences, Shpil'rein and Gellershtein actively engaged with Münsterberg's ideas, as well as other German, American, and French sources. Streetcar driving was Shpil'rein's research focus, and he dedicated several publications to the subject.[62] In his experiments geared toward aptitude testing,

56 Blatter, "Screening the Psychological Laboratory," 65.
57 Ibid., 65.
58 On Tramm, see Killen, "Accidents Happen," 81.
59 V. M. Munipov, "I. N. Shpil'rein, L. S. Vygotskii i S. G. Gellershtein—Sozdateli nauchnoi shkoly psikhotekhniki v SSSR," *Kul'turno-istoricheskaia psikhologiia* 4 (2006): 85–109, 88. Incidentally, Shpil'rein was a brother of the psychoanalyst Sabina Spielrein, famous for her research on the death drive and her relationship with Karl Jung.
60 E. A. Klimov and O. G. Noskova, *Istoriia psikhologii truda v Rossii* (Moscow: Izdatel'stvo Moskovskogo Universiteta, 1992), 167.
61 On Russian psychotechnics and its relation to the revolutionary culture, see Margarete Vöhringer, *Avangard i Psikhotekhnika: Nauka, Iskusstvo, i Metodiki Eksperimentov nad Vospriiatiem v Poslerevoliutsiuonnoi Rossii*, trans. K. Levinson and V. Dubina (Moskva: Novoe Literaturnoe Obozrenie, 2019).
62 Isaak Shpil'rein, "Psikotekhnika i vybor professii," *Vremia* 12 (1924): 75–76; Isaak Shpil'rein, *Rabochie Tramvaia: Trud, Utomlenie, Zabolevaemost', Psikhotekhnicheskii Podbor* (Moskva: Izdatel'stvo Narodnogo komissariata vnutrennikh del, 1928); Isaak Shpil'rein, *Prikladnaia Psikhologiia: Psikhologiia Truda i Psikhotekhnika* (Moskva: Izdanie B.Z.O. pri M.P.I., 1930).

(a)

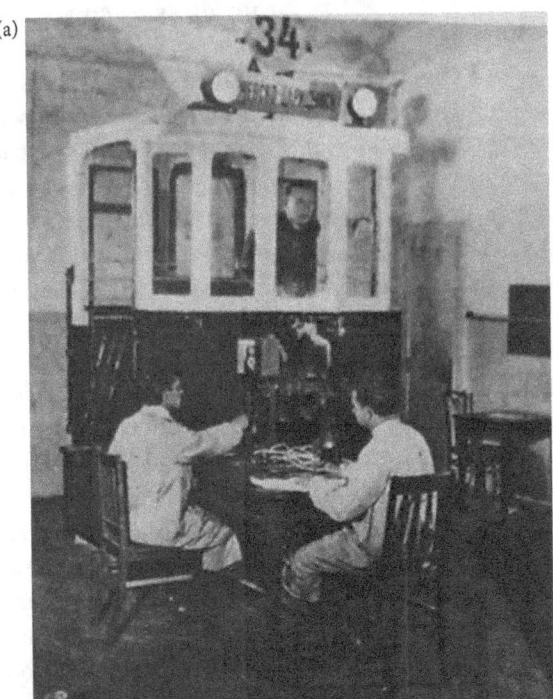

(b)

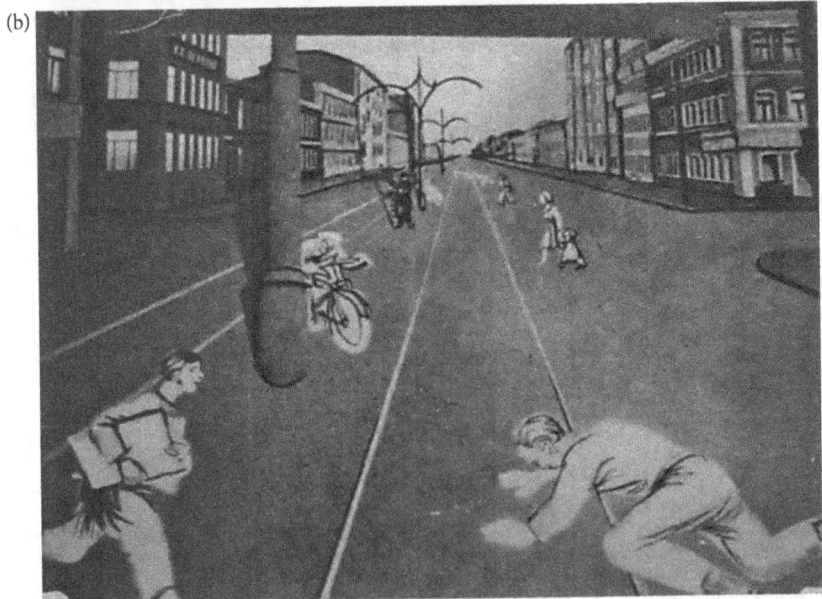

Fig. 5.8 Images from the Soviet film *A Scientific Choice of Profession* (*Nauchnyi vybor professii*, dir. A. Dubrovskii, Mezhrabpom-Film, 1928), published in the journal *Sovetskii Ekran* 6 (1928): 5. The image at the top (*a*) shows a model of a tram driver's cab, with the job applicant being tested by two experimenters. The shot below (*b*) shows an animated image of the street with cut-out figures darting across the tracks.

he discovered, for instance, that all subjects exhibit the same basic sensory-motor reactions to frequently encountered stimuli, but few drivers can handle rare and unusual situations, requiring extreme concentration and self-possession.[63] In the surviving images from this Soviet film on professional aptitude, we can see a tram driver standing in a booth that resembles a tram cabin. He is bent forward in a posture suggesting extreme concentration, with his gaze fixated at some point in the distance and his hands holding onto the controls firmly. Next to him, at a table, two laboratory assistants in white robes are taking written records and adjusting the projection apparatus. The model of cinema–spectator interaction that emerges from these images coincides with the one outlined in Münsterberg's *Photoplay*. The setup of the Soviet driving test is designed to examine how well the subject can perceive and interpret those cues of depth and movement that Münsterberg called a "mixture of fact and symbol," or how well he can judge the behavior of the passersby in city traffic. The driver too is a doubly wired spectator: while his sensory and mental resources are mobilized by a highly controlled visual environment, his body undergoes psychophysiological measurements, which will determine the scientists' judgment of his individual aptitudes.

The utilitarian context in which film viewing became an object of laboratory investigation highlights the full implications of Münsterberg's theoretical approach to cinema in *The Photoplay*. In the professional aptitude tests, two series of data are gathered and interpolated: the graphical recording of somatic processes and the unfolding visual stimuli. The experimental set-up implies the scientist's mastery of both data series: the visuals may be deemed effective or ineffective, more or less powerful in bringing out certain reactions; while the subjects' bodily processes, inscribed in the form of a curve, offer a record for diagnosing, classifying, predicting, and retraining their psychological dispositions. Such pragmatic orientation underwrites the model of spectator–screen interaction articulated in these tests, linking them to the managerial demands of the advanced industrial society. This context brings into a sharp relief the hidden logic of the subsequent psychophysiological audience tests done in a very different setting—in movie theaters, where the spectators were presumably consuming films as aesthetic objects. Friedrich Kittler was well aware of the significance of applied psychology in modernity, when he wrote this about the origins of film theory:

> Film theory (to say nothing of the assembly line and combat training) first became possible with psychotechnology, this coupling of physiological and technical experiments, of psychological and ergonomic data.... Münsterberg easily

[63] V. M. Kogan and L. I. Seletskaia, "Skromnoe nachalo: Vospominaniia o pervoi laboratorii psikhologii truda," *Voprosy psikhologii* 4 (1996): 111–126, 117. http://www.voppsy.ru/issues/1996/964/964111.htm.

proved that film is capable of implementing the neurological data flow itself. Whereas the traditional arts treat orders of the symbolic or orders of things, film emits to its viewers their own process of perception—and this with a precision available only to experiment, which is to say, that it cannot be accessed either by consciousness or language.[64]

Extending this insight, it is important to recognize that the interpretation of film images as catering to and reflecting the spectators' "neurological dataflow" is always contingent on the methodology and vocabulary of scientists. The coupling of psychotechnics and film theory at their inception points to their joint origin in modernity's commercial, technological, and political developments.

In the recent film scholarship, Münsterberg is frequently credited with anticipating cognitive neuroaesthetics and laying philosophical foundations for understanding our interaction with film media as embodied experience. Vivian Sobchack and Jennifer Baker emphasize this aspect of his work, reading it through the prism of Maurice Merleau-Ponty.[65] Giuliana Bruno underscores Münsterberg's quintessentially modern outlook on the process of film interpretation, in which the spectator's "bodily sensorium becomes the basis of a transitive, emotional knowledge."[66] She situates Münsterberg's argument in The Photoplay between Theodor Lipps's theory of empathy and Gilles Deleuze's neuroaesthetics.[67] Taking into account Münsterberg's recent revival, it is all the more important to examine the ways in which his scientific work gave rise to early studies of spectatorship in the 1920s. What these audience experts took from Münsterberg and the directions they went with it point toward a much less appealing side of his legacy. Whereas contemporary scholarship highlights a Deleuzian potential in Münsterberg's explorations of the sensorium as a material receptacle of affects, the scientists of the 1920s saw Münsterberg's The Photoplay as part of his work within the field of applied psychology, driven by utilitarian considerations. My exploration of this historical reception and continuation of Münsterberg's endeavors aims to raise awareness of the dangerous, manipulative applications of experimental psychophysiology in the early 20th century.

[64] Friedrich A. Kittler, "Romanticism—Psychoanalysis—Film: A History of the Double," in Essays: Literature, Media, Information Systems, ed. John Johnston, trans. Stefanie Harris (Amsterdam: Gordon & Breach, 1997), 85–100, 99.

[65] Vivian C. Sobchack, The Address of the Eye: A Phenomenology of Film Experience (Princeton, NJ: Princeton University Press, 1992), 207; Jennifer M. Barker, The Tactile Eye: Touch and the Cinematic Experience (Berkeley: University of California Press, 2009), 86.

[66] Giuliana Bruno, "Film, Aesthetics, Science: Hugo Münsterberg's Laboratory of Moving Images," Grey Room 36 (2009): 88–113, 92.

[67] Bruno, "Film, Aesthetics, Science," 91, 92.

Vetting Hollywood's Emotions: Marston's Work at Universal Studios

William Moulton Marston was the man who brought Münsterberg's film theory to its logical conclusion: he employed a blood pressure gauge for analyzing spectators' emotions and applied his expertise in Hollywood. Today, Marston is remembered as one of the inventors of the polygraph lie detector and the creator of the comic book star Suprema, or Wonder Woman, whose magical "lasso of truth" brought criminals to justice in a manner similar to a pneumographic lie detector.[68] Between 1911 and 1915, Marston was an undergraduate at Harvard College, where he became exposed to Münsterberg's ideas.[69] He must have been especially impressed by his professor's foray into forensic psychology, summed up in a volume entitled *On the Witness Stand* (1908), in which Münsterberg discussed ways of identifying "traces of emotions" experienced by criminal suspects.[70] Marston chose a version of this topic for his doctoral thesis at Harvard, which was entitled "Systolic Blood Pressure and Reaction Time Symptoms of Deception and Constituent Mental States" (1921). Though the methods delineated in this study were clearly inspired by Münsterberg, in the years to come, Marston would downplay his former teacher's influence. One reason for this self-distancing was the general ostracism that Münsterberg experienced in the years before his death in 1916, thanks to his pro-German views during World War I. After getting his PhD in psychology, Marston pursued legal recognition for his "lie detector test," but as a court in Washington, DC, set a precedent for rejecting it in 1923, he switched to an academic career, and eventually, began applying his expertise in the realm of advertising and popular culture.[71]

Marston launched himself as a film audience expert on January 30, 1928, at New York's high-end Embassy Movie Theater, where he staged a public demonstration of his psychophysiological instruments for evaluating emotions.[72] At the time, he was a lecturer in psychology at Columbia University, and the

[68] I am grateful to Jeremy Blatter for the insight regarding Wonder Woman's weapon's resemblance to the lie detector.

[69] William Moulton Marston, "Autobiographic entry," Harvard College Class of 1915, *Twenty-Fifth Anniversary Report* (Cambridge, MA: Cosmos Press, 1940), 480–482, 480.

[70] Hugo Münsterberg, *On the Witness Stand: Essays on Psychology and Crime* (New York: Doubleday and Page, 1917), 118.

[71] Marston, "Autobiographic entry," 480–482.

[72] "Blondes Lose Out in Film Love Test," *The New York Times*, January 31, 1928, 25. For a discussion of this event and its resonance for Marston's career as a scientist see, Alder, *The Lie Detectors*, 185–188.

experimental study of spectators' reactions came in the wake of his long-term investigation of emotional processes in collaboration with his partner Olive Byrne.[73] His book *Emotions of Normal People*, detailing his perspective, was scheduled to come out in the same year. Possessing a singular flair for self-advertising, Marston found a way to create a media buzz around his "objective" methods for detecting and deciphering inner experiences. The surviving photographs of this widely publicized event (Figs. 5.3, 5.9a, and 5.9.b) show how carefully it was organized to give the impression of glamor and chic. Overnight, Marston turned from a little-known academic into a minor celebrity. For the public experiment, Marston selected love scenes featuring Hollywood's most desirable couple, Greta Garbo and John Gilbert, in *Flesh and the Devil* (1926) and *Love* (1927). Both of these screen dramas, produced by MGM, were renowned for their seductive eroticism. The subjects of Marston's experiment were six beautiful chorus girls—blondes and brunettes from Ziegfeld's Broadway shows. Marston's instrument, nicknamed "the love meter," was set to gauge how titillated these young creatures would become at the sight of screen passions.[74] To amplify the thrill even further, Marston declared that he would find out what type of girl was the most excitable, capitalizing on the popular craze for speculating about the sexual temperament of women with different hair color (Fig. 5.10). This fad was started by Anita Loos's novel *Gentlemen Prefer Blondes* (1925), its eponymous film adaptation by Paramount Famous Lasky released a fortnight before Marston's test, and other cultural events, such as Adolphe Menjou's film *Blonde or Brunette* (1927). Marston explained that Loos's novel summed up the popular opinion that a blonde is "a perfect type of 'gold-digger,' that is, a girl who really loves nobody but herself," and suggested that his emotional tests confirmed the Arians' proverbial sangfroid.[75] "This is the heritage of their Northern ancestry, warriors, adventurers," he claimed.[76] In a sarcastic, yet detailed report on the experiment, *The New York Times* wrote:

> By elaborate and allegedly delicate instruments known in scientific circles as the sphygmomanometer and the pneumograph, by charts and graphs, and by the simpler expedient of holding hands, Dr. William Marston, a lecturer on psychology at Columbia University, proved yesterday in the presence of coy press agents, camera men, motion picture operators and columnists that brunettes react far more violently to amatory stimuli than blondes.[77]

[73] Lepore, *The Secret History of Wonder Woman*, 124, 133.

[74] Lepore, *The Secret History of Wonder Woman*, 134.

[75] William M. Marston, "Bodily Symptoms of Elementary Emotions," *Psyche* 38 (1929): 70–86, 85.

[76] Marston quoted in Marquis Busby, "What Every Lover Should Know," *The Motion Picture Classic* 28.4 (1928): 28.

[77] "Blondes Lose Out in Film Love Test," 25.

(a)

(b)

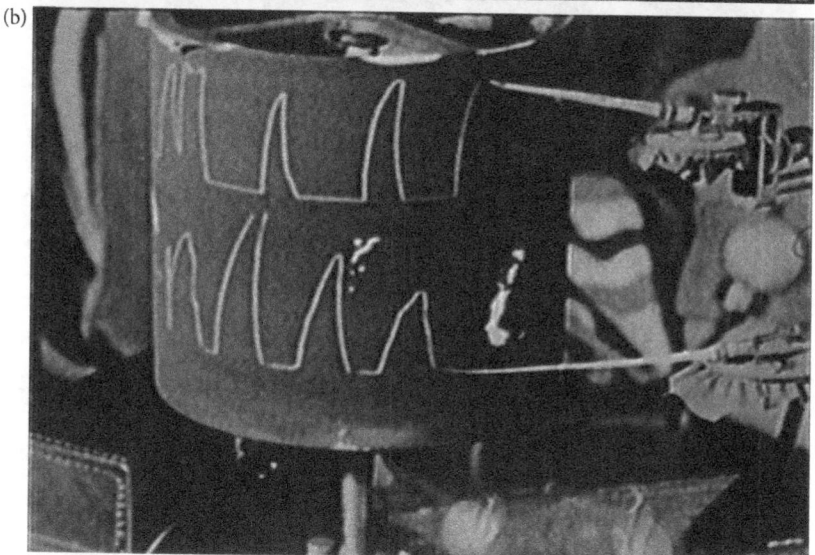

Fig. 5.9 (*a* and *b*) Images from a newsreel, showing a blonde and a brunette watching romantic scenes with Garbo and Gilbert, while Marston's "love meter" is recording changes in their respiration patterns. Entitled "Measure for Love," this newsreel was presumably filmed by Pathé. In the 1950s, it was reedited with a voice-over narration for TV, becoming part of *Yesterday Newsreel* series. Image courtesy F.I.L.M. Archive Inc., New York.

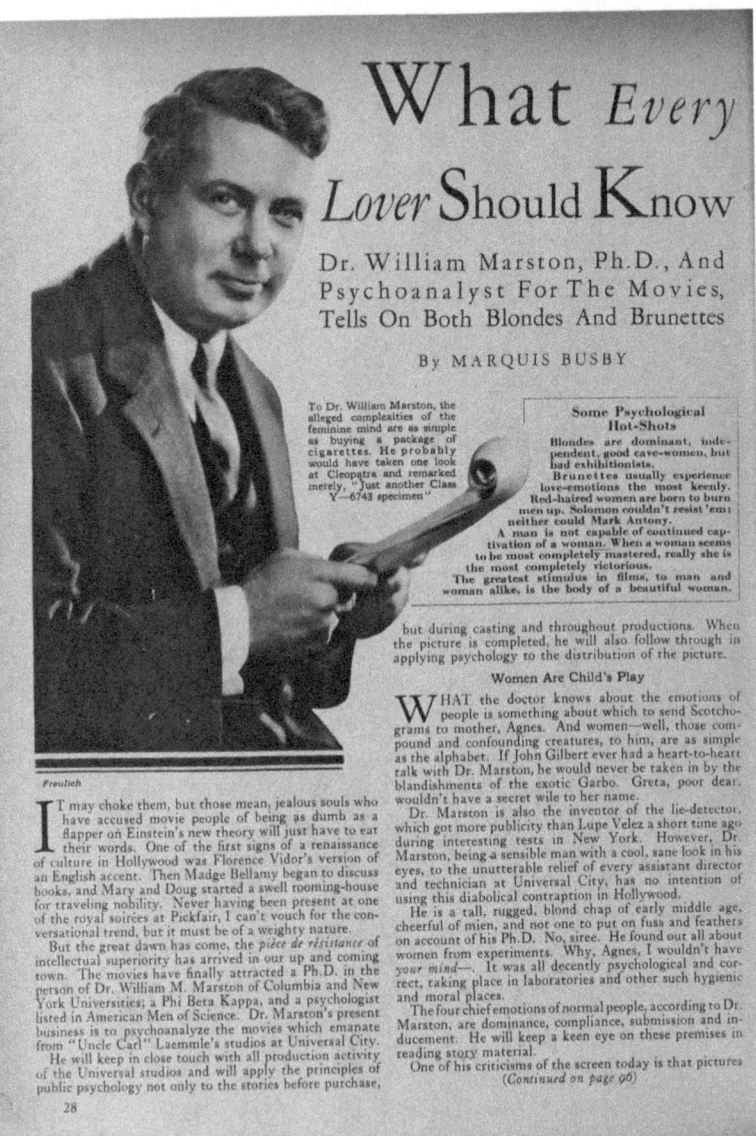

Fig. 5.10 "What Every Lover Should Know"—a review of Marston's blondes and brunettes spectator test, full of sexist humor, in *The Motion Picture Classic* 28.4 (1928): 28.

So great was the publicity of this event that it reached Soviet Russia. It was no other than Pera Atasheva, the future wife of Sergei Eisenstein and a connoisseur of American film culture, who wrote a mocking review of Marston's experiment in the journal *Sovetskii Ekran*. In her essay, Atasheva condemned the sexist spectacle in which "the faithful apparatus recorded all truth there was to know about blondes and brunettes," while "Greta Garbo and John Gilbert were intertwined in a passionate 'clinch' onscreen."[78]

Besides raising some red flags for sexism and racism, Marston's seemingly "objective" psychological experiment reveals some characteristic traits of his subsequent approach to spectatorship studies. First, he operates on the problematic assumption that all that there is to know about the subjects' emotional world lies in blood pressure fluctuations. Second, Marston uses his subjects for self-advertising. He plays a double game, posing at once as a neutral and objective man of science, and as a showman exhibiting glamorous Broadway girls in the capacity of stereotypical "blondes" and "brunettes." The precipitations of the kymograph curves pointing to the women's inner trepidations become the main attraction presented to the public. Even though in the press release Marston stated that his eventual goal was "to compare the show girls' emotional scores with the graphed and tabulated reactions of housewives and college girls,"[79] he seemed to know that statistical results from large groups would not win him such publicity. An image of the Broadway starlets tied up by pneumographs had a much greater exhibition value. It was this photo (Fig. 5.3) that he chose to include in his scientific paper for the British journal *Psyche*, where he discussed the methods and results of the experiment.[80] Summarizing the details of the setup for a scientific publication, he found himself in the uncomfortable position of needing to explain his classification of subjects according to hair color. He briefly cited the fact that the "endocrine glands," which "control emotional responsiveness," are also known to influence the "pigmentation of the skin," but ultimately conceded that this issue had no explanation.[81] Hence, the third typical trait of Marston's character as a researcher: his willingness to court sensation and abide by popular stereotypes at the risk of compromising his scientific integrity. Finally, one more characteristic methodological principle that may be highlighted in Marston's Embassy Theater affair: his preference for clear-cut film personae and narrative situations. As with his showgirl subjects, whose complex inner personalities were reduced to stereotypical labels,

[78] Pera Atasheva, "Chem zhivet Amerika?" *Sovetskii Ekran* 41 (1928): 10. The word "clinch" referred, in the American movie slang of the 1920s, to an amorous embrace. Marston himself once defined "clinch" as "a mutual and complete captivation between two successful lovers" and a sine qua non element of all romantic films that hope to satisfy the public fully (Walter B. Pitkin and William M. Marston, *The Art of Sound Pictures* [New York: D. Appleton and Co., 1930], 164).
[79] "Blondes Lose Out in Film Love Test," 25.
[80] Marston, "Bodily Symptoms," 71.
[81] Ibid., 83.

in the subsequent analyses of spectator reactions, Marston preferred using scenes without inconvenient narrative ambiguity and open-ended characterization.

Marston's psychophysiological testing raises epistemological and ethical issues, relevant for any spectatorship analysis that foregrounds the physical, "objective" signs of the viewers' responses. These issues come forward if we focus on the subjects of Marston's test. How is their personal experience made knowable? How is it represented? What parts of it are left out? How does the experimental setup position them as subjects? The press reporting on Marston's testing marveled and cheered at the "brunettes' seismic reaction" to the filmic love scenes.[82] Marston's own discussion of the test in a scientific paper focused on the abstract kymograph statistics, fitting it with his classification of emotional reactions.[83] In the experiment, female spectators are deprived of language and the capacity for reflection. The scientist cares little about their interpretative understanding, their imagination and cultural memory, or the reasons they signed up for psychological testing. The inexhaustible fullness of these women's psychological life is reduced to a twitching line recorded by the apparatus. The voiceless subjects of the test are there to highlight the scientist's stature as arbiter of human emotion. Though mentioned only in passim, these women are the very center of the scientific spectacle. Far-going conclusions about human experience are being made on their behalf. Although the stimulus in the experiment is clearly an artistic product, Marston makes no distinction between an aesthetic reaction and emotions experienced by a voyeur of love scenes in real life. Film scholar Mary Ann Doane has pointed out that traditional discussions of female audiences tend to fall back on the stereotype of the "enraptured," "naïve" spectator—someone oblivious to the processes of mediation and representation.[84] It seems that Marston embraces this rather condescending outlook. On the methodological level, there is also a problem with Marston's vagueness in defining the notion of "reaction" to the screen image. One may wonder to what extent the dramatic kymographic curves of his "susceptible" subjects represent their response to the movies, and to what extent the pneumograph actually reflects the Broadway starlets' anxiety about the setup or the thrill at being surrounded by newsagents.

Tenuous or not, Marston's demonstration of his psychophysiological apparatus for audience research caught the eye of the directorial board of the Universal Pictures Corporation. Eleven months after the gala presentation at the Embassy Theater, he accepted an invitation from Universal's director Carl Laemmle to "apply psychology to all departments of the motion picture concern."[85] Historian

[82] "Blondes Lose Out in Film Love Test," 25.

[83] Marston, "Bodily Symptoms."

[84] Mary Ann Doane, *The Desire to Desire: The Woman's Film of the 1940s* (Bloomington: Indiana University Press, 1987), 1.

[85] The announcement of Marston's contract with Universal appeared in "Psychology for Films," *The New York Times*, December 25, 1928, 33.

Jill Lepore points out that in the summer of 1928, Laemmle had put out an ad seeking the services of a consulting psychologist for his studio, and Marston applied for the job.[86] On December 24, 1928, Marston's engagement by Universal was announced, and in the following month, the psychologist relocated from New York to Universal City, California, to take the position of Director of the Public Service Bureau—a new department that Laemmle opened specifically for him.[87] What exactly did the oldest Hollywood's studio hire him for, and did he fulfill its expectations? We can reconstruct some aspects of Marston's engagement from the period press. Reports on Marston's employment in the period emphasize Universal's desire to improve scripts by matching them to the audiences' preferences: "Professor Marston's duties will be to look over story material with a view to injecting proper psychology into them, to study audience reactions, and to do all those things, which will better gauge public tastes."[88] In an interview, Marston stated that his goal was to help the Studio connect to the audience:

> Mr. Laemmle is making a systematic attempt to get together with the public emotionally. Through his column in the *Saturday Evening Post* he has questioned the public about its likes and dislikes in relation to motion pictures, and has received a tremendous number of helpful and intelligent suggestions. . . . he expects me to apply the knowledge of emotions and human behavior which I have obtained in psychological experiments and clinical cases to select more entertaining and more realistic motion pictures.[89]

Marston's view of his mission may benefit from some contextualization. The founder of Universal, Carl Laemmle was an experienced businessman, who knew the value of maintaining the image that the company cares for the opinion of its patrons. He was indeed always looking for promising scripts and welcomed letters from the public with story ideas and feedback on past productions. Laemmle's biographer describes him as an adventurous entrepreneur and a generous spirit, who liked to take risks and grant opportunities to people who were yet to build their reputation in the film world.[90] Marston was one such example. Another was Laemmle making his twenty-one-year-old son Carl Laemmle,

[86] Lepore, *The Secret History of Wonder Woman*, 132.

[87] Grace Kingsley, "Universal Signs Psychologist: Inventor of Lie Detector Will Analyze U[niversal] Pictures," *Los Angeles Times*, January 11, 1929, A10.

[88] "Psychologist to Assist Universal Production: Professor William M. Marston Engaged by Carl Laemmle to Assist in Injecting Proper Psychology in Motion Pictures," *Motion Pictures* (New York) 5.1 (1929): 7.

[89] Ibid.

[90] John Drinkwater, *The Life and Adventures of Carl Laemmle* (New York: G.P. Putnam's Sons, 1931).

268 PSYCHOMOTOR AESTHETICS

Jr. the head of Universal's productions in the late spring of 1929.[91] Under the young management, the company began to move steadily toward ever more grand and elaborate pictures—"the best that money and brain can devise."[92] This was Universal's strategy to catch up with competitors, because its staple second-tier Westerns and melodramas were no longer doing well in the market. The studio was also racing to integrate sound into its productions. At this time of big changes, the Laemmles were especially sensitive to their script material selection. As the old film magnate put it, "The story which is right emotionally is a natural box-office winner."[93] Apparently, Marston managed to persuade the studio executives that there was a scientific way to determine what is emotionally "right" and would go off well with the public. One journalist speculated that the credit for getting Marston involved was due to the "enterprising young Carl."[94] Marston was appointed to sit in on all scenario discussions of the Board and express his recommendations. Within a few months' of hiring Marston, Laemmle Jr. also brought in the scientist's colleague from Columbia University, the short story writer and philosopher Walter B. Pitkin. He too was to join the business of creating powerful scripts on the basis of Marston's "new psychology."[95]

In addition to securing box-office revenues, there was one more serious issue that the Laemmles had to think about when signing the contract with Marston. This was the pressure from various morality watch groups to purge films of lurid and blasphemous elements. Tensions had been building up for several years already, resulting in Hollywood studios adopting a voluntary Production Code in the late 1929. In fact, Laemmle Jr. was present on the board that approved the resolution about the subjects that should not be shown in films.[96] It is possible that in hiring Marston, the Laemmles took into account his previous service with the National Committee for Mental Hygiene and his familiarity with current bureaucratic standards and discourses on protecting the population's mental health.[97] Marston press releases after joining Universal emphasize the noble goals of cinema, in the vein of old Roman maxim *docere, delectare, movere*. He stated that Universal's films must deliver "a vast preponderance of pleasant impressions," while appeasing vicious inclinations and instructing in the ways of the good.[98] Some ten years later he would recall, with much greater cynicism, that what he did at Universal was try "to out-guess the state censors" and advise producers

91 Drinkwater, *The Life and Adventures of Carl Laemmle*, 235.
92 Ibid., 218.
93 Grace Kingsley, "Universal Signs Psychologist: Inventor of Lie Detector Will Analyze U[niversal] Pictures," *Los Angeles Times*, January 11, 1929, A10.
94 Ibid.
95 "Professor Joins Movies: A Story Expert," *The Times of India*, July 12, 1929, 12.
96 Drinkwater, *The Life and Adventures of Carl Laemmle*, 238.
97 Marston, "Autobiographic entry," 480–482, 481.
98 Kingsley, "Universal Signs Psychologist."

how to reedit films in order to avoid distribution bans and financial losses.[99] In 1929, the Laemmles also used him as a spokesperson to address institutions like The California Federation of Women's Clubs and assure them that "Universal Pictures is heartily in sympathy with the mother's movement to secure not only cleaner, more wholesome pictures for children, but also pictures which are positively constructive in educating the children emotionally in the right way."[100]

Yet Marston's primary professional interest lay in identifying "the real drawing cards" of film scripts and mise en scènes—that is, those elements which, as he thought, were sure to make a film successful with the audience.[101] He believed that one could predict the viewers' emotional reactions to film scenes and thus program the picture in such a way that the spectators would leave the movie hall with the feeling of pleasant satisfaction. Convinced that people come to cinemas to experience powerful thrills, he defined his mission in analyzing the mechanisms of these affective responses for the sake of the industry.

In Marston's theory, an emotion is defined as "the consciousness of an attitude toward an object or person. The attitude may be of alliance or antagonism; and it may make the person feel inferior or superior to the stimulus, which causes the attitude."[102] These four fundamental attitudes combine to make four primary emotions: compliance (giving way to someone or something we perceive as stronger than us and hostile to us); dominance (wanting to vanquish someone or something that we sense is antagonistic to us and weaker than us); inducement (a desire to direct someone or something that we see as weaker than us and positively disposed toward us); and submission (surrendering to the power of someone or something that is stronger than us and favorable toward us). Marston believed that the existence of these four primary emotions could be proved through characteristic neurophysiological signs unique to each of them. Emotions, in his theory, are a kind of energy field propagated through synapses between nerve cells all over the body, from the brain to glands and muscles.[103] His views on the somatic substrate of emotions were indebted to William James's theory. However, he added a modification that we always instinctively take into account our own position within the situation that is causing us an emotional experience. In other words, according to Marston, we feel fear not simply because we find ourselves running away from a bear, as James would have it, but "because we are not running away fast enough."[104] This is why his elementary

[99] Marston, "Autobiographic entry," 480–482, 481.
[100] "Emotion Pictures: A Film Psychologist's Views," *The Times of India*, May 31, 1929, 12.
[101] Grace Kingsley, "Hollywood's First 'No' Man Turns Down Plays," *Los Angeles Times*, January 26, 1929, A6.
[102] Walter B. Pitkin and William M. Marston, *The Art of Sound Pictures* (New York: D. Appleton and Co., 1930), 129.
[103] William M. Marston, "Bodily Symptoms of Elementary Emotions," *Psyche* 38 (1929): 70–86, 70.
[104] William M. Marston, "A Theory of Emotions and Affection Based upon Systolic Blood Pressure Studies," *The American Journal of Psychology* 35.4 (1924): 469–506, 474.

emotions—compliance, dominance, inducement, and submission—reflected the person's self-positioning vis-à-vis the stimulus. He set out to demonstrate the materialization of these emotions in the body by registering changes in his subjects' systolic blood pressure. In a 1929 paper, he wrote that the only difficulty thus far in getting clinical proof of the exact correlation between physiological signs and emotions was due to the fact that people tend to have different reactions to the same stimulus presented to them in the laboratory.[105] Their imagination wanders, they rely on their past experiences, and they have different associations with the same object. However, Marston argued, this methodological problem can be solved by showing the subjects carefully selected film clips. Following the unfolding narrative, forming psychological alliances with heroes, and judging the arising situations is an emotional process, which, as he argued, is going to be uniform for most viewers. "Moving pictures," Marston boasted, "are about the only emotional stimulus in the world that will compel thousands of people to feel the same emotion."[106]

To prove the uniformity of human reactions to movies, Marston measured the systolic blood pressure, the strength of the right hand grip, respiration, and the "psycho-galvanic reflex" of twenty-eight men and twenty-eight women while they watched film scenes intended to evoke the four elemental emotions that he defined.[107] "Compliance" was represented by a clip from *The Student Prince in Old Heidelberg* directed by Ernst Lubitsch (MGM, 1927). In this film, an Austrian prince becomes a university student and falls in love with a commoner only to find out that he would be forced to abandon her if he wishes to succeed to the throne. Marston's clip showed the prince, played by Ramon Navarro, backing away from his courtiers as he succumbed to the unpleasant circumstances of his new position as royalty. This, for Marston, was compliance, and he hoped that his film viewers would feel it by identifying with the lead character. The blood pressure of his subjects showed a drop in 81.4 percent of cases, which he interpreted as a confirmation of his prediction. For "dominance," Marston chose a clip from a gruesome boxing documentary, in which the prizefighter overpowered his opponents. Once again, the spectators were expected to sympathize with the champion. The apparatus recorded a rise of the blood pressure, 70.2 percent of times in accordance with Marston's supposition. "Inducement" was created by love scenes with John Gilbert and Greta Garbo in *Love* and *Flesh and the Devil*— the same films Marston used in the blondes and brunettes' test (Fig. 5.11). In

[105] Marston, "Bodily Symptoms of Elementary Emotions," 70–86, 72.

[106] "Emotion Pictures," 12. On the methodological problem of inducing real emotions in the laboratory setting at the turn of the 20th century, see Otniel E. Dror, "Dangerous Liaisons: Science, Amusement and the Civilizing Process," in *Representing Emotions: New Connections in the Histories of Art, Music, and Medicine*, ed. Penelope Gouk and Helen Hills (London: Ashgate, 2005), 223–234.

[107] Marston, "Bodily Symptoms of Elementary Emotions," 70–86, 76.

Fig. 5.11 A love scene between Garbo and Gilbert in *Flesh and the Devil*, a film used by Marston during testing. Image source: Walter B. Pitkin and William M. Marston, *The Art of Sound Pictures* (New York: D. Appleton and Co., 1930), 134.

these scenes of mutual seduction, according to Marston, each player "induced an attractive person, weaker than himself, to yield to the inducer's commands."[108] The blood pressure of 73.4 percent of Marston's subjects rose in the way he thought it would. Finally, for "submission," Marston chose Fred Niblo's film *The Devil Dancer* (1927) (Fig. 5.12). He used a dance sequence with the actress Gilda Gray, in which, as he phrased it,

> the girl is represented as a captive of Tibetan priests, by whom she had been taught to express submission of the people to their Gods. The dancer's costume, as well as her dance movements, express admirably a willing devotion to her masters.[109]

Reactions to this scene allegedly perplexed Marston, because few of his subjects of both sexes showed any physical signs of "submission." Their blood pressure did not drop, as he expected, but on the contrary, rose. He interpreted this

[108] Marston, "Bodily Symptoms of Elementary Emotions," 70–86, 76.
[109] Ibid.

Fig. 5.12 A scene from *The Devil Dancer* used by Marston to evoke the emotion of "submission." The star of this now lost film was Gilda Gray, a Polish-American actress famous for popularizing the shimmy dance. According to Marston, the scene he selected showed a "captive girl, trained to perform a dance expressive of submission to the Devil God" Image source: Walter B. Pitkin and William M. Marston, *The Art of Sound Pictures* (New York: D. Appleton and Co., 1930), 134.

phenomenon as an indicator that seeing Gilda Gray's dance caused men and women in his test to feel the emotion of "inducement" rather than "submission": they identified not with Gray's character (who was, as Marston described it, meekly giving herself away to the Devil God), but rather with the priests who held her captive.[110] Marston emphasized that it was especially the female viewers who reported verbally that they felt as if they were the "mistresses or captors of the girl dancer," whom they found very attractive.[111]

Marston's discussion of his test results foregrounds not only his beliefs in the physical imprint of affective processes—their materialization in the jumps of systolic blood pressure—but also his perspective on the way in which film viewers relate to the scenes they see. He attempts to theorize the mechanisms of identification and suggestion, proposing that sometimes the viewers sympathize or

[110] Ibid., 78.
[111] Ibid., 79.

identify with the heroes, and sometimes they mimic the attitudes other characters express toward the lead stars.[112] In fact, he thought that the movies influence spectators in a way reminiscent of hypnotic suggestion, because narrative situations with well-delineated character relations are capable of instilling a particular outlook on the events in their minds. He stated that "by showing very clearly through the actions of the leading characters what relations the other characters, the villains, etc. have towards the leading characters, we can compel the people to feel a corresponding emotion."[113] It may be noted that Marston's ideas on the suggestive powers of cinema are somewhat less subtle than Münsterberg's, whose *Photoplay* recognized the spectators' ability to retain independent judgment, even when they are inoculated by the characters' emotions and mimic them somatically.[114]

What makes Marston's theory especially interesting is his head-on confrontation of sexuality and power relations in spectators' reaction to screen images. Indeed, Marston's review of his subjects' reaction to Gilda Gray in *The Devil Dancer* anticipates Laura Mulvey's insights, though without any references to psychoanalysis. An eroticized image of the exotic dancer, with the accompanying Orientalist accouterments, is saturated to the highest degree with that kind of dangerous libidinous energy that Mulvey associates with scopophilia.[115] Marston is sensitive to the seductive pleasures of this spectacle. Yet he believes that the woman is not the victim of the situation. According to his definition of "inducement," Gray is the one who holds the power—she is the queen of the stage, who is well aware of the control that she exercises over those who watch her with avid admiration. Thus endowing the seminude dancer with phallic magnetism, Marston celebrates the pleasure of both male and female spectators. Though it may seem that he is well ahead of his time in validating potentially lesbian tendencies exhibited by his female subjects, his conjecture that the women identified with the dancer's captors suggests that he still operates within a potentially sadistic, male-centered scenario of voyeurism. Laura Mulvey has cautioned against the tendency to ascribe a stereotypically voyeuristic "masculine 'point of view'" to female spectators.[116] Indeed, Marston is only capable of imagining women's desire for the dancer as narcissism, which confirms Mary Ann Doane's observation about the female spectator positioning in mainstream visual

[112] "Emotion Pictures," 12.

[113] Ibid., 8.

[114] Münsterberg, "The Photoplay," 45–164, 105.

[115] Laura Mulvey, "Visual Pleasure and Narrative Cinema," in *Film Theory and Criticism: Introductory Readings*, ed. Leo Braudy and Marshall Cohen (New York: Oxford University Press, 1999), 837–848.

[116] Laura Mulvey, "Afterthoughts on 'Visual Pleasure and Narrative Cinema' Inspired by King Vidor's *Duel in the Sun* (1946)," in *Feminist Film Theory: A Reader*, ed. Sue Thornham (New York: New York University Press, 1999), 122–130, 122.

culture.[117] In a book of advice on scriptwriting that Marston coauthored with Walter Pitkin in 1930, he expounded his convictions about the workings of feminine sexuality and the way it should be represented in cinema.[118] In his theory, women are happy when they know that they are "irresistibly attractive" and that their (masculine) lovers have abandoned all other pursuits.[119] Correspondingly, men in Marston's model enjoy a chivalrous surrender and service to the objects of their desire. His advice for scriptwriters mixed these romantic notions with flapper-girl-era feminism:

> This is an age in which Victorian hokum has gone out of date. The modern girl . . . has repudiated the silly clinging wine formula of the last century. She is determined to exercise her captivation powers over men, frankly and freely, when and as she will. To do this, she has found it necessary to earn her own living and to compete with men in the economic field. . . . Make your screen heroines modern young women. Make them conscious of the fact that woman is, and always has been, the love leader in the affairs of the heart. Make them conquer the world, or at least enough of it to give them a good living. Then show how their economic conquest enables the girls to captivate the men of their choice.[120]

Affirming the screen image of a confident, independent woman, Marston nevertheless implied that she was forever entangled in scenarios of heterosexual romance with marriage resolution, as per the classical Hollywood formula.[121] His use of the blondes and brunettes from the Ziegfeld Follies as attractions in his scientific spectacle amounted to their manipulative exhibition, rather than empowerment. If Marston himself considered his perspective feminist, it was but an immature feminism of the roaring 1920s.

Did Marston's experiments and his conception of the audience's emotional reactions have any tangible consequences for Hollywood's output? This question would require more research in the archives of Universal Pictures in 1929. The trade press reports of that year suggest that his position at the studio was quite influential: he participated in all discussions of film scripts to be taken on for production and had the power to reject or modify story proposals that he thought were destined to fail.[122] One columnist called him "Hollywood's first 'no' man,"

[117] Mary Ann Doane, "Film and Masquerade: Theorizing the Female Spectator," in *Feminist Film Theory: A Reader*, ed. Sue Thornham (New York: New York University Press, 1999), 131–145, 135.

[118] Pitkin and Marston, *The Art of Sound Pictures*, 156–164.

[119] Ibid., 157.

[120] Ibid., 161.

[121] David Bordwell, Janet Staiger, and Kristin Thompson, *The Classical Hollywood Cinema: Film Style and Mode of Production to 1960* (New York: Columbia University Press, 1985), 16.

[122] Kingsley, "Universal Signs Psychologist."

citing his negative evaluation of several plays that Universal was ready to buy, on the basis that audiences would find it hard to relate to the plots.[123] The same journalist names the first film that was "to receive the benefit of the psychologist" in 1929—*Broadway* directed by Pál Fejös and produced by Carl Laemmle Jr.[124] Marston and Pitkin discuss this film briefly in *The Art of Sound Pictures* as an example of a plot that had impressive "intensity and variety of . . . emotional appeals," but which nevertheless risked flopping because at that time, the market was oversaturated with stage plays and movies about "Broadway nightlife and gunmen."[125] In Marston's writings we also find mention of a prescreening test that he did with "a group of 1,000 students at the University of California" for his studio's film *The Love Trap*, directed by William Wyler.[126] In this film, "the rich young husband's family snubbed his wife, a poor young chorus girl. . . . The climax of the picture showed the defeat of the family by the girl" and her righteous revenge.[127] Marston prescreened a version of the film, which ended with the climax and did not contain a coda, depicting how the girl is "enjoying her newly found social prestige."[128] The UCLA audience found the film lacking, which led Marston to formulate a psychological recommendation that movie scripts must tie up all elements in such a way as to produce the "emotion of satisfaction" in the audience, resolving their expectations and wishes for the character.[129] The historian Ken Alder suggests that Marston's boisterous intervention in the production decisions at Universal eventually turned the producers against him, leading to his dismissal at the end of 1929.[130] Although some reports suggest that Marston's performance had not been "satisfactory,"[131] the studio evidently valued the kind of psychological expertise he provided, because they immediately hired Marston's competitor—another lie detector proselytizer, Leonarde Keeler.[132] Keeler would go on to do tests for the thrill value of Universal's horror film *Frankenstein* (1931), using a systolic blood pressure measurement procedure similar to Marston's.[133] According to Jill Lepore, when Marston left Universal, he was briefly hired as a consultant by Paramount, where he gauged the blood pressure of spectators during the prescreening of an early version of *Dr. Jekyll and Mr. Hyde* (1931).[134] After this stint, Marston founded his own production company

[123] Kingsley, "Hollywood's First 'No' Man Turns Down Plays," A6.
[124] Kingsley, "Universal Signs Psychologist."
[125] Pitkin and Marston, *The Art of Sound Pictures*, 20.
[126] Ibid., 154–155.
[127] Ibid., 155.
[128] Ibid.
[129] Ibid.
[130] Alder, *The Lie Detectors*, 187.
[131] Howard T. Lewis, *The Motion Picture Industry* (New York: D. Van Nostrand, 1933), 88.
[132] Ibid., 188.
[133] Ibid.,188.
[134] Lepore, *The Secret History of Wonder Woman*, 141.

called Equitable Pictures in partnership with Walter Pitkin, but it folded at the onset of the Great Depression.[135]

Beyond these anecdotes, the greatest source that can help us reconstruct his potential influence on Hollywood cinema is a guide for beginner scriptwriters that he coauthored with Walter Pitkin, entitled *The Art of Sound Pictures*. It presents the opinions that Marston must have advocated during his time with Universal. Whether he gave the studio new ideas or reinforced the tendencies that already existed is a question that is very difficult to assess. As a psychologist, he was convinced that successful movies balance pleasant and unpleasant emotions, with the former prevailing, especially at the end of the story.[136] This, of course, was not a surprise for Hollywood film producers. However, Marston had very concrete recommendations on what constituted visual and narrative pleasure. Among the four elementary emotions that Marston defined, "compliance" was considered the least pleasant, because the person experiencing this emotion was surrendering to an antagonistic and superior force. "Dominance" was slightly more pleasant, because the subject felt strong enough to resist the opponent. "Inducement" and "submission" ranked the highest on the scale of pleasantness. In *The Art of Sound Pictures*, Marston gave multiple detailed examples of possible scenarios that elucidate each of the four primary emotions. By classifying narrative situations and entire plot lines in these four emotional categories, he intended to provide possible models for scriptwriters. He also described the physiological signs corresponding to each of the emotions, so that the actors portraying them would know what to strive for. In Marston's theory, the four primary emotions could be combined within a short interval of time, producing more complex emotional dispositions, such as joy, sorrow, pity, fear, jealousy, sympathy, and admiration.[137] Depending on the components, these dispositions too could be pleasant, or unpleasant, and it is the task of a good studio producer to ensure that the former wins over the latter.

Marston's conviction about the ranking of the four emotions on the scale of pleasantness was founded on the basis of the grand test, in which he measured the systolic blood pressure of fifty-six male and female viewers exposed to scenes of "compliance," "dominance," "inducement," and "submission."[138] Having ascertained their somatic responsiveness to each of the four film sequences, Marston asked his subjects to rate their experiences. These responses revealed that "women derive greatest pleasure from inducement emotion and least from dominance," while men enjoy "submission" and "dominance."[139] In terms of film

135 Ibid., 142.
136 Pitkin and Marston, *The Art of Sound Pictures*, 128.
137 Ibid., 149.
138 Marston, "Bodily Symptoms of Elementary Emotions," 76.
139 Ibid., 82.

samples, this meant that the women liked the scenes with Greta Garbo enticing John Gilbert and disliked the boxing match; while men liked Gilda Gray's exotic dance and boxing. Marston amplified the status of each of these reactions to the level of psychological law and insisted that this law was universally applicable. Thus, for instance, he analyzed success in Universal's cowboy movie *The Winged Horseman* (1929), explaining that

> Westerns appeal to both men and women, but more to men as there is more action in them than love. For men, they satisfy mostly the emotion of dominance—as when Hoot Gibson finally wins out after deferring to the villain at first. Women find pleasant emotion in seeing the girl get her man. This satisfies their "inducement emotion." They also react pleasantly because both the villain and the hero strive for the girl—which is gratifying to the feminine sex.[140]

These are the type of platitudes that Marston's audience research and emotion theory ultimately amounted to. He called the Western genre a brute force of emotional arousal and suggested that these films were especially suitable for small rural towns. There, Marston stated, the undiscerning audiences "have fewer inhibitions than city folks" and react with wild glee to "the natural simple scenes, such as the hero saving the girl and the villain being foiled by the hero's six-shooter."[141] One hardly needed an extensive psychophysiological testing program to affirm this snobbish opinion. As Lea Jacobs has observed, Hollywood trade press in the 1920s routinely ascribed stereotyped taste preferences to small-town as opposed to metropolitan spectators, and to males as opposed to females. [142] None of these colorful opinions were substantiated by more than hearsay or the speculative opinion of the journalists. However, the authority of Marston's scientific methods and his prestigious doctoral degree granted weight to his pronouncements.

Reflexes of Proletarian and Peasant Spectators

In 1929, the year when Marston was actively engaged in Hollywood, the Soviet critic and performance couch Ippolit Sokolov commended Hollywood

[140] "Western Pictures," *The Times of India*, May 24, 1929, 12.
[141] Ibid.
[142] Lea Jacobs, *The Decline of Sentiment: American Film in the 1920s* (Berkeley: University of California Press, 2008), 20–23. For example, in the 1920s, it became fashionable to assert, without much evidence, that women's sentimental preference for the "weepies" had been replaced by their love for transgressive jazz-era sensuality.

producers for their pragmatic assessment of audience responses, citing the testimony of Carl Laemmle's one-time protégé, the director Ernst Lubitch:

> Since the early years of its existence, the American film industry has established the practice of sneak previews, or the so-called "tests on dogs." In one of his articles, Ernst Lubitsch writes about the pre-screenings of comedies: "New films are usually first screened under a fake title in a small, peripheral movie theater. Studio representatives sitting in the movie hall write down when the audience laughs, when it chuckles, and when it smiles. At the end, laughter, chuckling, and smiles are calculated. For an average success, a two-act comedy must have at least 30 instances of laughter, 40 chuckles, and 25 smiles. Finally, the studio gives each spectator a survey, in which he is asked to state his honest opinion about the film."[143]

Like the Board of Universal Pictures, Soviet film producers and cultural authorities regarded the issue of winning wide audiences a matter of utmost importance. And like the Laemmles, they were intrigued by methods that could aid in this formidable task. On a very basic level, the growing film industries in the United States and Soviet Russia were confronting the same problem: the idea of modeling the mass viewer. According to Miriam Hansen, in the United States, an abstract, universalizing notion of the spectator had formed already around 1910, at the end of the nickelodeon period.[144] The rise of this universalizing category reflected "the industry's efforts to build an ostensibly classless mass audience," "standardize the consumption of films," and reinforce a unifying "consumerist subjectivity" across social divides.[145] To be sure, as Richard Abel has argued, the uniform approach that lumped immigrants and minorities together with Anglo-Saxon cinema patrons concealed the "conflicted principles of inclusion and exclusion" operative in American culture.[146] While in the 1920s direct audience research was only sporadic, in the 1930s and 1940s mature Hollywood studios went on to invent ways of averaging the responses of diverse demographics while investing in production and marketing strategies to increase the universal appeal of their pictures.[147] In Russia, where the growth of the film industry was

[143] I. Sokolov, "Rabotat' na massovogo kinozritelia! (V poriadke obsuzhdeniia)," *Kino i zritel'* 2 (1929); cited in Iu.U. Fokht-Babushkin, "Primechaniia," *Publika kino v Rossii: Sotsiologicheskiie svidetel'stva, 1910–30kh gg.*, ed. Iu.U. Fokht-Babushkin (Moscow: Gosudarstvennyi institut iskusstvoznaniia, 2013), 478.

[144] Miriam Hansen, *Babel and Babylon: Spectatorship in American Silent Film* (Cambridge, MA: Harvard University Press, 1991), 84.

[145] Ibid., 85.

[146] Richard Abel, *Americanizing the Movies and "Movie-Mad" Audiences, 1910–1914* (Berkeley: University of California Press, 2006), 14.

[147] Jacobs, *The Decline of Sentiment*, 19. Sarah E. Igo, *The Averaged American: Surveys, Citizens, and the Making of a Mass Public* (Cambridge, MA: Harvard University Press, 2007); Susan Ohmer, *George Gallup in Hollywood* (New York: Columbia University Press, 2012).

disrupted by the 1917 Revolution, the Civil War, and the economic calamities of War Communism, the re-emergence of domestic cinema as popular entertainment became possible only in the mid-1920s. The lack of equipment and raw film stock, disrupted distribution networks, and inadequate screening facilities throughout the country amounted to a practical catastrophe, which could only be remedied through massive investment and systematic reconstruction under savvy management.[148] The appearance of explicitly commercial productions from 1924 onward was a strategy introduced by the leaders of the national distribution authority Sovkino, Il'ia Trainin and Mikhail Efremov, to amass the critical capital necessary for the industry's development and alleviate the burden on the government's budget.[149] These managers believed that cinema should be self-sustainable and banked on big-budget narrative dramas to target wide audiences at home and abroad. Trainin, in particular, cited Carl Laemmle's efforts in anticipating the spectators' needs as a valuable lesson, noting that while Hollywood releases ideologically shallow films, "there is one general law that the Americans know very well: it is that each film must be engaging."[150] The Bolshevik government had singled out cinema as "the most important of the arts" due to its potential for propaganda, and yet, the ideologically impeccable domestic agit-films never turned profit.[151] For all their anti-bourgeois stance, experimental avant-garde features hardly ever were box-office hits.[152] The dilemma that the Soviet film industry in the 1920s faced was attracting the mass viewer to movie theaters without catering to the "petit-bourgeois" taste.[153]

While the political indoctrination of workers and peasants, as well as the integration of youth into the communist culture had been a priority ever since the Bolshevik Revolution, the actual programs for testing how well various art projects fulfill their "social order" came into prominence only in the second half

[148] Natalie Ryabchikova, "Proletkino: Ot Goskino do Sovkino," *Kinovedcheskie Zapiski* 94 (2010), http://www.kinozapiski.ru/ru/article/sendvalues/1215.

[149] Denise J. Youngblood, *Movies for the Masses: Popular Cinema and Soviet Society in the 1920s* (Cambridge: Cambridge University Press, 1999), 15. Kristin Thompson, "Government Policies and Practical Necessities in the Soviet Cinema of the 1920s," in *Red Screen: Politics, Society, Art in Soviet Cinema*, ed. Anna Lawton (New York: Routledge, 1992), 19–41, 27.

[150] I. Trainin, "Sovetskaia fil'ma i zritel'," in *Publika kino v Rossii: Sotsiologicheskiie svidetel'stva, 1910–30kh gg.*, ed. Iu.U. Fokht-Babushkin (Moscow: Gosudarstvennyi institut iskusstvoznaniia, 2013), 252–266, 265.

[151] Youngblood, *Movies for the Masses*, 17. The designation of "most important art" attributed to Lenin appears in Anatoly Lunacharsky, "A Conversation with Lenin" (1922), in *The Film Factory: Russian and Soviet Cinema in Documents*, ed. Richard Taylor and Ian Christie, trans. Richard Taylor (Cambridge: Cambridge University Press, 1988), 57.

[152] Youngblood, *Movies for the Masses*, 19. Low attendance of avant-garde films became a trump card in the campaign against "formalism" in the late 1920s and early 1930s (see Peter Kenez, *Cinema and Soviet Society from the Revolution to the Death of Stalin* [London: I.B. Tauris, 2001], 98).

[153] Galiia Iusupova, 'S bol'shim material'nym i khudozhestvennym uspekhom... 'Kassovye fenomeny populiarnogo iskusstva 1920-kh gg.: Kino, literatura, teatr (Moscow: Gos. Institut Iskustvoznaniia, 2015), 9.

of the 1920s, when the increasingly powerful institutions began to voice their critique of films that were inaccessible to the masses, ideologically dubious, or did poorly at the box office. In the mid-1920s, numerous research centers devoted to audience studies in the domains of cinema, theater, and other forms of mass spectacle sprung up in Moscow, Leningrad, and regional centers across the USSR. Some of these initiatives were coming from the artists themselves, as in the case of Sergei Eisenstein's former mentor in theater, Vsevolod Meyerhold, and several other prominent theater studios, such as The Mossovet State Academic Theater (MGSPS) in Moscow, The Young People's Theater in Leningrad (TIuZ), and the Yaroslavl Itinerant Theater. Meyerhold's first attempts to evaluate audience feedback on the basis of questionnaires date back to 1921, and in 1925, his troupe pioneered a variety of methods for recording spectators' reactions in the course of the play.[154] Other audience research initiatives were academic: the program of The Committee on Spectatorship at the State Academy of Artistic Sciences (GAKhN) focused on theoretical issues, such as perceptual psychology and sociology of reception, while The Committee on Spectatorship and Readership at the Communist Academy debated the efficacy of ideological education. Yet the most systematic and far-reaching were the initiatives sponsored by the People's Commissariat of Enlightenment (Narkompros)—the Bolshevik government's ministry of propaganda and education. A Narkompros division, called the Artistic Council of the Central Committee for Political Education (*Khudozhestvennyi sovet Glavpolitprosvet*), oversaw audience studies conducted by a special Theater Research Workshop (*Issledovatel'skaia teatral'naia masterskaia*).[155] The influence of cinema on children was investigated by The State Institute of Experimental Psychology, The Krupskaya Academy of Communist Upbringing, the Institute for Methods of Extracurricular Work, and the Institute for Methods of School

[154] D. N. Kozhanov, "Ob uchete reaktsii zritelia. Razrabotka temy po zadaniiu rezhisserskoi gruppy GEKTEMAS" (November 29, 1929), RGALI f. 998 op.1. ed.khr. 2906. Meyerhold pioneered audience questionnaires in 1921 for his productions of *Dawns* and *Mystery-Bouffe* at the RSFSR-1 Theater. His troupe began developing a systematic program for audience observation during performances in 1925 (see M. Zagorskii, "Kak reagiruet zritel'? *LEF* 2 [1924]: 141–151; V. F. Fedorov, "Opyty izucheniia zritel'nogo zala," *Zhizn' Iskusstva* 18 [1925]:14–15; V. F. Fedorov, "Opyty izucheniia zritel'nogo zala," *Zhizn' Iskusstva* 23 [1925]:10–11; Mariia Egorova, *Teatral'naia publika: evoliutsiia anketnogo metoda* (Moscow: Gos. Institut Iskustvoznaniia, 2010), 32.

[155] Glavpolitprosvet began its spectator research in theater and cinema in 1925 ("Kratkii otchtet o rabote komissii po izucheniiu zritelia pri khudozhestvennom otdele Glavpolitprosveta za period oktiabr'-iul' 1925–1926," RGALI f. 645 op. 1. ed.khr. 312 l.118). Some accounts of Glavpolitprosvet's Artistic Council's findings on theatergoers appear in M. Broide, "Izuchenie zritelia," *Novyi Zritel'* 23 (1926):10 and E. K., "Neposredstvennoe izucheniie zritelia," *Novyi Zritel'* 34 (1926): 8. For a review of survey-based film audience studies in the 1920s, see Maia Turovskaia, "Pochemu zritel' hodit v kino," in *Zhanry kino* (Moskva: Iskusstvo, 1979), 138–155. A detailed mapping of various trends in early Soviet film audience research is provided in Anna Toropova, "Probing the Heart and Mind of the Viewer: Scientific Studies of Film and Theatre Spectators in the Soviet Union, 1917–1936," *Slavic Review* 76.4 (2017): 931–958; see also E. Zelentsov, "Iz istorii konkretno-sotsiologicheskikh issledovanii kinozritelia v SSSR," *Trudy NIKFI* 60 (1971): 141–148.

Work.[156] The Society of Friends of Soviet Cinema (*Obshchestvo Druzei Sovetskoi Kinematografii, ODSK*) organized discussions of domestic films in factories and schools and researched the spectators' opinions using surveys.[157] The Association of Revolutionary Cinematography (*Assotsiatsia Revoliutsionnoi Kinematografii, ARK*) often hosted debates on the needs of the proletarian audience and published articles discussing potential methods of reception studies.

From the beginning of the Soviet film industry, many filmmakers and authorities supervising production and distribution sensed that there was a wide cultural divide between ethnic communities in various regions of the USSR, as well as between audiences in large cities and agrarian provinces. Even in large urban centers, spectators' class origins, upbringing, occupation, and age appeared to be significant factors determining their film preferences. To bring these diverse demographics to a common denominator and, moreover, to instill in all of them a correct ideological perspective, was a utopian task that the Soviet film industry hoped to accomplish. Having visited Moscow in 1926, Walter Benjamin captured the scale of this ambition, when he reported:

> The mode of mental reception of the peasant is basically different from that of the urban masses. To expose such audiences to film and radio constitutes one of the most grandiose mass-psychological experiments ever undertaken in the gigantic laboratory that Russia has become.... At the moment, the establishment of an "Institute for Audience Research" in which audience reactions could be studied both experimentally and theoretically is being considered.[158]

Thus approaching the issue of the peasant audiences' encounter with film from an angle that we now associate with the "modernity thesis," Benjamin pointed out that the USSR's grand cultural experiment unfolded on two planes.[159] For

[156] A. M. Gel'mont, "Izuchenie vliania kino na detei," *Kino i kul'tura* 4 (1929): 38–46, 38.

[157] Vincent Bohlinger, "Engrossing? Exciting! Incomprehensible? Boring! Audience Survey Responses to Eisenstein's *October*," *Studies in Russian and Soviet Cinema* 5.1 (2011): 5–27; Peter Kenez, *Cinema and Soviet Society from the Revolution to the Death of Stalin* (London: I.B. Tauris, 2001), 252. For a review of the ODSK's structure and activities, see Richard Taylor, *The Politics of the Soviet Cinema, 1917–1929* (Cambridge, UK: Cambridge University Press, 1979), 99 ff.

[158] Walter Benjamin, "On the Present Situation of Russian Film," in *The Work of Art in the Age of Its Technological Reproducibility and Other Writings on the Media*, ed. Michael W. Jennings, Brigid Doherty, and Thomas Y. Levin, trans. Edmund Jephcott et al. (Cambridge, MA: Harvard Belknap Press, 2008), 323–328, 325. Benjamin's beloved, Asja Lacis, whom he followed to Moscow, would go on to write a book on cinema and children's mental hygiene (Lacis A. and L. Keilina, *Deti i kino* [Moscow: Tea-kino-pechat', 1928]).

[159] "Modernity thesis" refers to the idea that an exposure to cinema and other novel sensory experiences brought about by modern technologies impacted human perception and cognition. For a critical overview of debates surrounding this notion, see Ben Singer, "The Ambimodernity of Early Cinema: Problems and Paradoxes in the Film-as-Modernity Discourse," in *Film 1900: Technology, Perception, Culture*, eds. Klaus Kreimeier and Annemone Ligensa (New Burnet, England: John Libbey, 2009), 37–52.

the diverse audiences across the country, many of whom were experiencing the moving image for the first time, an exposure to film screenings amounted to a test of perceptual schemata and cultural understanding. For the government authorities and film producers, the grand experiment entailed designing methods of engaging viewers and assessing their responses. At an emergent juncture of media theory, aesthetic psychology, and sociology, Soviet researchers of the 1920s were laboring to explain and codify the spectators' affective and cognitive processes.

The challenges of this task were especially prominent when the prioritized demographic was concerned: workers (deemed to be the vanguard of the Revolution), peasants, multiethnic communities in Soviet republics, and children—the future builders of socialism. From the official standpoint, these social groups appeared at once the most impressionable, and therefore requiring guidance, and the most elusive when reporting their feelings about films. It is in dealing with these groups that psychophysiologicial methods of reaction studies appeared especially useful. A 1925 article published in the journal *Kinozhurnal ARK*, which frequently discussed the issue of the cinefication of rural communities, is exemplary in presenting the rationale behind reflexological studies of peasant viewers. [160] The author, Anatolii Terskoi, who had served as a traveling film-show organizer, points out that populations of different regions of the Soviet Union are prepared for film screenings to different degrees: a Siberian from a hunter-gatherer community can be expected to have more trouble relating to a film coming from Moscow than an artisan living in an advanced agricultural region in European Russia.[161] Questionnaires are for the most part inadequate, because they impose a straightjacket on the viewers' responses, failing to capture more spontaneous, unforeseen points of view.[162] Direct observation of the audience also gives incomplete results, because the researcher can never pay attention to all individuals in the dark screening hall.[163]

[160] Terskoi, "S"emka refleksov litsa kak material izucheniia derevenskogo zritelia," 10–12. The issue of peasants' inability to relate to films and provide meaningful feedback was frequently discussed on the pages of this journal. Thus, the filmmaker Iurii Tarich, like Terskoi, proposed registering attentiveness, laughter, coughing, and other "objective" reaction signs throughout screenings (see Iurii Tarich, "Ob"ektivom k derevne," *Kinozhurnal ARK* 10 [1925]: 15). The photographing of audience reactions was also discussed in A. Katsigras, "Opyt fiksatsii zritel'skikh interesov" (1925), *Publika kino v Rossii: Sotsiologicheskiie svidetel'stva, 1910–30kh gg.*, ed. Iu.U. Fokht-Babushkin (Moscow: Gosudarstvennyi institut iskusstvoznaniia, 2013), 307–308; G. D. "Izuchenie krest'ianina-zritelia," *Sovetskii Ekran* 11 (1925); L. Skorodumov, "Issledovatel'skaia rabota so zritel'skim kinoaktivom," in *Publika kino v Rossii: Sotsiologicheskiie svidetel'stva 1910–30kh gg.*, ed. Iu.U. Fokht-Babushkin (Moscow: Gosudarstvennyi institut iskusstvoznaniia, 2013), 320–327, 327.

[161] Terskoi, "S"emka refleksov litsa kak material izucheniia derevenskogo zritelia," 10.

[162] Ibid.

[163] Ibid.

Тип крестьянина

Fig. 5.13 A photograph from Terskoi's article entitled "A Peasant Type." Image source: A. Terskoi, "S"emka refleksov litsa kak material izucheniia derevenskogo zritelia," *Kinozhurnal ARK* 8 (1925): 10–12, 10. I am indebted to Maxim Pozdorovkin for locating this source.

As an ethnographer, Terskoi advocated the use of a hidden camera to photograph "the facial reflexes" of the public (Fig. 5.13). Citing Darwin's *Expression of Emotions* as a theoretical source, he argued:

> Considering the fact that emotional states are expressed all over the world in a remarkably similar manner, our study of expressive facial muscles and reflexes provides useful material for examining the emotions of a peasant audience. By comparing these emotions to those intended by the director, we can see whether a given film has succeeded, and whether its compositional structure is suitable for the rural audience of this particular region.[164]

[164] Ibid.

Terskoi reported to have implemented this method in the Smolensk region, taking approximately one hundred shots of audience faces at climactic moments of Ivan Perestiani's film *In the Days of Struggle* (*V dni bor'by*, 1920). For Terskoi, photographs appeared to be an infinitely more revealing and trustworthy source than interviews with spectators. He believed that after the screening, peasants usually "could not sort out their feelings" and failed to verbalize what aspects of the film impressed them.[165] In addition, he claimed, very few examiners from the city could establish the necessary rapport with peasant audience to get a sincere and detailed commentary. The faces of rural spectators, on the other hand, appeared to researchers like Terskoi to be a transparent manifestation of everything that is going on in their naive psyche. As Terskoi's colleague Aleksandr Katsigras, also employed in the rural cinefication movement, put it:

> The peasant, untouched by the visual culture of cinema, nor by the conceptual culture of the book, reacts to films with all immediacy. The inner world of feelings is expressed, as in a mirror, in his facial expressions, posture, gesture, and actions.... As I have already stated elsewhere, "the impact of cinema on the peasants may be compared to the impression produced by a mythical painter, whose images of fruit made birds flock to the painting and peck it."[166]

In foregrounding the supposed transparency of the body, authors such as Terskoi and Katsigras thus effectively deprived the rural subjects of language, turning audience research into a matter of detached surveillance. Terskoi, in particular, relegated the duty of registering and interpreting human reactions to the all-seeing eye of the camera. The experimenter fantasized about the possibility of complementing the snapshots with film camera footage, in order to get both the highlights and the ongoing record of audience activity:

> Film footage showing the spectators' emotions shot-by-shot would allow us to evaluate all changes of facial reflexes, revealing all nuances in the gradual course of experience. This would enable us to mark all rises and falls in the perception of any given person in relation to moments of film action. Converting this data into charts, we could compare the resulting curves and find a median demonstrating the reception of the film by the masses.... Based on the audience's reflexes we can find out how it reacts to one or another formal element of the movie.... We will see what effects are produced by details and close-ups, whether the intertitles were readable.... The montage of the film also

[165] Ibid.
[166] Katsigras, "Opyt fiksatsii zritel'skikh interesov," 305.

lends itself to assessment. The curves will reveal which regions need elementary narrative exposition and where the American editing is suitable.[167]

In Terskoi's proposal, the observer's camera is given the same function as the sphygmomanometer and the plethysmograph in Toulouse and Mourgue's and Marston's spectatorship tests. Like his Western counterparts, the Russian examiner was eager to obtain charts of the unfolding neurophysiological materializations of emotions in real time. What distinguished his methodological ideas from the previous examples of psychophysiological reaction studies was that Terskoi planned to pay attention not only to the narrative and character relations in particular scenes, but also to the formal features, such as editing style. It is likely that his perspective on what constitutes the film's powers of impression was nourished by the Soviet avant-garde theorists' discourse.

Terskoi's photographs of facial expressions, which he calls "reflexes" in recognition of the broader cerebral mechanisms involved in regulating behavior and adapting to the environment, is a practical application of the reflexological theory of spectatorship born in the avant-garde circles. In 1923, Sergei Eisenstein and Sergei Tret'iakov at the Proletkult theater proclaimed that an effective performance should be structured as a chain of "attractions," or "aggressive moments," that exert "calculated pressure on the spectator's attention and emotions" and guide his or her psychophysiological responses in a specific, ideologically advantageous direction.[168] In "The Montage of Film Attractions" (1924), Eisenstein recast this thesis in reflexological terms and applied it to cinema, asserting that "the method of agitation through spectacle consists in the creation of a new chain of conditioned reflexes by associating selected phenomena with the unconditioned reflexes they produce."[169] Eisenstein stated that agitational films appeal to the baggage of universal, instinctive reactions and link them to new stimuli, thereby ingraining new attitudes in the audience's mind and inculcating "the conditioned reflexes ... useful to our class."[170]

Eisenstein referenced Ivan Pavlov's experiments, in which dogs were trained to salivate in response to a random signal, such as a needle prick, which repeatedly accompanied their feeding. In Pavlov's terms, a "conditioned reflex" was built on the substrate of the dogs' evolutionary adaptation mechanism—an inborn, automatic reaction of salivation (an "unconditioned reflex"). Pavlov maintained that

[167] Ibid., 11.

[168] Sergei Eisenstein, "The Montage of Attractions," in Selected Works, ed. and trans. Richard Taylor, vol. 1 (London: I.B. Tauris, 2010), 33–38, 34. See also Sergei Tret'iakov, "The Theater of Attractions," trans. Kristin Romberg, October 118 (2006): 19–26, 23.

[169] Sergei Eisenstein, "The Montage of Film Attractions," in Selected Works, ed. and trans. Richard Taylor, vol. 1 (London: I.B. Tauris, 2010), 39–58, 45.

[170] Sergei Eisenstein, "The Method of Making a Worker's Film," in Selected Works, ed. and trans. Richard Taylor, vol. 1 (London: I.B. Tauris, 2010), 65–66, 66.

a conditioned reflex can only be formed on the basis of the unconditioned one if the latter has a "dominant" status for the organism, for example, if the dog indeed always responds to food by salivation. As the dog senses food, specific areas of its cortex and subcortex become a source of persistent excitation, causing the organism to produce saliva while inhibiting any other possible reactions. When a random, conditional signal, such as a sound of the bell, gets picked up by the cortex, it becomes associated with the ongoing dominant excitation.[171]

An early attempt to apply this principle can be found in Eisenstein's *Strike* (*Stachka*, 1925): the director deliberately appeals to the audience's maternal instinct in order to instigate hatred against the Cossacks, who, in the course of suppressing the workers' uprising, throw one proletarian baby down the stairwell and nearly trample another child by their horses. The calculation is that the audience's dominant reaction of protectiveness toward the endangered baby would translate into the revolutionary class-consciousness. It is important to note that in Pavlov's theory, conditioned reflexes are mindless automatisms, geared toward helping the organism adjust to the environment. Yet Pavlov regarded these reactions as elemental building blocks explaining larger behavioral tendencies. Reflexology blurred the lines between conscious effort and unconscious predisposition, between willful action and instinctive drive. Pavlov saw his task in breaking down behavioral patterns into concrete constituents, that is, identifying combinations of reflex excitation and inhibition within the animals' neural system, triggered by carefully controlled stimuli. In his experiments, Pavlov persistently focused only on the reflex of salivation, rather than more sophisticated reactions.[172] Though he saw his research on dogs as relevant for understanding human psychology, he was reluctant to make far-reaching claims in the area that was outside his expertise.[173] Despite Pavlov's commitment to purely neurophysiological investigations, in the politicized climate of the 1920s, reflexology became an applied science.

Eisenstein's evocation of conditioning in relation to such a sophisticated cognitive act as film interpretation was ridden with problems, many of which the director sensed. For one, this model presupposed the existence of universally effective visual stimuli and did not account for the possibility of idiosyncratic, unpredictable responses. As we saw in Chapter 4, Eisenstein tempered his

[171] The notion of the "dominant" was elaborated by Pavlov's contemporary, Aleksei Ukhtomskii, and goes back to Ukhtomskii's teacher Nikolai Vvedenskii and, ultimately, to Richard Avenarius (A. Ukhtomskii, *Dominanta: stat'i razykh let, 1887–1939* [Sankt-Peterburg: Piter, 2002], 98).

[172] This was a major flaw of Pavlov's methodology, according to his competitor Vladimir Bekhterev, who argued that salivation plays but a modest role in animals' and, especially, humans' adaptive response to environmental stimuli (B. R. Hergenhahn, *An Introduction to the History of Psychology* [Belmont, CA: Wadsworth, 1992], 346).

[173] Ivan Pavlov, "Otvet Fiziologa Psikhologam," in *Dvadtsatiletnii Opyt Izucheniia Vyshei Nervnoi Deiatel'nosti (Povedeniia) Zhivotnykh* (Moskva: Nauka, 1973), 370–395.

enthusiasm about the possibility of reflexologically programming the audience's experience with an ironic observation that catering to spectators' instincts often results in representational clichés.[174] By the end of the 1920s, Eisenstein no longer considered reflexology a source of simple explanations for films' captivating power, but rather a springboard for the more sophisticated exploration of human perception and interpretation. Euphoria has given way to sarcasm, as in this frustrated exclamation in "My Art in Life" (1927): "Go try finding amidst Pavlov's saliva and dominants an answer to the question of how you should dress your actress, or whether you should cut out the repeated shot in the montage sequence!"[175] Nevertheless, the idea that films and other cultural phenomena take advantage of unconditional reflexes to build a superstructure of tendentious conditioned reflexes in the audience's nervous system remained a basic principle in Eisenstein's film theory throughout his life.

The prestige of reflexology compelled many Soviet authors to describe film viewing with references to Pavlov's insights. In her essay "Reflexes in Cinema" (1926), the scriptwriter Nina Agadzhanova-Shutko, Eisenstein's collaborator on the script for *The Battleship Potemkin*, used reflexological terminology to tackle the issue of the viewers' absorption in the spectacle:

> The shot is composed out of things: the model-actor [*naturshchik*], objects, and light. The construction of the shot requires a careful selection of objects in order to achieve the required visual effect. A better understanding of the properties of each thing, a stricter choice of objects, and more correct relations between shots bring about the highest and fullest visual reflex. We get a "click," because the stimuli are working and acting upon the viewer, compelling him to feel the maximal plenitude of impressions, while temporarily suspending all other reflexes. The viewer "forgets" where he is.[176]

In this presentation, the notion of "reflex" refers to an amalgam of emotional, cognitive, and somatic reactions. Getting engrossed in the spectacle requires the inhibition of irrelevant reflexes, that is, reactions that have nothing to do with the film. Agadzhanova echoes Eisenstein's recognition of the cultural-sociological factors that influence film reception, by suggesting that screen stimuli do not

[174] Eisenstein, "The Montage of Film Attractions," 39–58, 45.
[175] Sergei Eisenstein, "My Art in Life" (1927), *Kinovedcheskie zapiski* 36/37 (1997–1998): 13–23, 14–15.
[176] N. Agadzhanova, "Zametki o refleksakh v kino," *Kinofront* 9–10 (1926): 23–24. For an analysis of Agadzhanova's position in the context of Soviet film theory in the 1920s, see N. Khrenov, "K probleme sotsiologii i psikhologii kino 1920-kh gg," *Problemy kinoiskusstva* 17 (1976): 163–184; Natalie Ryabchikova, "Nina Agadzhanova-Shutko," in *Women Film Pioneers Project*, ed. Jane Gaines, Radha Vatsal, and Monica Dall'Asta, New York: Columbia University Libraries, 2016, https://doi.org/10.7916/d8-rswd-9k23.

always resonate with all spectators, depending on their background and past experiences. Moreover, film viewers differ with regard to their capacity for critical reflection: spectators with a more "advanced nervous organization" are harder to win over and require "stronger" stimuli to get captivated by the screen.[177]

The most sophisticated reflexological spectator testing program in Soviet Russia in the 1920s was put forward by the Theater Research Workshop (*Issledovatel'skaia Teatral'naia Masterskaia*, ITM) at the Glavpolitprosvet of the Narkompros Ministry. Led by Andrei Troianovskii, Ruben Egiazarov, and Evgenii Konstantinovskii, the ITM began its work in 1925.[178] Despite its title, the Theater Research Workshop had very broad interests, defining its goal as the "scientific examination of issues related to the building of Soviet spectacle culture [*zrelishchnaia kul'tura*]: theater, cinema, popular music, circus, and amateur performance clubs."[179] Approaching the "spectacle" as a "matter of bio-social order," the ITM committed to using "strictly objective methods of modern materialist science" and battling the antiquated "introspective-descriptive" data collection.[180] It also sought to foster new cadres qualified to conduct research and serve as "theorists of the spectacle culture."[181] From the point of view of Glavpolitprosvet, the propaganda division of the Narkompros that oversaw the ITM, the urgent task of culture policy was to assess the actual audiences' tastes and make use of their preferences when targeting them with ideological content.[182] In the words of one the ITM's consultants, Viktor Pertsov (a literary critic affiliated with the Left Front of the Arts and Aleksei Gastev's Central Institute of Labor),

the objective of studying film audience lies in the scientifically managed control of our film products' impact. . . . Fundamentally, a feasible goal of such control is to execute a correct artistic maneuver, given the viewers' cultural level. . . . The control data regarding the impact of films on viewers of particular class [*klassovyi zritel'*] must become part of the objective science of cinema.[183]

[177] Agadzhanova, "Zametki o refleksakh v kino," 24.

[178] Andrei Troianovskii and Ruben Egiazarov, "Izuchenie kinozritelia (po materialam Issledovatel'skoi Teatral'noi Masterskoi)," in Iu.U. Fokht-Babushkin, ed. *Publika kino v Rossii*, 346–397, 396.

[179] "Programma Issledovatel'skoi Teatral'noi Masterskoi," RGALI f. 645 op.1. ed. khr. 312. l. 115. "Spisok rabotnikov Issledovatel'skoi Teatral'noi Masterskoi na 15 dekabria 1927 g.," RGALI f. 645 op.1. ed. khr. 31 l.117.

[180] "Programma Issledovatel'skoi Teatral'noi Masterskoi," RGALI f. 645 op.1. ed. khr. 312. l. 115.

[181] Ibid.

[182] Iusupova, 'S bol'shim material'nym i khudozhestvennym uspekhom, 245–246.

[183] V. Pertsov, "Izuchenie kinozritelia v sviazi s postroeniem khudozhestvenno-proizvodstvennogo plana" (April 1926), RGALI f. 645 op. 1 ed.khr. 312 l. 123. An expanded version of this paper appears in V. Pertsov, "Reshaiushchaia instantsiia: k voprosu ob izuchenii kinozritelia" (1926), *Publika kino v Rossii: sotsiologicheskiie svidetel'stva 1910–30kh gg.*, ed. I. Fokht-Babushkin (Moscow: Gosudarstvennyi institut iskusstvoznaniia, 2013), 315–319.

In their quest to elaborate a successful methodology, the leaders of the ITM culti-
vated relations with other centers of audience research by inviting guest speakers,
observing existent procedures of data collection, and giving talks at institutions,
such as GAKhN and the Communist Academy (intriguingly, the latter organi-
zation was cited by Sergei Eisenstein as a sponsor of his reflexological audience
test at the Polytechnical Museum in 1928, which makes it not unlikely that the
director may have been at least indirectly familiar with the ITM's methods).[184]
Polling via postscreening questionnaires remained ITM's preferred method of
assessing the audience's views, along with collecting attendance statistics.[185] But
in addition to gathering verbal feedback, the Workshop also developed other
forms of audience research, which involved the direct observation of spectators'
reactions. Initially inspired by charts of audience behavior pioneered by
Vsevolod's Meyerkhol'd GEKTEMAS studio, the ITM's methods of registering
spectators' responses were deeply steeped in physiological psychology.[186] Thus
the ITM's program statement reveals a thoroughly reflexological perspective:

The spectacle is an innervating stimulus [razdrazhaiushchii stimul] and the
spectators are an organized mass that is being innervated. . . . Stage stimuli
evoke a series of viewer reactions—conditioned and unconditioned reflexes. . . .
We must study the nature of factors that combine to make up the innervating
stimulus, that is, the spectacle. . . . The conditioned and unconditioned reflexes
[of the spectators] are the visual and auditory phenomena, which the observer
must register during the performance in a special chart. . . . For the purposes
of statistical analysis, the play must be divided into segments based on the so-
cial and psychological content. The most vivid, self-evident impressions from
these scenes (i.e. dominants) are imprinted on the spectator's cortex each mo-
ment. . . . The physiological processes accompanying the viewers' reflexological
reactions (pulse, respiration, etc.) must be recorded by special equipment. Such
recording is impossible for all audience, and thus should be conducted for se-
lect spectator groups in a special experimental lounge. . . . These subjects will
also be used to investigate the "firm imprint" that the spectacle will have left on

[184] Troianovskii's lectures at GAKhN in 1926 and 1927 are listed in V. G. Iakushkina, ed.,
"Vopsrosy izucheniia zrelishchnykh iskusstv v Gosudarstvennoi Akademii Khudozhestvennykh
Nauk (GAKhN), 1921–1930 gg," Zrelishchnye iskusstva: referativno-bibliograficheskaia informatsiia
1 (1995): 22, 28. Troianovskii's professional relationship with the Communist Academy has been
noted in N. M. Lukianova, "Osvnye etapy sotsiologicheskoi razrabotki problem kinoauditorii," in
Sotsiologiia vchera, segodnia, zavtra, ed. O.B. Bozhkov (St. Petersburg: Eidos), 265–284, 267.
[185] Issledovatel'skaia Teatral'naia Masterskaia,"Kratkii otchtet," l.118. The Workshop's early
methods are also described in Andrei Troianovskii and Ruben Egiazarov, "Izuchenie kinozritelia
(1928)," Iu.U. Fokht-Babushkin, ed. Publika kino v Rossii: Sotsiologicheskiie svidetel'stva 1910–30kh
gg. (Moscow: Gosudarstvennyi institut iskusstvoznaniia, 2013), 346–397).
[186] Troianovskii and Egiazarov, "Izuchenie kinozritelia," 377.

their nervous system. This "firm imprint" amounts to the educational impact of the spectacle.[187]

The view of the audience that emerges from this statement—"the mass that is being innervated"—echoes the rhetoric of Soviet avant-garde theorists, particularly Sergei Eisenstein's and Sergei Tret'iakov's theory of attractions. The idea that the play leaves an "imprint" on the cortical reflexes recalls Aleksei Gastev's belief in reinforcing socially useful brain synapses through training (see Chapter 3). The notion of the "dominant" references both the Formalist concept of a salient stylistic device, and Pavlov's and Ukhtomskii's idea of the prevalent source of nervous excitation in the cortex that supersedes all other behavioral reactions of the organism at a given moment.[188]

All in all, the ITM's program emphasized a biological perspective on the audiences' responses, where even reflection and judgment were deemed "reflexes of the higher order: esthetic, intellectual, and ethical."[189] The ITM's protocol for the use of the "experimental lounge" envisaged cooperating with the producers of the show to note the intended "sequence of the dominants" [khod dominant], defined as "the most vivid and clearest concentration of stimulants from the outside world, as well as internal excitations of the organism [presented] within the cortex at specific moments."[190] This sequence, coupled with a libretto [montazhnyi list], would serve a baseline against which the spectator's reactions were tested. The experimenters planned to register not only the psychophysiological experiences of the viewers, but also the performers enacting the drama onstage. The subjects' vital signs would be taken before and after the spectacle, so as to measure the effects of impressions reverberating through their bodies. Procedures for the use of the lounge prescribed a two-step examination process: first came the "medical" part and then the "experimental-reflexological" one.[191] The first stage involved a physical exam, including "anthropological data," "somatic data," "breathing (spirometry)," "dynamometry," "aesthesiometry," "ergography," "blood analysis," and "blood circulation" characteristics, such as "pulse, plethysmography, and blood pressure."[192] The second stage investigated the subject's perceptual, cognitive,

[187] Issledovatel'skaia teatral'naia masterskaia, "Tezisy doklada o metodakh izucheniia teatral'nogo zritelia," RGALI f. 645 op.1. ed. khr. 312. l. 159.

[188] The concept of dominanta was used by the Russian Formalists, such as Iurii Tynianov and Boris Eikhenbaum, to denote the prevailing stylistic principle of the artistic composition, which impacts the audience's perception of all other elements. The Formalists borrowed this concept from Broder Christiansen. See Carol Any, "Russian Literary Formalism," in Routledge Encyclopedia of Philosophy. Volume Eight: Questions to Sociobiology, ed. Edward Craig, London: Routledge, 1998, 409–413.

[189] Issledovatel'skaia teatral'naia masterskaia, "Protocol No. 14. Uslovnye refleksy vysshego poriadka: esteticheskiie, intellektual'nye, nravstvennye," RGALI f. 645 op.1. ed. khr. 312. l. 121.

[190] Ibid.

[191] Issledovatel'skaia teatral'naia masterskaia, "Nabliudenie zritelia eksperimental'noi lozhi," RGALI f. 645 op.1. ed. khr. 312. l. 113.

[192] Ibid.

and affective processes. The laboratory assistants had to test the subjects' motor reactions to auditory stimuli, the memory and forgetting curve (i.e. "inhibition of conditioned reflexes"), and their capacity to make abstract generalizations (i.e., "memory for the dominant notion and idea").[193] Cognitive processes to be taken into account included responsiveness to specific stimuli, associations, and the "motoric elements of thinking," such as "speech," and "facial expressions."[194] Affective responses to be recorded consisted of unconditioned reflexes, instincts, and primeval feelings of pleasure, displeasure, and pain.[195] In another methodological protocol, the ITM stated that these psychophysiological indices had to be mapped onto other variables, including the audience's sociological data and the hygienic conditions of the show: the largeness of the hall, ventilation, temperature, and seat quality.[196]

The ITM's archive has not preserved any reports on the studies conducted using the "experimental lounge," although it is clear that the leaders of this organization attached importance to laboratory testing.[197] We do not know whether the tests had actually been done and, if so, what results they yielded and what conclusions were drawn from them. There is one piece of evidence that proves that the Workshop's plans for the "experimental lounge" were serious. It is a surviving budget that lists the prices of various psychological instruments, the salaries of the experimenters, and remunerations for spectators and performers to be tested.[198]

The extant research materials of the ITM include its multiple observation records for audience behavior as a group, rather than individuals tethered to psychophysiological sensors. The ITM regularly published its statistical data on audiences' laughter, applause, and other forms of reactions to various theater performances in the journal Zhizn' Iskusstva (The Life of Art).[199] A surviving original chart, designed by the ITM for its fieldwork, reveals that the observers treated even the slightest and seemingly irrelevant body motions and unconscious actions such as coughing or munching as potential clues in judging the viewers' engagement (Figs. 5.14–5.15, Tables 5.1, 5.2). The ITM's chart invites the observer to evaluate the "energy characteristics" of motor reactions and

[193] Ibid.
[194] Ibid.
[195] Ibid.
[196] Issledovatel'skaia teatral'naia masterskaia, "Protokol No. 14. Uslovnye refleksy vysshego poriadka: esteticheskiie, intellektual'nye, nravstvennye," RGALI f. 645 op.1. ed. khr. 312. l. 121.
[197] Troianovskii and Egiazarov, "Izuchenie kinozritelia," 383.
[198] "Smeta po issledovaniiu tsirkovogo aktera i zritelia," RGALI f.645 op.1. ed. khr. 312.l.226.
[199] Issledovatel'skaia Teatral'naia Masterskaia, "Otello-Rossov i zritel': Zamoskvoretskii teatr" Zhizn' iskusstva 23 (1925): 11; Issledovatel'skaia Teatral'naia Masterskaia, "Rozita v moskovskom Kamernom Teatre," Zhizn' iskusstva 16 (1926): 15; Issledovatel'skaia Teatral'naia Masterskaia, "Konets Krivoryl'ska-zare navstrechu! v Teatre Revoliutsii," Zhizn' iskusstva 15 (1926): 14–15.

Театр -
Спектакль -

Сетка записи рефлексс зрительн

БЕЗ СЛОВНЫЕ РЕФЛЕКСЫ И ИНСТИНК...

1. Смех
2. Плач
3. Кашель
4. Зевота
5. Вздох
6. Чихание
7. Еда
8. Двигательное беспокойство
9. Приподнимание с мест
10. Пластическая помощь актеру
11. Шум
12. Переглядывание (механическое)
13. Расслабление
14. Напряжение
15. Наклонение к сцене
16. Ритмическое колебание
17. Комплекс наступательных движений
18. -»- оборонительных -»-
19. Зрительный
20. Слуховой
21. Мимические напряжения на внешние раздражения

УСЛОВНЫЕ РЕФЛЕ'СЫ

22. Переглядывание
23. Перемигивание
24. Приподымание с мест
25. Шарканье
26. Шиканье
27. Стук
28. Свист
29. Аплодисменты
30. Разговор между собою
31. Коллективные реплики
32. Индивидуальные -»-
33. Разговор с актером
34. Пение индивидуальное
35. -»- коллективное
36. Расслабление
37. Напряжение
38. Передвижение по залу
39. Выход из зала
40. Бросание предметов на сцену
41. Вбегание на сцену
42. Помогание актеру
43. Ораторские выступление
44. Зрительный - избирательного типа
45. Слуховой - -»- -»-
46. Мимич. напряж. на изоляции внешн. раздраж.

Отметки Исследоват. Театральной Мастерской:

Подпись заполнявш сетку

Fig. 5.14 The left side of "The Chart for Recording Audience Reflexes" developed by the Theater Research Workshop. Image source: RGALI f. 645 op.1 ed. khr. 312. l. 228.

other neurophysiological processes. Specialized terms, derived from Pavlov's teachings on the higher nervous activity, are used to characterize the dynamics of viewers' reactions, such as "excitation" (the activation of a reflex), "inhibition" (the slowing down and stopping of a reflex), "irradiation" (the spread of inner-vation), and "induction" (positive—the activation of cortical areas adjacent to

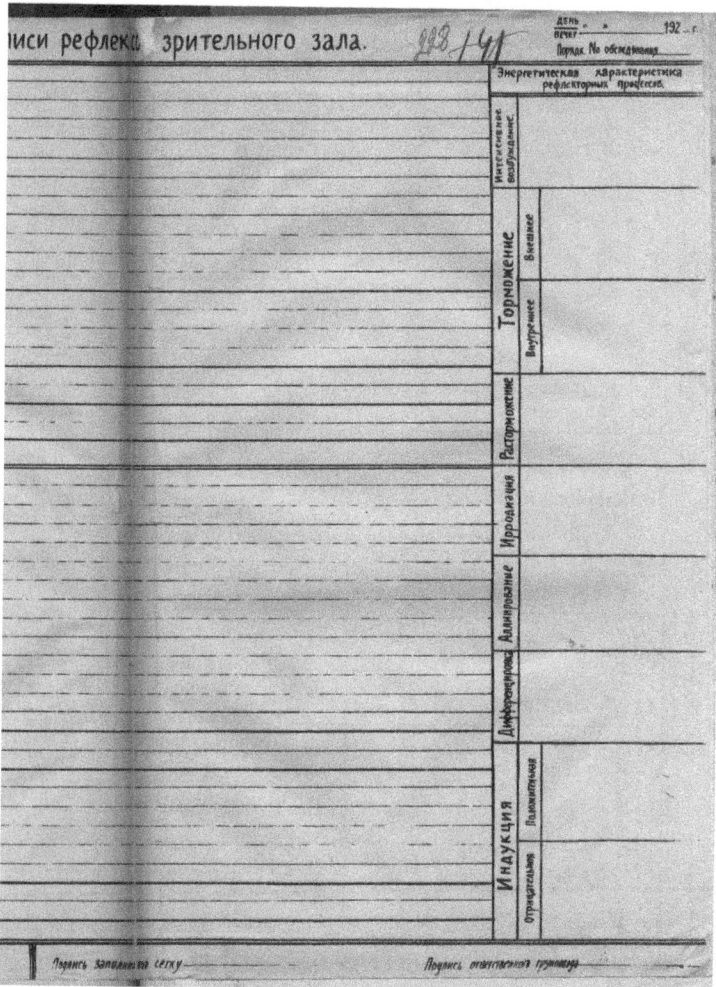

Fig. 5.15 The right side of "The Chart for Recording Audience Reflexes" developed by the Theater Research Workshop. Image source: RGALI f. 645 op.1 ed. khr. 312. l. 228.

the source of excitation; negative—the extinction of activity near the source of excitation).[200] The objective signs of the audience's absorption in the spectacle, according to the chart, include such physical actions as leaning toward the stage and swaying rhythmically. The ultimate peak of engagement consists of running

[200] For a discussion of these terms in Pavlov's oeuvre, see Roger Smith, *Inhibition: History and Meaning in the Sciences of Mind and Brain* (London: Free Association Books, 1992), 198.

Table 5.1 A Translation of the Chart for Recording Audience Reflexes (left side), shown in Fig. 5.14

Theater:			
Performance:			GRAPH FOR RECORDING AUDIENCE REFLEXES
UNCONDITIONAL REFLEXES AND INSTINCTS	Facial and bodily reflexes	Reflexes of the acoustic-kinetic type	1. Laughing
			2. Crying
			3. Coughing
			4. Yawning
			5. Sighing
			6. Sneezing
			7. Eating
			8. Movement disquietude
			9. Rising from the seats
			10. Aiding the actor by movement
			11. Noise
			12. Exchanging glances (instinctive)
		Reflexes of the muscular tonus	13. Relaxation
			14. Straining
			15. Leaning toward the stage
			16. Rhythmical oscillation
		Coordination of movement	17. A system of offensive movements
			18. A system of defensive movements
	Reflexes of attention	Orientation reflexes	19. Visual
			20. Auditory
		Inner concentration	21. Facial straining in response to an external stimulus
CONDITIONAL REFLEXES	Facial and bodily reflexes	Reflexes of the acoustic-kinetic type	22. Exchanging glances
			23. Exchanging winks
			24. Rising from the seats
			25. Shuffling
			26. Booing
			27. Knocking
			28. Whistling
			29. Applause
			30. Talking among each other
			31. Collective comments
			32. Individual comments
			33. Talking to the actor
			34. Singing, individual
			35. Singing, collective
		Reflexes of the muscular tonus	36. Relaxation
			37. Straining
		Coordination of movement	38. Moving about the hall
			39. Exiting the hall
			40. Throwing something onto the stage
			41. Running up onto the stage
			42. Helping the actor
			43. Orator's speech
	Reflexes of attention	Orientation reflexes	44. Visual, of selective kind
			45. Auditory, of selective kind
		Inner concentration	46. Facial straining to screen out external stimuli

Notes by the Theater Research Workshop:

Table 5.2 A Translation of the Chart for Recording Audience Reflexes (right side), shown in Fig. 5.15

	Day/Evening dd/mm/192___	
	Examination number:	
	Energy characteristics of the reflexological processes	
	Intense excitation	
	Inhibition	External
		Internal
	Disinhibition	
	Irradiation	
	Alliance	
	Differentiation	
	Induction	Positive
		Negative

Signature of the staff member filling in this graph: Signature of the team supervisor:

up onto the stage and helping the actor. Undoubtedly, the inclusion of this peak level was a nod to the concept of participatory theater made fashionable by Nikolai Evreinov, Vsevolod Meyerhold and Sergei Eisenstein.

The ITM used its multistage gradation of spectators' responses not only in the theater, but in the cinema as well. Listing potential reactions on the scale from zero interest to "active intervention in the course of action," the ITM staff drew flowcharts, reminiscent of cardiograms. Table 5.3 (Fig. 5.16) and Fig. 5.17 show one such graph made in 1926, which represents the audience's reactions to Eisenstein's drama *The Battleship Potemkin*. The audiences' verbal remarks tied to various moments of the narrative were meticulously recoded on a separate sheet.[201] Other films investigated by the ITM in a similar manner included the revolutionary blockbuster *Strike* (dir. Sergei Eisenstein, USSR, 1925), the science fiction epic *Aelita* (dir. Yakov Protazanov, USSR 1924), the historical drama *Taras Shevchenko* (dir. Petr Chardynin, USSR, 1926), Pat and Patachon's comedy *Can Love Be Cured?* known in the Soviet distribution as *Vse vidim, vse znaem* (dir. Lau Lauritzen Sr., Denmark, 1923), and a kulturfilm *Ways to Strength and Beauty* (dir. Nicholas Kaufmann and Wilhelm Prager, Germany, 1925).[202] In discussing the results of their findings, the leaders of the ITM drew attention to instances of misunderstanding and inappropriate reactions, such as a suppressed laughter at the sight of a naked statue in a museum in *Taras Shevchenko*, as well as appropriate, but overly emotional responses, such as women spectators lowering their heads in dismay during the scene of Taras being battered by his father.[203] While the ITM's fieldwork revealed that the viewers' sociocultural background played an important role in their interpretation of films, the overall reception statistics based on reflexes was deemed usable for the purposes of judging films' objective merit: "A large amount of positive reactions to the socially significant moments is a sign of the film's high quality. Positive reactions to the ideologically pernicious moments [must serve as] a basis for a strong critique."[204]

While the ITM used its audience reaction analysis to issue straightforward, if somewhat simplistic recommendations to film producers and cultural authorities, a much more complex task for the Soviet psychologists turned out to be studying children spectators. Underage viewers constituted a large percentage of moviegoers, and the public's concern about cinema's corrupting effects and harmful overtaxing of the young audience's senses was a glaring item on the

[201] Issledovatel'skaia Teatral'naia Masterskaia, "Zapis' replik zala. *Bronenosets Potemkin*," RGALI f. 645. op. 1. ed. khr. 312, l. 162–163.

[202] Issledovatel'skaia Teatral'naia Masterskaia, "Kratkii otchet," l. 118; Troianovskii and Egiazarov, "Izuchenie kinozritelia," 379, 381, 383. The audience of *Taras Shevchenko* was examined not in Moscow, but rather in the town of Rutchenkovo in the Donbass region.

[203] Troianovskii and Egiazarov, "Izuchenie kinozritelia," 380.

[204] Ibid., 383.

Soviet government's agenda. In fact, this concern had a long history in Russia, dating back, as in Europe and the United States, to the 1900s and early 1910s.[205] In the Soviet Union, the long-standing anxiety about potential links between cinema's temptations and juvenile delinquency came to overlap with the fear of exposing the youth to ideologically unsuitable films, especially those coming from abroad.[206] Soviet authors were woefully aware of the inappropriateness of most shows and the scarcity of domestic productions that could win over the young spectators (the first studio catering specifically to children, Souizdetfil'm, would open only in 1936).[207] Scientific research on the young audience gained traction in the mid-1920s. By 1929, Moscow alone had several prominent psychological centers working on the issue of children's perception of films: The State Institute of Experimental Psychology, the Psychological Laboratory of the Krupskaya Academy of Communist Upbringing, The Institute of the Methods of Extracurricular Work, and The Pedological Department of the Institute of the Methods of School Work.[208] Psychologists were joined by sociologists and cultural officials in multiple other Moscow institutions studying children spectators, including the Scientific Research Institute of Cinema and Photography, the Central House for Children's Artistic Development, the Central Experimental Theater of the Young Viewer, the Theater Research Workshop (ITM), and the Association of the Revolutionary Cinematography.[209]

The task of studying young spectators posed unique challenges compared to the research on adults: in addition to social background and other relevant demographic factors, the data collectors had to bear in mind the factors of developmental psychology, such as age-specific cognitive milestones, attention span, and verbal skills. As child psychology was a young discipline in the 1920s, all of these categories were still a subject of active research, with multiple fractions of Soviet pedology proposing competing viewpoints on the child's mental growth

[205] P. I. Liublinskii, "Kinematograf i deti," in *Publika kino v Rossii*, ed. Iu.U. Fokht-Babushkin (Moscow: Gosudarstvennyi institut iskusstvoznaniia, 2013), 437–453, 438. For a history of American psychologists' efforts to assess the effects of cinema on children between 1930 and 1935, see Garth S. Jowett, Ian C. Jarvie, and Kathryn Fuller-Seeley, *Children and the Movies: Media Influence and the Payne Fund Controversy* (Cambridge: Cambridge University Press, 2007). In 1929, the American sociologist Alice Miller Mitchell assessed the film-going behavior and responses to films of 10,052 schoolchildren in Chicago via questionnaires and essays (see Amanda C. Fleming, "In Search for the Child Spectator in the Late Silent Era," in *Making Sense of Cinema: Empirical Studies into Film Spectators and Spectatorship*, ed. Carrie Lynn D. Reinhard and Christopher J. Olson [New York: Bloomsbury Academic, 2017], 119–138).
[206] These concerns are articulated in A. Latsis and L. Keilina's *Deti i kino*; V. Vainshtok and D. Jakobzon's *Kino i molodezh'*, V. Pravdoliubov's *Kino i nasha molodezh'*, and other sources anthologized in I. Fokht-Babushkin, ed., *Publika kino v Rossii* (Moscow: Gosudarstvennyi institut iskusstvoznaniia, 2013).
[207] Ryabchikova, "Proletkino," 235.
[208] Iu.U. Fokht-Babushkin, *Publika kino v Rossii* (Moscow: Gosudarstvennyi institut iskusstvoznaniia, 2013), 17.
[209] Ibid.

Table 5.3 Translation of Fig. 5.16. Audience's Reactions to the First Fourteen Minutes of *The Battleship*

		1. The sea	2. The battleship	3. The sailors	4. Night time	5. Surveying
Active intervention into the course of action	Активное вмешательство в ход действия.					
Talking relevant to the scene	Разговоры по существу момента.					
Applause	Овации.					
Laud laughter (+); crying, fright (–)	Сильный смех +. плач, испуг –.					
Soft laughter (+); crying, fright (–)	Слабый смех +. плач, испуг –.					
Disinhibition	Расторможение.					
Tense silence	Напряженная тишина.					
Silence	Тишина.					
Lack of focus	Рассеянность.					
Irrelevant conversations	Разговоры не по существу.					
Negative active intervention into the action	Отрицат. активн. вмешательство в ход действия					

#	English	Russian
6.	Beating	Бьет.
7.	Irritation	Возмущэнiэ.
8.	The morning	Утро.
9.	Cooking	Стрпня.
10.	About the meat	О мясэ.
11.	Maggots	Чэрви.
12.	The doctor speaking	Доктор говорит.
13.	Giliarovskii	Гиляровскiй.
14.	The cook	Новар.
15.	Cleaning	Чпстка.
16.	The dinner	Обэд.
17.	The officer	Офицэр.
18.	The shop	Лавка.
19.	At the top tower	На вышкэ.
20.	The cook	Повар.
21.	Washing dishes	Мытьэ тарэлок.
22.	The dish is broken	Тарэлка разбита.

8 ч. 20 м.

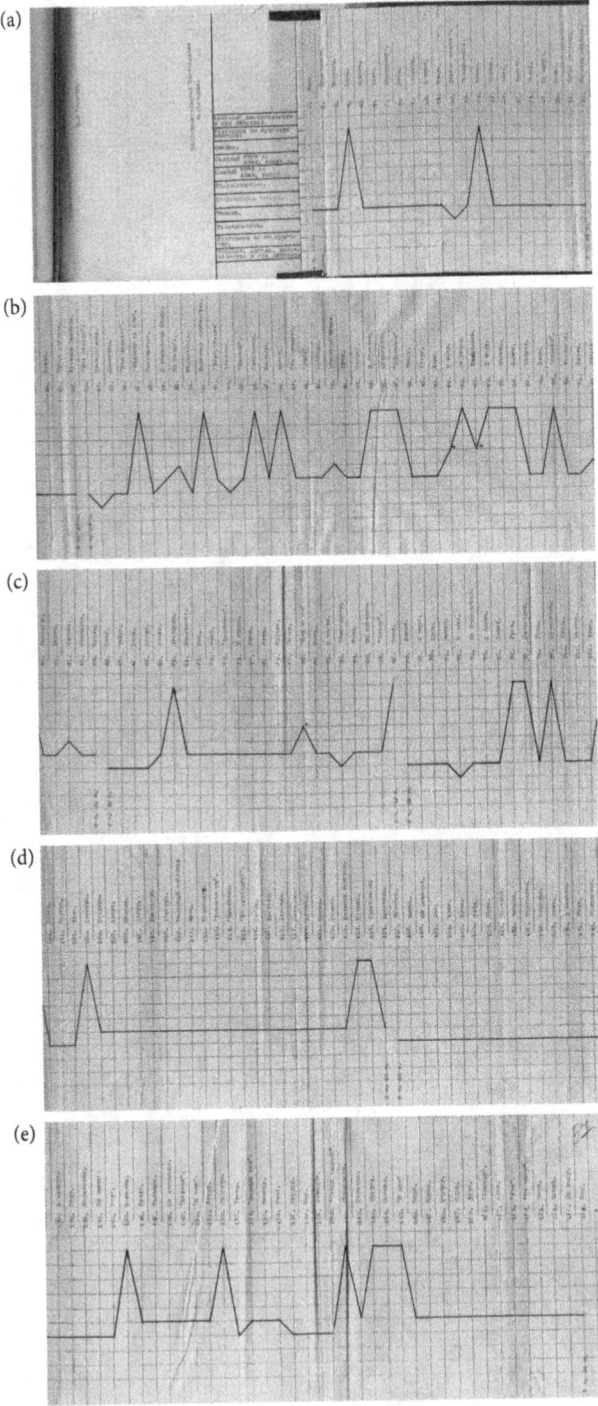

Fig. 5.17 An entire record of audience behavior during *The Battleship Potemkin*, charted by the Theater Research Workshop. While the peak reaction of "active intervention" was never achieved, the curve hikes numerous times to signal "relevant remarks," especially during the firing squad scene on the battleship

Fig. 5.17 *Continued* deck and the Odessa stairs massacre. The audience "laughs" during the scene of the navy priest pretending to be dead during the riot on the battleship and once more when a detractor shouts "Beat the Jews" to derail the townspeople's solidarity rally. The accompanying minutes of the audience's remarks during the screening confirms the anti-Semitic premise of the latter instance of laughter: the audience member states: "He said, 'Beat the Jews,' but he is a Jew himself." Image source: Issledovatel'skaia teatral'naia masterskaia, "Bronenosets Potemkin," June 16, 1926. RGALI f. 645 op.1. ed.khr. 57. For the minutes of the audience remarks, see RGALI f. 645 op.1. ed.khr. 312, l.162, l.163.

and best methods to assess it.[210] With the rising Stalinism toward the end of the 1920s, defining age-appropriate milestones and expectations for specific cognitive abilities became an increasingly sensitive issue: underachievement among children of previously disenfranchised social classes had to be interpreted in a nonstigmatizing way; otherwise the researcher risked being accused of class prejudice and slander.[211] The underage audience thus constitutes an instructive case study for the notion of "doubly wired spectator" in the Soviet Union: the researchers' interpretation of the child' psychological processes and the alleged impact of the screen reflects both their methodological quest to pin down the laws of perception, emotion, and cognition, and their effort to ascertain the relevance of their lab's research direction within a highly politicized environment.

Such convergence of challenges may be exemplified by an incident at the Krupskaya Academy of the Communist Upbringing on October 11, 1928, where Lev Vygotsky's close associates Aleksei Leont'ev and Alexander Luria (at this time, already a friend of Sergei Eisenstein) launched a study of children's perception of films.[212] Under the auspices of the Psychological Circle within the Academy, Luria and Leont'ev invited a group of middle-schoolers ("young pioneers") to watch avant-garde animated films *Vintik-Shpintik* (*The Important Small Things*, dir. Vladislav Tvardovskii, 1927), *Katok* (*The Ice Rink*, dir. Ivan Ivanov-Vano and Daniil Cherkess, 1927), and *Prikliucheniia Bolvashki* (*The Adventures of Bolvashka*, dir. Iurii Zheliabuzhskii, 1927). During the postscreening discussion,

[210] E. M. Balashov, *Pedologiia v Rossii v pervoi treti XX veka* (St. Petersburg: Nestor-Istoriia, 2012); Jaan Valsiner, *Developmental Psychology in the Soviet Union* (Bloomington: Indiana University Press, 1988).

[211] The allegation that elite psychologists overdiagnosed "backwardness" among children of the working class and ethnic minorities was one of the central accusations levied by Stalin's apparatus to justify the crackdown on Soviet pedology in 1936. (Andy Byford, "The Mental Test as a Boundary Object in Early 20th-century Russian Child Science," *History of the Human Sciences* 27.4 (2014): 1–37, 2).

[212] A. Luria and A. Leont'ev, "Protokol No.3 zaniatii psikhologicheskogo kruzhka ot 11 oktriabria 1928," in Arhiv Akademii Kommunisticheskogo Vospitaniia im. N. Krupskoi. TsGA (The Central State Archive of St. Petersburg), f. R-3106 op.1, ed. khr. 634, l.2.

the young viewers reported their preference for the action-packed slapstick comedies *The Ice Rink* and *Bolvashka* and incomprehension of the educational *Vintik-Shpintik*, a cartoon about a factory machine coming to life to tell the story of the interdependence of its parts. Assessing these responses, the scientists were overwhelmed by the number of variables that may have influenced the children's statements. Summing up the failure of the data collection strategy, Leont'ev pointed out that, at present, it was wrong to jump to conclusions either about social factors affecting children's responses, or the impact of specific cinematic devices, because "the problem of the child's perception" needed to be solved first.[213] It became apparent that the adults' analysis of the films was not an objective baseline against which they could compare children's responses: in the words of Luria, "the refraction of the seen in the child's mind" deserved to be studied on its own terms.[214] This kind of methodological hedging countered the vulgarized Marxism of cultural sociologists who insisted on class origin as the single most important factor shaping the reception of artworks, and who assumed the transparency of propagandistic messages transmitted through art. The postscreening debates at the Krupskaya Academy of Communist Upbringing were predicated on Vygotsky school's inquiry into the stages of child's cognitive development and the young mind's gradual mastering of concepts and instruments available in a specific culture. For these researchers, remarks by the young spectators could only be adequately understood with reference to the developmental factor and the qualitative transformations that each child's cognitive framework underwent through interaction with his or her environment.[215]

[213] Ibid.

[214] Ibid., l.2 verso. To the best of my knowledge, Luria did not continue analyzing children's perception of films after the initial attempt. Leont'ev, on the other hand, extended his study of "the influence of cinema on the spectator" in collaboration with researchers Petr Rudik and Aleksandr Tiagai into the year 1929 (Akademiia Kommunisticheskogo Vospitaniia im. N. Krupskoi, "Otchet o rabote fakul'tetov i kabinetov za 1927–28 g," TsGA [The Central State Archive of St. Petersburg], f. R-3106 op.1, ed. khr. 582, l.171. verso). In the 1930s, Rudik would go on to conduct spectator studies at the All-State Institute of Cinematography, VGIK (see Toropova, "Probing the Heart and Mind of the Viewer," 948ff.). Tiagai was affiliated with the Mezrabpom studio's unit for scientific *kulturfilms* and directed films such as *Alcohol, Labor, and Health* (*Alkogol', trud i zdorov'e,* 1927). See Oksana Sarkisova, "The Adventures of *Kulturfilm* in Russia," in *A Companion to Russian Cinema,* ed. Birgit Beumers, Chichester: Wiley Blackwell, 2016, 92–117, 102; Iurii Tiurin, "Pervyi i edinstvennyi fil'm Chaianova," *Den' i noch': literaturnyi zhurnal dlia semeinogo chteniia,* 5–6 (1997), *krasdin.ru/1997-5-6/s061.htm.* I am thankful to Julia Vassileva and Naum Kleiman for the references on Tiagai.

[215] Akademiia Kommunisticheskogo Vospitaniia im. N. Krupskoi, "Otchet o rabote fakul'tetov . . . ," l.171. verso. Rudik's spectator studies at the VGIK (All-State Institute of Cinematography) in the 1930s arrived at conclusions that were increasingly in line with the Stalinist attack on the avant-garde, causing directors like Lev Kuleshov to publicly defend their films. The evidence of the VGIK psychologist team's clash with Lev Kuleshov regarding the plotline of his film *Velikii Uteshitel'* (*The Great Consoler*) may be found in E. K.-va., "Problemy izucheniia zritelia," in *Publika kino v Rossii,* ed. Iu.U. Fokht-Babushkin, 141–142.

For other researchers, the answer to the problem of the opacity of children's verbal responses to films lay in supplementing their data collection strategy with psychophysiological methods. The leader of this research direction in 1929 was The Pedological Department of the Institute of the Methods of School Work in Moscow, where psychologists Abram Gel'mont and Vladimir Pravdoliubov developed a multifaceted testing program based on a battery of psychophysiological and cognitive measures. Gel'mont's overall ambition was to study

> children's perception of cinema (a psycho-physiological analysis of children's processing of images that are rapidly changing and flickering in the dark), and the way in which children of various ages and socio-economic background react to a variety of factors in film (content, editing style, running length, design, etc.). We have in mind a study of both immediate reactions to the film and the influence that the cinema may have on the child's subsequent behavior.[216]

The team was following up on an earlier wave of questionnaire-based research, implemented by the same institution under the guidance of N. A. Rybnikov in 1927. This time, however, the team felt that a real-time record of the actual psychophysiological reactions of individual children could provide a more in-depth picture of the young mind's grappling with screen images, compared to postfactum remarks collected in large data sets via questionnaires.[217] In 1929, Gel'mont began group and individual experiments in order to assess the children's "emotional reactions" and "fatigue" caused by the moving image. In group studies with up to thirty participants, the researcher observed the young viewers' behavior during the film and noted any salient "motor and verbal reactions" tied to specific moments throughout the screening.[218] In a different publication, Gel'mont specified that he defined a scale of observable external reactions, from "tense silence" and relevant "whispering" to "booing and leaving the auditorium," with a variety of steps—laughter, crying, absent-mindedness, jostling about, and so on—in between.[219] This scale was very similar to the one used by the ITM, except that the highest peak in Gel'mont's study was not the spectator's "participation" in the virtual narrative, but rather "applause" and "ovation."[220] In the individual experiments, kymographs recorded the young spectators' respiration and pulse, as well as their "motor-rhythmical reactions" (the child was asked to tap her finger lightly on a little tambour while watching a film, and a special

[216] A. M. Gel'mont, "Izuchenie vliiania kino na detei," *Kino i kul'tura* 4 (1929): 38–46, 38.

[217] Ibid., 40.

[218] Ibid.

[219] A. M. Gel'mont, "Izuchenie detskogo kinozritelia," in *Publika kino v Rossii*, ed. I. Fokht-Babushkin (Moscow: Gosudarstvennyi institut iskusstvoznaniia, 2013), 398–437, 427.

[220] Gel'mont, "Izuchenie detskogo kinozritelia," 427.

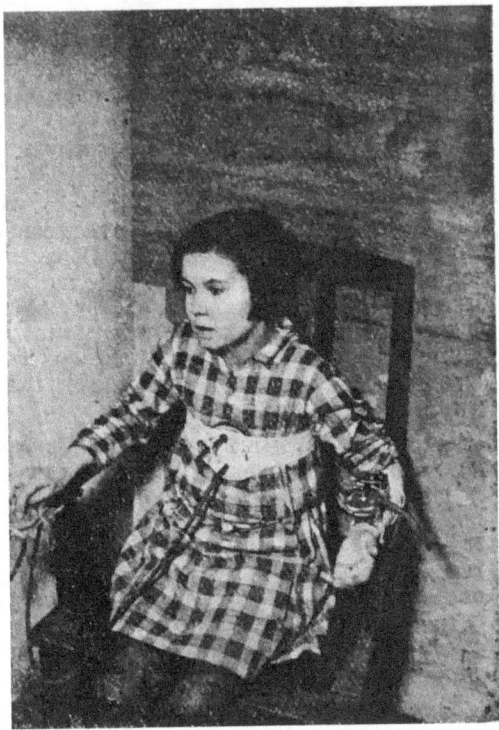

Fig. 5.18 A young spectator in Abram Gel'mont's study, wearing a sphygmomanometer and a pneumograph, while tapping on a tremor-detecting tambour with her right hand index finger. Image source: A. Gel'mont, "Izuchenie vliiania kino na detei," *Kino i kul'tura* 4 (1929), 38–46, 44.

device registered any pauses or changes in the tapping rhythm) (Fig. 5.18). Finally, the experimenters collected data on the children's "neuro-psychological reactions" to the film overall, using Carl Jung's "method of associations," a plot comprehension test, and an essay-writing task.[221] "The method of associations" involved testing the children's verbal reactions to a series of twenty "stimulus words" before and after the screening, in order to assess "the degree to which the images and actions in the film influenced the course of the child's associations."[222] The test on associations was a rapid one, lasting no longer than three minutes. Each child subject had to state whatever first came to her mind, while an electric Jaquet time-marker measured how long she hesitated before answering

221 Ibid., 41.
222 Ibid. 44.

(a) 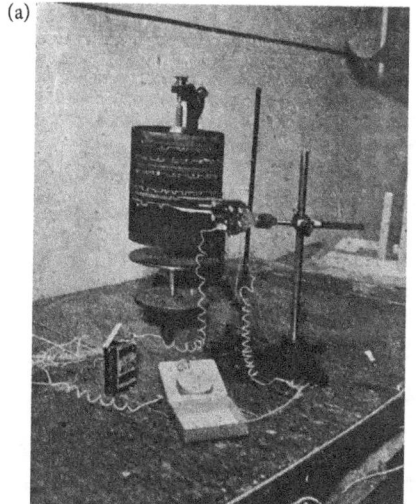 (b)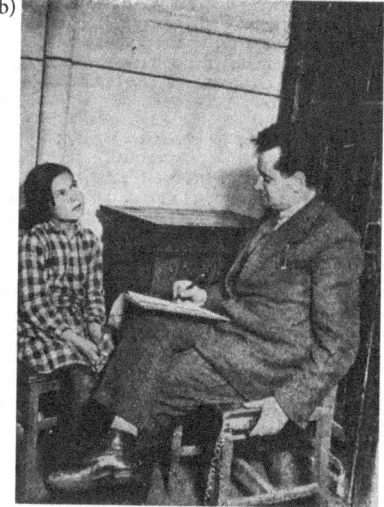

Fig. 5.19 (*a* and *b*) A child taking an association test in Gel'mont study, with a Jaquet time-marker recording how long it took to verbalize the reaction. Image source: A. Gel'mont, "Izuchenie vliiania kino na detei," *Kino i kul'tura* 4 (1929), 38–46, 42.

(Figs. 5.19a and 5.19.b). The comprehension of the plotline was evaluated by having the child sort a set of screenshots in an order she thought these moments appeared in the film. The time of completion and the nature of errors were noted. A final twenty-minute essay in response to an open prompt—"What did I see in this film?"—was employed to demonstrate "the way in which the prism of the child's creativity refracted what they saw in the film, and which elements captured their attention, etc."[223]

Emotions experienced by the child in the course of the film were deciphered on the basis of respiration and pulse curves "according to the well-known method by Wundt."[224] Two measures were taken into account: the frequency and the amplitude of oscillations in each of these curves, corresponding to the rate and strength of the recorded waves, respectively. Specific combinations of their downward and upward trends were interpreted as indices of emotional states, such as "pleasure," "displeasure," "excitement," "calming down," "tenseness," and "relaxation, or release" (Fig. 5.20 and Table 5.4). For example, the marker of pleasure was a weak, quickened breathing coupled with a slower, but stronger pulse. These data were supplemented with one more curve, showing the child's

[223] Ibid.
[224] Ibid.

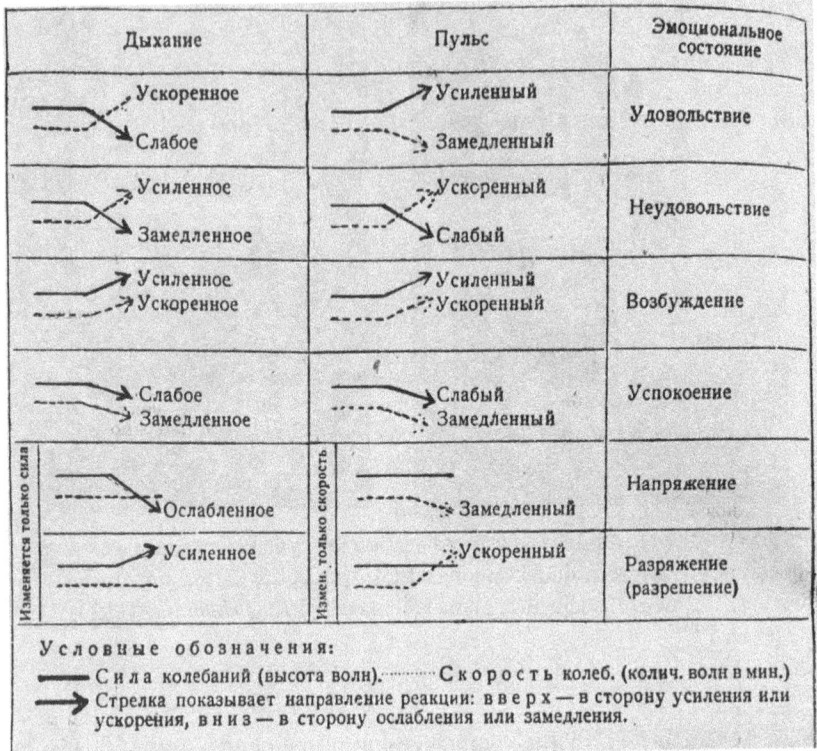

Fig. 5.20 Physiological expressions of emotional states, according to Gel'mont. This table was used for deciphering children's reactions to film scenes. Image source: A. Gel'mont, "Izuchenie vliiania kino na detei," *Kino i kul'tura* 4 (1929), 38–46, 46.

finger-tapping patterns recorded by the tremograph. The resulting "pneumo-sphygmo-tremo-grams" were tied to specific shots on the running filmstrip (Fig. 5.21).

More details about Gel'mont's research group's "method of external expressions" are provided in a 1929 book by his colleague at the Institute of the Methods of School Work, Vladimir Pravdoliubov. In addition to charting the children's pulse, respiration, and tapping patterns, in other experiments the group attempted taking photographs of children's faces before and after film screenings. These shots, according to Pravdoliubov, provided "a vivid image of the changing facial expressions, and, in particular, illustrate[d] the children's fatigue and agitation after the show; a number of photographs "show[ed] tear drops on the moist little eyelashes and cheeks."[225] Pravdoliubov's own research

[225] Pravdoliubov, "Kino i nasha molodezh," 203.

Table 5.4 A Translation of Fig. 5.19.

Breathing		Pulse		Emotional State
Faster Weak		Stronger Slower		Pleasure
Stronger Slower		Faster Weak		Displeasure
Stronger Slower		Stronger Faster		Agitation
Weak Slower		Weak Slower		Calming down
Only strength changes	Weaker	Only the rate changes	Slower	Tension
	Stronger		Faster	Relaxation (release)

Index:
-- The strength of oscillations (the amplitude
 of waves)
- - - - The rate of oscillations (the number of waves per
 minute)
→ The arrow shows the trend of the
 reaction: upward—toward strengthening or
 acceleration; downward—toward weakening or
 retardation.

concentrated on the problem of sensory exhaustion and emotional over-
strain, as he prepared to issue safeguards for the length of film programs and
spectators' age limit. In the beginning of the book, the researcher—who had
been an ordained priest prior to becoming a psychotechnics specialist—points
to the cases of screen addiction among very young children and narrates a heart-
breaking story of a two-year-old traumatized by *The Peasant Women of Ryazan*
(*Baby Riazanskie*, dir. Olga Preobrazhenskaia, 1927), a film with scenes of sexual
abuse and suicide.[226] In order to formulate authoritative recommendations
on shielding the children from harm, the researcher launched an investiga-
tion into the overtaxing of young spectators' nervous system by film shows.
His initial focus of research was fatigue. To assess how tired the child becomes
after watching a show, Pravdoliubov tested a variety of psychophysiolog-
ical approaches, seeking to find an objective and revealing method. He used a

[226] Ibid., 144.

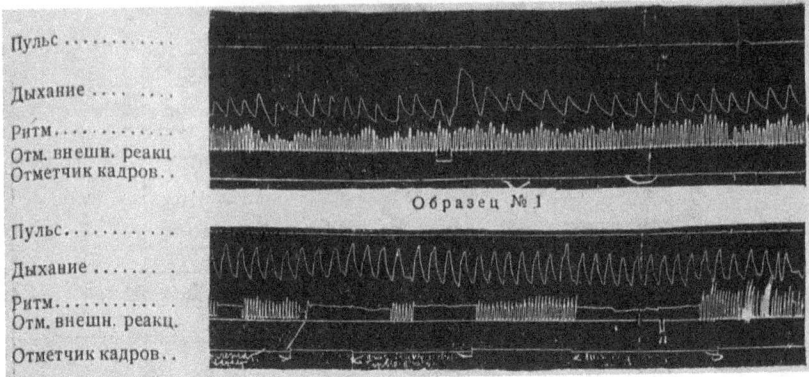

Fig. 5.21 Gel'mont's "pheumo-sphygmo-tremograms" showing pulse, respiration, and the tapping rhythm with supplementary marks noting "external reactions" and exact film shots. Image source: A. Gel'mont, "Izuchenie vliiania kino na detei," *Kino i kul'tura* 4 (1929), 38–46, 45.

Collin's dynamometer (Fig. 5.1) and its Russian-made equivalent, outfitted with a with a quicksilver scale and a rubber pear, to measure the children's handgrip (*vyderzhka*) before and after the screening, with the latter instrument revealing that watching a film shortened the time of strong hold.[227] Further, Pravdoliubov employed a modified "graphic tremometer of Thorndike," which compelled the children to draw a line following a straight, zigzagging, and curving pattern, revealing that after the film, the young subjects tended to complete the task faster, but with significantly more errors.[228] "Vivid results" of the postscreening fatigue, manifesting itself in the inability to concentrate and unhealthy excitation, were obtained by Pravdoliubov also with the help of a method developed by the psychologist Alexander Nechaev, which focused on the coordination of fine motor skills in a writing task and a memory and attention test.[229] Overall, Pravdoliubov concluded that a typical film show exhausts ten-to-twelve-year-olds more than the whole day at school.[230]

Despite the diversity of psychophysiological approaches in audience studies deployed by Pravdoliubov and Gel'mont at the Institute of the Methods of School Work in Moscow, it is important to note that they also relied on the children's verbal feedback in questionnaires, essays, and postscreening discussions. In this respect, the team considered the physiological markers an important illustrative

227 Ibid., 204. For Pravdoliubov biography, see Fokht-Babushkin, *Publika kino v Rossii*, 464.
228 Pravdoliubov, "Kino i nasha molodezh," 204.
229 Ibid.
230 Ibid., 205.

component of their data, but not a sole indicator of the little viewers' experience.[231] Moreover, like Leont'ev and Luria, Pravdoliubov and Gel'mont took precautions to account for the developmental factor in evaluating the child's potential mis-understanding of the plotline. Their methodology therefore was remarkable for its wholesome, open-ended treatment of the subjects' responses. In integrating psychophysiological and cognitive parameters, in granting the children a chance to express themselves verbally, and in validating their right to misunderstandings and unexpected interpretation in the essays, Gel'mont developed an approach that was far ahead of Toulouse and Mourgue's purely physiological study of spec-tatorship less than a decade ago. The unorthodox thinking of the research team at the School of the Methods of School work was also exemplified by their choice of films, which did not snub the children's preference for foreign blockbusters with Douglas Fairbanks and domestic action thrillers, such as *The Little Red Devils* (*Krasnye D'iavoliata*, dir. Ivan Perestiani, 1923).[232] At a time when the highly politicized atmosphere in the Soviet Union prioritized ideological indoctrination, only one of the three short films in Gel'mont's 1929 psychophysiological study ex-plicitly referenced the Civil War and was "saturated with the appropriate class ide-ology."[233] The other two "film stimulants" [*kino-razdrazhiteli*]—as Gel'mont called his screened sequences with a nod to reflexology—included a twelve-minute compilation from a Harry Piel adventure film and a similar-length excerpt from a "serene, touristic-anthropological *kulturfilm*."[234] The choice of a Harry Piel mys-tery was particularly controversial, because this German star's adventure thrillers were frequently singled out in the Soviet press as an epitome of the ideologically inappropriate, foreign content seducing the Soviet children. The defenders of the genre were the avant-gardists, such as Lev Kuleshov and The FEKS, or The Factory of the Eccentric Actor, whose cinematic careers began in dialog with the fast-paced, suspenseful "Americanism" in the early 1920s. They believed that well-made American-style adventure films cultivate a daring, self-reliant, and open-minded spirit: Kuleshov, for instance, ended his debut feature *The Extraordinary Adventures of Mr. West in the Land of the Bolsheviks* (*Neobychainye prikliucheniia mistera Vesta v strane bol'shevikov*, 1924) with an image of a Russian orphan boy proudly putting on a "cowboy" hat and opening an English-language textbook, so as to emulate his "American" hero Jeddy. In the words of Kuleshov's friend and ac-tive contributor to the Left Front of the Arts, the writer Nikolai Aseev,

In the business of the child's upbringing and organization of his psyche, cinema must not play the role of the old nurse, who sprinkles him with the holy water

[231] Ibid., 202, 203.
[232] Ibid., 156, 163, 188–189.
[233] Ibid., 42, 43.
[234] Ibid.

of ideology. It must become a captivating storyteller, capable of touching the child's incredible suggestibility and imagination. . . . No such films are to be seen . . . Meanwhile, the demand for the children's films is growing, which is why the street urchins, having watched Harry Piel, won't care for some kind of bugs and beetles pushed in school lessons. . . . Why not show foreign lands? Distant prairies? Show them to the kids, and you will direct the workings of their brain away from Moscow's dungeons towards ardent curiosity and desire to find their own place in this wide, unknown world.

Remarkably, a similar view is expressed in Gel'mont's colleague's Vladimir Pravdoliubov's 1929 book, which summed up his several years of experience as a researcher at the Institute of the Methods of School Work. In the concluding section of his study, where he offers his recommendations as a child psychologist, he praises adventure stories reminiscent of Jules Vernes and "fairytales" such as Douglas Fairbanks's The Thief of Bagdad, because these have a potential to "provide the viewers with new ideas, open new horizons and perspectives to them, stimulate them to work on improving themselves, and cultivate a creative and imaginative mindset."[235] While it is imperative to shield the young viewers from pornography, sadism, and other traumatizing and antisocial behavior onscreen, Pravdoliubov argues, a great variety of genres are suitable for children.[236] Without prioritizing "revolutionary" films over "adventures," or avant-garde films over commercial ones, the researcher concludes that any film will have success with the young audience, as long as it is "artistic, well-made, rich in content and yet fully accessible; [is] lively, fun, and original . . . and contains an element of learning."[237] Responses to questionnaires and essays showed that children, especially of young age, respond better to films with a clear narrative, a simple and logical exposition, and a consecutive chronology of events presented as complete scenes, "without abrupt interruptions" and "chaotic jumps from place to place."[238] However, this preference does not automatically exclude experimental films. Taking cue from children's ranking of Eisenstein's Battleship Potemkin alongside Fairbanks's The Mark of Zorro (1920), Robin Hood (1922), and The Thief of Bagdad (1924), Pravdoliubov argues that what these films have in common is the motif of heroic struggle.[239] A plot centered on struggle, competition, or contest is sure to "excite the youth of all ages without exception," and thus provides a pedagogical opportunity to redirect bellicose instincts

[235] Pravdoliubov, "Kino i nasha molodezh," 188–189.
[236] Ibid., 187.
[237] Ibid., 163.
[238] Ibid.
[239] Ibid., 163, 189.

toward social good—for example, by compelling the children to root for a hero-leader embodying the will and aspirations of the whole community.[240] Overall, Pravdoliubov concluded that young viewers come to the cinema to learn about the world and human relations, and will take away lessons commensurate with the level of their cognitive development and personal maturity.

Pravdoliubov's and Gel'mond's general open-mindedness, refusal to demonize foreign films, and judicious efforts to synthesize psychophysiological data with audiences' verbal feedback were a rarity in the Soviet public discourse in 1929. Known as the Year of the Great Break, 1929 marked the onset of an aggressive phase of Stalin's cultural revolution. In psychology, as in other scientific disciplines, vibrant debates between multiple schools of thought were increasingly forced into a single, monolithic framework. In the general atmosphere of fear, opportunists took every chance to prove their loyalty to the regime. Disciplinary debates were reconfigured as class struggle in the sphere of ideas. Career leaps were made by exposing the flaws in competitors' research and presenting these drawbacks as systemic anti-Communist sabotage. In psychology, "mechanistic," psychophysiological approaches were decried as limiting and were replaced by new trends, focused on conscious rather than unconscious processes. In effect, this new framework proved even more doctrinaire and inflexible, as the scientists now derived "categories of consciousness directly from the works of Marx, Engels, Lenin, and Stalin."[241] The shift away from the psychophysiological methods meant the end of inquiry into the intersubjective mechanisms of mass communication based on affective and perceptual processes linking the body and the mind. Instead, the individual will and its role within the collective took center stage in psychological research—an approach which in reality amounted to setting normative expectations and policing deviations. Emblematic of this new trend in audience studies is a 1931 article in the journal *Proletarian Cinema* (*Proletarskoe kino*) with a call to replace the "pundits of psycho-technics" with "psychologists and sociologists":

Art organizes consciousness, meaning, of course, not the consciousness of each separate individual, but the class consciousness of specific collectives. Our ultimate goal is to describe what kind of person the viewer was when he came to the show, and what kind of person he was when he left. Psycho-physiology and psychotechnics, with their measurements of the speed of reactions, pulse, blood pressure, and various tests are helpless. By concentrating on reflexes, reactions, and in the best case, emotions, all of these methods cover only the

[240] Ibid., 189.
[241] Alex Kozulin, *Psychology in Utopia: Toward a Social History of Soviet Psychology* (Cambridge, MA: MIT Press, 1984), 21, 59.

sphere of automatisms and habits. The competence of these methods ends at the threshold, where the sum of reactions makes a "leap" into a qualitatively different dimension. This is the sphere of consciousness—consciousness, which is actively revealing itself through drawing conclusions and making deductions.[242]

Within this new paradigm, the documenting of external reactions of viewers as in the charts of the ITM, the "pheumo-sphygmo-tremograms" of Abram Gel'mont, and the psychophysiological fatigue tests of Vladimir Pravdoliubov was unthinkable. In 1929, the same year as his book on children spectators was released, Pravdoliubov was purged and subsequently executed by the firing squad in 1937. His colleague Gel'mont was spared this fate, but his post-1930 publications differ significantly in tone from his earlier articles, in that he is careful to insert the prerequisite "Aesopian language." He now condemns "the poisoning of our children by the pulpy detective films made in the Harry Piel style (harri-pilevshchina)," emphasizes older children's preference for "revolutionary" themes as opposed to mindless stunts, and enlists fellow psychologists in the task of making "cinema . . . a weapon in educating healthy, energetic, selfless fighters for the international revolution, devoted to the cause of the working class, the cause of Marx-Lenin-Stalin."[243] This kind of rhetoric was typical of the first five-year plan of the Stalinist cultural revolution. As Anna Toropova has demonstrated, by dispensing with admittedly limited biosocial typologies of spectators and psychophysiological approaches to understanding spectators' experience during film screenings, Soviet researchers began to promote a new fiction, that of a monolithic collective consciousness maximally responsive to the narrative style of the nascent Socialist Realism.[244]

In conclusion, the psychophysiological tests of spectators in the Soviet Russia and the United States in the 1920s provide an instructive example of the science and film industry converging in the name of decoding spectators' perceptual and emotional processes and deciphering the mystery of mass appeal. Grown out of the turn-of-the century empirical psychology and its subsequent extensions in applied psychotechnics and reflexology, these studies located the truth about the aesthetic experience in the body of the spectator, without ever putting to question the interpretative framework they were imposing on the corporeal data. William Moulton Marston tried to fit the patterns of blood pressure change into his theory of emotions, limited to four possible categories. The same four basic emotions guided his choice of narrative situations in

[242] Skorodumov, "Issledovatel'skaia rabota so zritel'skim kinoaktivom," 320.
[243] Gel'mont, "Izuchenie detskogo zritelia," 399.
[244] Toropova, "Probing the Heart and Mind of the Viewer," 953.

Hollywood drama. The conclusions he drew from the oscillations of the kymograph line by and large confirmed speculative, stereotyped opinions about blondes and brunettes, men and women, and rural and urban audiences. Soviet studies, which focused on the external expressions of the spectators' inner experiences—from facial reflexes to scales of reactions culminating in "participatory action"—likewise promulgated a patronizing attitude toward subjects, alleging that their bodies revealed more about their experience than these individuals were capable of verbalizing. In the end of the 1920s, Gel'mont's and Pravdoliubov's analyses of children spectators' responses stood out for their effort to synthesize psychophysiological and cognitive measures. However rich in potential, their inquiries drowned in the surge of Stalinist repressions: in the 1930s, Soviet audience specialists began to promote a preconceived dogma about the needs and wants of the viewers, instead of confronting the messy and inconvenient data from empirical studies.

What is the ultimate historical lesson to be derived from the psychophysiological incursion into cinema in the 1920s? Returning to the epigraph from Theodor Adorno's *Aesthetic Theory* I placed at the opening of this chapter, what can the body tell us about the viewers' emotions, and what do these physical signs have to do with the aesthetic rapture? Today, when neuroscience is beginning to judge film spectators' responses by specific patterns of cortical activity, it is instructive to recall Gilles Deleuze's provocative 1986 interview-essay for *Cahiers du Cinema*, in which he explores the question of what "the biology of the brain" could offer to film analysis. [245] Like Hugo Münsterberg in 1915, Deleuze insists on an analogy between the brain and the screen; but in contrast to the father of psychotechnics, the philosopher proposes an image of the brain defined by plasticity. For Deleuze, "the circuits and linkages of the brain do not preexist the stimuli, corpuscles, and particles [*grains*] that trace them."[246] Likewise, the moving image for him is defined by its radical openness, its capacity to produce "linkages [that] are often paradoxical and on all sides overflow simple associations of images." Deleuze further argues that "in creative works there is a multiplication of emotion, a liberation of emotion, and even the invention of new emotions."[247] Following these insights, it is possible to see that the danger of biologically oriented approaches to spectatorship lies in reducing diverse, idiosyncratic, and unexpected responses to prefabricated molds presented as biological universals—a tendency amply illustrated in the psychophysiological spectator studies in the 1920s.

[245] Gilles Deleuze, "The Brain Is the Screen: An Interview with Gilles Deleuze," in *The Brain Is the Screen: Deleuze and the Philosophy of Cinema*, ed. Gregory Flaxman (Minneapolis: University of Minnesota Press), 365–374, 366.
[246] Ibid.
[247] Ibid., 370.

Epilogue

Contemporary Neurocognitive Aesthetics and the Historical Lessons of *Psychomotor Aesthetics*

Over the past twenty years, evolving technologies have allowed us to map the activity of the brain with unprecedented precision. Initially driven by medical goals, neuroscience has advanced to the level where it is rapidly transforming our understanding of emotions, empathy, reasoning, love, morality, and free will. What is at stake today is our sense of the self: who we are, how we act, how we experience the world, and how we interact with it. By now nearly all of our subjective mental states have been tied to some particular patterns of cortical activity. Beyond the radical philosophical implications, these studies have far-reaching social consequences. Neuroscientists are authoritatively establishing norms and deviations; they make predictions about our behavior based on processes that lie outside our conscious knowledge and control. The insights of neuroscience are being imported into the social sphere, informing debates in jurisprudence, forensics, healthcare, education, business, and politics. A recent collection of essays, compiled by Semir Zeki, a leading European proponent of applied neuroscience, in collaboration with the American lawyer Oliver Goodenough, calls for further integration of lab findings into discussions of public policy and personnel training.[1] Neuroscience thus plays an increasingly active role in shaping society, intervening into the arena traditionally overseen by the humanistic disciplines: political science, law theory, sociology, history, and philosophy.

In the cultural sphere, neuroscience has invigorated the study of art psychology by highlighting neurophysiological processes that accompany the creation and appreciation of art. Within the burgeoning transdisciplinary field of neuroaesthetics, researchers are evaluating the responses of the amygdala to paintings ranked by subjects as "pleasant" or "unpleasant," documenting patterns of distraction during the reading of Jane Austen's novels, and exploring the neural mechanisms involved in watching dance—to name but a few recent high-profile projects.[2] Yet it is not always clear how the data gathered in these

[1] Oliver R. Goodenough and Semir Zeki, *Law and the Brain* (Oxford: Oxford University Press, 2006), xiii.

[2] S. Zeki and T. Ishizu, "The Brain's Specialized Systems for Aesthetic and Perceptual Judgment," *European Journal of Neuroscience* 37 (2013): 1413–1420; Natalie Phillips, "Distraction as Liveliness of Mind: A Cognitive Approach to Characterization in Jane Austen," in *Theory of Mind and*

Psychomotor Aesthetics. Ana Hedberg Olenina, Oxford University Press (2020). © Oxford University Press.
DOI: 10.1093/oso/9780190051259.001.0001

cutting-edge studies could figure in crucial disciplinary debates within literature, visual art, or performance studies. More often than not, laboratory experiments are operating with reductive models that take into account only a limited set of variables. In their current state, the "neuro" subfields within the humanities are making little use of the wealth of knowledge accumulated by the established methods of interpretation, such as historical contextualization, hermeneutics, formal analysis, semiotics, narratology, sociological reception studies, gender studies, and ideological critique.

The "neuro-turn" sweeping the humanities has already generated a great deal of skepticism. Many of these objections revolve around the mind-body problem. As the philosopher Alva Noë, a long-term critic of applied neuroscience, puts it, no research has ever been able to demonstrate how consciousness arises out of brain processes.[3] The reduction of our mind to the latter is not simply a pet peeve of the entrenched humanitarians; rather, it is bad science. To give an obvious example, writes Noë, considering depression as solely a neurochemical brain disorder would mean disregarding the social and psychological factors that contributed to it.[4] By analogy, detailing the functional anatomy of the brain will not provide us with a full picture of the subject's unique lifetime experiences, which have influenced the formation of cortical synapses. What is more, in explaining mental states on the basis of brain processes, scientists are often drawing on animal research without duly acknowledging the vast gap that separates us from other species. In doing so, researchers frequently fall prey to what Raymond Tallis calls the fallacy of "Darwinitis" (to be distinguished from legitimate Darwinism), where the complexity of our mental behavior is reduced to a simplified account of evolutionary adaptation.[5]

Looking back in time may help us understand the promises and limitations of neuroscience and its impact on the cultural and public spheres. Both a history and a critical project, *Psychomotor Aesthetics* has attended to the ways in which artists and theorists dealt with the materialist reductionism inherent in biologically oriented psychology—at times, endorsing the positivist, deterministic outlook, and at times, resisting, reinterpreting, and defamiliarizing scientific notions. Particularly revealing are cases in which the explanatory power of

Literature, ed. Paula Leverage (West Lafayette: Purdue University Press, 2011), 105–122; Bettina Bläsing, "The Dancer's Memory: Expertise and Cognitive Structures in Dance," *The Neurocognition of Dance: Mind, Movement and Motor Skills*, Bettina Bläsing, Martin Puttke, and Thomas Schack, (New York: Psychology Press, 2010), 75–98.

[3] Alva Noë, *Out of Our Heads: Why You Are Not Your Brain, and Other Lessons from the Biology of Consciousness* (New York: Hill and Wang, 2009), vi.

[4] Noë, *Out of Our Heads*, viii.

[5] Raymond Tallis, *Aping Mankind: Neuromania, Darwinitis and the Misrepresentation of Humanity* (Durham, England: Acumen, 2011).

science was overstretched, leading to dubious results. For example, when the inventor of the polygraph lie detector, William Moulton Marston, was recruited by Universal Studios to gauge the emotional responses of film spectators by recording changes in their respiration patterns and systolic blood pressure, his findings only replicated gender stereotypes of his time in suggesting that women spectators are predisposed to fall for scenes of romantic conquest.

The historical case studies presented in this book alert us to the fact that science always exists in contexts, both institutional and cultural-political. Science is not neutral: biases play into the design of experiments and interpretation of data, as well as the extrapolation of findings beyond each individual experiment. The application of science in other areas—law, business, education, or aesthetics—is never a direct, transparent channeling of "truth" to achieve more "progressive" results. Bearing this in mind, it is especially alarming to read the news that technologies such as "brain fingerprinting" are entering the arsenal of police interrogators.[6] Brain fingerprinting supposedly can reveal whether the subject has any vivid emotional memories associated with the circumstances of the crime, as it detects surges of electrical activity of the brain in response to the interrogator's prompts. Heavily criticized by leading neuroscientists as underdeveloped, this technology has nevertheless been already adopted in court procedures in India, and it is currently being tested in Singapore and the state of Florida.[7] Historians of science working on the 19th and early 20th century are familiar with the devastating social consequences of discredited scientific concepts such as phrenology, Alphonse Bertillon's photographic "galleries of rogues," and the polygraph lie detector. In today's world, neuroscientists such as Paolo Legrenzi and Carlo Umiltà issue warnings that laboratories of applied neuroscience often misrepresent the revelatory powers of brain research.[8] Perhaps errors in science will eventually be corrected by science itself, but the intervention of the humanities is necessary in order to avoid the oversimplification of premises used in experiments and to warn policymakers about rushed wholesale applications of neurosciencientific data.

The humanities can help neuroscience to become aware of its current blind spots, to define more profound questions for research experiments, and design more sensitive and responsible methods for applying scientific insights outside the laboratory space. For instance, in the field of neuroaesthetics, how can we account for the complexity of human engagement with art objects? Too often we hear of studies that operate with a reductive model of aesthetic experience,

[6] David Cox, "Can Your Brain Reveal You Are a Liar?" *BBC Future*, January 25, 2016, http://www.bbc.com/future/story/20160125-is-it-wise-that-the-police-have-started-scanning-brains?

[7] Cox, "Can Your Brain Reveal You Are a Liar?"

[8] Paolo Legrenzi and Carlo Umiltà, *Neuromania: On the Limits of Brain Science* (Oxford: Oxford University Press, 2011).

relying on the subject's reports of pleasure correlated with certain cortical activity and formal patterns of the art piece. Yet, as the Russian Formalist scholars have argued in the 1910s–1920s, the response of pleasure or displeasure may be determined by a great variety of factors, from the shallow adulation of the author and identification with characters to the appreciation of artwork's formal virtuosity, perceptual novelty, and profound intellectual implications—what Viktor Shklovskii called defamiliarization. Furthermore, the perceptual properties of an art piece are not the only variable shaping our response: a much greater role is played by our cultural background, situational awareness, and psychological priming. Is there a way to create an empirical, quantificational method to factor in these variables? This formidable task cannot be accomplished without cultural historians, communication specialists, psychologists, and sociologists. Working toward this goal would give us a more nuanced view of the individual, contextualized, situational reactions, instead of the limited sets of universal, ahistorical laws that neuroscience gravitates toward.

Bibliography

Abel, Richard. *Americanizing the Movies and "Movie-Mad" Audiences, 1910–1914.* Berkeley: University of California Press, 2006.

Adorno, Theodor. *Aesthetic Theory.* Ed. Gretel Adorno and Rolf Tiedemann. Trans. Robert Hullot-Kentor. Minneapolis: University of Minnesota Press, 1997.

Agadzhanova, Nina. "Zametki o Refleksakh v Kino." *Kino-front* 9–10 (1926): 23–24.

Akademiia Kommunisticheskogo Vospitania im. N. Krupskoi. "Otchet o rabote fakul'tetov i kabinetov za 1927-28 g." TsGA (The Central State Archive of St. Petersburg). f. R-3106 op.1, ed. khr. 582, l.171.

Akavia, Naamah. *Subjectivity in Motion: Life, Art, and Movement in the Work of Hermann Rorschach.* New York: Routledge, 2017.

Alder, Ken. *The Lie Detectors: The History of an American Obsession.* Lincoln: University of Nebraska Press, 2009.

Alexander, S. "Foundations and Sketch-Plan of a Conational Psychology." *British Journal of Psychology* 4.3 (1911): 239–267.

Allen, Grant. *Physiological Psychology.* London: Henry S. King, 1877.

Alpatov, V. M. "Evgenii Polivanov." In *Otechestvennye Lingvisty XX Veka: Sbornik Statei,* vol. 2., ed. Fedor Berezin, 97–110. Moskva: INION RAN, 2003.

Amar, Jules. *Le Moteur Humain et les Bases Scientifiques du Travail Professionel.* Paris: H. Dunod et E. Pinat, 1914.

Ames, Eric. "The Image of Culture, or, What Münsterberg Saw in the Movies." In *German Culture in Nineteenth-Century America: Reception, Adaptation, Transformation,* ed. Lynne Tatlock and Matt Erlin, 21–41. Rochester, NY: Camden House, 2005.

Andrew, Dudley. *The Major Film Theories: An Introduction.* London: Oxford University Press, 1976.

Andriopoulos, Stefan. *Possessed: Hypnotic Crimes, Corporate Fiction, and the Invention of Cinema.* Chicago: University of Chicago Press, 2008.

Any, Carol J. "Boris Eikhenbaum in OPOIaZ: Testing the Limits of the Work-Centered Poetics." *Slavic Review* 49.3 (1990): 409–426.

Any, Carol J. *Boris Eikhenbaum: Voices of a Russian Formalist.* Stanford, CA: Stanford University Press, 1994.

Any, Carol J. "Russian Literary Formalism." In *Routledge Encyclopedia of Philosophy. Volume Eight: Questions to Sociobiology,* ed. Edward Craig, 409–413. London: Routledge, 1998.

Any, Carol J. "Teoriia iskusstva i emotsii v formalisticheskoi rabote Borisa Eikhenbauma." *Revue des Etudes Slaves* 57.1 (1985): 137–144.

Arnheim, Rudolf. "Zum Geleit: Für Hugo Münsterberg: Das Lichtspiel." *Montage/ AV: Zeitschrift für Theorie und Geschichte audiovisueller Kommunikation* 9.2 (2000): 55–57.

Aronson, Oleg. "Teatr i affect. Biomekhanika Meierkhol'da vs. psikhotekhnika Stanislavskogo." In *Sovetskaia vlast' i media,* ed. Hans Günther and Sabine Hänsgen, 296–305. Sankt-Peterburg: Akademicheskii proekt, 2006.

Arsenjuk, Luka. "*The Notes for a General History of Cinema* and the Dialectic of the Eisensteinian Image." In *Sergei M. Eisenstein: Notes for a General History of Cinema*, ed. Naum Kleiman and Antonio Somaini, 289–298. Amsterdam: Amsterdam University Press, 2016.

Arvatov, Boris. "Teatr i byt. V poriadke diskussii." *Zhizn' Iskusstva* 31 (1925): 8–9.

Atasheva, P. M., and N. I. Kleiman. "Kommentarii." In Sergei Eisenstein, *Izbrannye proizvedeniia v shesti tomakh*, vol. 4, 741–779. Moskva: Iskusstvo, 1966.

Attasheva [Atasheva], Pera. "Chem zhivet Amerika?" *Sovetskii Ekran* 41 (1928): 10.

Balashov, E. M. *Pedologiia v Rossii v pervoi treti XX veka*. St. Petersburg: Nestor-Istoriia, 2012.

Balázs, Béla. *Béla Balázs: Early Film Theory: Visible Man and the Spirit of Film*. Trans. Erica Carter. New York: Berghahn Books, 2010.

Baraduc, Hyppolite. *L'âme humaine: ses mouvements, ses lumières et l'iconographie de l'invisible fluidique*. Paris: G. Carré, 1896.

Barker, Jennifer M. *The Tactile Eye: Touch and the Cinematic Experience*. Berkeley: University of California Press, 2009.

The Battleship Potemkin [Bronenosets Potemkin], dir. Sergei Eisenstein. DVD. Kino Lorber, 2007.

Baudelaire, Charles, "Le Paintre de la Vie Moderne," *Oeuvres Complètes de Charles Baudelaire: L'art Romantique*, ed. Calmann Lévy, vol. 3, 51–114, Paris: Ancienne Maison Lévy Frères, 1885.

Beer, Daniel. *Renovating Russia: The Human Sciences and the Fate of Liberal Modernity, 1880–1930*. Ithaca, NY: Cornell University Press, 2008.

Bekhterev, Vladimir. *Budushchee Psikhiatrii: Vvedenie v Patologicheskuiu Refleksologiiu*. Sankt-Peterburg: Nauka, 1997.

Bekhterev, Vladimir. "Chto dala initsiativnaia konferentsiia po nauchnoi organizatsii truda." In *Voprosy izucheniia truda*, ed. V. M. Bekhterev, V. P. Kashkadamov, and V.V. Belousov, 5–26, Sankt-Peterburg: Gos. Izdatel'stvo, 1922.

Bekhterev, Vladimir. *Collective Reflexology: The Complete Edition*. Ed. Lloyd H. Strickland. Trans. Eugenia Lockwood and Alisa Lockwood. New Brunswick, NJ: Transaction Publishers, 2001.

Bekhterev, Vladimir. "Die Medizin der Gegenwart in Selbstdarstellungen." In E.V. Sharova, ed. *Professor V.M. Bekhterev i nashe vremia (155 let so dnia rozhdeniia)*, 439–454. Sankt-Peterburg: Politekhnika, 2015.

Bekhterev, Vladimir. *General Principles of Human Reflexology*. New York: Arno Press, 1973.

Bekhterev, Vladimir. "Kinematograf i nauka." *Vestnik kinematografii* 110.8 (1915): 39–40.

Bekhterev, Vladimir. "Kollektivnaia refleksologiia." In *Izbrannye Raboty po Sotsial'noi Psikhologii*, ed. V. A. Kol'tsova and M. V. Mulenkova, 18–349. Moskva: Nauka, 1994.

Bekhterev, Vladimir. *Ob"ektivnaia Psikhologiia*. Ed. V.A. Kol'tsova. Moskva: Nauka, 1991.

Bekhterev, Vladimir. "Obosnovanie ob"ektivnoi psikhologii." *Vestnik psikhologii, kriminal'noi antropologii i gipnotizma 1* (1907): 3–20.

Bekhterev, Vladimir. *Obshchie osnovy refleksologii cheloveka: Rukovodstvo k ob"ektivnomu izucheniiu lichnosti*. 4-e izdanie. Moskva: Gos. Izdatel'vo, 1928.

Bekhterev, Vladimir. "O prichinakh obmolvok rechi." *Golos i rech.'* September 9 (1913): 3–6.

Bekhterev, Vladimir. *Zadachi i metod ob"ektivnoi psikhologii*. Sankt-Peterburg: Tip. S.M. Proppera, 1909.

Bekhterev, V. M., and G. E. Shumkov. "Mimiko-somaticheskii refleks nastorazhivaniia." In *Novoe v refleksologii i fiziologii nervnoi sistemy*, ed. V. M. Bekhterev, 248–253. Leningrad: Gos. Izdatel'stvo, 1925.

Bely, Andrei. "Emblematika smysla (1904)." In *Simvolizm kak miroponimanie*, ed. L. A. Sugai, 25–82. Moskva: Respublika, 1994.

Bely, Andrei. *Glossolalie—Glossolalia—Glossolaliia: Poem Über Den Laut—a Poem About Sound-Poema O Zvuk*, ed. Thomas R. Beyer. Dornach, Switzerland: Pforte, 2003.

Bely, Andrei. "Porok bezlichiia." In *Simvolizm kak miroponimanie*, ed. L. A. Sugai, 145–152. Moskva: Respublika, 1994.

Benjamin, Walter. "On the Present Situation of Russian Film." In *The Work of Art in the Age of Its Technological Reproducibility and Other Writings on the Media*, ed. Michael W. Jennings, Brigid Doherty, and Thomas Y. Levin and trans. Edmund Jephcott et al., 323–328. Cambridge, MA: Harvard Belknap Press, 2008.

Benjamin, Walter. "The Work of Art in the Age of Mechanical Reproduction." In *Illuminations*, ed. Hannah Arendt and trans. Harry Zorn, 217–252. London: Pimlico, 1999.

Benjamin, Walter. "The Work of Art: Second Version." In *The Work of Art in the Age of Its Technological Reproducibility and Other Writings on the Media*, ed. Michael W. Jennings, Brigid Doherty, and Thomas Y. Levin and trans. Edmund Jephcott et al., 19–55. Cambridge, MA: Harvard Belknap Press, 2008.

Bernshtein, Nikolai. *Ocherki po fiziologii dvizhenii i fiziologii aktivnosti.* Moskva: Meditsina, 1966.

Bernshtein, Sergei. "Curriculum vitae (c.1922)." *Materialy Instituta Zhivogo Slova Narkomprosa RSFSR*, RGALI (the Russian State Archive of Literature and Arts) f. 941 op. 4. ed. khr. 2(2). l.44.

Bernshtein, Sergei. "Esteticheskie predposylki teorii deklamatsii." In *Poetika: Vremennik otdeleniia slovsenykh iskusstv Gos. Instituta Istorii Iskusstv*, vol. 3, 25–44. Leningrad: Academia, 1927.

Bernshtein, Sergei. "Golos Bloka (1921–1925)." In *Blokovskii Sbornik*, ed. A. Ivich and G. Superfin, 454–525. Tartu: Tartusskii gos. universitet, 1972.

Bernshtein, S. I. "Opyt esteticheskogo analiza slovesno-khudozhestvennogo proizvedeniia." In *Zvuchashshaia Khudozhestvennaia Rech', 1923-1929*, ed. Witalij Schmidt and Valeriy Zolotukhin, 325–377. Moscow: Tri Kvadrata, 2018.

Bernshtein, Sergei. "Zvuchashchaia khudozhestvennaia rech' i ee izucheniie." *Poetika: Vremennik slovesnogo otdela Instituta istorii iskusstv Leningradskogo universiteta* 1 (1926): 41–55.

Bershtein, Evgenii. "Eisenstein's Letter to Magnus Hirschfeld: Text and Context." In *The Flying Carpet: Studies on Eisenstein and Russian Cinema in Honor of Naum Kleiman*, ed. Joan Neuberger and Antonio Somaini, 75–86. Milan: Éditions Mimésis, 2018.

Bingham, Walter Van Dyke. "Studies in Melody." *Psychological Review Monograph Supplements* 12.3 (1910): 1–88.

Bettina Bläsing, "The Dancer's Memory: Expertise and Cognitive Structures in Dance." *The Neurocognition of Dance: Mind, Movement and Motor Skills*, ed. Bettina Bläsing, Martin Puttke, and Thomas Schack, 75–98. New York: Psychology Press, 2010.

Blatter, Jeremy. "Screening the Psychological Laboratory: Münsterberg, Psychotechnics, and the Cinema." *Science in Context* 28.1 (2015): 53–76.

"Blondes Lose Out in Film Love Test." *The New York Times*. January 31, 1928, 25.

Blumer, Adler G. "Music in Its Relation to the Mind." *American Journal of Insanity* 48 (1892–1893): 350.

Bobrinskaia, E. A. "Predsiurrealisticheskie motivy v esteticheskikh kontseptsiakh A. Kruchenykh kontsa 1910-ykh godov." *Russian Literature* 65 (2009): 339–354.

Bobrinskaia, E. A. *Russkii avangard: Istoki i metamorfozy.* Moscow: Piataia Strana, 2003.

Bobrinskaia, E. A. "Teoriia 'momental'nogo tvorchestva' A. Kruchenykh." In *Russkii avangard: Istoki i metamorforzy,* 94–117. Moskva: Piataia Strana, 2003.

Bobrinskaia, E. A. "Zhest v poetike rannego russkogo avangarda." In *Russkii avangard: Istoki i metamorforzy,* 199–209. Moskva: Piataia Strana, 2003.

Bochov, Jörg. "Eizenshtein–patognomik? Fiziognomicheskie aspekty v teorii vyrazitel'nosti i fil'makh Sergeia Eizenshteina." *Kinovedcheskie Zapiski* 47 (2000). http://www.kinozapiski.ru/ru/article/sendvalues/381/

Bogdanov, Konstantin. "Pravo na son i uslovnye refleksy: Kolybel'nye pesni v sovetskoi kul'ture, 1930–1950-e gg." *Novoe Literaturnoe Obozrenie* 86 (2007). *Zhurnal'nyi Zal,* http://magazines.russ.ru/nlo/2007/86/bo1.html

Bogomolov, N. A. "Spititizm Valeriia Briusova: Materially i nabliudeniia." In *Russkaia literatura nachala XX veka i okkul'tizm,* 279–310. Moscow: Novoe literaturnoe obozreniie, 1997.

Bohlinger, Vincent. "Engrossing? Exciting! Incomprehensible? Boring! Audience Survey Responses to Eisenstein's October." *Studies in Russian and Soviet Cinema* 5.1 (2011): 5–27.

Bondarko, L. V. "Eksperimental'naia fonetika v Sankt-Peterburgskom gosudarstvennom universitete: Vtoraia polovina stoletiia." *Kafedra fonetiki i metodiki prepodavaniia inostrannykh iazykov. Sankt-Peterburgskii Gosudarstvennyi Universitet.* January 27, 2012. http://phonetics.spbu.ru/history.html

Bordwell, David. *The Cinema of Eisenstein.* Cambridge, MA: Harvard University Press, 1993.

Bordwell, David, Janet Staiger, and Kristin Thompson. *The Classical Hollywood Cinema: Film Style and Mode of Production to 1960.* New York: Columbia University Press, 1985.

Borishpol'skii, Efim Solomonovich. "Curriculum vitae." In *Materialy Instituta Zhivogo Slova Narkomprosa RSFSR.* RGALI (The Russian State Archive of Literature and Art) f. 941 op.4, ed. khr. 2(1), l.26.

Bourdon, Benjamin. *L'éxpression des émotions et des tendances dans le langage.* Paris: F. Alcan, 1892.

Bourdon, Benjamin. "L'application de la méthode graphique à l'étude de l'intensité de la voix." *L'année psychologique* 4 (1897): 369–378.

Bowlt, John. "Ippolit Sokolov and the Gymnastics of Labor," *Eksperiment/Experiment* 2 (1996): 411–421.

Boym, Svetlana. "History Out-of-Sync." In *The Off-Modern,* ed. David Damrosch, 3–8. London: Bloomsbury Academic, 2017.

Boym, Svetlana. "Poetics and Politics of Estrangement: Victor Shklovsky and Hannah Arendt." *Poetics Today* 26.4 (2005): 581–611.

Brain, Robert. "Étienne-Jules Marey and Charles Rosapelly. Vocal Polygraph." *Grey Room* 43 (2011): 88–117.

Brain, Robert. *The Pulse of Modernism: Physiological Aesthetics in Fin-De-Siècle Europe.* Seattle: University of Washington Press, 2015.

Brain, Robert. "Self-Projection: Hugo Münsterberg on Empathy and Oscillation in Cinema Spectatorship." *Science in Context* 25 (2012): 329–353.

Brang, Peter. *Zvuchashchee Slovo: Zametki po Teorii i Istorii Deklamatsionnogo Iskusstva v Rossii.* Moskva: Iazyki slavianskoii kul'tury, 2010.

Braun, Marta. "Le corps au travail: éducation physique." In *La Science du Mouvement et l'Image du Temps: Exposition Virtuelle Marey,* Jean-Francois Vincent and Jacques Gana, eds., 2005, pp. 24–25. Collège de France & Bibliothèque Interuniversitaire de Médicine et d'Odontologie. https://www3.biusante.parisdescartes.fr/marey/debut.htm

Braun, Marta. *Picturing Time: The Work of Etienne-Jules Marey (1830–1904).* Chicago: University of Chicago Press, 1992.

Bridge, Helen. "Empathy Theory and Heinrich Wölfflin: A Reconsideration." *Journal of European Studies* 41.1 (2011): 3–22.

Briusov, Valerii. "Esche raz o metodakh mediumizma." In N. A. Bogomolov, *Russkaia literatura nachala XX veka i okkul'tizm,* 279–310. Moskva: Novoe literaturnoe obozreniie, 1997.

Broide, M. "Izuchenie zritelia." *Novyi Zritel'* 23 (1926): 10.

Brücke, Ernst Wilhelm von. *Die physiologischen Grundlagen der neuhochdeutschen Verskunst.* Wien: C. Gerold, 1871.

Bruno, Giuliana. "Film, Aesthetics, Science: Hugo Münsterberg's Laboratory of Moving Images." *Grey Room* 36 (2009): 88–113.

Bruno, Giuliana. *Streetwalking on a Ruined Map: Cultural Theory and the City Films of Elvira Notari.* Princeton, NJ: Princeton University Press, 1993.

Buck-Morss, Susan. "Aesthetics and Anaesthetics: Walter Benjamin's Artwork Essay Reconsidered." *October* 62 (1992): 3–41.

Buck-Morss, Susan. *Dreamworld and Catastrophe: The Passing of Mass Utopia in East and West.* Cambridge, MA: MIT Press, 2000.

Bulgakowa, Oksana. "Eizenshtein i ego psikhologicheskii Berlin: mezhdu psikhoanalizom i strukturnoi psikhologiei." *Kinovedcheskiie Zapiski* 2 (1988): 174–189.

Bulgakowa, Oksana. "From Expressive Movement to the "Basic Problem." In *The Cambridge Handbook of Cultural-Historical Psychology,* ed. Anton Yasnitsky, René Veer, and Michel Ferrari, 423–448. Cambridge: Cambridge University Press, 2014.

Bulgakowa, Oksana. "Laboratoriia pravil'nogo dvizheniia." In Oksana Bulgakowa, *Fabrika zhestov,* 130–136. Moscow: NLO, 2005.

Bulgakowa, Oksana. "Montazh v teatral'noi laboratorii 1920-kh godov." In *Montazh: literatura, iskusstvo, teatr, kino,* ed. M. B. Iampol'skii and B. V. Raushenbakh, 78–98, Moskva: Nauka, 1988.

Bulgakowa, Oksana. *Sergei Eisenstein: A Biography.* Berlin: Potemkin Press, 2001.

Bulgakowa, Oksana. *Sovetskii Slukhoglaz: Kino i ego organy chuvstv.* Moskva: Novoe literaturnoe obozrenie, 2010.

Bunn, Geoffrey C. *The Hazards of the Will to Truth: A History of the Lie Detector.* PhD dissertation. York University, Ontario, 1997.

Bunn, Geoffrey C. "The Lie Detector, Wonder Woman and Liberty: The Life and Work of William Moulton Marston." *History of the Human Sciences* 10.1 (1997): 91–122.

Bunn, Geoffrey C. *The Truth Machine: A Social History of the Lie Detector.* Baltimore: Johns Hopkins University Press, 2012.

Burch, Noel. *Life to Those Shadows.* Ed. and trans. Ben Brewster. Berkeley: University of California Press, 1990.

Burnham, John C. *Accident Prone: A History of Technology, Psychology, and Misfits of the Machine Age.* Chicago: The University of Chicago Press, 2009.

Busby, Marquis. "What Every Lover Should Know." *The Motion Picture Classic* 28.4 (1928): 28.

Byford, Andy. "The Mental Test as a Boundary Object in Early 20th-Century Russian Child Science." *History of the Human Sciences* 27.4 (2014): 1–37.

Byford, Andy. "V. M. Bekhterev in Russian Child Science, 1900s–1920s: 'Objective Psychology'/'Reflexology' as a Scientific Movement." *Journal of the History of the Behavioral Sciences* 52.2 (2016): 99–123.

By the Law [*Po Zakonu*], dir. Lev Kuleshov. DVD. *Landmarks of Early Soviet Film.* Los Angeles: Flicker Alley, 2011.

Carnicke, Sharon M. *Stanislavsky in Focus.* Amsterdam: Harwood Academic Publishers, 1998.

Carroll, Noel. "Film/Mind Analogies: The Case of Hugo Munsterberg." *Journal of Aesthetics and Art Criticism* 46.4 (1988): 489–499.

Cassedy, Steven. *Flight from Eden: the Origins of Modern Literary Criticism and Theory.* Berkeley: University of California Press, 1990.

Certeau, Michel de. *The Practice of Everyday Life.* Trans. Steven Rendall. Berkeley: University of California Press, 1984.

Chéroux, Clément, Andreas Fischer, Pierre Apraxine, Denis Canguilhem, and Sophie Schmit, eds. *The Perfect Medium: Photography and the Occult.* New Haven, CT: Yale University Press, 2005.

Choun, Ekaterina, and Craig Brandist. "Iz Predystorii Instituta Zhivogo Slova: Protokoly Zasedanii Kursov Khudozhestvennogo Slova." *Novoe Literaturnoe Obozreniie* 86 (2007): 96–106.

Chubarov, Igor'. *Kollektivnaia chuvstvennost': Teorii i praktiki levogo avangarda.* Moskva: Izdatel'skii dom Vysshei shkoly ekonomiki, 2014.

Colapietro, Vincent. "Let's All Go to the Movies: Two Thumbs Up for Hugo Münsterberg's the Photoplay (1916)." *Transactions of the Charles S. Peirce Society: A Quarterly Journal in American Philosophy* 36.4 (2000): 477–501.

Conolly-Smith, Peter. "Hugo Münsterberg's Life, Career and Photoplay: A Psychological Study." In *German? American? Literature? New Directions in German-American Studies,* ed. Winfried Fluck and Werner Sollors, 263–314. New York: Peter Lang, 2002.

Cowan, Michael. *Cult of the Will: Nervousness and German Modernity.* University Park: Penn State University Press, 2012.

Cowan, Michael. *Technology's Pulse: Essays on Rhythm in German Modernism.* London: Institute of Germanic & Romance Studies, School of Advanced Study, University of London, 2011.

Cox, David. "Can Your Brain Reveal You Are a Liar?" *BBC Future,* January 25, 2016. http://www.bbc.com/future/story/20160125-is-it-wise-that-the-police-have-started-scanning-brains?

Crary, Jonathan. *Suspensions of Perception: Attention, Spectacle, and Modern Culture.* Cambridge, MA: MIT Press, 1999.

Crary, Jonathan. *Techniques of the Observer: On Vision and Modernity in the Nineteenth Century.* Cambridge, MA: MIT Press, 1990.

Cyon, Elie [Tsion, Iliia]. *Atlas zur Methodik der Physiologischen Experimente und Vivisectionen.* St. Petersburg: Carl Ricker, 1876. *Max Planck Institute for the History*

of Science. The Virtual Laboratory. http://vlp.mpiwg-berlin.mpg.de/technology/data?id=tec579

Curtis, Robin. "*Einfühlung* and Abstraction in the Moving Image: Historical and Contemporary Reflections." *Science in Context* 25.3 (2012): 425–446, 427.

Curtis, Scott. *The Shape of Spectatorship: Art, Science, and Early Cinema in Germany,* New York: Columbia University Press, 2015.

Damasio, Antonio R. *Descartes' Error: Emotion, Reason and the Human Brain.* New York: Penguin Books, 2005.

Danius, Sara. *The Senses of Modernism: Technology, Perception, and Aesthetics.* Ithaca, NY: Cornell University Press, 2002.

Danziger, Kurt. "Wundt and the Two Traditions of Psychology." In *Wilhelm Wundt and the Making of a Scientific Psychology,* ed. R. W. Rieber, 73–115. New York: Plenum Press, 1980.

Darwin, Charles. *The Expression of the Emotions in Man and Animals.* New York: D. Appleton and Co., 1897.

Darwin, Charles. *O Vyrazhenii Oshchushchenii u Cheloveka i Zhivotnykh.* Ed. A. Kovalevskii. Sankt Peterburg: Tip. F.S. Sushchinskago, 1872.

Dearborn, G. V. N. "The Relation of Muscular Activity to the Mental Process." *American Psychological Education Review* 14.1 (1909): 10–16.

"Deceived by the Eye." *The Implet,* May 4, 1912.

Delabarre, E. B. "Volition and Motor Consciousness Theory." *Psychological Bulletin* 9.11 (1912): 409–413.

Delaporte, François. *Anatomy of the Passions.* Trans. Susan Emanuel. Ed. Todd Meyers. Stanford, CA: Stanford University Press, 2008.

Deleuze, Gilles. "The Brain Is the Screen." An Interview of *Cahiers du Cinéma* with Gilles Deleuze. In *The Brain Is the Screen: Deleuze and the Philosophy of Cinema,* trans. Gregory Flaxman, 365–371. Minneapolis: University of Minnesota Press, 2000.

DeMeester, Karen. "Trauma and Recovery in Virginia Woolf's Mrs. *Dalloway*." *Modern Fiction Studies* 44.3 (1998): 649–673.

Deraze, Marianne et Xavier Loyant. "Représenter la parole. Autour des premiers appareils de laboratoire de l'Institut de phonétique de Paris," *Revue de la BNF* 48.3 (2014): 12–18.

Dernova-Iarmolenko, A. *Refleksologicheskii Podkhod v Pedagogike.* Leningrad: Izd-vo khnizhnogo sektora GUBONO, 1925.

"Did You Ever Make a Phonograph Record?" *The Edison Phonograph Monthly* 10.9 (1912): 11.

Didi-Huberman, George. *Invention of Hysteria: Charcot and the Photographic Iconography of the Salpêtrière.* Trans. Alisa Hartz. Cambridge, MA: MIT Press, 2003.

Didi-Huberman, Georges "Pathos and Praxis (Eisenstein vs Barthes)." In *Sergei M. Eisenstein: Notes for a General History of Cinema,* ed. Naum Kleiman and Antonio Somaini, 309–322. Amsterdam: Amsterdam University Press, 2016.

Doane, Mary Ann. *The Desire to Desire: The Woman's Film of the 1940s.* Bloomington: Indiana University Press, 1987.

Doane, Mary Ann. "Film and Masquerade: Theorizing the Female Spectator." In *Feminist Film Theory: A Reader,* ed. Sue Thornham, 131–145. New York: New York University Press, 1999.

Dogiel, Johannes [Dogel', Ivan]. "Ueber den Einfluss der Musik auf den Blutkreislauf." *Archiv f. Anatomie und Physiologie* (1880): 416–428.

Douglas, Charlotte. "Energetic Abstraction: Ostwald, Bogdanov, and Russian Post-Revolutionary Art." In *From Energy to Information: Representation in Science and Technology, Art, and Literature*, ed. Bruce Clarke and Linda Dalrymple Henderson, 76–94. Stanford, CA: Stanford University Press, 2002.

Drinkwater, John. *The Life and Adventures of Carl Laemmle*. New York: G.P. Putnam's Sons, 1931.

Dubrovskii, A. "Kak delaetsia nauchnaia kartina." *Sovetskii Ekran* 6 (1928): 5.

Duchan, Judith Felson. "Edward Wheeler Scripture." In *A History of Speech—Language Pathology*. Department of Communicative Disorders and Sciences at the State University of New York at Buffalo. January 27, 2012. http://www.acsu.buffalo.edu/~duchan/history_subpages/scripture.html

Duchenne de Boulogne, G.-B. *Mécanisme de la physionomie humaine, ou Analyse électro-physiologique de l'expression des passions applicable à la pratique des arts plastiques*. Paris: Chez Ve Jules Renouard Libraire, 1862.

D'Udine, Jean (pseudonym of Albert Cozanet). *L'art et Le Geste*. Paris: Félix Alcan, 1910.

Eagle, Herbert. "Visual Patterning, Vertical Montage, and Ideological Protest: Eisenstein's Stylistic Legacy to East European Filmmakers." In *Eisenstein at 100: A Reconsideration*, ed. Albert J. LaValley and Barry P. Scherr, 169–192. New Brunswick: Rutgers University Press, 2001.

E. K. "Neposredstvennoe izucheniie zritelia." *Novyi Zritel'* 34 (1926): 8.

E. K.-va. "Problemy izucheniia zritelia." In *Publika kino v Rossii: Sotsiologicheskiie svidetel'stva 1910-30kh gg*, ed. Iu. U. Fokht-Babushkin, 141–142. Moscow: Gosudarstvennyi institut iskusstvoznaniia, 2013.

Efrussi, P. O. "Programmy kursov 'Obshchaia psikhologiia,' 'Psikhologiia myshleniia i rechi,' 'Psikhologiia tvorchestva.'" In *Zapiski Instituta Zhivogo Slova*, 42–43. Petrograd: Narodnyi kommisariat po prosveshcheniiu, 1919.

Eggert, B. "Untersuchungen über Sprachmelodie." Ed. H. Ebbinghaus and W. A. Nagel. *Zeitschrift für Psychologie und Physiologie der Sinnesorgane* 49 (1908): 218–237.

Egorova, Maria. *Teatral'naia publika: Evoliutsiia anketnogo metoda*. Moskva: Gosudarstvennyi Institut Iskusstvoznaniia, 2010.

Eikhenbaum, Boris. *Anna Akhmatova: Opyt Analiza*. Paris: Lev, 1980.

Eikhenbaum, Boris. "Curriculum vitae." *Materialy Instituta Zhivogo Slova Narkomprosa RSFSR* (The Russian State Archive of Literature and Art), f. 941 op.4, ed. khr. 2(1), l.32.

Eikhenbaum, Boris. "Kak sdelana 'Shinel' Gogolia." In *Skvoz' literaturu*, 171–195. Leningrad: Academia, 1924.

Eikhenbaum, Boris. *Melodika Russkogo Liricheskogo Stikha*. St. Peterburg: OPOIaZ, 1922.

Eikhenbaum, Boris. "O chtenii stikhov." *Zhizn' Iskusstva* 290 (November 12, 1919): 1.

Eikhenbaum, Boris. "O kamernoi deklamatsii." In *Literatura: Teoriia, kritika, polemika*, 226–249. Leningrad: Priboi, 1927.

Eikhenbaum, Boris. "O tragedii i tragicheskom." In *Skvoz' literaturu*, 71–83. Leningrad: Academia, 1924.

Eikhenbaum, Boris. "O zvukakh v stikhe." In *Skvoz' literaturu*, 201–208. Leningrad: Academia, 1924.

Eisenstein, Sergei. "Biomekhanika." In *Stenogramma lektsii v Proletkul'te* (1922), ed. V. V. Zabrodin. *Kinovedcheskiie zapiski* 41 (1999): 68–72.

Eisenstein, Sergei. "Dramaturgie der Film-form." In *Jenseits der Einstellung. Schriften zur Filmtheorie*, ed. Felix Lenz, 88–111. Frankfurt/Main: Suhrkamp, 2006.

Eisenstein, Sergei. "Dramaturgiia kinoformy." In *Formal'nyi metod: Antologiia russkogo modernizma*, trans. N. I. Kleiman and I. G. Epstein, 357–378. Tom 1: Sistemy, ed. Serguei Oushakine, 2016.

Eisenstein, Sergei. "The Dramaturgy of Film Form (The Dialectic Approach to Film Form)." In *Selected Works, Volume 1: Writings, 1922–1934*, ed. and trans. Richard Taylor, 161–180. London: I.B. Tauris, 2010.

Eisenstein, Sergei. *The Film Sense*. Ed. Jay Leyda. New York: Harcourt, Brace and World, 1970.

Eisenstein, Sergei. "The Fourth Dimension in Cinema." In *Selected Works, Volume 1: Writings, 1922–1934*, ed. and trans. Richard Taylor, 181–194. London: I.B. Tauris, 2010.

Eisenstein, Sergei. "How I Became a Director." In *Selected Works*, 3 vols., vol. 3, trans. William Powell, ed. Richard Taylor, 284–290. London: I.B. Tauris, 2010.

Eisenstein, Sergei. "Kak delaetsia pafos?" (1929). RGALI (the Russian State Archive of Literature and Arts), f. 1923 op. 1 ed. khr. 793 l. 31.

Eisenstein, Sergei. "Iz Lektsii vo VGIKe, 22 sentiabria 1934 goda." In *Eizenshtein o Meierkhol'de*, ed. Vladimir Zabrodin, 205–223. Moscow: Novoe izdatel'stvo, 2005.

Eisenstein, Sergei. "Konspekt lektsii V.E. Meierkhol'da, GVYRM i GVYTM, 1921–1922." In Vsevolod Meierkhol'd [Meyerhold], *K istorii tvorcheskogo metoda. Publikatsii. Stat'i by*, ed. N. V. Pesochinskii and E. A. Kukhta, 32–33. Sankt-Peterburg: Kul'tInformPres s, 1998.

Eisenstein, Sergei. "The Method of Making a Worker's Film." In *Selected Works*, ed. and trans. Richard Taylor, vol. 1, 65–66. London: I.B. Tauris, 2010.

Eisenstein, Sergei. "Methods of Montage." In *Film Form: Essays in Film Theory*, trans. and ed. Jay Leyda, 72–83. New York: Harcourt Brace, 1949.

Eisenstein, Sergei. "Montage 1937." In *Selected Works, Vol. 2: Towards a Theory of Montage*, trans. Michael Glenny, ed. Michael Glenny and Richard Taylor, 11–58. London: I.B.Tauris, 2010.

Eisenstein, Sergei. "Montage and Architecture." In *Selected Works*, vol. 2, Michael Glenny and Richard Taylor, eds., 59–82. London: I.B. Tauris, 2010.

Eisenstein, Sergei. "The Montage of Attractions." In *Selected Works*, ed. and trans. Richard Taylor, vol. I, 39–58. London: I.B. Tauris, 2010.

Eisenstein, Sergei. "Montazh kinoattraktsionov." In *Formal'nyi metod: Antologiia russkogo modernizma*, 379–400. Tom 1: Sistemy, ed. Serguei Oushakine. Moskva: Kabinetnyi uchenyi, 2016.

Eisenstein, Sergei. "My Art in Life." *Kinovedcheskie zapiski* 36–37 (1997–1998): 13–23.

Eisenstein, Sergei. "Perspectives (1929)." In *Selected Works*, ed. and trans. Richard Taylor, vol. I, 182. London: I.B. Tauris, 2010.

Eisenstein, Sergei. "Plan rabot kinosektsii." RGALI (the Russian State Archive of Literature and Arts), f. 923, op.1, ed. khr. 2405.

Eisenstein, Sergei. "The Problem of the Materialist Approach to Film." In *Lines of Resistance: Dziga Vertov and the Twenties*, ed. Yuri Tsivian, trans. Julian Graffy, 126–127. Sacile: Le Giornate del Cinema Muto, 2004.

Eisenstein, Sergei. "Rezhissura. Iskusstvo mizanstseny." In *Izbrannye proizvedeniia v shesti tomakh*, ed. P. M. Atasheva, N. I. Kleiman, and S. I. Iutkevich, vol. 4, 13–674. Moskva: Iskusstvo, 1966.

Eisenstein, Sergei. "Stanislavskii i Loiola." Ed. Naum Kleiman. *Kinovedcheskie Zapiski* 47 (2000), http://www.kinozapiski.ru/ru/article/sendvalues/384

Eisenstein, Sergei. "S zaranee obdumannym namereniem: 'Montazh attraktsionov.'" In *Metod*, ed. N. I. Kleiman, vol. 1, 49–63. Moskva: Muzei kino, 2002.

Eisenstein, Sergei. "Za kadrom." In *Izbrannye proizvedeniia v shesti tomakh*, ed. P. M. Atasheva, N. I. Kleiman, and S. I. Iutkevich, vol. 2, 283–296. Moskva: Iskusstvo, 1964.

Eisenstein, Sergei, and Grigorii Aleksandrov. "Dvenadtsatyi." *Sovetskii Ekran* 6 (November 1928): 4–5.

Eisenstein, Sergei, and Grigorii Aleksandrov. "The Twelfth Year." In *Sergei Eisenstein: Selected Works*, trans. and ed. Richard Taylor, vol. 1, 123–126. London: I.B. Tauris, 2010.

Ellenberger, Henry. *The Discovery of the Unconscious: The History and Evolution of Dynamic Psychiatry*. New York: Basic Books, 1970.

"Emotion Pictures: A Film Psychologist's Views." *The Times of India*, May 31, 1929, A12.

Epstein, Jean. "Magnification." In *French Film Theory and Criticism: A History/Anthology, Volume I: 1907–1929*, ed. Richard Abel, 235–240. Princeton, NJ: Princeton University Press, 1988.

Erlich, Victor. *Russian Formalism: History, Doctrine*. 3rd ed. New Haven, CT: Yale University Press, 1981.

Erlich, Victor. *Russkii formalizm: Istoriia i teoriia*. Trans. A. Glebovskaia. St. Petersburg: Akademicheskii proekt, 1996.

Etkind, Aleksandr. "James and Konovalov: The Varieties of Religious Experience and Russian Theology Between Revolutions." In *William James in Russian Culture*, ed. Joan Delaney Grossman and Ruth Rischin, 169–188. Lanham, MD: Lexington Books, 2003.

Etkind, Efim. "Vjaceslav Ivanov et les questions de poétique. Années 1920." *Cahiers du monde russe: Russie, Empire russe, Union soviétique, États indépendants* 35.1–2 (1994): 141–154. *Persee*. April 16, 2009. http://www.persee.fr/web/revues/home/prescript/article/cmr_1252-6576_1994_num_35_1_2381

Fechner, Gustav T. *Elemente Der Psychophysik*. Leipzig: Breitkopf und Härtel, 1860.

Fedorov, V. F. "Opyty izucheniia zritel'nogo zala (1)." *Zhizn' Iskusstva* 18 (1925): 14–15.

Fedorov, V. F. "Opyty izucheniia zritel'nogo zala (2)." *Zhizn' Iskusstva* 23 (1925): 10–11.

Fel'dberg, Davyd Vladimirovich. "Curriculum vitae." *Materialy Instituta Zhivogo Slova Narkomprosa RSFSR*. RGALI (the Russian State Archive of Literature and Arts), f. 941 op.4, ed. khr. 2(2), l.59.

Féré, Charles. *Sensation et Mouvement: Études Expérimentales de Psycho-Mécanique*. Paris: F. Alcan, 1887.

Figes, Orlando. *A People's Tragedy: A History of the Russian Revolution*. New York: Viking Penguin, 1996.

Fizer, John. *Alexander A. Potebnja's Psycholinguistic Theory of Literature: A Metacritical Inquiry*. Cambridge, MA: Harvard University Press, 1988.

Fleming, Amanda C. "In Search for the Child Spectator in the Late Silent Era." In *Making Sense of Cinema: Empirical Studies into Film Spectators and Spectatorship*, ed. Carrie Lynn D. Reinhard and Christopher J. Olson, 119–138. New York: Bloomsbury Academic, 2017.

Fletcher, John. *Freud and the Scene of Trauma*. New York: Fordham University Press, 2013.

Fokht-Babushkin, Iu. U. "Primechaniia." In *Publika kino v Rossii: sotsiologicheskiie svidetel'stva, 1910- 30kh gg*, ed. Iu. U. Fokht-Babushkin, 454–488. Moscow: Gosudarstvennyi institut iskusstvoznaniia, 2013.

Foregger, Nikolai. "Otvety na voprosy redaktsii." *Zrelishcha* 6 (1922): 12.

Frederickson, Donald. *The Aesthetic of Isolation in Film Theory: Hugo Munsterberg.* New York: Arno, 1977.

Friedberg, Anne. *Window Shopping: Cinema and the Postmodern.* Berkeley: University of California Press, 1993.

Fülöp-Miller, René. *The Mind and Face of Bolshevism: An Examination of Cultural Life in Soviet Russia.* London: G. P. Putnam's Sons, 1927.

G.D. "Izuchenie krest'ianina-zritelia." *Sovetskii Ekran* 11 (1925).

Gaidenko, Piama. *Vladimir Solov'ev i Filosofiia Serebriannogo Veka.* Moskva: Progress-Traditsiia, 2001.

Gan, Aleksei. "Kino-tekhnikum." *Ermitazh* 10 (1922): 10–11.

Garbuz, A. V., and V. A. Zaretskii. "K etnolingvisticheskoi konceptsii mifotvorchestva Khlebnikova." *Mir Velimira Khlebnikova.* 331–347.

Gardin, Vladimir. *Vospominania.* 2 vols. Moskva: Goskinoizdat, 1949.

Gastev, Aleksei. *Kak nado rabotat': Vvdedenie v nauchnuiu organizatsiu truda.* 2nd ed. Moskva: Ekonomika, 1972.

Gastev, Aleksei. "Kak nado rabotat'. Azbuka raboty. Central'nyi Institut Truda." Poster Image. In *Kak nado rabotat': Vvdedenie v nauchnuiu organizatsiu truda*, 2nd ed., 2. Moscow: Ekonomika, 1972.

Gel'mont, A. M. "Izuchenie detskogo kinozritelia." In *Publika kino v Rossii: Sotsiologicheskii svidetel'stva 1910–30kh gg*, ed. Iu. U. Fokht-Babushkin, 398–436. Moscow: Gosudarstvennyi institut iskusstvoznaniia, 2013.

Gel'mont, A. M. "Izuchenie vlania kino na detei." *Kino i kul'tura* 4 (1929): 38–46.

Gerigk, Horst-Jürgen. *Lesendes Bewusstsein: Untersuchungen Zur Philosophischen Grundlage Der Literaturwissenschaft.* Berlin: W. De Gruyter, 2016.

Ghidini, Maria Candida. "Zvuk i smysl. Nekotorye zamechaniia po teme glossolalii u Viacheslava Ivanova." In *Viacheslav Ivanov i ego vremia: Materialy VII Mezhdunarodnogo simpoziuma*, eds. Sergei Averintsev and Rosemarie Ziegler, 65–83. Frankfurt: Peter Lang, 2002.

Giedion, Sigfried. *Mechanization Takes Command, a Contribution to Anonymous History.* New York: Oxford University Press, 1948.

Giraudet, Alfred. *Mimique, Physionomie et Gestes: Méthode Pratique D'après le Système de F. Del Sarte pour Servir à L'expression des Sentiments.* Paris: Ancienne Maison Quantin, 1895.

Gitelman, Lisa. *Scripts, Grooves, and Writing Machines: Representing Technology in the Edison Era.* Stanford, CA: Stanford University Press, 1999.

Givler, Robert Cenault. "The Psycho-physiological Effect of the Elements of Speech in Relation to Poetry." *Psychological Review: The Psychological Monographs* 19.2 (1916): 1–132.

Golston, Michael. *Rhythm and Race in Modernist Poetry and Science: Pound, Yeats, Williams, and Modern Sciences of Rhythm.* New York: Columbia University Press, 2008.

Goodenough, Oliver R., and Semir Zeki. *Law and the Brain.* Oxford: Oxford University Press, 2006.

Gordon, Rae B. "From Charcot to Charlot: Unconscious Imitation and Spectatorship in French Cabaret and Early Cinema." *Critical Inquiry* 27.3 (2001): 515–549.

Gordon, Rae B. *Why the French Love Jerry Lewis: From Cabaret to Early Cinema.* Stanford, CA: Stanford University Press, 2001.

Gough, Maria. *Artist as Producer Russian Constructivism in Revolution.* Berkeley: University of California Press, 2014.

Gross, Daniel. "Defending the Humanities with Charles Darwin's *The Expression of Emotions in Animals and Man* (1872)." *Critical Inquiry* 37.1 (2010): 34–59.

Grossman, Joan Delaney, and Ruth Rischin. *William James in Russian Culture*. Lanham, MD: Lexington Books, 2003.

Guido, Laurent. *L'âge du Rythme. Cinéma, Musicalité et Culture du Corps dans les Théories Françaises des Années 1910–1930*. Paris: L'Age d'Homme Editions, 2014.

Gunning, Tom. "An Aesthetic of Astonishment: Early Film and the Incredulous Spectator." In *Viewing Positions: Ways of Seeing Film*, ed. Linda Williams, 114–133. New Brunswick, NJ: Rutgers University Press, 1994.

Gunning, Tom. "The Cinema of Attractions: Early Film, Its Spectator and the Avant-Garde." In *Early Cinema: Space, Frame, Narrative*, ed. Elsaesser Thomas and Adam Barker, 56–62. London: British Film Institute, 1990.

Gunning, Tom. "In Your Face: Physiognomy, Photography, and the Gnostic Mission of Early Film." *Modernism/modernity* 4.1 (1997): 1–29.

Hansen, Miriam. *Babel and Babylon: Spectatorship in American Silent Film*. Cambridge, MA: Harvard University Press, 1991.

Hansen, Miriam. *Cinema and Experience: Siegfried Kracauer, Walter Benjamin, and Theodor W. Adorno*. Berkeley: University of California Press, 2012.

Hansen, Miriam. "The Mass Production of the Senses: Classical Cinema as Vernacular Modernism." *Modernism/modernity* 6.2 (1999): 59–77.

Hansen-Löve, Aage Ansgar. *Russkii Formalism: Metodologicheskaia Rekonstruktsiia Razvitiia Na Osnove Printsipa Ostraneniia*. Trans. S. A. Romashko. Moskva: iazyki russkoi kul'tury, 2001.

Hamsun, Knut. *Hunger*, trans. Robert Bly. New York: Farrar, Straus and Giroux, 1967.

Harston, Louis D. "Stetson: A Biographical Sketch." In *R.H. Stetson's Motor Phonetics*, ed. J. A. S. Kelso and K. G. Munhall, 1–8. Boston: Little, Brown and Co., 1988.

Hatfield, Gary. "Helmholtz and Classicism: The Science of Aesthetics and Aesthetics of Science." In *Hermann Von Helmholtz and the Foundations of Nineteenth-Century Science*, ed. David Cahan, 522–558. Berkeley: University of California Press, 1993.

Heller-Roazen, Daniel. *The Fifth Hammer: Pythagoras and the Disharmony of the World*. New York: Zone Books, 2011.

Heller-Roazen, Daniel. *The Inner Touch: Archaeology of a Sensation*. New York: Zone Books, 2007.

Helmholtz, Hermann von. *Handbuch der physiologischen Optik*. Hamburg: L. Voss, 1896.

Helmholtz, Hermann von. *Die Lehre von den Tonempfindungen als physiologische Grundlage für die Theorie der Musik*. Braunschweig: Friedrich Vieweg und Sohn, 1863.

Herbart, Johann F. "Psychologische Untersuchungen." In *Johann Friedrich Herbart's Sämmtliche Werke*, ed. Gustav Hartenstein, vol. 7, 1850–1852. Leipzig: L. Voss.

Hergenhahn, B. R. *An Introduction to the History of Psychology*. Belmont, MA: Wadsworth, 1992.

Hoffman, Michael J. "Gertrude Stein in the Psychology Laboratory." *American Quarterly* 17.1 (1965): 127–132.

Holl, Ute. *Cinema, Trance and Cybernetics*. Trans. Daniel Hendrickson. Amsterdam: Amsterdam University Press, 2017.

Hurst, A. S., and John MacKay. "Experiments of the Time Relations of Poetic Meters." *University of Toronto Studies Psychological Series* 1.3 (1899): 157–175.

Iakubinskii, Lev. "O dialogicheskoi rechi." In *Russkaia rech': Sborniki statei pod red. L. Shcherby*, 96–194. Petrograd: Izdanie foneticheskogo instituta prakticheskogo izucheniia iazykov, 1923.

Iakubinskii, Lev. "O zvukakh poeticheskogo iazyka." In *Poetika: Sborniki po teorii poeticheskogo iazyka*, 44–45. Petrograd: 18-aia Gos. Tipografiia, 1919.

Iakushkina, V. G., ed. "Vopsrosy izucheniia zrelishchnykh iskusstv v Gosudarstvennoi Akademii Khudozhestvennykh Nauk (GAKhN), 1921–1930 gg." *Zrelishchnye iskusstva: Referativno-bibliograficheskaia informatsiia* 1 (1995): 22–28.

Iampol'skii, Mikhail. "Eizenshteinovskii sintez." In *Uskol'zaiuschshii kontekst: Russkaia filosofiia v XX v.*, ed. Mikhail Ryklin, Dirk Uffelmann, and Klaus Städtke, 77–104. Moskva: Ad Marginem, 2002.

Iampol'skii, Mikhail. "Kuleshov and the New Anthropology of the Actor." In *Inside the Film Factory: New Approaches to Russian and Soviet Cinema*, ed. Richard Taylor and Ian Christie, 31–50. London: Routledge, 1991.

Iampol'skii, Mikhail. "Ot Proletkul'ta k Platonu: Eizenshtein i proekt smyslovoi samoorganizatsii zhizni." *Kinovedcheskie Zapiski* 89 (2009). http://www.kinozapiski.ru/ru/article/sendvalues/960/

Iampol'skii, Mikhail. "Smysl prikhodit v mir: Zametki o semantike Dzigi Vertova." *Kinovedcheskie Zapiski* 87 (2008): 54–65.

Igo, Sarah E. *The Averaged American: Surveys, Citizens, and the Making of a Mass Public.* Cambridge, MA: Harvard University Press, 2007.

Issledovatel'skaia Teatral'naia Masterskaia. "Grafik reaktsii kinozritelei na pokaz fil'ma 'Bronenosets Potemkin' 16 iunia 1926." *Materialy Issledovatel'skoi Teatral'noi Masterskoi Glaviskusstva Narkomprosa.* RGALI (the Russian State Archive of Literature and Arts), 645 op. 1. ed. khr. 389 l. 57.

Issledovatel'skaia Teatral'naia Masterskaia. "*Konets Krivoryl'ska-zare navstrechu!* v Teatre Revoliutsii." *Zhizn' iskusstva* 15 (1926): 14–15.

Issledovatel'skaia Teatral'naia Masterskaia. "Kratkii otchet o rabote komissii po izucheniiu zritelia pri khudozhestvennom otdele Glavpolitprosveta za period oktiabr'-iiul' 1925–1926 gg." *Materialy Issledovatel'skoi Teatral'noi Masterskoi Glaviskusstva Narkomprosa* RGALI (the Russian State Archive of Literature and Arts), f. 645. op. 1. ed. khr. 312, l. 118.

Issledovatel'skaia Teatral'naia Masterskaia. "Nabliudenie zritelia eksperimental'noi lozhi." *Materialy Issledovatel'skoi Teatral'noi Masterskoi Glaviskusstva Narkomprosa* RGALI (the Russian State Archive of Literature and Arts), f. 645 op.1. ed. khr. 312. l. 113.

Issledovatel'skaia Teatral'naia Masterskaia. "*Otello-Rossov* i zritel': Zamoskvoretskii teatr." *Zhizn' iskusstva* 23 (1925): 11.

Issledovatel'skaia Teatral'naia Masterskaia. "Programma issledovatel'skoi teatral'noi masterskoi." *Materialy Issledovatel'skoi Teatral'noi Masterskoi Glaviskusstva Narkomprosa.* RGALI (the Russian State Archive of Literature and Arts), f. 645 op.1. ed. khr. 312. l. 115.

Issledovatel'skaia Teatral'naia Masterskaia. "Protokol No. 14. Uslovnye refleksy vysshego poriadka: esteticheskiie, intellektual'nye, nravstvennye." *Materialy Issledovatel'skoi Teatral'noi Masterskoi Glaviskusstva Narkomprosa* RGALI (the Russian State Archive of Literature and Arts), f. 645 op.1. ed. khr. 312. l. 121.

Issledovatel'skaia Teatral'naia Masterskaia. "*Rozita* v moskovskom Kamernom Teatre." *Zhizn' iskusstva* 16 (1926): 15.

Issledovatel'skaia Teatral'naia Masterskaia. "Smeta po issledovaniiu tsirkovogo aktera i zritelia." *Materialy Issledovatel'skoi Teatral'noi Masterskoi Glaviskusstva Narkomprosa* RGALI (the Russian State Archive of Literature and Arts), f.645 op.1. ed.khr. 312 l. 226–227.

Issledovatel'skaia Teatral'naia Masterskaia. "Spisok rabotnikov Issledovatel'skoi Teatral'noi Masterskoi na 15 dekabria 1927 g." *Materialy Issledovatel'skoi Teatral'noi Masterskoi Glaviskusstva Narkomprosa.* RGALI (the Russian State Archive of Literature and Arts) f. 645 op.1. ed. khr. 31.l.117.

Issledovatel'skaia Teatral'naia Masterskaia. "Tezisy doklada o metodakh izucheniia teatral'nogo zritelia." *Materialy Issledovatel'skoi Teatral'noi Masterskoi Glaviskusstva Narkomprosa* RGALI (The Russian State Archive of Literature and Art), f. 645 op.1. ed. khr. 312. l. 159.

Issledovatel'skaia Teatral'naia Masterskaia. "Uslovnye refleksy vysshego poriadka: esteticheskiie, intellektual'nye, nravstvennye." *Materialy Issledovatel'skoi Teatral'noi Masterskoi Glaviskusstva Narkomprosa.* RGALI (the Russian State Archive of Literature and Arts) f. 645 op.1. ed. khr. 312. l. 121.

Issledovatel'skaia Teatral'naia Masterskaia. "Zapis' replik zala. *Bronenosets Potemkin.*" (the Russian State Archive of Literature and Arts) RGALI f. 645. op. 1. ed. khr. 312, l. 162–163.

Iusupova, Galiia. '*S bol'shim material'nym i khudozhestvennym uspekhom . . .* ' Kassovye fenomeny populiarnogo iskusstva 1920-kh gg.: Kino, literatura, teatr. Moscow: Gos. Institut Iskustvoznaniia, 2015.

Ivanov, Viacheslav V. "Analiz glubinnykh struktur semioticheskikh system iskusstva." *Ocherki po istorii semiotiki v SSSR.* Moskva: Nauka, 1976.

Ivanov, Viacheslav V. *Izbrannye Trudy po Semiotike i Istorii Kul'tury.* Vol. 1. Moskva: Iazyki russkoi kul'tury, 1998.

Ivanov, Viacheslav V. *Izbrannye Trudy po Semiotike i Istorii Kul'tury.* Vol. 4. Moskva: Shkola Iazyki russkoi kul'tury, 2007.

Ivanov, Viacheslav I. "K probleme zvukoobraza u Pushkina." In V. I. Ivanov, *Lik i Lichiny Rossii: Estetika i Literaturnaia Teoriia,* ed. S. S. Averintsev, 242–247. Moskva: Iskusstvo, 1995.

Jacobs, Lea. *The Decline of Sentiment: American Film in the 1920s.* Berkeley: University of California Press, 2008.

Jakobson, Roman, and Linda R. Waugh. *The Sound Shape of Language.* 2nd ed. Hague: Mouton de Gruyter, 2002.

James, William. *The Principles of Psychology.* 2 vols. New York: Henry Holt and Co., 1890.

James, William. *Psychology. A Briefer Course.* New York: Henry Holt and Company, 1892.

James, William. "What Is an Emotion?" *Mind* 9 (1884): 188–205, 192–193. *Classics in the History of Psychology.* Ed. Christopher D. Greene. http://psychclassics.yorku.ca/James/emotion.htm

Janecek, Gerald, and Peter Mayer. Annotation for "On Poetry and Trans-Sense Language" by Viktor Shklovskii. Trans. and ed. Gerald Janecek and Peter Mayer. *October* 34 (1985): 3–24.

Jean-Paul Morel, "Le Docteur Toulouse ou le cinéma vu par un psycho-physiologiste, 1912–1928." *1895: Bulletin de l'Association française de recherche sur l'histoire du cinéma* 60 (2010): 123–155.

Johansson, Kurt. *Aleksej Gastev. Proletarian Bard of the Machine Age*. Stockholm: Almqvist and Wiksell, 1983.

Jones, Caroline A. *Eyesight Alone: Clement Greenberg's Modernism and the Bureaucratization of the Senses*. Chicago: University of Chicago Press, 2005.

Jones, Daniel. *Intonation Curves, a Collection of Phonetic Texts, in Which Intonation Is Marked Throughout by Means of Curved Lines on a Musical Stave*. Leipzig: B. G. Teubner, 1909.

Jowett, Garth S., Ian C. Jarvie, and Kathryn Fuller-Seeley. *Children and the Movies: Media Influence and the Payne Fund Controversy*. Cambridge: Cambridge University Press, 2007.

Kaganovsky, Lilya. *How the Soviet Man Was Unmade: Cultural Fantasy and Male Subjectivity Under Stalin*. Pittsburgh: University of Pittsburgh Press, 2008.

Kaganovsky, Lilya. *The Voice of Technology: Soviet Cinema's Transition to Sound, 1928–1935*. Bloomington: Indiana University Press, 2018.

Kagarov, E. "O ritme russkoi prozaicheskoi rechi." *Nauka na Ukraine* 4 (1922): 324–332.

Kanunikov, I. E., "Ivan Mikhailovich Sechenov—The Outstanding Russian Neurophysiologist and Psychophysiologist." *Journal Of Evolutionary Biochemistry and Physiology* 40.5 (2004): 596–602.

Karokhin, Lev. "V svoei sem'e on byl voron'im pugalom: Vospominaniia S.G. Vysheslavtsevoi o Mandel'shtame." *Sankt-Peterburgskie vedomosti*. January 13, 2001. *Elektronnyi Arkhiv Gazet i Zhurnalov na Servere DUX*. February 13, 2011. http://www.pressa.spb.ru/newspapers/spbved/2001/arts/spbved-2396-art-21.html

Katsigras, A. "Opyt fiksatsii zritel'skikh interesov" (1925). In *Publika kino v Rossii: sotsiologicheskiie svidetel'stva, 1910–30kh gg.*, ed. Iu. U. Fokht-Babushkin, 307–308. Moscow: Gosudarstvennyi institut iskusstvoznaniia, 2013.

Kenez, Peter. *Cinema and Soviet Society from the Revolution to the Death of Stalin*. London: I.B. Tauris, 2001.

Khokhlova, Ekaterina. "Commentary on Kuleshov's *Znamia Kinematografii* [*The Banner of Cinema*]." Lev Kuleshov and Aleksandra Khokhlova. *50 let v kino*. Moskva: Iskusstvo, 1975.

Khokhlova, Ekaterina. "Kuleshov's Effects." *Russian Heritage* 2 (1993): 110–115.

Khokhlova, Ekaterina, Kristin Thompson, and Yuri Tsivian. "The Rediscovery of a Kuleshov Experiment: A Dossier." *Film History* 8.3 (1996): 357–367.

Khrenov, N. "K probleme sotsiologii i psikhologii kino 1920-kh gg." *Problemy kinoiskusstva* 17 (1976): 163–184.

Kiaer, Christina. *Imagine No Possessions: The Socialist Objects of Russian Constructivism*. Cambridge, MA: MIT Press, 2008.

Kichigina, Galina. *The Imperial Laboratory: Experimental Physiology and Clinical Medicine in Post-Crimean Russia*. Amsterdam: Rodopi, 2009.

Killen, Andreas. "Accidents Happen: The Industrial Accident in Interwar Germany." In *Catastrophes: A History and Theory of an Operative Concept*, ed. Nitzan Lebovic and Andreas Killen, 75–92. Berlin: De Gruyter, 2014.

Kingsley, Grace. "Hollywood's First 'No' Man Turns Down Plays." *Los Angeles Times*, January 26, 1929, A6.

Kingsley, Grace. "Universal Signs Psychologist: Inventor of Lie Detector Will Analyze U[niversal] Pictures." *Los Angeles Times*, January 11, 1929, A10.

Kiterman, Boris. "Emotsional'nyi smysl slova." *Zhurnal ministerstva narodnago prosveshcheniia* 19.1 (1909): 164–176.

Kiterman, Boris. "Emotsional'nye elementy slova." *Golos i rech'* 5-6 (May–June 1913): 30–33.

Kittler, Friedrich A. "Romanticism—Psychoanalysis—Film: A History of the Double." In *Essays: Literature, Media, Information Systems*, ed. John Johnston and trans. Stefanie Harris, 85–100. Amsterdam: Gordon & Breach, 1997.

Kittler, Friedrich A. *Gramophone, Film, Typewriter*. Trans. Geoffrey Winthrop-Young and Michael Wutz. Stanford, CA: Stanford University Press, 1999.

Klee, Paul. "Pädagogische Skizzenbuch." *Bauhausbücher* Bd. 2. München (1925).

Klimov, E. A,. and O. G. Noskova. *Istoriia psikhologii truda v Rossii*. Moscow: Izdatel'stvo Moskovskogo Universiteta, 1992.

Kogan, V. M., and L. I. Seletskaia. "Skromnoe nachalo: Vospominaniia o pervoi laboratorii psikhologii truda." *Voprosy psikhologii* 4 (1996): 111–126. http://www.voppsy.ru/issues/1996/964/964111.htm

Konovalov, Dmitri. "Magisterskii disput. *Religioznyi Ekstaz v Russkom Misticheskom Sektanstve*. Chast' 1, vypusk 1, Fizicheskie iavlenia v kartine sektantskogo ekstaza." *Bogoslovskii Vestnik* 1.1 (1909): 152–167, 167. *Khristianskaia Teologiia i Antropologiia*, http://www.xpa-spb.ru/libr/Konovalov-DG/magisterskij-disput-1.pdf

Konovalov, Dmitri. *Religioznyi ekstaz v russkom sektanstve*. Sergiev Posad: Tip. Sergievoi Lavry, 1908.

Konovalov, Dmitri. "*Religioznyi Ekstaz v Russkom Misticheskom Sektanstve*. 1. Kartina sektantskogo ekstaza." *Bogoslovskii Vestnik* 1.3 (1907): 595–614, 602. *Khristianskaia Teologiia i Antropologiia* http://www.xpa-spb.ru/libr/Konovalov-DG/religioznyj-ekstaz-3.pdf

Korvin, A. A. "Programma kursa 'Vvedenie v prakticheskie zaniatiia po plastike.'" *Zapiski Instituta Zhivogo Slova*. Petrograd: Narodnyi kommisariat po prosveshcheniiu, 1919.

Koss, Juliet. "On the Limits of Empathy." *The Art Bulletin* 88.1 (2006): 139–157.

Kostyleff, Nicolas. *La crise de la psychologie expérimentale*. Paris: F. Alcan, 1911.

Kostyleff, Nicolas. *Le mécanisme cérébral de la pensée*. Paris: F. Alcan, 1914.

Koutstaal, Wilma. "Skirting the Abyss: a History of Experimental Explorations of Automatic Writing in Psychology." *Journal of the History of the Behavioral Sciences* 28.1 (1992): 5–27.

Kovarskii, Nikolai. "Melodika Stikha." In *Poetika: Vremennik otdeleniia slovsenykh iskusstv*, 26–44. Leningrad: Academia, 1928.

Kozhanov, D. N. "Ob uchete reaktsii zritelia. Razrabotka temy po zadaniiu rezhisserskoi gruppy GEKTEMAS." (November 29, 1929). *Lichnyi Arkhiv V. E. Meierkhol'da*. RGALI (The Russian State Archive of Literature and Art), f. 998 op.1. ed.khr. 2906.

Kozulin, Alex. *Psychology in Utopia: Toward a Social History of Soviet Psychology*. Cambridge, MA: MIT Press, 1984.

Kozulin, Alex. *Vygotsky's Psychology: A Biography of Ideas*. Cambridge, MA: Harvard University Press, 2001.

Kracauer, Siegfried. *Theory of Film: The Redemption of Physical Reality*. New York: Oxford University Press, 1960.

Král, Joseph, and F. Mareš. "Trvání Hlásek A Slabik Dle Objektivní Míry." *Listy filologické* 20 (1893): 257–290.

"Kratkii otchtet o rabote komissii po izucheniiu zritelia pri khudozhestvennom otdele Glavpolitprosveta za period oktiabr'-iul' 1925–1926." RGALI f. 645 op. 1. ed.khr. 312 l.118.

Kravchenko, A. I. *Istoriia menedzhmenta*. Moskva: Akademicheskii proekt, 2005.

Kreimeier, Klaus, and Annemone Ligensa, eds. *Film 1900: Technology, Perception, Culture.* New Burnet, England: John Libbey, 2009.

Krikler, Dennis M. "The Search for Samojloff: a Russian Physiologist, in Times of Change." *British Medical Journal* 295 (1987): 1624–1627.

Kruchenykh, Aleksei. "Novye puti slova." In *Manifesty i programmy russkikh futuristov. Die Manifeste und Programmschriften der russischen Futuristen*, ed. Vladimir Markov, 64–72. München: Fink, 1967.

Kruchenykh, Aleksei. *Piatnadtsat' let russkogo futurizma, 1912–1927.* Moskva: vserossiiskii soiuz poetov, 1928.

Kruchenykh, Aleksei, and Velimir Khlebnikov. *Slovo kak takovoe.* [Moskva]: Tipo.-lit. Ia. Dankin i Ia. Khomutov, 1913.

Kruchenykh, Aleksei. *Vzorval'*, 2nd ed., with illustrations by N. Kul'bin, N. Goncharova, O. Rozanova, K. Malevich, and N. Al'tman. Sankt-Peterburg: Litografiia Svet, 1913.

Kuleshov, Lev. "Chto nado delat's v kinematograficheskikh shkolakh?" *Lev Kuleshov. Stat'i. Materialy*, 155–160. Moskva: Iskusstvo, 1979.

Kuleshov, Lev. "Esli teper' . . ." *Lev Kuleshov. Sobranie sochinenii*, ed. A. S. Khokhlova, I. L. Sosnovskii, E. S. Khokhlova, vol. 1, 90–91. Moskva: Iskusstvo, 1987.

Kuleshov, Lev. "Iskusstvo kino. Moi opyt." *Lev Kuleshov. Sobranie sochinenii*, ed. A. S. Khokhlova, I. L. Sosnovskii, E. S. Khokhlova, vol. 1, 161–226. Moskva: Iskusstvo, 1987.

Kuleshov, Lev. "Kinematograficheskii naturshchik." *Zrelishcha* 1 (1922): 16.

Kuleshov, Lev. "Montazh." *Kino-fot* 3 (1922): 11–12.

Kuleshov, Lev. "Otchet za pervuiu polovinu 1923 g. i preiskurant raboty zhivogo materiala eksperimental'noi laboratorii na 1923/24 gg." *Lev Kuleshov. Sobranie sochinenii*, ed. A. S. Khokhlova, I. L. Sosnovskii, E. S. Khokhlova, vol. 1, 356–370. Moskva: Iskusstvo, 1987.

Kuleshov, Lev. "Plan eksperimental'noi kinolaboratorii, 1923–1924." *Lev Kuleshov. Sobranie sochinenii*, ed. A. S. Khokhlova, I. L. Sosnovskii, E. S. Khokhlova, vol. 1, 371–380. Moskva: Iskusstvo, 1987.

Kuleshov, Lev. "Praktika rezhissury." *Lev Kuleshov. Sobranie sochinenii*, ed. A. S. Khokhlova, I. L. Sosnovskii, E. S. Khokhlova, vol. 1, 227–1342. Moskva: Iskusstvo, 1987.

Kuleshov, Lev. "Programma kinematograficheskoi eksperimental'noi masterskoi kollektiva prepodavatelei po klassu naturshchika." *Lev Kuleshov. Sobranie sochinenii*, vol. 1, ed. A. S. Khokhlova, I. L. Sosnovskii, E. S. Khokhlova, 349–353. Moskva: Iskusstvo, 1987.

Kuleshov, Lev. "Rabota ruk." *Lev Kuleshov. Sobranie sochinenii*, ed. A. S. Khokhlova, I. L. Sosnovskii, E. S. Khokhlova, vol. 1, 109–110. Moskva: Iskusstvo, 1987.

Kuleshov, Lev. "Spravka o naturshchike." *Lev Kuleshov. Sobranie sochinenii*, ed. A. S. Khokhlova, I. L. Sosnovskii, E. S. Khokhlova, vol. 1, 86. Moskva: Iskusstvo, 1987.

Kuleshov, Lev. "Tvorcheskaia Zaiavka na Prikliuchencheskii Fil'm s Uchastiem I.V. Il'inskogo." *Lev Kuleshov. Sobranie sochinenii*, ed. A. S. Khokhlova, I. L. Sosnovskii, E. S. Khokhlova, vol. 2, 374–379. Moskva: Iskusstvo, 1988.

Kuleshov, Lev. "Znamia Kinematografii." *Lev Kuleshov. Stat'i. Materialy*, 87–113. Moskva: Iskusstvo, 1979.

Kuleshov, Lev, and Aleksandra Khokhlova. *50 let v kino.* Moskva: Iskusstvo, 1975.

Kuleshov, Lev, and Viktor Shklovskii. "Funtik." *Lev Kuleshov. Sobranie sochinenii*, ed. A. S. Khokhlova, I. L. Sosnovskii, E. S. Khokhlova, vol. 2, 332–355. Moskva: Iskusstvo, 1988.

Kuprin, Aleksandr. *Olesia.* S.-Peterburg: Izdat. M. O. Vol'f, 1900.

Kursell, Julia. "Piano Mécanique and Piano Biologique: Nikolai Bernstein's Neurophysiological Study of Piano Touch." *Configurations* 14.3 (2006): 245–273.

Kussmaul, Adolph. *Entsiklopedicheskii slovar' Brokgauza i Efrona*. Based on the 1890–1907 edition. CD-ROM. IDDK Media Project. Eds. Mikhail Zlokazov, Ekaterina Aleksandrova, and Vitalii Belobrov. Moscow: Adept, 2002.

Kussmaul, Adolph. *Die Störungen der Sprache: Versuch. einer Pathologie der Sprache.* Leipzig: Vogel, 1910.

Kussmaul', Adol'f." *Entsiklopedicheskii slovar' Brokgauza i Efrona*. Based on the 1890–1907 edition. CD-ROM. IDDK Media Project. Eds. Mikhail Zlokazov, Ekaterina Aleksandrova, and Vitalii Belobrov. Moskva: Adept, 2002.

Lachmann, Renate. *Memory and Literature: Intertextuality in Russian Modernism.* Trans. Roy Sellars and Anthony Wall. Minneapolis: University of Minnesota Press, 1997.

Lacis, A., and L. Keilina. *Deti i kino.* Moscow: Tea-kino-pechat', 1928.

Lahy, Jean-Maurice. *La sélection psychophysiologique des travailleurs, conducteurs de tramways et d'autobus.* Paris: Dunod, 1927.

Landry, Eugène. *La Théorie Du Rythme Et Le Rythme Du Français Déclamé: Avec Une Étude "expérimentale" De La Déclamation De Plusieurs Poètes Et Comédiens Célèbres, Du Rythme Des Vers Italiens, Et Des Nuances De La Durée Dans La Musque.* Paris: H. Champion, 1911.

Langdale, Allan. "S(t)imulation of Mind: The Film Theory of Hugo Münsterberg: Editor's Introduction." In *Hugo Münsterberg on Film: The Photoplay: a Psychological Study and Other Writings,* ed. Allan Langdale, 1–44. New York: Routledge, 2002.

Langen, Timothy. *The Stony Dance: Unity and Gesture in Andrey Bely's Petersburg.* Evanston, IL: Northwestern University Press, 2005.

Lapshin, Ivan. "Chuvstvovaniie." In *Entsiklopedicheskii slovar' Brokgauza i Efrona.* Based on the 1890–1907 edition. CD-ROM. IDDK Media Project. Eds. Mikhail Zlokazov, Ekaterina Aleksandrova, and Vitalii Belobrov. Moskva: Adept, 2002.

Larguier de Bancels, J. "Sur les concomitants respiratoires et vasculaires des processus psychiques: Une revue de Zoneff, P. et E. Meumann. "Ueber Begleiterscheinungen psychischer Vorgänge in Athem und Puls"" *L'Année psychologique* 9.9 (1902): 256–259.

Larin, B. A., L. R. Zinder, and M. I. Matusevich, eds. *Pamiati Akademika L'va Vladimirovicha Shcherby, 1880–1944.* Leningrad: Izdatel'stvo Leningradskogo Gos. Univeriteta, 1951.

Law, Alma H., and Mel Gordon. *Meyerhold, Eisenstien and Biomechanics: Actor Training in Revolutionary Russia.* Jefferson, NC: McFarland & Company, 2012.

Lebedev, K. V., I. N. Volkova, and L. N. Zefirov. *Iz istorii Kazanskoi fiziologicheskoi shkoly.* Kazan': Izdatel'stvo Kazanskogo universiteta, 1978.

Lebedeva, Irina. "The Poetry of Science: Projectionism and Electroorganism." In *The Great Utopia: the Russian and Soviet Avant-Garde, 1915–1932,* 441–449. New York: Guggenheim Museum, 1992.

Legrenzi, Paolo, and Carlo A. Umiltà. *Neuromania: On the Limits of Brain Science.* Trans. Frances Anderson. Oxford: Oxford University Press, 2011.

Lepore, Jill. *The Secret History of Wonder Woman.* New York: Vintage, 2015.

Leumann, Ernst. "Die Seelenthätigkeit in ihrem Verhältnisse zu Blutumlauf und Athmung." *Philosophische Studien* 5 (1888): 618–631.

Lewis, Howard T. *The Motion Picture Industry.* New York: D. Van Nostrand, 1933.

Lipps, Theodor. *Raumästhetik und geometrisch-optische Täuschungen.* Leipzig: Barth, 1897.

Lipps, Theodor. *Ästhetik: Psychologie des Schönen und der Kunst. Erster Teil: Grundlegung der Ästhetik*. Hamburg: Voss, 1903.

Liublinskii, P. I. "Kinematografi deti." In *Publika kino v Rossii*, ed. Iu. U. Fokht-Babushkin, 437–453. Moscow: Gosudarstvennyi institut iskusstvoznaniia, 2013.

Liubomudrov, M. N. "Teatry Moskvy. Po materialam arkhivov i periodicheskoi pechati." In *Russkii Sovetskii Teatr, 1921–1926*, ed. A. Trabskii, 353–360. Leningrad: Iskusstvo, 1975.

Livshits, Benedikt. *Gileia*. New York: M. Burliuk, 1931.

London, Jack. "The Unexpected." In *The Complete Short Stories of Jack London: 3*, 998–1016. Stanford, CA: Stanford University Press, 1993.

Lote, Georges. *L'alexandrin d'après la phonétique expérimentale*. Vol. 1. Paris: Editions de la Phalange, 1913.

Lotze, Hermann. *Geschichte Der Aesthetik in Deutschland*. Munich: J.G. Cotta, 1868.

Lotze, Hermann. *Microcosmus: An Essay Concerning Man and His Relation to the World*. Trans. Elizabeth Hamilton and E. E. Constance Jones. Edinburgh: T. & T. Clark, 1885.

Luchishkin, Sergei. *Ia ochen' liubliu zhizn'. . . Stranitsy vospominanii*. Moskva: Sovetskii khudozhnik, 1988.

Lukianova, N. M. "Osvnye etapy sotsiologicheskoi razrabotki problem kinoauditorii." In *Sotsiologiia vchera, segodnia, zavtra*, ed. O. B. Bozhkov, 265–284. St. Petersburg: Eidos.

Lunacharskii, Anatolii. "A Conversation with Lenin" (1922). In *The Film Factory: Russian and Soviet Cinema in Documents*, ed. Richard Taylor and Ian Christie, trans. Richard Taylor, 57. Cambridge: Cambridge University Press, 1988.

Lunacharskii, Anatolii. "Programma kursa 'Vvedenie v estetiku.'" In *Zapiski Instituta Zhivogo Slova*, 48. Petrograd: Narodnyi kommissariat po prosveshcheniiu, 1919.

Lunacharskii, Anatolii. "Rechi, proiznesennye na otkrytii Instituta Zhivogo Slova 15 noiabria 1918 g." In *Zapiski Instituta Zhivogo Slova*,12–24. Petrograd: Narodnyi kommissariat po prosveshcheniiu, 1919.

Luria, Aleksandr. *Priroda chelovecheskikh konfliktov: Ob"ektivnoe izuchenie dezorganizatsii povedeniia cheloveka*. Ed. V. I. Belopol'skii. Moskva: Cogito Centr, 2002.

Luria, A. R. "The New Method of Expressive Motor Reactions in Studying Affective Traces." In *Ninth International Congress of Psychology held at Yale University, New Haven, September 1–7, 1929: Proceedings and Papers*, 294–296. Princeton, NJ: The Psychological Review Company, [c.1930].

Luria, A., and A. Leont'ev. "Protokol No.3 zaniatii psikhologicheskogo kruzhka ot 11 oktiabria 1928." Arhiv Akademii Kommunisticheskogo Vospitania im. N. Krupskoi. TsGA (The Central State Archive of St. Petersburg), f. R-3106 op.1, ed. khr. 634, l.2.

Mach, Ernst. "Untersuchungen über den Zeitsinn des Ohres." *Wiener Sitzungsberichte der Kaiserlichen Akademie der Wissenschaften: Mathematisch-Naturwissenschaftliche Classe* 51.2 (1865): 133–150.

MacKay, John. "Film Energy: Process and Metanarrative in Dziga Vertov's *The Eleventh Year*." *October* 121 (2007): 41–78.

Macmillan, Malcolm. *Freud Evaluated: The Completed Arc*. Cambridge, MA: MIT Press, 1997.

Mallgrave, Harry Francis, and Eleftherios Ikonomou. "Introduction." In *Empathy, Form, and Space: Problems in German Aesthetics, 1873–1893*, ed. Harry Francis Mallgrave and Eleftherios Ikonomou, 1–88. Santa Monica, CA: The Getty Center for the History of Art and the Humanities, 1994.

Mal'tseva, E. A. "Osnovnye elementy slukhovykh oshchushchenii." *Sbornik rabot Fiziologo-Psikhologicheskoi Sektsii G.I.M.N.* 1 (1925): 29–30.

Mandel'shtam, Osip. "O prirode slova." In *Sobranie sochinenii*, vol. 2, ed. A. Mets and F. Lhoest, 64–81. Moskva: Progress Pleiada, 2010.

Mandel'shtam, Osip. "Slovo i kul'tura." In *Sobranie sochinenii*. vol. 2, ed. A. Mets and F. Lhoest, 49–55. Moskva: Progress Pleiada, 2010.

Mandelker, Amy. "Russian Formalism and the Objective Analysis of Sound in Poetry." *The Slavic and East European Journal* 27.3 (1983): 327–338.

Marbe, Karl. "Autobiography." In *History of Psychology in Autobiography*, ed. Carl Murchison, vol. 1, 181–213. New York: Russell & Russell, 1930.

Marbe, Karl. *Über den Rhythmus der Prosa*. Giessen: J. Ricker, 1904.

Marbe, Karl. "Über die Verwendung russender Flammen in der Psychologie und deren Grenzgebieten." Ed. H. Ebbinghaus and W. A. Nagel. *Zeitschrift für Psychologie und Physiologie der Sinnesorgane* 49 (1908): 206–217.

Marbe, Karl, and Albert Thumb. *Experimentelle Untersuchungen über die psychologischen Grundlagen der sprachlichen Analogiebildung*. Leipzig: Verlag von Wilhelm Engelman, 1901.

Marbe, Karl, and M. Seddig. "Untersuchungen schwingender Flammen." *Annalen der Physik* 30.4 (1909): 579–592.

Marcus, Laura. *The Tenth Muse: Writing About Cinema in the Modernist Period*. Oxford: Oxford University Press, 2007.

Marini, Alessandro. "Spettatori nel 1911." *Acta Universitatis Palackianae Olomucensis, Románica* 9 (2000): 115–124.

Marston, William M. Autobiographic entry. In *Twenty-fifth anniversary report* by Harvard College Class of 1915, 480–482. Cambridge, MA: Cosmos Press, 1940.

Marston, William M. "Bodily Symptoms of Elementary Emotions." *Psyche* 38 (1929): 70–86.

Marston, William M. "Reaction Times Symptoms of Deception." *Journal of Experimental Psychology* 3 (1920): 72–87.

Marston, William M. "Systolic Blood Pressure Symptoms of Deception." *Journal of Experimental Psychology* 2 (1917): 117–163.

Marston, William M. "A Theory of Emotions and Affection Based upon Systolic Blood Pressure Studies." *American Journal of Psychology* 35 (1924): 469–506.

Mayakovsky, Vladimir. "Kak delat stikhi?" In *Polnoe Sobranie Sochinenii v trinadtsati tomakh*, ed. V. F. Zemskov, F. N. Pitskel', A. M. Ushakov, and A. V. Fevral'skii, vol. 12, 81–117. Moskva: Gos. izd-vo khudozhestvennoi literatury, 1959.

McCarren, Felicia. *Dancing Machines: Choreographies of the Age of Mechanical Reproduction*. Stanford, CA: Stanford University Press, 2003.

Meyer, Ernst A. "Beiträge Zur Deutschen Metrik." *Neure Sprachen* 6.1 (1898): 121–131.

Miliakh, Andrei. "Teorii novoi antropologii aktera i stat'ia S. Eizenshteina i S. Tret'iakova 'Vyrazitel'noe dvizhenie.'" *Mnemozina: Istoricheskii al'manakh* 2 (2006): 280–291.

Miller, Martin. *Freud and the Bolsheviks: Psychoanalysis in Imperial Russia and the Soviet Union*. New Haven, CT: Yale University Press, 1998.

"mimic, adj. and n." *The Oxford English Dictionary Online*. 3rd ed. March 2002. Oxford University Press. http://www.oed.com

Misler, Nicoletta. "Iskusstvo dvizheniia." In *Shary sveta-stantsii t'my. Iskusstvo Solomona Nikrinina (1898–1965)*, ed. N. Adaskina et al., 116–138. Thessaloniki: State Museum of Contemporary Art, 2004.

Misler, Nicoletta. *V nachale bylo telo: Ritmoplasticheskie eksperimenty nachala XX veka: Khoreologicheskaia Laboratoriia GAKhN.* Moskva: Iskusstvo XXI vek, 2011.

Mitrofanova, Alla. "Conditioned Reflexes: Music and Neurofunction." In *Lab: Jahrbook 2000 für Künste und Apparate,* ed. Hans U. Reck, Siegfried Zelinski, Nils Röller, and Wolfgang Ernst, 171–182. Köln: Kunsthochschule für Medien, 2000.

Miyake, Ishiro. "Researches on Rhythmic Action." *Studies from the Yale Psychological Laboratory* 10 (1902): 1–48.

Monakhov, S. I., K. Iu. Tver'ianovich, and E. V. Khvorost'ianova. "Kommentarii k stat'e 'Problema stikhotvornogo ritma.'" In Boris Tomashevskii, *Izbrannye raboty o stikhe,* ed. S. I. Monakhov, K. Iu. Tver'ianovich, and E. V. Khvorost'ianova, 371–379. St. Petersburg: Filologicheskii fakul'tet SpbGU, 2008.

"monster, n.". *The Oxford English Dictionary Online.* November 2010. Oxford University Press. http://www.oed.com

"monstration, n.". *The Oxford English Dictionary Online.* November 2010. Oxford University Press. http://www.oed.com

"mōnstrum, n.". In Charlton T. Lewis, *An Elementary Latin Dictionary.* New York: American Book Company. 1890. *Perseus Digital Library.* Perseus 4.0. http://www.perseus.tufts.edu

Moore, Rachel O. *Savage Theory: Cinema As Modern Magic.* Durham, NC: Duke University Press, 2000.

Morel, Jean-Paul. "Le Docteur Toulouse ou le Cinéma vu par un psycho-physiologiste, 1912–1928)." *1895: Bulletin de l'Association française de recherche sur l'histoire du cinéma* 60 (2010): 123–155.

Morochowetz, L. "Die Chronophotographie im physiologischen Institut der K. Universität in Moskau." *Le Physiologiste Russe* 2 (1900): 51–61.

Mosso, Angelo. *Fear.* Trans. E. Lough and F. Kiesow. London: Longmans, Green, and Co.

Mosso, Angelo. *Sulla circolazione del sangue nel cervello dell'uomo: ricerche sfigmografiche.* Roma: Coi Tipi del Salviucci, 1880.

Moussinac, Léon. *Naissance Du Cinéma.* Paris: J. Povolozky, 1925.

Mulvey, Laura. "Afterthoughts on 'Visual Pleasure and Narrative Cinema' Inspired by King Vidor's *Duel in the Sun* (1946)." In *Feminist Film Theory: A Reader,* ed. Sue Thornham, 122–130. New York: New York University Press, 1999.

Mulvey, Laura. "Visual Pleasure and Narrative Cinema." In *Film Theory and Criticism: Introductory Readings,* ed. Leo Braudy and Marshall Cohen, 837–848. New York: Oxford University Press, 1999.

Munipov, V. M. "I.N. Shpil'rein, L.S. Vygotskii i S.G. Gellershtein—sozdateli nauchnoi shkoly psikhotekhniki v SSSR." *Kul'turno-istoricheskaia psikhologiia* 4 (2006): 85–109.

Münsterberg, Hugo. *Business Psychology.* Chicago: La Salle Extension University, 1915.

Münsterberg, Hugo. *On the Witness Stand: Essays on Psychology and Crime.* New York: Doubleday and Page, 1917.

Münsterberg, Hugo. "The Photoplay: a Psychological Study." In *Hugo Münsterberg on Film: The Photoplay: A Psychological Study and Other Writings,* ed. Allan Langdale, 45–164. New York: Routledge, 2002.

Münsterberg, Hugo. *Psychology and Industrial Efficiency.* Boston: Mifflin, 1913.

Münsterberg, Hugo. *Psychotherapy.* New York: Moffatt, Yard, and Co., 1909.

Münsterberg, Hugo. "Why We Go to the Movies." In *Hugo Münsterberg on Film: The Photoplay: A Psychological Study and Other Writings,* ed. Allan Langdale, 181–182. New York: Routledge, 2002.

"My v sezone 1926–27 pokazhem . . ." *Broshiura Mezhrabpom-Rus'*, 1926. RGALI (the Russian State Archive of Literature and Arts) f. 1921. op. 2. ed. khr. 29.

Nerlich, Brigitte, and David D. Clarke. "The Linguistic Repudiation of Wundt." *History of Psychology* 1.3 (1998): 179–204.

Neuberger, Joan. "Another Dialectic: Eisenstein on Acting." In *The Flying Carpet: Studies on Eisenstein and Russian Cinema in Honor of Naum Kleiman*, ed. Joan Neuberger and Antonio Somaini, 255–278. Milan: Éditions Mimésis, 2018.

Neustroev, A. *Muzyka i chuvstvo: Materialy dlia psikhicheskogo osnovaniia muzyki*. St. Peterburg: Tip. V.F. Kirshbauma, 1890.

Nicolas, Serge. "Benjamin Bourdon (1860–1943): Fondateur du laboratoire de psychologie et de linguistique expérimentale à l'Université de Rennes (1896)." *L'année psychologique* 98.2 (1998): 271–293.

Nietzsche, Friedrich. *The Will to Power. An Attempted Transvaluation of All Values*, vol. 2 (1888). Trans. Anthony M. Ludovici. London: Allen and Unwin, 1910.

Nikiforov, Anatolii. *Bekhterev*. Moskva: Molodaja gvardiia, 1986.

Nikritin, Solomon. "Zapisi k zaniatiiam v masterskoi Proektsionnogo teatra." RGALI f. 2717, op.1, ed.khr. 22.

Noë, Alva. *Out of Our Heads: Why You Are Not Your Brain, and Other Lessons from the Biology of Consciousness*. New York: Hill and Wang, 2009.

Nordau, Max Simon. *Paradoxe*. Leipzig: Elischer, 1885.

Obraztsov, V. N. *Pis'mo dushevno-bol'nykh: Posobie k klinicheskomu izucheniiu pikhiatrii s risunkami i tablitsami pis'ma*. Kazan: Tipo-lit. Imperatorskago Universiteta, 1904.

Ohmer, Susan. *George Gallup in Hollywood*. New York: Columbia University Press, 2012.

Old and New [*Staroe i novoe*], dir. Sergei Eisenstein. DVD. *Landmarks of Early Soviet Film*. Los Angeles: Flicker Alley, 2011.

Olenina, Ana Hedberg, "The Junctures of Children's Psychology and Soviet Film Avant-garde: Representations, Influences, Applications." In *The Brill Companion to Soviet Children's Literature and Film*, ed. Olga Voronina, 73–100. Leiden: Brill Press, 2019.

Olenina, Ana Hedberg, "Poeziia kak dvizhenie: teoria stikha S. Vysheslavtsevoi mezhdu formalizmom i revoliutsionnoi estradoi." In *Zvuchashshaia Khudozhestvennaia Rech'*, *1923–1929*, ed. Witalij Schmidt and Valeriy Zolotukhin, 459–489. Moscow: Tri Kvadrata, 2018.

Olenina, Ana Hedberg, and Irina Schulzki. "Mediating Gesture in Theory and Practice." *Apparatus. Film, Media and Digital Cultures in Central and Eastern Europe* 5 (2017). http://dx.doi.org/10.17892/app.2017.0005.100

Ozarovskii, Iurii. *Muzyka zhivogo slova. Osnovy khudozhestvennogo chteniia*. St. Peterburg: Izd. T-va O.N. Popovoi, 1914.

P. S. "Znachenie fotografii dlia psikhologii." *Sine-fono: zhurnal sinematografii, govoriashchikh mashin i fotografii* 7 (1912): 8–9.

Parnis, A. E. "Zametki k dialogu Viacheslava Ivanova s Futuristami." In *Viacheslav Ivanov: arkhivnye materialy i issledovaniia*, ed. L.A. Gogotishvili and A.T. Kazarian, 412–432. Moskva: Russkie slovari, 1999.

Patrizzi, M. L. "Primi esperimenti intorno all' influenza della musica sulla circolatione del sangue nel cervello umano. *Archivio di psichiatria, scienza penale e antropologie criminale* 17 (1896): 390–406.

Patterson, William M. *The Rhythm of Prose: An Experimental Investigation of Individual Difference in the Sense of Rhythm*. New York: Columbia University Press, 1916.

Pavlov, Ivan. "Otvet Fiziologa Psikhologam." In *Dvadtsatiletnii Opyt Izucheniia Vyshei Nervnoi Deiatel'nosti (Povedeniia) Zhivotnykh*, ed. E. A. Asratian, 370–395. Moskva: Nauka, 1973.

Pertsov, V. "Izuchenie kinozritelia v sviazi s postroeniem khudozhestvenno-proizvodstvennogo plana" (April 1926). RGALI f. 645 op. 1 ed.khr. 312 l. 123

Pertsov, V. "Reshaiushchaia instantsiia: k voprosu ob izuchenii kinozritelia" (1926). In *Publika kino v Rossii: sotsiologicheskie svidetel'stva 1910- 30kh gg.*, ed. Iu. U. Fokht-Babushkin, 315–319. Moscow: Gosudarstvennyi institut iskusstvoznaniia, 2013.

Petrovskii, V. A. *Psikhologiia v Rossii. Dvadtsatyi vek.* Moskva: URAO, 2000.

Phillips, Natalie. "Distraction as Liveliness of Mind: A Cognitive Approach to Characterization in Jane Austen." In *Theory of Mind and Literature*, ed. Paula Leverage, 105–122. West Lafayette, PA: Purdue University Press, 2011.

Piderit, Theodor. *Wissenschaftliches System Der Mimik Und Physiognomik.* Detmold: Klingenbergische Buchhandlung, 1867.

Pillsbury, Walter Bowers. "The Place of Movement in Consciousness." *Psychological Review* 18.2 (1911): 83–99.

Pitchard, Hamish. "New Emotion Detector Can See When We're Lying." *BBC News Online*. September 11, 2011. September 15, 2011. http://www.bbc.co.uk/news/science-environment-14900800

Pitches, Jonathan. *Science and the Stanislavsky Tradition of Acting.* London: Routledge, 2006.

Pitkin, Walter B., and William M. Marston. *The Art of Sound Pictures.* New York: D. Appleton and Co., 1930.

Plamper, Jan, ed. *Emotional Turn? Feelings in Russian History and Culture.* Special Section of *Slavic Review* 68.2 (2009): 229–330.

Plamper, Jan, Schamma Schahadat, and Marc Elie, eds. *Rossiiskaia Imperiia Chuvstv: Podkhody k Kul'turnoi Istorii Emotsii.* Moskva: Novoe literaturnoe obozrenie, 2010.

Podoroga, V. A. *Mimesis: Materialy po Analiticheskoi Antropologii Literatury.* Vol. 2. Moskva: Kul'turnaia revoliutsiia, 2011.

Polivanov, Evgenii. "Po povodu 'zvukovykh zhestov' iaponskogo iazyka." In *Poetika*, 26–36. Petrograd: 18-aia Gos. Tipografiia, 1919.

Pomorska, Krystyna. *Russian Formalist Theory and Its Poetic Ambiance.* The Hague: Mouton, 1968.

Potebnia, Aleksandr. *Mysl' i iazyk.* Kiev: Sinto, 1993.

Pozner, Valerie. "Vertov before Vertov: Psychoneurology in Petrograd." In *Dziga Vertov: The Vertov Collection at the Austrian Filmmuseum*, ed. Thomas Tode and Barbara Wurm, 12–15. Vienna: SINEMA, 2007.

Pravdoliubov, V. "Kino i nasha molodezh." In *Publika kino v Rossii: Sotsiologicheskie svidetel'stva 1910-30kh gg*, ed. Iu. U. Fokht-Babushkin, 143–211. Moscow: Gosudarstvennyi institut iskusstvoznaniia, 2013.

Prinz, Wolfgang, Sara de Maeght, and Lothar Knuf. "Intention in Action." In *Attention in Action: Advances from Cognitive Neuroscience*, ed. Glyn W. Humphreys and M. J. Riddoch, 95. Hove, UK: Psychology Press, 2005.

Prodger, Phillip. *Darwin's Camera: Art and Photography in the Theory of Evolution.* New York: Oxford University Press, 2009.

"Professor Joins Movies: A Story Expert." *The Times of India*, July 12, 1929, A12.

"Psychologist to Assist Universal Production: Professor William M. Marston Engaged by Carl Laemmle to Assist in Injecting Proper Psychology in Motion Pictures." *Motion Pictures* (New York) 5.1 (1929): 7.

"Psychology for Films." *The New York Times*, December 25, 1928, A33.

Pudovkin, Vsevolod. "From Film Technique." In *Film Theory and Criticism: Introductory Readings*, ed. Leo Braudy and Marshall Cohen, 7–12. New York: Oxford University Press, 2009.

Rabinbach, Anson. *The Human Motor: Energy, Fatigue, and the Origins of Modernity.* Los Angeles: University of California Press, 1992.

Rabinbach, Anson. *The Human Motor: Energy, Fatigue, and the Origins of Modernity.* Berkeley: University of California Press, 2016.

"Raboty GAKhN." *Kino* 46 (1926): 1.

Rajchman, John. *The Deleuze Connections.* Cambridge, MA: MIT Press, 2000.

Rambosson, Jean-Pierre. *Phénomènes nerveux, intellectuels et moraux: Leur transmission par contagion* Paris: Firmin-Didot, 1883.

Rassanov, A. Iu. "Serebrianyi vek russkoi literatury v fonofonde Gosudarstvennogo muzeiia istorii rossiiskoi literatury imeni V.I.Dalia." In *Zvuchashchii Serebriannyi Vek: Chitaet Poet*, ed. E.M. Shuvannikova, 367–409. St. Petersburg: Nestor-istoriia, 2018.

Rebecchi, Marie, *Paris 1929: Eisenstein, Bataille, Buñuel.* Milan: Mimesis, 2018.

Rebecchi, Marie, Elena Vogman, and Till Gathmann. *Sergei Eisenstein and the Anthropology of Rhythm.* Rome: Nero, 2017.

"Refleksologiia." *Bol'shoi psikhologicheskii slovar'.* Ed. B. G. Meshcheriakov and V. P. Zinchenko. St. Petersburg: Praim-Evroznak, 2003.

Reynolds, Dee. *Rhythmic Subjects: Uses of Energy in the Dances of Mary Wigman, Martha Graham and Merce Cunningham.* Alton: Dance Books, 2007.

Richer, Paul Marie Louis Pierre. *Études cliniques sur la grande hystérie ou hystéro-épilepsie.* Paris: A. Delahaye, 1885.

Rigollot, H., and A. Chavanon. "Projection des phénomènes acoustiques." *Journal de Physique Théorique et Appliquée* 2.1 (1883): 553–555.

Roach, Joseph R. *The Player's Passion: Studies in the Science of Acting.* Ann Arbor: University of Michigan Press, 1993.

Robinson, Douglas. *Estrangement and the Somatics of Literature: Tolstoy, Shklovsky, Brecht.* Baltimore: Johns Hopkins University Press, 2008.

Ronen, Omry. *An Approach to Mandel'shtam.* Bibliotheca Slavica Hierosolymitiana. Jerusalem: Hebrew University Magness Press, 1983.

Room, Abram. "Akter-polpred idei (1)." *Kino* 7 (1932): 3.

Room, Abram. "Akter-polpred idei (2)." *Kino* 11 (1932): 3.

Room, Abram. "Akter-polpred idei (3)." *Kino* 15 (1932): 3.

Room, Abram. "Akter-polpred idei (4)." *Kino* 17 (1932): 3.

Room, Abram. "Moi ubezhdeniia." *Sovetskii Ekran.* February 23 (1926): 5.

Rosenblatt, Nina Lara. "Photogenic Neurasthenia: On Mass and Medium in the 1920s." *October* 86 (1998): 47–62.

Rousselot, J.-P. *Principes De Phonétique Expérimentale: 2.* Paris: Welter, 1908.

Rudneva, Stefanida Dmitrievna. "Curriculum vitae." *Materialy Instituta Zhivogo Slova Narkomprosa RSFSR.* RGALI f. 941. op. 4. ed. khr. 2(2). l.57.

Rutz, Ottmar. *Musik, Wort und Körper Als Gemütsausdruck.* Leipzig: Breitkopf & Härtel, 1911.

Rutz, Ottmar. *Psyche und Tonorgan, Joseph Rutz und Seine Tonstudien.* München: Allgemeinen Zeitung, 1904.

Rutz, Ottmar. *Sprache, Gesang und Körperhaltung: Handbuch Zur Typenlehre Rutz.* München: C.H. Beck, 1922.

Ryabchikova, Natalie. "Proletkino: ot Goskino do Sovkino." *Kinovedcheskie Zapiski* 94 (2010). May 25, 2017. http://www.kinozapiski.ru/ru/article/sendvalues/1215/

Ryabchikova, Natalie. "Nina Agadzhanova-Shutko." In *Women Film Pioneers Project,* ed. Jane Gaines, Radha Vatsal, and Monica Dall'Asta, New York: Columbia University Libraries, 2016. https://doi.org/10.7916/d8-rswd-9k23/

Ryan, Judith. *Vanishing Subject: Early Psychology and Literary Modernism.* Chicago: University of Chicago Press, 1991.

Sabaneev, Leonid. *Muzyka Rechi: Esteticheskoe Issledovanie.* Moskva: Izdatel'vo rabotnik prosveshcheniia, 1923.

Salper, Donald. "Onomatopoeia, Gesture, and Synaesthesia in the Perception of Poetic Meaning." In *Studies in Interpretation,* vol. 2., ed. Esther M. Doyle and Virginia Hastings Floyd, 115–123. Amsterdam: Rodopi, 1977.

Samojloff, A. "Graphische Darstellung der Vokale." *Le Physiologiste Russe* 2 (1900–1902): 62–69.

Saran, Franz. *Der Rhythmus Des Französischen Verses.* Halle: M. Niemeyer, 1904.

Saran, Franz. *Deutsche Verslehre.* München: C.H. Becksche Verlagsbuchhandlung, 1907.

Sarkisova, Oksana. "The Adventures of *Kulturfilm* in Russia." In *A Companion to Russian Cinema,* 92–117, ed. Birgit Beumers, Chichester: Wiley Blackwell, 2016.

Saussy, Haun. *The Ethnography of Rhythm: Orality and Its Technologies.* New York: Fordham University Press, 2016.

Schwartz, Hillel, "Torque: The New Kinaesthetic of the Twentieth Century." In *Incorporations,* ed. Jonathan Crary and Sanford Kwinter, 71–127. Cambridge: Zone Books, 1994.

Schweinitz, Jörg. "Psychotechnik, idealistische Ästhetik und der Film als mental strukturierter Wahrnehmungsraum: Die Filmtheorie von Hugo Münsterberg." In *Hugo Münsterberg. Das Lichtspiel. Eine psychologische Studie (1916) und andere Schriften,* ed. Jörg Schweinitz, 9–26. Vienna: Synema, 1996.

Scripture, Edward W. *The Elements of Experimental Phonetics.* New York: Scribner, 1902.

Scripture, Edward W. "The Nature of Verse." *The British Journal of Psychology* 11 (1921): 225–235.

Scripture, Edward W. *Researches in Experimental Phonetics: The Study of Speech Curves.* Washington, DC: Carnegie Institution of Washington, 1906.

Scripture, Edward W. "Studies in Melody of English Speech." In *Philosophische Studien. Festschrift Wilhelm Wundt zum Siebzigsten Geburtstage überreicht von seinen Schülern,* 599–615. Leipzig, 1902.

Sechenov, Ivan. "German f.-Gel'mgol'tz kak fiziolog." In *Izbrannye proizvedenia,* ed. Kh. S. Khoshtoyants, vol. 1, 497–509. Moskva: Izdatel'stvo Akademii Nauk SSSR, 1952.

Sechenov, Ivan. "Reflexes of the Brain." In *Selected Physiological and Psychological Works,* ed. Kh. Koshtoyants, trans. S. Belsky and G. Gibbons, 31–139. Moscow: Foreign Languages Publishing House, 1965.

Seifrid, Thomas. *The Word Made Self: Russian Writings on Language, 1860–1930.* Ithaca, NY: Cornell University Press, 2005.

Seltzer, Mark. *Bodies and Machines.* New York: Routledge, 1992.

"Setka zapisi refleksov zritel'nogo zala." *Materialy Issledovatel'skoi Teatral'noi Masterskoi Glaviskusstva Narkomprosa*. RGALI f. 645 op.1 ed. khr. 312 l. 228.

Serdiukov, A. R. *Petr Nikolaevich Lebedev, 1866–1912*. Moscow: Nauka, 1978.

Shalamov, Varlam. *Novaia kniga: Vospominaniia, Zapisnye Knizhki, Perepiska, Sledstvennye Dela*. Ed. I. P. Sirotinskaia. Moskva: Eksmo, 2004.

Shalamov, Varlam. "Zvukovoi povtor—poisk smysla: zametki o stikhovoi garmonii." *Semiotika i informatika* 7 (1976): 128–147.

Shcherba, Lev. "Opyty lingvisticheskogo tolkovaniia stikhotvorenii. I. 'Vospominanie' Pushkina." In *Russkaia rech': Sborniki statei pod red. L. Shcherby*, 13–56. Petrograd: Izdaniie foneticheskogo instituta prakticheskogo izucheniia iazykov, 1923.

Shershenevich, Vadim. *Igor' Il'inskii*. Moskva: Kinopechat', 1926.

Shilov, Lev. "Istoriia odnoi kollektsii." In *Zvuchashchii mir: Kniga o zvukovoi dokumentalistike*, 121–145. Moskva: Iskusstvo, 1979.

Shilov, Lev. *Ia slyshal po radio golos Tolstogo: ocherki zvuchashchei literatury*. Moskva: Iskusstvo, 1989.

Shimmin, Sylvia, and Pieter J. Van Strien. "History of the Psychology of Work and Organization." In *Introduction to Work and Organizational Psychology*, ed. Pieter J. D. Drenth, Henk Thierry, and Charles J. Wolff, 2nd ed, 71–86. Hove, UK: Psychology Press, 1998.

Shklovskii, Viktor. "Ikh nastoiashchee." In *Za sorok let. Stat'i o Kino*, ed. N. Zelichenko, 65–86. Moskva: Iskusstvo, 1965.

Shklovskii, Viktor. "K voprosu ob izuchenii zritelia." *Sovetskii Ekran* 50 (1928): 6.

Shklovskii, Viktor. "Kinofabrika." In *Za sorok let. Stat'i o kino*, ed. N. Zelichenko, 56–64. Moskva: Iskusstvo, 1965.

Shklovskii, Viktor. *Literature and Cinematography*. Trans. Irina Masinovsky. Champaign, IL: Dalkey Archive Press, 2008.

Shklovskii, Viktor. "On Poetry and Trans-Sense Language." Trans. Gerald Janecek and Peter Mayer. *October* 34 (1985): 3–24.

Shklovskii, Viktor. "O poezii i zaumnom iazyke." In *Poetika. Sborniki po teorii poeticheskogo iazyka*, 13–26. Petrograd: 18-aia Gos. Tipografiia, 1919.

Shklovskii, Viktor. "O ritmiko-sintaksicheskikh opytakh professora Siversa." In *Poetika: Sborniki po teorii poeticheskogo iazyka*, 2nd ed., 87–94. St. Peterburg: Tipografiia Sokolinskago, 1917.

Shklovskii, Viktor. "Oshibki i izobreteniia (1928)." In *Za sorok let. Stat'i o Kino*, ed. N. Zelichenko, 99–103. Moskva: Iskusstvo, 1965.

Shklovskii, Viktor. "Osnovnye zakony kinokadra." In *Za sorok let. Stat'i o kino*, ed. N. Zelichenko, 43–56. Moskva: Iskusstvo, 1965.

Shklovskii, Viktor. "O zaumnom iazyke. 70 let spustia." In *Russkii literaturnyi avangard: Materialy i issledovaniia*, ed. Marzio Marzaduri, Daniela Rizzi, Mikhail Evzlin, 253–259. Trento: Universita di Trento, 1990.

Shklovskii, Viktor. "Pis'mo Tynianovu." In Viktor Shklovskii. *Eshche nichego ne konchilos'*, with introduction by A. Galushkin, 375–376. Moskva: Propaganda, 2002.

Shklovskii, Viktor. "Po zakonu: otryvok stenariia." *Kino* 13 (133), March 30, 1926.

Shklovskii, Viktor. "Potebnia." In *Poetika. Sborniki po teorii poeticheskogo iazyka*. 2nd ed., 3–6. Petrograd: 18-aia Gos. Tipografiia, 1919.

Shklovskii, Viktor. "Sovetskaia shkola akterskoi igry." In *Za sorok let. Stat'i o kino*, ed. N. Zelichenko, 107–108. Moskva: Iskusstvo, 1965.

Shklovskii, Viktor. "Sviaz' priemov siuzhetoslozheniia s obshchimi priemami stilia." In *Poetika. Sborniki po teorii poeticheskogo iazyka*, 113–150. Petrograd: 18-aia Gos. Tipografiia, 1919.

Shklovskii, Viktor. "Voskresheniie slova" (1914). In *Gamburgskii Shchet: Stat'i, Vospominaniia, Esse, 1914-1933*, ed A. Iu. Galushkin and A. P. Chudakov, 36–42. Moskva: Sov. pisatel', 1990.

Shklovskii, Viktor. "Zaumnyi iazyk i poeziia" (c.1913–1914). RGALI The State Russian Archive of Literature and Arts f. 562. op. 1. ed. khr. 63.

Showalter, Elaine. *Hystories: Hysterical Epidemics and Modern Media*. New York: Columbia University Press, 1997.

Shpil'rein, Isaak. *Prikladnaia Psikhologiia: Psikhologiia Truda i Psikhotekhnika*. Moskva: Izdanie B.Z.O. pri M.P.I., 1930.

Shpil'rein, Isaak. "Psikotekhnika i vybor professii." *Vremia* 12 (1924): 75–76.

Shpil'rein, Isaak. *Rabochie Tramvaia: Trud, Utomlenie, Zabolevaemost', Psikhotekhnicheskii Podbor*. Moskva: Izdatel'stvo Narodnogo komissariata vnutrennikh del, 1928.

Sievers, Eduard. *Metrische Studien*. Leipzig: B. G. Teubner, 1901.

Sievers, Eduard. *Rhythmisch-melodische Studien, Vorträge und Aufsätze Von Eduard Sievers*. Heidelberg: C. Winter, 1912.

Sievers, Eduard. *Ziele und Wege der Schallanalyse*. Heidelberg: C. Winter, 1924.

"Sinematograf pri nauchnykh issledovaniiakh." *Sine-fono* 4 (1911): 10.

Singer, Ben. "The Ambimodernity of Early Cinema: Problems and Paradoxes in the Film-as-Modernity Discourse." In *Film 1900: Technology, Perception, Culture*, ed. Klaus Kreimeier and Annemone Ligensa, 37–52. New Burnet, UK: John Libbey, 2009.

Sirotkina, Irina. "Kinemologiia, ili nauka o dvizhenii. Zabytyi proekt GAKhN." In *Mise en geste. Studies of Gesture in Cinema and Art*, ed. by Ana Hedberg Olenina and Irina Schulzki. Special issue of *Apparatus. Film, Media and Digital Cultures in Central and Eastern Europe* 5 (2017). http://dx.doi.org/10.17892/app.2017.0005.81

Sirotkina, Irina. *Mir kak zhivoe dvizhenie: Intellektual'naia Biografiia Nikolaia Bernshteina*. Moskva: Kogito-Tsentr, 2018.

Sirotkina, Irina. *Shestoe Chuvstvo Avangarda: Tanets, Dvizhenie, Kinesteziia v Zhizni Poetov i Khudozhnikov*. Sankt-Peterburg: Izdatel'stvo Evropeiskogo universiteta, 2014.

Sirotkina, Irina. *Svobodnoe Dvizhenie i Plasticheskii Tanets v Rossii*. Moskva: Novoe literaturnoe obozrenie, 2011.

Sirotkina, I., and E. V. Biryukova. "Futurism in Physiology: Nikolai Bernstein, Anticipation, and Kinaesthetic Imagination." In *Anticipation: Learning from the Past. The Russian and Soviet Contributions to the Science of Anticipation*, ed. M. Nadin, 269–285. Berlin: Springer International Publishing, 2015.

Sirotkina, Irina, and Roger Smith. *Sixth Sense of The Avant-Garde: Dance, Kinaesthesia and the Arts in Revolutionary Russia*. London: Methuen, 2017.

Skorodumov, L. "Issledovatel'skaia rabota so zritel'skim kinoaktivom." In *Publika kino v Rossii: sotsiologicheskiie svidetel'stva 1910–30kh gg*, ed. Iu. U. Fokht-Babushkin, 320–327. Moscow: Gosudarstvennyi institut iskusstvoznaniia, 2013.

Smith, Roger. *Inhibition: History and Meaning in the Sciences of Mind and Brain*. London: Free Association Books, 1992.

Sobchack, Vivian C. *The Address of the Eye: A Phenomenology of Film Experience*. Princeton, NJ: Princeton University Press, 1992.

Sofia, G. "Towards a 20th-century History of Relationships Between Theatre And Neuroscience." *Brazilian Journal on Presence Studies* 4.2 (2014): 313–332.

Sokolov, Ippolit. "Autobiografiia, 17 dekabria 1926." Lichnoe delo Sokolova, Ippolita Vasil'evicha, 1925–1926. *Gosudarstvennaia Akademiia Khudozhestvennykh Nauk.* RGALI f. 941 op. 10. ed. khr. 583.

Sokolov, Ippolit. "Industrial'no-plasticheskaia gimnastika." *Organizatsiia truda* 2 (1921): 114–118.

Sokolov, Ippolit. "Metody igry pered kino-apparatom (1)." *Kino-front* 5 (1927): 10–14.

Sokolov, Ippolit. "Metody igry pered kino-apparatom (2)." *Kino-front* 6 (1927): 11–13.

Sokolov, Ippolit. "N.O.T. v kinoproizvodstve." *Kino-front* 7 (1926): 9–13.

Sokolov, Ippolit. "Rabotat' na massovogo kinozritelia! (V poriadke obsuzhdeniia)." *Kino i zritel'* 2 (1929).

Sokolov, Ippolit. "Teilorizovannyi zhest." *Zrelishcha* 2 (1922): 11.

Sokolov, Ippolit. "Vospitaniie aktera. Kritika ne sleva, a priamo." *Zrelishcha* 8 (1922): 11.

Solomons, Leon M., and Gertrude Stein. "Normal Motor Automatism." *Psychological Review* 3.5 (1896): 492–512.

Souza, Robert. *Questions De Métrique. Le Rythme Poétique.* Paris: Perrin, 1892.

Spirtov, I. N. "O vliianii muzyki na mushechnuiu rabotu." *Obozrenie psikhiatrii, nevrologii i eksperimental'noi psikhologii* 6 (1903): 425–448.

Spirtov, I. N. "O vliianii muzyki na krovianoe davlenie." *Obozrenie psikhiatrii, nevrologii i eksperimental'noi psikhologii* 5 (1906).

Stebbins, Genevieve. *Delsarte System of Expression.* New York: E.S. Werner, 1892.

Stein, Gertrude. "Cultivated Motor Automatism: A Study of Character in Its Relation to Attention." *Psychological Review* 5.3 (1898): 295–306.

Steiner, Peter. *Russian Formalism: A Metapoetics.* Ithaca, NY: Cornell University Press, 1984.

Steinthal, Heymann. "Assimilation und Attraction." *Zeitschrift für Völkerpsychologie und Sprachwissenschaft* 1 (1859): 107–117.

Sternberger, Dolf. *Panorama of the Nineteenth Century.* New York: Urizen, 1977.

Stetson, R. H. "A Motor Theory of Rhythm and Discrete Succession." *Psychological Review* 12.4 (1905): 250–270.

Stetson, R. H. "Rhythm and Rhyme." *Psychological Review: Psychological Monographs* 4.1 (1903): 413–466.

Stimpson, Catharine R. "The Mind, the Body, and Gertrude Stein." *Critical Inquiry* 3.3 (1977): 489–506.

Strauven, Wanda, ed. *Cinema of Attractions Reloaded.* Amsterdam: Amsterdam University Press, 2006.

Svetlikova, Ilona. *Istoki Russkogo Formalizma: Tradicija Psichologizma i Formal'naja Shkola.* Moskva: Novoe Literaturnoe Obozrenie, 2005.

Tallis, Raymond. *Aping Mankind: Neuromania, Darwinitis and the Misrepresentation of Humanity.* Durham, England: Acumen, 2011.

Tarich, Iu. "Obektivom k derevne." *Kinozhurnal ARK* 10 (1925): 15.

Tarkhanov, Ivan. "Influence de la musique sur l'homme et sur les animaux. *Archives italiennes de biologie* 21 (1894).

Taylor, Richard. *The Politics of the Soviet Cinema, 1917–1929.* Cambridge, UK: Cambridge University Press, 1979.

Tchougounnikov, Sergei. "Ritmicheskaia koncepcija O. Brika v kontekste issledovanii v oblasti vyrazitel'nykh dvizhenii." In *Brikovskii sbornik*, ed. G.V. Vekshin, 2, 370–374. Moskva: Azbukovnik, 2014.

Tenner, Julius. "Uber Versmelodie." *Zelfschrift für Aesthetick und allgemeine Kunstwissenschaft* 8 (1913): 247–279.

Termine, Liborio. "Mario Ponzo: Uno spettatore sdoppiato lo psicólogo al cinema." *Cinema Nuovo* 4–5 (1985): 53–59.

Terskoi, A. "S"emka refleksov litsa kak material izucheniia derevenskogo zritelia." *Kinozhurnal ARK* 8 (1925): 10–12.

"Tezisy doklada o metodakh izucheniia teatral'nogo zritelia." *Materialy Issledovatel'skoi Teatral'noi Masterskoi Glaviskusstva Narkomprosa*. RGALI the Russian State Archive of Literature and Arts f. 645 op.1. ed. khr. 312. l. 159.

Thompson, Kristin. "Government Policies and Practical Necessities in the Soviet Cinema of the 1920s." In *Red Screen: Politics, Society, Art in Soviet Cinema*, ed. Anna Lawton, 19–41. New York: Routledge, 1992.

Tichi, Cecelia. *Shifting Gears: Technology, Literature, Culture in Modernist America*. Chapel Hill: University of North Carolina Press, 1987.

Tikhonov, A. "Kinematograf v nauke i tekhnike." In *Kinematograf: Sbornik Statei pod Redaktsiei Foto-Kinematograficheskogo Otdela Narkomprosa*, 63–85. Moskva: Gosizdatel'stvo, 1919.

Tikka, Pia. *Enactive Cinema: Simultatorium Eisensteinense*. Helsinki: University of Art and Design, 2008.

Tiurin, Iurii. "Pervyi i edinstvennyi fil'm Chaianova," *Den' i noch': literaturnyi zhurnal dlia semeinogo chteniia*, 5–6 (1997). krasdin.ru/1997-5-6/s061.htm.

Todes, Daniel P. "From the Machine to the Ghost within: Pavlov's Transition from Digestive Physiology to Conditional Reflexes." *American Psychologist* 52.9 (1997): 947–955.

Todes, Daniel P. *Ivan Pavlov: A Russian Life in Science*. Oxford: Oxford University Press, 2015,

Tolstoy, Leo. *Anna Karenina*. Trans. Marian Schwartz, ed. Gary Saul Morson. New Haven: Yale University Press, 2014.

Tomashevskii, Boris. "Curriculum vitae." *Materialy Instituta Zhivogo Slova Narkomprosa RSFSR*. RGALI the Russian State Archive of Literature and Arts f. 941 op. 4. ed. khr. 2(2). l.51-51verso.

Tomashevskii, Boris. "Problema stikhtotvornogo ritma." *Literaturnaia Mysl'* 2 (1923): 124–140.

Tomashevskii, Boris. "Problema stikhotvornogo ritma." In *Izbrannye raboty o stikhe*, ed. S. I. Monakhov, K. Iu. Tver'ianovich, and E. V. Khvorost'ianova, 24–52. St. Petersburg: Filologicheskii fakul'tet SpbGU; Moskva: Akademiia, 2008.

Toropova, Anna. "Probing the Heart and Mind of the Viewer: Scientific Studies of Film and Theatre Spectators in the Soviet Union, 1917–1936." *Slavic Review* 76.4 (2017): 931–958.

Toulouse, E., and R. Mourgue. "Des réactions respiratoires au cours de projections cinématographiques." In *Compte-rendu de la 44e session d'Association française pour l'avancement des sciences, Strasbourg 1920*, 377–382. Paris: Masson, 1920.

Townsend, Reginald D. "The Magic of Motion Study." *The World's Work*. 32.3 (1916): 321–336.

Trainin, I. "Sovetskaia fil'ma i zritel'." In *Publika kino v Rossii: Sotsiologicheskiie svidetel'stva, 1910- 30kh gg.*, ed. Iu. U. Fokht-Babushkin, 252–266. Moscow: Gosudarstvennyi institut iskusstvoznaniia, 2013.

Tramm, K. A. *Psychotechnik und Taylor System*. Vol. 1. *Arbeitsuntersuchungen*. Berlin: Springer, 1921.

Tret'iakov, Sergei. "Buka russkoi literatury." *Strana-perekrestok*. Moskva: Sovetskii pisatel', 1991. 530–538.

Tret'iakov, Sergei. "The Theater of Attractions." Trans. Kristin Romberg. *October* 118 (2006): 19–26.

Tret'iakov, Sergei. "Velimir Khlebnikov." In *Strana-perekrestok*, ed. T.S. Gomolitskaia-Tret'iakova, 524–530. Moskva: Sovetskii pisatel', 1991.

Troianovskii, Andrei, and Ruben Egiazarov. *Izuchenie kinozritelia* (1928). *Publika kino v Rossii: Sotsiologicheskie svidetel'stva 1910–30kh gg*, ed. Iu. U. Fokht-Babushkin, 346–397. Moscow: Gosudarstvennyi institut iskusstvoznaniia, 2013.

Trotsky, Leon. *Literatura i revoliutsiia*. Moskva: Izd.-vo politicheskoi literatury, 1991.

Trovillio, Paul. "A History of Lie Detection." *Journal of Criminal Law and Criminology* 30.1 (1939): 104–119.

Tsivian, Yuri. "O Chapline i v Russkom Avangarde i Zakonakh Sluchainogo v Iskusstve." *Novoe Literaturnoe Obozrenie* 81 (2006): 99–142.

Tsivian, Yuri. *Early Russian Cinema and Its Cultural Reception*. London: Routledge, 1994.

Tsivian, Yuri. *Na podstupakh k karpalistike: Dvizhenie i zhest v literature, iskusstve i kino*. Moskva: Novoe literaturnoe obozrenie, 2010.

Turovskaia, Maiia. "Pochemu zritel' hodit v kino." In *Zhanry kino*, ed. V. Fomin, 138–155. Moskva: Iskusstvo, 1979.

Tynianov, Iurii. "Curriculum vitae (c.1922)." *Materialy Instituta Zhivogo Slova Narkomprosa RSFSR*, RGALI f. 941 op. 4. ed. khr. 2(2). l.53.

Tynianov, Iurii. *The Problem of Verse Language*. Trans. Michael Sosa and Brent Harvey. Ann Arbor, MI: Ardis, 1981.

Tynianov, Iurii. *Problema stikhotvornogo iazyka*. Photomechanic Reprint. The Hague: Mouton and Co., 1963.

Tynianov, Iurii. "Promezhutok." *Poetika. Istoriia literatury. Kino*. Moskva: Nauka, 1977. 168–195.

Ukhtomskii, A. *Dominanta: stat'i razykh let, 1887–1939*. Sankt-Peterburg: Piter, 2002.

"Ustav Instituta Zhivogo Slova" (c. 1922). RGALI (the Russian State Archive of Literature and Arts) f. 941 op.4, ed. khr. 2(1).

Vaingurt, Julia. *Wonderlands of the Avant-Garde: Technology and the Arts in Russia of the 1920s*. Evanston, IL: Northwestern University Press, 2013.

Valsiner, Jaan. *Developmental Psychology in the Soviet Union*. Bloomington: Indiana University Press, 1988.

Vassena, Raffaella. "K rekonstrukcii istorii i deiatel'nosti Instituta Zhivogo Slova (1918–1924)." *Novoe Literaturnoe Obozrenie* 86 (2007): 79–95.

Vassilieva, Julia. "Eisenstein and Cultural-Historical Theory." In *Flying Carpet, Studies on Eisenstein and Russian Cinema in Honor of Naum Kleiman*, ed. Joan Neuberger and Antonio Somaini, 421–442. Paris: Mimesis, 2017.

Veder, Robin. *The Living Line: Modern Art and the Economy of Energy*. Dartmouth, NH: Dartmouth University Press, 2015.

Veliamovich, V. *Psikhofiziologicheskie osnovaniia estetiki: Suchshnost' iskusstva, ego sotsial'noe znachenie, i otnoshenie k nauke i nravstvennosti*. Sankt-Peterburg: Tip. L. Fomina, 1878.

Ven, V. "V Politekhnicheskom muzee sozdana laboratoriia po izucheniiu kinozritelia." *Kino* 49 (December 4, 1928): 5.

Vernon, Lee, and Clementina Anstruther-Thomson. *Beauty and Ugliness and Other Studies in Psychological Aesthetics*. London: John Lane, 1912.

Verrier, Paul. *Essai Sur Les Principes de la Métrique Anglaise: Notes de métrique expérimentale*. Paris: Welter, 1909.

Verrier, Paul. *L'isochronisme Dans Le Vers Français*. Paris: Alcan, 1912.

Verrier, Paul. *Théorie Générale Du Rythme*. Paris: Welter, 1909.

Vertov, Dziga. "O kino-pravde." In *Dziga Vertov: Iz naslediia. Tom vtoroi: Stat'i i vystuplenia*, ed. Aleksandr Deriabin, 267–275. Moskva: Eizenshtein-tsentr, 2008.

Vertov, Dziga. "Three Songs of Lenin and Kino-Eye." In *Kino-Eye: The Writings of Dziga Vertov*, ed. Annette Michelson, trans. Kevin O'Brien, 123–125. Berkeley: University of California Press, 1984.

Vertov, Dziga. "We: Variant of a Manifesto" (1922). In *Kino-Eye: The Writings of Dziga Vertov*, ed. Annette Michelson, trans. Kevin O'Brien, 5–9. Berkeley: Univ. of California Press, 2008.

Vinogradov, V. V. "Obshchelingvisticheske i grammaticheskie vzgliady akad. L. V. Shcherby." In *Pamiati Akademika L'va Vladimirovicha Shcherby (1880–1944): Sbornik Statei*, ed. B. A. Larin, L. R. Zinder, M. I. Matusevich, 31–62. Leningrad: Izdatel'svo Leningradskogo gos. universiteta, 1951.

Vogman, Elena. *Sinnliches Denken. Eisensteins exzentrische Methode*. Zürich: Diaphanes, 2018.

Volkelt, Johannes. *Der Symbol-Begriff in der neuesten Aesthetik*. Jena: Hermann Dufft, 1876.

Volkonskii, Sergei. *Vyrazitel'nyi chelovek: Stsenicheskoe vospitanie zhesta po Del'sartu*. Sankt-Peterburg: Apollon, 1913.

Volkonskii, Sergei. "Anatomiia soglasnykh." *Golos i rech'*, February 2 (1913): 3–6.

Volkonskii, Sergei. *Moi vospominania*. 2 vols. Moskva: Iskusstvo, 1992.

Vöhringer, Margarete. *Avangard i Psikhotekhnika: Nauka, Iskusstvo, i Metodiki Eksperimentov nad Vospriiatiem v Poslerevoliutsiuonnoi Rossii*. Trans. K. Levinson and V. Dubina. Moskva: Novoe Literaturnoe Obozrenie, 2019.

Vsevolodskii-Gerngross, Vsevolod. "Zakonomernost' melodii chelovecheskoi rechi." *Golos i rech'*. March 13 (1913): 10–14.

Vichyn, Bertrand. "Innervation." In *International Dictionary of Psychoanalysis*, ed. Alain de Mijolla, vol. 2, 836. Detroit, MI: Macmillan Reference, 2005.

Vygotsky, Lev. "Istoriia razvitiia vysshikh psikhicheskikh funktsii." In *Sobranie sochinenii v shesti tomakh*, ed. M.G. Iaroshvskii, vol. 3. Moskva: Pedagogika, 1983.

Vygotsky, Lev. *Psikhologiia iskusstva*. Ed. M. G. Iaroshevskii. Rostov-na-Donu: Feniks, 1998.

Vygotsky, Lev. "Uchenie ob emotsiiakh: Istoriko-psikhologicheskoe issledovanie." In *Sobranie sochinenii v shesti tomakh*, ed. M. G. Iaroshvskii, vol. 6, 92–318. Moskva: Pedagogika, 1984.

Vysheslavtseva, Sofiia. "Motornye impul'sy stikha." In *Poetika: Vremennik otdeleniia slovsenykh iskusstv*, vol. 3, 45–62. Leningrad: Academia (1927).

Vysheslavtseva, Sofiia. "Prikhodite pogovorit' o poezii . . ." *Avrora* 10 (1975): 70–72.

Vysheslavtseva, S. G., Z. M. Zadunaiskaia, L. A. Samoilovich-Ginzburg, S. I. Sergei Bernshtein, "Stikhotvoreniie Ber-Gofmana 'Schlaflied für Mirjam' v interpretatsii A.Moissi." In *Zvuchashshaia Khudozhestvennaia Rech', 1923–1929*, ed. Witalij Schmidt and Valeriy Zolotukhin, 292–324. Moscow: Tri Kvadrata, 2018.

"Western Pictures: A Psychologist's Opinion." *The Times of India*, May 24,1929, 12.

Wicclair, Mark. "Film Theory and Hugo Munsterberg's *The Film: A Psychological Study.*" *Journal of Aesthetic Education* 12 (1979): 33–50.

Widdis, Emma. *Socialist Senses: Film, Feeling, and the Soviet Subject, 1917–1940.* Bloomington: Indiana University Press, 2017.

Will, Barbara. "Gertrude Stein, Automatic Writing and the Mechanic of the Genius." *Forum for Modern Language Studies* 37.2 (2001): 169–172.

Wölfflin, Heinrich. "Prolegomena to A Psychology of Architecture" (1886). In Harry Francis Mallgrave and Eleftherios Ikonomou, eds. and trans., *Empathy, Form, and Space: Problems in German Aesthetics, 1873–1893*, 149–190. Santa Monica, CA: The Getty Center for the History of Art and the Humanities, 1994.

Wundt, Wilhelm Max. *Grundzüge Der Physiologischen Psychologie.* Leipzig: Engelmann, 1903.

Wundt, Wilhelm Max. *The Language of Gestures.* Trans. J. S. Thayer, C. M. Greenleaf, and M. D. Silberman. *Approaches to Semiotics Paperback Series.* Ed. Thomas Sebeok. The Hague: Mouton, 1973.

Wundt, Wilhelm Max. *Outlines of Psychology.* Trans. Charles Hubbard Judd. 2nd English ed. Leipzig: Wilhelm Engelmann, 1902.

Wundt, Wilhelm Max. *Principles of Physiological Psychology.* Trans. and ed. Edward B. Titchener. London: Sonnenschein, 1904.

Wundt, Wilhelm Max. *Völkerpsychologie. Eine Untersuchung der Entwicklungsgesetze von Sprache, Mythus und Sitte.* Vol. 1. (*Die Sprache*). 2nd ed. Leipzig: Wilhelm Engelmann, 1904.

Wundt, Wilhelm Max. *Völkerpsychologie. Eine Untersuchung der Entwicklungsgesetze von Sprache, Mythus und Sitte.* Vol. 1. (*Die Sprache*). 4th ed. Stuttgart: Alfred Kröner Verlag, 1921.

Wuss, Peter. "Hugo Münsterberg: Erste Psychologie und Ästhetik des Films." In *Kunstwert des Films und Massencharakter des Mediums*, ed. Peter Wuss, 66–76. Berlin: Henschel, 1990.

Youngblood, Denise J. *Movies for the Masses: Popular Cinema and Soviet Society in the 1920s.* Cambridge: Cambridge University Press, 1999.

Zabrodin, Vladimir V. *Eizenshtein: Popytka Teatra: Stat'i, Publikacii.* Moskva: Eizenshtein-Tsentr, 2005.

Zagorskii, M. "Kak reagiruet zritel'?" *LEF* 2 (1924): 141–151.

Zalkind, A. B. "Refleksologiia i nasha sovremennost'." In *Novoe v refleksologii i fiziologii nervnoi sistemy*, ed. V. M. Bekhterev, v–vii. Leningrad: Gos. Izdatel'stvo, 1925.

Zefirov A. L. and N. V. Zvezdochkina, "Aleksandr Filippovich Samoilov— osnovopolozhnik elektrofiziologicheskikh issledovanii kazanskoi fiziologicheskoi shkoly." *Zhurnal Fundamental'noi Meditsiny i Biologii* 2 (2017): 50–57.

Zeki, S., and T. Ishizu. "The Brain's Specialized Systems for Aesthetic and Perceptual Judgment." *European Journal of Neuroscience* 37 (2013): 1413–1420.

Zelentsov, E. "Iz istorii konkretno-sotsiologicheskikh issledovanii kinozritelia v SSSR." *Trudy NIKFI* 60 (1971): 141–148.

Zelinskii, Faddei. "Vil'gel'm Vundt i psikhologiia iazyka." In *Iz zhizni idei: nauchno-populiarnyia statii F. Zelinskago*, 2nd ed., 151–221. St. Petersburg: Tipografiia M.M. Stasiulevicha, 1908.

Zielinski, Siegfried. *Deep Time of the Media: Toward an Archaeology of Hearing and Seeing by Technical Means.* Cambridge, MA: MIT Press, 2009.

Zimmermann, E. *Psychologische und Physiologische Apparate: Liste 50.* Leipzig: Zimmermann Wissenschaftliche Apparate, 1928.

Zinger, Lev. "Shcherba i fonologiia." In *Pamiati Akademika L'va Vladimirovicha Shcherby (1880–1944): Sbornik Statei,* eds. B. A Larin, L. R. Zinder, and M. I. Matusevich, 61–72. Leningrad: Izdatel'svo Leningradskogo gos. universiteta, 1951.

Zolotukhin, Valeriy. "Ob izuchenii zvuchashchei khudozhestvennoi rechi v Rossii v 1910-1920-e gody." In *Zvuchashchii serebriannyi vek. Chitaet poet,* ed. E.M. Shuvannikova, 301–317. St. Petersburg: Nestor Istoriia, 2018.

Zoneff, P., and E. Meumann. "Über Begleiterscheinungen psychischer Vorgänge in Athem und Puls." *Wundt's Philosophische Studien* 18.1 (1901): 1–114.

Index

Page numbers in *italics* indicate illustrations. Titles of books and articles are located under the author's name; films are indexed by title.